DATE DUE			
Oct 21 '80			

THE PELICAN HISTORY OF ART
Joint Editors: Nikolaus Pevsner and Judy Nairn

Sinclair Hood
THE ARTS IN PREHISTORIC GREECE

Sinclair Hood was born in 1917, and after studying Classics at Harrow School took his degree in Modern History at Oxford. While at Oxford he developed an interest in art as well as archaeology, and formed plans for making a career in Byzantine art. But at the end of the war his interest became centred upon the Bronze Age of Crete, and after taking the Diploma in Prehistoric Archaeology at London University under the late Professor Gordon Childe, he went in 1947 as a student to the British School at Athens. In the following years he travelled in Greece, Syria, and Turkey, taking part in various excavations, notably at Jericho under Dame Kathleen Kenyon and at Atchana under the late Sir Leonard Woolley. He served for a couple of years as Assistant Director of the British School at Athens, and from 1954 to 1961 was Director. During this time he worked at Mycenae under the late Professor Wace, and conducted excavations for the British School at Emporio in Chios and at Knossos in Crete. Since 1961 he has been engaged in preparing reports of these excavations, in intervals of lecturing in this country and in America. He lives near Oxford, and is married, with three children, a son and two daughters. Previous books include *The Home of the Heroes: the Aegean before the Greeks* (1967), and *The Minoans: Crete in the Bronze Age* (1971).

Sinclair Hood

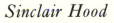

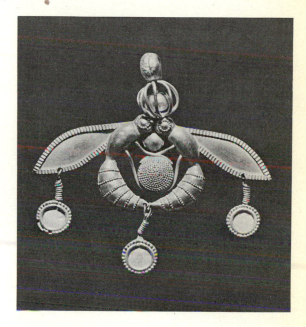

THE ARTS
IN
PREHISTORIC
GREECE

Penguin Books

709.38
H76a
109041
april 1979

TO MY WIFE

Penguin Books Ltd, Harmondsworth, Middlesex, England
Penguin Books, 625 Madison Avenue, New York, New York 10022, U.S.A.
Penguin Books Australia Ltd, Ringwood, Victoria, Australia
Penguin Books Canada Ltd, 2801 John Street, Markham, Ontario, Canada L3R 1B4
Penguin Books (N.Z.) Ltd, 182–190 Wairau Road, Auckland 10, New Zealand

Copyright © Sinclair Hood, 1978
First published 1978

Set in Monophoto Ehrhardt
by Oliver Burridge Filmsetting Ltd, Crawley, Sussex
Made and printed in Great Britain by
Fletcher & Son Ltd, Norwich
Designed by Gerald Cinamon and Paul Bowden

LIBRARY OF CONGRESS CATALOGING IN PUBLICATION DATA

Hood, Sinclair.
 The arts in prehistoric Greece.
 (The Pelican history of art)
 Bibliography: p. 277
 Includes index.
 1. Art, Prehistoric—Greece, Modern. 2. Greece,
Modern—Antiquities. I. Title. II. Series.
N5310.5.G8H66 709'.38 77-28512
ISBN 0 14 0561.42 0

CONTENTS

ACKNOWLEDGEMENTS

To all those who have helped me with advice and information I am deeply grateful, and notably to Professor Mark Cameron, who was kind enough to read a draft of the chapter on Painting. I have learnt much from his comments, and have benefited from discussions with him, although I must take full responsibility for any views stated which are not in agreement with his own.

Mr John Betts kindly read through a draft of the chapter on Seals and Gems, and I am very much indebted to him for helpful information and advice, from which I have greatly profited, although once again I must take the responsibility where I have ventured to go against his opinion.

I am obliged to Dr Reynold Higgins for his patience in answering my importunate questions about jewellery and other matters. It will be seen that I have leant heavily upon his admirable short introduction to the subject, *Minoan and Mycenaean Art*. I am also grateful to Dr Oliver Dickinson for the information he gave me about new work in Greece and for various references.

It gives me pleasure to express my gratitude to Professor Dale Trendall and Sir Nikolaus Pevsner who first invited me to undertake this work, and to Professor John Barron, as well as to my wife, for their sympathetic encouragement which kept me at my task when I despaired of ever completing it; also to Mrs Judy Nairn for the able manner in which she has improved the text and organized the book through the press, and to Mrs Susan Rose-Smith for the efficiency with which she has gathered the illustrations.

Mrs Patricia Clarke made all but two of the drawings, apart from those taken from other books and articles. I am exceedingly grateful to her for the skill and enterprise with which she has carried out this work.

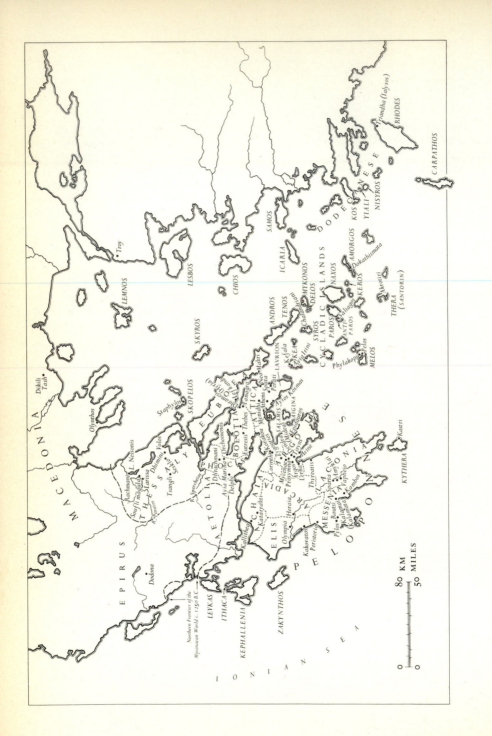

TROMBA (Ialysos)
RHODES
CARPATHOS
NISYROS
KOS
YIALI
DODECANESE
AMORGOS
Dokathismata
Akrotiri
THERA (SANTORIN)
KEROS
NAXOS
CYCLADIC ISLANDS
SYROS
ANTI PAROS
PAROS
Saliagos
Kephala
Ag.Irini
Phylakopi
Pelos
MELOS
MYKONOS
DELOS
KEA
LAVRION
Perati
Vromi
Thorikou
SAMOS
ICARIA
CHIOS
ANDROS
TENOS
LESBOS
Troy
LEMNOS
SKYROS
SKOPELOS
Staphylos
DIKILI TASH
Olynthos
MACEDONIA
THESSALY
Rachmani
L. Nesonis
Souphli magoula
R.Peneios
Larissa
Volos
Dhimini
Sesklo
Tsangli
Ag.
R.Spercheios
EPIRUS
Dodona
AETOLIA
Dhrakhmani
Krisa
Delphi
Ayia Marina
Kallithea
Katarrakti
ACHAIA
ELIS
Olympia
Kakovatos
ITHACA
LEVKAS
KEPHALLENIA
ZAKYNTHOS
EUBOEA
Lefkandi (Xeropolis)
PHOCIS
Orchomenos
BOEOTIA
Thebes
Eutresis
Manika
Nea Nikomedeia
ATTICA
Thorikou
Ag.Kosmas
Brauron
Menidhi
Eleusis
Athens
Marathon
Koukounaries
Perati
Eutresis
Corinth
Mycenae
Prosymna
Tiryns
Asine
Lerna
AEGINA
Argos
Nauplia
Dendra
Berbati
Midea
ARCADIA
Heraia
Asea
Thriacatis
ARGOLID
MESSENIA
Pylos
Routsi
Peristeria
Kalamata
Vapheio
Nichoria
Sparta
Amyklai
Menelaion
PELOPONNESE
KYTHERA
Kastri
Northern Frontier of the
Mycenaean World c.1250 B.C.

80 KM
50 MILES
0

IONIAN SEA

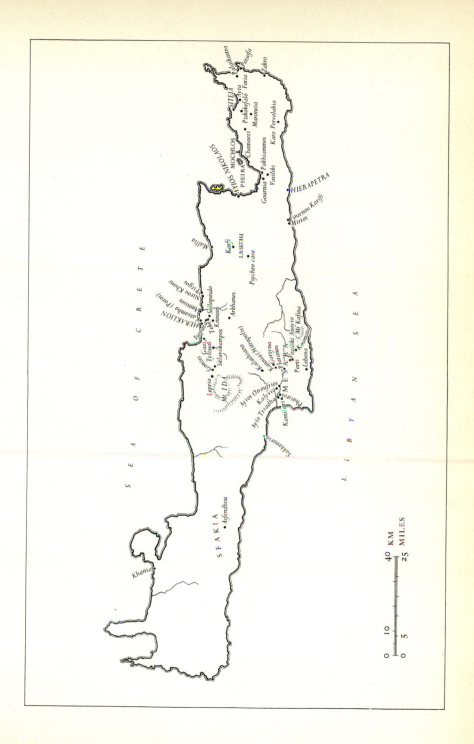

SEA OF CRETE

LIBYAN SEA

Palaikastro
Ayia Fotia
Zakro
SITEIA
Ayia
Piskokefalo
Pesofa
Chamaezi
Maroneia
Pakhiammos
Kato Parvolakia
AYIOS NIKOLOS
MOCHLOS
PSEIRA
Gournia
Vasilki
HIERAPETRA
Fournou Korifi
Mirtos
Mallia
Karfi
LASITHI
Psychro cave
Nirou Khani
Amnisos
Pirgos
Katsamba (Poros)
Vathypetro
Sellopoulo
Arkhanes
HERAKLION
Tekke
Knossos
Gazi
Skalavokampos
Gortyna
Tylissos
Kamilari Mitropolis (?)
Gonies
Lebena
Phaistos
Leptia
Mt. IDA
Kamilari
Ayia Triadha
Apoyia
Mt Kofina
Porti
Lebena Kourmulo
Ayios Onoufrios
Kalyvia
Saklionia
Skdibonia
MESSARA

SFAKIA
Asfendhou

Khania

40 KM
25 MILES

10
5
0
0

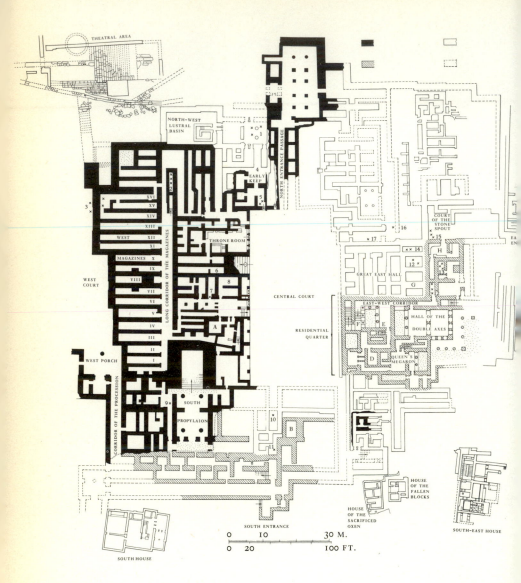

THEATRAL AREA

NORTH-WEST
LUSTRAL
BASIN

NORTH ENTRANCE PASSAGE

EARLY
KEEP

XVI
XV
XIV
XIII
WEST XII
XI
MAGAZINES X
IX
WEST VIII
COURT VII
VI
V
IV
III
II
I

LONG CORRIDOR OF THE MAGAZINES

THRONE ROOM

CENTRAL COURT

RESIDENTIAL
QUARTER

COURT
OF THE
STONE
SPOUT

EA
EN

GREAT EAST HALL

EAST-WEST CORRIDOR

HALL OF THE
DOUBLE AXES

QUEEN'S
MEGARON

H

G

F E

D

WEST PORCH

CORRIDOR OF THE PROCESSION

SOUTH
PROPYLAION

B

HOUSE
OF THE
FALLEN
BLOCKS

HOUSE
OF THE
SACRIFICED
OXEN

SOUTH-EAST HOUSE

SOUTH ENTRANCE

0 10 30 M.
0 20 100 FT.

SOUTH HOUSE

A. Central Treasury
B. Seal Workers' Shop
C. Shrine of the Double Axes
D. Treasury
E. Service Stairs
F. Grand Staircase
G. Loomweight Basement
H. School Room

▅

Walls in use at the time of the final destruction in the fourteenth century: ground floors at level of Central Court

▨

Walls in use at the time of the final destruction in the fourteenth century: ground floors below level of Central Court

▭

Earlier walls and foundations, some of which may have been in use at the time of the final destruction

▢

Conjectural walls and foundations

1. North-West Fresco Heap
2. Hieroglyphic Deposit
3. Camp Stool Fresco
4. Saffron Gatherer Fresco
5. Miniature Frescoes and
 Spiral Reliefs from Ceiling
6. Jewel Fresco
7. Vat Room Deposit
8. Temple Repositories
9. Cup Bearer Fresco
10. Priest King Fresco
11. Palanquin Fresco
12. High Reliefs
13. Store of Spartan Basalt
 (Lapis Lacedaemonius)
14. Faience 'Town' Mosaic
15. Taureador Frescoes
16. Draughtboard
17. Ladies in Blue Fresco

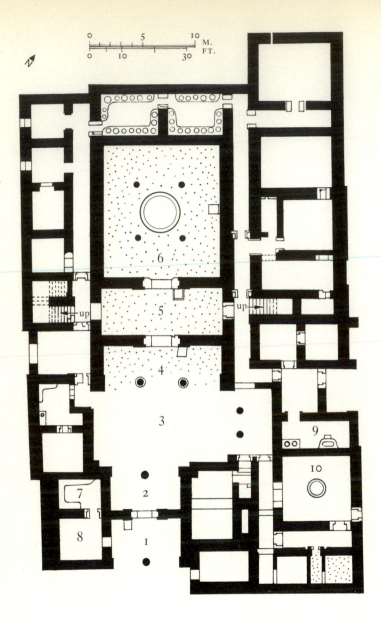

PYLOS, PLAN OF PART OF THE PALACE

1, 2	Monumental propylon with porch each side	6	Megaron
3	Courtyard	7, 8	Archives rooms with tablets
4	Portico	9	Bathroom
5	Vestibule of the megaron	10	Queen's Hall

Floors of painted plaster

B.C.	Egypt	Crete (Minoan)	Cyclades (Cycladic)	Mainland (Helladic)	Thessaly	B.C.
1000	XXI	SUB-MINOAN		PROTO-GEOMETRIC		1000
1100	XX	LATE MINOAN III C	LATE CYCL.	LATE HELLADIC / MYCENAEAN — SUB-MYC. III C		1100
1200	XIX	B		B		1200
1300		A 2 1	III PHYLAKOPI	A 2 1		1300
1400	Amarna	II		II	MIDDLE	1400
1500	XVIII	I B / A / LATER PALS.	Conquest of Crete / Eruption of Thera	I — Shaft Graves	BRONZE	1500
1600	Hyksos	MIDDLE MINOAN III B / A	MIDDLE CYCL. III	MIDDLE HELLADIC / LERNA	AGE	1600
1700	XIII-XIV					1700
1800		II B / A EARLIER PALACES	II		V	1800
1900	XII	I B / A	I		EARLY BRONZE	1900
2000	XI	EARLIER PALACES	I KASTRI	III / IV	AGE	2000
2100		III	III	EARLY HELLADIC		2100
2200	F.I.P. VIII-X	EARLY MINOAN	EARLY CYCLADIC		RAKHMANI	2200
2300		C		II / III	LARISSA	2300
2400	VI	B	II SYROS		DHIMINI 4	2400
2500	V	II A			3	2500
2600	IV	B	I PELOS	I ?	NEOLITHIC 2 ARAPI	2600
2700		I A		LATE II	1 TSANGLI	2700
2800	III			NEOLITHIC	SESKLO	2800
2900	II		LATE	MIDDLE	PRE-SESKLO	2900
3000	I	LATE	NEOLITHIC	I	PROTO-SESKLO	3000
	PRE-DYNASTIC	NEOLITHIC MIDDLE		EARLY	EARLY POTTERY	
		EARLY II / I	?			
		PRE-POTTERY	?	PRE-POTTERY	PRE-POTTERY	

INTRODUCTION

This volume covers the Neolithic and Bronze Ages of the Aegean, a span of some five thousand years, of which the Bronze Age accounts for less than two thousand: from *c.* 3000* or later to shortly before 1000. The area here considered divides into three main regions: Crete, the Cycladic islands, and the Greek mainland. Each had recognizably different traditions throughout most of the long span of time covered. Nevertheless it has seemed to me less confusing to organize the material by categories, e.g., pottery, painting, sculpture, etc., rather than by geographical regions or periods of time.

It is true that the Bronze Age of the Aegean is conveniently separated by two major political events: an irruption of invaders, apparently from Anatolia, into some of the islands and parts of the Greek mainland a couple of centuries or so before 2000; and a horizon of destruction in Crete, effected it seems by conquerors from the mainland *c.* 1450, some fifty years after a great eruption of the volcano on the island of Thera (Santorin). These events, however, while they profoundly affected life and the development of the arts in the Aegean area, are hardly comparable with the periods of foreign domination, the First and Second Intermediary Periods, which divide the Old from the Middle, and the Middle from the New Kingdom in Egypt. The Anatolian invasions of the Aegean towards the end of the third millennium do not appear to have touched Crete, and the conquest of Crete by people from the mainland *c.* 1450 occurred at a time when they had already begun to appreciate and enjoy the fruits of Cretan civilization.

The Bronze Age civilization of Crete has been named Minoan, after Minos, the legendary king of Knossos; that of the Cyclades is called Cycladic, that of the Greek mainland Helladic.

*All dates are B.C. unless A.D. is specified.

The term Mycenaean is used to describe the Late Bronze Age civilization of the mainland from *c.* 1550 onwards, and is often extended to cover the civilization of the Aegean as a whole in the centuries after the mainland conquest of Crete *c.* 1450.

Even during this period at the end of the Bronze Age there are clear regional differences between Crete, the Cyclades, and the Greek mainland; earlier, and notably during the long Neolithic period which preceded the Bronze Age, they are still more obvious. The differences in pottery styles are particularly striking. But such differences may have existed against a background of a certain uniformity of customs and ways of life even in Neolithic times. Thus at the beginning of the Neolithic the same types of figurines were at home from Thessaly to the southern Peloponnese on the Greek mainland. The use of obsidian from the island of Melos throughout the Aegean from the beginning of the Neolithic onwards suggests a certain amount of contact, if not a common understanding, between the different parts of it.

At the beginning of the Bronze Age what can reasonably be described as a *koine*, a common civilization although with regional differences, arose in the Aegean area. The existence of this *koine* is reflected in discussions as to whether marble figurines of Cycladic type found in Crete were made there or imported from the islands (see p. 94), and whether the large collections of sealings from Lerna on the Greek mainland were impressed by Cretan or by native seals (see p. 214).

The unitary character of Aegean Bronze Age civilization, although lost for a time during the period of invasions of the mainland and islands at the end of the third millennium, became even more strongly marked owing to the process of Minoanization from *c.* 1700 onwards. It is reflected in an acute way when it comes to a con-

sideration of the treasures from the Mycenae shaft graves dating from the beginning of the Late Bronze Age in the sixteenth century; are they imports from Crete, made by Cretan artists adapting to mainland tastes, or by natives trained in a Cretan manner, or by natives in a style of their own? The conventional view of the earliest wall-paintings of the mainland, assignable to the period immediately after the shaft graves, regards them as Cretan work. All this emphasizes the difficulties in the way of a satisfactory regional division of the artistic material.

Note on Chronology

The Aegean Bronze Age is dated by correlations with Egypt, which enjoys a history based upon written records of some kind from the time of the Old Kingdom in the third millennium onwards. The earlier part of the Bronze Age in the Aegean was roughly parallel with the Old Kingdom and the First Intermediary period; the Aegean Middle Bronze Age with the Middle Kingdom, the Eleventh and Twelfth Dynasties, and the Hyksos period; and the Late Bronze Age with the New Kingdom from the Eighteenth Dynasty onwards. Dates obtained by scientific methods, mostly radiocarbon dates from samples of wood or bone, but including some thermoluminescent dates from pottery, are now available for the Bronze Age and Neolithic of the Aegean area. But, as far as the Bronze Age is concerned, they are not yet precise enough to be useful as a check upon dates obtained by archaeological correlations with the historical chronology of Egypt.

Absolute dates can only be given within wide limits, and those quoted are conventional, although the margin of error for the earlier part of the Bronze Age is unlikely to be more than a few centuries; for the period after *c.* 2000 it is much narrower, and for the end of the Bronze Age from *c.* 1500 onwards narrower still. The margin of error is chiefly due to the imprecise or disputable nature of the evidence derivable from Egyptian contacts. At the same time Egyptian dates themselves are not for the most part fixed beyond dispute or the possibility of

change in the light of new evidence. The Egyptian dates used here are those adopted by Drioton and Vandier[1] – not that these are necessarily more correct than other systems, but because they provide a convenient norm in the absence of universal agreement.

The archaeological periods to which objects are assignable have normally been given as well as conventional dates. The Chronological Table on p. 15 shows how the archaeological periods of each region of the Aegean are related, and how they are dated here. But until the Late Bronze Age it is by no means certain how the sequences in the different regions of the Aegean – Crete, the Cyclades, and the Greek mainland – are related except within relatively wide limits.

These archaeological periods are defined by changes of style, especially those that can be detected in the shapes and decoration of pottery. This has led to some confusion in terminology, the same terms being employed both for periods of time and for pottery styles. But pottery styles may linger in some regions long after they have gone out of fashion in others, continuing that is to say over more than one period. As a consequence the use of the same terminology for periods and for pottery styles has given rise to curious illogicalities of expression and thought, with periods conceived as overlapping in time. The undesirability of this confusion has often been emphasized,[2] and the warning as often ignored. The terms Minoan, Cycladic, Helladic, and their subdivisions, are best reserved for periods of time, and not for styles.[3]

But because the definition of these archaeological periods is indissolubly linked with changes in pottery styles, it has seemed advisable to deal with pottery first, although it was in most periods a relatively humble art. Painting and sculpture, which were probably the most important of the arts in the eyes of contemporaries, are considered next. The so-called minor or applied arts follow, classified by material (wood, shell, bone, and ivory; faience and glass), or by a mixture of material and function (stone and metal vases), or by function alone (arms, jewellery, seals and gems).

HISTORICAL SUMMARY

The Aegean area forms more or less of a geographical and climatic unity. Throughout most of history it has been occupied by successive peoples or groups of related peoples sharing the same civilization and often joined in a single political body. But from time to time the eastern shores of the Aegean have become incorporated in a separate political and cultural area; during most of the Neolithic and Bronze Ages they formed part of the Anatolian world of which Troy was a main centre.

Those parts of the Aegean which concern us fall into three main regions, from south to north: (1) Crete; (2) the islands of the Cyclades and other neighbouring groups of islands such as the Dodecanese with Rhodes, and the Sporades; (3) the Greek mainland, or rather southern and central Greece including the Peloponnese, Attica, and Boeotia (the northern parts of Greece, Thessaly and Macedonia, virtually belong to a different cultural sphere until the very end of the Bronze Age).

The Aegean is an area of mountains, and the Cycladic islands are really the peaks of submerged mountain chains. But cultivable plains are to be found in every region, although these are more extensive in the north, in central Greece and Thessaly. The sea has always acted as a link rather than as a divide in this area. The coastal regions enjoy a particularly genial climate. The earth is bountiful, and was better watered during the Neolithic and Bronze Ages than it is now, when so much of the forest cover which helped to retain ground water has succumbed to the ravages of men and goats. The vine and the olive grow throughout the coastal regions of the Aegean area, and their fruits were no doubt staples of diet in the Bronze Age, if not earlier, as they still are.

In short the coastal parts of the Aegean area fall within the zone of the most favourable Mediterranean climates in post-glacial times.[1]

It was an area which would have offered an attractive home to any people coming from the eastern shores of the Mediterranean, from Cilicia, Syria, or Palestine, which had a similar ecology and climate. As in later times, the Aegean would have equally presented a temptation and an attraction to the inhabitants of harsher and less favoured regions, such as the Balkans to the north, or the hinterland of Anatolia to the east.

In the last three thousand years successive conquerors – Romans, Slavs, Arabs, Latins from the west and Turks from the east – have overrun and settled the whole or parts of the Aegean area. In addition it has suffered from many transient incursions, by Persians, Gauls, Herules, Goths, and others. It is therefore hardly surprising that the archaeological evidence should hint at a number of invasions and migrations during the span of several millennia which concerns us.

NEOLITHIC

The mainland of Greece has been inhabited more or less continuously from the earliest times. Traces of Palaeolithic occupation have been noted in various parts of the Peloponnese. Both there and in Thessaly Upper Palaeolithic industries were succeeded by varieties of Mesolithic, which eventually gave way to a phase of agricultural settlement without the use of pottery. If the calibrated radiocarbon dates are to be trusted the beginnings of agriculture on the Greek mainland might date from as early as the seventh millennium, but it is not clear whether they reflect the arrival of immigrants from beyond the Aegean area, driving out the few Mesolithic hunters or mixing with them, or whether the necessary ideas and skills were adopted by the native population as a result of contacts with people further east. Such contacts no doubt

existed: obsidian from the island of Melos was in use for implements in Thessaly by Mesolithic times, which implies that boats were already making voyages across the Aegean.

In Crete, however, there are no indisputable traces of Palaeolithic or Mesolithic occupation, and a Prepottery phase at the base of the Neolithic deposits at Knossos appears to reflect the arrival of the first human inhabitants from overseas.[2] Moreover the earliest Neolithic pottery of Knossos is very evolved, as if it had been introduced by a new wave of immigrants from some more civilized region.[3] In Thessaly by contrast what appear to be rudimentary first attempts at pot-making have been identified,[4] although it is still likely that even there the idea of making pottery was adopted from beyond the Aegean to the east.

In Thessaly as in Crete the Neolithic inhabitants appear to have been at a relatively advanced stage of civilization almost from the start. They lived in houses with rectangular rooms and buried their dead outside their settlements. Eventually Neolithic settlements with ways of life based upon agriculture came to be established in all parts of the Greek mainland as well as in Crete and the islands. Some of these settlements, like that at Knossos in Crete and one at Sesklo in Thessaly, were very extensive, towns rather than villages.

There are considerable variations in the types of pottery made during the Neolithic in different parts of Greece, and important differences in such basic matters as burial customs. But figurines of the same naturalistic type were in use in the early part of the Neolithic from Thessaly to the southern Peloponnese [68], and comparable figurines were current in Crete [67C]. These figurines are related to types found in early Anatolia and further east. The successive fashions in pottery in the Neolithic of the Greek mainland similarly appear to reflect stages which follow each other in the Near East.[5] The Neolithic of Crete, however, seems to have developed with relatively little influence from abroad.

In some parts of the Aegean area, including Crete, copper tools were already in use before the end of the so-called Neolithic. Traces of metal-working with fragments of crucibles have been identified in the settlement of Kefala on Kea assignable to the Late Neolithic of the Cyclades,[6] and some Late Neolithic pottery on the Greek mainland seems to have been made in imitation of imported metal vases (see p. 30).

EARLY BRONZE AGE (c. 3000–2000 B.C.)

The beginning of the Bronze Age in the Aegean is defined in terms of changes in pottery, which are very marked in Crete and in the southern part of the Greek mainland. These changes may reflect some degree of immigration into the Aegean, and new immigrants might even have introduced techniques of metal-working to Crete, where there are signs of dislocation suggestive of warfare and possible invasion at the end of the local Neolithic. Crete may well have been a goal for immigrants from the eastern shores of the Mediterranean, ravaged by wars of conquest and invasions of barbarous peoples from time to time during the course of the third millennium.

Each of the four main areas of the Aegean has something of an independent development at the beginning of the Early Bronze Age, most marked in the case of Thessaly and Macedonia, where the end of the Neolithic may date from a time when the Early Bronze Age further south was well advanced. The archaeological sequences for Thessaly and Macedonia, and for the three main regions – the southern part of the Greek mainland, the Cyclades, and Crete – have been given different names in recognition of the differences that exist between them.

The first reasonably complete sequence for the Aegean Bronze Age was established by excavations at Phylakopi on Melos, where three successive 'cities' were identified on the analogy of the 'cities' noted by Schliemann and Dörpfeld at Troy. Melos was the main source of the obsidian which was used for tools throughout the Aegean area from Neolithic times or earlier. The work at Phylakopi was almost immediately

followed and largely eclipsed by the excavations of Sir Arthur Evans at Knossos in Crete from 1900 onwards.

Evans called the Cretan Bronze Age Minoan, after Minos, the legendary king of Knossos, and divided it into three periods, Early, Middle, and Late, each with three main subdivisions. Each of these nine subdivisions was definable in terms of changes of fashion, and more specifically in terms of changes of style in the pottery made at Knossos. This ninefold system was eventually imposed by Blegen and Wace upon the rest of the Aegean, using the term Helladic for the Bronze Age of the mainland, and Cycladic for that of the islands, although nine successive archaeological periods could not in fact be distinguished in those regions at the time. Thessaly and Macedonia have escaped this strait-jacket, and the archaeological sequences there are only now beginning to crystallize in the light of recent excavations.

There is no absolute agreement as to how these sequences should be correlated with each other. In general, those for Crete, the Cyclades, and southern Greece appear to be roughly parallel, so that Early Minoan II corresponds to Early Cycladic II and Early Helladic II. But what are defined as Early Minoan I and Early Cycladic I may have begun somewhat earlier than the rather shadowy Early Helladic I of the mainland (see p. 33). The beginning of the Cretan Bronze Age (Early Minoan I) may date from about the time of the First Dynasty in Egypt, in round terms c. 3000, or not much later.

About the middle of the third millennium, in Early Minoan II, Early Cycladic II, and Early Helladic II, a flourishing civilization of a primitive kind developed in the Aegean. This roughly overlapped with the Pyramid Age (Dynasties IV–V) in Egypt. The same types of bronze tools and weapons, the same kind of toilet implements reflecting similar fashions, were now in use in Crete, the Cyclades, and the southern part of the Greek mainland, if not in Thessaly and Macedonia. The peoples of the Aegean at this time had probably reached a similar stage of

development in terms of social organization as well as of material culture. A small palace of this period, the House of Tiles, has been identified at Lerna on the Gulf of Nauplia in the north-eastern Peloponnese. The peoples sharing this Early Bronze Age civilization in the Aegean may have been of related stock, speaking the same or similar languages of a non-Greek, and probably non-Indo-European type, with affinities to the earliest languages spoken in Anatolia.

The Early Bronze Age pottery, however, in each of the four regions of the Aegean reflects different traditions, and there was a considerable diversity in burial customs. In Crete burial was in communal tombs, of which the most spectacular were circular structures built above ground and apparently once domed.[7] These early Cretan tombs were used by a clan or a whole community for generations, and they often contained the remains of several hundred bodies. The people of the Cyclades, poorer in resources and supporting smaller, less wealthy communities – the lack of Egyptian and Oriental imports in the Cyclades in contrast to their relative abundance in Crete is striking – buried their dead in small tombs which usually contained only one body, although tombs might be grouped in family cemeteries.[8] On the mainland burial in family tombs seems to have been usual.

At Lerna and elsewhere on the mainland Early Bronze Age settlements were often defended by massive walls with towers, and it looks as if the Aegean at this time was divided between small independent states, which no doubt engaged in perennial warfare like the city states of Mesopotamia and Syria. A colony of Cretans appears to have replaced a settlement of people with pottery of Early Helladic II type on the island of Kythera between the western tip of Crete and the Peloponnese before the end of the third millennium.[9] There is no evidence that the Early Helladic II people here were absorbed by the Cretan immigrants. They were presumably massacred or enslaved, unless they escaped by sea to the mainland.

The flourishing Early Bronze Age (Early Helladic II) civilization on the mainland ended

with the sudden destruction of Lerna and many other settlements in the eastern part of the Peloponnese, followed by the arrival of new settlers who were evidently a good deal more barbarous than the previous inhabitants; the new types of pottery [2B] which they introduced, together with rough clay stamp seals (see p. 214), and long houses with a semicircular room at the far end opposite the door, suggest that they may have come from the hinterland of Anatolia.

About the same time, around 2000 or a century or two earlier, other people, undoubtedly in this case from Anatolia, moved into some of the Cycladic islands and into Euboea. One group settled at Ayia Irini on Kea, and another at Chalandriani on Syros, where they defended themselves with a double wall on a hill-top across the gorge from the previous settlement and its important cemetery of Early Cycladic II (Syros phase) date.[10] These island settlers may have come from the relatively civilized coastal areas of Anatolia, since they were already making pottery on the fast wheel – a useful invention soon adopted on the Greek mainland and in Crete.

There has been much speculation as to who these Anatolian invaders were. According to one view, those who occupied the mainland were the first Greeks to settle there, or at any rate spoke a language out of which the Greek dialects of later times were to develop. But it seems more likely that they were peoples with languages and traditions not unrelated to those already current in the Aegean area. This movement across the Aegean may have been stimulated, however, by the arrival of people of Indo-European speech, ancestral to Hittite and Luvian, in Anatolia.

MIDDLE BRONZE AGE (c. 2000–1450 B.C.)

There is some evidence for a second invasion of southern Greece and the Peloponnese at the end of Early Helladic III a couple of centuries or so later. The invaders on this occasion appear to have come from the Balkans to the north, and their arrival more or less coincided with the beginning of Middle Helladic on the main-

land – a moment actually defined in terms of the rise of a fashion for pottery decorated with designs in dull matt instead of shiny lustrous paint (see p. 40). As in Early Helladic III, the standard type of house on the mainland during the Middle Helladic period was long, with a semicircular room at one end. Burials were in earth-cut graves which might be lined with upright slabs of stone to form cists. At the beginning of the period graves were often placed inside the settlements, but they are also found out in the countryside, in cemeteries, or grouped in large artificial mounds, the latter especially at home in the western part of the Peloponnese in Messenia.

Crete does not seem to have been conquered or occupied by invaders during this period of upheaval on the mainland and in the islands, and Early Minoan civilization evolved without a break into that of Middle Minoan times. The beginning of Middle Minoan is defined as the point when dark-surfaced pottery decorated with designs in red as well as white paint came into fashion at Knossos. About this time palaces with rectangular central courts appear to have been constructed at the main centres of Knossos, Phaistos, and Mallia. Palaces something like this are found in Anatolia during the Bronze Age there, and it has been suggested that the development of comparable ones in Crete might reflect the presence of Anatolian conquerors; but the similarities are not close, and the great Cretan palaces seem more likely to be an expression of increasing wealth, even if, as is probable enough, some ideas for them reached Crete (and Anatolia) from the Near East.[11]

The palace at Phaistos was destroyed by fire towards the end of Middle Minoan II c. 1700, and there was evidently some damage to that at Knossos about the same time or not much later. These disasters may have been due to natural causes or to wars between local kings. The period of the later palaces is conventionally dated from the beginning of Middle Minoan III, but it looks as if at Knossos, and also perhaps at Phaistos, a great rebuilding was initiated at the end of Middle Minoan III a century or so later. Whatever the significance of this, the

seventeenth and sixteenth centuries were the most flourishing of the Cretan Bronze Age, and the bulk of the fine objects discussed in the following chapters dates from then, including the most beautiful of the wall-paintings, and the best of the gems and the remarkable stone relief vases. A marked decline in the quality of fine decorated pottery after *c.* 1700 no doubt reflects the availability of plate, vessels of gold and silver, at the tables of Cretan kings and nobles.

During the period from *c.* 1700 Cretan influence became increasingly predominant in the islands. Colonists from Crete appear to have settled in the seventeenth century at Ayia Irini on Kea, and somewhat later at Triandha (Ialysos) in Rhodes, as they had long before on Kythera. Other centres in the islands, and even parts of the Greek mainland, may have been tributary to Crete, as legend indicates.[12] Thera, so close to Crete, could hardly have escaped payment of tribute if it was exacted from other Cycladic islands, and some Cretans may have lived there. But the brilliant mixed civilization, owing much to Crete but subtly different in character, which has been revealed by recent excavations in the chief settlement near Akrotiri, seems to reflect a dominantly native population retentive of its own traditions.

By the end of the sixteenth century if not earlier, Crete appears to have been united under the rule of Knossos. But the existence of large palaces at other centres like Phaistos, Mallia, and Zakro, along with the scatter of smaller palaces and chieftains' houses throughout the island, suggests some kind of confederacy of local ruling families under the hegemony of Knossos, rather than a system of direct rule by officials despatched from the capital. The Greek mainland by contrast seems to have been divided between a number of small independent states, an easy prey to conquest and the imposition of tribute by a strong centralized power. Possibly the local dynasts buried in the shaft graves at Mycenae were tributary to Crete, but legend gives no hint of this.

The Shaft Grave Period on the Mainland (*c.* 1575–1475 B.C.)

Mainland contacts with Crete had never been interrupted for long, it seems, and after *c.* 1700 Cretan influences became increasingly strong there. This is reflected in the treasures of the two circles of shaft graves at Mycenae, with burials covering a period of about a hundred years, rather more than the span of Late Minoan I A, from early in the sixteenth into the first half of the fifteenth century. Each group of graves was enclosed by a circular wall. Circle A had six graves containing seventeen adult burials cleared by Schliemann in 1876, while circle B with some fourteen graves was discovered only in 1951. The burials, apparently those of rulers of Mycenae with their kinsmen, retainers, and womenfolk, seem to overlap in time, but in general the ones in circle B are earlier.

The graves, virtually unplundered, have produced a striking quantity of gold and silver vessels and gold ornaments of every kind which, displayed in the Mycenaean room of the National Museum at Athens, give an impression of boundless wealth. But the weight of the gold from the rich graves of circle A has been estimated at about fifteen kilos, less than the weight of an international air-travel baggage allowance, and considerably less than the weight of the inner coffin of Tutankhamun. Even with recent escalating prices for gold, assuming $125 the Troy ounce, the shaft grave gold would not be worth much more than $60,000. Moreover the shaft grave gold was very far from being pure.

Many of the objects from the shaft graves are in a fine Cretan style. There are also a number of objects decorated in a native style which is easily distinguishable from the Cretan. But it is often difficult to decide whether objects in a Cretan style were imports, or made by Cretans working to the orders of Mycenaean lords, or by natives taught by Cretan masters or imbued with Cretan ideas. The vessels of faience and stone appear to have been imported (pp. 135, 147). The evidence suggests that the few pieces

of Cretan-style jewellery, and (more debatably) the gold signet rings and seals, were also imports (pp. 199-200, 226). The same may be true of the two great silver relief vases (pp. 160-3), and, in spite of their large numbers, of the inlaid daggers and the swords of Cretan type (pp. 181, 175). But the less numerous type B swords with their gold mountings decorated in the native style were evidently of local manufacture, as were some of the gold and silver cups, even when their shapes were of Cretan derivation. Similarly the Mycenaean pottery which appears in some of the later shaft graves of circle A is of local fabric and appears to have been made by native craftsmen (see p. 40).

Cretan influence was strong by this time in other parts of the mainland besides the region of Mycenae, and nowhere stronger than in the south-western corner of the Peloponnese in Messenia, where local rulers were buried in circular vaulted tholos tombs instead of in shaft graves. These tombs seem to have been inspired by the earlier circular tombs of Crete, some of which were still in use for burials in the sixteenth century and later.[13] On the mainland, however, the circular chamber was covered by an earth mound, and was usually sunk deep in the ground, instead of being built above it as in Crete. The earliest tholos tombs, dating from c. 1550, are concentrated in Messenia, but within a couple of generations or so they had replaced shaft graves for the burial of princes at Mycenae and elsewhere in the Argolid. Their distribution was eventually coterminous with the area of the Mycenaean civilization on the Greek mainland.

The Eruption of Thera, and the Conquest of Crete c. 1450 B.C.

The settlements on Thera, with their lively hybrid civilization of Cycladic and Cretan origin, were overwhelmed by an eruption of the volcano in Late Minoan IA c. 1500. There is evidence for severe damage by earthquake at Knossos during the same period, and also it seems rather earlier in Middle Minoan IIIB when the Temple Repositories in the palace

were filled. Traces of dislocation, whether due to earthquake or to other natural causes, can be detected in Late Minoan IA at several other sites in northern and eastern Crete. Signs of an impoverishment and decline in artistic vitality observable during the succeeding Late Minoan IB period could be interpreted as an aftermath of the eruption, but are more likely to reflect the stagnation which often seems to follow success in conquest and the acquisition of empire.

Towards the end of Late Minoan IB c. 1450, settlements throughout the centre, south, and east of Crete were devastated by fire, and many of them were afterwards abandoned. These disasters have been attributed to a last catastrophic fling of the Theran volcano, but it seems more likely that they represent a conquest of Crete or parts of it by invaders from the Greek mainland, since there is a good deal of evidence for the presence of mainland conquerors at Knossos during the Late Minoan II period from c. 1450 onwards. Marked changes in Knossian pottery then seem to imply efforts to cater to mainland tastes (pp. 41-2), and warrior graves round Knossos, as well as richly furnished tombs near its harbour town at Katsamba, together with the Tombe dei Nobili at Kalyvia near Phaistos, appear to belong to some of the conquerors and their families.

The whole of the island was soon brought under their control, to judge from the spread of the Knossian pottery style with its mainland characteristics. After an interval, however, there are signs of renewed Cretan influence on the mainland. To some extent this may be due to an influx of captured Cretans, including artists and craftsmen, as a result of the conquest.

LATER BRONZE AGE (c. 1450 B.C. ONWARDS)

The mainland conquest of Crete does not appear to have brought the whole of the Aegean under one rule. Perhaps all Crete was now directly controlled from Knossos, the only Cretan site where there is certain evidence for the existence of a palace after c. 1450. But a number of great palatial centres are attested on

the mainland, and a small palace of mainland type was built at Phylakopi on the island of Melos.

The decline in the arts, of which the symptoms were already apparent in Crete during the generation or so before *c.* 1450, now became increasingly marked there. Indeed a steady deterioration of vitality and an increasing bankruptcy of ideas is noticeable throughout the Aegean. One art, however, beyond the pale of this book, showed no sign of decline. This was the art of war. Significant advances were made in weaponry: formidable swords adapted for slashing as well as thrusting replaced the long rapiers of the shaft grave period, and bronze plate armour may have been evolved in connection with the use of the war chariots listed on clay tablets from Knossos and from Pylos on the mainland.

Fire destructions of palaces and towns throughout the Aegean area in the centuries after *c.* 1450 are suggestive of war to the uttermost. Parts of Knossos were burnt towards the end of Late Minoan II *c.* 1400, and the palace there was finally destroyed at a date which has not yet been established beyond dispute, but which appears to have been in the fourteenth century or in the early part of the thirteenth.[14] The era of warrior graves at Knossos, and of burial in the princely cemeteries at Katsamba and at Kalyvia (the Tombe dei Nobili) near Phaistos, seems to have come to an end at about the same time. There is no evidence to suggest that these disasters in Crete were caused by enemies from beyond the frontiers of the Mycenaean world. Perhaps they reflect a conquest of Crete by the rulers of Mycenae, which appears to have replaced Knossos as the most important centre in the Aegean; in the thirteenth century it may have been the capital of a miniature empire with control over Crete and the Cycladic islands.

There is so far nothing that indicates the existence of palaces in any part of Crete after the final destruction of that at Knossos, but they continued to flourish at various centres besides Mycenae on the mainland. It is hard to believe that places as close to Mycenae as Argos and

Tiryns remained independent during this period, and their rulers may have bought a precarious toleration by the payment of tribute. Whether the rulers of more distant centres, such as Thebes in Boeotia or Pylos, were similarly tributary is more problematical.

The civilization of the thirteenth century throughout the Aegean is remarkably uniform in spite of local differences, notably in fashions of vase decoration. The frontiers of this Mycenaean world are sharply marked and defined by the use of wheel-made pottery and the building of tholos tombs; they ran through northern Thessaly, beyond the river Peneios and the vale of Tempe, but did not embrace the region of Mount Olympus, nor Epirus with the important Greek sanctuary of Dodona. Beyond the Mycenaean frontiers was barbarism, illiterate, and unskilled in arts.

This period of comparative uniformity in the Mycenaean world was combined with manifest artistic decline. It came to an end about the turn of the thirteenth and twelfth centuries with the destruction by fire of the palace at Mycenae, and of the palaces which still survived at other centres on the mainland like Tiryns and Pylos. They were never rebuilt, and there is evidence of subsequent depopulation in the Peloponnese, and of massive emigration of Mycenaean refugees to areas like Crete and the islands of the Cyclades, as well as further afield to Cilicia and Cyprus. These destructions mark the beginning of a Dark Age in the Aegean comparable with that inaugurated by the German and Slav invasions of the fifth and sixth centuries A.D.

There is no agreement as to the cause of these destructions. A change of climate initiating a period of drought and famine has been suggested,[15] but the scientific evidence seems against this ingenious theory.[16] Wars between the Mycenaean states, or an invasion of Dorian Greeks, or of other foreigners who then retired from the land which they had devastated, are among more plausible ideas. Alternatively the destroyers may have been the ancestors of the East Greeks, entering the Mycenaean world a century or so in advance of the Dorians;[17] but the weight of opinion today is in favour of bring-

ing the first people of Greek speech into the Aegean area at the end of the Early Bronze Age *c.* 2000 or not much later.

At all events much in the poems of Homer, including perhaps the Catalogue of Ships, seems to reflect this misty period at the end of the Bronze Age, when the arts of civilized life – fresco-painting, faience-making, ivory-carving, writing, and probably seal-engraving – were extinguished for a time in the Aegean area. The art of war, however, continued to flourish, and there is no indication that the building of complex military engines, like ships with rams and spoke-wheeled chariots, ever ceased there. This Dark Age of the arts was indeed in some ways a period of technical progress, when iron first began to come into general use in the Aegean for tools and weapons.

One skill which continued in most parts of the Aegean without a break was that of making pottery on the fast wheel and decorating it in shiny paint. About the middle of the eleventh century the Protogeometric style was developed in the region of Attica. This was entirely different in spirit and character from the Submycenaean out of which it evolved, and its appearance marks the end of the Bronze Age world in the Aegean and the beginning of the road towards the future civilization of Archaic and Classical Greece.

POTTERY

Pottery was the most ubiquitous of all the arts in ancient times. It was in daily use almost everywhere like glass and china now. Like them it was comparatively cheap to make and easily broken, although once methods of firing improved, relatively indestructible. Pottery therefore tends to form the bulk of what is left for archaeologists to find from the time when the making of it began early in the Neolithic of the Near East until the Middle Ages. As a consequence it has an immense value for chronology, and where historical records are lacking, as in the case of the Aegean Bronze Age, chronological systems tend to be founded upon developments that can be traced in the shapes and styles of decoration of clay vases.

But the importance of pottery in this connection usually outweighs its artistic value. For the art of the potter in most periods was a humble one. In early times clay vases were shaped by hand, and every household probably made what it required, although certain communities with access to good supplies of clay may have catered for a wider area. But with the evolution of the potter's kiln,[1] and above all with the introduction of the fast potter's wheel, specialized groups of potters emerged. A series of early seals from Crete engraved with pictures of men who appear to be making vases, may reflect the rise of this class of specialists there.[2]

For a short time in the first half of the second millennium the art of the potter reached a height of artistic perfection in Crete that it hardly if ever achieved again in Greek lands. The exquisite eggshell ware, and other fine vases with polychrome decoration, made in the workshops of the Cretan palaces in the nineteenth and eighteenth centuries, were surely produced by artists of the very first rank. But even these artists were heavily indebted to contemporary metal workers, from whom they borrowed vase shapes and the eggshell thinness of the finest

ware. It is symptomatic that at the time when the Bronze Age civilization of Crete was at its height c. 1600, the art of the Cretan potter reached an all-time low.

Nevertheless, because the art of making pottery was in most periods a relatively humble one, and since potters therefore tended to imitate, clay vases often provide evidence about achievements in nobler arts of which little or nothing has survived. Throughout the greater part of the Bronze Age the shapes of metal vases were reproduced in clay on a vast scale both in Crete and elsewhere in the Aegean area. Even the fluted and embossed decoration of metalwork was often imitated in paint on Cretan vases. But much of the decoration on the fine painted ware made in Crete and on the Greek mainland from the sixteenth century onwards appears to have been derived from the pictures which adorned the walls of palaces and houses at the time.

NEOLITHIC

Little of artistic interest survives from the Neolithic of the Aegean apart from figurines and pottery. The earliest pottery everywhere in the area was hand-made with plain burnished surfaces. The shapes were mostly simple varieties of jars and open bowls.

Crete

A relatively complete Neolithic pottery sequence is only available from Knossos. Important deposits uncovered at Phaistos seem to correspond to comparatively late phases of the Knossian Neolithic. Cretan Neolithic pottery appears to have evolved more or less in isolation, and is clumsy and primitive-looking, in spite of some astonishingly developed features in its earliest stages, which may reflect the character

of what the people who introduced it from overseas were making in their homeland at the time. The fine ware was invariably burnished, the surfaces of the vases being at first predominantly black, although sometimes brown or red, in colour. Brown and light-coloured surfaces, however, were more in evidence towards the end of the Cretan Neolithic. In all phases of it most of the vases were plain. Such decoration as there was in the Early Neolithic consisted of incisions [1], or more commonly of punctured

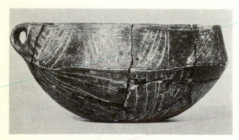

1. Bowl from Knossos. Early Neolithic II. Clay. H 0.105 m. *Herakleion Museum*

dots, filled with white or occasionally with red paste, making a bold contrast with the dark burnished surfaces. The dots were mostly arranged in triangles, or in zigzag strips or step patterns. Decoration in relief, with ribs, knobs, or warts of various sizes, was also characteristic, especially at the beginning of the Early Neolithic. During the Middle Neolithic a fashion arose for rippling the surface of the fine burnished ware through heavy pressure with the burnishing tool. The rippling, almost always vertical, catches the light in a similar way to the fluting on metal vases.

The Late Neolithic pottery of Knossos shows all the symptoms of decline.[3] The decoration continues to include a good deal of incision, but the patterns tend to be smaller and badly executed by comparison with earlier work. Some rippling is also still found, but a new technique now begins to come into fashion and at the beginning of the Bronze Age (Early Minoan I) virtually replaces incision as a way of decorating vases in Crete. This is pattern burnish, which

consists of making designs with the burnishing tool on parts of the vase which are either less well burnished, or left altogether unburnished, so that they appear a different and rather duller shade of colour. Towards the end of the Neolithic some burnished pottery in Crete was being decorated with designs in white paint, at times supplemented with red. This ware was first recognized at Phaistos, but has also been recovered at Knossos.[4]

The Cyclades

Not a great deal is yet known about the earliest history of the Cyclades. Most of the decorated ware from the only Neolithic settlement that has been excavated, at Saliagos off Antiparos, is reminiscent of the painted ware from the end of the Neolithic in Crete.[5] But the designs in white paint which might be supplemented in red include circles hanging from the rims of vases as found in the Late Neolithic of the Greek mainland. A distinctive shape is a bowl on a high foot comparable with a type which occurs in the mainland Late Neolithic.

The Mainland

The earliest Neolithic pottery of the mainland was plain burnished ware, but some pottery with painted decoration is found at a very early stage. One early (Proto-Sesklo) vase from Thessaly was adorned with a row of stylized dancing figures, although designs are usually quite abstract and linear.

2. Clay vases of various periods from the mainland (A), (B), (D), (F); Crete (C); and Thera (E) (scale 1:3, except (C) and (F), which are 1:2): (A) Bowl from Tsangli, Thessaly. Middle Neolithic. *Athens, National Museum* (B) Bowl of black burnished ware from Lerna. Early Helladic III, c. 2000. *Argos Museum* (C) Cup of metallic shape from Gournia. Middle Minoan IB, c. 1900. *Herakleion Museum* (D) Pedestal bowl of red burnished ware from Eutresis. Middle Helladic, c. 1700–1600. *Thebes Museum* (E) Jug from Akrotiri on Thera. Late Cycladic I, c. 1500. *Thera Museum* (F) Ephyraean goblet from Korakou. Late Helladic IIB, c. 1450–1400. *Corinth Museum*

A

B

C

D

E

F

In the Middle Neolithic (Sesklo phase) of Thessaly the painted ware with geometrical designs in red on a light, yellow or white, burnished surface, is often attractive in a primitive way. A characteristic design consists of flame-shaped spikes in a row [2A]. This style may have connections, even if remote ones, with the Early Chalcolithic painted ware of the Hacilar area in south-eastern Anatolia. Distinctive shapes include bowls on wide, high bases, and cups with sharp angles and broad, thin strap handles which suggest the possibility that they were inspired by the sight of metal vases from the East.[6]

In central Greece and the Peloponnese the same basic development can be traced as in Thessaly, with a phase of plain burnished ware succeeded by one where vases are decorated with red paint on a light-coloured surface. But the Neolithic painted ware of southern Greece never achieves the variety that it does in the north, and in the Middle Neolithic, roughly contemporary with the Sesklo phase in Thessaly, a class of pottery with a plain lustrous wash comes into fashion. The use of lustrous paint was to remain characteristic of Aegean pottery for millennia, culminating in the fine black glaze of Classical Athens.[7]

The beginning of the Late Neolithic on the mainland, however, is defined by the appearance of matt-painted ware, on which the paint of the designs looks dull and lustreless because the surfaces of vases are no longer burnished after they have been decorated. Bowls on high narrow stems are among new shapes which came into fashion. The Late Neolithic in southern Greece is not well known, and it may have been succeeded by Early Helladic before the Late Neolithic further north in Thessaly came to an end.

In Thessaly the Middle Neolithic of the Sesklo phase blossomed into a Late Neolithic which has been named after the important site of Dhimini near Volos, although in fact only the last two phases (Dhimini 3 and 4) are well represented there. At the beginning of the period a fine black burnished ware with designs in white paint, which was made alongside the dark-on-light painted ware, may reflect an at-tempt to imitate the shapes and appearance of metal vases imported from Anatolia or further east.[8] New motifs of decoration include loops hanging from the rims of vases, as at Saliagos in the Cyclades, and eventually in Dhimini 3 spiral designs came into fashion together with a striking style of decoration in two colours, black and a shade of red, on a light surface [3].

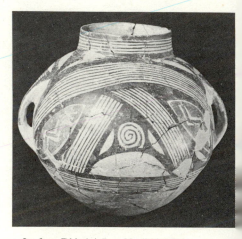

3. Jar from Dhimini. Late Neolithic. Clay. H 0.255 m. *Athens, National Museum*

EARLY BRONZE AGE (*c.* 3000–2000 B.C.)

Crete

There is a significant break in the history of pottery in Crete at the end of the Neolithic, and many new features mark the beginning of the Cretan Bronze Age (Early Minoan I), including painted ware of a distinctive type with simple linear designs in red, brown, or black on a light, yellowish surface. It is named Ayios Onoufrios ware after a site near Phaistos. Painted decoration is at first largely confined to vases of new shapes, notably the round-bottomed spouted jug which appears to be a replica in clay of a gourd vessel [4]. Narrow-necked jugs like this with handles and spouts for pouring are first attested in the Aegean in the Early Bronze Age.

Pattern burnish, which had begun to come into fashion at the end of the Neolithic, is now characteristic on vases with grey, light brown, or red surfaces, classified as Pirgos ware after an important burial cave on the northern coast east of Knossos. This pattern burnish is mostly found on bowls with tall narrow stems [5] akin to the high-stemmed bowls which appear in the Late Neolithic of the Greek mainland. There is also a fashion for it towards the end of the local Neolithic in some of the Cyclades like Kea, and in the southern part of the Greek mainland.[9] This raises the question of whether the beginning of the Early Minoan period in Crete may not overlap with the end of the Neolithic on the mainland and in the islands.

In Early Minoan II the fashion for pattern burnish disappears, and most of the finer vases are decorated with paint in the Ayios Onoufrios style. Vasiliki ware, named after an important Early Minoan settlement in eastern Crete, where it was most at home, has an overall wash, basically reddish-brown, mottled for decorative effect by deliberate control of the firing [6]. Some of the clay vases of this period clearly imitate metal ones,[10] and the mottling may have been an attempt to reproduce the sheen of copper; but it could have been inspired by the variegated surfaces of the stone vases then fashionable in parts of eastern Crete.[11]

Towards the end of the Early Minoan period wares with an overall wash and decoration in white become increasingly prominent at Knos-

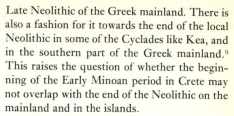

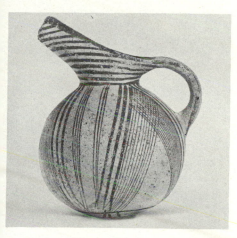

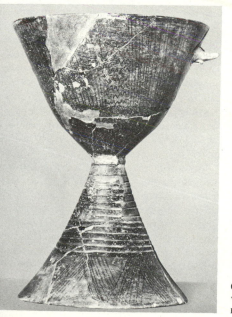

4 (*above, left*). Jug from Ayios Onoufrios. Early Minoan I or beginning of Early Minoan II, *c.* 2500. Clay. H 0.205 m. *Herakleion Museum*

5 (*left*). Pedestal bowl with pattern burnish from Pirgos. Early Minoan I, *c.* 2700. Clay. H 0.22 m. *Herakleion Museum*

6 (*above*). Teapot-shaped jar of Vasiliki ware from Vasiliki itself. Early Minoan II, *c.* 2500. H 0.185 m. *Oxford, Ashmolean Museum*

7 (*below*). Vase in the shape of a bird, perhaps a chicken, from an early circular tomb at Ayia Triadha. Probably Middle Minoan II–III, *c*. 1800 or later. Clay. H 0.065 m. *Herakleion Museum*

8 (*right*). Jar from Chalandriani on Syros. Early Cycladic II, *c*. 2500. Clay. H 0.222 m. *Athens, National Museum*

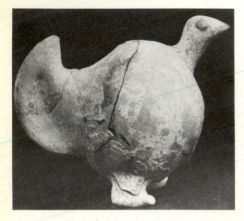

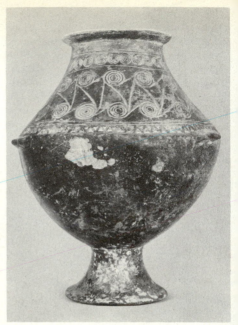

sos, and also it seems in eastern Crete. Eventually this light-on-dark fashion supplants the dark-on-light for the decoration of fine vases, and the latter is relegated to vases of ordinary domestic use, such as storage jars.

There is a fantastic variety and inventiveness in the shapes of vases during the Early Minoan period. Animal-shaped and bird-shaped vases were made as they were elsewhere in the Near East in early times [7]. One extraordinary vase from Fournou Korifi near Mirtos is in the shape of a long-necked woman, apparently a goddess, with a jug in her arms which acts as a spout.[12] This may be the earliest of a series of vases in the shape of women holding jugs or with their hands to their breasts.

The Cyclades

In the Early Cycladic I or Pelos phase of the Early Bronze Age of the islands simple incised decoration seems to be the rule. Shapes include bowls, jars on high feet (as illustration 128A), narrow-necked bottles, and circular boxes with lids. Later, in the Early Cycladic II (Syros) phase incised decoration was often combined with spirals and concentric circles made with the help of wooden stamps [8] (pp. 212–13). On the backs of the curious open dishes known as 'frying pans' (they may have been cult vessels, or even mirrors) the incised decoration sometimes incorporates boats with oars.[13] Vases with painted designs akin to those found in Crete and on the mainland at the time are also at home in the islands, but the lack of good clay may have stunted the development of a similar tradition of fine potting there.[14]

Before the end of the Cycladic Early Bronze Age vases in some of the islands like Melos were being decorated in dark matt paint on a light surface. This development may have been encouraged by the poor quality of island clay, but the inspiration for it probably came from the East. A rather comparable style, with vaguely similar vase shapes and motifs of decoration, was fashionable in Syria and Cilicia at the beginning of the local Middle Bronze Age about this time or rather earlier.

The Mainland

In Thessaly the Late Neolithic appears to have been succeeded by a couple of phases, one (named after Larissa) with fine black burnished ware decorated in white, the other (named after a settlement at Rachmani) characterized by fine crusted ware, where the decoration in thick white or rose paint was applied after the initial firing. An Early Bronze Age followed with rather coarse hand-made burnished wares of a vaguely Anatolian appearance as found in Macedonia to the north; but the Spercheios valley of southern Thessaly eventually saw a revival of painted ware with simple geometric decoration in matt black.[15]

A shadowy horizon with red burnished ware between the latest Neolithic and the appearance of characteristic Early Helladic II wares at Eutresis in central Greece has been defined as Early Helladic I.[16] It has affinities with the earliest Bronze Age (Pelos phase) of the Cyclades, and with the Kum Tepe I B horizon that immediately precedes the founding of Troy in north-western Anatolia, but it has not yet been substantially identified in the Peloponnese, where at most of the sites investigated the latest Neolithic is succeeded by levels definable as Early Helladic II.

Early Helladic II is broadly contemporary with the flourishing Early Cycladic II (Syros) phase and with Early Minoan II in Crete. The characteristic oval bowls with open spouts nicknamed 'sauceboats', often elegant and of fine fabric, may have been drinking cups.[17] There were gold sauceboats [144D] (see p. 153), but the shape is not a metallic one. At the same time it has no obvious ancestors in the Aegean. Possibly it is a reproduction of a drinking vessel made from a gourd by slicing it lengthwise and converting the neck into a spout.[18] Sauceboats and other types of vessel were often coated with a dark overall wash. Some Early Helladic II vases had incised decoration, usually quite simple, but including on one occasion a Cycladic boat,[19] and on another a lively figure of a dog.[20] There is also a class of pottery with a light surface and simple linear designs in dark lustrous paint akin to the contemporary painted ware of Crete and the islands.

The invaders who overran parts of the Greek mainland at the end of Early Helladic II evidently had no wish to drink from sauceboats, which abruptly disappear. Among new shapes introduced in Early Helladic III are two-handled bowls [2B] which may have ancestors in Anatolia.[21] By the end of the period some of them were being made on the fast potter's wheel, which first came into use on the mainland about this time. Eventually grey was to emerge as the standard colour for these bowls, and grey burnished ware of this kind became increasingly popular on the mainland during the Middle Helladic period; it is known as Minyan ware, a name given it by Schliemann after the legendary inhabitants of Orchomenos in Boeotia where he first came across it.

Some Early Helladic III pottery was decorated with simple linear designs in dark lustrous paint on a light ground. A type with designs in white paint on a dark wash, named after a site at Ayia Marina in central Greece where it appears to have been most at home, may have been inspired by Cretan light-on-dark wares of the end of Early Minoan times.

MIDDLE BRONZE AGE (c. 2000–1450 B.C.)

Crete

The change to a fashion of decorating vases with white paint on a dark surface which marked the end of the Early Bronze Age (Early Minoan III) gathered momentum, and the beginning of the Middle Minoan period is defined as the point when a fashion for decorating fine ware in two colours, white and red, became dominant at Knossos. This system of decoration had been anticipated at the end of the Cretan Neolithic (see p. 28) and it is always possible that it had lingered in some part of the island until its revival at Knossos at this time.[22]

The fast potter's wheel began to come into use during Middle Minoan I. In Crete, but not it seems elsewhere in the Aegean, the upper part on which the vase was thrown might consist of

a thick disc of clay.[23] The pottery of the earliest phase (A) of Middle Minoan I is still rough and primitive, and the designs painted on it remain largely geometric. The spiral hardly occurs on Knossian pottery of this period, although it was in general use by now in eastern Crete. The fashion for red and white designs, however, did not spread to eastern Crete until some time after it had become established at Knossos.

Many of the vases of Middle Minoan I copy the shapes of metal ones [2C] which may have been widely used in palaces and great houses before the end of the period (Middle Minoan IB) (see p. 153). Some Middle Minoan IB vases are of eggshell thinness, with stamped or painted designs imitating repoussé work on metal. The spiral has meanwhile become established as a motif of vase decoration at Knossos and Phaistos as well as in eastern Crete. Animals, and even human figures, are occasionally represented on pottery by this time. The mottling and veining of fine stone vases begins to be copied on clay ones; sometimes, with effect, if not altogether appropriately, on cups of metallic eggshell ware.[24]

With Middle Minoan II there are great advances in the potter's art, and the fine eggshell-ware cups of metallic derivation, in fabric, shape, and the beauty of their elaborate and skilfully applied polychrome designs (in white, crimson red, and orange), are of a quality and sophistication that are in some ways never rivalled again in Greek lands [9].[25] Most of the vessels made of gold and silver in Crete at this time were no doubt cups. It is therefore not surprising to find the use of eggshell ware virtually confined to drinking vessels. Small vases like these were normally thrown on the fast wheel, although some of the more elaborate may have been moulded. Many of the larger vessels, however, such as jugs and storage jars, continued to be made by hand, although like the smaller ones they were often decorated with elaborate and boldly conceived polychrome designs [10]. But this fine decorated ware was only made at the great centres – perhaps in the palace workshops; very little of it reached provincial sites.

While the shapes of the fine painted vases are often metallic, the elaborate designs are wonderfully adapted to their curves and angles. Superb use is made of spiral-based motifs, combined with stylized plant forms. Palm trees and octopuses are recognizable among the motifs fashionable at the end of the period.[26] A jar from Phaistos is adorned with leaping fish which have large ornamental loops coming out of their mouths [11],[27] but human figures are virtually excluded, on aesthetic grounds perhaps rather than for religious or magical reasons.

At the end of Middle Minoan II there was a decline in the quality of the finest pottery, and by the beginning of Middle Minoan III the manufacture of eggshell ware had ceased. Since this decline in the potter's art coincides with the period of the greatest prosperity and achievement of Bronze Age Crete, it no doubt reflects

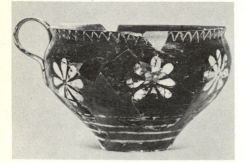

9. Cup of eggshell ware from the earlier palace at Knossos. Middle Minoan IB/IIA, *c.* 1800. Clay. H 0.075 m. *Herakleion Museum*

10. Polychrome jar from Knossos. Middle Minoan II, *c.* 1800. Clay. H 0.235 m. *Herakleion Museum*

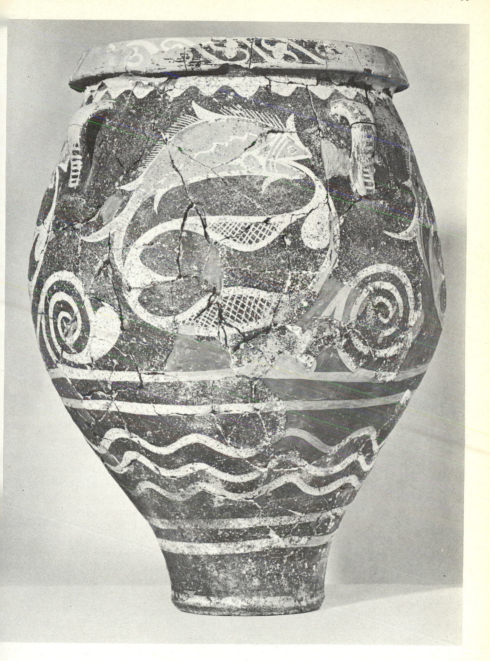

1. Jar from the early palace at Phaistos. Middle Minoan IIB, *c.* 1700. Clay. H 0.50 m. *Herakleion Museum*

the fact that, as vases of precious metal became more widely available, the lords of the Cretans no longer wanted fragile clay imitations of them.[28] At the same time the skilled craftsmen responsible for the production of eggshell ware may have been diverted to work in other more valuable materials.

But some fine vases with careful decoration were still made. A striking new development is the appearance of naturalistic decoration on vases assignable to the beginning of this period. Shells and crabs along with other marine creatures in relief are found on vases from Knossos

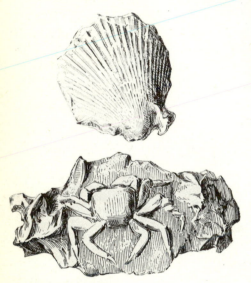

12. Marine reliefs on a vase from Knossos. Middle Minoan III, c. 1600. Clay. *Herakleion Museum*

[12], and leaping dolphins in high relief against a background of rockwork and shells on a remarkable tall vase support from Phaistos.[29] But painted decoration of plants and flowers in a naturalistic style was much commoner on clay vases than reliefs of this kind. A large jar from the palace at Knossos, assigned by Evans to the end of Middle Minoan II, but perhaps rather later in date, has groups of extremely life-like palm trees in white with details in red [13].[30] This sudden taste for naturalism was probably inspired by the earliest wall-paintings like the

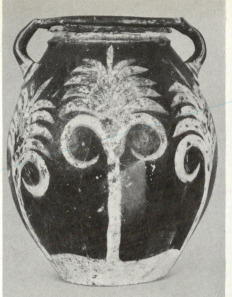

13. Jar with palm trees from the palace at Knossos. Probably Middle Minoan IIIA, c. 1600. Clay. H 0.545 m. *Oxford, Ashmolean Museum*

Saffron Gatherer [27] with its white flowers against a dark background (see p. 49).[31]

In the course of Middle Minoan III the fashion for light-on-dark pottery began to wane at Knossos, owing perhaps to the evanescent character of the white and red painted decoration. Whatever the reason, there was now a revival of fine ware decorated in brown, black, or red paint on a light, highly burnished surface. The reversion to burnishing might reflect an attempt to improve the efficiency of clay vases as containers of liquids.

Dark-on-light decoration was at first largely confined to Tortoise Shell Ripple, that is to say, to groups of close-set vertical stripes whose edges were blurred by painting them on a wet slip or burnishing before the paint was dry [14]. This austere but striking style may have been meant to imitate the shimmering flutes of metal vases.[32] But the taste for nature and for designs taken from plant life gathered momentum throughout Middle Minoan III, and plant de-

signs were soon being painted in dark-on-light as well as in light-on-dark, reflecting perhaps a change of fashion in wall-painting from dark backgrounds with flowers in white as in the Saffron Gatherer, to backgrounds of a lighter colour, white or blue, with flowers and plants

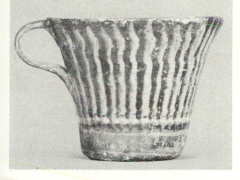

14. Cup with Tortoise Shell Ripple decoration from the palace at Knossos. Late Minoan IA, c. 1500. Clay. H 0.073 m. *Oxford, Ashmolean Museum*

showing dark against them.[33] The shift towards a dark-on-light style of vase decoration was gradual, however, even at Knossos. In eastern Crete the taste for light-on-dark lingered, and it

was still much in evidence in the early part of Late Minoan I.

In Middle Minoan III and Late Minoan IA the flowers and plants are often extraordinarily life-like, full of movement, as if blowing in the wind.[34] Late Minoan IB sees a greater variety of designs, often accompanied by a certain deterioration in the care with which the decoration is applied. Side by side with run-of-the-mill pottery, however, some outstandingly fine decorated vases have been found at Knossos and various other sites in Crete. At other sites these appear to be imports, or imitations of imports, which suggests that they may have been made originally in the palace workshops at Knossos. Much of this fine ware was decorated in a characteristic Marine Style with octopuses, argonauts, and other sea creatures, against a background of rocks and seaweed [15, A and C].[35] The elements of this style were no doubt derived from paintings, like some which have come to light in the Akrotiri settlement on Thera (pp. 63-4). The octopus with its writhing tentacles, so well adapted to enclasp curving surfaces, was skilfully exploited by the vase painters, and some of the finest examples of the Marine Style are flasks and globular stirrup jars such as illustration 15A.

15. Vases from (A) Gournia, (B) Pseira, and (C) Mallia. Late Minoan IB, c. 1450. Clay. *Herakleion Museum*

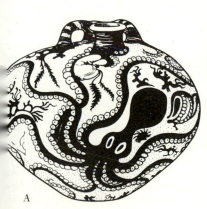

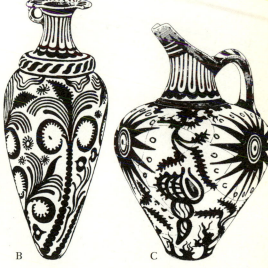

A

B

C

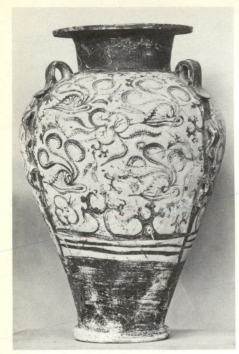

16. Jar with Marine Style decoration
from Kakovatos. Late Helladic IIA, *c.* 1450.
Clay. H 0.78 m. *Athens, National Museum*

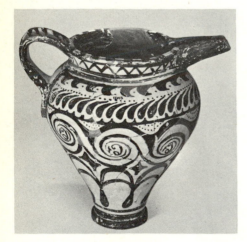

17. Jug with metallic features from
Knossos. Late Minoan IB, *c.* 1450. Clay.
H 0.22 m. *Herakleion Museum*

Most of the Marine Style, and many of the
other richly decorated vases produced at Knos-
sos at this time, were of a ritual character, or
appear to have been made for use in cult. These
cult vessels were exported throughout Crete,
and numbers of them have been recovered from
sites destroyed in the disasters of *c.* 1450. Fine
Late Minoan IB vases also reached the islands
and the Greek mainland, where they were duly
imitated [16]. As in earlier times, most of this
fine decorated ware was made in shapes copied
from metal; even the sharp rims, and the rivets
which fastened the handles of metal vases, were
carefully reproduced in clay [17].

By the end of Late Minoan IB the dark-on-
light style had almost entirely superseded the
old light-on-dark. In spite of the superb Marine
Style and other fine wares emanating from
Knossos, most of the pottery made there and
elsewhere in Crete by this time was carelessly
decorated and lacking in verve in comparison
with that of Late Minoan IA. The symptoms of
decline can be detected even in the case of the
fine wares. Thus some of the finest vases ex-
ported from Knossos, like the jug with papyrus
decoration found at Palaikastro [18], or the
Pseira palm-tree rhyton [15B],[36] 'tend towards
the grandiose "Palace Style" [Late Minoan II]
which led in due course to rigid Mycenaean
formalism'.[37]

The Cyclades

The most characteristic ware of this period as
found at Phylakopi in Melos is decorated with
simple geometric designs in dull matt brown or
black paint on a light ground. The development
of matt-painted ware may have been due in part
to the difficulty of obtaining a lustrous effect on
vases of island clay, but it also probably reflects
the spread of a fashion already at home in Syria
and in parts of Anatolia.

The islands came increasingly under the in-
fluence of Crete during the early part of the
second millennium. Cretan pottery was im-
ported and eventually imitated in towns like
Ayia Irini on Kea or Phylakopi on Melos. The
situation on Thera, nearest of the Cyclades to

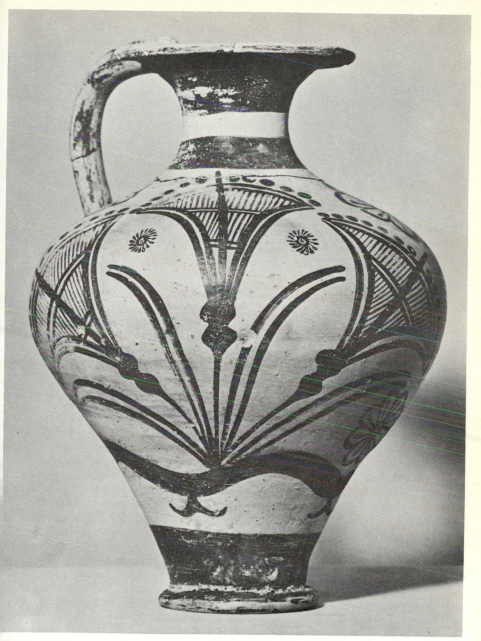

18. Jug with papyrus decoration from
Palaikastro. Late Minoan IB, c. 1450. Clay.
H 0.247 m. *Herakleion Museum*

Crete, is vividly illustrated by the new excavations in the important Akrotiri settlement, overwhelmed by the eruption of *c.* 1500.[38] Here, besides Late Minoan I A imports there are many vases of local fabric, but with shapes and decoration copied from Crete, and many others of traditional island ware like the jug of illustration 2E. Jugs of this type with backward-tilted spouts were peculiar to the islands, where they were already fashionable in the Early Bronze Age. They were conceived as women with a pair of breasts in relief and a string of beads painted round the base of the neck. The simple geometric decoration of the preceding period is now supplemented by charming designs taken from nature, mostly flowers and plants in the Cretan manner, but including griffins and birds, like the swallow of illustration 2E, foreign to the Cretan repertory. Cycladic bird vases were copied on the mainland.[39] Some of this later matt-painted ware of the islands is decorated in two colours, red and black.

The Mainland

The beginning of Middle Helladic has been defined as the moment when the fashion for pottery with simple geometric designs in dark matt paint as found in the Cyclades and further east was adopted on the mainland.[40] The immediate centre from which the fashion spread there may have been the island of Aigina, and matt-painted is sometimes called Aigina ware.

The grey burnished 'Minyan' ware (see p. 33) continued alongside it, and was now usually made on the fast wheel, in shapes which had become sharp and metallic. The smaller vases of matt-painted ware, especially cups, also tended to have angular shapes copied from those of metal vases (see p. 155). The original inspiration may have been imported Cretan metal vases, like those of the Tôd treasure (see pp. 153–4),[41] although none have been recovered on the mainland from a context earlier than the Mycenae shaft graves. Some of the plain burnished metallic ware was red [2D], and there was also a black variety (Argive Minyan) which had simple incised decoration. Eventually sharp edges were replaced by rounded profiles, and a yellow-surfaced version of Minyan became increasingly prominent alongside the grey and black.

The influence of Cretan pottery began to make itself felt during the period from *c.* 1700 onwards. The shapes, notably of cups, were much imitated, and designs of the revived dark-on-light style were copied on the mainland in matt paint. Matt-painted imitations of Cretan ware occur alongside imported Cretan vases in the shaft graves of circle B at Mycenae.

In some of the graves of circle A, however, there were a few vases of local manufacture with designs reminiscent of Late Minoan I A, executed in the Cretan technique with shiny lustrous paint. The appearance of this Mycenaean ware, as it is called, defines the beginning of the Late Helladic (Mycenaean) period on the mainland. Some of the earliest Mycenaean pottery was made by hand, although normally it seems to reflect the use of a slowly revolving wheel.[42] This tends to suggest that Mycenaean pottery was created by natives of the mainland and not by Cretan immigrants. But a clay potter's disc of Cretan type found on Aigina, in conjunction with imported Middle Minoan ware and imitations of it, might be taken to indicate the presence of Cretan potters there.[43]

The earliest Mycenaean ware may have been made in the region of Mycenae. But it is attested about the same time in Messenia in the southwestern corner of the Peloponnese, and the fashion for it appears to have spread rapidly throughout the area of what was to be the Mycenaean civilization on the Greek mainland. While the earliest designs are based upon those of Cretan Late Minoan I A, in Late Helladic II A, Marine Style and other Late Minoan I B styles of decoration came to be copied on Mycenaean vases [e.g. 16], which are then often hard to distinguish from Cretan ones.

As well as vases of Cretan shapes, others of types foreign to Crete but traditional on the mainland were painted in the new style. Thus two-handled goblets of yellow Minyan ware were decorated in an attractively restrained manner with simple designs of Cretan derivation, such as rosettes, argonauts, and lilies [2F],

one on each face of the vase. Such goblets are
known as Ephyraean, after Ephyra, somewhat
speculatively identified with the site (Korakou)
near Corinth where they were first recovered.
They were probably manufactured at a centre
somewhere in the Argolid. The decoration is
not framed between horizontal bands, as was
usual on Mycenaean vases. This freedom is
more reminiscent of Late Minoan I pottery than
of Mycenaean, and taken in conjunction with
the Cretan derivation of the designs suggests the
possibility that Ephyraean ware reflects the
presence of a Cretan potter of some merit in
the workshop which produced it.[44]

LATER BRONZE AGE (*c.* 1450 B.C. ONWARDS)

The pottery of Knossos in the period (Late
Minoan II) after *c.* 1450 shows many signs of
mainland influence.[45] A different spirit is at
work, and a tendency towards the grandiose is
expressed in the vast size and imposing but stiff

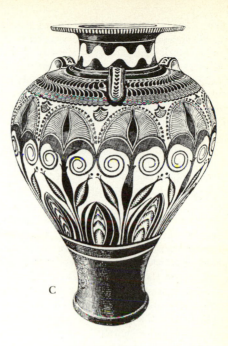

C

19. Palace Style jars with (A) birds from
Argos, (B) octopuses and (C) stylized papyrus
flowers from Knossos. *c.* 1400. Clay.
Athens, National Museum, and Herakleion Museum

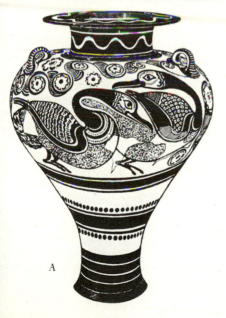

A

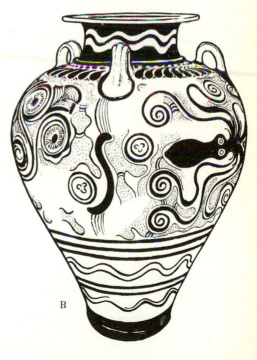

B

and frozen decoration of the so-called Palace Style amphorae, like those of illustration 19, B and C, which were peculiar to Knossos.[46] The new style appears to have developed there, but it rapidly spread to other centres. New shapes of vase introduced from the mainland include stemmed goblets decorated in the Ephyraean manner. Birds as on illustration 19A, and occasional human figures, reappear on Cretan vases, although motifs of decoration are derived for the most part from the repertory of the Plant and Marine Styles which had flourished before c. 1450. But these traditional Cretan motifs have begun to lose their life and movement. The decoration is no longer free to spread over the whole surface of the vase as in the finest products of Late Minoan I B; it is increasingly confined between horizontal bands, and regimented into upright and symmetrical forms. Even the octopus is organized with upright body and tentacles heraldically disposed each side.[47]

Both in Crete and on the mainland clay vases continue to be modelled in conscious imitation of metal ones. A group of silver vessels from a tomb at Dendra near Mycenae was found in association with clay replicas.[48] Some vases on the mainland were even coated with tin.[49]

A shape first developed in Crete in the sixteenth century, but very popular throughout the Aegean from c. 1400 onwards, is the stirrup jar like that of illustration 15A, with a narrow, easily sealed spout, and a false spout linking a pair of handles set on top next to it. The smaller stirrup jars are often elaborately decorated.

While the conquest of Crete c. 1450 brought mainland fashions there, it also helped in the long run to strengthen Cretan influence on the mainland.[50] In pottery styles as in other aspects of civilization its ultimate effect was to stimulate convergence between the mainland and Crete. During the course of the fourteenth century pottery throughout the Mycenaean world becomes increasingly standardized, and this may reflect some kind of political unity centred upon Mycenae. In the following century it is possible to speak of a *koine* or 'Empire' style, although local differences can be observed, notably in Crete. Designs ultimately derived from the

Plant and Marine Styles of Late Minoan I become more and more formal, until they bear little or no resemblance to their models in nature.

Nevertheless, while ornamentation became increasingly lifeless and monotonous, there was for a time at any rate a measure of technical advance. Methods of firing improved, and helped to make possible the creation of the high-stemmed goblet (kylix) [20] which was to be the

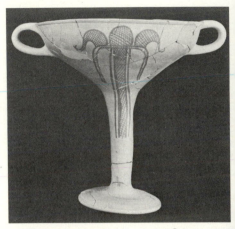

20. High-stemmed kylix with octopus-flower design from Zygouries. Late Helladic IIIB, c. 1250. Clay. H c. 0.18 m. *Corinth Museum*

standard form of drinking-cup throughout most of the Mycenaean world from the fourteenth century onwards.

While decoration throughout the Aegean is by now usually confined to a zone on the body of the vase with horizontal bands above and below, some kylikes like that of illustration 20 continue the tradition of the Ephyraean goblets into the thirteenth century, being decorated with a single motif on one side, while the other side, held towards the drinker and out of sight, is left plain. A fine collection of such kylikes, decorated with stylized octopuses and whorl-shell designs, or with extraordinary hybrids based upon combinations of flowers with them [20], was recovered from the so-called Potter's Shop, perhaps a part of the local palace, at Zygouries near Mycenae.[51]

Some large bowls carried pictures of chariots, ultimately derived from wall-paintings. The chariots often appear to form part of ritual scenes, like the one [43] on a fragment of wall-painting associated with the Palanquin fresco at Knossos (pp. 58–60). Vases with chariot scenes are first attested in the fourteenth century, and most of the known examples have been recovered from tombs in Cyprus [21]. The evi-

commonly goats, and imaginary sphinxes, make their appearance. The scenes with animals were also perhaps inspired by wall-paintings, even if indirectly through the medium of textile designs.[54] It may sometimes be possible to detect the hands of individual vase painters.[55]

A period of confused movements of peoples followed the destruction of the Mycenaean palaces at the end of the thirteenth century.

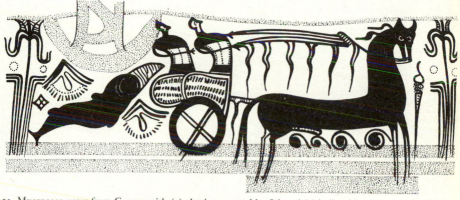

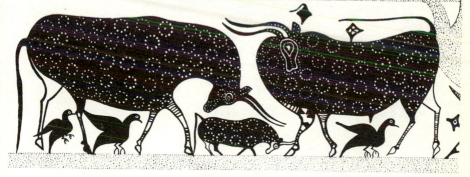

21. Mycenaean vases from Cyprus with (A) chariot pursued by fish and (B) bulls with birds. *c.* 1250. Clay

dence of clay tests, however, suggests that they were made in the Aegean, and their centre of production may have been in the region of Mycenae, from which they were exported.[52] Human figures are occasionally depicted in other contexts than chariot scenes: the lyre player with birds on a vase from Kalami in Crete recalls the 'Orpheus' fresco from Pylos.[53] Besides birds, animals like bulls [21B], or less

Some of the population of the mainland took refuge in regions such as the Cyclades, Crete, and Cyprus, but it looks as if in certain areas Mycenaean potters stayed to work for new masters. The basic Mycenaean traditions in vase shapes and decoration continue throughout the Aegean, but at the same time, as might be expected in such a period of warfare and disintegration, regional differences in pottery become

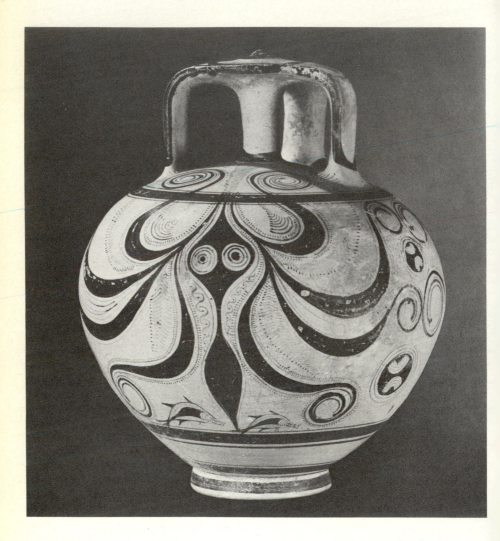

22. Stirrup jar with stylized octopus, probably from the Cyclades, but found in Attica. Late Helladic IIIc, *c.* 1150. Clay. H 0.243 m. *Copenhagen, National Museum*

more marked, with local styles tending to re-
place the comparative uniformity of the pre-
ceding age.

In a curious way the upheavals of the time
appear to have acted as a stimulus. A certain
measure of artistic revival is reflected in the most
elaborately decorated pottery of the period im-
mediately after c. 1200.[56] A class of vases in a
naïve and barbarous but lively Close Style,
where crowded ornament is rendered with
meticulous care, develops in the region of My-
cenae. A comparable style evolves in Crete, and
stirrup jars with stylized octopuses of Cretan
derivation are at home in the Cyclades [22].

Meanwhile vases continued to be adorned
with pictures of chariots and with birds and
animals of various kinds, although it seems un-
likely that there were any wall-paintings left to
give direct inspiration. The great bowl from
Mycenae with processions of warriors is as-
signed to this period. Some of these later picture
vases are still painted in white on a dark wash,
like the small jar from Lefkandi in Euboea with
a delightful pair of griffins and their nest [23].[57]

The artistic revival reflected in the fine decor-
ated ware in the years after c. 1200 was short-
lived. The Close Style did not continue long,
and the tradition of picture vases eventually
came to an end. On the mainland ideas of decor-
ation dwindled until they reached a point of
extreme simplicity, with ornament virtually
confined to straight or wavy lines horizontally
placed on vases of dull and uninspiring shapes.
But it was out of the ashes of this artistic bank-
ruptcy that the new Protogeometric style, with
shapes and decoration tense, disciplined, and
alert, arose phoenix-like in the region of Athens
about the middle of the eleventh century.

COFFINS AND BATHTUBS[58]

Oval clay coffins were in use in parts of Crete
from the Early Minoan period onwards. Middle
Minoan coffins were oval or rectangular, often
decorated with splashes of paint (trickle orna-
ment), or with large solid blobs which might be
linked together in spiraliform designs. While
most coffins were light surfaced with decoration

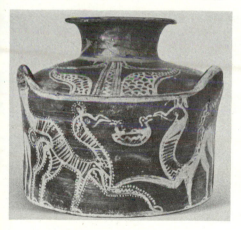

23. Jar with pair of griffins and their nest
from Lefkandi. Late Helladic IIIc, c. 1150.
Clay. H 0.183 m. *Khalkis Museum*

24 (*above, right*). Rectangular coffin with
gabled lid, decorated with papyrus plants, water
birds, and fish, from Vasiliki Anoyia in
the Mesara. Late Minoan IIIA, c. 1350. Clay.
Herakleion Museum

in dark paint, some had an overall dark wash and
decoration in white.

From the fourteenth century onwards a type
of rectangular coffin with low feet and a gabled
lid became standard in Crete [24] – such coffins
were evidently reproductions in clay of the
wooden storage chests which appear to have

been used in Cretan houses at the time, and which were themselves occasionally employed for burials.[59] Many were decorated in dark-on-light with elaborate scenes incorporating octopuses, stylized flowers, griffins and birds as on illustration 24, chariot and hunting scenes, and in one case at least a warship.[60] One or two had polychrome designs in rather evanescent colours – blue, red, and black – of the kind that may have been used to decorate wooden chests.[61]

Clay bathtubs were also adapted as coffins during this period in Crete [25]. Their outsides were usually decorated, and the insides of some

like illustration 25 were appropriately adorned with pictures of swimming fish.

The use of clay coffins and bathtubs for burials was sporadic on the mainland, although there is some evidence for wooden coffins or biers. But during the thirteenth century and into the twelfth a group of people living in the region of Tanagra on the borders of Attica and Boeotia buried many of their dead in small rectangular clay coffins of the Cretan type adorned with pictures of mourning women, heads of women at windows, bull-leaping, and chariots.[62] One remarkable scene shows the dead man being laid to rest in his coffin below a row of mourning women. In another, two men walk through a field of flowers in front of an enormous bird [26].

25 (*left*). Bathtub used as coffin from a tomb at Pakhiammos near Gournia. Late Minoan IIIA, *c.* 1350. Clay. H 0.48 m. *Herakleion Museum*

26 (*below*). Side of a rectangular coffin from Tanagra. Late Helladic IIIC, *c.* 1150. L 0.69 m. H 0.43 m. *Private Swiss Collection*

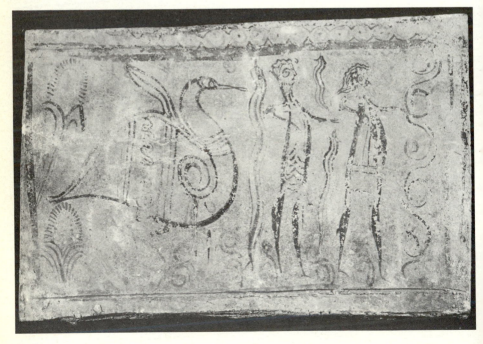

PAINTING

Fresco implies painting on plaster while it is still damp and soft, so that the colours sink into it and adhere. There has been much argument in the past as to whether the Bronze Age wall-paintings of the Aegean were frescoes in this sense (see p. 83). But the term has been hallowed by use, and is conveniently retained to refer to all Bronze Age decorative painting of plastered surfaces, whether on walls, floors, or ceilings, or on objects such as stone sarcophagi, hearths, and altars.

The best and most original artistic talent of the day was probably deployed in the art of wall-painting from the time of the later palaces in Crete onwards.[1] Kings doubtless liked to have their best craftsmen close at hand so that they might consult with them and supervise them. The so-called School Room, near the workshop of a maker of fine stone vases just north of the residential quarter of the palace at Knossos, might have been an atelier of fresco painters, if it was not a resort of scribes.[2]

The painters may have taken the lead in the artistic fashions of the time. There is evidence to suggest that scenes in the paintings which adorned the walls of the palace at Knossos were adapted on a reduced scale to vases of clay, stone, and metal, and even to gems, just as the great paintings of later Greece were copied by the vase painters and other artists.[3] But the influence was not necessarily all one way. Evans thought that designs on textiles might have inspired the painter responsible for the background of the Partridge fresco [41] (see p. 58).[4] Nautilus friezes at Pylos, it is suggested, might derive from the earlier use of nautiluses in rows as inlays or beads.[5]

Even where it was not a case of deliberate imitation, a close relationship clearly existed between the art of the fresco painters and those of the seal engravers, makers of stone relief vases, and artists in other media. Some of the great artists responsible for the wall-paintings may have executed relief vases in stone or metal, or carved ivory. Perhaps on occasion the fresco painters also decorated clay vases;[6] a fragment of a large clay storage jar from Knossos preserves part of a female head, about half life size, in a style so fine and so close to that of the wall-paintings as to suggest that it was the work of a fresco artist [52A].[7] But this is exceptional, and by and large it looks as if the vase decorators were not the artists of the wall-paintings. At the end of the Bronze Age indeed a certain dichotomy can be seen between the paintings that adorned the walls of the palaces on the mainland at the time of their destruction and the vases with chariot and other scenes [21, A and B] which appear to have been derived from them. The style of the vase pictures seems if anything more debased than the style of the wall-paintings.[8]

But it must always be remembered that clay vases on the whole did not have a long life, and those from destruction levels are therefore likely to have been made within a few years of the time they were lost. Paintings, however, may have survived on walls for decades, even centuries, before they were removed to make room for replacements or were engulfed in some destruction. In many parts of Greece today, and even in regions subject to earthquake like Crete, there are churches with wall-paintings dating back to the fourteenth or fifteenth century A.D. or earlier.[9] Lack of means to redecorate and the conservatism of cult have no doubt helped to preserve these paintings in churches. But religious considerations may have tended to the preservation of paintings even in the Bronze Age, since many of the wall pictures, on the mainland as well as in Crete and the islands, appear to have been religious in their content rather than merely decorative.

Owing to their chance of survival on walls and the fact that the contexts in which they have

been found are often not securely dated, the assignment of the Bronze Age paintings to one period or another inevitably depends to a large extent on stylistic considerations. In some cases, however, details such as the motifs of design on the dresses of large-scale figures, or the shape and style of decoration of vases depicted, help to suggest the date when the frescoes were painted.

CRETE AND THE CYCLADES

Walls were being covered with clay plaster during the Neolithic in Crete, and a fine plaster of mud or clay was used on walls of the House of Tiles at Lerna on the mainland during the Early Helladic period c. 2500.[10] Similar clay plasters, eventually with simple patterns in red and white, are attested in the Balkans and Central Europe at an early date.[11]

In Crete by the middle of the third millennium a fine white lime plaster was being applied to walls, and also it appears to floors and roofs as well. It was regularly painted dark red, which was to remain a favourite colour for plain wall surfaces in Crete throughout the time of the early palaces and later. After it had been painted the surface was lightly polished, rendering it harder and more resistant to water. Abundant remains of red-faced plaster were found in houses at Vasiliki in eastern Crete destroyed in Early Minoan II,[12] and scraps have been recovered from other Cretan sites of the time.[13] But the use of lime plaster does not appear to be attested on the mainland until the end of the Middle Helladic period nearly a thousand years later.

In some early settlements of the Near East, like Çatal Hüyük in central Anatolia and Teleilat Ghassul in the Jordan valley of Palestine, mud-plastered walls were adorned with religious or magical paintings, in continuation perhaps of a tradition of rock-paintings as found in western Europe during Palaeolithic and into Mesolithic times. Simple designs in contrasting red and white may have decorated walls in the settlement at Fournou Korifi and elsewhere in Crete in Early Minoan times, but the evidence is uncertain. A white plaster floor with a simple pattern in red in the early palace at Phaistos is assigned to Middle Minoan I.[14] A red floor in a house of about the same date at Mallia was divided by white bands into panels simulating paving.[15] Scraps of decorated wall plaster were found in a house at Phaistos with vases assignable to Middle Minoan I B c. 1800 or not much later.[16] Fragments of painted dadoes from the Loomweight Basement at Knossos seem to belong to an early phase of the palace.[17] But there is nothing to suggest the existence of actual pictures on Cretan walls or floors before c. 1600.[18]

Fragmentary wall-paintings from Atchana in northern Syria resemble those of Crete in technique and even in style.[19] The same kinds of paints were used, and they were applied in a similar way, with guide-lines for the borders made by incision or with taut string. One of these paintings from Atchana shows spiky plants reminiscent of the foliate band designs of Crete, set against a red background as found on some of the earliest Cretan wall pictures.[20] Level VII, from which this and the bulk of the paintings at Atchana came, ended c. 1650,[21] about the time when the later palaces in Crete were built. Perhaps the Cretans were inspired to decorate their walls with pictures by Syrian rather than by Egyptian example. Possibly, however, the Atchana paintings reflect Cretan influence despite their early date.[22] There was evidently a considerable interchange of ideas and know-how between Crete and Syria which were in close touch it seems from the earliest times.

The Saffron Gatherer [27] from the palace at Knossos may be the earliest surviving wall-picture in Crete.[23] It was found in the area of the so-called Early Keep above a floor overlying the walled pits, which may have been granaries rather than dungeons, and which appear to have been filled and covered at a very early stage in the history of the palace. Evans later claimed that the floor was an early one:[24] but he does not suggest this in the original report of the discovery, although he was already confident of the early character of the fresco.[25] He restored the blue figure as a boy, but it is in fact a monkey,[26] one of at least two involved in what may be some

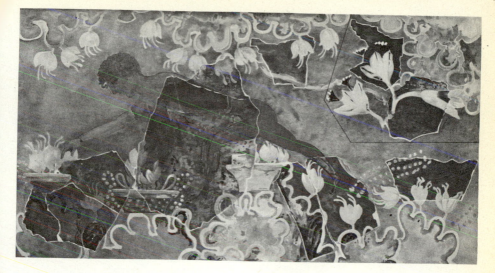

27. Saffron Gatherer fresco from the palace at Knossos. Shown as restored by Evans, but the boy is in fact a monkey [cf. 28]. Probably Middle Minoan IIIA, c. 1700–1600. c. 0.46 × 0.25 m. *Herakleion Museum*

28. Saffron Gatherer fresco from the palace at Knossos [cf. 27] restored with a monkey

kind of religious scene [28][27] – monkeys appear in association with an altar on a fresco from the Akrotiri settlement on Thera,[28] overwhelmed by an eruption of the volcano there in Late Minoan IA c. 1500. The saffron crocus was no doubt used in Bronze Age Crete for making yellow dye, but like the lily it may have been a special attribute of the Cretan goddess.[29] Fragments of other, although apparently later, frescoes of a religious character were recovered from this area of the palace at Knossos and may have decorated some kind of shrine or chapel there (see p. 62).

Early features in the Saffron Gatherer fresco include the use of a dark red background (see p. 48). The bowl out of which a monkey appears to be plucking saffron flowers is decorated with white spots on a dark ground and has a red band round the rim. This scheme of decoration was very much the fashion for clay vases during the first half of the Middle Minoan III period (Middle Minoan IIIA) and hardly continued later, which suggests that the picture may date from the seventeenth century, although arguments for a later date have been advanced.[30]

The Saffron Gatherer fresco illustrates one of the most striking conventions of Cretan art. The landscape is represented as if seen from above. Rocks and the flowers growing among them are depicted like stalactites and stalagmites in a cave, some rising from the border at the bottom, others hanging downwards from the top edge of the picture. The same strange convention is seen on the somewhat later paintings from the House of the Frescoes, and appears in relief on the Vapheio cups [160–3]. It was perhaps in-

spired by the Cretan landscape, where a hill or mountain is in the background of every inland view.[31] At the same time the manner in which the rockwork in the paintings was usually rendered may have been taken from the slabs of variegated gypsum used to veneer walls from the time of the early palaces onwards.[32] In contrast to the conventional rendering of the landscape in the Saffron Gatherer fresco is the naturalism of the flowers, which with their long stamens are easily recognizable as saffron crocuses.

Some important fragments of what Evans took to be early paintings were recovered from the lower cists in the Thirteenth Magazine in the western wing of the palace at Knossos [29, 30]. The cists seem to have been replaced by shallower ones after an earthquake in Middle Minoan IIIB about the middle of the sixteenth century, when the near-by Temple Repositories were closed. One of the fragments [29] shows the head of a bull, another [30] part of a crowd; the rest have architectural façades.[33] These fragments seem to be painted in an early style, notably the head of the bull, which may have belonged to a bull-leaping scene watched by a crowd of spectators. Horns of consecration and columns with double axes stuck into their capitals indicate the religious character of the façades, and would be appropriate in a scene of bull-leaping with its religious or magical basis, if they formed part of the same picture; but this is not certain. The painting of the rosette border on one of the façade fragments is curiously imprecise and careless, suggestive of later work.[34]

The bull [29] is extremely realistic. The eye with its circular pupil and red surround is reminiscent of the surviving eye of the bull rhyton from the Little Palace with its surround of red jasper [135A] (pp. 142–3). It is interesting to compare this bull's head with that in the Taureador fresco [44], which is to the same scale but later it seems in date (see p. 61). The rendering of the Taureador bull's head is totally different and very much cruder: the treatment both of the eye and of the hide is more conventional, less careful in style.

The fragment with spectators [30] may be the earliest known example of a kind of shorthand

29. Head of a charging bull on fragment of a wall-painting from the palace at Knossos. Probably Middle Minoan IIIB, *c.* 1600. 0.157 × 0.099 m. *Herakleion Museum*

30. Group of spectators on fragment of a wall-painting from the same area as illustration 29. Probably Middle Minoan IIIB, *c.* 1600. 0.016 × 0.011 m. *Herakleion Museum*

31–3. Wall-paintings from the House of the Frescoes at Knossos. Late Minoan IA, *c.* 1550. *Herakleion Museum.* 31 (*above, right*). As restored by M. Cameron. 32 (*right*). Blue bird (restored). H 0.60 m. 33 (*far right*). Fragments with crocuses. 0.13 × 0.073 m., 0.12 × 0.117 m.

technique used to depict crowds in pictures of similar type, but with smaller, truly miniature figures, of which fragments were recovered from the so-called Early Keep area in the north-west corner of the palace [46] (see p. 62). Evans dated these miniatures to Middle Minoan IIIB, but

they seem later in style than the fragments from the Thirteenth Magazine.

Evans assigned a large number of fragments of frescoes from the palace and houses at Knossos to Middle Minoan III, and especially to the latter part of the period, Middle Minoan III B. Many came from deposits below floors that were in use at the time of the final destruction of the palace, but some of these deposits may date from Late Minoan I rather than earlier.

An important group of fragments was found in what appears to be a destruction level of Middle Minoan III B during excavations on the north side of the Royal Road in 1957–61. These show an elegant pattern of alternate wavy black and white stripes enclosing areas of yellow which are studded with little black and red rosettes. The original plaster had been gouged away and replaced with new plaster for the yellow ground against which the rosettes were set (see p. 84). In spite of the delicate painting it has been suggested that this fresco may have adorned a floor rather than a wall.[35]

The end of Middle Minoan III and the early part of Late Minoan I were the apogee of the Minoan civilization of Crete. Some of the finest paintings of the Aegean Bronze Age have been found in destruction levels assignable to Late Minoan I A *c.* 1500. From a house of modest size, the House of the Frescoes, west of the palace at Knossos comes a remarkable series of paintings showing birds, some in flight, and

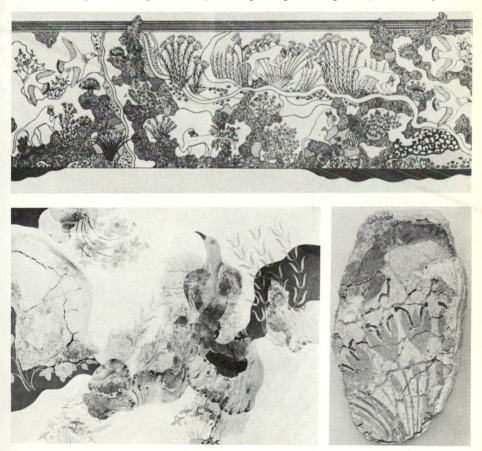

monkeys in a rocky landscape among streams and waterfalls with flowers of many different kinds [31–3, 50A]. One of the monkeys appears to be eating a bird's egg, and the scene may depict a raid on a nesting area.[36] Although there is no evidence to show that any of these paintings were religious in character, the room on an upper floor which they adorned may have been set aside for cult, like the contemporary frescoed rooms on upper floors of houses in the Akrotiri settlement on Thera (see p. 54). The scenes in the House of the Frescoes may date from early in Late Minoan IA,[37] but the house was destroyed by the great earthquake which afflicted the region of Knossos about the time of the Thera eruption towards the end of that period.

Very fine landscapes in a comparable style adorned a small ground-floor room which appears to have been a shrine in the royal villa at Ayia Triadha, the harbour town of Phaistos [34];[38] they were apparently painted about the same time, but survived in place until the building was destroyed in Late Minoan IB, c. 1450.[39] Three sides of the room seem to have been decorated with a scene reaching from floor to ceiling. On the narrow end wall a woman, evidently a goddess, wearing a richly decorated skirt, may have stood before a shrine. Rocky, flower-bedecked landscapes occupied the side walls. On the wall to the left as one faced the goddess at the end of the room was a woman, an attendant it seems, kneeling and perhaps engaged in picking sacred flowers such as lilies and crocuses. The landscape on the opposite wall was filled with animals, among them cats and apparently wild goats.[40] The large fragment on illustration 34, which is exceptionally well preserved although discoloured by fire, shows a cat stalking a small but elegant red bird with a long black tail. The bird is reminiscent of a pheasant,

34. Cat stalking a pheasant-like bird on a wall-painting from Ayia Triadha. Late Minoan IA, c. 1550. H 0.395 m. *Herakleion Museum*

but like many of the plants in Cretan frescoes, which look so natural while defying classification, it appears to be of a species unknown to nature. The flowers of these Ayia Triadha frescoes are instructive. The ivy and lilies are comparable with those from the House of the Frescoes at Knossos [50A].[41] But while some of the crocuses resemble ones from the House of the Frescoes [33],[42] others are more like those in the earlier Saffron Gatherer [27].[43]

A number of other pictures of the period before c. 1450 incorporated large figures of richly dressed women, perhaps goddesses or their attendants. A fragment from Phylakopi on Melos [35A] shows part of such a woman, seated and holding what must be a fishing net.[44] She was about a third life-size, and evidently one of a pair. Her dress was ornamented with birds like swallows, or possibly griffins;[45] the 'adder' or 'flame' pattern on their wings is certainly

standard on those of griffins but a similar one denotes the feathers of votive bone arrow plumes from the Temple Repositories at Knossos.[46]

This fragment and those of an attractive frieze of flying fish were found above the floor of a pillar crypt of the type common in Crete, but the paintings appear to have adorned the room over it. The deposit containing them was assigned by the excavators to the later period of the third settlement, that is, the end of Phylakopi II,[47] contemporary with Cretan Middle Minoan IIIB.[48] But some of the pottery from it as described by Duncan Mackenzie in the notebooks which he kept of the excavation seems characteristic of the early part of Phylakopi III, while evidence from the new excavations (1974–6) suggests that the frescoes may have been thrown from the walls and buried in a disaster which occurred during that phase but after the beginning of Late Minoan IB in Crete.[49]

35. Richly dressed women, apparently goddesses, seated on rocks in (A) a wall-painting from Phylakopi and (B) a relief fresco from Pseira. c. 1500. *Athens, National Museum, and Herakleion Museum*

These paintings from Phylakopi are close in style to ones from Crete and have been regarded as the work of Cretan artists.[50] But they are fragmentary, and the well preserved paintings that have come to light in the Akrotiri settlement on Thera, only some fifty miles away from Melos, appear to have been done by natives of the islands.[51] The Akrotiri settlement was evidently the capital of Thera at the time of the great eruption which buried it towards the close of Late Minoan IA *c.* 1500. The island was impregnated with Minoan civilization then, and may have been under Cretan rule. But the paintings from this Bronze Age Pompeii, although inspired by those of Crete, and superficially Cretan in appearance, are rather different in style. They seem to be technically cruder than the best Cretan work, and there is a coarseness of taste and a tendency to exaggeration which stamp them as provincial. At the same time they

are alive with a certain primitive vigour and possess a charm which rivals if it does not surpass that of the comparatively sophisticated art of Crete at the time. The contemporary pottery of the islands, decorated in a native style, but using shapes and motifs borrowed from Crete, has similar characteristics.

The settlement at Akrotiri appears to have been destroyed by a violent earthquake only a generation or so before it was finally abandoned *c.* 1500.[52] If, as is likely, the wall-paintings date from the period of reconstruction after this earthquake, they would not have been very old at the time the settlement came to an end. In each house there seems to have been a room on the upper floor used for cult, and many of the paintings so far recovered come from rooms of this kind,[53] like those from the contemporary House of the Frescoes at Knossos (pp. 51-2). An exception is the Spring fresco [36], which

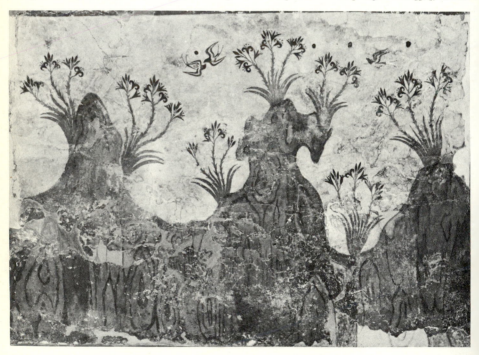

36. Spring fresco, with swallows and red lilies, from Akrotiri on Thera. Late Minoan IA, *c.* 1550. *Athens, National Museum*

adorned a little enclosed room on the ground floor of one of the houses. This, with its scenes of swallows and red lilies springing from a contorted rocky landscape, is among the best preserved and the most sympathetic of all the paintings recovered from the Akrotiri settlement to date.[54] The lilies closely resemble those from Ayia Triadha in Crete,[55] and ones from what appears to have been an actual colony of Cretans at Triandha in Rhodes.[56] There are similar lilies, but painted white instead of red, from the South East House[57] and the House of the Frescoes at Knossos.[58] The Akrotiri lilies are arranged in groups of three – a way of grouping plants and trees with a long history in Crete. Thus formal groups of three white lilies appear on the Knossos Lily vases,[59] assigned by Evans to the end of Middle Minoan III, and adorned the walls of a villa at Amnisos on the coast north of Knossos destroyed by fire at some point in Late Minoan I [37].[60] The stylized flowers, evidently meant for pancratium lilies, in the 'Room of the Ladies' at Akrotiri were also arranged in threes.[61]

Remarkable among the Akrotiri frescoes are the life-sized figures of women. A pair from the 'Room of the Ladies' are dressed in the Cretan manner in long V-fronted skirts and short-sleeved jackets. One of them, with an excessively thin waist and strangely pendant breasts, is leaning forward to offer something to the other, who is walking towards her. The face of this woman is wonderfully preserved, with her long black hair, reddened lips and cheeks, and massive gold earrings.

Another woman, apparently a priestess, from what appears to have been the main bedroom in the 'West House' is more crudely rendered [38]. She seems to be placing incense in a brazier, and wears a long cloak or robe and an elaborate form of loop earring. As well as her lips, her ear is shown as painted a bright red, a fashion which recurs in Europe during the Renaissance.[62] Her head is blue, as if it had been shaved, and afterwards stained that colour. A man carrying fish, one of a pair, from the living room adjoining the room with the priestess,

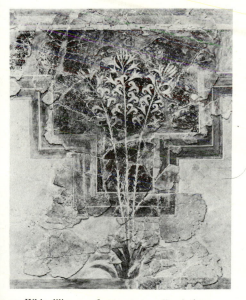

37. White lilies on a fragmentary wall-painting from Amnisos. Probably Late Minoan Ib, c. 1500. H c. 1.80 m. *Herakleion Museum*

38. Priestess on a wall-painting from Akrotiri on Thera. Late Minoan Ia, c. 1550. *Athens, National Museum*

also has a blue head shaved except for some long black locks which have evidently been allowed to grow.[63] Two boys or young men engaged in boxing with one glove each in a painting from another house have the same curiously shaved heads with exempt locks.

Animals in the Akrotiri frescoes include monkeys [39], in one instance associated with a

39. Blue monkey on a wall-painting from Akrotiri on Thera. Late Minoan IA, c. 1550. *Athens, National Museum*

shrine of some kind, and a pair of lively antelopes. Some of the subjects are comparable with ones that appear in Cretan paintings of the time. Thus miniature figures who may be boxers are visible on scraps of wall-paintings from a house at Tylissos, destroyed in Late Minoan IB c. 1450;[64] monkeys adorned the House of the Frescoes at Knossos; and part of what has been interpreted as a swallow survives on a fragment from the South House by the palace there.[65] This swallow fragment seems to have been buried after damage to the South House by the earthquake which afflicted Knossos in Late Minoan IA about the time of the eruption of Thera.

These paintings of the Late Minoan IA period in Crete and the islands vividly illustrate that essential quality of the finest Minoan art, the ability to create an atmosphere of movement and life although following a set of highly formal conventions. But already perhaps the tendency to conventionalization is more advanced than it was when the Saffron Gatherer [27] and the bull's head and spectators [29, 30] from the Thirteenth Magazine at Knossos were painted. The flowers from the House of the Frescoes [32, 33] and Ayia Triadha [34] are extraordinarily alive and look at first sight quite real. It is still at times easy to recognize the species, as it was in the case of the crocuses of the Saffron Gatherer.[66] But often now the painted flowers bear only a general resemblance to real ones: they are formalized and altered, so that a rose is given six petals for symmetry instead of the normal five [32],[67] while hybrids of a sacral character occur, half lily and half iris blended with Egyptian papyrus.

As with the flowers, so with animals. They are alive and normally recognizable, but they are not painted with the accuracy and degree of observation of Egyptian animal pictures: the bird which sits all unsuspecting of the cat behind it on illustration 34 from Ayia Triadha defies classification, and it is doubtful what species the painter of the birds and monkeys of the House of the Frescoes had in mind.[68]

The pictures on the walls of the royal villa at Ayia Triadha, although painted in Late Minoan IA c. 1500 or earlier, remained in place until the building was destroyed in Late Minoan IB c. 1450. But at Knossos and other sites in northern Crete paintings of earlier periods may have been lost as a result of earthquakes and *tsunamis* at the time of the eruption of Thera c. 1500; that is to say, some of the frescoes from Late Minoan IB deposits at Knossos and other sites in the northern coastal areas of Crete were very probably painted after the Thera eruption and not before it.

The little town on the island of Pseira in the Gulf of Mirabello would have been exposed to the force of any *tsunamis* consequent upon the eruption. It was finally abandoned at the time of the mainland conquest in Late Minoan IB. From a small building that may have been a shrine here came fragments of large relief paintings of seated women [35B], richly dressed and

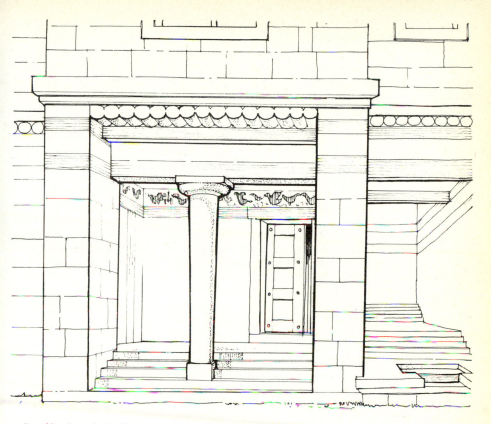

40. Partridge fresco in the Caravanserai at Knossos, as restored by Evans

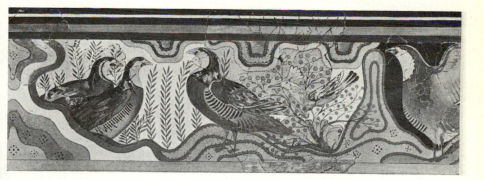

41. Partridge frieze from the Caravanserai at Knossos. Section as restored showing partridges and a hoopoe. Possibly Late Minoan IB, *c.* 1500. H 0.28 m. *Herakleion Museum*

apparently goddesses, like the pairs of women from Ayia Triadha and Phylakopi [35A] (see pp. 52–3).

Fragments of a comparable seated goddess or goddesses were recovered from the North-West Fresco Heap in the palace at Knossos.[69] Bits of these were in low relief, although they were painted for the most part on a flat wall surface (pp. 72–3). The North-West Fresco Heap was the name given by Evans to an important deposit of fragmentary paintings, close below the surface just north of the area of the so-called Early Keep, most of which he assigned to Middle Minoan IIIB.[70] Some, however, appear to be later: the running spirals made with dots on a relief fragment of dress from this deposit[71] occur on a larger scale on a frieze from a Late Minoan IB destruction level on the north side of the Royal Road at Knossos,[72] and they are also found on pottery of that date.

Scraps of another picture with large female figures, human or divine, were recovered from a deposit with burnt debris below the pavement of the Corridor of the Procession at Knossos.[73] In addition, the fragments of nearly life-sized figures of women known as the Ladies in Blue display comparable dress designs and may be of the same period.[74] The Ladies in Blue have been discoloured by fire, but were found on the opposite side of the palace from the Corridor of the Procession and were not in a stratified context. Evans, although at first inclined to date both these groups of paintings to the early part of Middle Minoan III, eventually assigned them to Middle Minoan IIIB.[75] However the designs on the dresses look a good deal later; some are comparable with ones on dresses worn by figures in the Procession fresco, which was still on the walls of the palace when it was finally destroyed in the fourteenth century.[76] The bead festoons and crocus pendants that adorn some of the finest clay vases of Late Minoan IB date may have been inspired by the beads in frescoes like the Ladies in Blue;[77] at the same time the treatment of the hand touching the necklace in the Ladies in Blue is in striking contrast to the hands of the large female figures of a later period on the mainland with their crudely striped

knuckles [61, B and C] (see p. 79). Perhaps the Ladies in Blue and the comparable fragments from below the floor of the Corridor of the Procession were involved in a destruction of parts of the palace by fire at the time of the mainland conquest of Crete c. 1450.

The Caravanserai across the stream south of the palace appears to have been used as a khan or hostel for strangers. From a room that Evans suggested was 'designed for refection' came a remarkable frieze with an 'appetizing subject' consisting of partridges and hoopoes in a very life-like style [40, 41].[78] The frieze was only 0.28 m. wide and evidently went around the top of the wall just below the ceiling, from which it was separated by a narrow band of red, yellow, black, and white stripes. Evans regarded this Partridge fresco as contemporary with those from the House of the Frescoes and assigned it to the end of Middle Minoan III or beginning of Late Minoan I. But the background to the partridges and hoopoes is very different in character from the landscapes in the paintings from the House of the Frescoes [32] and Ayia Triadha [34]. It is comparatively stylized, and looks as if it might represent a later fashion in the treatment of landscape. On stylistic grounds therefore it seems likely that the frieze was painted after the earthquake which afflicted Knossos in Late Minoan IA about the time of the eruption of Thera.

The fragments known as the Palanquin fresco [42, A and B][79] apparently come from a Late Minoan IB destruction level like the deposit of seal impressions found in the same area on the southern edge of the palace site (p. 222). They evidently formed part of a ritual scene; but the 'priestly figure' may have been sitting not in a palanquin, as Evans supposed, but on a folding stool set high on a stand with railings, representing perhaps the rectangular stone 'grandstand' on the edge of the Theatral Area beyond the north-west corner of the palace.[80] The priestly figure – if a man, not a woman, he may be the king – seems to have been watching some kind of religious procession which included chariots. Fragments of a chariot picture in the same style and to the same scale [43] recovered

42. (A) (*left*) and (B) (*above*). Heads of
men in the Palanquin fresco from the palace
at Knossos. *c.* 1500. Scale 3:4. *Herakleion Museum*

43 (*below*). Chariot scene associated with the
Palanquin fresco as restored by M. Cameron.
Scale 1:5

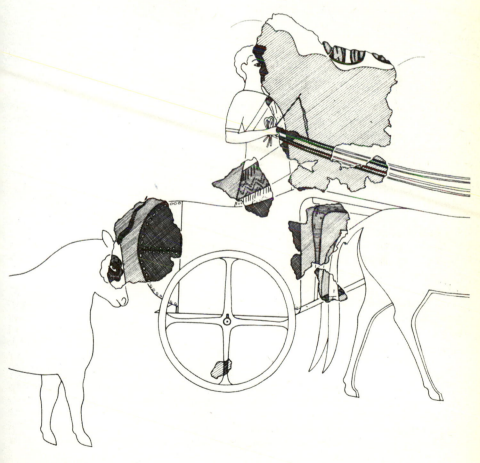

44. Taureador fresco from the palace at Knossos. Restored panel, one of a series, with bull-leaping scenes. Probably Late Minoan II, c. 1450. H with borders c. 0.70 m. *Herakleion Museum*

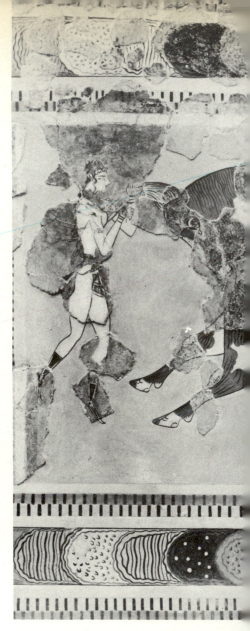

in this area of the palace appear to belong to a related scene.[81] One of the fragments shows the back of a chariot and behind it the nose of a bull being led it seems to the leaping games or to sacrifice. The work on all these fragments is distinctly coarse in style in comparison with frescoes assignable to the earlier part of Late Minoan I or to Middle Minoan III, and it has been argued that they must date from Late Minoan II (c. 1450–1425) if not later.[82] But in view of the context from which they came it seems difficult to believe that they were painted after the end of Late Minoan IB c. 1450.[83]

One curious feature in these frescoes is the exaggerated way in which the noses of the figures are turned outwards [42B], almost as if they were meant to be caricatures. Some of the men painted on walls at Pylos on the Greek mainland in the fourteenth or thirteenth century have noses of a similar type [52K],[84] but so does the bearded face on an amethyst gem of much earlier date from Mycenae shaft grave circle B [226] (see p. 224).

In the scale of the figures represented the Palanquin fresco is reminiscent of the famous Taureador frescoes [44], of which the fragments were recovered high in the fill above very late walls in the Court of the Stone Spout on the eastern side of the palace at Knossos.[85] The fragments appear to have been incorporated in debris piled behind the wall forming the western side of the Court. When this wall collapsed they were precipitated on top of the later walls and floors below. They were not in a well stratified context, but decorated pottery assignable to Late Minoan IB and Late Minoan II was found with them.[86]

The Taureador frescoes appear to have consisted of panels about 0.78 m. high with scenes of bull-leaping in which both men and women were taking part, the women being dressed like men. Lines on the body and legs of one woman

indicate the muscles in a manner unusual in the Bronze Age painting of the Aegean with its normally silhouette-like figures (see p. 236).[87] The restored panel [44] shows a man vaulting over the back of a bull with a woman standing behind it to receive him; but the fragment on

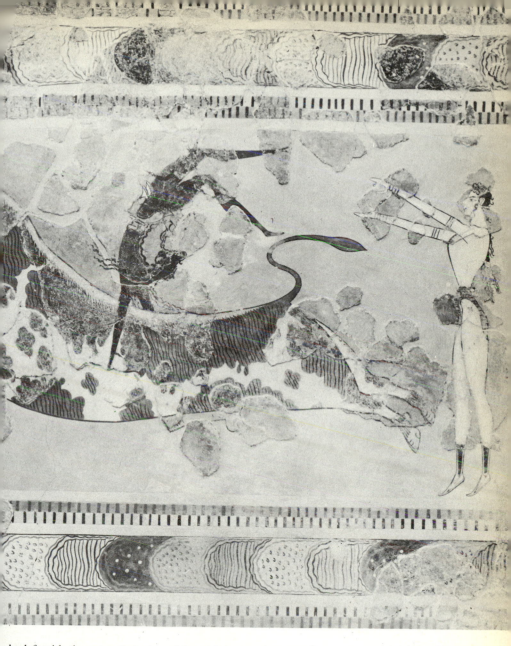

the left with the woman's body and horn tips appears to belong to another panel.[88]

Evans assigned the Taureador frescoes along with the Palanquin fresco to Late Minoan IA, or to the close of Late Minoan IA and Late Minoan IB.[89] The eye of the bull of the restored panel [44], however, is rendered in a different way from the eye of the bull following a chariot of illustration 43 from the Palanquin area, and resembles those of animals from Pylos on the Greek mainland painted in the fourteenth or thirteenth centuries. The black outlines of some

of the figures, and the stylized character of the imitation stonework of the borders, are also suggestive of a date after Late Minoan I,[90] but the delicacy of the treatment and the comparative freedom in the rendering of the hair make it unlikely that they were painted after the end of Late Minoan II *c.* 1425.

Miniature Frescoes

The term 'miniature fresco' was used by Evans to include not only true miniature scenes with tiny figures of men and women, but also similar minute figures, whether of people, animals, or birds, of imaginary sphinxes or griffins, or of inanimate objects, when they formed part of the woven decoration on the dresses of large figures of men or women represented in the paintings.[91] The dress worn by the goddess in the Phylakopi fresco [35A] has a pair of winged creatures, griffins or swallows, woven into it (see p. 53). The dresses of which fragments were recovered from the North-West Fresco Heap were decorated with butterflies, sphinxes, and griffins [45,

B and C],[92] together with heads of bulls with what appear to be 'snake frames' above them [45A],[93] as well as objects which Evans interpreted as pairs of flutes, although they look more like sheaths or quivers [45D].[94]

Among the fragments from the North-West Fresco Heap were scraps of the true miniature class, with ladies looking out of windows or standing on balconies.[95] These are comparable with, and may come from the same series as, the two important groups of fragments which were found a few metres away to the south in the area of the Early Keep, one showing crowds of people, apparently spectators of some game or ritual, beside a shrine [46], the other with similar crowds watching a dance of women near a grove of olive trees.[96] These two scenes may have adorned a little room devoted to cult on an upper floor in the angle between the North Entrance Passage and the Central Court of the Palace.

In these miniatures of the Shrine [46] and Sacred Dance the crowds of spectators are rendered by a kind of shorthand technique. The

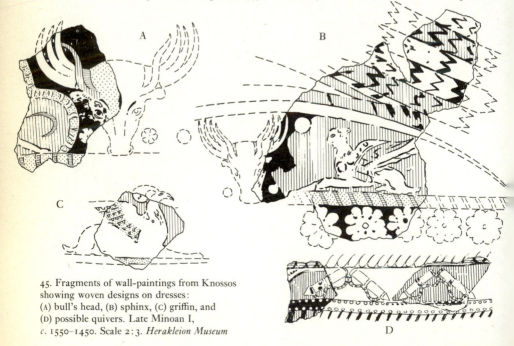

45. Fragments of wall-paintings from Knossos showing woven designs on dresses:
(A) bull's head, (B) sphinx, (C) griffin, and
(D) possible quivers. Late Minoan I,
c. 1550–1450. Scale 2:3. *Herakleion Museum*

outlines of the massed heads are sketched in black in a quick, impressionistic manner, upon a broad wash of red-brown for men, or upon an area left white indicating women. The eyes of the men and the necklaces that they wear are painted in white on the red-brown background.

may have been painted in Late Minoan I rather than in Late Minoan II after *c.* 1450, although they seem cruder in style than the fragments of miniatures from neighbouring Tylissos which suffered destruction in Late Minoan I B,[98] when scraps of miniatures from Katsamba,

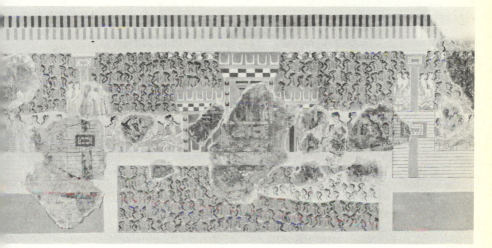

46. Spectators by a shrine, restored miniature fresco from the palace at Knossos.
Probably Late Minoan II, *c.* 1450. H without border *c.* 0.26 m. *Herakleion Museum*

The figures of the men are interesting to compare with those of the somewhat larger spectators on the fragment from the Thirteenth Magazine [30] (see p. 50). There is more detail in these later figures in spite of the smaller scale; but the style appears coarser, and the effect is perhaps more formal, less lively, than it was in the earlier scenes. Horns of consecration and circular beam ends are now outlined in black.

Although he eventually dated all the miniature frescoes to Middle Minoan III B, and thought of them as contemporary with the fragments from the Thirteenth Magazine, Evans himself was at first inclined to assign those from the Early Keep area to the 'latest phase of Knossian Palace art, and to an epoch on the brink of decadence'.[97] But the Early Keep miniatures

the harbour town of Knossos, may also have been lost.[99] The miniature frescoes from Ayia Irini on Kea appear to belong to the same general horizon as those from Tylissos and Katsamba.[100]

A remarkable frieze of the miniature class has been recovered from the room with the pictures of the two fishermen in the West House of the Akrotiri settlement on Thera [47].[101] It ran around the wall tops on at least three sides of the room, the north, east, and south, a distance of some twelve metres. Between six and seven metres of the frieze are reasonably well preserved, showing two groups of ships, one on the north, the other on the south wall, and a landscape with a stream on the east wall between them. Here on the east wall the height of the frieze was only 0.20 m., but elsewhere it appears to have been 0.40 m.

The ships on the north wall are shown in front of a sandy beach, which is flanked by a jutting cape indicated by rockwork of the kind visible on Marine Style vases of the following

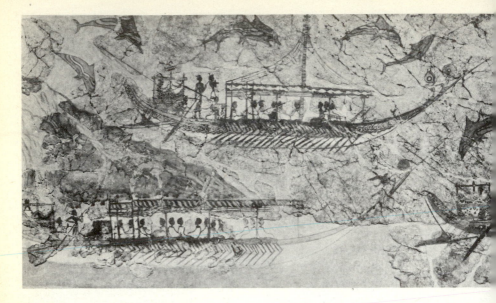

47. Miniature fresco with ships from the
West House at Akrotiri on Thera. Late Minoan IA,
c. 1550. H *c.* 0.40 m. *Athens, National Museum*

Late Minoan IB period in Crete, like those of
illustration 15, A and C. Even closer to the later
Marine Style is the scene of dolphins against a
background of rocks and waving seaweed on a
plaster table of offerings which was found on
the window sill of the adjoining bathroom in
the West House at Akrotiri.[102] The artists of the
Marine Style vases were evidently inspired by
paintings similar to these, which must also have
existed in Crete at the time.

Some of the ships seem to have been wrecked
in a sea-fight, to judge from the rectangular
shields in the water along with figures of men,
swimming or drowning. On the land above the
ships warriors equipped with similar tower-like
shields and helmets plated with boars' tusks
are standing with raised spears in front of the
houses of a settlement. The scene is vaguely
reminiscent of that on the silver Siege Vase from
Mycenae [154, 155] (pp. 160–3), but is not so
obviously war-like in character.

The landscape which fills the narrower band
of frieze on the east wall of the room has a stream

running through it flanked by palms and other
trees. A large winged griffin is extended in a
flying gallop towards the south wall, where a
lion is chasing two deer. Below the lion and the
deer is a second settlement by the sea with scat-
tered houses across the mouth of a stream from
it. From here a boat rowed by oarsmen is setting
forth at the rear of a fleet of large warships,
which head eastwards along the south wall
through a sea filled with dolphins towards the
third and most important settlement, where
Minoan-looking women greet the arrivals.

The upper warship on illustration 47 is
virtually complete. It is over 0.60 m. long, and
has a mast, but the sails are furled. The crew,
below a striped awning, face as if paddling to-
wards the high curved prow, which ends in a
long pole like a bowsprit, supporting giant
effigies of a butterfly and a flower. The stern
ends in the head of a lion or griffin. An elabor-
ately decorated cabin here, its sides covered
with ox-hides, must be for the captain. In front
of it the steersman stands holding his long steer-
ing oar. A projection from the stern may be a
gangplank.

The sand and rockwork on the coasts; the
blue stream flowing in a bed of yellow crossed

with red, with stripy egg-like boulders and waving trees beyond; the dense settlements of flat-roofed buildings with a scatter of isolated houses outside them; the detailed rendering of the ships, the lively movements of animals and dolphins, all give the scenes an extraordinarily life-like character, which is helped by the lack of inhibition, traditional in Aegean art, about dispensing with ground lines (p. 235). It is indeed tempting to see in these scenes so vividly depicted the record of an actual happening, if not, as Marinatos suggests, an expedition to some foreign country, possibly Libya, along the lines of the trading expeditions organized by Egyptian pharaohs.

Even more truly miniature is the bull-leaping scene on a crystal inlay plaque from the area of the Throne Room of the palace at Knossos [48].[103] This was painted on the flat under-side of the plaque so as to be visible through it. The

48. Charging bull painted on the back of a crystal plaque from the palace at Knossos. Probably Late Minoan I, before c. 1450. H 0.055 m. Herakleion Museum

background is blue, the bull red-brown, with the white body of a woman leaper flying through the air above it. Evans called this the 'ne plus ultra of the Minoan miniaturist's art', and it may be a work of the period before c. 1450, although lost at the time of the final destruction of the palace. The same technique was used to decorate the hollow inside of a large crystal pin head from Mycenae shaft grave III (see p. 200).

At the end of Late Minoan IB Crete seems to have been conquered by people from the Greek mainland. Knossos, Ayia Triadha, and Khania (ancient Kydonia), all of which may have been centres of political power at the time, are so far the only places where frescoes of the succeeding period have been found. These derive in style from ones painted before the conquest, and artists appear to have survived to work for the conquerors, but there are significant new developments. Processions and scenes in registers on the Egyptian model, and no doubt originally inspired by those of Egypt, are now very much in evidence in the frescoes of Crete as of the mainland.[104] Perhaps the formal Egyptian system of arrangement appealed to the taste of the people of the mainland in a way that it had not done to the Cretans.[105] It is true that some of the Cretan stone relief vases of pre-conquest date like the Boxer Vase [139] had scenes in registers, and the Harvester Vase [138] shows a religious procession of some kind; but these scenes were not formal and repetitive like those of the Egyptianizing processional frescoes of the post-conquest era. Nevertheless it is always possible that formal processions of this kind were already being painted on walls in Crete before c. 1450.

The Corridor of the Procession leading from the West Entrance of the palace at Knossos was widened after a destruction by fire, which Evans assigned to Middle Minoan IIIB, but for which a date in Late Minoan IB has been tentatively suggested above (p. 58). The frescoes which ultimately adorned it, showing life-sized figures of men and women engaged in some religious ceremony, were certainly among the finest and may have been the earliest of the new Egyptian-style paintings.[106] The work is careful, and the style is still close to that of Late Minoan I, which

might indicate that the paintings were done soon after the mainland conquest by Cretan artists who had survived it.[107] But for a time after the corridor was widened it may have had a dado of gypsum slabs which were only later replaced by the processional frescoes;[108] moreover the border of the robe of the woman nearest the West Entrance has a design found on the robes of figures on the Ayia Triadha sarcophagus and of women in the frieze from Thebes (pp. 70-1, 78-9),[109] and occurring on pottery of the earliest phase of Late Minoan III.

These frescoes were still in place when the palace at Knossos was destroyed in the fourteenth century. At the time of the excavations in A.D. 1900 a row of feet survived on the eastern wall of the corridor just inside the West Entrance. One pair belonged to a woman, who may have been a goddess, wearing an ankle-length robe; the men on each side of her were evidently facing inwards towards her. The long stretches of wall in the corridor and in the South Propylaion at the end of it must have been adorned with many hundreds of such figures,[110] but the only one whose face and body have survived is the so-called Cup-bearer [49]: a man holding a tall conical libation vase, coloured blue with stripes of yellow, suggestive of silver with gold mountings,[111] like the silver jug mounted with gold strips recovered from the palace at Zakro destroyed in Late Minoan I B c. 1450.[112] The Cup-bearer appears to have fallen from the western side wall of the South Propylaion, where, if not in the corridor, the figures may have been in two registers as often in Egypt.

49. Cup-bearer fresco from the palace at Knossos. Probably Late Minoan II, c. 1450. H 1.194 m. *Herakleion Museum*

The monumental beasts, evidently wingless griffins, which adorned the Throne Room in the west wing of the palace at Knossos were painted in a similar fine style [50B].[113] The throne appears to have been flanked by palm trees,[114] with a seated griffin against a background of papyrus reeds beyond them on each side. The griffins faced inwards towards the throne. Their legs and the lower parts of their bodies were decorated with hatching and cross hatching, as visible on illustration 50B. This may have been a conventional way of rendering hair, unless it was meant for shading.[115] Similar hatching is found on more or less contemporary Egyptian paintings of animals, and on griffins and other animals and birds in later frescoes from Pylos and Tiryns on the Greek mainland.[116] Evans thought that chevrons on the centrepieces of the large figure-of-eight shields painted on a wall in the residential quarter of the Knossian palace might have been intended to suggest shading of rounded surfaces,[117] but similarly placed chevrons in contemporary Egyptian paintings of shields do not appear to have this function.[118] Apart from these doubtful examples, and the

Yellow
Red
Blue
Green

A

50. Frescoes from Knossos: (A) 'sacral ivy' from the House of the Frescoes and (B) griffin from the Throne Room. *c.* 1550 and 1400. *Herakleion Museum*

B Red Yellow Blue

lines indicating muscles on the legs of bull-leapers in the Taureador frescoes, there is hardly any sign of attempts to show relief or perspective in the Bronze Age paintings of the Aegean. Animals and men are normally at any rate presented as silhouettes. When relief was wanted it was reproduced in plaster (pp. 71, 236).

The Camp Stool fresco was among the last pictures executed in the palace at Knossos.[119] It appears to have been a frieze rather over 0.60 m. wide adorning an upper room in the western wing, and was evidently painted after a fire which damaged this part of the building early in Late Minoan III. In the course of subsequent repair work the storage chests or cists below the floor of the Long Corridor of the West Magazines were filled and covered with pavement slabs,[120] and plain clay bowls with plaster in them dumped into the cists look as if they might have been used by decorators rendering the walls after the fire.

In the Camp Stool frieze small figures of men, in two registers in the Egyptian manner, were associated with a couple of larger pictures of women, richly dressed and apparently goddesses. The face of one, known as La Parisienne [51, 52D], is remarkably well preserved and has a lively charm despite the rather coarse style and crude execution: contrast the huge staring eye and coarse rendering of illustration 52D with earlier Knossian pictures of men and women such as illustration 52, E and B, or even with a comparatively late painting like the Dancing Girl [52C] which appears to be contemporary with the Taureador frescoes [44]. The white of the face of La Parisienne is heavily outlined in black against the blue background. This use of heavy black outlines appears in other late Cretan frescoes like the Captain of the Blacks (see p. 71), and in an accentuated form it is characteristic of the latest wall-paintings of the mainland like that of illustration 63.

The small figures of men appear to have been seated in facing pairs on the folding stools from which the Camp Stool fresco takes its name. They wear long oriental-looking robes and are evidently engaged in some kind of ritual symposium, since each pair seems to share a cup.

One of the cups, painted blue for silver, is a tall stemmed goblet of a type not current in Crete before Later Minoan III.[121] Like the system of registers, the combination of figures on different scales in the same picture is usual in Egypt, but not certainly attested in Crete or elsewhere in

51. 'La Parisienne' [cf. 52D] on a fragment of wall-painting from the palace at Knossos. Late Minoan IIIA, c. 1400 or later. H without border 0.20 m. *Herakleion Museum*

52. Faces in paintings from Crete (A)–(F) and the mainland (G)–(K), (A) from a large jar, the remainder from wall plaster (scales (A)–(F), (I)–(K) 1:2; (G)–(H) 1:4): (A) Woman from Knossos. c. 1400. *Herakleion Museum* (B) and (C) Women from Knossos. c. 1500–1400. *Herakleion Museum* (D) 'La Parisienne' [cf. 51] from Knossos. c. 1400 or later. *Herakleion Museum* (E) and (F) Men from Knossos. c. 1400 or earlier. *Herakleion Museum* (G) Woman, apparently a goddess, from Pylos. c. 1300. *Chora Museum, Messenia* (H) Woman from Tiryns. c. 1400. *Athens, National Museum* (J) and (K) Men from Pylos [cf. 60]. c. 1250. *Chora Museum, Messenia*

the Aegean before this time. It is, however, a feature of the latest frescoes on the mainland.

The paintings on the famous Ayia Triadha sarcophagus [53, 54] belong to the same late

sacrifice is taking place to the music of pipes. On each end of the coffin is a chariot with a pair of women, apparently goddesses, riding in it. One chariot is drawn by winged griffins, the other

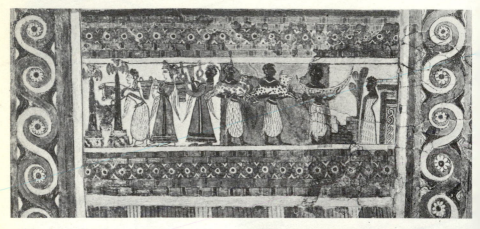

53 (*above*). Ayia Triadha sarcophagus. Long side showing the dead man before his tomb (*right*), while offerings are brought to him, and libations are made (*left*) to the tune of a lyre.
Late Minoan IIIA, *c.* 1400. Limestone, with the surface plastered and painted. L 1.37 m.
Herakleion Museum

54 (*right*). Ayia Triadha sarcophagus.
End showing a pair of goddesses in a chariot drawn by wild goats

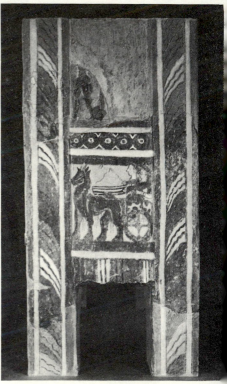

period.[122] This unique limestone coffin was found in A.D. 1903 in a small rectangular stone-built tomb in the cemetery east of the palace. Its surface was coated with a thin layer of white plaster on which scenes were painted as if on a wall. The shape and decoration of the vases represented and the style of the work suggest a date at the beginning of Late Minoan III. The scenes offer a unique record of funerary cult in Crete at the time. On one long side of the coffin [53] the dead prince himself, looking much like an Egyptian mummy, stands in front of his tomb to receive offerings brought by men dressed in skins which may be those of sacrificed animals, while women pour libations to the accompaniment of a lyre. On the opposite side a

[54] by goats.[123] Fragments of frescoes with comparable scenes of sacrifice, evidently dating from the same period, were recovered in a sounding between the tomb which contained the sarcophagus and the palace.[124] The subject of these frescoes and the place where they were found suggest that they may have adorned the walls of a tomb.[125]

No Cretan frescoes of the Bronze Age can be assigned with certainty to a period after the final destruction of the palace at Knossos. The fragment known as the Captain of the Blacks[126] was indeed found outside the palace area, and the crudity of the style might suggest that it was later than any of the paintings from the palace; but the subject, a native captain leading a troop of light-armed negro soldiers,[127] even if they are not the palace guards as Evans thought, appears to reflect a time when Knossos was still a centre of power.

Floors with simple linear designs are attested in Crete by c. 2000 if not earlier (see p. 48).[128] A fragment of plaster with spiral decoration from the Akrotiri settlement on Thera may have come from a floor,[129] as may decorated fragments found lying face upwards in the area of the residential quarter of the palace at Knossos,[130] since one group has panels of imitation gypsum slabs reminiscent of the later painted floors of the mainland (see pp. 82–3).[131]

Some Cretan floors were decorated with pictures. The Dolphin fresco was assigned by Evans to an earlier scheme of decoration on a wall of the Queen's Megaron in the palace at Knossos,[132] but from the situation in which it was found it seems more likely that it adorned the floor of an upper room there. The choice of something as insubstantial as the sea to decorate a floor may appear strange, but a comparable floor has been discovered in a shrine building by the palace at Ayia Triadha.[133] The shrine here continued in use into Late Minoan III times, but the sea-floor was not the latest one in it; it had been buried after a fire, almost certainly the same as that which destroyed the palace in Late Minoan I B c. 1450.[134] The sea-creatures here include an octopus, and fish set in rather unattractive rows; but this might

have been the scheme of arrangement of the fish of the Knossos Dolphin fresco, which has been conjecturally restored from disjointed fragments along the more pleasing lines of the frieze of flying fish from Phylakopi (see p. 53).

Ceilings in Crete may also have been decorated with painted designs: fragments of spirals in plaster relief from Knossos appear to come from ceilings (see p. 76).

Relief Frescoes

As already noted, some of the wall-paintings in the palace at Knossos were combined with plaster relief.[135] For convenience these relief frescoes are considered separately from the other paintings, although they merge into them. Actual relief was the only way of creating an illusion of modelling in the round in the absence of developed techniques of shading[136] (see p. 236). But Cretan relief frescoes may owe something to the painted stone reliefs of Egypt.[137] On occasion the relief was low, and might be confined to a few features in the picture. At the other extreme it was very bold, as in the case of the reliefs, perhaps among the latest in the series, that appear to have adorned a Great East Hall just north of the residential quarter of the palace (see p. 73).

The tradition of making plaster reliefs may go back to Middle Minoan II times at Knossos:[138] one scrap was recovered from a deposit of Middle Minoan II B date during the excavations in the Royal Road area in 1957–61. Some of the fragments from the palace may date from the beginning of Middle Minoan III as Evans proposed, although he eventually assigned the bulk of them to a period of restoration following the horizon of destruction in Middle Minoan III B. His opinion that relief frescoes were no longer made at Knossos after the early part of Late Minoan I (he regarded the Priest King, which he assigned to Late Minoan I A, as the last example of the art[139]) may not be far from the truth; there are reasons for thinking that none of the examples which still remain to us were on the walls of the palace after the end of Late Minoan I B.

Evans believed that several of the relief fres-
coes, such as the high reliefs that he assigned to
the Great East Hall (see p. 73), had remained
on the walls of the palace for many years until
its final destruction; indeed he supposed that
parts of the scene with a bull in relief from the
North Entrance Passage (see below) were visible
for centuries afterwards. But it is significant
that, while several fragments of relief frescoes
were recovered from deposits below the latest
floors in the palace,[140] none appear to have been
found in an indisputable association with debris
of the final destruction. Some relief frescoes
may date from the Late Minoan I period, and
could have been in place at the time of the
mainland conquest in Late Minoan Ib *c.* 1450,
but the fashion for them was possibly on the
wane by then – as suggested by their virtual
absence on the mainland (p. 77).

55. Bull's head from the palace at Knossos.
Probably Middle Minoan IIIb, *c.* 1600. Plaster relief,
painted. H without horns *c* 0.44 m.
Herakleion Museum

The figures in these Knossian relief frescoes,
whether human or divine or animal, were mostly
it seems large and more or less life-size, although
fragments of a bull below life-size were found in
the House of the Sacrificed Oxen just beyond
the south-eastern borders of the palace from
which it may have fallen.[141] The scraps of
figures from the North-West Fresco Heap have
already been discussed (p. 58). The relief
frescoes that will now be considered are the
*scenes of bull-grappling from the North Entrance
Passage*, the fragments of a *lion seizing its prey*,
and the *high reliefs* that appear to have adorned
the hypothetical Great East Hall, followed by
the *Jewel Fresco*, and the *Priest King*.

*Scenes of bull-grappling from the North En-
trance Passage.*[142] The head of a charging bull
[55] from the North Entrance Passage, the best
preserved of all the relief frescoes recovered at
Knossos, was found at a high level in the pas-
sage area along with other fragments which
evidently came from a large scene of bull-
grappling. Evans thought that this had adorned
an open portico overlooking the North Entrance
Passage on the west, a view reflected by the
portico as restored today with a facsimile of part
of the relief on the back wall. A scene of charg-
ing bulls on this side of the passage, he sug-
gested, might have been balanced by one show-

ing more peaceful methods of catching bulls in
a similar portico on its much-destroyed eastern
side. These would have corresponded to the
contrasting scenes on the two gold cups from
the Vapheio tomb [160–3] (see p. 166). The two
fragments of gypsum reliefs from the Treasury
of Atreus at Mycenae might have belonged to a
similar pair of scenes (see p. 100).

Fragments of this fresco were found high in
the fill of the North Entrance Passage, and
Evans explained this by assuming that much of
it had remained in place on the back wall of the
portico after the final destruction of the palace.
It was still visible there, he thought, to the Early
Iron Age inhabitants of Knossos, and the sight
of it might have given substance to the legend
of the Minotaur.[143] But he assigned the reliefs
to Middle Minoan IIIb, and they are clearly in
a fine, relatively early style.

Some of the fragments were recovered from
above the spot where a group of storage jars
(couple amphorae) was standing on the floor of
the North Entrance Passage at the time of the
final abandonment of the palace. Abundant re-
mains of burnt debris were found in and around

these jars, together with many Linear B clay tablets, but no fragments of the reliefs. On the other hand, according to a sketch plan made by Evans at the time of the excavations in 1900, much of the charging bull was recovered from inside the line of the terrace wall bounding the North Entrance Passage on the west.[144] Indeed a relief fragment that may have come from a bull-leaper connected with the scene was described as found in the make-up of an earlier wall in this area![145]

In the light of this it seems unlikely that the reliefs were on the walls of the palace when it was destroyed; they must have been removed at some earlier date and the fragments incorporated in a fill behind the massive terrace wall on the west side of the North Entrance Passage. At some point after the final destruction of the palace by fire the upper part of this wall and the fill behind it with the fragments of the bull reliefs appear to have collapsed forwards into the North Entrance Passage on top of the burnt debris: Evans in fact speaks of the 'debris of rubble masonry' in which the reliefs were found imbedded.[146]

Fragments of at least two bulls were recovered. Both male and female bull-leapers may have been represented as in the Taureador frescoes, to judge from the brown forearm of a man in relief and the fragments of a white-painted leg, thigh, and arm, attributable to one or more women. The background, partly in low relief, included conventional rockwork, and perhaps olive trees [56A], although the fragments with these were found some distance away from the rest. The head of a charging bull on illustration 55 is almost complete.[147] As Evans notes, it 'stands forth as one of the noblest revelations of Minoan Art. It is simple and large in style, but instinct with fiery life'. The eye was rendered in high relief, and the eyeball carefully painted in several different colours. The ear is actually in the round. 'The upstanding ear marks intense excitement; the tongue protrudes, the hot breath seems to blow through the nostrils. The folds of the dewlap show that the head was in a lowered position – it is that of a bull coursing wildly.'

The character of the reliefs, the strength and nobility of the charging bull, and details of the conventional rockwork of the background are consistent with the early date (Middle Minoan IIIB) which Evans gave them. The style of the olive sprays [56A] which may have formed part of the background compares with that of the plants on the Ayia Triadha frescoes,[148] assignable to a period before the eruption of Thera (see p. 52). Some fragments of the reliefs show traces of burning; but whether they were buried after the palace of Knossos was damaged by fire in Middle Minoan IIIB or on some later occasion is not certain.

Lion seizing prey.[149] Bulls were not the only creatures in relief on the palace walls at Knossos. From the south-eastern corner of the palace come a couple of tantalizing fragments, one from the leg, the other from the mane of a life-sized lion. On the fragment of mane are traces of what appears to be part of another animal which the lion has seized; a wild goat perhaps, if not a bull.[150]

High reliefs from the Great East Hall.[151] A group of fragments of relief frescoes from the eastern side of the palace just north of the residential quarter was assigned by Evans to a large hall which he assumed to have existed there. These fragments were found close together; some at a high level, virtually unstratified, beyond the hypothetical borders of the hall to the east,[152] others near by in a deposit below the latest surviving floor at the eastern end of the area of the hall itself.[153] The floor, with cooking pots resting on it, was eventually assigned by Evans to Middle Minoan IIIB, while he dated the deposit with the reliefs below it to Middle Minoan IIIA. He came to think that these two sets of fragments, stratified and unstratified, must have belonged to two successive schemes of decoration in the hall. But it seems more probable that they were in fact part of one and the same series, which, like the reliefs of the North Entrance Passage area, had been removed from the walls of the palace some considerable time before its final destruction.

Most of the fragments seem to come from scenes of men boxing and wrestling. But some

A

B

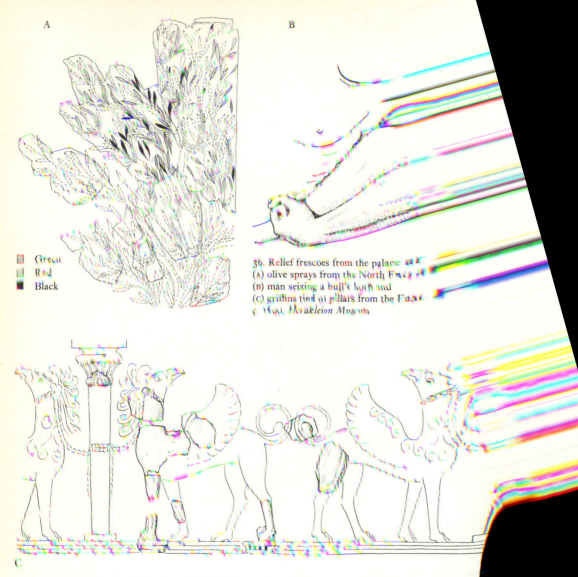

■ Green
▨ Red
■ Black

56. Relief frescoes from the palace at
(A) olive sprays from the North F...
(B) man seizing a bull's horn and
(C) griffins tied to pillars from the F...
(C) ... Herakleion Museum

C

of the stratified fragments belonged to bulls, and an unstratified fragment shows a finely modelled arm seizing the tip of a bull's horn [56B]. A pair of female breasts suggests that women as well as men were involved in the bull-grappling scenes, as on the Taureador frescoes found a short distance to the north (pp. 60–1). Evans assumed that these scenes in high relief must have decorated the wall at the eastern end of his Great East Hall. In a lofty room of the kind which he envisaged the bull-leaping scenes might have been in a different register from those of boxing and wrestling, as on the Boxer relief vase (see p. 146).

A few other fragments seemed to come from figures of griffins [56C] in very high relief – some

these jars, together with many Linear B clay tablets, but no fragments of the reliefs. On the other hand, according to a sketch plan made by Evans at the time of the excavations in 1900, much of the charging bull was recovered from inside the line of the terrace wall bounding the North Entrance Passage on the west.[144] Indeed a relief fragment that may have come from a bull-leaper connected with the scene was described as found in the make-up of an earlier wall in this area![145]

In the light of this it seems unlikely that the reliefs were on the walls of the palace when it was destroyed; they must have been removed at some earlier date and the fragments incorporated in a fill behind the massive terrace wall on the west side of the North Entrance Passage. At some point after the final destruction of the palace by fire the upper part of this wall and the fill behind it with the fragments of the bull reliefs appear to have collapsed forwards into the North Entrance Passage on top of the burnt debris: Evans in fact speaks of the 'debris of rubble masonry' in which the reliefs were found imbedded.[146]

Fragments of at least two bulls were recovered. Both male and female bull-leapers may have been represented as in the Taureador frescoes, to judge from the brown forearm of a man in relief and the fragments of a white-painted leg, thigh, and arm, attributable to one or more women. The background, partly in low relief, included conventional rockwork, and perhaps olive trees [56A], although the fragments with these were found some distance away from the rest. The head of a charging bull on illustration 55 is almost complete.[147] As Evans notes, it 'stands forth as one of the noblest revelations of Minoan Art. It is simple and large in style, but instinct with fiery life'. The eye was rendered in high relief, and the eyeball carefully painted in several different colours. The ear is actually in the round. 'The upstanding ear marks intense excitement; the tongue protrudes, the hot breath seems to blow through the nostrils. The folds of the dewlap show that the head was in a lowered position – it is that of a bull coursing wildly.'

The character of the reliefs, the strength and nobility of the charging bull, and details of the conventional rockwork of the background are consistent with the early date (Middle Minoan III B) which Evans gave them. The style of the olive sprays [56A] which may have formed part of the background compares with that of the plants on the Ayia Triadha frescoes,[148] assignable to a period before the eruption of Thera (see p. 52). Some fragments of the reliefs show traces of burning; but whether they were buried after the palace of Knossos was damaged by fire in Middle Minoan III B or on some later occasion is not certain.

Lion seizing prey.[149] Bulls were not the only creatures in relief on the palace walls at Knossos. From the south-eastern corner of the palace come a couple of tantalizing fragments, one from the leg, the other from the mane of a life-sized lion. On the fragment of mane are traces of what appears to be part of another animal which the lion has seized; a wild goat perhaps, if not a bull.[150]

High reliefs from the Great East Hall.[151] A group of fragments of relief frescoes from the eastern side of the palace just north of the residential quarter was assigned by Evans to a large hall which he assumed to have existed there. These fragments were found close together; some at a high level, virtually unstratified, beyond the hypothetical borders of the hall to the east,[152] others near by in a deposit below the latest surviving floor at the eastern end of the area of the hall itself.[153] The floor, with cooking pots resting on it, was eventually assigned by Evans to Middle Minoan III B, while he dated the deposit with the reliefs below it to Middle Minoan III A. He came to think that these two sets of fragments, stratified and unstratified, must have belonged to two successive schemes of decoration in the hall. But it seems more probable that they were in fact part of one and the same series, which, like the reliefs of the North Entrance Passage area, had been removed from the walls of the palace some considerable time before its final destruction.

Most of the fragments seem to come from scenes of men boxing and wrestling. But some

A

B

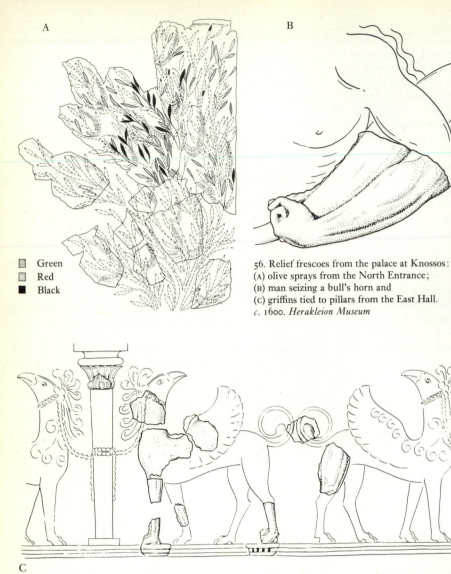

Green
Red
Black

56. Relief frescoes from the palace at Knossos:
(A) olive sprays from the North Entrance;
(B) man seizing a bull's horn and
(C) griffins tied to pillars from the East Hall.
c. 1600. *Herakleion Museum*

C

of the stratified fragments belonged to bulls, and an unstratified fragment shows a finely modelled arm seizing the tip of a bull's horn [56B].[154] A pair of female breasts suggests that women as well as men were involved in the bull-grappling scenes, as on the Taureador frescoes found a short distance to the north (pp. 60–1). Evans assumed that these scenes in high relief must have decorated the wall at the eastern end of his Great East Hall. In a lofty room of the kind which he envisaged the bull-leaping scenes might have been in a different register from those of boxing and wrestling, as on the Boxer relief vase (see p. 146).

A few other fragments seemed to come from figures of griffins [56C] in very high relief – some

of their forelegs were actually in the round. They had collars on their necks, and were apparently arranged in pairs, one each side of a column, to which they were tethered by means of beaded ropes. They were painted white with details in red and black: the background was blue. Evans suggested that the griffins might have formed a frieze above the level of the door lintels along the north and south sides of the hall.

With the stratified fragments were found the remains of a painted frieze with dotted spirals

1926, showed a man's finger and thumb in relief holding one end of a necklace of globular beads combined with pendants in the shape of heads wearing large triple earrings [190]. The beads and pendants were painted a dull orange indicating gold. The necklace was tied to some blue material which may have gone behind the neck. The man seems to have been placing it on the white breast of a woman, and Evans originally suggested that the fragment might come from a scene of a wedding ceremony, perhaps a Sacred Marriage.

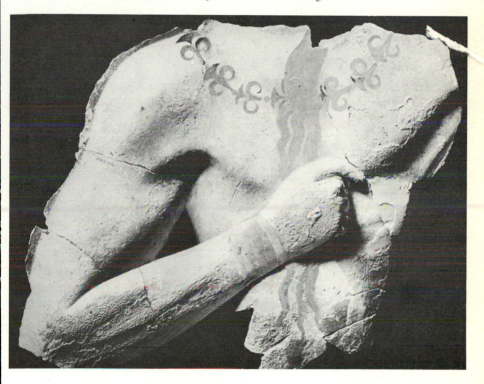

comparable with those of the spiral frieze from the Late Minoan I B destruction level on the Royal Road.[155] Spirals in relief among the unstratified fragments appear to come from a ceiling, like the relief spirals from the Early Keep area (see p. 76).

The Jewel fresco.[156] This scrap of fresco, unfortunately 'pulverized' by the earthquake of A.D.

57. Priest king fresco from the palace at Knossos. Perhaps Late Minoan IA, *c.* 1550. Life-size plaster relief, painted. *Herakleion Museum*

The Priest King [57].[157] Evans assigned this to Late Minoan IA and regarded it as the latest of the relief frescoes. The fragments were found close below the surface in the much eroded

southern region of the palace, and were therefore virtually unstratified.[158] The relief might have adorned the eastern side of a passage leading south from the Central Court. The face is unfortunately missing, but large fragments of a body, legs, and arms survive, together with a crown. The surfaces of the body fragments are much worn, and it has been suggested that they were originally painted white and that the figure was that of a girl.[159] But the chest is like that of a man, and some of the original brown paint has been preserved on its surface where it was covered by a necklace of lily-shaped beads. The paint of these has disappeared; or as Evans rather improbably suggested, the beads might have been applied in gold leaf.[160]

The figure as restored moves sideways to the left, with the trunk represented as if seen from the front, as often in Egypt and like the king or god on the Chieftain Cup (see p. 143). But the restoration is not certain, and the fragments may come from two or three different figures as Evans originally supposed.[161] The crown, in low relief, is surmounted by stylized papyruslilies. Long feathers on a separate fragment may have flowed from the top of the tall central lily. The crown may be meant for one of metal, the white, red, and blue of the lilies representing silver, gold, and inlays of blue paste. Crowns of a similar shape are worn by sphinxes [122, A and D], which are often if not always female,[162] and by the priestess on the Ayia Triadha sarcophagus [53] (pp. 70-1), and comparable but barbarized versions of flower-decked gold crowns in the Mycenae shaft graves evidently belonged to women [196] (pp. 198-9).[163] But a pair of similarly crowned figures leading crowned sphinxes on a much damaged ivory box from Mycenae appear to be male.[164] So the crown may have belonged to a male figure who was leading a sphinx,[165] or a griffin as Evans supposed, on a rope. The background of the scene appears to have been painted red and white. Fragments which Evans assigned to it include part of an iris-like flower on a white ground, and a butterfly against a red one.

Ceilings as well as walls may have been decorated in relief. Evans thought that fragments of

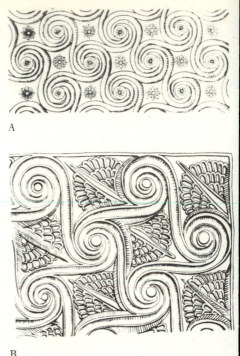

A

B

58. Relief ceilings: (A) in plaster from the palace at Knossos and (B) in stone from the Treasury of Minyas at Orchomenos

spirals in plaster relief came from a network that formed the ceiling of his Great East Hall. Fragments of smaller relief spirals found above the floor of a room in the Early Keep area of the palace [58A][166] may have fallen from an upper storey, where they could have been part of the scheme of decoration of a shrine whose walls were adorned with the panels of miniature frescoes like that of illustration 46 showing crowds watching games and dances (see p. 62). As early as A.D. 1902 they had been reconstructed as a ceiling formed by a network of spirals, which seems correct;[167] but at the time of their discovery in 1900 they were interpreted as the remains of a cornice,[168] and similar relief spirals actually served as a cornice round the top of a wall in an important room in the palace at Zakro

destroyed in Late Minoan IB *c.* 1450.[169] A unique stone ceiling with a papyrus design in low relief still adorns the side chamber of the great tholos tomb at Orchomenos [58B],[170] and a fragment of plaster from Knossos with a comparable papyrus in relief might have been part of a ceiling as Evans assumed.[171]

Relief frescoes were not confined to Knossos; fragments have been recovered from Khania, Phaistos, and Palaikastro, and from the palace at Gournia.[172] But the large figures, possibly of goddesses, from what appears to have been a shrine in the settlement on Pseira [35B] (pp. 56–8) are so close in style to the wall-paintings of Knossos as to suggest that they were the work of an artist from the capital.[173]

A fragment of a clothed figure found at Mycenae[174] is virtually the sole evidence for relief frescoes on the mainland, which suggests that Evans may have been right in assigning the bulk of those from Knossos to a comparatively early stage in the history of the later palace there. The fashion for reliefs may have been on the wane in Crete by the time of the mainland conquest *c.* 1450 when Gournia, Zakro, and Pseira were destroyed.

THE MAINLAND

Remains of wall-paintings have been noted at a large number of sites on the mainland, including not only Mycenae, Tiryns, and Pylos, but places of secondary importance like Zygouries.[175] The paintings at Zygouries came from the area of the Potter's Shop, so called from its stores of clay vases; it may have been part of a small 'palace' or residence of a local ruler, although it is probable that at the time the settlement was under the control of neighbouring Mycenae. At Mycenae itself wall-paintings were not confined to the palace; fragments of them have been recovered from houses and other buildings both inside and outside the citadel walls.[176]

The art of wall-painting appears to have been adopted by the people of the Greek mainland from Crete, and the first paintings there may have been the work of Cretan artists.[177] The earliest certain evidence comes from Mycenae, where a few scraps of painted wall plaster were recovered from below the floor of the East Lobby on the southern edge of the palace.[178] The associated pottery was assignable to Late Helladic I or Late Helladic IIA at the latest,[179] indicating a date before the mainland conquest of Crete *c.* 1450.

Another early group of frescoes was found at Mycenae in a deposit below the floors of the Ramp House inside the citadel.[180] This may have been formed when the citadel area was being reconstructed and replanned about the middle of the fourteenth century.[181] Pottery from it ranges from Late Helladic I to Late Helladic IIIA,[182] but the frescoes are likely to date from the beginning of that period,[183] since they show points of comparison with paintings from Knossos like the Ladies in Blue,[184] the Tripartite Shrine [46],[185] and the Taureador frescoes [44].[186] For example the way in which the body of the bull is coloured and shaded in the Knossos Taureador scene [44], and the manner of rendering its hoof, are closely matched on the bull on a fragment from the Ramp House deposit, although this is drawn to a smaller scale. Some of the fragments from the Ramp House have miniature figures comparable with those from Knossos and Tylissos; and one scene with miniatures was evidently framed in a panel like the Taureador frescoes, and had a similar border.[187] The same kind of border appears again with the Ramp House bull, which, though larger in scale than the human figures, appears to come from one of these miniature scenes. Miniature frescoes from Tiryns may go back to the same early period as the Mycenae Ramp House paintings.

Remains of paintings of two distinct periods have been found stratified in the House of the Oil Merchant outside the citadel at Mycenae.[188] The later frescoes were evidently on the walls of the house at the time of its destruction, which took place, it seems, early in Late Helladic IIIB soon after 1300,[189] but the earlier ones came from a deposit below the floor of a corridor with fourteenth-century (Late Helladic IIIA) pottery. The two groups of fragmentary paintings seem to correspond in style with the earlier and

later ones distinguishable at Tiryns and Pylos.

The numerous remains of frescoes from these two centres fall, as has just been said, into two chronological groups. Those of the earlier series, broadly assignable to the fourteenth century, are closely akin to contemporary Cretan frescoes in style. This is natural, seeing that the chief centres of Crete were controlled at the time by people from the mainland. But the latest paintings, those which were on the walls of the palaces at Tiryns and Pylos when they were destroyed at the end of the thirteenth century, are extremely crude. They look as if they were a good deal later in date than any Bronze Age frescoes yet recovered in Crete with the doubtful exception of the Captain of the Blacks (see p. 71).

The latest paintings at Pylos like the griffin's head [63] are clearly distinguishable in style from the earlier ones.[190] Abundant fragments of earlier frescoes like those shown in illustrations 59 and 60, found in a dump on the northwestern edge of the palace site, had evidently been removed from the walls when the palace was built or remodelled during the fourteenth or early thirteenth century. Related fragments were recovered from the site of the palace itself, since scraps of old plaster had been incorporated in the new plaster for its floors and walls. Apart from their different style, however, the unburnt condition of these scraps makes it clear that they were not exposed to view at the time the palace was destroyed by fire c. 1200.

Pottery from the fresco dump on the northwest slope at Pylos was assignable to a mature phase of Late Helladic III B, towards the end of the thirteenth century, but some of the older frescoes from the dump may go back to the beginning of Late Helladic III A c. 1400. One of the earliest of the Pylos fragments [59] has a small figure of a bull-leaper reminiscent of those of the Taureador frescoes from Knossos [44].[191] The man is dressed in a short kilt of the type worn by the bull-leapers of the Knossian Taureador frescoes, and by the related miniature figure from the Ramp House deposit at Mycenae (pp. 60, 77). Later scenes of bull-leaping from the mainland are very different in style.

Such are the fragments from Orchomenos,[192] and the well-preserved picture found by Schliemann at Tiryns, which has been castigated as a caricature in comparison with the Knossian Taureador frescoes.[193]

Processions in the Egyptian manner were a favourite scheme of decoration for walls on the mainland, as they appear to have been in Crete from c. 1450 onwards (see p. 65). The frieze

59. Bull-leaper on a fragment of early wall-painting from the palace at Pylos. Probably Late Helladic IIIA, c. 1350. 0.092 × 0.078 m. *Chora Museum, Messenia*

60. Men wearing skins on a fragment of late wall-painting from the palace at Pylos [cf. 52, J, K]. Late Helladic IIIB, c. 1250. 0.15 × 0.17 m. *Chora Museum, Messenia*

of women from Thebes may be among the earliest.[194] The women carried flowers, and objects which included an ivory box and a jar of veined stone, and were perhaps advancing towards a shrine or altar, of which nothing has survived.[195] The excavator, Keramopoullos, at first thought that the frieze had decorated a room on the second floor of this part of the palace,[196] but he later concluded that it had been stripped from the walls of the ground-floor room where it was found and buried under a new floor at a higher level than the original one.[197] Some fragments of other frescoes from a room just to the south had been overpainted with new ones in a cruder style, and this may have been done at the same time as the frieze of women was removed from the walls and buried.[198] All this part of the palace at Thebes was eventually destroyed by fire towards the end of the fourteenth century or later.[199]

The Theban frieze of women is comparable in style with the Procession fresco from Knossos, although it was almost certainly painted after it;[200] elements of the decoration on the dresses, as in illustration 61A, indicate a date after the beginning of Late Helladic IIIA c.

1425.[201] The knuckles [61B] are shown in a distinctive but rather crude way which does not appear to be attested in Crete,[202] and may represent a convention developed by artists working on the mainland: the knuckles of the women on a comparable and more or less contemporary frieze from Mycenae were rendered in a similar manner,[203] but the women were smaller – only about half life-size.

The women of a frieze from Tiryns with knuckles depicted in this way [61C] seem less elegant and may have been painted later.[204] Some of the faces, however, are relatively well preserved [52H],[205] as is the spectacular head, perhaps that of a goddess, recently found at Mycenae [62].[206] The Mycenae woman is delicately painted in a fine style suggestive of an earlier date than the women of the friezes from Tiryns or Thebes – her ear and eye in particular are more elaborately treated, and less stylized, than those of the Tiryns women; but the ear of an attractive profile of a woman [52G], apparently a goddess, one of the earlier series of frescoes from Pylos, is still more stylized and akin to the ears of the large plaster head from Mycenae (see p. 102).[207] Fragments of other mostly late fres-

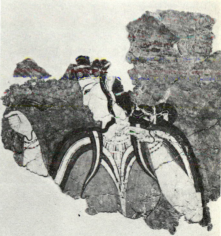

61. Details of paintings of c. 1400 onwards:
(A) Motif common on dresses (B) and (C) Women's hands showing knuckles from Thebes and Tiryns

62. Head of a woman on a wall-painting from Mycenae. Probably Late Helladic IIIA, c. 1350. H 0.53 m. *Athens, National Museum*

coes of women have been recovered at Pylos as well as at Mycenae and Tiryns.[208]

The richly dressed women of the friezes appear to have been taking part in religious ceremonies like the men and women of the Procession fresco at Knossos. On the mainland as in Crete a high proportion of wall-paintings was evidently devoted to scenes of ritual and cult. This is clear for instance in the case of the very late frescoes which adorned the walls of the palace at Pylos at the time of its destruction towards the end of the thirteenth century.[209] They provide the most complete series that has yet been recovered on the Greek mainland, and give some idea of what the overall scheme of decoration in a great Bronze Age palace was like.

The most important part of a mainland palace of the standard type was the megaron, or main living room and its approaches. At Pylos a monumental gateway (Propylon) with a porch at each side opened into a courtyard, and a portico at the opposite end of this court led into the vestibule of the megaron. The outer porch of the monumental gateway may have been decorated with a frieze of life-sized tribute bearers, reminiscent of the Procession fresco which began at the West Entrance of the palace at Knossos.[210] The inner porch had pictures of seated women, who may have been goddesses, together with architectural façades, perhaps those of shrines, and animals including horses, lions, and deer. The vestibule of the megaron was adorned with a scene of a religious procession in two registers after the Egyptian manner, like the Knossian Camp Stool fresco. A huge bull at the head of the procession occupied the height of both registers, as the Camp Stool goddesses may have done (see p. 68).

The pictures in the megaron itself included large bulls, lions, and deer, together with imaginary griffins. The throne, against the middle of the right hand wall on entering, appears to have been flanked by lions and griffins in a way comparable to the arrangement in the Throne Room at Knossos (see p. 66). In contrast to these groups of great beasts was a scene with little pairs of seated banqueters in long robes, remi-niscent of the pairs of long-robed figures in the Camp Stool fresco. A similar pair of seated figures, probably men, may have faced each other on a painted grave stele from a chamber tomb at Mycenae.[211] The Pylos banqueters were overlooked by a gigantic figure of a lyre-player, clad like them in a long Oriental-looking garment, and with a large bird in flight in front of him. The wall opposite the throne appears to have had a picture of a landscape with papyrus plants and deer in it.

The significance and meaning of these scenes on the walls of the megaron are obscure, but they may have been religious rather than secular. Other rooms in the palace, however, were decorated with pictures of warfare or hunting; one fragment appears to show armoured Mycenaeans battling with skin-clad barbarians, a theme that may have had a counterpart at Mycenae.[212] Scenes of this kind are more conspicuous on the mainland than they were in earlier times in Crete;[213] but evidence for their rendering there in other media, in the form of inlays,[214] for instance, or on stone relief vases,[215] suggests the possibility that the freaks of chance may have deprived us of Cretan frescoes with such themes. Two scraps of miniature frescoes from Knossos, assignable it seems to a period before the mainland conquest of c. 1450, show men hurling javelins, but whether in war or in sport is not clear.[216]

The frescoes which still adorned the walls of the megaron in the palace at Mycenae at the time of its destruction at the end of the thirteenth century appear to have been painted a good deal earlier than those of the final series at Tiryns and Pylos.[217] In contrast to the megaron at Pylos, that at Mycenae seems to have been decorated with scenes of warfare. They occupied a frieze about 0.65 m. high, which, if it ran all round the room, must have been some 46 m. in length, incorporating several hundred figures. The surviving fragments, recovered on various occasions, by Tsountas (1886), Rodenwaldt (1914), and Wace (1921), all come from the north side of the room, the south and east sides having long ago slipped down into the Chaos ravine below.

North of the great door at the west end of the room there appears to have been a camp scene with chariots being harnessed. Beyond it a battle was taking place, and further along, at the east end of the north wall, a fortress stood on a rocky height. The sequence of camp, battle, and beleaguered fortress brings to mind the siege of Troy as described by Homer, but has analogies in the pictorial art of Egypt at the time. One fragment shows what may be the belly of an immense horse, doubtless attached to a chariot, above a falling warrior with part of the fortress on a smaller scale beneath him; this is reminis-

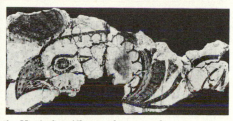

63. Head of a griffin on a fragment of wall-painting from the palace at Pylos. Late Helladic IIIB, *c.* 1250. 0.18 × 0.41 m. *Chora Museum, Messenia*

64. Wall-paintings from Tiryns: (A) huntsman with two spears (scale 1:5) and (B) deer (scale 1:6). *c.* 1250. *Athens, National Museum*

cent of Egyptian battle pictures incorporating a huge chariot-borne pharaoh and besieged enemy town. Another fragment seems to depict a warrior clad in a skin, but he wears greaves, unlike the skin-clad barbarians at Pylos.[218]

The latest mainland frescoes as known from Pylos, Mycenae, and Tiryns represent a great decline in skill and workmanship from those of earlier times. The drawing is usually crude, and often careless,[219] while the figures of people and animals are heavily outlined in black like the griffin's head on illustration 63. But the results are sometimes not without a certain lively charm. One of the most attractive of these late frescoes is the fragmentary hunt scene from Tiryns, which may have adorned the larger of the two megarons of the palace, with its improbable pink and blue dappled hounds in pursuit of wild boar,[220] one of which has been caught in a net. Other animals on the surviving fragments include a stag and hunting dogs. Women as well as men, as in illustration 64A, seem to have been represented among the hunters,[221] and there were at least six chariots. Another related scene from Tiryns shows a group of deer [64B], their coats dappled pink, violet, yellow, and blue, and marked according to old-established convention with black crosses.[222]

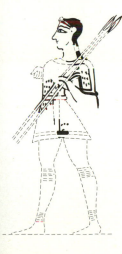

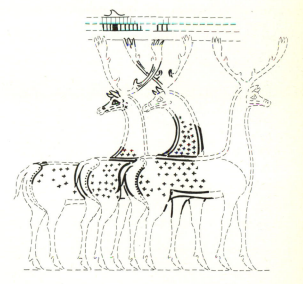

65. Goddess, holding plants or cereals in each hand.
Wall-painting from the citadel at Mycenae.
Late Helladic IIIB, *c.* 1250. *Nauplia Museum*

66. Floor of painted plaster in the palace
at Pylos. Restored drawing by Piet de Jong.
Late Helladic IIIB, *c.* 1250

Pictures in a late style also existed at My-
cenae. Scenes of a goddess with other smaller
figures and sacred pillars were recently dis-
covered still in place on the walls of a fire-
destroyed shrine in the Citadel House area
there.[223] The goddess [65], painted in thick
black outline against a white background, is
strikingly different from the elegant Mycenaean
women of an earlier age.[224]

Floors with painted decoration are more in
evidence on the mainland than in Crete. The
chief state rooms of the mainland palaces were
usually at ground level and their floors have
therefore survived, while their Cretan equiva-
lents were often on a raised piano nobile which
has disappeared or collapsed into basement
spaces below it. Moreover Crete had supplies of
gypsum for making attractively veined pave-
ment slabs. The gypsum for the slabs used to
form borders round the plaster floors in the

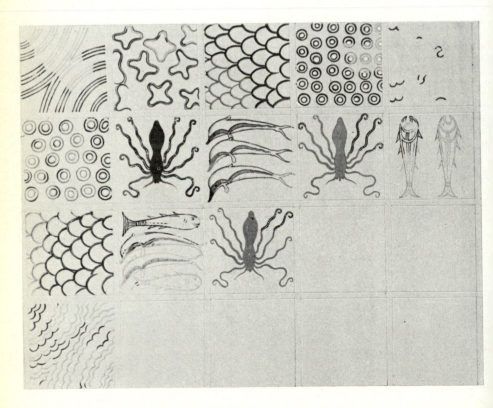

megaron and its approaches at Mycenae was probably brought from Crete.[225]

Painted floors occur, not only in the megarons and their approaches, but in many other rooms and corridors in the great palaces at Mycenae, Tiryns, and Pylos.[226] Mainland painted floors were almost invariably, it seems, divided into rectangular compartments. This system clearly originated from painted imitations of stone pavements, and the compartments are often filled with geometric designs derived from the veining of gypsum slabs. But they sometimes contain pictures of marine creatures in the tradition of the sea-floors of Crete (see p. 71). A solitary octopus adorned the rectangle in front of the throne in the megaron at Pylos, but marine creatures are better represented on some of the other floors of the palace there [66]. At Tiryns panels containing octopuses or dolphins were a feature of the floors in the larger megaron and its anteroom, as well as of those in the smaller megaron and elsewhere. Fragments of a large seascape have now also been recovered from Thebes,[227] but there is no evidence as yet to suggest that it decorated a floor rather than a wall.

Some fragments of plaster with red and white stripes from the palace at Pylos may have come from ceilings.[228]

TECHNIQUE

When a wall was to be decorated, the face of it, if it was built of rubble, was rendered more or less even with a backing of clay and straw or coarse plaster. On top of this a layer of fine lime plaster was spread to form a true surface. There is evidence from Knossos suggesting that wooden pegs were sometimes used to help keep this plaster on the walls.[229] Over the first layer, which might be some 0.015 m. thick, a second and final coat of plaster, varying from about 0.005 m. in thickness to a mere wash, was normally it seems applied if the wall was to be decorated.

Early Minoan plaster from Vasiliki was hard and durable, but relatively coarse in composition, with only about forty per cent of carbonate of lime in it.[230] More or less contemporary plaster from neighbouring Mirtos, however, was finer, with over sixty per cent of carbonate of lime, and it was more thinly applied to the walls.[231] At Knossos the lime content appears to have been increased during the course of the Middle Minoan period, until by Late Minoan times a plaster of pure burnt lime was in use there. This was less hard than earlier plaster, but it was of a brilliant whiteness with a very fine grain, and thus offered a better surface for decorative treatment.

When the first technical studies of the wall-paintings from Knossos and Tiryns were made, it was inferred that they were in true fresco like the *buon fresco* of the Italian Renaissance,[232] that is to say that the final coat of plaster was applied in patches as the work proceeded, and that the pictures were executed directly on it while it was still wet, the paint sinking in and thus adhering. This has since been denied,[233] and it has been suggested that the technique normally used for the Bronze Age wall-paintings of the Aegean area may have corresponded, not to the *buon fresco* of the Renaissance, but to the *fresco secco*, which involved damping the already prepared plaster surface before the paint was applied.[234]

There was no doubt some degree of variation in the methods employed. The existence of a thin upper coat of plaster is suggestive of a technique akin to *buon fresco*. At the same time the paints themselves may often at any rate have been mixed with slaked lime which helped to bind them to the damp lime plaster.[235] Details were evidently added and changes made as required after the main body of the painting had dried, and the colours used for these may have been combined with some kind of glue; but in the case of the miniature frescoes from Tylissos a thin slip of lime-white was employed as a base for colours other than red where they were overpainted on the red background.[236]

Guide-lines for the horizontal borders above and below the pictures were impressed with taut string in the surface of the plaster while it was still wet.[237] Sometimes the layout for details of the pictures themselves was sketched in the

wet plaster with string or incised; notably where architectural scenes were involved, or for the repetitive decoration on the dresses of life-size figures.[238] Incisions might of course be made in the surface of the plaster after it had dried. Chariot wheels at Tiryns and shields at Mycenae were outlined with large compasses,[239] and compasses were used to make painted beam ends and the centres of spirals at Pylos.[240] Evans thought that stencils or templates might have been employed for some of the decoration at Knossos, but this seems doubtful.[241]

As in Egypt, preliminary sketches might be painted on the white surface of the plaster in some shade of red or orange, or at Tiryns in yellow,[242] before the pictures were begun. But in the House of the Frescoes at Knossos [32] the preliminary sketches in thin orange paint were afterwards covered with a slip of very fine white lime a millimetre or less in thickness.[243] Now when dry this thin lime slip is opaque, concealing the preliminary sketches from sight; but horizontal guide-lines for the borders were impressed in it with taut string while it was still wet, and the paintings may have been executed at that stage. Some further sketches were made on the slip as the work proceeded.

The way in which the pictures were executed, and which parts of them were painted first, has been ascertained by careful study of some of those from Pylos.[244] A laborious technique, sometimes employed in Crete during the period before c. 1450, but also attested later on the mainland, involved cutting away the surface of some areas and refilling them with plaster of a different colour.[245] This was done in the case of the yellow areas with rosettes in red and black on a fresco of Middle Minoan III date from north of the Royal Road at Knossos (see p. 51). The white lilies in a wall-painting from a house at Amnisos destroyed in Late Minoan I were executed in a similar manner [37] (see p. 55).

The final stage in the creation of a picture was the polishing of the surface of the plaster. This was an ancient tradition; Early Minoan wall plaster was always polished,[246] and long before then highly polished plaster floors were charac-

teristic of the Prepottery phase of Neolithic at Jericho. The polished finish of the earlier Cretan wall-paintings, those assignable to Middle Minoan III and Late Minoan I, is noticeably more careful and thorough than it is in the case of the later ones.[247] In the House of the Frescoes, destroyed in Late Minoan I A c. 1500, the surface of the thin plaster slip appears to have been polished in places before the painting had been completed as well as afterwards.

Apart from a lime white which was the same as the plaster foundation, the paints used by Aegean Bronze Age artists included reds and yellows from iron-earths, such as haematite and yellow ochre,[248] and a black which in Crete at any rate appears to have been in the nature of a carbonaceous shale or slate akin to Italian 'black chalk':[249] but the black at Tiryns may have been prepared by charring bones.[250] The magnificent blue, rich and pure in tone, used for backgrounds both in Crete and on the mainland, was like that employed by the Egyptians from at least as early as the Old Kingdom.[251] It consisted of an artificial frit, or coarse powder, a compound of silica with copper and calcium oxides. The material for it may have been imported from Egypt,[252] at any rate in the first instance, and it was probably always an expensive colour. Azurite, a naturally occurring copper ore, was employed for blue in Egypt during the Old Kingdom, and extensively as face paint in the Cyclades in the Early Bronze Age,[253] but there appears to be no evidence for an azurite blue in the wall-paintings of the Aegean area. Lapis lazuli, however, from distant Afghanistan is reported to have been used for the blue on the Ayia Triadha sarcophagus [53, 54].[254]

Greens were normally a mixture of blue and yellow, but the clear green of the Shield fresco from Tiryns may have been made of pounded malachite, used as a green in Egypt from the earliest times.[255] The colours of the painting which survive have often been distorted by the fires which destroyed the buildings they adorned.[256] A rich, bright colouring is a characteristic of early paintings on the mainland as in Crete. New and duller, somewhat

muddy shades are found by contrast in the latest paintings of the mainland.[257] Paints appear to have been applied with brushes of which the marks are sometimes visible. Sponges were evidently employed on occasion to make decorative patterns on walls.[258]

The pictures varied in size, but a number of them consisted of friezes between 0.70 m. and 0.80 m. high set at eye level above a tall dado. The top of the picture would normally coincide with that of the door or doors leading into the room. This seems to have been the system in the Knossian House of the Frescoes, where the frieze of birds and monkeys was c. 0.80–0.85 m. high, with the bottom about a metre above the floor [31].[259] Many other wall-paintings of all periods both in Crete and on the mainland were set at eye level in this manner.[260] But some narrow friezes appear to have run around the tops of the walls above the lintels of the doors. The Partridge fresco, only 0.28 m. high, from the Caravanserai at Knossos was evidently like this [40],[261] as was the frieze with ships from the Akrotiri settlement on Thera [47] (see p. 63). There were also pictures which occupied most of the wall surface, like the fine early paintings with a goddess in a landscape from Ayia Triadha (see p. 52), or many of those from the Akrotiri settlement. Later examples include the scenes which covered the walls of the megaron in the palace at Pylos (see p. 80).

Whatever their size or position, wall pictures were normally bordered above and below by a series of parallel stripes.[262] In the earlier Cretan pictures these were neatly painted in strong contrasting colours, such as white and black, or blue and black, between guide-lines made in the damp surface of the plaster with taut string. The effect of these neat contrasting stripes above and below the pictures must have been striking. The inner stripe, forming an edge to the picture, was usually left white in Crete: and this happy idea was to a large extent, but not so universally, followed on the mainland.[263] Elements of the pictures such as patches of rockwork[264] or the heads of people[265] were often allowed to project into the white border stripe or beyond it.[266] A

similar convention is found in the scenes on Cretan stone relief vases, which appear to have been derived from wall-paintings or plaster reliefs.

The corners of rooms were ignored in the composition of pictures, which normally had no borders at the sides except where they were interrupted by the frames of doors or windows. But sometimes the vertical beams of the interlacing framework of timbers used to strengthen the walls appear to have projected beyond the plastered wall face, creating what were in effect framed panels.[267] The existence of long rectangular panels of this kind may have given the impression that paintings were sometimes done before they were fixed to the walls: thus it was suggested that the Phylakopi flying fish fresco might have been imported ready-framed from Knossos.[268] Less improbably the figures of nearly life-sized fishermen from the Akrotiri settlement on Thera are said to have been painted on slabs of clay which were afterwards fastened to the walls of the room where they were found.[269] In a few cases, like the Knossos Taureador frescoes [44], and the comparable bull-leaping scenes from the Mycenae Ramp House, friezes were separated into different panels by vertical painted divides, but this never seems to have been a common practice, and it is not yet attested in the later paintings of Crete or the mainland.[270]

The dadoes below the borders of the pictures in important buildings like the palaces might consist of gypsum slabs or even of carved stone, but painted dadoes were more usual, and stonework, whether carved or consisting of veined slabs or dressed masonry, was economically imitated by the fresco artist.[271] Painted reproductions were similarly made of the vertical and horizontal wooden beams which were often left showing in the wall surfaces. Such imitations of stone and wood had a long history in Crete, and are attested at Knossos in the House of the Frescoes[272] if not earlier.[273] Dadoes painted in imitation of veined stone have been found in the Akrotiri settlement on Thera overwhelmed in Late Minoan I A c. 1500.[274] They also appear to

have been common in the palace at Knossos during the last period of its existence, occurring for instance below the griffins in the Throne Room (see p. 66).

In the earliest paintings, like the Saffron Gatherer [27], or those from the House of the Frescoes at Knossos [32], the background of the pictures is red, or red combined with white, these being the traditional colours for plastered walls in Crete. The backgrounds of pictures from the Akrotiri settlement on Thera are white with occasional red areas. The white background of the woman holding a net from Phylakopi on Melos [35A] was apparently painted over plaster which had once been red.[275] But later, the clear, bright Egyptian blue was to become fashionable for backgrounds both in Crete and on the mainland. A trend away from this towards the end of the Bronze Age at Pylos[276] may reflect difficulties in obtaining blue paint, which must have been comparatively expensive to import or make. At Tiryns, also from motives of economy perhaps, the blue paint appears to have been mixed with black, so that it is dull and lifeless in colour compared with the bright clear blue of Knossos.[277]

In large pictures at any rate the background was normally varied, areas of white or yellow and contrasting ones of red or blue being divided from each other by straight or wavy lines, running vertically or horizontally, but never it seems diagonally across the field of the picture.[278] The wavy lines might be edged with black stripes. Sometimes the scenes painted against this varied background consisted entirely of figures, but in the earlier Cretan paintings people and animals were almost invariably it seems set in a landscape of some kind; although some early pictures, including several from Thera, and many later ones, especially processional scenes in the Egyptian manner, dispense with landscape altogether. But elements of landscape are still found among the very latest of the paintings at Pylos and Tiryns.

The earlier Cretan artists often depicted people and animals in the primitive manner as if they were in the air, whether they were against a plain background or in a landscape. But the men and women of the comparatively early frescoes from Thera are standing firmly on ground lines,[279] as are the figures in the Egyptian-style processional scenes of later times. Both conventions continued in use until the end of the Bronze Age; the little banqueters from the megaron at Pylos sit in the air, while the comparable but somewhat earlier Camp Stool figures of Knossos mostly have their feet on a ground line.[280]

Men were painted brown and women white. This was in line with Egyptian convention, but in Egypt women were more realistically painted a paler shade of brown than men. The white-painted figures wearing male dress in the Knossian Taureador frescoes [44] appear to be women in men's clothes, as Evans believed.

Floors as well as walls were often plastered, and a number were adorned with pictures. Some plastered ceilings may have had painted decoration (pp. 71, 83). In the Early Minoan settlement near Mirtos in southern Crete some of the external walls appear to have been painted red,[281] and plaster may have been used extensively to coat outside walls in later times.[282] There is no certain evidence, however, that exposed outside walls were ever decorated with pictures.[283] Traces of painted decoration were indeed noted on the north wall bounding the courtyard in front of the megaron of the palace at Mycenae,[284] but this and the painted plaster floor appear to date from a later period when, after damage by fire, the courtyard may have been covered with a roof.[285]

Owing to the wear and tear to which they were exposed, floors and dadoes often needed repainting or retouching. In the megaron at Mycenae at least five successive layers of painted floor were identified, keying into the ten layers of decorated plaster of the hearth.[286] Sometimes an old wall-picture was covered with a layer of plaster and a new one painted on top,[287] but the normal practice when a picture was to be replaced seems to have been to remove the old plaster and supply a new base.[288]

The caves which abound in Crete were sometimes used as sanctuaries during the Bronze Age, and it would not be surprising to find paintings in them; Faure indeed claims to have

recognized designs, including animals and sea-creatures, in black paint on the walls of a small cave near Kato Pervolakia in eastern Crete.[289] Tombs also were no doubt adorned with pictures on occasion – a group of late paintings from Ayia Triadha in Crete may have come from the walls of one (see p. 71). At Boeotian Thebes remains of frescoes including parts of two female figures have been found on one of the two entrances leading into a tomb of royal proportions whose rock-cut chamber was also painted, it seems.[290] The entrance façades of a relatively small number of other rock-cut tombs of the Late Bronze Age on the mainland were plastered and decorated with rosette or spiral designs.[291]

SCULPTURE

NEOLITHIC

In the Aegean, as elsewhere in Anatolia and the Near East, small figurines of human shape were made throughout the Neolithic. From the first, schematic or symbolic figures are found side by side with more representational ones. The latter fall into two main categories: squatting figurines, all female [67A]; and standing ones, mostly female but some male [67, B and C].[1] The women may have been meant for goddesses, but other interpretations are possible.[2] While most of the earliest Aegean figurines were made of clay like illustration 68, a few were of stone [67, A–C]. Some of the representational ones display a skill in modelling and a feeling that are scarcely equalled by those of later periods, when the time and energy of gifted craftsmen were otherwise deployed. Outstanding examples of Neolithic experiments in naturalism are a male figurine of polished white marble [67C] from an Early Neolithic I level at Knossos,[3] and a female one

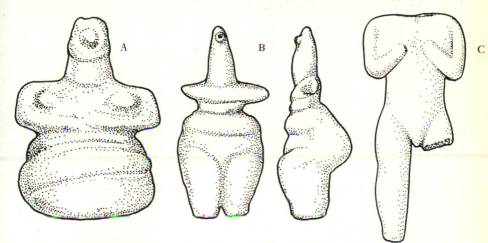

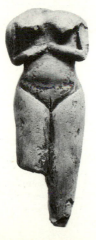

67. Early Neolithic figurines in hard white limestone or marble from the mainland (A)–(B) and Crete (C) (scale 2:3): (A) Squatting female from Patissia, Athens. *Athens, National Museum* (B) Standing female from the Sparta region. *Athens, National Museum* (C) Standing male from Knossos. *Herakleion Museum*

68 (*left*). Female figurine from Lerna. Later Neolithic. Clay. H preserved 0.182 m. *Argos Museum*

in clay found at Lerna in the Peloponnese in a horizon of the later Neolithic [68].[4] The heads of both are missing; they may have been more summarily treated than the bodies.

EARLIER BRONZE AGE (c. 3000–1700 B.C.)

Crete

Small figurines of stone, ivory, shell, and clay, mostly female, have been recovered from early settlements and communal tombs in Crete [69, A and B].[5] Some are more or less akin to types

[70, A and B], have been recovered from the Cretan hill-top or 'peak' sanctuaries.[10] The former were clearly votives, representing the worshippers who dedicated them; the latter, like those of illustration 70, A and B, cheap substitutes for sacrifices. Most of these may date from the time of the early palaces at the end of

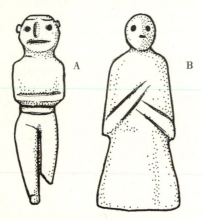
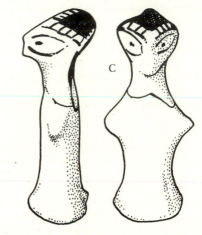

69. Figurines: (A) and (B) From Ayia Triadha, Crete. End of Early Minoan or beginning of Middle Minoan, c. 2000. Ivory (C) From Zygouries. Early Helladic II, c. 2400. Clay. Scale 3:4

the third and beginning of the second millennium, but they were still being made into the seventeenth and sixteenth centuries (see p. 105).

found in the Cyclades, and Cretan imitations of the standard Cycladic Folded-arm figurines were made in ivory [69A] and stone.[6] One or two figurines in a more naturalistic style, assignable perhaps to the end of this period or the beginning of the second millennium, represent men who appear to be worshippers with hands meeting on their chests. Notable is one of bluish steatite, only 0.063 m. high, from the early circular tomb at Porti in the Mesara;[7] another, stumpy and less elegant, has been found at Arkhanes.[8] A fine ivory head of a man from the Trapeza burial cave in Lasithi with traces of shell inlay round the eyes has been called an import, but seems to be Cretan work of this time.[9]

Large numbers of clay figurines of men and women [85], and model animals of various kinds

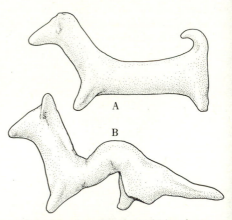

70. Animal figurines: (A) a dog and (B) perhaps a weasel from Petsofa. Probably Middle Minoan I, c. 2000 or later. Clay. Actual size. *Herakleion Museum*

Primitive rock-carvings in a small cave called 'Skordolakkia' near the hamlet of Asfendhou in Sfakia have been claimed as Mesolithic, but may date from *c*. 2000 or later, if not from the beginning of the Iron Age.[11] They show miniature animals, mostly wild goats, with the bows and arrows used to hunt them. What seem to be ships, if they are not traps, are also indicated.

The Cyclades

On the islands, with their poor clay and abundant supplies of white marble, a tradition of making stone figurines developed and flourished throughout the earlier part of the Bronze Age.[12] Clay figurines are unusual, but two or three were recovered from the Kefala cemetery on Kea assignable to the very beginning of the Bronze Age or the end of the local Neolithic.[13] One of these is crudely male, while a triangular head with a flat face and short projecting nose is reminiscent of marble figurines of the Folded-arm type (see pp. 91–4).

As in the Neolithic, schematic marble figurines [71A] continued to be made alongside more or less representational ones. While a few marble figurines are clearly male, the vast majority are female; whether they represent goddesses is uncertain,[14] although the large size of some of them has been used as an argument that they do.[15] Most have been found in graves, which might suggest that they were made for funerary use, if not for the solace of the dead in the world to come after the manner of Egyptian *ushabti* figures.[16] But fragments of them also occur in settlements.

A distinctive, markedly naturalistic early class of these marble figurines, the Plastiras type,[17] has been dated towards the end of the Pelos culture of Early Cycladic I. A number are male [71, B and C], and all of them stand upright, like the Neolithic statuettes from which they seem to have evolved.[18] The violin-shaped figurines like illustration 71A that have been found in some graves with those of the Plastiras type similarly appear to continue the tradition of the squatting females of Neolithic times. Plastiras figurines tend to be somewhat clumsy

and unattractive by comparison with the best of their Neolithic forerunners. Several have features like ears in relief, and a few, some of them clearly male, wear ribbed conical hats or cylindrical crowns [71C]. Their eyes and navels it seems were occasionally inlaid with dark polished pebbles.[19] Less naturalistic and more schematic, but still representational, are the statuettes of the Louros type,[20] also apparently dating from the end of the Pelos culture. Their heads are featureless, and they hold their stump-like arms outstretched cross-wise. Like their Neolithic counterparts, these earliest representational figurines of the Cycladic Bronze Age are relatively uncommon.

The vast majority of Cycladic marble figurines are assignable to the developed phase of the early Bronze Age, the period of the Syros culture of Early Cycladic II, more or less contemporary with the flourishing Early Helladic II and Early Minoan II periods of the Greek mainland and Crete. At this time there seems to have been a great spurt in the production of representational stone figurines in some of the islands, especially in Naxos with its supplies, not only of marble, but of the emery needed to work it. But they were not made on every island: very few have been recovered from the many graves in the important Early Cycladic II cemetery at Chalandriani on Syros.[21]

The Folded-arm figurines characteristic of this period are all female and differ radically from earlier types [71, E and F, and 72]. They have their arms folded across their chests, and instead of standing like Plastiras figurines, they are normally represented as if lying on their backs, naked, with their heads tilted backwards, legs flexed and toes outstretched. Occasionally they look as if they were pregnant.[22] Most are between 0.20 m. and 0.30 m. long, but some are smaller. The largest are up to 1.50 m. in length, and a few giant heads might have come from more than life-size statues, but no bodies to match them have been recovered.[23] Folded-arm figurines of the standard or developed type [71E, 72] are more or less naturalistic, and often of striking and impressive beauty, but there is a great deal of variation in the way the naked

71. Figurines of the earlier Bronze Age (scale 3:10), (A)–(H) from the Cyclades, Early Cycladic, before
c. 2000, marble, (I) from Crete, probably Middle Minoan I, c. 2000, clay: (A) Schematic, probably female,
from Antiparos (B) Male of the Plastiras type from Antiparos (C) Male of the Plastiras type (D) Male
related to the Folded-arm type (like G and H) from Syros (E) and (F) Females of the Folded-arm type from
Amorgos and Syros (G) and (H) Male pipes player and apparently male harp player from Keros
(I) Female in long robe from Chamaezi

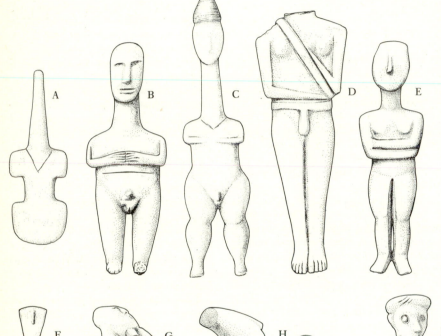

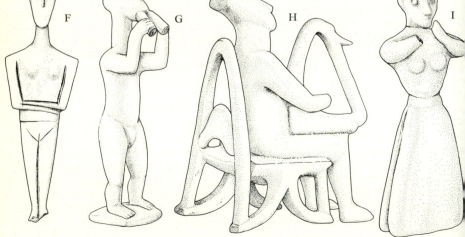

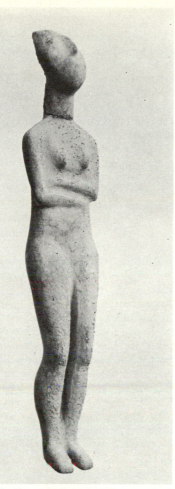

72. Female figurine of the Folded-arm
type from Amorgos. Early Cycladic II, *c.* 2400.
White marble. H 0.257 m. *Athens, National Museum*

reclining figure is rendered, and the blanket
praise sometimes bestowed on them is hardly
deserved.[24] The distinctive Angular [71F] and
Squat varieties are in effect simplified and per-
haps relatively late versions of the Developed
type – the Squat figurines in particular, mostly
less than 0.20 m. long, give the impression of
being made to meet a demand for cheap, mass-
produced idols. But some of the Angular type
like illustration 71F, with their elegant propor-

tions and clean, sharp lines, while they must
have been relatively simple to make, have an un-
deniable appeal.

Occasionally, it seems, Folded-arm figurines
of women were made with bases so that they
could stand upright.[25] A pair sharing a base from
Teke near Knossos may have been carved in
Crete.[26] A few Cycladic figurines contemporary
with those of the Folded-arm type represent
men, standing and often clothed, even if scantily,
with penis sheath, belt, and diagonal shoulder
strap [71D]; one is seated on a stool with a cup
in his outstretched hand.[27] Women with folded
arms are sometimes seated on stools or on chairs
with backs.[28] Most remarkable are the splendid
figures of men, largely from Keros and Thera,
sitting on chairs and carrying harps [71H], or
standing and playing double pipes of some kind
[71G].[29] Rare double figures include couples em-
bracing,[30] or one standing on top of another.

The heads of Folded-arm figurines and their
relatives are usually very schematic, with only
the nose projecting from the even curve of the
face, but occasionally other details like the ears
are incised, or even added in relief as in the case
of some of those of the earlier Plastiras type. On
the Folded-arm figurines, however, it was more
usual to show details such as the eyes and hair
in paint, traces of which, red, or red and blue
(or black which may have once been blue), have
sometimes survived. This painted decoration
was often it seems applied in the form of dots.
Dots and stripes on the faces of figurines no
doubt reflect a contemporary fashion of paint-
ing or tattooing. Some figurines it is suggested
may even have been adorned with silver diadems
of the kind worn in the Cyclades at the time (see
p. 192).[31]

Cycladic figurines appear to have been made
by taking a slab of marble and working it with
an abrasive, of which there was a supply to hand
in the form of Naxian emery, next in hardness
only to diamond. An emery splinter would have
been used for cutting the figure and engraving
lines on it; a block of emery, or emery powder,
for smoothing the surface. The work, especially
in the case of the seated figures with harps, must
have required great patience and considerable

skill. It has been suggested that many of the common Folded-arm figurines adhere to strict canons of proportion, being laid out with the aid of compass and ruler.[32]

Numbers of these figurines, including some of the most striking and unusual ones, are in private collections, and the problem of forgery cannot be ignored in considering them. Demand has clearly exceeded supply, and modern workshops in Athens and Naxos are reported as happily responding with figurines made of the same island marble.[33] In the Bronze Age as now such figurines were evidently valued abroad, since they found their way to the Greek mainland, and in considerable numbers to Crete, where they were imitated in ivory and also it seems in local marble (see p. 90).[34]

The manufacture of figurines of the Folded-arm type may have continued in the Cyclades into the Middle Bronze Age. A remarkable and highly representational marble head, about half life-size, from Amorgos [73] appears to date from that period rather than earlier,[35] but by the

73. Head of a statuette from Amorgos. Probably Middle Cycladic, c. 2000–1500. White marble. H 0.095 m. *Oxford, Ashmolean Museum*

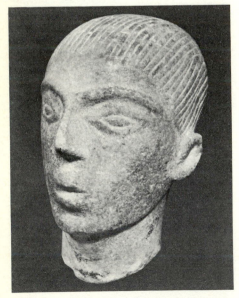

end of it only schematic figurines, it seems, were being made in stone.[36]

Cycladic stone carvers did not confine themselves to making vases and figurines: a unique model from Melos, cut from the local tufa and apparently found in a cist grave of Early Cycladic type, represents a rectangular building with a hooped roof. A model ship of the same stone from the cemetery area at Phylakopi could be of somewhat later date.[37]

The idea has been mooted that Early Cycladic figurines might have exerted some influence on the Archaic Greek sculpture of the islands.[38] If so, this could only be explained by the chance discovery of figurines in later times, not by their survival in use. The revival of seal-engraving in some of the islands after a lapse of centuries similarly appears to have been inspired by the discovery of ancient gems (see p. 241).

From Korfi t'Aroniou on the eastern coast of Naxos comes a remarkable series of marble plaques, ten in all, with little figures of men hunting animals [74B], standing in a boat [74A], and in one instance fighting, two against one, unless they are amicably joined in a dance [74C].[39] The plaques, which may have originally formed a kind of frieze on a wall, measure up to 0.50 m. in length and 0.30 m. in height. The figures are all about 0.15 m. high and crudely pocked in silhouette, not outlined with incision. The undistinguished pottery from the site appears to be of Early Cycladic date and not later.

The Mainland

Figurines of local manufacture are rare on the Greek mainland during the Early and Middle Bronze Ages; a small clay figurine in human shape from an Early Helladic II deposit at Zygouries in the Peloponnese [69C] was unique at the time of its discovery in 1921-2.[40] Clay animals are less uncommon. A group including some unusually well modelled bulls was found in what seems to have been a shrine assignable to Early Helladic III at Lithares near Thebes.[41] Possibly other figurines and larger sculpture were made of wood which has left no traces.

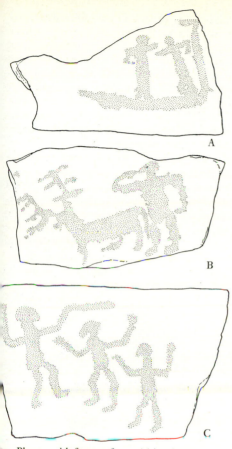

74. Plaques with figures of men, (A) in a boat,
(B) hunting deer, (C) fighting or dancing,
from Korfi t'Aroniou, Naxos. Apparently Early
Cycladic, before *c.* 2000. Marble. Scale 1:5.
Naxos Museum

LATER BRONZE AGE (*c.* 1700–1100 B.C.)

Crete

In striking contrast to contemporary Egypt or
later Greece, there are few examples of large
sculpture in stone dating from the Aegean
Bronze Age. This, however, does not necessar-
ily reflect religious prejudices or taboos. In
Crete, nurse of Aegean arts, while attractive
stones convenient for making vases and figur-
ines abound, there is a dearth of kinds suitable

for large statues and reliefs. White marble as
found in the Cyclades for instance only occurs
on a limited scale.[42] But timber was available,
and there is evidence for the existence of large
wooden and even metal statues in Crete during
the Bronze Age.[43] Four bronze curls may have
adorned a gigantic wooden goddess standing
2.80 m. or more high in the great East Hall of the
palace at Knossos (see p. 238).[44] This would
have been a startling sight, painted in bright
colours and adorned perhaps with inlays and
gold leaf, although no remains of these were
noted in the excavations. Some idea of how such
a large painted wooden statue might have looked
can be inferred from the exquisite little faience
model of a snake-wielding goddess from the
Temple Repositories at Knossos [123] (see
p. 133).

Smaller curls of bronze plate with remains of
gilding were recovered from debris assigned to
Middle Minoan IIIB below the latest floors of
the residential quarter of the Knossian palace.[45]
These had pins behind for attachment to wood,
of which abundant carbonized remains still ad-
hered to them. Evans conjectured that they
were from the mane of a wooden lion, but they
resemble the locks of hair of human figures such
as bull-leapers [44] and the dancing girl [52C]
as represented in the frescoes.[46] 'Two or three
curls of bronze', resembling those inserted in
the heads of the ivory figurines of bull-leapers
(see p. 119), were found by Evans in the Little
Palace at Knossos and might have come from a
wooden statuette.[47] Wooden figures of animals
no doubt existed in Crete as in Egypt, and pairs
of small bronze horns could have belonged to
wooden models of wild goats (agrimia).[48] A mask
of gold leaf from the early tomb IV at Mochlos
may have covered a wooden lion's head.[49] More-
over the cypress trees native to Crete and once
abundant there[50] could have been used for mak-
ing statues: in later times it was remarked that
the lasting quality of cypress wood rendered it
most suitable for cult images.[51] A number of
early Greek statues of which descriptions have
come down to us were made of wood. It has even
been suggested that some of the primitive
wooden statues (xoana) in the sanctuaries of later

Greece might have survived from the Bronze Age.[52] A couple of limestone heads, one from the Knossos region [75],[53] the other from Mirtos in

75. Male head from Monastiriako Kefali, Knossos. Probably Middle Minoan II-III, c. 1800-1550. White limestone. Scale 1:2. *Herakleion Museum*

southern Crete,[54] may have belonged to small statues whose bodies were of wood, as might a stone hand from Knossos, about half life-size, if it is really of Bronze Age date.[55] Such 'acrolithic' statues (wooden, but with heads and extremities of stone or ivory) were certainly made in later Greek times.

Their skill in carving stone libation vases in the shape of animal heads shows that Cretan artists of the Bronze Age were capable of making statues and reliefs in stone. Fragments of architectural friezes from the palace at Knossos are delicately carved with elaborate spiral and rosette designs.[56] A large wedge-shaped object of purple stone has a couple of superb octopuses in relief on it [76];[57] originally interpreted as a talent weight, but one which the octopus 'covers with the writhing pattern of its tentacles as the fish itself might clasp an anchor-stone',[58] it in fact appears to be a ritual anchor.[59]

Small stone figures continued to be made during the period after c. 1700, but the Fitzwilliam goddess with her attractive hair style and soft Classical look is almost certainly a

fake,[60] as is an ugly figurine alleged to come from Tylissos.[61] An excessively ugly fat man, however, with hand raised to forehead in an attitude of worship, was recovered from the palace at Phaistos and ought to be genuine.[62]

The Mainland

Stone-carving on a large scale is better represented on the mainland than in Crete. Decorative architectural pieces, inspired by Cretan models in stone or wood, have been recovered from the palaces at Mycenae,[63] Tiryns,[64] and Thebes.[65] The material of the so-called 'alabaster' frieze from Tiryns appears to be gypsum imported from Crete.[66] The façade of the greatest of the tholos tombs, the Treasury of

76. Anchor with octopuses in relief from the palace at Knossos. Probably Late Minoan I, c. 1550-1450. Purple gypsum. H 0.41 m. *Herakleion Museum*

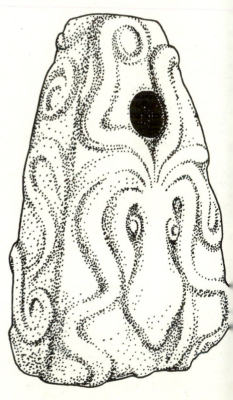

Atreus at Mycenae, was adorned with elabor-
ately decorated stone columns and with spiral
reliefs on slabs of contrasting red and green
marble brought from the southern Pelopon-
nese.[67] The side chamber of the comparable
Treasury of Minyas at Orchomenos had a stone
ceiling with an elaborate papyrus design in low
relief [58B].[68]

The few large stone reliefs with figures of
animals or people assignable to the Aegean
Bronze Age have nearly all been found at My-
cenae. The earliest, and in some ways the most
remarkable, are the reliefs on slabs (stelai) that
stood above some of the royal shaft graves [78].
Most of the slabs with pictures in relief come
from the later circle (A) of graves excavated by
Schliemann [77],[69] but the remains of two were
recovered from the earlier circle B.[70] The stelai,
which appear to have been carved and set over
the graves during the period of their use in the

sixteenth century, were massive rectangular
slabs of limestone, the largest more or less com-
plete example (stele IV from grave circle A)
being 1.86 m. high, 1.02 m. wide, and 0.14 m.
thick. The earliest of the pictured stelai is a
squat slab of soft grey limestone from circle B.
The chance discovery of part of this standing in
position above a grave in the spring of 1952 led
to the excavation of the new shaft grave circle.
The scene on it – men with spears coming to the
rescue of a bull, which is being attacked by a
lion or pair of lions – is not in relief, as on the
other pictured stelai, but merely incised in out-
line. This does not however necessarily indicate
an earlier date, since the helmeted head of a
warrior, about a third life-size, incised on a
fragmentary slab of white marble from Ayia
Irini on Kea, appears to date from Late Helladic
II–III, after the shaft grave era.[71] The Kea
helmet, with cheek-pieces and surmounted by

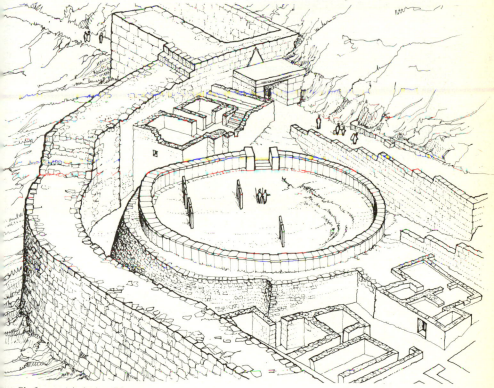

77. Shaft grave circle A at Mycenae.

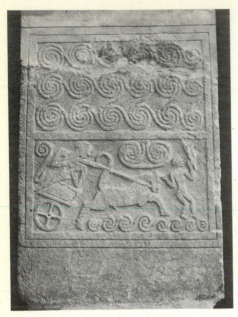

78. Stele V from shaft grave V at Mycenae
with relief of chariot. Late Helladic I,
c. 1550. H 1.34 m. *Athens, National Museum*

a knob to hold the flowing plume, is similar to
one from a warrior grave of *c.* 1400 at Knossos.[72]
The drawing and execution are careful and
deliberate: this is no graffito, like the Late
Bronze Age ships crudely scratched on a stone
from Dhramesi (Hyria) in central Greece.[73]

The second pictured stele from circle B had
later been cut in half and slotted to hold the base
of a plain stele, one of a pair set over a grave
there. It was carved in relief with a scene of two
lions attacking another animal, apparently, as
on the first stele, a bull, most of which was re-
moved by the slots made in the stone to convert
it into a base. In the corners above the lions are
two small men, one to the left upside down, and
probably dead, the other to the right armed with
what appears to be a slashing knife of the type
found in some of the graves of circle A. The
empty spaces in the background are filled with
ornament in relief, including (in the bottom
left hand corner) a motif derived from Cretan
'sacral ivy' and ultimately from the waz-sign or
sacred papyrus of Egypt.[74] Above is a panel

filled with a network of spirals as on illustration
78.

The stelai from Schliemann's circle of graves
(A) were the subject of a careful study by
Heurtley over fifty years ago.[75] He identified
the remains of at least eleven sculptured stelai
as well as of five or six plain ones,[76] allowing a
stele for each of the seventeen adults (nine men
and eight women) buried in the graves [77].[77]
The existence of plain stelai might be taken to
suggest that both they and the sculptured ones
had originally been coated with plaster bearing
painted decoration.[78] The sculptured stelai
would then approximate to the contemporary
relief frescoes of Knossos, while the stone sarco-
phagus of later date from Ayia Triadha in Crete
would offer a parallel for the plain ones, unless
they served as a base for plaster reliefs. Alter-
natively painted decoration might have been
applied directly to the stone.[79] A small stele with
incised ornament from a chamber tomb at My-
cenae had been covered with plaster and painted
with a scene of warriors,[80] but this concealed an
original incised design and reflected a later re-
use of the stele. Traces of paint or plaster ought
to have survived on some of the shaft grave
stelai if they had been treated in such a manner,
especially in the case of those from circle A,
which were deliberately buried when the level
of the ground was raised at the time the citadel
wall was built before the end of Late Helladic
IIIB.

The sculptured stelai from circle A fall into
three groups. The two assignable to the earliest
group (I), of soft limestone like the incised and
sculptured ones from circle B,[81] have plain
borders, and there is no sign of spiral decoration.
The reliefs appear to have been cut with a knife,
like the scenes on Cretan relief vases (see p.
143).[82] But the bulk of the stelai from circle A
belong to group II. Made from a harder shelly
limestone, they all have spiral designs like the
relief stele from circle B. On stele VI three
prancing horses are ranged one above the other
in a panel framed by spiral borders. The two
most interesting stelai, IV and V from grave V,
both show the dead man riding in his chariot
below panels filled with spiral networks. A man

on foot in front of each chariot has usually been interpreted as an enemy whom the charioteer is about to overthrow, but nobody is armed as for war – the lack of helmets in an age of elaborate martial head-gear is curious – and in view of this and the fact that the charioteer is alone in his car, it has been suggested that the scenes represent chariot races.[83] However the charioteer on stele V [78] is about to draw his sword, an encumbrance in a race, while the foot-man in front of him is armed with what appears to be a slashing knife like the warrior on the relief stele from circle B. As to riding to battle alone without drivers, contemporary Egyptian representations habitually show the giant figure of the pharaoh alone in his chariot mowing down his enemies with his bow.

Even the blank spaces in the panel with the chariot scene on stele V [78] have been filled with spiraliform designs as on the relief stele from circle B. This *horror vacui* is closely paralleled on the gold plaques which adorned the sides of a hexagonal wooden box and its lid from grave V [79].[84] Moreover two of the six plaques were decorated with spiral networks

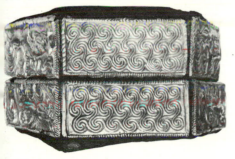

79. Hexagonal box from shaft grave V at Mycenae. Probably Late Helladic I, *c.* 1550. Wood, mounted with gold plaques decorated in repoussé. H *c.* 0.085 m. *Athens, National Museum*

like those on the stelai, and all appear to be the work of native craftsmen. The relief on the stelai is flat with little detail added. The spiral networks on stelai IV and V were not correctly planned and have had to be adjusted to fit the panels left for them, but the workmanship is careful, and the figures are evenly cut to a

uniform depth. The compass may have been used for the circles of the chariot wheels.[85] The impression the reliefs give is of experiment by artists, not incompetent, but unaccustomed to carve in stone on a monumental scale.

The spiraliform designs on the stelai [78, 80, 81] appear to be in a mainland tradition de-

80. Spiral design on a stele from shaft grave circle A at Mycenae.

scending from a common Aegean heritage, and most can be paralleled on seal impressions and wall-paintings from Crete.[86] A spiral network resembling those of shaft grave stelai like that of illustration 78, but more delicately rendered, graces a stone slab found in the unstratified fill-ing of a well north-west of the palace at Knos-sos.[87] But the best Cretan parallels date from the Early Bronze Age, when spiral decoration of this kind was already as much at home on the mainland and in the islands as in Crete. The stelai spiral designs are repeated on goldwork of native style from the shaft graves them-selves, and it is always possible that some of the goldsmiths responsible for this were en-trusted with the new venture of sculpturing reliefs in stone.[88] At the same time the reliefs have much in common with woodwork,[89] which suggests that a long tradition of carving in wood may lie behind them.

What appears to be the latest of the stelai (I) [81] was found above grave V along with the others (IV, V) which have chariot scenes. But it belongs in a group (III) by itself by reason of its material and the way it is carved: it is of soft grey limestone like the earliest stelai (group I)

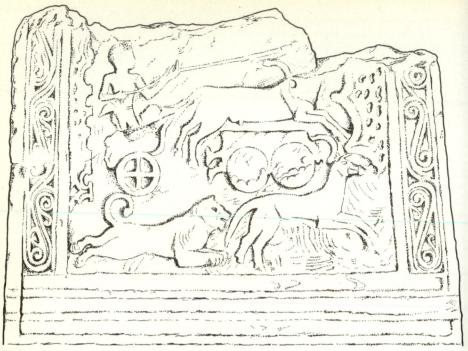

81. Latest of the carved stelai from shaft grave circle A at Mycenae. *c.* 1500. H 1.12 m. *Athens, National Museum*

of circle A and those from circle B, but the competence of the execution and the rendering of detail present a marked contrast to all the other stelai. The relief, although low, tends to be more rounded. The elaborate scene shows the dead prince in his chariot riding over what has been interpreted as a rocky landscape,[90] or more plausibly as a fallen warrior with crested helmet and figure-of-eight shield, while a lion, symbol of his prowess, if not an actual pet tamed to follow him, chases a goat-like animal below.[91] Conventional rockwork borrowed from Crete has replaced the spiral designs which fill spaces in the field on some of the earlier stelai. Rockwork of this type may have evolved in connection with the Cretan cycle of marine paintings and reliefs, but had already it seems been adapted to landscapes by this time.[92] Thus similar rockwork forms the background on an exquisite ivory plaque of more or less contemporary date with a long-necked bird from Palaikastro in eastern Crete [109] (see pp. 120-1).[93]

The shaft grave stelai as a whole are crude and native, not Cretan, in style. They give the impression of first attempts, reflecting, like the contents of the graves themselves, 'a short episode in the art of the mainland, at the moment before the temporary fusion between Cretan and Mycenaean art was complete'.[94] Other stone reliefs found at Mycenae are more sophisticated, however. They include the famous Lion Gate [82]; and two fragments, one with the feet, the other with the head of a bull,[95] Cretan in style and carved on slabs of gypsum which probably came from Crete.[96] These may have adorned the Treasury of Atreus,[97] and could even have been brought from Crete as plunder of war by the great king buried there.[98] But the dovetail hole in the back of one of the reliefs is said to be like one in the left column of the entrance façade;[99] and although the gypsum used for paving the floors of the palace megaron and its approaches at Mycenae may have been imported from Crete, the slabs

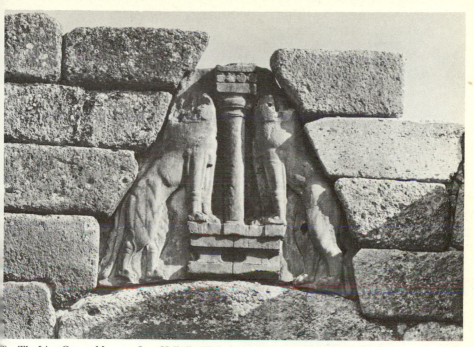

82. The Lion Gate at Mycenae. Late Helladic III, before *c*. 1200. Limestone. H *c*. 3.30 m.

must certainly have been cut to shape on the spot.

The unique triangular relief [82] above the citadel's main gate, known from it as the Lion Gate, is some 3.00 m. wide and 3.30 high.[100] It is carved from a single block of hard grey limestone which appears to be local. A pair of waisted altars of Cretan type support a pillar flanked by animals resembling lions, their forepaws resting upon the altars. Dowels in the tops of their necks show that their heads (now missing) were made separately, perhaps of some other material, such as bronze over a wooden core or a finer stone like serpentine or white marble. Whether the heads were really those of lions cannot be determined now; the animals could have been sphinxes[101] or griffins[102] with lion-bodies. Pausanias calls them lions, but the heads may have disappeared before his time. The top of the relief above the column is flat, and a rectangular dowel hole has been identified in it, implying that the column was surmounted

by something, a pair of birds it may have been, or horns of consecration, as in comparable representations on seal stones.

There have been many different interpretations of the relief. It has been regarded as a badge or emblem of the rulers of Mycenae, the pillar standing for the palace or a shrine, but it seems more likely that the pillar signifies the goddess of the place, or shows her in aniconic form, supported by a pair of griffins or lions, as depicted on gems.[103] The relief was doubtless set above the chief gate of the citadel to invoke divine power in its defence;[104] possibly the gates of other Mycenaean fortresses were crowned by similar reliefs,[105] although no traces of them have been recovered. On the other hand, the relief may be earlier than the gate, which appears to have been erected in the thirteenth century, and it may even have been designed to occupy some other position such as the relieving triangle over the entrance of a tholos tomb.[106] It was doubtless carved by the methods used in

shaping stones for architecture at the time, that is to say, with the help of abrasives such as emery or sand moved by saws and hollow drills.[107] It would have been finished by hammering or punching with a blunt punch, and by rubbing with abrasives such as pumice.[108]

Another unique relic from Mycenae is the plaster head [83] found by Tsountas in 1896 in the ruins of a building on the western side of the citadel, not far from the shrine recently discovered in that area.[109] It is about two thirds life-size, and female to judge from the white skin. Decoration is in three colours. Red was used for the lips, ears, and head-band, as well as for the marks on the cheeks, forehead, and chin, reminiscent of those which suggest painting or tattooing on the faces of early Cycladic marble

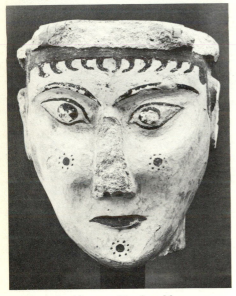

83. Head of goddess or sphinx from Mycenae. Probably Late Helladic IIIB, c. 1250. Plaster with painted decoration. H 0.168 m. *Athens, National Museum*

figurines, and of the red paint on the faces and ears of women on frescoes from Thera (see p. 55). The hair and the eyes were painted black, and blue was combined with black for the cap or crown above the head-band. The head

may have been that of a goddess, or of a sphinx as Tsountas believed. The large eyes and awesome expression are reminiscent of the little faience snake goddess from Knossos [123], although the Mycenae head may date from as late as the thirteenth century. The stylized treatment of the ears resembles that of the ear of the goddess on a fragment of fresco from Pylos [52G] (see p. 79). At the same time the shape of the face seems to anticipate the Dedalic art of Archaic Greece.[110]

A smaller plaster head was found at Mycenae in association with the ivory trio (see p. 124).[111] A vertical hole under the neck indicates that it was fixed to something, perhaps a body of some other material. The fact that no corresponding fragments of bodies have been identified suggests that both plaster heads belonged to wooden statues, like the earlier stone heads from Crete (see p. 96). White plaster may have been a cheap substitute for ivory, and an ivory head which appears to have come from a wooden statuette was recently discovered at Mycenae [115] (see p. 126).

A slab of stone, crudely shaped to represent the enigmatic figure, about life-size, of a warrior, or (if the small breasts are female) of an armed goddess, has been unearthed near Soufli Magula in Thessaly [84].[112] Five necklaces are indicated on the chest. The head seems to be concealed by a helmet, and a small dagger is set diagonally below the right hand. A snake in relief wriggles up each edge of the slab from the waist to the neck. On the back is a curious design of sunk panels. The date of this statue and the exact circumstances of its discovery are uncertain. If, as has been suggested, it was serving as the cover of a cist grave of the Late Mycenaean period it could in fact be earlier, even Late Neolithic, in date, since cremation burials assigned to the Larissa phase of the Thessalian Late Neolithic have been recovered in the area. But the dagger indicates a later horizon, and the helmet is vaguely reminiscent of a bronze one from a Submycenaean grave at Tiryns,[113] while rough menhir-like statues dating from the very end of the Bronze Age were found in the Cenotaph tomb at Dendra.[114] Vaguely comparable stone

figures, often it seems associated with burial mounds, in eastern Europe and southern Russia appear to have been made by widely different peoples at various times between the beginning of the Bronze Age and the Middle Ages.[115]

Clay Statues and Figurines

Small clay figures, human and animal, were being made in Crete throughout the period of the earlier palaces, and large numbers have been recovered from the 'peak sanctuaries' of the time (see p. 90). These show considerable variations in style and execution. Animals like those of illustration 70, A and B, are often lively; but most of the human figures [71, 1, 85] tend to be rather crude, with faces represented in a

84. Slab carved in the shape of a warrior or armed goddess from Soufli Magula, Thessaly. Possibly very late Bronze Age, *c.* 1200 or later. Stone. H *c.* 2.00 m. *Larissa Museum*

85. Figurine of a man in a loincloth with a dagger from a sanctuary on Petsofa.
Middle Minoan I–II, *c.* 2000 or somewhat later.
Clay. H 0.175 m. *Herakleion Museum*

schematic way, like those of Cycladic marble figurines. Eventually, however, some figurines of great beauty, modelled with skill and care, came to be made in Crete. An exceptionally fine head from Phaistos is assignable to the early part of the Middle Minoan period,[116] but the stylized face, that of a woman to judge from the white paint, forms a striking contrast to the naturalistic rendering of some figurines which appear to be rather later in date – notable among them being a damaged head of a man with beard and moustache from Knossos,[117] and the remarkable heads of women with crowns or elaborate hair styles from a sanctuary at Piskokefalo in eastern Crete.[118] One of the most attractive of the Piskokefalo heads, discovered by chance many years ago, has even passed for later Greek work [86, *left*].[119] These naturalistic

87. Head, apparently of a woman, from Mochlos. Middle Minoan III, *c.* 1600. Clay. Actual size. *Herakleion Museum*

woman was recovered at Mochlos [87][120] from a context datable to Middle Minoan III, when clay figurines were still being dedicated in some

86. Heads of female figurines from Piskokefalo. Probably Middle Minoan III, *c.* 1700 or later. Clay. Actual size. *Herakleion Museum*

figurines were probably made towards the end of Middle Minoan times. A finely modelled clay head of this class with a white face indicating a

of the peak sanctuaries: a large collection from that on Mount Kofina in southern Crete ha been assigned to this horizon.[121]

Early Minoan figurines were decorated lik the pottery of the time with dark, usually red o brown, lustrous paint on a light ground. Whil many run-of-the-mill examples of the succeed

ing Middle Minoan period appear to have been plain, some were treated like the contemporary fine ware and coated with a red or black lustrous wash which might serve as a basis for decoration in white or red and white. Some statuettes of the fine naturalistic class assignable to Middle Minoan III may have been plain, but a number were evidently decorated with paints applied after firing and therefore more than usually evanescent. With the change from a light-on-dark to a dark-on-light style of pottery at the end of the Middle Minoan period, Cretan figurines eventually came to be decorated in black or red lustrous paint on a light ground like the vases.

Some elaborate clay models were made in Crete during the period of the later palaces (Middle Minoan III–Late Minoan I) from c. 1700 onwards. Notable are three from the circular tomb at Kamilari near Phaistos.[122] One

88. Model of a shrine with offerings being presented to divine couples from Kamilari.
Probably Middle Minoan III, c. 1700 or later.
Clay. *Herakleion Museum*

[88] shows a shrine with votaries pouring libations or setting offerings on altars before a pair of couples, who may be gods and goddesses, or perhaps the dead regarded as divine; the second represents a woman squatting on the ground and kneading dough; and the third, with four men engaged in a round dance, is reminiscent of a somewhat later model of women dancing to the sound of a lyre from Palaikastro.[123] A model of a woman in a swing supported between dove-topped posts was recovered from a tomb at Ayia Triadha.[124] All these clay models were evidently religious in character, but a remarkable one of a two-storeyed building from a deposit of early Middle Minoan III date at Arkhanes near Knossos, bearing traces of painted decoration in white, red, and black, appears to represent a house rather than a shrine.[125]

Small clay reliefs and relief plaques were also made in Crete. The body of a man wearing a kilt and codpiece, carefully modelled and standing when complete some 0.29 m. high, was recovered from a stratum assigned to Middle Minoan IIIB in the House of the Sacrificed

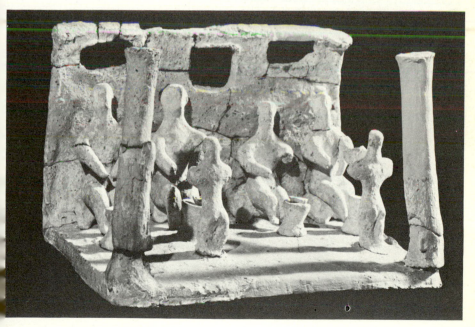

Oxen at Knossos.[126] A small hole in the waist evidently held a pin for affixing the figure to a flat surface, and it may have formed part of a processional scene of the kind depicted on a fragment of a more or less contemporary stone relief vase.[127] This outline relief is in a fine style which forms a striking contrast to the curious reliefs on a rectangular plaque from Kannia near Gortyna in southern Crete with a lopsided composition of the heraldic type, reminiscent of the Mycenae Lion Gate, but consisting of a pair of rudely modelled sphinxes, wearing helmets and joining forepaws across the top of a waisted altar surmounted by a palm tree.[128] Another fragmentary plaque found with it shows a long-skirted goddess with upraised arms.[129] These plaques and some wheel-made clay idols [89B, 91] came from a building destroyed by fire during the events of c. 1450, but it has been argued that they must all date from a much later period if not from the end of the thirteenth century (see p. 108).

Clay libation vessels (rhyta) in Crete were sometimes made in the shape of animals or of their heads. Two finely modelled bull rhyta from the settlement on Pseira appear to have been formed in moulds.[130] They are assignable to Late Minoan I, and some moulds of about the same date from neighbouring Gournia might have been employed for making clay objects,[131] although such use is not attested in the Aegean after this until the seventh century.

Fragments of large clay statues have been recovered from some of the Cretan peak sanctuaries. Part of the face of one from Petsofa above Palaikastro is modelled in a fine naturalistic style, but appears to be contemporary with the mass of the figurines there which are thought to date from the beginning of Middle Minoan times.[132] Some clay figures in the sanctuary on Mount Kofina assigned to Middle Minoan III were evidently quite large, and some were hollow; they included bulls which must have been over 0.80 m. long.[133] But the most impressive remains of Bronze Age clay statues yet discovered in the Aegean come from the settlement of Ayia Irini on the Cycladic island of Kea [89A, 90].[134] There are fragments of at least nine-

89. Clay goddesses of the Late Bronze Age, (A) a statue, (B)–(D) figurines with bodies made on the fast wheel (scale 1:10): (A) From Ayia Irini on Kea. Late Cycladic I, c. 1550–1450
(B) From Kannia (Mitropolis) in the Mesara. Probably Late Minoan IB. c. 1500–1450
(C) From the palace at Knossos.
Probably Late Minoan IIIA, c. 1375 or later
(D) From the citadel at Mycenae, with attendant snake Late Helladic IIIB, c. 1250

teen, and probably twenty-four or more large clay statues, which evidently varied in size, but some of them must have been not less than 1.5 m. high. Most if not all were made during the period covered by Middle Minoan III and Late Minoan I in Crete. They appear to have stood in a sanctuary, where they were overthrown and damaged at the time the settlement was destroyed c. 1450.

All the statues are of women, standing up

B

C

D

90. Upper part of a statue of a goddess
from Ayia Irini on Kea. Probably Late Cycladic I,
c. 1500. Clay. H preserved 0.535 m. *Kea Museum*

right or bent slightly forward. They are Cretan
in style, and with their naked breasts and long
flaring skirts resemble the little faience snake
goddess from Knossos [123] (see p. 133). Their
arms are held downwards, hands on hips, as
seen in some representations of Cretan god-
desses or their priests and worshippers. There
is much variety in the faces, and the eyes in par-
ticular are rendered in different ways. Some if
not all appear to have been goddesses and ob-
jects of cult.[135] One large head resurrected after
the destruction *c.* 1450 was still being used in
this way in a restored version of the sanctuary in
the twelfth century, and another was actually
installed as a cult object in the sanctuary which
occupied the site in later Greek times.

The method of manufacture of these clay statues is interesting. Normally it seems the skirt was built from the bottom by adding successive strips of clay. When the top was reached, a vertical post was set upright in it, and the body was formed around this. A wooden cross-bar was often inserted to support the shoulders, and smaller pieces of wood might be used to strengthen the arms, but these were not joined together, and the statues were not built round a framework or armature. Sticks of wood were used in a similar way to strengthen some large clay figures of Cretan aspect found at the site of the Aphaia temple on Aigina, but these are later in date.[136]

Conical clay cups of a type in general use in contemporary Crete had been employed as a basis for the breasts in the case of two of the Ayia Irini statues. At least one statue was covered with plaster, and traces of paint have been noted on others, including white for skin, yellow for a bodice, and red for a necklace. In their original state, when covered with paint, these clay statues would have been virtually indistinguishable from wooden ones. Perhaps clay was used here as a cheap substitute for the wood of which comparable statues may have been made at main centres in Crete (see p. 95),[137] for the settlement at Ayia Irini was small and comparatively provincial, although there seems to have been a Cretan element among its inhabitants.

The technique of using the faster potter's wheel for making clay statuettes appears to be of great antiquity in Crete. But there is a distinctive class of large, rather crude, figures, apparently idols or goddesses, composed from hollow wheel-made cylinders worked into human shape while the clay was still pliant.[138] A wide cylinder was employed for the long skirts, and the figures therefore have a bell-shaped appearance. A hole was often made in the top of the head, evidently to facilitate firing, but small holes through the centres of the ears appear to have been meant to help the figures hear prayers addressed to them. Most of these idols may have been private dedications rather than cult images, and most, it seems, were left

plain, or if they had painted decoration the traces of it have not survived. It has been argued that the earliest of them date from the last stages of the Bronze Age in the fourteenth or even the thirteenth century,[139] but those from the shrine at Gournia[140] and from the building at Kannia near Gortyna [89B, 91][141] appear to have been involved in the destructions which overwhelmed those sites c. 1450,[142] and another from Sakhtouria in southern Crete should also perhaps be assigned to a comparatively early period.[143] These were clearly rude, provincial works, and style may be a misleading guide in dating them where the archaeological context in which they were found is not clear. But the faces from Kannia [91] and Sakhtouria seem closer to those

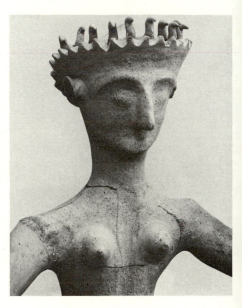

91. Top of a goddess from Kannia (Mitropolis) in the Mesara. Probably Late Minoan I, c. 1500. Clay. *Herakleion Museum*

92 (*right*). Goddess with poppy-headed pins in her diadem from Gazi. Probably Late Minoan IIIA, c. 1350. Clay. H 0.79 m. *Herakleion Museum*

93 (*far right*). Goddess from the refuge settlement on Karfi. Subminoan, after c. 1050. Clay. H 0.86 m. *Herakleion Museum*

of the Kea statues than they do to those of Cretan wheel-made idols undoubtedly of the end of the Bronze Age, like the ones from Gazi near Herakleion [92], which still retain something of the earlier style, or the yet later goddesses from the refuge settlement on Karfi [93],[144] with their small breasts, sharp chins, thin pointed noses, and harsh brow ridges.

Large clay figures also existed on the mainland during the Late Bronze Age. Some were evidently modelled with care like the statues from Ayia Irini or the best of the Cretan wheel-made goddesses: scraps from Amyklai near Sparta include a finely modelled left hand clasping a stemmed goblet,[145] and from the slopes of the acropolis at Athens comes a fragment of a face, about a third life-size, apparently female,[146] and possibly, since it is hollow, from a wheel-made figure. Most of the large wheel-made figures on the mainland, however, appear to be relatively late, and they are crude in comparison with Cretan ones. They do not have differentiated skirts, and the upper parts of the bodies are less carefully treated. Features like arms, eyes, noses, mouths, and hair are often merely applied instead of being modelled as in Crete.[147]

An important group of some nineteen large wheel-made idols, all apparently female, has been found in a shrine at Mycenae destroyed towards the end of Late Helladic IIIB c. 1200 [89D].[148] Finished like contemporary pottery with an overall dark wash or with decoration in

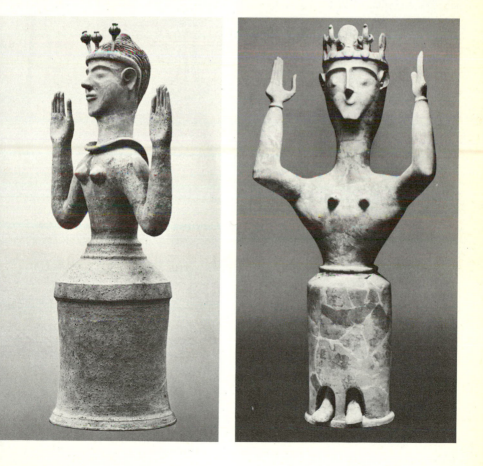

dark paint on a light ground, the idols are of sinister and outlandish aspect, but with their upraised arms, staring eyes, and associated snakes [89D] preserve some faint reminiscence of the exquisite faience goddess from the Temple Repositories at Knossos [123] (see p. 133). An unusually large and impressive wheel-made head from a shrine of the twelfth century at Asine in the eastern Peloponnese[149] has a hole in the top and ears pierced for hearing prayers, and wears a flat crown resembling that of the plaster head from Mycenae (see p. 102). In spite of its bearded look it may be female, although it conceivably belonged to a sphinx or other animal-bodied creature rather than to a human figure.[150] Perhaps it came from a large statue, smashed at the time of the disasters which overwhelmed the Peloponnese *c.* 1200, and was afterwards rescued for cult like the clay head at Ayia Irini (see p. 107).[151]

Some small clay figurines of goddesses or their attendants were thrown on the fast wheel like the larger idols: a number assignable to the fourteenth century or later have been recovered in Crete and on the mainland [89C].[152] But most of the clay statuettes of all periods of the Bronze Age in the Aegean were hand-made. Clay figurines of any kind are curiously rare on the mainland during the earlier part of the Bronze Age (see p. 94). Eventually, however, some 'goddesses' from Crete reached the mainland,[153] and during Late Helladic II in the fifteenth century, when Cretan influence was at its height, they began to be imitated there.[154] At first these native figurines were relatively scarce in numbers, although varied in type and naturalistic in appearance, like the Cretan ones from which they were derived. But the fashion took root, and from the second quarter of the fourteenth century onwards the demand suddenly appears to have expanded in certain regions like the Argolid, where little clay female figures of Late Helladic III A–B date have been recovered in vast numbers [94, A–C].[155] While these Mycenaean figurines ultimately derive from types current in Crete,[156] the explosion of fashion for them may reflect influence from Syria, where little clay 'goddesses' abounded at the time.

Most of the figurines made on the mainland in the late fourteenth and thirteenth centuries are female, and basically they seem to represent goddesses, many of them crowned, and all wearing long skirts and standing in traditional poses: with hands on hips or between the breasts [94A], with elbows raised and fists brought back against the top of the chest [94B], or with uplifted arms [94C].[157] These three main types are called re-

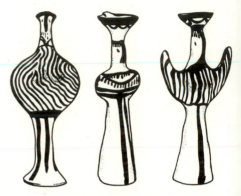

94. Figurines: (A) Phi type, (B) Tau type, and (C) Psi type. Late Helladic III, after *c.* 1400. Clay

spectively Phi, Tau, and Psi, from their resemblance in shape to those Greek letters. A rare type has both hands placed on top of the head, which is normally crowned but sometimes bare, in the gesture of a mourning woman.[158] The types are rather standardized as befits mass production, and the figurines appear stylized in comparison with those of earlier times, but are not without a certain charm. They were placed in sanctuaries and used as votives: many have also been found in tombs, notably it seems in association with the burials of children, whom they may have accompanied as toys or as protective goddesses and divine nurses.[159]

Very few Mycenaean clay figurines are male, but figures of animals, notably oxen, are not uncommon: some may have been offered as substitutes for real sacrifices as in Crete, while others were no doubt toys. Less common, and perhaps secular in origin, although sometimes used as votives, are chariots with their drivers,

what appear to be ploughing scenes, and horse-men, one of whom at least is armed as a warrior.[160] There are also enthroned goddesses, the goddess sometimes made separately from her throne.[161] Entwined couples on beds may represent Sacred Marriages.[162] Model boats of various kinds occur.[163] A goddess with upraised arms rides side-saddle on a horse.[164] What seem to be a bull-leaper,[165] a bread-maker,[166] and a sedan chair,[167] are also attested. But unique figur-ines bought from dealers are always suspect.

Some Mycenaean figurines found their way abroad to Crete, Cyprus, and Syria. Refugees spreading from the Peloponnese after the dis-asters of *c.* 1200 appear to have brought the custom of making them to islands like Melos, and to parts of Crete – where, however, the tra-dition of making clay figurines of all kinds had continued without interruption. A varied col-lection assignable to Late Minoan III and the beginning of the Iron Age, found in association with a shrine at Ayia Triadha near Phaistos,[168] included male and female figurines, birds of various kinds, and animals, notably bulls (as in illustration 95) and horses, besides clay wheels for model vehicles, models of altars, and one of a ship. A number of the larger figures were wheel-made, and had animal bodies with human heads, some apparently female, but others male.[169] The ears of a few were pierced, like those of the large wheel-made goddesses found in Crete and on the mainland. If this was to help them hear prayers it would suggest that these centaur-like creatures were divine.

These 'centaurs' from Ayia Triadha are re-lated to a class of large clay animals with wheel-made bodies and painted decoration, mostly bulls as on illustration 95 but including horses, attested at the end of the Bronze Age in Crete and on the mainland as well as in some of the islands.[170] In the case of the largest, the legs, neck, and head were shaped from separate wheel-made cylinders which were then joined to the cylinder forming the body. These were evidently votives, substitutes for sacrifices per-haps, and placed in open-air sanctuaries, where they must have been an impressive sight crowd-ing round the altars. Unusually fine examples

95. Bull from Phaistos. Late Minoan IIIc, after 1200. Clay, both horns and three legs restored. H without horns *c.* 0.35 m. *Herakleion Museum*

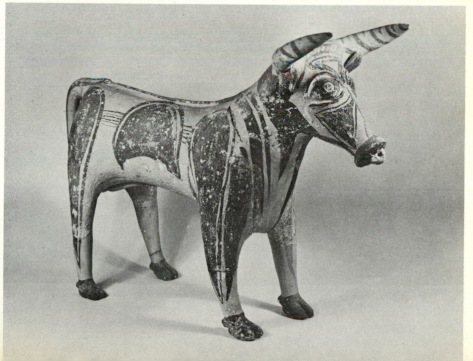

were recovered from the site of the former palace at Phaistos [95].[171] The evidence from the sanctuary on Mount Kofina suggests that hollow clay figures of animals including some of considerable size were already being made on the island during the Middle Minoan period (see p. 106). The fashion for large wheel-made animals with painted decoration may have developed in Crete towards the end of the Bronze Age,[172] spreading in the course of the twelfth century to various centres of the Mycenaean world, and eventually to Cyprus, where some of the figures of this class boast human heads like the Ayia Triadha 'centaurs'.[173]

The tradition of making these large votive figurines with the help of the fast potter's wheel continued beyond the end of the Bronze Age in some parts of the Aegean which were not over-run by the Dorian Greeks, notably in Attica and on the island of Samos; in Crete itself, in spite of the Dorian conquest, it lasted throughout the Dark Ages and into the ninth and eighth centuries or even later.

Bronze Figurines[174]

These seem to be distinctively Cretan. They range in height from about 0.07 m. to 0.25 m., and vary much in quality; but the finest, assignable to the flourishing period of Middle Minoan III–Late Minoan I from c. 1700 to c. 1450, are of great power and beauty. Some surviving figurines may be earlier than Middle Minoan III,[175] and their manufacture continued in Crete until the end of the Bronze Age, and even perhaps without a break into the Iron Age, when new types were evolved.[176]

These bronze figurines were evidently made as votives, and many of them represent worshippers, both men and women, standing with their right hands, or sometimes with both hands, raised in prayer or adoration. One of the first to be discovered is also among the finest, the figure of a woman stooping forward,[177] her head entwined with three snakes,[178] unless these are really just thick tresses of hair [96].[179] Men are normally thin-waisted in the conventional Cretan manner. One or two figurines of fat men

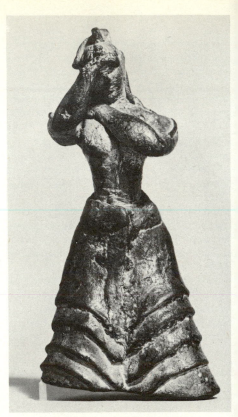

96. Figurine of a woman standing in worship, allegedly from the Troad, but of Cretan origin. Late Minoan I, before c. 1450. Bronze. H 0.184 m. (*West*) *Berlin, Staatliche Museen der Stiftung Preussischer Kulturbesitz (Antikenabteilung)*

like illustration 97A may possibly reflect the appearance of their dedicators. A handsome crawling baby from the Psychro cave [98] is reminiscent of the ivory boys from Palaikastro [108] and the child of the ivory triad from Mycenae [114].[180]

There are also figurines of animals, notably a series from Ayia Triadha which includes lively horses, deer, and oxen, together with a cow suckling her calf.[181] These came from the sanctuary area where the late clay figurines were recovered (see p. 111). But two long-horned

goats [99] from Phaistos are in a fine style assignable to Late Minoan I before *c*. 1450.[182] A noble statuette, said to have been found south of Rethimno, shows a charging bull with a leaper on his back [97B][183] whose forearms and restored lower legs may have been lost as the result of defective casting – apparently the bugbear of these early Cretan bronzes.[184]

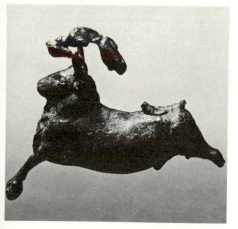

97. Statuettes of (A) a worshipper from Tylissos and (B) a bull-leaper.
Late Minoan I, *c*. 1550–1450. Bronze. Scale 1:3.
Herakleion Museum and London, British Museum

98. Figurine of a crawling baby from the Psychro cave. Probably Late Minoan I, before *c*. 1450. Bronze. L 0.048 m. *Oxford, Ashmolean Museum*

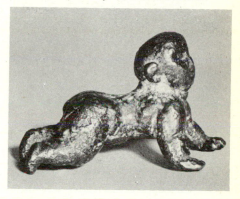

99. Figurine of a reclining goat from Phaistos. Probably Late Minoan I, before *c*. 1450. Bronze. L 0.055 m. *Herakleion Museum*

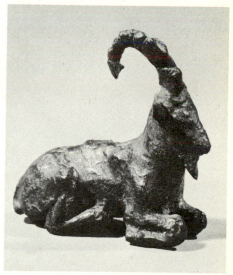

Elsewhere in the Aegean, bronze figurines seem to be rare before the Iron Age. A male one of unusual type was found at Phylakopi in Melos,[185] and there is a bronze lion from Kea.[186] A little horse from Mycenae may also be of Bronze Age date.[187]

These figurines were cast in solid bronze, evidently by the cire perdue process from a wax model, the clay mould enclosing it being held upside down and the metal poured through the feet.[188] The metal in the pouring hole was normally left when the mould was removed so that it formed a peg under the feet of the figure. Even the finest of these figurines are curiously unfinished in appearance. The rough and bubbly texture of the surface may be due to the fact that the alloy used was poor in tin, with the consequence that the metal did not flow well,[189] but the surface was evidently left as it emerged from the mould without any attempt to smooth it. The Rodinesque look resulting from this neglect of finish may be due not so much to a taste for impressionism on the part of Cretan artists[190] as to the fact that these figurines were votives to be hidden away in sanctuaries: several as a matter of fact have been recovered from the dark recesses of caves.

The Cretans may have made figurines of this kind in gold and silver. Some lead ones have survived, most of them rather crude, like a small goddess with upraised arms from the Little Palace at Knossos;[191] but two, a man in the attitude of a worshipper, and a woman wearing a long skirt, from a tholos tomb at Kambos in the southern Peloponnese are of exceptional quality although only 0.12 m. and 0.09 m. high.[192] Both look as if they were Cretan work of Late Minoan I date.

WOOD, SHELL, BONE, AND IVORY: FAIENCE: GLASS

A. Wood, Shell, Bone, and Ivory

Wood. Little Bronze Age wood-carving has survived in Greek lands, but the safe depths of the Mycenae shaft graves have preserved a few wooden objects, including a small rectangular jewel box, only 0.11 m. high, with pairs of dogs carved in relief on two sides [100].[1] The dogs are crouched above ivory plinths, symbolizing perhaps flat house-roofs from which they are keeping guard over the treasures within. But similar plinths occur below Knossian relief frescoes, and they were also reproduced in Crete on a miniature scale as here.[2] The dogs, solid and heavy-limbed, but alert and vigorous, are skilfully rendered and look not altogether unlike the lion of the latest of the shaft grave stelai [81] (see p. 100). It seems unnecessary to regard them and the box which they adorn as Egyptian.[3]

101. Lid from Saqqara, Egypt. *c.* 1450–1400. Wood

Somewhat later in date is a little wooden object, only *c.* 0.06 m. in diameter, which was found long ago at Saqqara in Egypt [101].[4] The lid of a cosmetic jar rather than a miniature bowl, it is carved in relief with animals set in four panels divided by conventional rockwork. A winged griffin in one panel stalks a goat in the next, while a lioness rounds on a pair of deer or antelope. The style is Aegean, and suggests that the lid was made in that area soon after *c.* 1450, although it was apparently found in a tomb of the time of Akhnaton (Amenhotep IV), who reigned about a hundred years later. The rockwork divisions are comparable with those on the magnificent gold octopus cup from the royal tholos tomb at Dendra [166] which may date from about the same time (see p. 169). The

100. Wooden box with dogs in relief above ivory plinths, from Mycenae shaft grave V. Probably Late Helladic I, *c.* 1550. The wood is said to be sycamore. H 0.11 m. *Athens, National Museum*

carved surfaces of the Saqqara lid may have once been covered with gold leaf, in the same way as some relief vases from Crete (see p. 147). Like the Dendra octopus cup, the Saqqara lid might be the work of a Cretan artist transported to the mainland after the disasters of *c.* 1450 (p. 24).

Shell. The use of shell inlays has a long history in Mesopotamia.[5] Some Cretan shell figurines and inlays are assignable to the third millennium and to the time of the early palaces. One stylized woman may date from the end of Neolithic or beginning of Early Minoan times,[6] and two figurines from the Trapeza burial cave assigned to the end of the Early Minoan period are even more rudimentary.[7] Shell figurines of Early Bronze Age type have also been recovered in the Cyclades.[8]

Plain shell inlays were among the objects in the Vat Room deposit in the palace at Knossos assignable it seems to Middle Minoan IB *c.* 1900.[9] From what may have been an early circular tomb at Ayios Onoufrios near Phaistos comes a plaque in the shape of a male head rendered in low relief with thick lips and short beard and moustache [102].[10] The eyes were once inlaid in some other material. A rectangular plaque, 0.08 m. long, from the palace at Phaistos, carved with reliefs of four curious animal-headed figures in long robes with tasselled belts,[11] was evidently affixed by holes at the corners to a curving surface, presumably of wood. Some details were incised and painted; traces of dark blue have survived in the eyes, belts, and tassels.

An interesting relief from the Throne Room of the palace at Knossos showing a dagger in its sheath which is attached to a belt or baldric [103][12] seems assignable to the beginning of the

103. Development of relief of dagger with sheath from Knossos. Probably Late Minoan I, *c.* 1500–1450 Shell. About actual size. *Herakleion Museum*

Late Minoan period, but most of the shellwork from Crete appears to date from earlier times. The use of shell for inlays and figurines may have declined as more ivory became available.

Evans assumed that the shell of these Cretan inlays and figurines was *Tridacna*, imported from the Red Sea,[13] but the oyster-like *Spondylus gaederopus L.* native to the Aegean would have supplied pieces of shell large enough for such objects.[14] Spondylus was exploited in the Cyclades in early times for bracelets, figurines, and pestles, and it was imported from the Mediterranean to the Balkans and central Europe to make bracelets, amulets, and beads.[15]

Bone was used throughout the Bronze Age in the Aegean for small carved objects and inlays of the kind which also occur in ivory: indeed there is always a risk with small objects that what has been called ivory is really bone or

102. Plaque showing the head of a man with beard and moustache from Ayios Onoufrios. Probably Middle Minoan, after *c.* 2000. Shell. L from chin to top of ear 0.045 m. *Oxford, Ashmolean Museum*

antler.[16] But in colour and texture bone is inferior to ivory, and the size of what can be made from it is more limited. Thus of the bone and ivory discs with compass-made designs in the style of those on the gold discs from the Mycenae shaft graves (see p. 204), found in one of the tholos tombs at Kakovatos assignable to the early fifteenth century, the smaller were mostly of bone, while the larger ones with the more elaborate decoration tended to be ivory.[17]

Bone was sometimes used for objects of fine quality, however, even during the most flourishing period of the Minoan civilization of Crete. Thus bone inlays in the shapes of buds and flowers suggested by those of a pomegranate were recovered from the Temple Repositories at Knossos (see p. 132),[18] and the head of a woman from Palaikastro in eastern Crete, also made of bone, had sockets for inlaid eyes and holes for inserting hair like some ivory heads from Knossos (see p. 119).[19]

IVORY: EARLY AND MIDDLE BRONZE AGE (UNTIL *c.* 1450 B.C.)

Carving in ivory is like wood-carving. Ivory is in effect a fine white wood conveniently free from grain, and the opposite in colour to ebony with which it was often combined for contrast in Egypt.[20] The import of ivory was thus on a par with the import of fine woods like ebony for decorative inlays and carvings. Ivories serve to augment the meagre evidence of what Aegean wood-carvers could do. They are also to some extent a guide to the character of the large-scale sculpture and relief-work of the time.

Crete

There is no certain evidence that the Neolithic people of Crete worked ivory,[21] but it was being used there from early in the Bronze Age for making seals. Some of these are in the shape of animals, and are masterpieces of miniature sculpture. A remarkable series has been recovered from early circular tombs in the Mesara region of southern Crete, notably one from Kalathiana in the shape of a man crushed be-

neath a lion,[22] and another from Koumasa in the form of a dove with her young [210B].[23] Similar seals have also been found in the northern part of the island, and a large collection, including one in the shape of a fly and another of a dog, is reported from the early cemetery on the hill of Fourni at Arkhanes just south of Knossos.[24] A few are shaped like monkeys, or are surmounted by them like one from the Trapeza burial cave [210C],[25] which might suggest that the ivory for seals was brought from Africa or Egypt where monkeys were native.[26] But elephants also lived in northern Syria until the ninth or eighth centuries, when they appear to have been hunted to extinction, early victims of ecodoom.[27] Some complete tusks were recovered from the palace at Zakro in eastern Crete destroyed in the disasters of *c.* 1450.[28]

Ivory was also used for making small figurines and pendants, some in the shape of women, others of men.[29] Two little ivory gaming pieces from the early palace at Phaistos are in the form of a bull's leg and a lion's head.[30] The mane of the lion was plated with gold – the earliest certain instance from the Aegean of that effective combination of gold and ivory that was to reach its most striking expression in the great chryselephantine statues of Classical times. Ivory was also used for the handles of metal tools such as razors, and for dagger pommels, of which examples were found in some of the early Mesara tombs.[31] From the time of the later palaces, *c.* 1700 onwards, it was much employed (as in Egypt) for inlaying or applying to boxes and other articles of wooden furniture – an ivory plaque from the Arkhanes cemetery may be the earliest known example.[32]

With increasing wealth, supplies of ivory seem to have become more abundant. The great draughtboard from the palace at Knossos, nearly a metre (0.965 m.) long and 0.553 m. wide, had an ivory framework plated with gold and set with transparent plaques of crystal backed with blue paste or silver [104].[33] Round the ivory edges of the board flowers were carved, their centres consisting of convex discs of rock crystal that may have been backed with gold. The whole was almost certainly mounted on wood, and

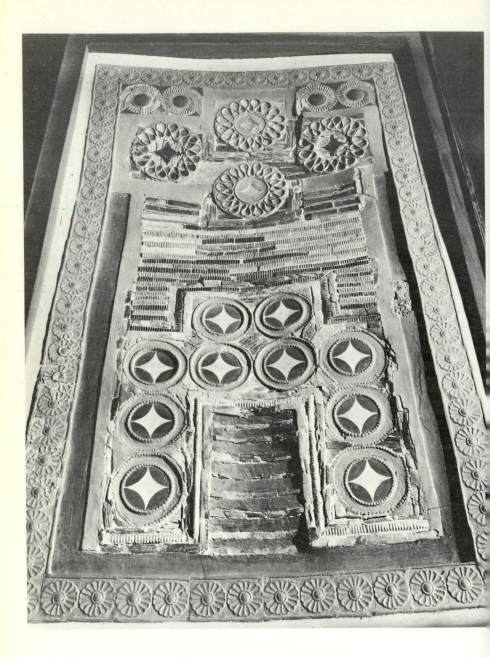

104. Draughtboard from the palace at Knossos. Probably Middle Minoan IIIB, *c.* 1600. Ivory plated with gold and inlaid with crystal. L 0.965 m., W 0.553 m. *Herakleion Museum*

some other ivory reliefs, including small argonauts, which were found with the board appear to have decorated its sides. The board no doubt served as the lid of the box which contained the pieces for the game. It was assigned by Evans to Middle Minoan IIIB, although he dated the deposit from which it came to the beginning of Late Minoan times.

Ivory statuettes made in several pieces because they were too large to carve in one from the material available were among the most remarkable creations of Cretan artists during the period of the later palaces from *c.* 1700 onwards. The arm of a small statuette of this type from the Chrysolakkos burial complex at Mallia[34] may date from the beginning of this period rather than earlier (like the Aigina treasure of jewellery which is thought to have come from there; see p. 195). Remains of such ivories were found below the later floors in the residential quarter of the palace at Knossos in deposits assigned by Evans to a horizon of destruction in Middle Minoan IIIB. From a small space below a stairway (the Service Stairs) came fragments of figures of young men, with one perhaps of a girl, engaged in the act of springing down as if to grapple the heads of charging bulls.[35] One which could be restored is nearly 0.30 m. long, with arms and legs outstretched and head thrown back, in the characteristic pose of a bull-leaper [105]. The carving is of extreme delicacy,

and in spite of the small scale the muscles of the legs and arms, and even details like the veins on the backs of the hands and the finger-nails, are rendered with accurate and minute care. While several of the limbs had resisted decay, only one of the heads from the Ivory Deposit preserved the face intact [106]. Round the top and sides

106. Head of male figurine, found with that of illustration 105 and of the same date. Ivory. H 0.045 m. *Herakleion Museum*

are holes for inserting hair, remains of which, consisting of strands of gold-plated bronze wire twisted together in pairs, had survived on the fragment of another head. The figures may have worn loin-cloths of thin gold plate, scraps of which were found with them.

Fragments of similar large ivory figures have been recovered from other parts of the site at Knossos and from elsewhere in Crete. An important series, apparently connected with the debris of an ivory-worker's shop overwhelmed in the disasters of *c.* 1450, came to light in the area of the Royal Road at Knossos during the excavations of 1957-61.[36] Some of the fragments belonged to figures of men even larger in scale than the bull-leapers from the Ivory Deposit in the palace. They included several feet and part of an ivory kilt, together with an arm bent at the elbow and clasping what may be the horn of a bull.[37] Another bent arm with a clenched fist [107], and half of a man's chest, appear to come

105. Figurine, apparently of a bull-leaper, from the palace at Knossos. Probably Middle Minoan IIIB, *c.* 1600. Ivory, much decayed. L *c.* 0.295 m. *Herakleion Museum*

107. Arm of a large statuette, apparently of a man, from the area of the Royal Road west of the palace at Knossos. Probably Late Minoan IB, *c*. 1500–1450. Ivory. L to elbow 0.087 m. *Herakleion Museum*

kastro [108],[44] are of excellent workmanship, but although closely resembling Egyptian ivories of much earlier, Middle Kingdom, date they appear to be Cretan.[45]

108. Figurine of a boy from Palaikastro. Probably Late Minoan I, *c*. 1500–1450. Ivory. Scale 1:2. *Herakleion Museum*

from an exceptionally large figure which, it can be estimated, was made up from some twelve or more separate parts held together by a system of pins and dowels; when complete it may have stood as much as 0.40 m. high.[38] The indications, slight as they are, suggest that these Royal Road figures, like those from the Ivory Deposit, were human rather than divine.

Many gold and ivory statuettes allegedly from Crete found their way into museums and collections abroad during the period just before and after the First World War.[39] Most appear to be forgeries,[40] but the first to make her *début*, the attractive snake goddess acquired by Boston in 1914,[41] remains the least unconvincing and is widely accepted as genuine,[42] despite the soft, appealing expression of the face, more reminiscent of a lady of the Edwardian era than of a Bronze Age goddess.

During the later palace period from *c*. 1700 onwards, small figurines were carved from a single piece of ivory as in earlier times. A pair of curious male figures with long pins for affixing into a base of some kind was recovered from the mansion at Nirou Khani destroyed in the disasters of *c*. 1450.[43] Two ivory boys, found in a destruction level of the same period at Palai-

Animals carved in the round are less in evidence than figures in human shape. A bird with one raised wing, partridge perhaps or dove, from the Royal Road area at Knossos was carved on both sides of a thick ivory plaque,[46] but it was evidently part of some larger object, as the holes for affixing it indicate. The surface of the bird was polished, except for some parts which were left rough as if they had been concealed by gold leaf.

There were also inlays and appliqué plaques adorning boxes or other articles of wooden furniture. From the horizon of the Ivory Deposit in the palace at Knossos came a bird's wing, exquisitely carved, together with another fragment of a wing and a plume which seem to have belonged to a large composite figure of a sphinx.[47] A little plaque from what was evidently an important house destroyed *c*. 1450 at Palaikastro has a delicate relief of a long-necked bird with crested head, its wings raised as if about to alight in the rocky landscape which surrounds it [109].[48] The bird, variously interpreted as a peacock or a heron, may be as much a product of the lively Cretan imagination as many of the flowers in contemporary wall-paintings (pp. 52–3, 235). A rough piece from

the centre of a tusk suggests that in spite of their fine quality this and other carved ivories from the same part of the site were the work of artists living at Palaikastro.

110. Relief of a griffin seizing the leg of a bull from Knossos. Probably Late Minoan I, *c.* 1500. Ivory. Actual size. *Herakleion Museum*

109. Plaque with relief of a long-necked bird from Palaikastro. Probably Late Minoan IB, *c.* 1500-1450. Ivory. H 0.07 m. *Herakleion Museum*

A remarkable fragment of a plaque carved in high relief with a griffin attacking a bull [110] was found in the South House at Knossos,[49] destroyed it seems in the disasters of *c.* 1450 rather than later.[50] The modelling is exceedingly fine and powerful. The eyes of the griffin, now hollow, were once filled with inlays of some kind. Ivories from the palace at Zakro, destroyed *c.* 1450, include plaques shaped like double axes, and one like an elegant butterfly.[51]

A circular box cut from a section of elephant tusk was found in a tomb at Katsamba, the seaport of Knossos [111].[52] It may be the earliest ivory box of the kind yet known from the Aegean area. The tomb is assignable to Late Minoan IIIA, a generation or so after the disasters of *c.* 1450, but the relief scene on the box (of which the bottom part is missing) and the way it is carved suggest that it was made somewhat before that time.[53] A bull is charging through a

rocky landscape with two palm trees in the background. A man balances on the bull's horns, clasping them with crossed arms. Perhaps he has dropped from the palm tree behind the bull and is about to twist its head and bring it to the ground. Two other men are running away, the one in front waving what may be a net, the other behind holding a spear which he aims at the bull's head. Above the spearman flies a long-necked bird.

111. (A) Circular box from a tomb at Katsamba showing a charging bull. Probably Late Minoan IB, c. 1500–1450. Ivory, from a section of tusk. H of box 0.092 m. *Herakleion Museum* (B) Development of the scene. Drawing by T. Phanourakis

The Mainland

Bone was being cut for inlays and appliqués before the end of the Middle Helladic period on the mainland. The bone mounting of a dagger sheath from Asine is competently engraved with spiral designs of the type found on objects from the Mycenae shaft graves.[54] Ivory was not over-abundant in the shaft graves,[55] but even in those of circle B there was a certain amount, including a pin and two combs, and plaques apparently from sheaths, although much of this may represent Cretan imports, like the ivory pommels of two fine type A swords, and the handles of some leaf-shaped razors.[56] Inlays from graves of circle A may come from wooden boxes like that with the dogs in relief above ivory plinths (see p. 115). A mirror handle from grave V with two lions in high relief may be Cretan work,[57] but a comb from grave IV with a simple design of

concentric circles is defiantly barbarous in its sordid use of fine material.[58]

LATER BRONZE AGE (c. 1450 B.C. ONWARDS)

The disasters which overwhelmed Crete with the mainland conquest c. 1450 mark a great divide in the history of the Aegean Bronze Age. Most Aegean ivories come from deposits later than this, and the vast majority have been found on the mainland. Ivories and the furniture they adorned were easily transported, however, and the evidence of Assyrian palaces shows how foreign ivories were valued as booty of war. It is always possible therefore that some ivories in a fine style from mainland deposits are work of an earlier period brought from Crete, although most of those found on the mainland were evidently made there, and the craft of ivory work-

ing appears to have survived transplantation from Crete with its vitality more or less unimpaired.[59]

some, assignable to the period immediately after the Mycenae shaft graves, appear to be native work. A remarkable box carved from a

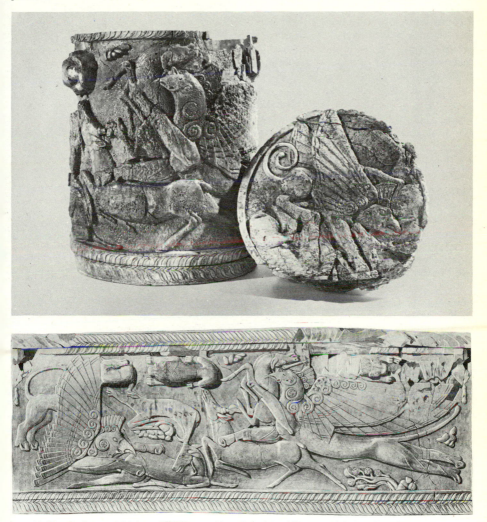

112. (A) Circular box and lid from Athens carved in relief with griffins attacking deer. Late Helladic IIIA, *c.* 1400. Ivory, from a section of tusk. H of box 0.16 m. *Athens, Agora Museum*
(B) Development of the scene. Drawing by Piet de Jong

A large proportion of mainland ivories may have been carved by Cretan craftsmen brought there after the conquest *c.* 1450, or by craftsmen trained in schools which they initiated; but

section of elephant's tusk was recovered from a tomb in the area of the later agora at Athens in association with vases of fourteenth-century date (Late Helladic IIIA) [112].[60] The inside

was lined with thin strips of tin. On the outside and carved in one piece with it are two pairs of lugs, which held the handles of string or wire. One of the lugs in each pair is different in size from the other, the smaller being in the shape of a fawn with twisted body, the larger of a crouched lion. The reliefs show an attack by griffins upon a herd of deer: on the lid are a griffin and two deer, and round the sides of the box a pair of griffins with four deer. The technical skill is of a high order, and the style is vigorous; but the design is crowded and confused, and the way in which the head of one of the griffins appears guillotined from its hindquarters by its extended wing savours more of incompetence than of distortion for artistic effect. Indeed the artist has not developed much beyond the crowded and formless designs on the gold plaques of the hexagonal box from shaft grave V with their acute *horror vacui* [79] (see p. 99), and it is a far cry from the ordered composition and sense of design of the great stone relief vases [137-9] that were being made in Crete before the time of the mainland conquest (pp. 143-7). The ill-balanced lugs and the stylized treatment of the crouching lions are also in harmony with the view that the box was carved by a native craftsman, imitating the Cretan style, but not yet thoroughly imbued with a Cretan sense of design and taste.

It is hardly possible, however, in the case of most Aegean ivories from contexts of the fourteenth and thirteenth centuries to distinguish whether they are Cretan or mainland work, and it may not be meaningful to do so, since Crete was by then almost certainly under the control of mainland rulers. Ivories like that of illustration 113 from the unplundered side chamber of a princely tomb at Arkhanes south of Knossos, assignable to the early part of the fourteenth century,[61] emphasize this difficulty.

Besides circular boxes carved from sections of tusk, Aegean ivories of this period include many inlays and appliqués of various kinds. In addition there are elaborately carved mirror handles and combs, and fragments of a lyre decorated with reliefs were recovered from a tholos tomb at Menidhi near Athens.[62] The few

113. Plaque with relief of a goat from a tomb at Arkhanes. Late Minoan IIIA, *c.* 1375. Ivory. H 0.085 m. *Herakleion Museum*

statuettes from contexts after *c.* 1450 have all been found on the mainland. A leg from Mycenae, and an arm with clenched fist, very finely worked, evidently come from figurines made in several pieces like earlier Cretan ones; and small figurines of long-robed women from there and from neighbouring Prosymna may represent goddesses: two at least had their hands to their breasts, like the women of faience relief plaques from Mycenae, Dendra, and Knossos (see p. 136).[63] Unique and reckoned among the finest of all Aegean Bronze Age ivories is the trio of two women and a boy from the acropolis at Mycenae [114].[64] This remarkable group, only 0.078 m. high, was cut from a single piece of ivory with all the grace and attention to detail characteristic of Cretan figurines of the best period before *c.* 1450. The somewhat harsh appearance of the surviving woman's face might have been mitigated if the deep grooves of the eyebrows and eyes had been filled with inlays. The women, bare-breasted and wearing long flounced dresses, share some kind of heavy

114. Statuette, apparently representing a pair of goddesses with a child, from the citadel at Mycenae. Probably Late Helladic IIIA, before *c.* 1300. Ivory. H 0.078 m. *Athens, National Museum*

shawl or cloak; the boy is clad in an ankle-length robe girdled at the waist. This is no domestic scene, and has reasonably been interpreted as a group of deities. A triad like that of Eleusis – Demeter, Persephone, and the boy Iakchos, or Bronze Age deities who may have preceded them under other names – seems involved:[65] some later Greek terracottas represent Demeter and Persephone (or pairs of their worshippers) sharing a single garment somewhat in this manner.[66] The ivory group was no doubt lost when the palace at Mycenae was destroyed at the end of the thirteenth century, but it may well have been carved at the beginning of the century or earlier.

Another remarkable ivory from Mycenae with an early look is a head about 0.06 m. across wearing a narrow diadem over short-cropped hair that almost resembles a wig [115].[67] The eyes are outlined in relief. Each ear has a central in-dentation, reminiscent of the holes in the ears of clay statues of gods and goddesses to assist them in hearing the prayers addressed to them (see p. 108). The hair style and the shape of the face combine with the diadem to give the head quite a Roman appearance, although it was found in a Mycenaean shrine in the fill of a bench made at some point before the end of Late Helladic III B c. 1200, when the building was destroyed by fire. Like the heads of white plaster [83] which may have been a cheap substitute for ivory (see p. 102), it could have been attached to a wooden body. In the fill of the bench along with it was a large ivory lion, about 0.18 m. in length, also carved in the round.

Circular boxes made from sections of tusk are commoner on the mainland than in Crete. Some are plain,[68] but many have elaborate carved decoration, usually consisting of scenes with animals as on the box from the tomb in the

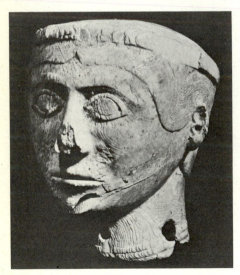

115. Head wearing a diadem from the citadel at Mycenae. Late Helladic III, before c. 1200. Ivory. W c. 0.06 m. *Nauplia Museum*

116. Tusk carved in relief with a sacred column opposite a large male figure flanked by goats from a tomb at Mycenae. Late Helladic III, before c. 1300. Ivory. H 0.259 m. *Athens, National Museum*

Athenian agora [112] (pp. 123–4), but some-
times merely ornamental, like the design of
argonauts on an ivory box from the same tomb,[69]
or the vertical bands of spirals on an unusually
tall one from the Pylos area.[70]

From a tomb at Mycenae comes the complete
end of a tusk carved in low relief with an unusual
scene of what appears to be a sacred column sur-
mounted by an embryo Ionic capital with
flowers springing from its volutes [116].[71] The
column is flanked by lotus flowers and buds, and
on the opposite face of the tusk is a large human
figure, evidently male, wearing a necklace and
many bracelets, with a long-horned goat on each
side of him. Above the column are traces of a
great bird in flight. The concepts and the work-
manship suggest that the carving was done by
an Aegean craftsman.[72] The tusk is hollow, and
might have served as a rhyton for pouring
libations.[73] But the designs on rhytons of conical

Some ivory boxes were made in the shape of
birds, evidently ducks, with back-turned heads;
unless they were meant to represent duck-
headed boats, of which there are pictures on
seals and seal-impressions from Crete. No com-
plete example has yet been recovered from the
Aegean area, although a number have been
found in Syria; but it has been suggested that
the type might have evolved in the Aegean,
where the theme of the bird with back-turned
head was early at home.[75]

A large oval lid from a tomb at Knossos [117]
consisted of a flat ivory background 0.39 m. long
and 0.148 m. wide, on top of which were fastened
figure-of-eight shields of various sizes.[76] The
box to which this belonged was presumably
made of wood, and bone inlays found by the lid
may perhaps have come from it.[77]

Decorated inlays and appliqués abound.
These no doubt once adorned wooden furni-

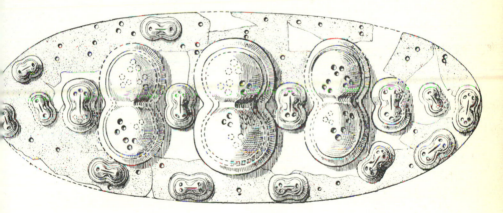

117. Lid with figure-of-eight shields from Knossos. After *c.* 1400. Ivory. *Herakleion Museum*

shape invariably, it seems, take the point as the
bottom and the rim as the top, so that the scene
on the Mycenae tusk would be upside down.
Perhaps it was a trumpet, like the 'oliphants' of
medieval warriors, as has been suggested in the
case of a similar, but larger and more complete
carved tusk of more or less contemporary date
from Ras Shamra in Syria.[74]

ture such as chests, beds, and chairs:[78] ivory-
decorated beds, and chairs and stools of ebony
inlaid with ivory, are mentioned in a thirteenth-
century tablet from Ras Shamra in northern
Syria,[79] and a set of Linear B inscribed clay
tablets from Pylos has been interpreted as re-
ferring to inlaid furniture of this kind.[80] Groups
of ivories found in position in tombs at Arkhanes

in Crete, and at Mycenae and Dendra on the mainland, may have adorned the fronts of footstools like the one below the feet of the seated goddess on the gold signet ring from the Tiryns treasure (see p. 231).[81]

Inlays might be flat, cut in the shape of such things as dolphins, whorl shells, or helmeted heads, and with details incised, like a large number from the House of Shields outside the citadel walls at Mycenae.[82] More elaborate ivory cutouts show complete scenes like a remarkable plaque from a deposit below the Hellenistic Artemision at Delos with a griffin attacked by a lion.[83] Others were in relief, and applied rather than inlaid; examples in the shape of figure-of-eight shields, like those on the oval lid [117] from Knossos, were common both in Crete and on the mainland.[84] Another standard type of appliqué in that military age was the head of a warrior encased in a helmet mounted with boar's tusks [118]:[85] several have been recovered on the mainland, and the footstool from Ar-

khanes in Crete appears to have had one on each side (pp. 127–8). A relief cut-out from the palace at Pylos destroyed c. 1200 is in the shape of a Minoan genius.[86]

Numbers of model ivory columns and half-columns have been recovered from Arkhanes in Crete, and from Mycenae and Delos.[87]

Much of the best Aegean ivory carving of the fourteenth and thirteenth centuries is in relief on rectangular plaques that were once applied to furniture of some kind: a very fine example from Mycenae assignable to the early part of the period shows a seated griffin against a background of papyrus-like flowers [119];[88] and

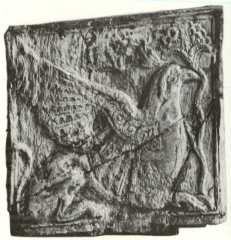

119. Plaque with relief of a seated griffin from Mycenae. Probably Late Helladic IIIA, before c. 1300. Ivory. Maximum H 0.068 m. *Athens, National Museum*

from Thebes in Boeotia come three with a pair of wild goats, their bodies crossed, and one with lion-headed monsters akin to Minoan genii carrying stags on their shoulders and facing palm trees.[89] Plaques with a superb griffin in high relief were found with other ivories in a twelfth-century destruction level in the palace at Megiddo in Palestine.[90] While most of the Megiddo ivories are of local Syrian workmanship, a few like these appear to be imports from the Aegean.[91] An ivory strip about half a metre

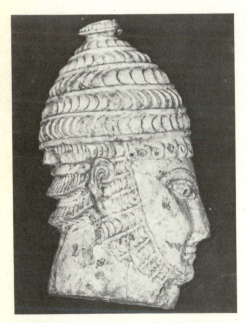

118. Plaque in the shape of a warrior's head from Mycenae. Late Helladic III, before c. 1200. Ivory. H 0.085 m. *Athens, National Museum*

long and fragments of others from the Arte-
mision deposit on Delos have reliefs of lions,
and in one case a griffin, attacking deer and
oxen.[92]

Figures in human shape apart from helmeted
heads are not so well represented on these reliefs
and inlays. But there is the male figure on the
tusk from Mycenae (see p. 127), while frag-
mentary reliefs from the sacrificial pit in the
royal tholos tomb at Dendra show the body of a
woman in a richly decorated skirt, a very fine
male head with curly hair, and a little figure of
a man behind a large wing, presumably that of
a sphinx or griffin.[93] From Mycenae come a
somewhat oval box with two men apparently
leading sphinxes;[94] a damaged relief plaque
with a goddess wearing a conical hat [122C];[95]
and an elegant relief, cut *au jour*, representing a
goddess, the raised arms (made separately) and
the head unfortunately missing, seated on a rock
[120] like the goddesses in plaster relief from
Pseira or those painted on a wall at Phylakopi on
Melos [35, A and B] (pp. 53, 56–8).[96] A large

plaque from the Artemision deposit on Delos
has a relief of a warrior with boar's tusk helmet
and figure-of-eight shield [121].[97] The heavy
limbs and massive nose give him an Anatolian
appearance, but his thin waist is typically
Aegean, as is his armament.

Both in Crete and on the mainland ivory was
sometimes used instead of wood for combs, and
for the handles of mirrors. The tops of ivory
combs normally had carved decoration: one
from Routsi near Pylos was the field for a pic-
ture in very low relief of birds attacked by cat-
like animals reminiscent of scenes on an inlaid
dagger blade from the Mycenae shaft graves

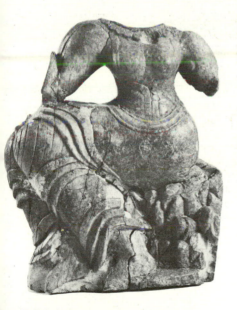

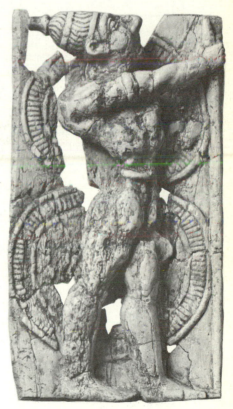

120. Relief of a headless goddess sitting on a rock
from Mycenae. Probably Late Helladic IIIA,
before *c.* 1300. H 0.082 m. *Athens, National Museum*

121. Plaque with relief of a warrior from the
Artemision on Delos. Probably Late Helladic IIIB,
c. 1250. Ivory. H 0.118 m. *Delos Museum*

A

122. (A) Mirror handle from Knossos,
(B) and (C) lid from Minet el Beida, Syria, with
goddess, and a similar goddess on a plaque
from Mycenae, and (D) and (E) plaques with
sphinxes and lion attacking a bull from
Spata, Attica. After *c*. 1400. Ivory. Scale (except D)
2:3. *Herakleion Museum, Paris,*
Louvre, and Athens, National Museum

B

C

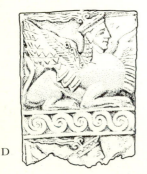

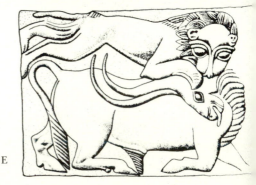

D

E

[179] (see p. 181).[98] Some of the finest ivory reliefs are on the wide upper parts of mirror handles which clasped the bronze reflecting discs.[99] The earliest known is a fragmentary handle with lions on it which comes from Mycenae shaft grave V and another comparatively early one with fine reliefs of a cow suckling her calf has been recovered from the unplundered side chamber with the burial of a princess assignable to the early fourteenth century in the tholos tomb at Arkhanes in Crete (see p. 124).[100] Later Aegean mirror handles are conceived as palm trees, with the plaques which clasped the edge of the bronze disc set above their drooping branches [122A]. Two exceedingly fine handles of this type found in 1892 in a grave in the dromos of the tholos Tomb of Clytemnestra at Mycenae have pairs of women in long flounced dresses in relief on each side.[101] A wooden mirror handle carved with comparable pairs of women had miraculously survived in a tomb at neighbouring Dendra.[102]

The taste and skill of Aegean ivory-carving were appreciated in the Near East at this time, and a school of ivory-carving arose in Syria and Palestine owing much to Aegean models, making it difficult to distinguish between Aegean imports and works produced locally in an Aegean style there. These 'Mycenaeanizing' ivories were particularly at home it seems in Cyprus and northern Syria. The famous ivory draughtboard from Enkomi in Cyprus, for instance, with its outlandish ruler driving in his chariot is certainly of local manufacture. The reliefs on a circular box lid from Minet el Beida, the harbour town of Ras Shamra on the Syrian coast, also appear to be local work, in spite of the waisted altar of Cretan type occupied by the rather ugly goddess in her long flounced skirt [122B].[103] But a goddess with the same attributes and also wearing a conical hat appears on the damaged ivory plaque from Mycenae [122C] (see p. 129).

In the aftermath of the disasters which overwhelmed it towards the end of the Bronze Age c. 1200 the art of ivory-carving appears to have become extinct in the Aegean. But in Syria the 'Mycenaeanizing' style survived the Dark Ages of the centuries between c. 1200 and 900, and ivories with traits derived from those of the Aegean Bronze Age were still being carved there in the ninth and eighth centuries, until the elephants which supplied the raw material became extinct.

Since ivory was a luxury material which had to be imported, the art of carving it in the Aegean may always have been confined to the main centres. Debris of an ivory worker's shop has been reported from the eastern wing of the palace at Mycenae, but another workshop has been identified outside the palace there.[104] Similarly in Crete ivory-carving appears to have been more than just a palace industry. The workshop of an ivory carver has been identified on the Royal Road outside the palace at Knossos, and a lump of raw material from the area of the house where the plaque with the long-necked bird was found at Palaikastro [109] suggested that it and other carved ivories recovered there might be local work (see pp. 120-1).

There is a great variation in the quality of the ivories produced in the Aegean area in the fourteenth and thirteenth centuries. A number of poor examples may have been carved late in the period, unless they are to be regarded as the provincial creations of second-rate artists. Many, like illustration 122E from a rock-cut tomb at Spata near Athens, are noticeably crude in style compared with those from main centres like Mycenae or Knossos:[105] contrast the elegant sphinx on the mirror handle from Knossos [122A] (see above) with that on the plaque from Spata [122D] with its lumpish body, harsh, straight-falling locks, degenerate facial profile, and exaggeratedly large nose and eye.

Ivory carving is akin to working in hard woods like box or cedar, and the tools and methods used were no doubt similar.[106] Small bronze saws with fine teeth from Zakro and Tylissos in Crete may have been employed for cutting ivory,[107] but would have been equally useful for fine woodwork. Possibly some kind of lathe was employed before the end of the Bronze Age in the Aegean for shaping wooden objects if not ivory ones.[108] The incised designs on flat ivory plaques may owe something to designs

traced on contemporary metalwork,[109] but in-cised decoration on shell, bone, and ivory had a long history in Mesopotamia.[110]

Some Aegean ivories were evidently tinted with colours like contemporary Egyptian ones.[111] Homer describes an ivory cheekpiece which some Maeonian or Carian woman stains with red, to be a treasure for a king and a glory both for horse and charioteer,[112] and parts of what may be meant for an ivory box carried by one of the women in the painted frieze from Thebes are also coloured red;[113] red filling was pre-served in notches on bone models of an arrow plume from the Temple Repositories at Knos-sos,[114] and there were traces of red on some of the incised bone and ivory discs from Kako-vatos.[115] An ivory duck's head, evidently from a box (see p. 127), found at Asine had been painted a dark colour, and remains of blue were left in the incisions of the eye.[116]

B. Faience

Unlike stone, wood, bone, or ivory, faience is an artificial substance. Ancient faience consisted of a core of crushed quartz grains, coated with an alkaline glaze which was in effect glass and was usually coloured blue or green by the addition of traces of copper compounds. Faience has a long and flourishing history in Egypt, where objects were being made of it before the end of the Predynastic period, but it seems to be at-tested earlier in Mesopotamia, and may have been invented in that region.[117]

EARLY AND MIDDLE BRONZE AGE (UNTIL c. 1450 B.C.)

Beads and a fragmentary bowl of faience re-covered from contexts in a tomb at Mochlos in Crete assigned to Early Minoan II in the third millennium may have been imported,[118] but some faience beads from early circular tombs in the Mesara region seem to be Cretan.[119] Faience was evidently being made by the beginning of the second millennium at Knossos, where a considerable amount of it has been found in deposits covering every period in the life of the

palace. The earliest of these was below the floor of the Vat Room, and is assignable it seems to Middle Minoan I B, c. 1900 or not much later.[120] Faience objects from it include inlays which appear to be of local manufacture, even if beads with them are Egyptian. An arm of faience evi-dently belonged to a small statuette, a fore-runner of the remarkable ones buried in the near-by Temple Repositories some four or five centuries later (see below).

A miniature vase of pale blue faience with gold foot and top was found in a Middle Minoan II B context in the Loom Weight Basement on the eastern side of the palace.[121] Fragmentary inlay plaques of faience from this area were assigned by Evans to the same period, although they came from a somewhat later deposit.[122] The most striking and the best preserved are in the shape of houses, two or three storeys high, apparently from a scene of an attack on a forti-fied town comparable with that on the Siege Rhyton from Mycenae [154, 155] (pp. 160–3). Other fragments show men's legs, heads in helmets, and bows. Water is represented, and there are men swimming like frogs as on the Mycenae Siege Rhyton. What may be part of a ship's prow has survived. These inlays probably came from more than one picture. Plaques with trees or bushes painted on them, and others with wild goats in relief, are suggestive of hunting scenes, and one scrap has the foot of an ox or bull in relief on it. The pictures may have decor-ated a wooden chest of some kind. Faience in-lays, some coated with gold foil, and plaques of rock-crystal found with the remains of a wooden box or chest which they had adorned in one of the cists below the floor of the Long Corridor of the Magazines of the palace were assigned by Evans to the same period as the objects from Temple Repositories.[123]

The Temple Repositories

These were a pair of stone-lined cists sunk in the floor of a room on the western edge of the Central Court of the palace at Knossos.[124] In them, apparently buried there after parts of the palace were damaged by fire in Middle Minoan

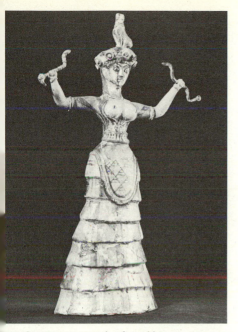

123. Statuette, apparently of a goddess, from the palace at Knossos. Middle Minoan IIIB, c. 1600. Faience. H 0.295 m. *Herakleion Museum*

IIIB *c.* 1550, was some of the furniture of a shrine, representing the most important collection of faience objects ever recovered from the Aegean. It includes the remains of three statuettes of women, who appear to be goddesses rather than priestesses:[125] the two best preserved at any rate wielded snakes, and wore striking head-gear, one a tall cylindrical crown with a snake winding round it, the other a flat tiara surmounted by a cat-like animal, apparently a leopard [123]. Originally some 0.30 m. or more high, the figurines were delicately modelled and elaborately coloured, a milky white being kept for the flesh and background, with details added in orange, shades of purple, purplish-brown, and black.

Other faience objects from the Temple Repositories, apart from beads and pendants, included flower-decked votive girdles and robes,[126] and exquisite relief plaques, some of goats [124], others of cows suckling their young.[127] There were also plaques in the form of saffron flowers, and a remarkable one in high

124. Plaque with a goat suckling her young from the palace at Knossos. Middle Minoan IIIB, c. 1600. Faience. L 0.195 m. *Herakleion Museum*

relief in the shape of a tree or plant of some imaginary and no doubt sacral kind.[128] Faience shells, notably argonauts executed in the round, together with plaques in low relief representing flying fish and sections of rockwork, had evidently formed part of a marine scene.[129] These marine objects and the other faience plaques must have been applied to backgrounds, perhaps to wooden cult furniture, or to chests and boxes. Some flat inlays may have come from a gaming board like the ivory draughtboard found on the other side of the palace (see p. 117).[130]

The Temple Repositories also contained a number of small faience vases,[131] including a bowl with shells in relief on the rim and another with handles in the shape of figure-of-eight shields. The most remarkable were tall cups with outward-curving rims and leafy sprays painted on their sides [125]; one had a plant in relief spreading over the top of the handle across the inside of the rim.

the back of the head were holes for attaching it to a body, which may have been carved out of wood or ivory.

Clay moulds might have been used in making faience objects in Crete as they sometimes were in Egypt;[133] some of the smaller ones from Gournia, it has been suggested, were for the manufacture of faience ornaments, although none were found to match them.[134]

The Mycenae Shaft Graves

Some of the burials in the shaft graves may date from about the time when the Temple Repositories were filled. The only faience vase discovered in circle B is a cup reminiscent of those with leafy sprays [125] from the Temple Repositories; it appears to be an import from Knossos.[135] Well over a dozen vases of faience however are attested from circle A: the remains of at least eight came from the women's grave

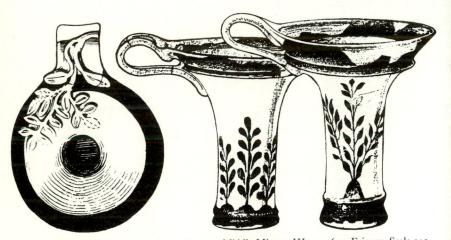

125. Vases from the Temple Repositories at Knossos. Middle Minoan IIIB, *c.* 1600. Faience. Scale 1:2. *Herakleion Museum*

A small bull's head of whitish faience was found in the deposit with the ivory bull-leapers in the residential quarter of the palace (see p. 119).[132] This was elaborately made with gold tubes for the insertion of the horns; the eyes of blue glass appear to have been set in shell. At

III,[136] and of four or more from grave I.[137] A faience jar from grave II is interesting because it appears to have been made on the fast wheel instead of by hand or in a mould.[138] The two large graves IV and V, the richest in weapons and in gold and silver, only produced one

faience vase: a little bowl from grave IV.[139] But in the same grave were found some fittings of faience belonging to a pair of libation vases (rhytons) made from ostrich eggs,[140] and flat inlays, some like ones from the Knossian Temple Repositories, others with rosettes, all of which may have come from a draughtboard.[141] The rosettes are comparable with faience ones on an ivory box-lid from Tylissos in Crete lost at the time of the disasters of *c.* 1450.[142] Six large sacral knots of faience, also from grave IV, may have been applied to the draughtboard, indicating the ritual character of the game played on it.[143] Moreover five elegant faience dolphins adorned the surface of an ostrich-egg rhyton from grave V,[144] which also yielded part of a figurine of a crouching beast of prey, a griffin perhaps, or a lion.[145]

The vases and other objects of faience from the Mycenae shaft graves may all be imports from Crete.[146] Where the shapes of the vases can be inferred, they appear to be in a Cretan rather than a mainland tradition: thus the libation vessel in the shape of a conch shell from grave III is matched by one from Mirtos,[147] and the curious double jug mouth from the same grave is also distinctively Cretan.[148] Beads and ornaments of faience tend to abound in areas where faience is made, and they were to become common on the mainland in later times; but there are comparatively few of them from the shaft graves,[149] and this in itself is a strong argument against the existence of a manufacture of faience in the region of Mycenae at the time.

In this context great interest attaches to the fragments of a small faience jug from grave III, the spout of which had in relief on each side the head of a warrior wearing a helmet with an elaborate horned crest.[150] Assuming that this jug was a Cretan import,[151] it opens the door to the possibility that the Siege Rhyton [154] and the other great silver jar with military scenes from grave IV were also made in Crete (see p. 60). But Mycenae was not the only place on the mainland which faience vases were reaching during this period: there seem to have been one or more for instance in tholos A at Kakovatos assignable to the early fifteenth century.[152]

From their shapes and the contexts in which they have been found it is clear that most if not all of the faience vases from the Knossos Temple Repositories and the Mycenae shaft graves were intended for ritual use. The same is true of those lost in Crete at the time of the mainland con-

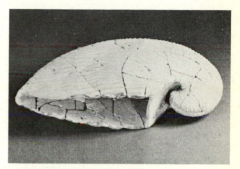

126. Vase in the shape of an argonaut shell from the palace at Zakro. Late Minoan I, before *c.* 1450. Faience. *Herakleion Museum*

127. Spouted jar from the Central Treasury at Knossos. Probably Late Minoan I, before *c.* 1450. Faience. Scale 1:4. *Herakleion Museum*

quest *c.* 1450, notable among them being vessels in the form of shells: an argonaut from the palace at Zakro [126],[153] and a conch from the mansion at Mirtos on the southern coast.[154] An elegant spouted jar of faience [127] accompanied the cache of stone ritual vases in the Central

Treasury of the palace at Knossos which may
have been buried at this time rather than later
(see pp. 143, 154).[155]

LATER BRONZE AGE (c. 1450 B.C. ONWARDS)

Faience beads and ornaments were common
both on the mainland and in Crete during the
period after c. 1450. Some were no doubt imports
from outside the Aegean area, but an attractive
little animal-shaped pendant from a tomb of c.
1400 at Katsamba, the harbour town of Knossos,
seems likely to be Cretan,[156] and faience reliefs
and relief beads of long-skirted women or god-
desses from the palace at Knossos and from
tombs at Mycenae and Dendra on the mainland
are defiantly Aegean in character.[157]

A faience industry appears to have been
established on the mainland by this time for the
manufacture of vases as well as of beads and
ornaments. A remarkable juglet embossed with
gold beads, the larger ones made by granulation,
from a tholos tomb at Ktimeni in Thessaly
seems to come from an Aegean workshop.[158]
Fragments of stemmed cups and of a libation
vessel, apparently formed in moulds, were re-
covered from the House of Shields at Mycenae
destroyed in the thirteenth century. The shapes
of these are Aegean, and the vases may have
been produced in the region of Mycenae.[159] But
faience vases of Aegean shapes were also created
in Cyprus if not further afield towards the end
of the Bronze Age.[160]

C. Glass

Beads of glass were being made in Mesopo-
tamia, it seems, by the end of the third millen-
nium under the Dynasty of Akkad, and they are
first attested in Egypt about the same time. In
Crete glass was already in use for seals and
ornaments during the period before the disasters
of c. 1450. Two flat glass beads with sacral ivy
in relief on one side from Mycenae shaft grave
III are evidently Cretan imports;[161] they, and a
few other beads from grave I which were im-

ported from the Near East,[162] appear to be the
only glass objects from the shaft graves. Some
of the glass from tholos A at Kakovatos in Mes-
senia, with burials assignable to the early fif-
teenth century, may also have come from Crete;
one remarkable pendant in the form of a bull
with patches for inlays in the hide looks very
Cretan.[163] But other glass objects from the tomb
are clearly imports from the Near East, like the
beads from Mycenae shaft grave I. In the four-
teenth century, however, ornaments and beads
of glass were evidently produced on a large
scale, along with ones of faience, both on the
mainland and in Crete, and a number of moulds
for making them have been recovered, mostly
from Knossos and Mycenae.[164]

The manufacture of vessels from glass seems
to have begun in northern Mesopotamia, the
Hurrian-Mitannian area, towards the end of the
sixteenth or early in the fifteenth century,[165] but
glass vases were already being made in Egypt in
the reign of Thoutmosis III (1504-1450),[166]
and the art of forming them may have been in-
troduced to the Aegean (directly from northern
Mesopotamia perhaps rather than from Egypt)
about the same time or not much later. Some
glass vessels from Bronze Age contexts in Crete
have been identified as Egyptian imports,[167] but
a large bowl found with burials of the fifteenth
century at Kakovatos in Messenia looks as if it
was an Aegean product.[168] It has scalloped
sides, and appears to have been cast in a mould,
unless it was shaped by grinding.[169] Other rela-
tively ambitious glass objects besides vases were
sometimes made by Aegean craftsmen during
the period after c. 1400. These include a small
dagger- or sword-hilt of the standard cruciform
type found at Mycenae.[170]

Some of the objects of faience and glass paste
recovered from tombs at Perati on the eastern
coast of Attica may have been manufactured in
the Aegean during the time the cemetery there
was in use, at the very end of the Bronze Age in
the twelfth century.[171] But the arts of making
faience and glass were eventually lost, it seems,
and were only later reintroduced to Greece from
Egypt or the Near East.

STONE VASES

Stone vases were being produced on a massive scale in Egypt from early in Predynastic times. By the Protodynastic period at the beginning of the third millennium some of those from Egyptian royal cemeteries were of a remarkable quality and made of hard materials such as rock-crystal and obsidian.[1] Nearer to the Aegean the people of Khirokitia in Cyprus already had large numbers of stone vessels as early as the sixth millennium (if the radiocarbon dates are to be trusted), at a time when the manufacture of pottery was only in a rudimentary stage of development there.[2] On the Greek mainland stone vases were in use from an early stage of the local Neolithic: a good many fragments, some with incised decoration, were found in Early Neolithic levels at Nea Makri on the eastern coast of Attica,[3] while in the region of Lake Nessonis in Thessaly vases were apparently being manufactured from local white and green marbles by the Proto-Sesklo phase of the Early Neolithic, and exported to other sites in the area.[4] A fragment of a white marble bowl from the Late Neolithic settlement at Olynthos on the coast of Macedonia has a lug in the shape of an animal's head set just below the rim,[5] but a stone bowl with a similar lug from Tiryns is assigned to Early Helladic.[6] In general, however, the manufacture of stone vases seems to have been virtually discontinued on the mainland at the beginning of the Bronze Age. Three small marble bowls, which may have been used for crushing face paint, were recovered from the cemetery of the Early Helladic settlement at Ayios Kosmas on the southern coast of Attica; but they are exactly like Cycladic ones and could be imports.[7] Most of the other stone vases, few in number as they are, from Early and Middle Helladic contexts on the mainland appear to have been imported from the islands or from Crete.[8]

Stone vases were already in use in the Cyclades during the Neolithic. Only two fragments of marble bowls were recovered from the Neo-

A B

128. (A) Jar from Paros. Probably Early Cycladic I, *c.* 2500 or earlier. White marble. Scale 1:5. *Athens, National Museum* (B) Cup from Mycenae shaft grave IV. Probably Cretan work of Middle Minoan III–Late Minoan I, *c.* 1600–1500. White marble-like stone. Scale 1:5. *Athens, National Museum*

lithic settlement on Saliagos off Antiparos, but the stone of one at least might be local.[9] An elegant conical jar of white marble, forerunner of a shape standard in the Early Bronze Age of the islands, was found in a tomb of the Late Neolithic settlement at Kefala on Kea.[10] During the Early Bronze Age the manufacture of stone vases appears to have flourished in several of the islands, reflecting, it has been suggested, the development of a demand for enduring vessels to place with burials.[11] Most are of white marble, which is in good supply in nearly all the islands.[12] The shapes are relatively few: bowls, tall conical jars, and pedestal jars like that of illustration 128A, all of which may have lugs, solid or with string-holes. Vases of these types were also made in clay. Some of the marble vases are elegant in shape and finish, although virtually

all have plain undecorated surfaces; but there are a couple of large open dishes (one from Keros 0.38 m. across) with a row of birds across the centre,[13] and a unique jar supposedly from Naxos is in the shape of a woman with arms and legs in relief and hands to breasts, reminiscent of an early class of anthropomorphic clay vases found in Crete.[14] Two unusual marble vases from Naxos appear to be imitations at long remove of a type of vessel originally developed in Mesopotamia for drinking beer![15]

A softer stone, serpentine, easier to carve, was used for an exceptional group of small jars which were probably made to hold cosmetics.[16] One has simple incised decoration, but three others are covered with spirals in relief. The most elaborate, in the shape of a building, evidently a granary complex, with seven round

129. Cosmetic jar in the shape of a granary complex, apparently from Phylakopi. Early Cycladic I-II, c. 2500. Serpentine. H 0.10 m. *Munich, Museum of Antiquities*

silos [129],[17] is unique. It appears to have been looted from one of the tombs at Phylakopi in Melos at the time of Napoleon's expedition to Egypt. The lid, which it must once have had like the other vases of the group, is now missing. The entrance to the courtyard round which the silos are grouped has a gabled roof with hatched incised triangles which also appear as decoration on contemporary clay cosmetic jars in the islands, as do connecting spirals: but on clay vases spirals are incised or stamped, not executed in relief.[18] A double jar lid from Naxos belonging to this group has elaborate linear decoration in relief not unlike that on some early Cretan seals.[19]

Towards the end of the Early Bronze Age the manufacture of stone vases seems to have declined in the Cyclades. No fragments were recovered from the fortified settlement on Kastri near Chalandriani in Syros, although they occurred in graves of the earlier cemetery across the gorge to the south. There is one fragmentary marble jar of Early Cycladic type from Phylakopi in Melos,[20] but serpentine vases from levels of Phylakopi III all appear to be imports from Crete.[21] Stone vases were made at Ayia Irini on Kea during the Middle Bronze Age to judge from the recovery of bore cores there,[22] but this industry may reflect the presence of Cretan settlers.

In Crete, unlike the Cyclades and the mainland of Greece, there is no evidence for the use of stone vases until the end of the Neolithic, when some, imported perhaps from Egypt, began to reach Knossos; but they do not appear to have been made in Crete before Early Minoan II in the first part of the third millennium. Several of the earliest [130, 131] are decorated with hatched incised triangles and spirals in relief like the serpentine cosmetic jars from the Cyclades, but they tend to be distinctively Cretan in shape, and the material of most of them is the native chlorite or chlorite schist.[23] The most characteristic types are spouted bowls and circular cosmetic jars. Some of the jars, unlike Cycladic ones, were joined from two separate pieces; a fine example is the elaborately decorated little jar complete with lid from

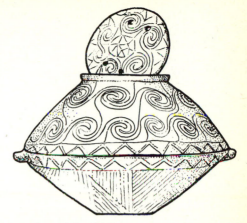

130. Cosmetic jar with lid from Maroneia. Early Minoan II, c. 2500. Chlorite. *Herakleion Museum*

Maroneia in eastern Crete [130]. A few cosmetic jars of cylindrical shape as found in the Cyclades had lids with a handle in the form of a recumbent dog,[24] 'the sprawling, restless street-dog of a Cretan village' [131].[25] The idea of animal-

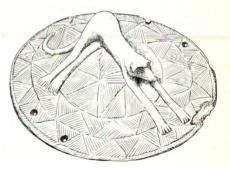

131. Lid with dog handle from Mochlos. Early Minoan II, c. 2500. Chlorite. Scale 1:2. *Herakleion Museum*

handled lids might have reached Crete from the east, but a stone bowl from Byblos with a bull on the lid appears to be considerably later in date.[26]

The vases of this 'Cycladic' group are assignable to Early Minoan II and perhaps to an early phase of it. So far they have only been found in

the southern and eastern parts of Crete, which may indicate that a native manufacture was first established there. But since no vases of this group have yet been recovered from the centre of the island round Knossos, it is always possible that a different tradition flourished in that region, stemming perhaps from Egypt, which was after all the greatest centre of the industry in early times. The base of a stone vase, apparently imported from Egypt, was indeed found in the latest horizon of the Neolithic settlement at Knossos,[27] and several other examples of Predynastic or Protodynastic date have been recovered in Crete [142]. A number of these may have arrived in later times as 'antiques',[28] but some at any rate appear to have been imported soon after they were made and before a native manufacture was established.[29] Some early Cretan stone vase types are copies of Egyptian ones, while many others, although not direct copies, look as if they owed something to Egypt. Importing of contemporary Egyptian stone vases continued throughout the flourishing period of the Cretan civilization and after the mainland conquest c. 1450; no less than ten made in the Eighteenth Dynasty were recovered from the Isopata royal tomb at Knossos.[30]

Vast masses of stone vases have come from early communal tombs in the Mesara region of southern Crete, and a number of exceedingly fine ones from early tombs at Mochlos on the northern coast, but their manufacture and use appears to have been confined to certain parts of the island. The three of which fragments were found in the Early Minoan II settlement at Mirtos were probably imports,[31] and comparatively few appear to have been recovered from the great Early Minoan cemetery at Ayia Fotia in eastern Crete.[32] Most of those from the Mesara tombs are small, and they may have been manufactured especially as offerings for the dead.[33] But by Middle Minoan times vases made in a variety of stones were evidently in general use in palaces and houses throughout the eastern and central parts of Crete, although very few have been recovered in the west. Most of these were open bowls of one kind or another. The commonest type is like a bird's nest with

a high shoulder [132A]; a variety of it, rather tall, and with petals in relief, known as a Blossom bowl [132B], was very fashionable during the period of the later palaces. Both shapes seem to have been inspired by Egyptian models.

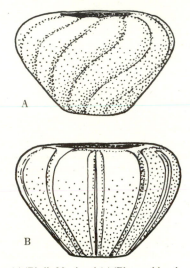

132. (A) 'Bird's Nest' and (B) 'Blossom' bowls from Crete. Stone

Some very large vases including storage jars (pithoi) were carved from stone in Crete during the period of the later palaces in the sixteenth and fifteenth centuries. Fragments of two large pithoi found in the tholos Tomb of Clytemnestra at Mycenae on the mainland[34] were of serpentine, as were most of the larger Cretan stone vases, and they appear to have been imported from Crete. A good many Cretan stone vases of all sizes were reaching the mainland from the time of the Mycenae shaft graves in the sixteenth century onwards. Most have been found in the Argolid, especially at Mycenae itself, and they include some of the finest of all known Cretan stone vessels, like the remarkable three-handled cup from shaft grave IV [128B].[35] This is made of white marble-like stone. The three curling handles were carved separately and held in place by wire. The cup has a small hole

in the base, and belongs to a class of libation vases of which many clay examples of Late Minoan I (*c.* 1550–1450) have been found in Crete.

Most of the more striking and elaborate Cretan stone vases of this period are libation or ritual vessels: notable deposits of stone cult vessels have been found in the palace at Zakro,[36] destroyed at the time of the mainland conquest in Late Minoan I B *c.* 1450, and in the Central Treasury in the western wing of the palace at Knossos.[37] The Central Treasury deposit may be later in date, but it has been suggested that none of the vases from it need belong to a period after the end of Late Minoan I B.[38] An alabaster triton shell vase, however, from the Tombe dei Nobili at Kalyvia near Phaistos assignable to the fourteenth century closely resembles one from the Treasury [135C],[39] although it is just possible that this was plundered from Knossos or elsewhere in Crete at the time of the destructions there *c.* 1450.

While the surfaces were mostly left plain, many Cretan stone vases in all periods were decorated, normally by incision. Abstract ornamental patterns were the rule, but there are two lively doves with ringed necks on each of the longer sides of a bowl for offerings from the early palace at Phaistos assignable to the eighteenth century or earlier [133A];[40] the shorter sides were adorned with rectangular inlays, now

missing. This Oriental technique of inlay decoration was more common in the time of the early palaces before *c.* 1600, but continued later.[41] The inlays usually consisted of pieces of shell or white stone set against a darker background, as on the spouted jars with white spots found at Knossos and apparently dating from Middle Minoan III A in the seventeenth century [133B].[42] The sides of ewers of breccia and limestone found with some of these spouted jars in the Northwest Lustral Area of the palace were covered with a skilful imitation of plaitwork in relief.[43] Fluting and ribbing – vertical, horizontal, or upon occasion spiralling – became increasingly fashionable during the period of the later palaces from *c.* 1700 onwards.

The common Blossom bowl [132B] is virtually a vase in the shape of an open flower. Isolated theriomorphic stone vases are shaped like an Egyptian scarab beetle, a seated monkey,[44] and a sphinx.[45] The sphinx, from a tomb in the cemetery at Ayia Triadha, is made of serpentine, and had inlaid eyes and white inlays, now for the most part missing, in the square hollows on the neck and tail and down the back. It is solid, except for a bowl-like cavity in the top of the back, which may have been meant for offerings of some kind, or for incense,[46] unless, as Evans thought, it held a separate stone inkwell on the analogy of animal-shaped ink-stands

133. (A) Vase from the earlier palace at Phaistos. Probably Middle Minoan II, *c.* 1800. Black serpentine. Scale 1:2. *Herakleion Museum* (B) Jar from the palace at Knossos. Middle Minoan IIIA, *c.* 1700–1600. Brown limestone with white inlays. Scale 1:2. *Herakleion Museum*

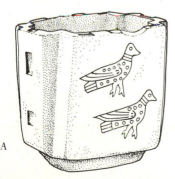

A

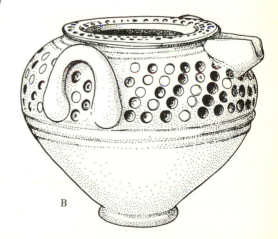

B

from Mesopotamia. The idea of the sphinx, with lion's body and woman's head, reached Crete from the East, and this object has been taken to be an import from Anatolia or Syria,[47] but the material and the system of inlays seem Cretan.

Although another unique vase, the crystal duck bowl found in grave Omikron of Mycenae shaft grave circle B [134],[48] has been widely re-

134. Bowl with open spout and handle in the form of a duck's head from shaft grave circle B at Mycenae. Probably Middle Minoan III, after *c.* 1700. Rock-crystal. L 0.132 m. *Athens, National Museum*

garded as an import from Egypt or elsewhere, there seems no reason why it should not be Cretan work.[49] Rock-crystal was being used for the manufacture of vases in Crete by this time (see p. 148). Moreover the basic shape, an oval bowl with open spout at one end and handle at the other, is a Cretan one, adopted for many of the earliest stone vases made in Crete; while birds were sometimes represented there with backward-turning heads like that of the crystal duck: the doves on pillars of a clay model shrine from Knossos assignable to the eighteenth century are an instance.[50]

Several Cretan stone vases of the period from *c.* 1700 onwards were in the shape of triton or dolium shells [135C],[51] and these appear to have been meant for ritual use, like contemporary faience shell vases (see p. 135). Libation vessels (rhyta) were now sometimes made to resemble the heads of animals; lions, lionesses, and bulls. The most remarkable is the serpentine bull's

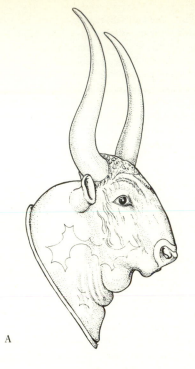

A

B

C

135. (A) and (B) Libation vessels shaped like the heads of a bull and a lioness and (C) triton shell vase from Knossos. Late Minoan I, before *c.* 1450. Serpentine, limestone, and Egyptian alabaster. Scale 1:6. *Herakleion Museum*

head rhyton [135A] from the Little Palace at Knossos,[52] which is closely paralleled by another, of chlorite and somewhat smaller, from the palace at Zakro destroyed at the time of the mainland conquest c. 1450.[53] The Knossos bull's head rhyton may have been damaged and lost then or somewhat later. The ears and the plate at the back of the neck were made separately from the head. The horns have been restored; the originals were probably of gilded wood. The liquid for the libation was inserted through a small hole in the top of the neck, and escaped through an outlet in the mouth. The woolly tufts on top of the head are carved in relief, but the rest of the detail was incised. The surrounds of the nostrils were inlaid with shell, either Tridacna imported from the Red Sea, or Spondylus from the Aegean itself (see p. 116). The eyes were bordered with inlays of red jasper. The right eye, which alone survives, consisted of a crystal lens, of which the back was slightly hollow, and had the pupil and the iris painted on it in red and black, the cornea being rendered in white. The lens served to magnify the pupil, making the eye extraordinarily lifelike. The lioness head rhyton [135B] from the Central Treasury at Knossos appears to have had similar crystal eyes. It is made of creamy white translucent limestone, almost like marble. There were inlays of red jasper round the eyes and on the nose.[54] Like the bull's head rhytons this magnificent vase may date from before c. 1450.

A number of fine vases of the later palace period from c. 1700 onwards are decorated in relief. These relief vases were made of soft, easily cut stones like chlorite or serpentine. The decoration might consist of formal patterns like the continuous leafy sprays (foliate bands) on a bowl from the town of Mochlos destroyed c. 1450,[55] but some were carved with scenes, including pictures of animals and men. Most of the picture-vases are libation vessels (rhyta), and the few that are not may have been intended for ritual use. A small number of fragmentary stone libation vases have versions of the Marine Style, as found on the finest of the pottery produced at Knossos during Late Minoan I B (c.

1500–1450) (see pp. 37–8), but the exceptional quality of the style and execution of the pictures on some of these, like the dolphins on a fragment of a chlorite rhyton from Zakro,[56] or the lurking octopus on another rhyton fragment

136. Octopus on a vase fragment from the Throne Room at Knossos. Late Minoan I, before c. 1450. Chlorite. Scale 2:3. *Herakleion Museum*

from the Throne Room at Knossos [136],[57] suggests that the Marine Style was already employed by the makers of stone relief vases, as it was by fresco painters, some time before it was transferred to clay vases in Late Minoan I B (see pp. 63–4).[58]

The vase from which the lurking octopus of illustration 136 came was probably as fine as any surviving work of the Cretan stone carver, but great interest attaches to the relief vases with scenes of contemporary life, involving shrines, religious rites, and perhaps hunting and warfare. The most outstanding are three from the palace at Ayia Triadha destroyed in Late Minoan I B c. 1450: the Chieftain Cup, the Harvester Vase, and the Boxer Vase [137–9]. The first two at any rate appear to be the work of the same artist, and all may have been made at Knossos.[59]

On the serpentine Chieftain Cup [137] a tall figure with long flowing side-locks, evidently a

137. The Chieftain Cup from the palace at Ayia Triadha. Middle Minoan III–Late Minoan I, *c.* 1650–1500. Serpentine. H 0.115 m. *Herakleion Museum*

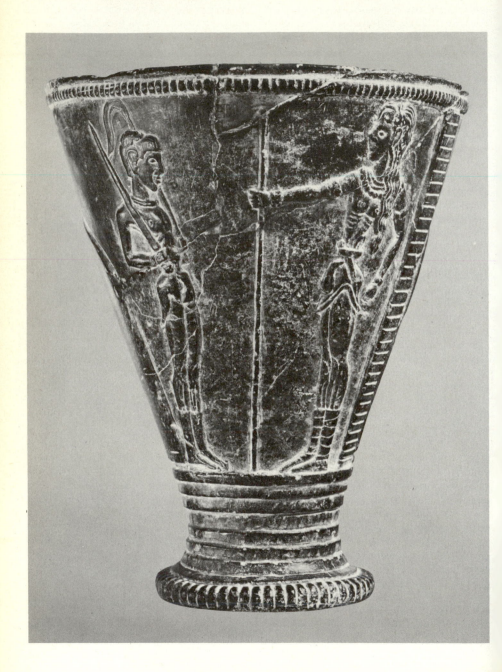

prince or god, stands in front of a hatched pillar (on the right) which may be meant to represent a palace or a shrine.[60] He is slender and thin-waisted in the ideal Cretan manner, and naked except for a stiff kilt or loincloth and what appear to be puttees wound round his legs. In his hair and round his neck are strings of beads. His wrists and arms are encircled with bracelets. He stands in a position of command, holding a spear or staff. Before him to the left with head deferentially inclined stands another figure, similarly but more simply attired, wearing short boots and holding a sword and what may be a ritual sprinkler in his left hand. Three men in a row out of sight behind him appear to be supporting large hides, possibly those of sacrificed bulls which had afterwards been dedicated for

the manufacture of the great body-shields in use at the time.[61]

The Harvester Vase [138] of black serpentine or steatite is the top half (the lower half made in a separate piece was never found) of an ostrich-egg-shaped rhyton.[62] Around it is carved a processional dance of twenty-six men led by a long-haired priest in a scaly ritual cloak. Midway in the procession (out of sight on illustration 138) comes a group of four bare-headed singers, one of whom is waving a rattle. The singers are dressed somewhat differently from the rank and file, who wear short stiff kilts, like those of the 'king' and 'officer' on the Chieftain Vase, and flat roll-brimmed caps. The vivid scene, with its impression of vital, rhythmic movement, has been variously interpreted as a triumph of

138 (*below*). The Harvester Vase, upper part of a libation vessel in the shape of an ostrich egg, from the palace at Ayia Triadha. Middle Minoan III–Late Minoan I, *c.* 1650–1500. Serpentine. H preserved 0.096 m. *Herakleion Museum*

139 (*right*). The Boxer Rhyton, fragmentary conical libation vase from the palace at Ayia Triadha. Middle Minoan III–Late Minoan I, *c.* 1650–1500. Serpentine. H without handle 0.465 m. *Herakleion Museum*

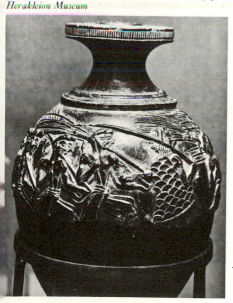

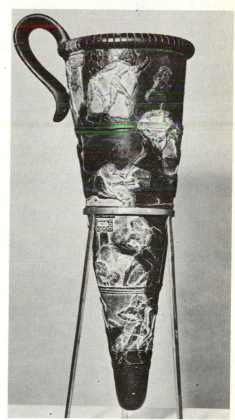

warriors, a sowing festival, or a harvest home. The curious three-pronged poles which the rank and file support on their shoulders and the bag-like objects that swing about their knees are the crux of the problem. Are they carrying combined willow shoots and hoes, with bags of seed-corn slung from their belts, indicating a sowing festival? Or winnowing forks tied to sickles, and whetstones to sharpen the latter, if the scene is a harvest home? A man with head turned back towards the end of the procession seems to be addressing himself to his companion whose head appears at his waist level; a drunk, or perhaps, on the analogy of sowing festivals elsewhere, someone detailed to dance his way through the procession hurling abuse at his comrades.

The third of the great relief vases from Ayia Triadha was a conical rhyton of serpentine [139].[63] Large parts of it are missing, but it evidently had four rows of scenes with men wrestling and boxing and leaping over bulls. The men wear short stiff kilts and puttees on their legs like the 'king' on the Chieftain Cup. The boxers seem to be using knuckledusters, and some have bronze helmets with cheek-pieces. These savage sports were almost certainly religious or magical in character. Pillars with box-like projections in the background may be the bases of 'flag-poles' of the kind flanking the shrine on the rhyton from Zakro described below. No doubt they are meant to indicate the presence of a shrine, like the isolated columns on later Greek vases.[64]

The Zakro rhyton [140] is pear-shaped, made of soft chlorite, and carved with a scene in low relief of a 'peak sanctuary' on a mountain to judge from the rocky landscape indicated round it.[65] At the top is the shrine, of squared stone, with a high central doorway adorned with spirals. An amorphous object above the doorway may be intended for a baetyl or aniconic image of the divinity, like the curiously shaped natural stones which the Cretans sometimes employed as cult statues. This is flanked by four wild goats which take their ease on the roof while another bounds over the rocks below. A pair of birds hover round the shrine, of which

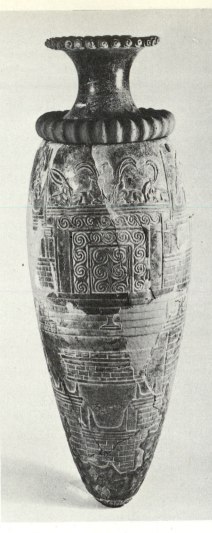

140. Pear-shaped libation vase from the palace at Zakro, with reliefs of a peak sanctuary. Middle Minoan III–Late Minoan I, *c.* 1650–1500. Chlorite. H without neck 0.311 m. *Herakleion Museum*

the parts each side of the doorway are surmounted by horns of consecration and topped by what may be flagpoles on the analogy of those which flank the pylons of Egyptian temples,[66] unless they were masts intended to attract lightning in connection with the cult.[67] Below, leading down to a forecourt enclosed by walls of squared masonry crowned with horns of consecration, are steps bearing two altars, a small one of the waisted type in front of the central doorway of the shrine, and a stepped one overhung by a tree to one side of it. A third altar in the forecourt is larger and appropriate for burnt sacrifices. Here and there on the surface are scraps of gold leaf, with which the whole or parts of the vase were evidently once covered. Other stone relief vases were no doubt similarly gilded, although it is difficult to believe that the polished black surface of the Harvester Vase [138] was meant to be concealed in this manner.[68] No human figures appear on the Zakro rhyton, but three fragments of stone rhytons from Knossos with reliefs of sanctuaries show men bearing offerings or otherwise engaged in religious ceremonial.

Some stone ritual vases were evidently adorned with scenes of warfare or hunting: the wild boar on a rhyton fragment from Palaikastro (which at the time it was found had a bit of gold leaf still adhering to it) might have formed part of a hunting scene,[69] and on the scrap of a serpentine rhyton from Knossos a bearded archer is drawing a bow.[70]

Several fragments of stone relief vases, all probably imports from Crete, have been recovered on the mainland. One from the acropolis at Athens has a bull-leaping scene, and a scrap of a rhyton from Tiryns shows part of a building, doubtless a shrine.[71] A fragment from Epidauros is of exceptional interest for the reliefs preserved on it, consisting of a dolphin above what may be part of a warship, and at the top the feet of a group of soldiers ready on shore to repel invaders.[72] The vase may have been carved with scenes comparable with those on the silver Siege Rhyton (pp. 160–3).

All the stone vases from the Mycenae shaft graves like that of illustration 128B appear to be imports (see p. 23). There is indeed no evidence for the manufacture of stone vases on the mainland until the thirteenth century, when those being produced at Mycenae itself were of Cretan types, made according to Cretan techniques and perhaps by Cretan craftsmen in the first instance.[73] The fashion does not appear to have struck deep roots on the mainland, and stone vases are uncommon in Late Bronze Age tombs there. Fragments of some half dozen fine ones were recovered from the ruins of the palace at Pylos destroyed c. 1200,[74] but some of these at any rate may have been foreign and relatively antique at the time they were lost.

Materials

The earliest Cretan stone vases seem to have been made of soft stones, notably varieties of schist or chlorite schist, serpentine, and steatite, all of them intrusive rocks that merge into one another and outcrop in various parts of eastern and central Crete.[75] These were to remain favourite materials, especially serpentine, of which forty-seven per cent of all Cretan vases are made; the major source for the commonest variety is at Lepria near Gonies some 25 km. west of Knossos.

It became easier to attack harder stones with the introduction of the drill for hollowing interiors. A variety of attractively mottled and veined stones exploited by the Bronze Age vase makers – including veined limestones and marbles of different kinds, multi-coloured breccias, wavy-banded tufas, and gabbro – were native to Crete, and others were imported. A distinctive obsidian, speckled with flecks of white pumice like Liparite, was being brought from Yiali (Glass Island) near Carpathos by the time of the early palaces before c. 1700:[76] a footed goblet of this material is among the sacred treasures from the palace at Zakro destroyed c. 1450. A plain black obsidian used for three fine vases of the later palace period may come from the Çiftlik area of Cappadocia.[77] Other foreign stones employed at this time included green speckled lapis lacedaemonius (Spartan basalt) and red antico rosso, both from

deposits in the southern tip of the Peloponnese; there was a storeroom with a large supply of lumps of the former below a vase maker's workshop in the east wing of the palace at Knossos at the time of its final destruction in the fourteenth century.

The hardest stone attacked by Cretan vase makers was rock-crystal, of which vessels were being made in Egypt by the time of the Old Kingdom in the third millennium; a crystal drill-core from the Vat Room deposit in the palace at Knossos assignable to Middle Minoan I B[78] suggests that by the beginning of the second the Cretans themselves were already working in this material. A few small and mostly fragmentary crystal vases are assignable to the later palace period from c. 1700 to 1450. A remarkable rhyton from Zakro [141], with the body

141. Pear-shaped libation vase from the palace at Zakro. Late Minoan I, before c. 1450. Rock-crystal. *Herakleion Museum*

carved from a block of crystal, has a separate neck held in place by a collar made of segments of crystal alternating with thin sections of ivory covered with gold.[79] The handle is composed of crystal beads threaded on bronze wire. Rock crystal occurs in Crete, but large pieces like that out of which the Zakro rhyton was made may have been imported.[80]

A softer imported stone, much used during the period of the later palaces, was Egyptian alabaster (calcite). Some forty Cretan vases are known to have been made of it, and many Egyptian vases of this material also found their way to Crete. Indeed the Cretan vase makers sometimes took Egyptian vases and adapted them. One of the most elaborate and successful conversions, from shaft grave V at Mycenae,[81] was an Egyptian alabaster jar of the alabastron shape which the craftsman, almost certainly a Cretan, had turned upside down, altering the mouth into a pedestal base, and removing the original base to leave a wide mouth which was enhanced by a moulded rim of gilded bronze. Wooden handles coated with gold leaf and a spout (now missing) were added to transform the vase into a jar of standard Cretan type. Two 'antique' Egyptian bowls, dating from the Protodynastic period (early third millennium) and found in the deposit of stone ritual vessels in the palace at Zakro, had been the victims of similar adaptations.[82] The more attractive is a fluted bowl of porphyritic rock with white crystals in a brown matrix. Most of the original rim was removed by the Minoan craftsman and used to make a ring base. The stump of the rim was then carved with ribs to convert it into a rim of Cretan type, while holes were bored through the solid lugs for the insertion of wire loop-handles. The other vase [142], of similar stone, was deprived of its Egyptian lug-handles, and transformed into a standard Cretan type by the addition of new handles (now missing) and a spout with holes for inlays to match the white crystal of the original bowl.

It was only it seems in the period after the mainland conquest c. 1450 that the makers of stone vases began to exploit the veined white gypsum which outcrops at Knossos and in many

other places in Crete.[83] The material may have come into favour, not merely because it was soft and easy to work, but also as a cheap substitute for Egyptian alabaster which it somewhat resembles. It was used for making vases in the palace at Knossos, where the debris of a vase maker's workshop consisting entirely of gypsum was apparently found in the cists of the Thirteenth Magazine.[84] The workshop was no doubt situated on an upper floor, and the debris may have been swept into the cists when they were closed after damage to this part of the palace by fire early in Late Minoan III c. 1400 (see p. 68): Perhaps the decision was taken then to transfer the manufacture of stone vases to the eastern wing of the palace, where at the time of the final disaster in the fourteenth century a stone vase maker's workshop was situated above the store

of lapis lacedaemonius mentioned on p. 148.

The large squat ointment jars (alabastra) which were standing on the floor of the Throne Room in the palace at that time were carved from gypsum. Similar alabastra, along with other gypsum vases, have been found on the mainland.[85] Vases of gypsum recovered from Cretan tombs which appear to date from a period after the final destruction of the palace at Knossos might perhaps suggest that they were still being made into that age of impoverishment and decline.[86] But it looks as if by the fourteenth century the stone vase industry had dwindled into being a palace art in Crete. Possibly the destroyers of the palace at Knossos removed the craftsmen to the mainland, where at Mycenae a manufacture of fine stone vases is attested in the thirteenth century (see p. 147).

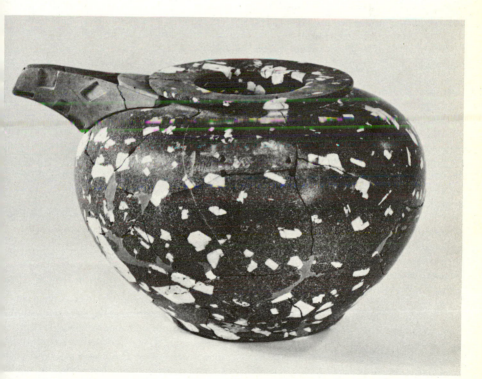

42. Egyptian stone bowl of the Protodynastic period (early third millennium) transformed into a spouted ar of Cretan type in Middle Minoan III–Late Minoan I, c. 1650–1500. From the palace at Zakro. orphyritic rock with white crystals. H 0.173 m. *Herakleion Museum*

Methods of Manufacture[87]

In Neolithic times vases of soft stone were no doubt laboriously carved with the aid of tools of flint or obsidian, but the vases of the Early Bronze Age in the Cyclades, and the Cretan ones inspired by them, were shaped with flat-edged chisels of which the marks can often be detected on their inner surfaces. At an early stage, however, Cretan artificers began to use the hollow drill to excavate the interiors, as was usual in Egypt by the Early Dynastic period;[88] but while they may have adopted this device from Egypt, they did not necessarily copy Egyptian practice in every respect. In Egypt, for instance, it appears to have been the custom to finish the outside of the vase before tackling the inside; while in Crete, the inside was normally, it seems, hollowed out by chiselling or drilling after the outside had been roughed into shape but before it had been finished.

Usually a tough reed was employed as a hollow drill, and this twirled an abrasive, either sand locally obtained or emery imported from Naxos or elsewhere in the Cyclades, which in fact did the cutting of the stone.[89] The cylindrical cores left standing by the drill were afterwards prised or knocked away. Many drillings would be required to excavate the interior of a large vase; the process is well illustrated by the workshop debris of a craftsman who died at his post making obsidian vases when Atchana in Syria was destroyed c. 1650.[90] But some Cretan vases, notably the common Bird's nest bowls like that of illustration 132A, were hollowed out in a single drilling, often 0.10 m. or more in diameter, too large to have been made by a reed, and reflecting the use of some other type of drill which was not it seems hollow, since the largest surviving bore cores, inevitable products of the hollow drill, are normally not much more than 0.03 m. in diameter, although one with a diameter of 0.043 m. is attested.

At first drills may have been turned by hand as in Egypt, where pictures of Old Kingdom date show them with stone weights tied to them and crank handles being used to excavate the insides of stone vases. But eventually no doubt the bow-drill was adopted by the Cretans, as it appears to have been by the Egyptians. In some cases the drill may have been fixed, while the vase was rotated, turned perhaps on a fast wheel of the kind employed by Cretan potters from c. 2000 or earlier (see p. 33).[91] The visible surfaces of the vase were eventually rubbed smooth by grinding with a stone helped by an abrasive in the form of sand or emery. In the final stage the outside may have been polished with olive oil.[92]

Most Cretan stone vases were bowls, and the hollowing of their insides presented no great technical problem. But some of the finest and most elaborate were closed vases of various shapes including jugs and jars. One obvious way of making vases with narrow mouths, regularly adopted in Egypt, was to carve them in two separate pieces which were afterwards joined together, and this system was followed in the case of the early Cretan cosmetic jars like that of illustration 130 inspired by those of the Cyclades (see p. 139). Elaborate closed vases from the period of the later palaces (c. 1700-1450) were not only made in two halves but might have separate mouths, spouts, and handles added to them [138, 141].

By the beginning of the fourteenth century if not earlier the compass was being used in Crete to lay out spiral designs on stone vases. Traces have been identified on vases that were involved in the final destruction of the palace at Knossos: on a huge jar of banded tufa standing unfinished in the workshop above the store of lapis lacedaemonius, and on the squat gypsum alabastra from the Throne Room.[93]

Lamps

Stone was used as well as clay for making lamps in Crete from the time of the early palaces at the end of the third millennium.[94] During the later palace period from c. 1700 onwards stone lamps were in general use at Knossos and other main Cretan centres. Many had elaborate carved decoration. Notable are the lamps on pedestals some of them in the form of columns. One [143] from the South East House at Knossos was

adorned with spiral flutes which flanked bands of stylized ivy leaves.[95] Like some other Cretan lamps this was made of antico rosso imported from the southern Peloponnese, but the material usually selected for lamps was dark serpentine, although limestone was also used. Lamps of white limestone were occasionally it seems decorated with paint.[96] Like stone vases, lamps of stone were exported from Crete, and have been found at Troy and at Atchana in Syria, as well as on the Greek mainland. Whether stone lamps were actually made on the mainland seems doubtful, although fragments of several were recovered from the palace at Pylos.[97]

143. 'Sacral ivy' on a pedestal lamp from Knossos. Late Minoan I, before *c.* 1450. Antico rosso. Scale 1:6. *Herakleion Museum*

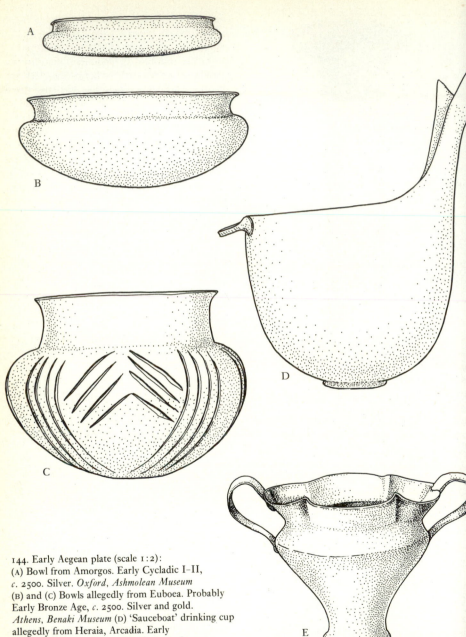

144. Early Aegean plate (scale 1:2):
(A) Bowl from Amorgos. Early Cycladic I–II,
c. 2500. Silver. *Oxford, Ashmolean Museum*
(B) and (C) Bowls allegedly from Euboea. Probably
Early Bronze Age, c. 2500. Silver and gold.
Athens, Benaki Museum (D) 'Sauceboat' drinking cup
allegedly from Heraia, Arcadia. Early
Helladic II, c. 2500–2100. Gold. *Paris, Louvre*
(E) Two-handled cup with scalloped rim
from Gournia. Middle Minoan IB–IIA, c. 2000–
1800. Silver. *Herakleion Museum*

METAL VASES

Vases beaten from sheets of copper were in use in Egypt by the time of the First Dynasty,[1] and the burnished red and grey wares of the Predynastic Uruk period in Mesopotamia, with their sharply angled profiles, look as if they might have been deliberate copies of contemporary copper and silver vessels of which several have been recovered.[2]

EARLY AND MIDDLE BRONZE AGE (UNTIL c. 1450 B.C.)

Metal vases imported from the Near East may have influenced the shapes of pottery in Thessaly from the beginning of the Late Neolithic (Dhimini 1 or Tsangli phase) if not earlier (see pp. 20, 30). A silver bowl from Amorgos in the Cyclades [144A] is not unlike some Thessalian clay bowls of the Dhimini 2 (Arapi) phase in shape: it is assigned to the beginning of the Cycladic Early Bronze Age, which may overlap with Thessalian Late Neolithic (see p. 20).[3] A similar bowl in New York is decorated with incised hatched triangles like some of the earliest stone vases from Crete and the islands (see p. 139).[4] Another is said to have been found in Euboea, along with other vessels of gold and silver [144B] now in the Benaki Museum in Athens.[5] They include two primitive-looking gold vases [144C] that are more Trojan than Aegean in character.[6] Gold 'sauceboats', however, like that of illustration 144D, show that the people of the mainland were making vases of precious metal during the local Early Bronze Age.[7] These oval spouted bowls seem to have been drinking cups (see p. 33). Illustration 144D, in the Louvre in Paris since 1887, and said to have been found near Heraia in Arcadia, is beaten out of a single sheet of gold, except for the handle.

Some of the high-footed bowls of dark burnished ware which became fashionable at the end of the Neolithic in Crete have a cordon round the waist suggestive of a type of Protodynastic Egyptian copper vase.[8] A class of fine grey pottery with incised or channelled decoration which appears to be characteristic of the early part of Early Minoan II about the middle of the third millennium may be inspired by contemporary silver vessels. Two silver vases assignable to the Early Minoan II period have been recovered from tomb VI at Mochlos: a miniature bowl, and a handled cup of some kind which was found packed full with gold jewellery.[9] A fluted silver bowl from a tomb at Dokathismata on Amorgos is often assigned to Early Cycladic II, but may date from the beginning of the second millennium (pp. 192, 197).

Much of the fine decorated pottery of Crete was being made in imitation of metal ware by the beginning of Middle Minoan times before c. 2000, copying not only the shapes, but details such as the profiles of rims and the rivets by which handles were attached. Before the end of Middle Minoan IB early in the second millennium the fluted and impressed decoration of metal ware was being simulated in paint or by moulding the surfaces of vases like that of illustration 2C, and there were even attempts to reproduce in clay the thin fabric of metal. This fashion reached its apogee in the fine 'eggshell' cups [9] of the succeeding Middle Minoan II period from c. 1900 onwards.

A study of this pottery might reveal much about the kind of metal vases in use in Crete at the time. These must have existed in a wide variety of shapes, although the fact that it was thought worthwhile to expend time and skill on making the exquisite but fragile 'eggshell ware' imitations like illustration 9 suggests that vases of gold and silver at any rate were somewhat scarce and relatively more valuable than they became later. But the silver cups, a hundred and fifty three of them with one of gold, found at

145. (A) and (B) Two-handled cup and bowl from Tôd, Upper Egypt. Probably Middle Minoan IB, *c*. 2000-1900. Silver. *Paris, Louvre*

Tôd in Upper Egypt may be Cretan work of the Middle Minoan IB period [145, A and B].[10] They had been buried in the foundations of a temple in copper boxes engraved with the name of the Pharaoh Amenemhet II (*c*. 1938-1904). Their shapes, and the fluted and spiraliform decoration of some of them, look Cretan, and although they probably formed part of the tribute paid by some Syrian ruler, perhaps the king of the great city of Byblos then subject to Egypt, there is no reason why they should not have been made in Crete, since the other objects found in the copper boxes with them included unworked lumps of lapis lazuli from Afghanistan,[11] and Mesopotamian cylinder seals of lapis, equally foreign to Syria.

One of the silver cups from Tôd [145A] has two vertical strap handles. The only vase of precious metal of this period that has survived in Crete ·is a silver two-handled cup with a crinkled rim from a tomb at Gournia [144E].[12] But a number of comparable Cretan cups in clay (illustration 2C is an example) are assignable to Middle Minoan IB-II.[13] The relatively small size of a gold cup of this type in New York and the foliate bands on its handles suggest that it may be Cretan work, although of a somewhat

later period, perhaps Late Minoan I.[14] Such cups could have been the prototypes for the gold two-handled cups like that of illustration 148A and their clay counterparts manufactured on the mainland (see p. 40).

Silver was more valuable than gold in Egypt at this time.[15] There were supplies in some of the islands of the Cyclades and in the Lavrion area of Attica on the mainland. The Lavrion silver was certainly being exploited by the beginning of the Late Bronze Age, and the working of it may have begun there much earlier.[16] Two silver vases which may be Cretan work, a cup with spirals in relief and a spouted jar resembling a tea-pot, were found in the coffin of a prince of Byblos who lived about the time of Amenemhet III (1850-1800).[17] The jar [146] resembles one of faience from the cache of stone vases in the Central Treasury of the palace at Knossos [127].[18] It is just possible that this cache was lost at the time of the disasters which overwhelmed Crete *c*. 1450 rather than later (see pp. 135, 143).

146. Spouted jar from Byblos. Perhaps Middle Minoan II, *c*. 1850. Silver. Scale 1:4

The decline in the production of small clay vases of fine table ware towards the end of the Middle Minoan period from *c*. 1700 onwards may reflect the fact that metal vessels of all kinds were now more easily available in Crete. A number of large vases of clay and stone dating from this time appear to be copied from metal types. Some have fluted decoration, and they

include jugs with wide flat mouths and ribs at the base of the neck which reproduce the ribs concealing the area of the joint between the body of the vase and the neck in the case of metal vases.[19] A gold cup [147] (the handle missing) from the so-called Aigina treasure in the British Museum, with elegant repoussé decoration of running spirals on the body, and a rosette on the base like some of the silver cups from Tôd, appears to be Cretan work of the seventeenth

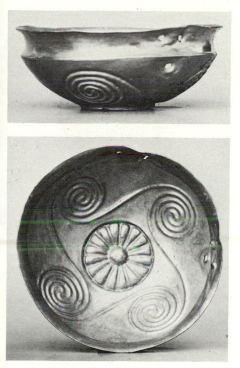

147. Cup from the Aigina Treasure possibly found in the Chrysolakkos burial complex at Mallia. Middle Minoan III, c. 1700–1550. D of rim 9.7 in. *London, British Museum*

or sixteenth century (see p. 195);[20] similar running spirals appear on a small silver jug and bowl from the South House at Knossos, destroyed it seems at the time of the mainland conquest c. 1450.[21] Another silver jug, with embossed gold bands, was recovered from the palace at Zakro which was also destroyed c. 1450.[22] Further light on Cretan plate of this

period is shed by metal-imitating pottery and by the representations of what appear to be meant for gold and silver vessels of basically Cretan types in the hands of Aegean envoys depicted on the walls of tombs of high Egyptian officials of the late sixteenth and fifteenth centuries.[23]

The most striking examples of Greek plate of the Archaic and Classical periods have been recovered from peripheral areas: Thracian tombs in the Balkans and Scythian tombs in south Russia.[24] Similarly the best evidence of all for Cretan gold and silver plate in the era before the disasters of c. 1450 comes, not from Crete itself, but from the shaft graves of the native princes of Mycenae on the mainland. The so-called 'Minyan ware' of the Middle Bronze Age on the mainland with its sharply angled profiles appears to be imitating metalwork: the standard grey surfaces may be meant for silver, red for copper, and yellow, only fashionable late in the period, for gold. Some vases, notably cups, of the contemporary matt-painted ware are also metallic in shape (see p. 40).[25]

Drinking cups appear to have been the type of vessel most commonly made of gold or silver in Crete. This was also the case on the mainland to judge from the evidence of metal-imitating pottery and the plate from the Mycenae shaft graves. Kings and great men probably drank from their own personal cups of precious metal: a custom not out of keeping with the atmosphere of Homer, but in striking contrast to Greek practice in Archaic and early Classical times, when plate does not appear to have been used in houses, and was reserved for dedication in sanctuaries.[26] At least five of the seven vessels of precious metal from the shaft graves of circle B, assignable to the sixteenth century or earlier, are cups. Two gold ones were found in grave Gamma, and one of gold together with one of silver in grave Nu. An elegant silver cup with a gold rim from grave Iota looks as if it must be a Cretan import.[27] Much larger numbers were recovered from the graves of circle A, however, and especially from the rich graves IV and V. Grave IV with five burials contained eight gold cups and some nine or more silver ones, besides one of electrum, a natural alloy of gold and

A

B

C

D

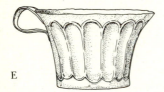

E

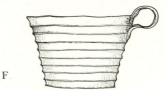

F

G

148. Vessels: (A)–(F) from shaft grave circle A at
Mycenae and (G) from its area. Late
Minoan I and Late Helladic I–II, *c.* 1550–1400.
Gold. Scale 1:5. *Athens, National Museum*

silver. In grave V, which had traces of three burials, there were five gold and twelve silver cups. The shaft grave cups vary a good deal in workmanship, and also in the expenditure of material, some being light and flimsy, others heavy with thick solid walls. Most are of Cretan shapes or of shapes that may be of Cretan origin, very few of distinctively mainland types; but this does not necessarily mean that any of them was imported from Crete, since much of the mainland pottery was being made in versions of Cretan shapes by this time.

Cups of the truncated conical (Vapheio) shape like those of illustration 148, D–F, standard in Crete since *c*. 2000 or earlier, are the most common.[28] These were beaten from a single sheet of gold or silver. The handles, made separately and fastened in place with rivets, are of two types: most are strap handles of the kind usual on the metal-imitating clay cups of this shape in Crete, their edges normally strengthened with concealed bronze wire; but some are spool handles, consisting of a horizontal plate above and below joined by a thick vertical rivet, like those of the gold cups with bull-catching scenes from Vapheio near Sparta [161–3] (see p. 166). One of the silver cups belonging to the Tôd treasure boasts a handle of this curious type,[29] which evidently had a long history in Crete, where clay imitations of it are attested in Middle Minoan times.[30] Many of these truncated conical cups from the shaft graves are plain, but some are decorated with horizontal or vertical flutes [148, E and F], or with designs in repoussé. A gold cup with dolphins in relief from grave III [149]

seems likely to be a Cretan import;[31] but four with arcades above horizontal notched bands like illustration 148D may be local work,[32] although their comparatively poor craftsmanship is not a safe argument for this, in view of the competence of much of the ornamental goldwork of native tradition from the graves (pp. 203–5).

There are a few hemispherical silver cups with straight rims from circle A;[33] two others of this shape have everted rims.[34] This type also appears to be of Cretan origin. But a plain two-handled gold cup from grave IV [148A] can be paralleled among native clay imitations of metal.[35] It is well made, of thick gold, and the edges of the handles appear to have been strengthened with silver instead of the usual copper wire. Other gold cups of this shape have been recovered on the mainland, notably a group of three found in the region of Kalamai (Kalamata) in the southern Peloponnese.[36]

A cup with a low foot from grave IV [150] is unique among the shaft grave vessels in being made of electrum, and it is the only one with inlays like the famous inlaid dagger blades (see p. 181).[37] Bands of shiny black niello flanked the zone of the handle, which was of the spool type: the upper band served as a background for a thin gold strip, the lower one for a row of gold dots, and the space between was inlaid with three gold 'altars' bedecked with flowers, their details shown by incisions, which may also have been filled with niello. Niello is usually blue-black or grey-black, with a slight gloss.[38] It differs from black enamel in being metallic instead of vitre-

49. Dolphins on a cup from shaft grave III at Mycenae. Probably Late Minoan IA, *c*. 1550. Gold. Scale 1:2. *Athens, National Museum*

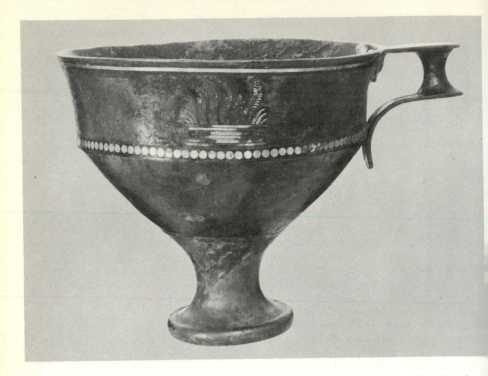

150. Cup inlaid with flower-decked 'altars'
from Mycenae shaft grave IV.
Probably Middle Minoan III–Late Minoan I,
c. 1650–1500. Electrum with inlays
of gold against a background of niello.
H 0.155 m. *Athens, National Museum*

ous and was made by melting copper and silver
(in later times with lead added) with sulphur. It
was used to decorate objects in antiquity and
again in the Middle Ages. In the Aegean Bronze
Age it appears to have been applied in the form
of a mixture of powdered sulphides of copper
and silver and then heated until the powder be-
came tacky, when it could be pressed home.
Aegean craftsmen of the Bronze Age employed
niello to emphasize the fine lines of incised
decoration, or to fill cuttings where it might
serve as a bed into which metal cut-outs could
be set. It was also it seems applied to the surface
of silver relief vases to provide a contrasting
background for the repoussé decoration (see
p. 160).

Some fragmentary vessels with inlays from
tholos 2 at Peristeria in Messenia may date from
the time of the Mycenae shaft graves or not
much later.[39] Gold lilies on one recall those on a
dagger blade from grave V (see p. 178). No
examples of this metal inlay, or 'painting in
metals', have been found in Crete, while a
number of inlaid vases and daggers have been
identified on the mainland. But knowledge of
the technique may have been introduced to the
mainland from Crete in the first instance (see
p. 181). The electrum cup from grave IV [150]
looks Cretan; its flower-decked 'altars' are remi-
niscent of a fragmentary wall-painting from
Amnisos,[40] and the rivets which hold the handle
are unusual in being heart-shaped like a type of
bead or amulet which was at home in Crete but
not on the mainland.[41]

Five shaft grave cups have more or less high
feet. Two, one of gold [148C], the other of silver
are plain and correspond to shapes known in
clay on the mainland.[42] The other three, how

ever, are of Cretan shapes and have relief decor-
ation. One of them from grave III, of silver with
a row of gold rosettes,[43] may be a Cretan import,
like the exceptionally fine cup from grave IV,
with the bowl and foot beaten from a single sheet
of massive gold and a row of elegant rosettes on
the bowl [151].[44] The fifth cup, which comes

from grave V, was also skilfully beaten from a
single sheet of gold, but it is less elegant in shape,
and the handle is less neat [152].[45] The rather
crude and schematic style of the running lions
in relief on the bowl has suggested that it might
be local work.

The gold 'Cup of Nestor' [153] from grave
IV, with a plain conical bowl on a high cylin-
drical stem, is unique among the shaft grave
treasures.[46] A tall stem painted yellow for gold
on a fragment of the Camp Stool fresco from
Knossos might have belonged to a cup of similar
type,[47] and there are a few later Mycenaean clay
vases of this shape, but without handles, in-
cluding an elegant example from a tholos tomb
near Pylos and some from Cyprus and Syria.[48]
A related variety has a deeper bowl and shorter
foot, like a silver cup from Dendra (see p. 169),
and a number of Cretan stone vases, one of
which was actually found in shaft grave IV with
the Cup of Nestor.[49] The pair of spool handles
on the Cup of Nestor may have been an after-
thought, and still later it seems the cup was
strengthened by the addition of the two long
struts which connect handles and base.[50] The

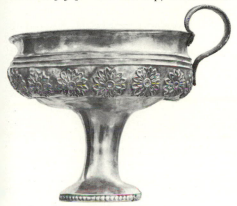

151. Cup with rosettes in repoussé from Mycenae
shaft grave IV. Probably Late
Minoan IA, c. 1550-1500. Gold. H 0.15 m.
Athens, National Museum

152. Cup with running lions in repoussé from
Mycenae shaft grave V. Probably Late
Helladic I, c. 1500. Gold. H with handle 0.128 m.
Athens, National Museum

153. Cup of Nestor from Mycenae shaft grave IV.
Possibly Late Minoan IA, c. 1550-1500, with the
handles surmounted by doves and the long openwork
struts added later. Gold. H c. 0.145 m.
Athens, National Museum

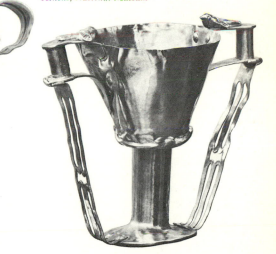

birds with outstretched wings gracing the tops of the handles appear to be doves.[51]

Other vessels of precious metal from the shaft graves of circle A include little boxes and jars of primitive appearance, but skilfully beaten from single sheets of gold, their lids being attached by gold wires [148B].[52] These are thought to be of native tradition and local make; but silver jugs of shapes standard in Crete may be imports.[53] One large silver jug with a flat mouth from grave V is in shape very like a bronze one [168A] of exactly the same size from the so-called North West Treasury adjacent to the palace at Knossos,[54] while its repoussé design of spirals over arcades is characteristic of fine metal-imitating pottery of the Late Minoan I B period (c. 1500-1450) like illustration 17,[55] and duplicated on the gold cup from a later warrior grave near Knossos (see p. 167). Although this jug stands 0.345 m. high, its body was beaten from a single sheet of silver, to which the neck and rim were added, the joint being concealed by a notched rib which was strengthened with bronze, as were the rim and base. All the lower part of the vase appears to have been coated with a layer of niello, and there was niello in the notches of the rib at the base of the neck.[56]

Two large silver vases from grave IV were adorned with scenes of battle. The more remarkable of these, only restored within the last few years, has emerged as a great two-handled jar some 0.50 m. high.[57] The rim was strengthened with a bronze band, and the handles and foot were of bronze plated with silver. The decoration in low relief, covering virtually the whole of the vase except the rim, showed a rocky landscape with two groups of warriors, four on each side, struggling over the body of a ninth who had fallen wounded. They are mostly armed with long spears, although one on each side is a bowman, and wear tasselled 'shorts' like the men in the scene on the lion hunt dagger, with which there are other points of comparison (pp. 179-81). All the warriors have boar's tusk helmets, and the groups are only distinguished by their great body shields, rectangular on the one side, figure-of-eight-shaped on the other. Much of the detail was incised and may have

been filled with niello, but no traces of it remain, although the whole of the background is said to have been coated with it; if so, the contrast between the shiny black background and the large silver figures standing out in relief from it must have been striking indeed.

This great vase with its boldly conceived battle scene was certainly one of the most spectacular of the shaft grave treasures. Was it made on the mainland or brought from Crete? The shape is exceptional, and not easy to parallel in either area. The style of the relief decoration and the sense of composition, however, are surely Cretan: there is nothing of the primitive or barbaric here, as there is in the case of the shaft grave stelai, and of some of the goldwork and other objects found in the graves themselves. The tasselled 'shorts' of the men are better attested on the mainland, it is true, but they are worn by monsters on seal impressions from Zakro [223F],[58] buried when the palace and settlement there were destroyed by fire c. 1450. Figure-of-eight shields are of Cretan origin, although representations of them on the island hardly occur before c. 1600,[59] and it has been suggested that they were evolved in connection with chariot warfare about that time.[60] The bow seems more at home as a weapon on the mainland, but it was certainly used in Crete, although the rarity of arrow-heads there implies that they were normally made of bone or wood.[61] Helmets armed with boar's tusks are attested on the mainland before the end of the Middle Helladic period, but wild boar existed in Crete, and boar's tusk helmets appear to be depicted on seal impressions from Zakro and Ayia Triadha dating from before c. 1450.[62] Possibly this great silver jar and other comparable shaft grave treasures, like the inlaid daggers [177-9] and the gold seals [228, A-C], were the work of one or more gifted Cretan artists living at Mycenae and working for its rulers; but until some unplundered royal or princely tomb of this period is revealed in Crete it is difficult to be certain.

The other silver relief vase from grave IV is the so-called Siege Rhyton for pouring libations, conical and with a single handle as standard in Crete [154, 155].[63] The rim was strength-

154. Siege Rhyton from shaft grave IV at Mycenae as reconstructed by W. S. Smith [cf. 155]

155. Drawing by E. Gilliéron of a fragment from the upper part of the Siege Rhyton, a silver conical libation vase from Mycenae shaft grave IV. Probably Late Minoan IA, c. 1550–1500. *Athens, National Museum*

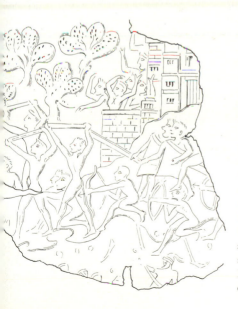

ened with bronze and gilded. Gold figure-of-eight shields flanked the handle, whose edges were stiffened with bronze wire. Guide-lines were incised, but the reliefs as executed in repoussé do not always coincide with them. Details were afterwards added to the reliefs with incision. There is a suggestion that the background might have been coated with niello.[64] The main fragment [155], from the top of the vase below the rim, shows a town on a hill overlooking the sea. It is defended by a wall with a bastion constructed of isodomic masonry, it seems, rather than mud-brick, and there are buildings three storeys or more high inside it. The town gate, on the right, is closed. To the left is an olive grove, and on flat ground by the shore below the town naked and bare-headed men armed with slings and bows appear to be doing battle in its defence, while their women-folk wave and gesticulate from the walls. Behind the slingers and archers to the right are two men armed with spears and rectangular shields.[65] A man on the left seems to have been wounded, and a fragment with other dead or wounded men may have fitted to the left of this, between the defenders and the attackers, some of whom appear to be represented on a fragment which shows parts of two men with raised arms wielding what might be clubs or throwing-sticks, if they are not battle knives of the type found in several of the shaft graves and represented perhaps on the stelai (see p. 98). In the sea at the bottom of the main fragment is the head of a man wearing a plumed helmet of Aegean type and apparently steering a boat. The helmets of some of his companions are preserved to the left of him. Perhaps these are more of the attackers about to land from the sea. The open sea with its waves represented by scales stretches down to the conical tip of the vase, where a tree-decked strip of land meets it. In the sea swim men resembling frogs [154], naked like the defenders, and vanquished perhaps in a sea-fight by the attackers. All is conjecture; but in the atmosphere of the time, and on the analogy of scenes of attacks on cities in Egyptian and later Assyrian art, the enemy are likely to be the defenders of the place and 'we' the attackers.

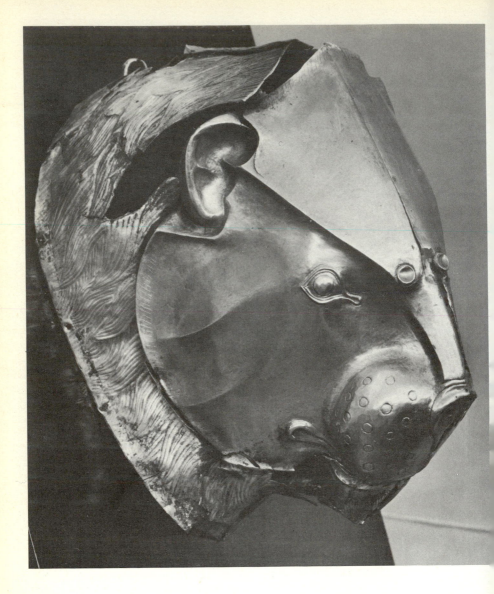

156. Libation vase in the shape of a lion's head from Mycenae shaft grave IV. Late Minoan IA or Late Helladic I, c. 1550–1500. Gold. H 0.20 m. *Athens, National Museum*

It has been inferred that the town was in Crete because of 'horns of consecration' visible in it; but the supposed 'horns' look somewhat atypical, and Cretans do not seem to have walled their towns at this time. The masonry walls and high buildings, however, suggest that the town is civilized, despite its naked defenders. The helmeted attackers, if they are such, landing from the boat seem meant for Cretans or people from the mainland. Perhaps the scene is historical, like Egyptian pictures of attacks on cities,[66] and the town might have been on one of the Cycladic islands;[67] but a similar scene, which included men swimming, appears to have existed in faience mosaic on a wooden box of much earlier date from Knossos (see p. 132).[68]

Two other metal rhytons for libations were recovered from grave IV, one of gold in the shape of a lion's head [156], the other a bull's head of silver [157].[69] The nose and lips of the bull were plated with gold, and the horns were of thin gold over a wooden core. The ears were made separately of bronze, overlaid with gold inside and silver outside. A gold rosette was fastened to the forehead by a bronze nail. The pupils of the eyes were evidently once inlaid, in gold perhaps or niello. The hair, well preserved on top of the head, is modelled in a style comparable with, but if anything superior to, that found on Cretan stone rhytons in the shape of bull's heads like that of illustration 135A (pp. 142–3). Both of these fine pieces may have been made in Crete, although the rather harsh appearance of the lion is compatible with a mainland origin; but a curious vase from the same grave, in the shape of a stag and made from an alloy of silver and lead, is thought to come from Anatolia.[70]

The remarkable gold masks which accompanied some of the princes buried in the Mycenae shaft graves were clearly local products [158, 159]. Their comparative crudity and the stylized treatment of the ears and hair form a striking contrast to the bull's head rhyton from grave IV. They were not placed with every burial and never with those of women. Five were recovered from circle A – three (including illustration 158) from grave IV and two [159] from

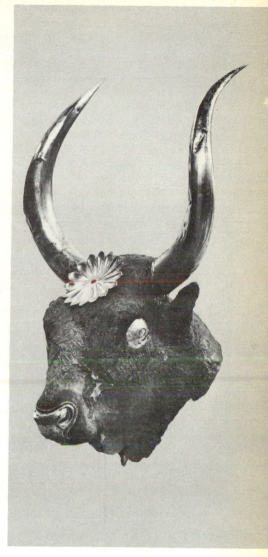

157. Libation vase in the shape of a bull's head from Mycenae shaft grave IV.
Probably Late Minoan IA, c. 1550–1500.
Silver with gold mountings,
the ears bronze plated with gold and silver;
the horns of gilded wood.
H with horns c. 0.30 m. *Athens, National Museum*

grave V[71] – but only one, of electrum not gold, from the earlier circle B.[72] All the masks are conventionalized faces of men, with slight differences in the way such features as the ears and eyes are rendered; but the finest of them [159] (often miscalled Schliemann's Agamemnon) is surely in some real sense a portrait.[73] The delicate features and straight slender nose are still at home in Greece today. The face is that of a man with beard and neat moustache. One of the masks from grave IV shows a moustache, but no beard, and no beards or moustaches are rendered on the other four, three of which – the one from circle B and two

the other elaborately decorated with a network of spirals in the native tradition.[75] A couple of children in grave III had sheets of gold over their legs and arms as well as over their bodies and faces;[76] holes for mouths and eyes were no doubt to let them see and breathe. The idea of covering the dead with gold may have been inspired by contemporary Egyptian practice as illustrated by the gold coffin of Tutankhamun, but whether it reached the mainland direct or through the intermediary of Crete is uncertain in default of unplundered Cretan royal tombs.

Mycenae was not the only centre on the mainland where vessels of gold and silver were in use

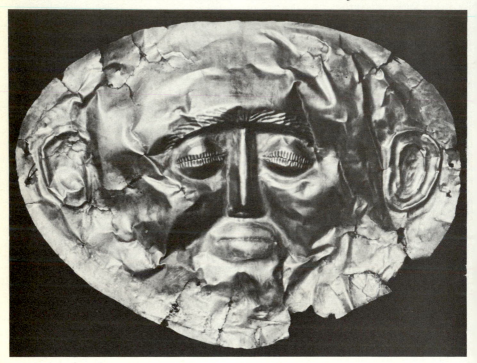

158. Mask from Mycenae shaft grave IV.
Late Helladic I, c. 1500. Gold.
H 0.205 m., W 0.275 m. *Athens, National Museum*

from grave IV of circle A [158][74] – are closely similar in treatment.

The two burials with masks in grave V were also provided with gold breastplates, one plain,

at this time. From the corner of a pit below the floor of tholos tomb 3 at Peristeria in Messenia came three gold cups with spirals in relief comparable with some of those from the shaft graves.[77] The shapes of the cups are of Cretan derivation, but they may have been made on the mainland. The somewhat crude style of a fragmentary plaque from the largest of the Peris-

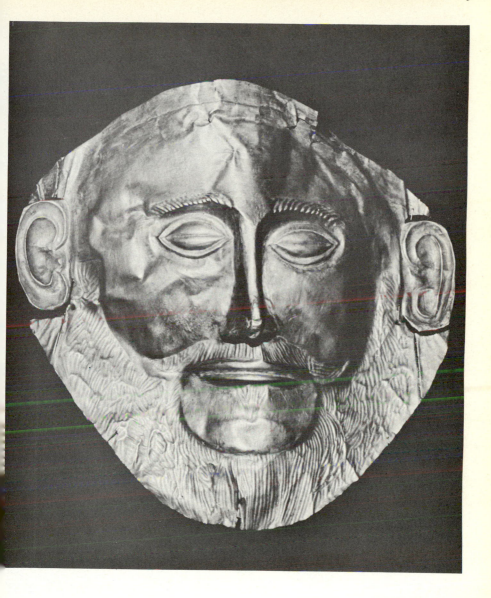

159. Mask from Mycenae shaft grave V. Late Helladic I, *c.* 1500. Gold. H 0.26 m., W 0.265 m.
Athens, National Museum

teria tombs, tholos 1, assignable to the same period or not much later, with a procession of young men and boys in relief on it, suggests that it is local work.[78]

Very different is the impression made by the bull-catching scenes on the famous pair of gold cups found in 1888 in an unplundered grave in the Vapheio tholos tomb near Sparta [160-3].[79] The first of these [160, 161] shows three bulls running in a rocky landscape, apparently goaded to charge. One has been brought to the ground by a stout rope cradle tied between two olive trees [160], another escapes behind a palm tree

[161], while the third has by-passed the cradle, sweeping a young man to the ground, only to be attacked by another young man (or a girl, if Evans is right) who has sprung 'from some coign of vantage', and locking arms and legs round the bull's horns is twisting its head with a pull on its right ear, and threatens to fell it if not break its neck.[80] The second cup [162, 163] seems to portray three different episodes in the capture of a bull or bulls with the help of a decoy cow. Moving left from the handle [162] a bull scents a cow by an olive tree, and succumbs to her blandishments beyond it. In the third scene

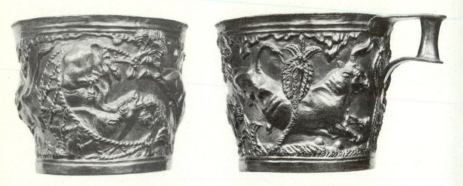

160 (*above, left*). Cup from Vapheio with scenes of bull-catching in high relief. Possibly mainland work of Late Helladic II, *c.* 1450. Gold. H 0.084 m., D of rim 0.108 m. *Athens, National Museum*

161 (*above, right*). A bull escapes behind a palm tree, to the right of the scene in illustration 160

162 (*below, left*). Cup found with that of illustrations 160 and 161, with scenes of bull-catching by means of a decoy cow. Probably Middle Minoan IIIb–Late Minoan Ia, *c.* 1600–1500. Gold. H 0.079 m., D of rim 0.108 m. *Athens, National Museum*

163 (*below, right*). The opposite side of the cup of illustration 162

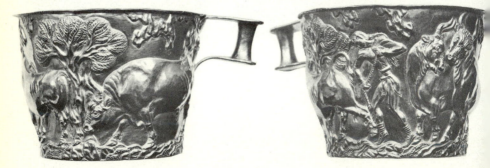

[163] one of his legs has been tied with a rope by a young man dressed like those on the first cup in a short stiff kilt and codpiece in the Cretan manner. The rocky ground at the bottom on both cups is rendered in a different way, and with more variation, than the conventional rock-work which hangs downwards from their top edges. The suggestion that the latter is meant to represent clouds seems unlikely:[81] the whole of the background on the ivory pyxis from Kat-samba [111] for instance is similarly rendered (pp. 121–2). Each of the cups is lined with a sheet of plain gold which overlaps the top of the sheet with the reliefs to form a neat rim.

While the scenes in relief are complementary, the cups are not a matching pair, and may not come from the hand of the same craftsman.[82] The cup with the charging bulls [160, 161] has borders at the top and bottom, and there are slight differences between the way the bulls are rendered on this and the other cup.[83] The work on the cup with the decoy cow [162, 163] is distinctly finer: the composition is better, the rock-work more flexible, less repetitive, and there is no unnecessary detail. Contrast the mini-palms inserted on the other cup [161, on the left], crowding the scene and detracting from it. But while the execution of the reliefs on the charging bull cup is in some ways rougher and less finished, it is at the same time perhaps more vigorous. Was the charging bull cup made by an exceptionally gifted mainland craftsman as a companion for the other one which had been brought from Crete?[84]

The reliefs on the Vapheio cups are higher, and were therefore more difficult to execute, than any on vases from the Mycenae shaft graves. Clay vases from the tomb at Vapheio are assignable to the first half of the fifteenth century, contemporary with the end of the shaft grave period or somewhat later,[85] but treasures like the gold cups might have survived in use for a considerable time before they were buried. The grave in the Vapheio tomb also contained two silver cups of the same shape, and a silver cup with out-turned rim decorated in relief and mounted with gold, together with a silver ladle.[86]

LATER BRONZE AGE (c. 1450 B.C. ONWARDS)

Little gold or silver plate assignable to this period has yet been recovered in Crete. The palace at Knossos was evidently ransacked before it was destroyed by fire in the fourteenth century, but a gold cup from a late-fifteenth-century warrior grave there is decorated with spirals over arcades, like the large silver jug from Mycenae shaft grave V (see p. 160).[87] This design is at home on fine pottery like illustration 17 of the Late Minoan I B period before the disasters of c. 1450, and the cup may have survived from that time. It is light in weight, and beaten from a single sheet of metal: an extension from the rim was bent downwards to form the handle. Plain silver cups of this shape, with the handles similarly in one piece, were recovered from shaft graves I and IV at Mycenae.[88] A silver cup, the rim and base strengthened with bronze and with gold-mounted rim and handle, comes from a warrior grave of c. 1400 near the Temple Tomb at Knossos,[89] and another was found with burials of the same period at Arkhanes.[90] Cups of gold and silver appear to be represented on fragments of the Camp Stool fresco from Knossos assignable to the early fourteenth century (see p. 68).[91] A tall yellow stem may have belonged to a gold cup resembling the Cup of Nestor [153] in its original form, while a bowl, painted blue for silver, evidently topped a stemmed goblet (kylix) of a type standard in Crete and on the mainland from c. 1400 onwards. A fragmentary silver goblet of this shape was recovered from the Royal Tomb at Isopata north of Knossos.[92]

On the mainland in contrast to Crete a good deal of plate has been found in contexts assignable to the period after c. 1450.[93] A set of four two-handled gold cups with low stems of a type datable c. 1400 formed part of a treasure discovered in 1877 in the area of shaft grave circle A at Mycenae [148G],[94] perhaps deposited there by ancient tomb robbers. The bowls and the stems of the cups were made separately. The handles end in the heads of dogs, with leashes round their necks, and biting the rim across

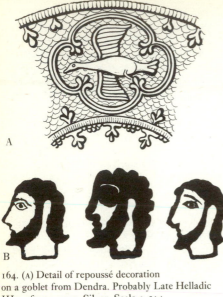

A

B

164. (A) Detail of repoussé decoration
on a goblet from Dendra. Probably Late Helladic
IIIA, after *c.* 1400. Silver. Scale *c.* 3:4.
Athens, National Museum (B) Inlays of a metal vase
from the palace at Pylos. Probably
Late Helladic IIIB, *c.* 1250. Gold and niello.
Scale 3:4. *Athens, National Museum*

which they face. In the same treasure was a small
lion, only 0.031 m. long but very finely rendered,
sitting on a curved strip, all of solid gold.[95]

A stemmed cup of silver found outside a
tholos tomb at Katarrakti (Pharai) in Achaia
was decorated with figure-of-eight shields in
relief.[96] A set of silver vessels from a pit in the
chamber of a rock-cut tomb at Dendra near My-
cenae included cups with low stems, and a long
spoon like that from the Vapheio tomb but with
repoussé decoration on the bowl.[97] One of the
cups has the rim and handle mounted with gold
like the cup of similar shape from a warrior
grave near the Temple Tomb at Knossos (see
p. 167), while the bowl is elaborately decorated
in repoussé with five baroque-looking quatre-
foil panels, each framing a long-necked bird
with outstretched wings [164A].[98] A stemless
silver cup with this set of vessels has a massive
gold rim and gold-plated handle bearing elegant
spiral decoration in relief.[99] Another pit, evi-
dently a grave, in the same tomb produced a
magnificent gold cup with eight-lobed rim and
a stylized ivy chain in bold relief round the sides
[165].[100]

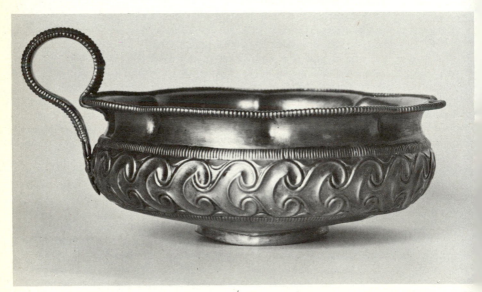

165. Cup from Dendra with a stylized ivy chain in repoussé. Late Minoan or Late Helladic II–IIIA,
c. 1450–1350. Gold. H with handle 0.075 m. *Athens, National Museum*

An outstanding collection of plate was found in the royal tholos tomb in the same cemetery at Dendra. The decorated pottery from the tomb is assignable to the period *c.* 1400,[101] but some of the vases of precious metal may be older, notably a truncated conical cup like those from the Vapheio tomb [160–3], and made in the same way with an inner lining of gold;[102] but in this case the outer sheet with reliefs of charging bulls is of silver. This was found in the king's grave, along with three other cups of precious metal. One is of plain silver, with the handle in one piece with it, like the gold cup from Knossos and the hemispherical silver cups from the Mycenae shaft graves (pp. 167, 157).[103] A silver goblet with a high foot and no handles, although resembling a number of Cretan stone vases in shape, is decorated in a low relief which gives the impression of mainland work.[104] The somewhat confused scene with large dogs pursuing and overthrowing deer recalls that on the ivory griffin pyxis from Athens, where deer are likewise the victims [112] (see p. 124). The fourth cup, of gold, with an attached rim and handle [166, 167],[105] is decorated in relief with four octopuses, set in panels bordered by conventional rockwork and sand amidst which small dolphins and argonauts are arranged. The scene is reminiscent of the Marine Style as found on Cretan vases like those of illustration 15, A and C, of the Late Minoan IB period immediately before *c.* 1450, but it is a somewhat stylized and consciously organized version, which may point to a date after *c.* 1450 and a place of manufacture on the mainland.[106] The tails of the dolphins are fat and inelegant, the argonauts are marshalled in rows and have very small tentacles, the rockwork displays a repetitive and aimless system with acute *horror vacui*.

A remarkable inlaid cup from what may have been the grave of a queen in the same tomb at Dendra is hemispherical, with a wishbone-shaped handle.[107] Like the Vapheio-type cup with bulls in relief from the king's grave it was made of silver with a lining of thick gold. The outside was inlaid with bands of gold, and in the space between was a row of five incised bull's heads with inlays of gold and niello. A similar

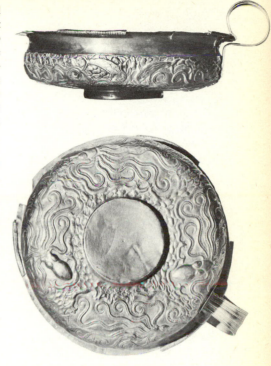

166 and 167. Cup from Dendra with marine decoration in repoussé. Probably Late Helladic IIB–IIIA, *c.* 1450–1350. Gold. H with handle 0.07 m., D of rim 0.185 m. *Athens, National Museum*

cup from a tomb at Enkomi in Cyprus has six bull's heads instead of five, and lacks the gold lining of that from Dendra,[108] although the decorative scheme is considerably more elaborate, with arcades enclosing rosettes below the bull's heads. The rendering of the heads is less refined, however, and the shape of the cup has been slightly changed, so that it approximates to that of a standard type of Cypriot clay bowl. It might be a very competent local imitation of an Aegean model, corresponding to some of the 'Mycenaeanizing' ivories from other tombs at Enkomi.[109] Bull's heads that seem to be meant for inlays appear on a cup of the Vapheio type painted in the tomb of Senmut at Egyptian Thebes.[110]

A silver cup from a tomb at Mycenae was inlaid with a row of gold heads of bearded men.[111] The details of their faces were incised and filled with niello, while a strip of niello inset with a gold foliate band ran above and below them. There are remains of a similar cup from the palace at Pylos destroyed c. 1200 [164B].[112] A bronze cup handle from Mycenae is inlaid with gold argonauts,[113] and other bits of inlay from metal vases found there include the wing of a griffin or sphinx apparently of silver inlaid with gold.[114] Fragments of one or more silver cups of the Vapheio shape inlaid with gold rosettes and double axes were recovered from a tomb at Dendra.[115]

The art of working precious metals in repoussé was evidently still practised in parts of the Aegean after the disasters of c. 1200. From a tomb of the twelfth century on Naxos comes a gold plaque embossed with a curious child-like figure,[116] and small crouching lions of gold plate crudely decorated with dot repoussé from another Naxian tomb may be of the same date;[117] their primitive style is a commentary on the times.

COPPER AND BRONZE VESSELS

Vessels of copper and bronze may have been in use in the Aegean area by the middle of the third millennium, but they only appear to have become common in the sixteenth and fifteenth centuries. A two-handled copper pan from the settlement by the early circular tomb at Kalathiana in southern Crete is usually taken to be of Middle Minoan date.[118] In shape it resembles silver bowls like that of illustration 145B from the Tôd treasure, but it is much larger.[119]

By the end of the Middle Minoan period a wide variety of metal vessels was available for household or cooking purposes in Crete. The sharp rims and channelled decoration on clay cooking pots with tripod feet at Knossos appear to be copied from metal ones. Cauldrons from a house at Tylissos involved in the disasters of c. 1450 were large enough for boiling a sheep or goat whole.[120] Numerous copper or bronze vessels of domestic use, recovered from the ruins of houses at Knossos destroyed in the early part of the fifteenth century either by earthquakes about the time of the eruption of Thera c. 1500 or in the calamities of c. 1450, include tripod-footed cooking bowls and large flat-mouthed jugs, as well as basins of various kinds.[121] Two-handled pans resemble the one from the settlement at Kalathiana which is thought to be earlier in date.[122] Most of these vessels are severely functional, but a few are richly ornamented, like the bronze jug [168A] which closely resembles the silver one from shaft

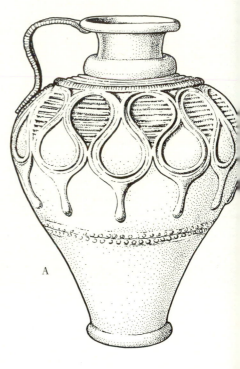

A

168. (A) and (B) Jug and basin from the North West Treasury at Knossos and (C) a similar basin from Mochlos. Late Minoan I, before c. 1450. Bronze. Scales c. 1:7 (jug) and 1:4 (basins)

grave V at Mycenae (see p. 160).[123] With it in the North West Treasury cache at Knossos were four bronze basins, like hemispherical cups in shape but much larger, one measuring 0.39 m. across the rim. Three of these including illustration 168B had elaborate decoration in relief on the rim and handle, like a richly ornamented basin found in the settlement at Mochlos, destroyed at the time of the mainland conquest *c.* 1450 [168C].[124] A bronze cup of the truncated conical Vapheio shape from a tomb of *c.* 1500 at Mochlos has ivy leaves in relief on the outside.[125]

Numbers of copper and bronze vessels for cooking and domestic use were recovered from the Mycenae shaft graves, mostly large jugs (hydrias), and basins or cauldrons with two or three handles on the rims. They were no doubt made locally even if the types were of Cretan origin. A bronze jug with spirals in relief from grave V may have been imported from Crete like the silver jug of comparable shape and size found with it.[126] Two small bronze cups with spouts and side handles, one of them with a foliate band on the rim, also appear to be

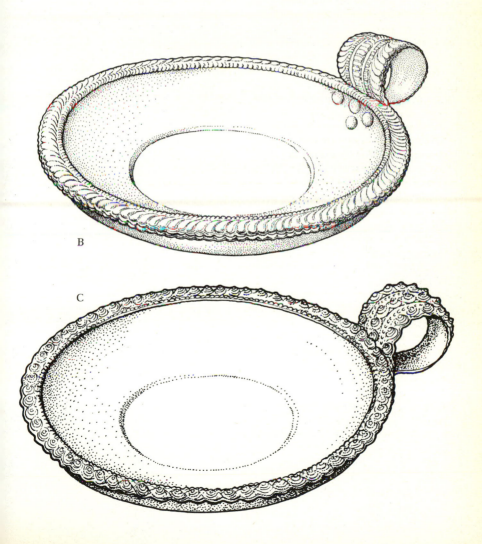

B

C

Cretan.[127] Spouted cups of this type were a standard shape in pottery at Knossos during the first half of the fifteenth century. The handles and rims of some bronze vessels from the shaft graves were plated with gold or silver.[128]

Several tombs of the period after *c.* 1450 both in Crete and on the mainland have yielded a rich assortment of copper or bronze vessels, mostly of domestic use, but including table ware. A large array, some with incised or relief decoration, was recovered from the 'Cenotaph' tomb at Dendra,[129] and a collection of a similar kind from the Tomb of the Tripod Hearth at Knossos included a two-handled goblet on a high stem.[130]

Vessels of copper and bronze were still being made and used in the Aegean at the time of the disasters at the end of the thirteenth century and even later: stirrup jars and other vessels that appear to be of Aegean shapes and made of metal are depicted on the walls of the tomb of the Egyptian Pharaoh Ramses III (1198-1166).[131] But only two metal vases were recovered from the large and important cemetery of twelfth-century date at Perati in Attica.[132] Two bronze urns, however, appear to have contained a pair of cremations in a large royal tomb of the first half of the eleventh century at Kourion in Cyprus.[133] One was crudely made, without any decoration, and might be more or less contemporary,[134] but the other, of which only the rim and the two handles survive, could date from as early as the fourteenth century to judge from the character of the relief decoration. On the rim is a row of tall jugs, in shape not unlike one painted on the Ayia Triadha sarcophagus, while four pairs of Minoan genii decorate each of the handles. A roundel at the base of each handle has a couple of octopuses reminiscent of those on the gold octopus cup from the tholos tomb at Dendra (see p. 169). Like the superb gold sceptre from the same tomb, this fine vase with its early-looking relief decoration may have been brought from the Aegean by the newcomers who were buried here (see p. 206).

TECHNIQUE[135]

Wherever possible vases of gold and silver were raised by hammering from single sheets of metal; it seems unlikely that the lathe was employed by makers of metal vases during the Bronze Age.[136] A small depression, visible on the underneath of the base on some cups, may reflect the use of the compass in marking on a flat metal sheet a circular piece from which the vase was to be raised.[137] Cup handles, and the upper parts of closed vases such as jugs, were normally made from separate pieces of metal and riveted in place. While the art of hard soldering appears to have been known to Aegean craftsmen of the Bronze Age, it was evidently distrusted for joining parts of vessels.[138] Rims, bases, and handles of gold and silver vessels were often strengthened with copper or bronze, which was concealed from sight. Cups with repoussé decoration sometimes had a plain inner lining like the Vapheio cups. Such repoussé designs, especially when they were in high relief as on the Vapheio cups [160-3], demanded great skill in execution. The scene on the Mycenae Siege Vase [154-5] seems to have been sketched with incisions before it was executed. Repoussé decoration was regularly finished by chasing. In the case of the silver cups with inlays of gold and niello like illustration 150 the surface was first gouged away with the chasing tool. Gold inlays were either tooled into place in spaces cut to fit them, or set in niello which was then fused by heat and allowed to harden.[139]

Copper and bronze vessels, like those of gold and silver, were normally beaten from flat sheets of metal; but jugs and cauldrons were made in several pieces held together by rivets, although some form of soldering may also have been practised,[140] as appears to have been the case with the neck of the jug [168A] and rims of basins like that of illustration 168B from the North West Treasury at Knossos.[141] Relief decoration might be cast, or hammered in repoussé, or chased.

ARMS

In most societies in the past men have delighted in adorning and beautifying their arms. Daggers with decorated hilts are already attested in the Aegean at the beginning of the Bronze Age, and some of the finest ornamental weapons made in antiquity come from the Mycenae shaft graves of the sixteenth century.

Crete

A few early dagger blades in Crete were of silver alloyed with copper,[1] and silver rivets were sometimes employed instead of copper ones for affixing dagger hilts.[2] Later, both in Crete and on the mainland, bronze rivets were often capped with gold or silver. The silver capping on the rivets of a dagger in Cambridge, apparently Cretan and assignable to the fifteenth century, may have been fixed by a method akin to that more recently discovered for making Sheffield plate.[3] Some early Cretan daggers had elegant midribs and attractive stone pommels.[4] A hilt with spirals in relief was found in one of the circular tombs at Platanos.[5] A blade from Mochlos with delicate ribs in relief down its length and a design like a Maltese cross on the hilt [175A], in spite of its early-looking shape, may have been made in the seventeenth century or later.[6] A strip of thin gold from the same tomb might have adorned a sheath of cloth or leather.[7]

From the palace at Mallia come two groups of richly ornamented weapons, both apparently lost or buried at some point before the final destruction by fire c. 1450. The weapons of the first group, which seem to be of an older type and may come from an earlier context,[8] consist of a sword and dagger with gold-plated handles.[9] They are a matching pair or set, the sword being

merely a lengthened version of the dagger. The dagger blade, only 0.21 m. long, has a wide flat midrib and rounded hilt [169A]. The four rivets which clasped the wooden handle to the hilt

169. (A) Dagger and (B) hilt of sword found with it in the palace at Mallia. Probably Middle Minoan, before c. 1600. Bronze mounted with gold. *Herakleion Museum*

were capped with gold, and the handle itself had been entirely concealed by thin gold plate, the surviving fragment of which has rows of incised herringbone decoration of primitive appearance flanked by lines in repoussé. The sword [169B] resembled the dagger, but was nearly four times as long (0.79 m.). Its handle, also fixed by means of four rivets across the top of the hilt, was made of a fine grey limestone originally covered with thin gold which was decorated at the top and bottom with incised herringbone designs like those of the dagger. A large piece of rock-crystal with eight facets served as a pommel.

170. Leopard axe from the palace at Mallia. Probably Middle Minoan, before *c*. 1600. Brown schist. Scale 1:2. *Herakleion Museum*

A remarkable ceremonial axe of brown schist [170] was found in a clay jar near these weapons, and had evidently been lost or buried at the same time. Its butt is in the shape of the fore-part of a large cat, leopard or panther or lioness. The surface is decorated with a network of spirals, except for the tip of the blade and the legs and head of the animal, which has a wide collar with a band running from it under the chest, as if it were harnessed to draw a chariot, of some god perhaps. Its eyes were once inlaid, and there are drop-shaped holes for inlays on the shoulders. Other fine ceremonial weapons of stone have been recovered from the Knossos region, notably an axe-hammer from a tomb of the sixteenth century at Poros, the harbour town of Knossos,[10] and a mace-head from one of the Isopata tombs of *c*. 1400 or not much later.[11] Double hammers made from attractive veined stones from contexts of the sixteenth and early fifteenth centuries in Crete may have had some ritual rather than merely practical use.[12]

The second group of weapons from Mallia consists of a pair of swords from a deposit below the latest paved floor in the north-western quarter of the palace.[13] These are of a more advanced type, and have long, rapier-like blades. From their rounded hilts short tangs project with rivets to help fix the handles. Swords of this type appear to have been in use in Crete by *c*. 1500, and they are well represented in the Mycenae shaft graves.[14] One of the Mallia swords was richly ornamented; the rivets on the hilt to hold the wooden hilt-plates were capped with silver, and the base of the large bone pom-mel was supported by a circular sheet of gold

decorated in low relief with a remarkable figure of an acrobat, curved head to toes [171]. His short curly hair might suggest a foreigner rather than a Cretan, and his kilt held in place by a tasselled cord is reminiscent of the dress of warriors on objects from the Mycenae shaft graves, although also found on Cretan represen-tations of the period before *c*. 1450 (see p. 197).

171. Acrobat on a roundel at the base of a sword pommel from Mallia. *c*. 1550-1500. Gold. Actual size. *Herakleion Museum*

The Mainland

Gold mountings from two wooden dagger grips were recovered in graves on the island of Levkas with pottery assignable to Early Helladic II.[15]

One of these had rows of little impressed tri-
angles at the wider end where it clasped the hilt
and a band of incised spirals at the top below the
pommel. The two blades from the same grave
(R. 17a), to one of which the grip presumably
belonged, are indistinguishable from Cretan
daggers of a type well represented in the early
circular tombs of the Mesara, notably in the
upper level of the great tholos A at Platanos.[16]
The other gold mounting (from grave 7) may
have adorned a longer dagger of similar type
which was found with it.[17]

The Mycenae Shaft Graves

The most remarkable collection of fine weapons
ever found in the Aegean area comes from the
shaft graves of circle A at Mycenae. The stan-
dard weapons represented were swords, dag-
gers, spears, and slashing-knives. Spearheads
and slashing-knives tended to be severely func-
tional, but swords, and more especially daggers,
were often lavishly decorated with gold and
silver and rare stones. Here once again it is
difficult to distinguish what is Cretan from what
is of native mainland tradition.

The swords are of two types, A and B.[18] Those
of type A are like the pair from Mallia, with
long narrow blades rounded at the top from
which a thin tang once projected. This tang was
inserted into the grip, hilt and grip being norm-
ally of wood and often decked with ivory or
gold. In most cases it seems the wooden hilt
spread outwards in the form of horns which
helped to protect the grip. The type is certainly
of Cretan origin, but most of the swords from
the shaft graves may have been manufactured
on the mainland.

Swords of type B were less common, in the
proportion of rather under 1:2. The blades tend
to be shorter and wider, adapted perhaps for
cutting as well as thrusting strokes, and at the
top their sides actually coincided with those of
the wooden hilt, instead of being enclosed by it;
moreover the projecting tang was no longer in-
serted into the grip, but was made the same
width. This meant that instead of a one-piece
wooden handle, which clasped the top of the
blade, there had to be separate plates for each

side. Flanges round the edges of the top of the
blade and the sides of the tang helped to keep
these hilt and grip plates in position. The hilts
of some type B sword blades are horn-shaped
like the wooden hilts of type A swords, but in
general the type B horns are atrophied, leaving
the tops of the hilts more or less straight. The
type B sword may be a local Mycenaean develop-
ment.[19] But daggers with flanged hilts were
being made in the Near East before this time,[20]
and a short sword of comparable type, with
wide blade and flanged cruciform hilt, had
already been developed in Crete it seems.[21]

The bold midribs of the long type A swords
were sometimes flanked by neat ridges or
channels, or occasionally by spirals[22] or other

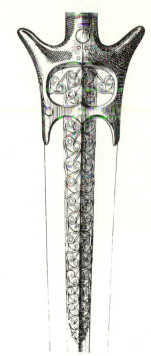

172. Sacral ivy on a sword blade from
shaft grave IV at Mycenae. c. 1550. Bronze.
Athens, National Museum

designs in low relief.[23] The sacral ivy with ele-
gant spirals on the blade of what may be a
Cretan import from grave IV was gilded [172].[24]

One type A sword from the same grave had griffins, another from grave V wild-looking horses [176A], galloping down each side of the midrib.[25] Another sword from grave IV had a row of figure-of-eight shields down the length of a broad flat midrib resembling those of the early sword and dagger from Mallia [169, A and B].[26] The shields, and the rows of running spirals which flanked them on each side, had evidently been gilded. This relief decoration was cast with the blade, and the outlines were afterwards sharpened by chasing. Further details might be added by means of incision.[27] Type B swords might also have ridges or channels down the length of their midribs, some of which were decorated with horizontal or diagonal notches,[28] but the elaborate relief decoration found on type A blades is not in evidence.

The hilts and grips of swords and daggers from the shaft graves were normally made of wood which might be plated with ivory or gold, occasionally with bronze or silver.[29] The gold-plated hilt and grip of a type A sword from circle B were decorated in repoussé with a spiral network ending below in lion's heads which confronted each other across the top of the midrib [173]: the horned shoulders of the hilt were adorned with smaller animal heads.[30] The blade of this sword was engraved with griffins, and it was surmounted by a large ivory pommel.

Type B swords may have had six-sided grips, to judge from some gold plating which has survived from them.[31] The spiral designs of native tradition on the gold mountings from the hilts and grips of type B swords are consistent with the view that they are of local origin. One set of gold mountings has an imitation in repoussé of the plaitwork which may have been the standard covering for wooden sword handles to strengthen them and improve the grip.[32]

A number of ivory sword and dagger hilts like that of illustration 175C were decorated with spiral or maeander designs made with little gold pins which might have short bars as heads (see p. 185).[33] The bronze rivets fastening the hilts and grips to the blades, when not concealed by gold plate, were often capped with gold, less

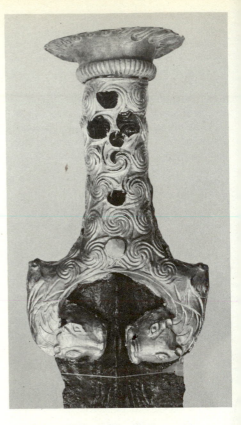

173. Plating of hilt and grip of type A sword from shaft grave circle B at Mycenae. Possibly Cretan work of Middle Minoan IIIB, c. 1600–1550. Gold. Greatest W 0.079 m. *Athens, National Museum*

commonly with silver. Many pommels were made of wood, and might be plated with gold, but others were of bone, ivory, or alabaster: a few of these boasted spirals or other designs in relief.[34] The spirals on one alabaster pommel had inlaid centres.[35] Among the elaborate pommels, one of ivory was carved in relief with four lions at the gallop, their noses meeting in the centre of the top,[36] while the gold casing of a wooden one was decorated in repoussé with a lion seizing a spotted panther or leopard [174].[37] Such ornate examples may have belonged to daggers.

The daggers from the Mycenae shaft graves were even more richly decorated than the swords.[38] The hilt of one remarkable dagger from grave IV [175B] was entirely encased in gold plate, on which scale-shaped compartments of gold (their position indicated on the plate beforehand by lightly incised patterns) had been soldered to hold inlays of lapis lazuli. The hilt ended below in the heads of eagles (or griffins) which clasped the top of the blade like the lion's heads of the gold sword hilt from circle B [173] (see above). The wood of the grip had been enclosed in openwork gold plate forming a network of cross-shaped flowers, their petals with soldered compartments holding inlays of lapis lazuli like the scales on the hilt. The spaces left open between the flowers were originally filled with rock-crystal.[39] This ex-

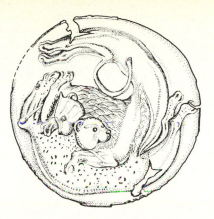

174. Lion chasing a panther on a pommel from shaft grave IV at Mycenae. *c.* 1550–1500. Gold. Actual size. *Athens, National Museum*

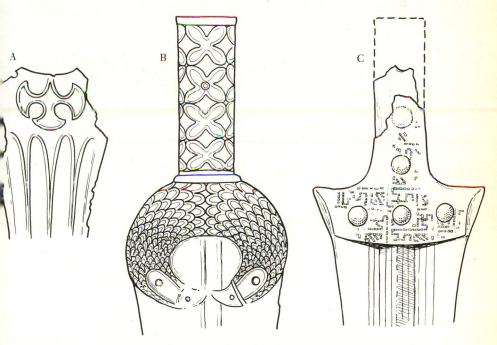

175. Dagger hilts (scale 2:3): (A) From Mochlos. Probably Middle Minoan III, after *c.* 1700. Bronze. *Herakleion Museum* (B) From the shaft graves at Mycenae. Middle Minoan IIIB–Late Minoan IA, *c.* 1600–1500. Bronze with gold plated hilt inlaid with lapis lazuli and rock crystal. *Athens, National Museum* (C) From the shaft graves at Mycenae. Late Helladic I, *c.* 1550–1500. Ivory with gold pins. *Athens, National Museum*

ceptionally fine weapon may have been made in
Crete. A 'Caphtorite', presumably Cretan,
weapon adorned with gold and lapis lazuli is
listed on one of the tablets from Mari in Meso-
potamia destroyed by Hammurabi in 1759.[40]

Short dagger blades did not require a midrib
for strength like sword blades. Instead, most of
the shaft grave daggers have between the cut-
ting edges a wide, more or less flat central space
which lent itself to relief, or incised, or inlaid
decoration. For example four griffins of dim-
inishing size in very low relief, reminiscent of
those which flank the midrib of the sword from
grave IV,[41] gallop down the flat central space of
an unusually long dagger of a type with flanged
shoulders and tang from grave V [176B].[42] The
flat centre of another dagger of this type has an
elegant network of spirals which decrease in
size as they approach the tip of the blade.[43] The
ivory grip was decorated with similar spirals
inlaid with fine gold pins (see p. 185).

The most remarkable of the daggers are those
with a metal strip inserted into the space be-
tween the cutting edges on each face of the
blade. On one from grave V the strips, appar-
ently of silver, were left plain,[44] but normally
they bore designs or pictures of some kind. Thus
the gold strips on another blade from grave V
were incised with an elegant network of spirals
filled with black niello.[45] The spirals diminish
in size towards the tip of the blade, and the
larger ones have rosette centres. Still more
elaborate are the strips with inlays in shades of
gold, silver, and electrum, combined with
niello, such as those of some hard alloy inlaid
with electrum lilies in the faces of yet another
dagger blade from grave V.[46] The lily design
was continued in repoussé on the gold mount-
ings of the hilt and grip.

The three most celebrated of these inlaid
blades are one from grave V with scenes in a
landscape reminiscent of Egypt [179],[47] and two

176. (A) Horses on a sword and (B) griffin on a dagger from shaft graves IV and V at Mycenae. *c.* 1550–1500.
Bronze. Actual size. *Athens, National Museum*

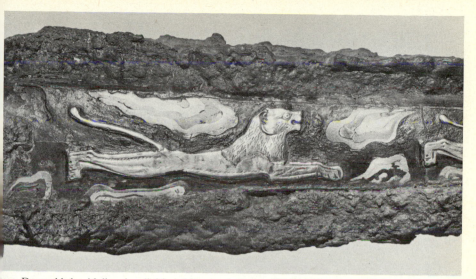

177. Dagger blade with lions in relief from Mycenae shaft grave IV. Possibly mainland work of Late Helladic I, *c.* 1500. Bronze, inlaid with gold and silver against a background of niello; the lions plated with gold. w 0.045 m. *Athens, National Museum*

178. The Lion Hunt dagger blade from Mycenae shaft grave IV. Perhaps Cretan work of Late Minoan IA, *c.* 1550–1500. Bronze, inlaid with gold and silver against a background of niello. w 0.063 m. *Athens, National Museum*

from grave IV: the Lion Hunt dagger [178]; and another which is unique in combining inlays with relief [177]. The decorated strip inset on each face has three running lions cast in low relief and plated with gold, a darker shade being used for their manes. The lions are curiously stiff and heraldic in appearance, although they are rendered with great skill and attention to detail. The conventional rocky landscape above and below them is inlaid in two different shades of gold and in white silver.[48]

The Lion Hunt dagger is the largest of the three.[49] The inlaid strips are made of some dark alloy and have slightly curving faces. On one side a solitary lion has seized a gazelle, while four other gazelles make their escape. On the other side [178] is the lion hunt, with five men dressed in tasselled 'shorts' and armed with bows

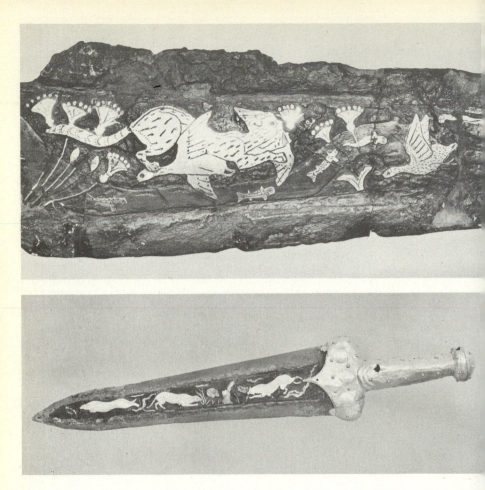

179. Dagger blade inlaid with Nilotic scene from Mycenae shaft grave V. Probably Cretan work of Late Minoan IA, *c.* 1550–1500. Bronze inlaid with gold and silver against a background of niello. W 0.047 m. *Athens, National Museum*

180. Dagger with gold-plated hilt, and scenes of large cats hunting on the blade, from a tholos tomb at Routsi in Messenia. Possibly made on the mainland in Late Helladic II–IIIA, *c.* 1450–1350. Bronze inlaid with gold and silver. L 0.32 m. *Athens, National Museum*

or with spears and great body shields, like the warriors on the silver relief vase from grave IV (see p. 160), except that the hunters are not wearing helmets. A wounded lion has felled one of his attackers, while two other lions run away. The figures are composed of electrum of three different shades, silvery, light golden, and darker red-gold. Details were incised and filled with niello.

The dagger from grave V [179] is the smallest of the three, but the most interesting from a technical point of view.[50] The scenes on it are evidently based upon Egyptian pictures of trained hunting cats. On each face two cat-like animals chase water-fowl against a background of stylized papyrus plants with a winding stream full of silvery fish. The cats are depicted in shades of gold, the birds and plants in combinations of gold and silver. Details in the figures were incised and filled with niello, and the whole of the background on each face was cut away and replenished with niello, except for the streams, which were therefore the only parts of the strips forming the base of the decoration left visible.

Other inlaid daggers recovered from somewhat later contexts on the mainland include two large and very fine ones from a tholos tomb at Routsi near Mirsinokhori in Messenia,[51] one [180] with scenes of cat-like animals hunting against a background of niello reminiscent of the shaft grave dagger, the other adorned with rows of gold and silver argonauts amidst rock and seaweed recalling the Marine Style of Crete. A dagger found outside a tholos tomb at Katarrakti (Pharai) in Achaia was inlaid with gold dolphins with details in silver and niello.[52] Remains of another with scenes which included men swimming were recovered from the Vapheio tholos tomb near Sparta[53] together with a pair of flying fish on such a different scale as to suggest that they were inlays from another dagger.[54]

The technique of this 'painting in metal' was elaborate. Sometimes, when the design was simple, as in the case of the solitary dolphins on each side of a dagger with silver-capped rivets from Prosymna,[55] the cuttings for the inlays were made directly in the faces of the blade. Normally, however, the designs were executed on separate strips of some different alloy from the blade, selected perhaps because it was easier to work. Inlays of gold and silver were cold-hammered into place in shallow cuttings prepared for them, but where niello was used as a background they might be simply embedded in it before it was hardened by heat. Details were regularly incised and filled with niello. After the decoration had been completed the strips were hammered into slots down the middle of each side of the blade. The artists showed great skill in combining the different precious metals, silver, gold, and electrum. The shades of gold which they exploited were probably the result of natural impurities rather than of deliberate alloying to obtain variety of colour.

The technique of inlaying in precious metals combined with niello appears to have reached the Aegean from Syria.[56] Although the scenes and the style in which they are executed on many of the daggers look Cretan, no daggers or metal vases with inlays have yet been identified in Crete, while the number from the mainland continues to increase. But the blade of a large dagger inlaid with gold axes against a background of niello found many years ago on the island of Thera[57] must date from the period before the eruption of c. 1500, when the island was strongly under Cretan influence, and there are also arguments for thinking that the inlaid cup [150] from Mycenae shaft grave IV is Cretan work (see p. 158). It is therefore just possible that the absence of inlaid metal work from Crete may prove to be a freak of chance.

A dagger blade allegedly from the Lasithi plain in Crete, with remains of silver capping on one of the three large rivets, has a man spearing a wild boar engraved in outline on one face and a battle between two bulls on the other.[58] The engravings look genuine, although they have been suspected as modern additions. The outlines might originally have been filled with gold wire, and this could be interpreted as a stage in the development of inlays on dagger blades; but the blade, with a tang (now missing) for the grip and a hilt with flanged, slightly cruciform,

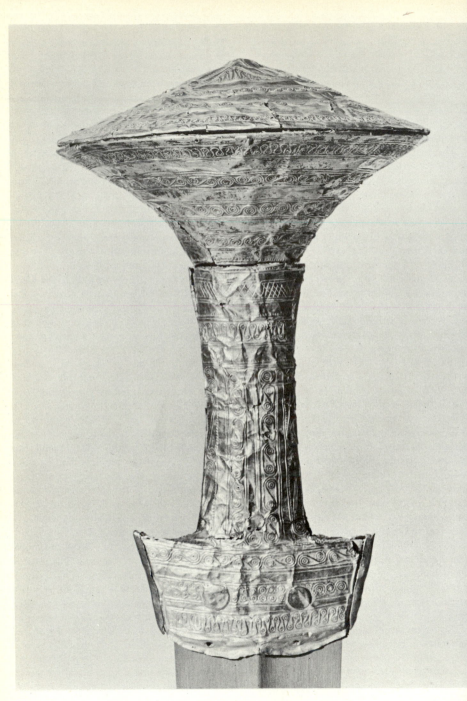

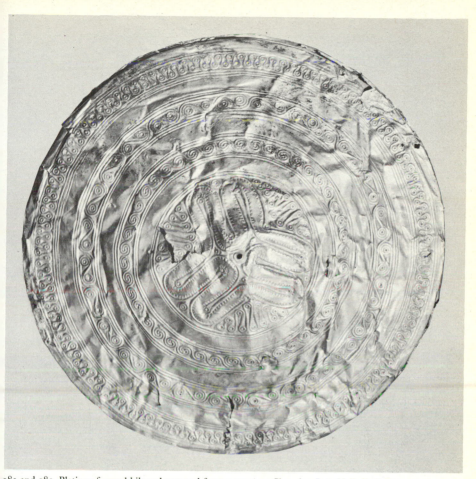

181 and 182. Plating of sword hilt and pommel from a grave on Skopelos. Late Helladic I–II, *c.* 1550–1450. Gold. L 0.24 m., D of pommel 0.14 m. *Athens, National Museum*

shoulders, belongs to a type still current in Crete in the early part of the fifteenth century, and might therefore be contemporary with, or not much earlier than, the inlaid daggers from the Mycenae shaft graves.[59]

Shaft graves were not confined to Mycenae: plundered examples of about the same period have been identified at Lerna.[60] A tomb which may have been a kind of shaft grave at Staphylos on the island of Skopelos in the northern Aegean

produced treasures comparable with those from Mycenae, including a gold diadem and silver cups, along with a large type B sword [181, 182].[61] Its hilt, grip, and outsized pommel were entirely covered in gold which bore elaborate spiraliform decoration of the native type so well represented in the Mycenae graves.[62] The tomb, however, with pottery including 'Ephyraean' stemmed goblets and squat alabastra appears to date from *c.* 1450, after the shaft grave era.

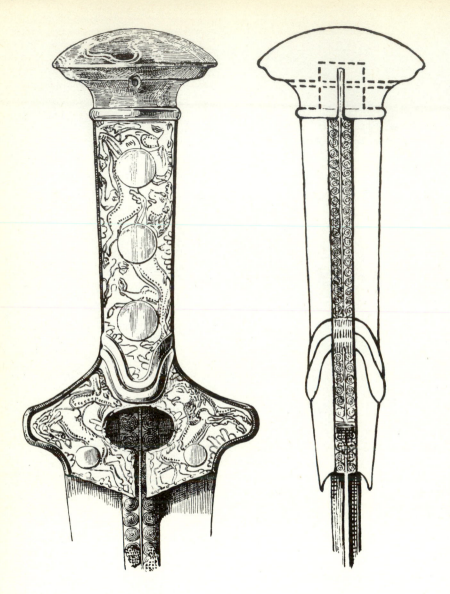

183. Sword hilt from Knossos. Late Minoan II, *c.* 1400. Gold-plated. Actual size. *Herakleion Museum*

Fine gold-mounted weapons have been recovered both in Crete and on the mainland from later graves, notably those of warriors of the end of the fifteenth and beginning of the fourteenth centuries at Knossos, and from contemporary tombs at Dendra in the region of Mycenae. In the so-called Chieftain's Tomb at Knossos were two swords, one with a cruciform hilt and an agate pommel [183], the other with a horned type of hilt and an ivory pommel.[63] The midribs and the sides of the flanges round the hilts and grips of both were decorated with running spirals in relief, but the hilt and grip of the cruciform sword were covered with gold plate incised with pictures of lions chasing wild goats [183]. A neat spiral network in low relief adorned the gold plating over the grip and hilt of a cruciform sword with ivory pommel from another contemporary warrior grave at Knossos. The socket of the long spearhead from the same grave was incised with a butterfly with outspread wings.[64]

The spearheads of this period both in Crete and on the mainland were often cast in attractive shapes with flutes and ridges down the midribs and sockets. Neatly incised spirals run the length of the blade and socket on a large one found with burials of late-fifteenth-century date at Arkhanes near Knossos,[65] and four like those from Knossian warrior graves had been placed with the king's burial in the tholos tomb at Dendra along with five richly decorated swords.[66] One of these resembled swords of type B from the Mycenae shaft graves;[67] two of the others were of the horned, two of the cruciform type. The hilts and grips of the type B sword and of the two cruciform ones had gold mountings with spiral or other designs on them. The hilt, grip, and pommel of one of the horned swords were of ivory decorated with little gold nails with bar-heads of the kind found on some of the shaft grave swords and daggers like that of illustration 175C (pp. 176, 178).[68] About five thousand of these gold nails, it has been estimated, were required to complete the scheme of decoration

here. Another sword, apparently from the tomb at Dendra in which the bronze plate armour was found, had a similar ivory pommel with little gold nails of this kind, but in this case the bar-heads had been hammered flat to make a uniform surface which was then exquisitely engraved with interlocking spirals.[69] The hilt of a short sword (length 0.375 m.) found with a cruciform sword in a rock-cut tomb of about this time at Mycenae was also decorated with bar-headed nails:[70] the gold caps of the pair of rivets on the shoulder were edged with granulation forming a surround for blue material which appears to have been enamel (see p. 207), while the gold cap of the solitary rivet in the grip was surmounted by a rosette in cloisons with traces of similar blue material in them.

The evidence from the Mycenae shaft graves suggests that sword and dagger sheaths were made of leather, or of wood covered with leather or linen.[71] Those from the shaft graves were often enriched with goldwork, which normally bears decoration of some kind.[72] The shell cameo from the Throne Room of the palace at Knossos [103] shows a decorated sheath holding a sword or dagger with the belt or baldric from which it was slung (see p. 116).[73]

Shields of various types were current in the Aegean area during the Bronze Age, but the representations of them do not suggest that they were decorated or emblazoned like those of later Greece. Similarly the bronze plate armour in use by the end of the fifteenth century was for the most part at any rate severely functional to judge from the little which has survived.[74] Helmets on the other hand were often elaborate,[75] and by the time of the Mycenae shaft graves the basic conical type might be adorned with bronze plates or encased entirely in bronze with a plume flowing from the top. Many were covered with gleaming white boar's tusks – some apparently of this kind are depicted with a variety of horns and knobs projecting from them. The bronze casing of a helmet from a sub-Mycenaean grave at Tiryns is unique in having simple openwork and repoussé ornament.[76] But this dates from a time after the disasters which overwhelmed the mainland of Greece *c.* 1200, and

the decoration reflects the new style with north-
ern affinities that makes its appearance in the
Mycenaean world then (see pp. 25-6, 240-1).
The bosses in relief on a bronze belt and pair of
greaves which were found together with a burial
of the twelfth century in a chamber tomb at
Kallithea in Achaia are less obviously non-
Mycenaean in character.[77]

JEWELLERY

NEOLITHIC

The Neolithic peoples of the Aegean adorned themselves with simple beads and pendants of stone, clay, or shell. Curious stone objects from Early Neolithic levels in Thessaly may have been worn in the ears or nose [184A],[1] and from the earliest Neolithic deposits at Knossos in Crete come very fine stone rings that could have been used as bracelets by children or as pendants by adults.[2] Ring-pendants with a loop for suspension, an Oriental type with a long history in the Aegean as well as in Europe to the north, were normally of stone [184C], but a gold example was found at Sesklo in Thessaly in a Late Neolithic (Dhimini) context [184B].[3] In

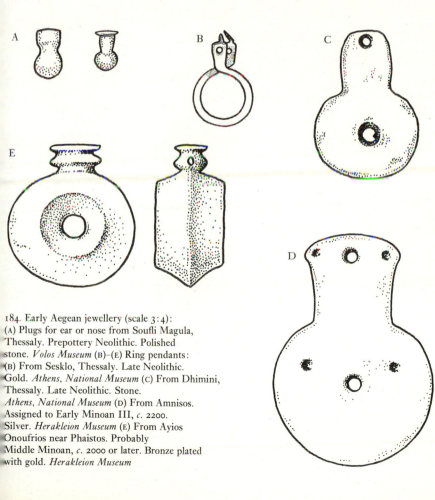

184. Early Aegean jewellery (scale 3:4):
(A) Plugs for ear or nose from Soufli Magula, Thessaly. Prepottery Neolithic. Polished stone. *Volos Museum* (B)–(E) Ring pendants: (B) From Sesklo, Thessaly. Late Neolithic. Gold. *Athens, National Museum* (C) From Dhimini, Thessaly. Late Neolithic. Stone. *Athens, National Museum* (D) From Amnisos. Assigned to Early Minoan III, *c.* 2200. Silver. *Herakleion Museum* (E) From Ayios Onoufrios near Phaistos. Probably Middle Minoan, *c.* 2000 or later. Bronze plated with gold. *Herakleion Museum*

general, however, there is little evidence for gold and silver jewellery in the Aegean before the Bronze Age.

EARLY BRONZE AGE (*c.* 3000-2000 B.C.)

Crete

The largest collection of jewellery assignable to the early part of the Bronze Age comes from communal tombs at Mochlos, notably from tomb II with burials of the Early Minoan II period dating from about the middle of the third millennium onwards.[4] Most of the similar jewellery recovered from early deposits in some of the communal tombs of the Mesara region of southern Crete, however, appears to date from the time of the early palaces *c.* 2000 or somewhat later.[5] Jewellery of a type vaguely comparable with that of the Mochlos tombs was at home in Egypt and Mesopotamia during the third millennium, but the antecedents of this

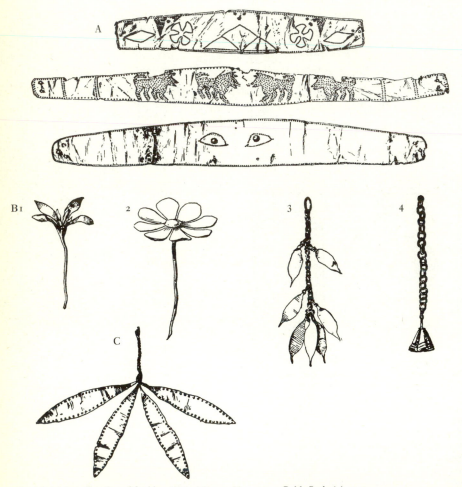

185. (A)–(C) Jewellery from Mochlos. Early Minoan II, *c.* 2500. Gold. Scale (A) 1:3; (B)–(C) 1:2. *Herakleion Museum*

earliest Cretan jewellery may lie in Syria and ultimately in Mesopotamia rather than in Egypt.[6]

The techniques used were relatively simple. Sheets of metal cut to the requisite shapes were decorated with dots raised from the back in repoussé. Gold and silver were also made into wire, and fine gold wire was used for chains with simple or double loops [185B (4), (3)]. Seager describes the chains from Mochlos as 'the finest specimens of gold work from the cemetery'.[7] A gold pendant on a double-looped chain like that of illustration 185B (3) from Mochlos was recovered from the lower deposit in the great circular tomb (tholos A) at Platanos,[8] and similar chains continued in use in Crete into the second millennium;[9] they are conspicuous in the jewellery of the Aigina treasure (see pp. 195-7) and also occur in the Mycenae shaft graves.[10]

Gold is the material chiefly used for the Mochlos jewellery as for the later jewellery from the Mesara tombs. The bulk of it, including the most elaborate varieties, appears to have been worn by women in their hair. Conspicuous at Mochlos are head-bands or diadems between 0.20 m. and 0.30 m. long with holes at the ends for strings by which they were fastened round the head. Some have simple decoration of dots in repoussé [185A]. While the designs are mostly geometric, one diadem [185A, below] has a pair of eyes, another four dog-like animals [185A, centre] represented in dots:[11] both show considerable traces of use, indicating that they were not just flimsy substitutes made for placing with burials, like much jewellery from Egyptian graves and some of that from the shaft graves at Mycenae.

A diadem with wild goats in dot repoussé, recently found with other gold jewellery in a silver vase at Mochlos, had upright strips attached to the upper edge,[12] while another with simple repoussé decoration from an early circular tomb at Lebena on the northern coast of Crete is cut to shape so as to leave a vertical strip rising from the centre. A fragment of gold from Calathiana in the Mesara, apparently from a diadem, boasts repoussé dot rosettes combined

with cut-out decoration reminiscent of the simpler cut-outs on a silver diadem from Amorgos (see p. 192).[13] This and most of the other gold diadems from Mesara tombs may date from the beginning of the second millennium rather than earlier.

Hair ornaments from Mochlos include flower-headed pins like illustration 185B (1), (2), which may have been worn with diadems, if they were not actually stuck through them to help keep them in place.[14] Some of the diadems show random pin-holes, while others have larger holes round their upper edges,[15] but these were probably for the attachment of upright strips, like those which still adorn the diadem recently found in a silver vase. The fashion of wearing flower-headed pins with diadems, which was in line with contemporary Oriental practice, and evidently sprang from an age-old custom of decking the hair with flowers in their season, was to be long-lived in the Aegean, and comparable head-dresses [196] accompanied women buried in the Mycenae shaft graves in the sixteenth century. The combination can still be observed on clay statues of goddesses from Crete assignable to the very end of the Bronze Age, like one from Gazi, who wears a head-band with poppies, or rather poppy-headed pins, rising above it [92] (see pp. 109, 199).[16]

The Mochlos jewellery includes beads and pendants of various kinds. Gold pendants, often in the shape of leaves, dangling from fine chains, like illustration 185B (3), (4) and 185C, may have formed part of the elaborate head-dresses worn by women. The two diadems from Schliemann's Treasure of Priam at Troy, buried about the same time as the Mochlos jewellery or not much later, consisted of chains with elaborate systems of pendants, in one case hanging from a narrow gold band.[17] There is no certain evidence for earrings at Mochlos,[18] although they were being worn at Troy by the time of Troy II and were in general use in Crete and elsewhere in the Aegean in later times. Stars and discs of gold appear to have been sewn on to clothes, like the somewhat comparable gold objects from the shaft graves at Mycenae several centuries later (see p. 203). Gold strips probably formed the

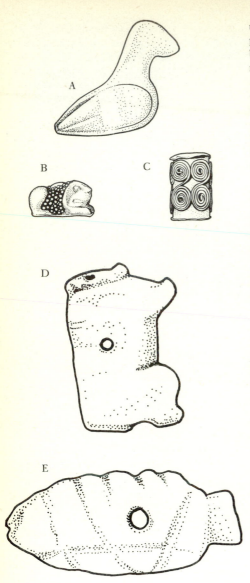

uprights of diadems as already described (see p. 189). Bracelets of gold plate may have had a backing of wood or leather.[19] They were often made in two separate halves, to judge from the Mochlos evidence. Thin gold foil was similarly employed during this early period in Crete to cover objects of other material. It was more commonly decorated than plate, because thinner, and therefore easier to work. Armlets, bracelets, and finger rings were also made of gold and silver wire.

Silver jewellery was rare in Crete at this time:[20] little was recovered at Mochlos, and it hardly occurs in the tombs of the Mesara region. But silver and lead seem to be more in evidence in northern Crete, owing perhaps to contacts with the Cyclades which had supplies of them. A remarkable silver pendant [184D] from what appears to have been an Early Minoan context in a burial cave near Amnisos north of Knossos is curiously like gold pendants of the Late Neolithic and Chalcolithic in the Balkans.[21] Other early Cretan pendants are in the shape of animals [186, B and D]. Several are of ivory [186, D and E],[22] and a bronze lion and a fine crystal bird [186A] were recovered from Mochlos.[23] Ivory birds and fish pendants [186E] and an elaborate ring-pendant were among jewellery from a circular tomb at Arkhanes assigned to Early Minoan III.[24] Ring-pendants of gilded bronze from Ayios Onoufrios near Phaistos may be of this period or somewhat later [184E].[25]

The Cyclades

The inhabitants of the islands lived in smaller, less wealthy communities than their contemporaries in fertile Crete. Jewellery like that from early Cretan tombs has been recovered from graves in the Cyclades, but there are scarcely any gold ornaments, and relatively few of native silver. Disc beads[26] and bird pendants[27] of soft stone resemble Cretan ones of gold or chalcedony, and a stone animal pendant is reminiscent of ivory ones from Crete.[28] Dress-pins mostly of bone or bronze, but sometimes of silver, may have ornamental heads in the shape of birds, jugs [187B], or double spirals [187A].[2]

186. Pendants and beads from early Cretan tombs: (A) Bird from Mochlos, crystal, (B) lion from Koumasa, gold with granulation, (C) cylindrical bead from Kalathiana, gold with filigree, (D) animal, probably a seated monkey, from Platanos, ivory, (E) fish from Koumasa, ivory. Early Minoan II– Middle Minoan I, c. 2500–2000 or later. Scale 3:2. *Herakleion Museum*

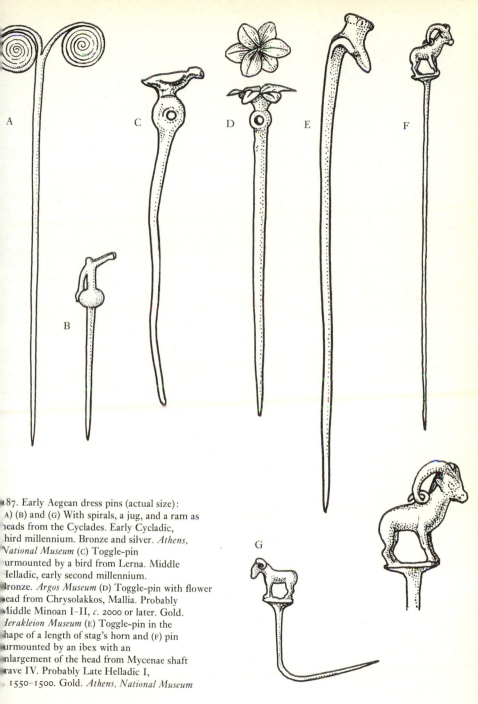

187. Early Aegean dress pins (actual size):
(A) (B) and (G) With spirals, a jug, and a ram as
heads from the Cyclades. Early Cycladic,
third millennium. Bronze and silver. *Athens,
National Museum* (C) Toggle-pin
surmounted by a bird from Lerna. Middle
Helladic, early second millennium.
Bronze. Argos Museum (D) Toggle-pin with flower
head from Chrysolakkos, Mallia. Probably
Middle Minoan I–II, *c.* 2000 or later. Gold.
Herakleion Museum (E) Toggle-pin in the
shape of a length of stag's horn and (F) pin
surmounted by an ibex with an
enlargement of the head from Mycenae shaft
grave IV. Probably Late Helladic I,
1550–1500. Gold. *Athens, National Museum*

188. Diadem from Chalandriani on Syros. Possibly *c.* 2000 or later. Silver. Scale 1:2. *Athens, National Museum*

A silver diadem from the Kastri settlement at Chalandriani on Syros, 0.048 m. wide and when complete nearly half a metre long, is decorated in repoussé with an elaborate scene of sun-discs flanked by dogs wearing collars and what appears to be a bird-headed deity with upraised arms [188].[30] Another from the Dokathismata cemetery on Amorgos[31] is plain, but has a serrated top with triangular cut-outs, reminiscent of a type of rayed diadem at home in Mesopotamia and recognizable in the reconstructed diadems from the Mycenae shaft graves (see p. 198).[32] With it was found a fluted silver bowl, and a silver pin surmounted by a ram [187G] which also has a shaft grave parallel [187F].[33] Both these diadems may date from the beginning of the second millennium rather than earlier.

The Mainland

Simple jewellery of gold and silver assignable to the Early Helladic II period contemporary with Early Minoan II in Crete has been recovered from tombs at Zygouries near Mycenae and on the island of Levkas. At Zygouries rings of gold and silver occurred singly in graves, suggesting that they were for the hair rather than the ears;[34] but a silver ring with a gold pendant attached [189B] seems to be an earring, and there may have been a custom of wearing only one.[35] Other finds included a small gold ring-pendant [189A], and a silver pin with a double spiral head like illustration 187A from the Cyclades.[36] Fragmentary silver diadems, one with traces of decoration in dot repoussé, are reminiscent of those worn in Crete and the Cyclades at the

time.[37] Similar jewellery from the contemporary R graves on Levkas included bracelets like those of illustration 189, E–F. A young woman was accompanied by a necklace of gold beads, mostly biconical in shape, and had a spiral bracelet of silver on each arm [189F]. Three gold rings like those from Zygouries may have been worn in the hair rather than in the ears [189D],[38] but a pair of triple rings [189C] from a cremation place in another of the burial mounds recalls the earrings worn by the head-shaped beads of the Knossos Jewel fresco [190] (see p. 75).[39]

A remarkable treasure in Berlin, said to come from Thyreatis in the eastern Peloponnese, has analogies with the jewellery from the destruction level of Troy II.[40] It may have been lost at the end of Early Helladic II, or in Early Helladic III at the beginning of the second millennium. An elaborate necklace has triangular pendants hanging from gold chains.[41] There are also a gold pin surmounted by a bull's head, and a gold juglet which evidently formed the top of another pin comparable to ones from Troy II and the Cyclades [187B].

In terms of jewellery this was an age when fashions were international throughout the Aegean. But Crete it seems was already in the lead in the march towards civilization, although the predominance of gold, as opposed to the silver more common in the Cyclades and on the mainland, may not be significant: in Egypt where gold abounded it was at one time less valuable than silver (see p. 154), and the use of gold in Crete may simply reflect the greater scope of foreign contacts, as indicated by the imported Egyptian stone bowls of Old Kingdom date found there.

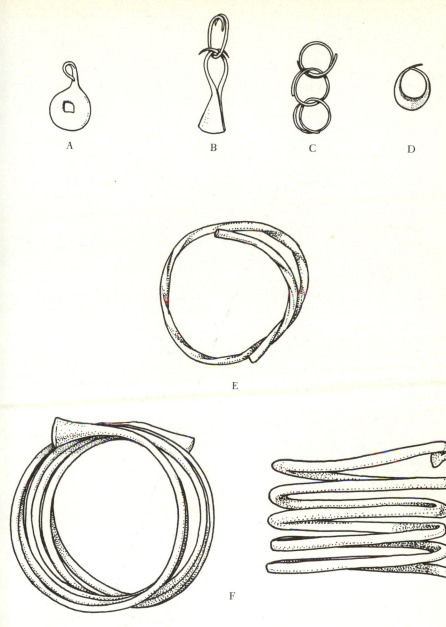

189. Jewellery from graves at Zygouries (A)–(B) and on Levkas (C)–(F): (A) Gold ring-pendant, (B) silver earring with gold pendant, (C) triple gold rings, probably an earring, (D) gold earring, (E)–(F) silver bracelets. Early Helladic II, c. 2500–2200. Scale 3:4. *Corinth and Levkas Museums*

MIDDLE BRONZE AGE (*c.* 2000–1450 B.C.)

Crete

The bulk of the jewellery from the circular tombs of the Mesara region appears to be assignable to the period of the early palaces round 2000 and later.[42] The chief collections come from the tomb at Kalathiana and from the upper level of the large tholos A at Platanos.[43] New techniques now employed include filigree and granulation, i.e. the art of decorating the surface of the gold with patterns made with fine gold wire or with minute grains of gold. The secret of attaching the grains was lost after about A.D. 1000, and has only been rediscovered in recent times.[44] A minute crouching lion of solid gold from one of the early circular tombs at Koumasa is decorated with granulation and had a design in filigree on the flat bottom [186B],[45] and fine spirals in filigree adorn cylindrical beads from Platanos and Kalathiana [186C].[46]

Earrings of the tapered hoop or penannular type, common in the Near East in early times,[47] were by now at home in Crete, where they occur in gold, silver, bronze plated with silver, and plain bronze. Triple-loop earrings are worn by the head-shaped beads of the Jewel fresco from Knossos [190] (see p. 75).[48] Finger rings with

▨ Yellow

▧ Red

■ Black

190. Head-shaped bead in the Jewel fresco from Knossos, now destroyed

bezels, at first circular, but later usually oval, were now in use, and by the end of the period gold rings and their bezels were being decorated with inlays held in place by cloisons like illustration 207A.[49]

Hard stones like rock-crystal, imported amethyst, and cornelian were already used for beads and pendants by *c.* 2000. A hollow gold bead in the shape of four human heads from a Late Minoan IB deposit in the Cretan settlement of Kastri on Kythera recalls those of the Jewel fresco, while ones in the form of animals, which appear to be of more or less the same date, include three from the palace at Knossos – a lion, a duck, and a fish [207B] – made like the Kythera bead of two thin plates of gold with overlapping edges and a fill of some kind of plaster.[50] The duck, which was found in a deposit below the floor of the upper East-West corridor in the residential quarter, is decorated with granulation, and the lion has a granulated mane. Two gold beads in the form of hollow plaques with a flat backing and a relief of a long-necked bird preening itself against a background of lilies have been recovered from a tomb of Middle Minoan III–Late Minoan I date at Poros, site of the harbour town of Knossos.[51] Beads appear to have been used for bracelets and armlets as well as for necklaces (pp. 197, 206), and as in later times women might wear them in their hair.[52]

Short bronze dress-pins were not uncommon in Middle Minoan tombs in the Ailias cemetery at Knossos. A gold one with flower head and swelling for a string-hole perforation, as found on Syrian 'toggle-pins', came from the Chrysolakkos funerary complex at Mallia [187D].[53] This great building may have been the tomb of the royal family who occupied the palace there during the first half of the second millennium. It was apparently plundered by the local inhabitants in the latter part of the nineteenth century A.D., and the name 'Gold Hole' suggests what they looted from it. But they overlooked, not only the flower-headed pin, but also one of the most remarkable pieces of jewellery ever found in excavations on Cretan soil [191]: a gold pendant in the shape of two bees heraldically posed each side of a granulated disc which

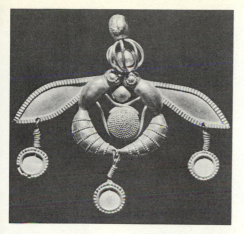

191. Bee pendant from the Chrysolakkos funerary complex at Mallia. Probably Middle Minoan IIB–IIIA, *c.* 1800–1600. Gold, with filigree and granulation. w 0.046 m. *Herakleion Museum*

may be meant for a honeycomb. Above their heads is a filigree cage, with a gold bead hanging loose inside it and a loop for suspension on top. The back of the pendant consists of a flat sheet of gold.[54]

The jewellery of the so-called Aigina Treasure which reached the British Museum in 1891 may have come from Chrysolakkos.[55] It seems to be Cretan work of the seventeenth and sixteenth centuries. A few of the objects, notably some gold beads in the shape of palm branches, are

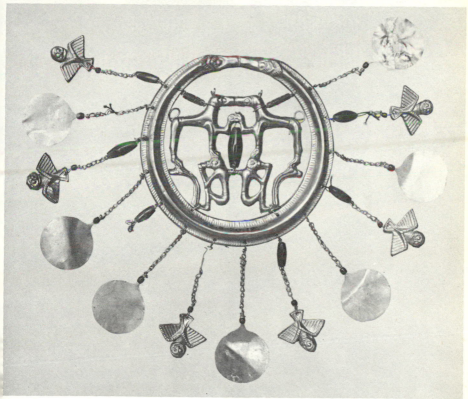

192. Earring from the Aigina Treasure, possibly from the Chrysolakkos funerary complex like illustration 191, and almost certainly Cretan work of Middle Minoan III, *c.* 1700–1550. Gold, with cornelian beads. w 0.065 m. *London, British Museum*

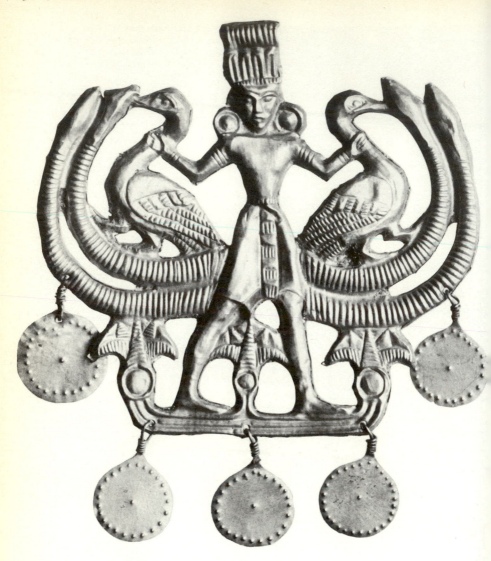

193. Pendant from the Aigina Treasure, possibly from the Chrysolakkos funerary complex like illustration 191, and almost certainly Cretan work of Middle Minoan III, *c.* 1700–1550. Gold. H 0.06 m. *London, British Museum*

comparable with ones from the shaft graves at Mycenae.[56] The treasure includes beads and pendants of gold, lapis lazuli, cornelian, rock-crystal, amethyst, and green jasper; gold finger rings, and discs and strips for sewing on to clothes, reminiscent of those from the Mycenae shaft graves; and three diadems, one of them decorated with running spirals executed in the traditional technique of dot repoussé. But the most remarkable of the gold objects are the great earrings and pendants. Two pairs of similar earrings, reversible and in openwork repoussé, consist of a ring in the form of a two-headed snake encircling a pair of greyhounds with collars and leashes [192], their muzzles joining over a long cornelian bead. Below them are a pair of monkeys seated back to back and engaged it seems in eating. From the ring hang gold double-loop chains with cornelian beads terminating in gold discs and flying owls. The finest of the pendants [193] is not reversible, but is backed by a flat gold sheet like the Chrysolakkos bees of illustration 191.[57] The upper plate, in repoussé, shows a god wearing a kilt with a long tassel hanging down in front, akin to that worn by the acrobat of the Mallia sword pommel [171] (see p. 174). He has a tall crown of what seem to be feathers, large disc-shaped earrings, and spiral bracelets on his wrists and arms; and he grasps the necks of a pair of birds, apparently geese. The curious bud-like objects to left and right are found in a sacral connection on later seal stones.[58]

The Cyclades

Some jewellery that has been assigned to the Early Bronze Age of the islands may date from this period, notably the silver diadem and ram-headed pin from Amorgos (see p. 192). Short bronze dress-pins and a group of silver rings, either earrings or hair-rings, have been recovered from the Akrotiri settlement on Thera buried by the eruption of c. 1500.[59] Wall-paintings from Akrotiri like illustration 38 show men and women with large circular earrings of the tapered hoop or penannular type common in Crete.[60] These are painted yellow for gold,

while armlets and bracelets are blue for silver. One of the boxers from Akrotiri wears anklets, and an armlet and necklace, all apparently made of silver beads (see p. 56).[61] Bracelets, evidently of twisted gold, worn by a woman in the wall-painting from Phylakopi on Melos [35A] (see p. 53) recall a twisted bronze one found at Mallia in Crete.[62]

The Mainland

Penannular or tapered hoop earrings like those from Crete have been recovered from several Middle Helladic tombs,[63] and a pair resembling ones from the Troy II treasures was found with the burial of a woman of early Middle Helladic date at Drachmani in central Greece.[64] Gold spiral rings with the same burial may have been worn in the hair, unless they were also for the ears. Dress-pins of the period were occasionally surmounted by animals, or by birds and jugs like those of earlier times.[65] A bronze bird-headed pin from Lerna [187C] has a swelling with a thread-hole like the gold flower-headed pin from Mallia [187D].[66]

From late Middle Helladic tombs at Corinth come bracelets of silver sheet and a diadem with repoussé decoration of dots, circles, spirals, and rosettes, reminiscent of diadems from the Mycenae shaft graves.[67] Gold beads from a tomb covered by a mound on the northern edge of the Bronze Age settlement at Thebes have an attractive arrangement of pendant spirals with drops resembling the Cretan papyrus-lily;[68] although tentatively assigned to Early Helladic II, they look as if they might be later.

The Mycenae Shaft Graves[69]

The collection of jewellery found in the shaft graves of circle A at Mycenae (see p. 23), although rich in terms of sheer bullion, is artistically disappointing. Most of it is of local make, with spiraliform and geometric designs in the native style, and many of the objects appear to be cheap, flimsy substitutes, carelessly produced for burial use. Nothing could be more eloquent than the contrast between the harsh, stylized

appearance of some gold lion ornaments from shaft grave III [194] and the alert look of illustration 195 from Ayia Triadha in Crete, with its rounded contours and delicate modelling, not to

194. Ornament in the shape of a crouching lion from Mycenae shaft grave III for contrast with illustration 195. Late Helladic I, *c.* 1550–1500. Gold. L 0.036 m. *Athens, National Museum*

195. Ornament in the shape of a crouching lion from a tomb at Ayia Triadha, for comparison with illustration 194. Probably Late Minoan I, *c.* 1550–1450. Gold. L 0.027 m. *Herakleion Museum*

mention the realistic tail in place of the spirals which serve its shaft grave relatives.[70] Indeed there is little fine jewellery in the Cretan tradition, and Cretan imports seem restricted to a

magnificent pair of earrings [200], a hair-pin [199], and an armlet [202], all from graves of circle A.[71] The situation is very different when it comes to the weapons, where Cretan types and the Cretan style of decoration predominate. Men it seems coveted the fine weapons of Crete, but were content to adorn themselves and their women-folk with traditional native ornaments. Most of the jewellery belonged to women, although some of it, including the superb gold and silver armlet of Cretan origin [202], was evidently associated with the burials of men.

The shaft grave jewellery continues the tradition of earlier jewellery of the Aegean area. Gold hair-bands or diadems are reminiscent of ones from contexts of the Early Bronze Age in Crete and elsewhere, and of those of the later Aigina treasure,[72] but most of them are wider, and somewhat oval in shape like some in use alongside narrow ones in northern Mesopotamia by *c.* 2000 or rather earlier.[73] The shaft grave diadems mostly have spiraliform or other designs in repoussé, and all appear to be local work:[74] there are two similar diadems, one with primitive dot repoussé decoration, from early Mycenaean tombs near Pylos,[75] and a fine example was found along with the gold cups (see p. 164) in the oldest of the tholos tombs at Peristeria.[76] While most of the Mycenae diadems came from women's graves,[77] one at least from grave IV may have been associated with a man.[78] This is unique, both for its archaic strip-like shape, and for the designs in a primitive-looking technique of punctuation. It is also unusual in having pendants hanging by chains from its lower edge.

Some of the shaft grave diadems had flowers attached to their upper edges [196]. Similar but more sophisticated examples of this type may have existed in contemporary Crete to judge from the Knossian Priest King fresco (see p. 76).[79] Narrow triangles of gold plate, their long sides strengthened with bronze wire, appear to have been associated with diadems in some of the shaft graves and may have formed rayed crowns above them.[80] Four such rays made of silver, but with similar bronze strengthening,

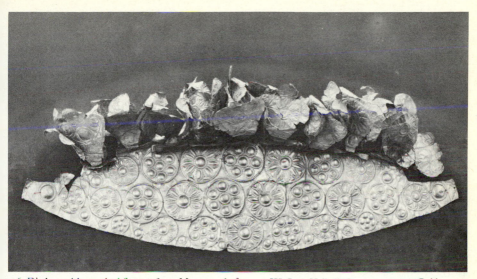

196. Diadem with attached flowers from Mycenae shaft grave III. Late Helladic I, *c.* 1550–1500. Gold.
H *c.* 0.27 m., L 0.625 m. *Athens, National Museum*

were recovered from an early Mycenaean tomb at Pylos:[81] the way the conventional palm trees which decorate these are set indicates that they were meant to stand upright.

Pins with star-shaped flowers like illustration 197, larger and more stylized than those from Mochlos, seem to have been hair ornaments worn in connection with diadems. A little girl in grave XI of circle B was accompanied by a gold diadem and three gold rosettes attached to bronze pins. Her locks were held in place by gold rings. Beads of rock-crystal, cornelian, and amethyst appear to have hung on her forehead.[82] Wall-paintings in Crete dating from before *c.* 1450, and later ones on the mainland, show the long hair of women entwined with strings of beads (see p. 194). Pins of bronze or silver with large heads of rock-crystal [198, B and C], ivory, or wood sheathed in gold, also appear to have been worn in the hair.[83] Some of the heads may represent poppies, like those springing from the diadem of the clay goddess from Gazi in Crete [92] (pp. 109, 189).[84] One, a Cretan import

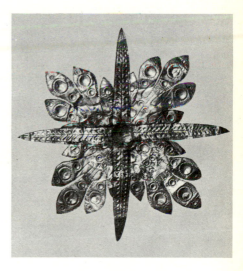

197. Flower head of a pin from Mycenae shaft grave III. Late Helladic I, *c.* 1550–1500. Gold. W 0.185 m. *Athens, National Museum*

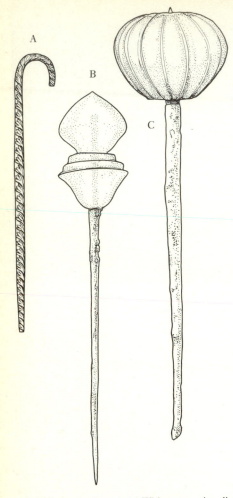

A

B

C

silver from the Mavrospelio cemetery at Knossos has a row of crocuses in relief on one side of the stem, and an inscription in the Linear A script on the other [198A].[86] Another, also of silver, but with a large and elaborate gold head in the shape of a long-skirted goddess, recovered from grave III at Mycenae [199],[87] may be Cretan in spite of its rather rough workmanship. The goddess, with her long flounced skirt and breasts exposed, wears bracelets and armlets like the god of the pendant from the Aigina Treasure on illustration 193 (see p. 197). Above her head rises an immense spray of papyrus-like flowers from which long branches droop

199. Head of a silver pin from Mycenae shaft grave III. Possibly Cretan work of Late Minoan IA, *c.* 1550-1500. Gold. H 0.067 m. *Athens, National Museum*

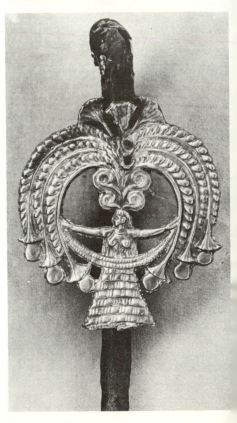

198. Hairpins (scale 1:2): (A) With crocuses in relief and an inscription down the length from the Mavrospelio cemetery at Knossos. Probably Late Minoan I, before *c.* 1450. Silver. *Herakleion Museum* (B) and (C) From shaft grave III at Mycenae with burials of women. Late Minoan I or Late Helladic I, *c.* 1550-1500. Bronze with crystal heads. *Athens, National Museum*

perhaps, was hollow, with a design like the veining of marble in red, white, and black paint, which showed through the transparent crystal.[85]

A type of hair-pin found in Crete during this period is curved at the top. Such a pin made of

ending in similar flowers with globular fruits or buds in them.

Objects with wooden stems sheathed in gold from the women's grave III appear to be spindles rather than hair-pins.[88] Dress-pins with thread-holes, reminiscent of the earlier pins from Mallia and Lerna [187, D and C] (see p. 197), are all it seems associated with burials of men.[89] With one exception[90] these 'toggle-pins' are of solid gold; the heads of two are in the shape of stag's horns with thread-holes running down their length [187E],[91] while one topped by an ibex [187F] resembles an earlier pin [187G] from Amorgos in the Cyclades.[92]

shaft graves. These great rings were hung from the ears by loops of thin gold wire. Most of the earrings from the shaft graves, however, are derivatives of an old Oriental type which was at home at Troy by the end of Troy II. A pair from grave Omikron of circle B are still close to early Oriental models.[95] But those from grave III of circle A have the ends converted into spirals [201A],[96] like some recovered from contexts of the local Early Bronze Age in the Balkans to the north.[97] The same graves yielded a certain amount of other, primitive-looking spiral wire jewellery, including armlets and beads [201B].[98] The closest relatives for the beads are again in

200. Earring from Mycenae shaft grave III. Probably Cretan work of Late Minoan IA, c. 1550–1500. Gold. W 0.075 m. *Athens, National Museum*

201. (A) Earring and (B) spiral bead of native types from shaft grave III at Mycenae. Late Helladic I, c. 1550. Gold. Actual size. *Athens, National Museum*

A

B

Earrings are attested only in the graves of women. One large gold pair appears to be Cretan [200],[93] elaborate versions of the tapered hoop or penannular type found at Knossos and elsewhere in the Aegean during the Middle Bronze Age (pp. 194, 197). The four-leafed petals resemble those of the dagger hilt inlaid with lapis lazuli, almost certainly Cretan work, from grave IV [175B] (see p. 177), while the arcades of the outside edges are reminiscent of those on Cretan vases of clay and metal assignable to the period before c. 1450.[94] Balls of gold, soldered at the centres of the petals and where they meet, are the only examples of true granulation from the

the Near East.[99] Similar spiral-ended jewellery has been recovered from a tomb at Thebes in Boeotia dating from the time of the Mycenae shaft graves,[100] and from a tholos tomb at Pylos in Messenia.[101]

Men as well as women wore armlets and bracelets, as shown in representations of Cretan origin, like the god of the Aigina Treasure [193], or the goddess of the pin from grave III [199]. The Cup-bearer of the Knossos fresco [49] also has a bracelet and an armband painted blue to indicate silver.[102]

The rather crude rosettes on a pair of gold armbands from grave IV at Mycenae, evidently made with a stamp pressed from the back of the sheet,[103] are local work, but a superb armband which comes from the same grave appears to be a Cretan import [202].[104] It consists of gold and

fresco (pp. 65–6).[107] Four belts or baldrics of gold plate were recovered from graves IV and V at Mycenae;[108] two are decorated in repoussé with rather crude six-petalled rosettes in the local style like the stamped armlets described above. The overlapping ends were fastened in position with solid gold toggles similar to gold and silver examples from later graves in Crete and on the mainland.[109] Anklets were worn in Crete, as represented on the feet of men as well as women in the remains of the Procession fresco to which the Cup-bearer [49] belonged,[110] but they do not appear to be attested on the

202. Armlet from shaft grave IV at Mycenae. Cretan work of Late Minoan IA, c. 1550–1500. Gold and silver. Actual size. *Athens, National Museum*

silver, cleverly combined: a gold base was partly overlaid by silver, which in turn was plated with gold. This brings to mind the Knossos Cup-bearer [49], who seems to be wearing a belt of silver combined with gold, unless the yellow is meant for copper or bronze.[105] A fragment of a metal belt from the Hittite capital, Boğazköy, was made of thin sheet silver cased in two sheets of bronze, the outer decorated with a sunk design of interlocked spirals picked out with gold wire.[106] It is uncertain whether the belt was an import or of local manufacture; but similar interlocked spirals on a scrap of wall-painting from Knossos appear to have decorated the belt of a large figure like those of the Procession

mainland: there are none from the shaft graves.

Necklaces were worn by men as well as by women in Crete. In the Mycenae shaft graves, however, beads from necklaces were very much commoner with the burials of women.[111] Some beads and even whole necklaces may have been imported, but foreign materials like amethyst and cornelian could have been worked locally, since they were used for making seals before this in Crete and later on the mainland. Vast quantities of amber beads were found in some of the shaft graves – over 1,200 in grave IV alone,[112] and a number in grave V with the burials of men.[113] The amber came from the Baltic, and may have been imported ready-

made as necklaces, since the beads are of different types from the mass of Aegean ones. The large rectangular spacers often found with them suggest that the necklaces were of the lunate shape, ultimately copied from Egyptian prototypes, but fashionable in parts of barbarian Europe by this time. The same shape is reproduced in the gold crescentic collars of the earliest Bronze Age of the British Isles.[114]

Gold beads are somewhat rare in the shaft graves. Spiral ones from grave III belong to the same family as the rest of the wire jewellery like illustration 201B found there.[115] A number of reversible gold relief plaques from this grave, mostly in the shape of octopuses, have string-holes which suggest that they also came from necklaces.[116] Two spherical gold beads have small lumps in repoussé that appear to be imitations of granulation,[117] the use of which is only attested in the shaft graves on the great earrings from grave III [200] (see p. 201). The fashion for it might have suffered a temporary eclipse in Crete at this time, since while it occurs on the bee pendant [191] from Chrysolakkos at Mallia, it is curiously absent from the jewellery of the Aigina Treasure like that of illustrations 192 and 193, which is thought to have come from the same tomb. But there are several gold objects with granulation from the Vapheio and Kakovatos tholos tombs assignable to the period immediately following the shaft graves, and granulation is well represented in later graves at Mycenae.[118]

Various strips of gold from the shaft graves appear to have been sewn on to clothes or material.[119] The same is no doubt true of the decorative gold plaques. Many of those found with the women in grave III are in the shape of animals or other objects [203, A–H]. Each consists of a plate of thin repoussé gold backed by a plain one to leave an empty space between.[120] Dogs, stags, leopards, lions, and imaginary sphinxes and griffins are represented, besides octopuses, birds, butterflies, and flowers. Two plaques are in the shape of shrines [203H], three of women who may be goddesses, one of them with birds on her head and shoulders [203G]. The themes of these ornaments, which number

203. (A)–(I) Cut-outs from the shaft graves at Mycenae. Late Minoan I or Late Helladic I, c. 1550–1500. Gold worked in relief, except (I) which is incised. Scale 1:2. Athens, National Museum

204. (A)–(C) Roundels with incised designs from shaft grave III at Mycenae. Probably Late Helladic I, *c.* 1550–1500. Gold. Scale 3:4. *Athens, National Museum*

some seventy-five in all, are Cretan, and they could have been imported, already sewn perhaps to some costly product of Cretan looms, since most of them have thread-holes. But similar ornaments have been recovered elsewhere on the mainland, notably from the early tholos tomb at Peristeria in Messenia along with the gold cups and a diadem comparable with ones from the shaft graves (pp. 164, 198).[121]

Much commoner were flat plaques with incised designs [2031, 204A–C],[122] most of them roundels like those of illustration 204 and largely of local manufacture, it seems. The designs are often very elaborate, and neatly made with skilful use of the compass [205]. Some are of Cretan derivation, although the majority are in the native spiraliform style like illustration 204C. About seven hundred of these plaques were recovered from the women's grave III, but there were over a hundred with the men in grave V. Some have thread-holes allowing them to be sewn to material, and these were no doubt used

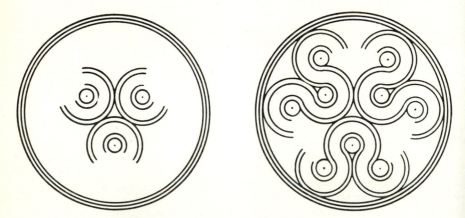

205. System of making designs with a compass on shaft grave gold ornaments

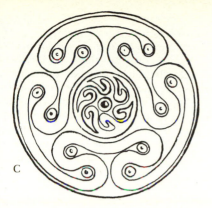

C

There seem to have been important changes of
fashion at the beginning of this period. Diadems
of precious metal are scarcely attested now,
although a fragmentary gold 'belt' from Kephal-
lenia looks as if it might have been a diadem,[124]
and diadems of gold beads may have been
worn.[125] Dress-pins are mostly simple and made
of bone. Earrings are no longer found on the
mainland, although they continue in Crete,
where a variety of tapered hoop, small but with
a richly granulated cone-shaped pendant, al-
ready fashionable before *c.* 1450, flourishes into
this time [206].[126] In general, however, the
jewellery in use throughout the Aegean after *c.*
1450 was very standardized. Perhaps as a re-
flection of gradual impoverishment, glass cast

as dress ornaments like the relief plaques, but
many without such holes may have been made
to place with the burials as substitutes for real
dress ornaments. In any case the plaques seem
to have belonged with the clothes in which the
dead were dressed, or with the shrouds or
bandages in which they were wrapped if that
was their manner of burial, for some of them
were recovered from below the bodies, while
others were found underneath the gold masks
and breastplates of the men in grave V.

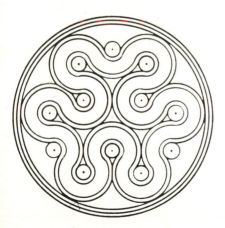

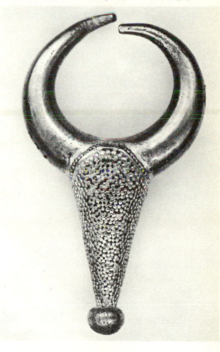

206. Earring with granulated pendant from the
Mavrospelio cemetery at Knossos.
Probably Late Minoan IB–IIIA, *c.* 1500–1300.
Gold. L *c.* 0.035 m. *Herakleion Museum*

in moulds became increasingly popular as a material at the expense of gold, of which the use came to be largely confined to the application in the form of gold leaf to glass beads, until at last moulded glass beads without any covering were the general rule except in Crete and Rhodes.

Beads were of many different varieties. Some had a Cretan ancestry which went back before *c.* 1450. Many of the shapes are derived from nature, such as rosettes, lilies, ivy and palm leaves, argonauts, and cockle shells [207C], but

Refugees from the Greek mainland and from Crete seem to have escaped to Cyprus in considerable numbers during the period after the disasters of *c.* 1200, and there may have been expert jewellers among them, since Mycenaean influence becomes apparent in Cypriot jewellery then. But the magnificent gold sceptre surmounted by a pair of hawks and decorated with cloisonné enamel coloured white, green, and mauve, from what was evidently a royal tomb of *c.* 1100 at Kourion, must be earlier Mycenaean

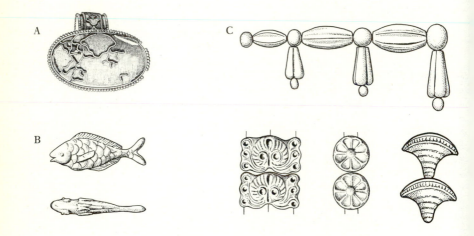

207. (A) Gold ring from Phaistos and (B) fish bead from the palace at Knossos with (C) later beads of gold and lapis lazuli from tombs at Knossos. *c.* 1500–1400. Actual size. *Herakleion Museum*

others include figure-of-eight shields, altars, and jugs, one of which from Pylos is decorated with inlays set in cloisons.[127] Cones, spiralling like snail shells, appear to have been especially favoured as belt ornaments.[128] The curious 'brackets' or 'curled leaf ornaments', commoner on the mainland than in Crete, may have been employed in crowns or diadems.[129] A diadem found in position on a skull in a tomb near Olympia consisted of rectangular glass plaques with spirals in relief.[130] These spiralled plaques, it seems, and also perhaps the 'curled leaf ornaments', were meant to imitate locks of hair.

work [208].[131] It was no doubt brought from the Aegean, like the bronze jar with reliefs on the handles which appears to have held one of a pair of cremation burials in the tomb (see p. 172).

Certain innovations in jewellery found on the Greek mainland during the twelfth and eleventh centuries are among the few positive hints that newcomers from the north have begun to settle in the Mycenaean world. These innovations include spiral-ended finger rings, reminiscent of the spiral jewellery like illustration 201B of the shaft grave period and earlier, but with contemporary parallels outside Greece to the north,

208. Sceptre from a royal tomb of *c.* 1100 at Kourion in Cyprus. Late Minoan/Late Helladic III, before *c.* 1200. Gold with enamel. H 0.165 m. *Nicosia, National Museum of Cyprus*

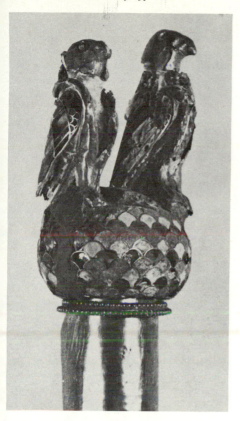

and wheel-shaped pendants and long dress-pins. The way in which these pins occur, one on each shoulder, with some burials of women suggests the introduction of a new and more primitive type of dress in the shape of the blanket-like peplos, which was still retained by the conservative Dorian Greeks in later times.[132]

TECHNIQUE

The earliest jewellery of the Aegean was composed of wire, and of gold plate or thinner gold foil cut to shape and decorated by embossing with punched dots in repoussé. Later, complex designs and figures were modelled in repoussé on jewellery as on plate, and stamps and moulds which were probably made of wood were also used.

Early in the second millennium the Cretans had learnt the art of hard soldering from Syria or Egypt, and were using it to fix wire (filigree) or minute globules of gold (granulation) to a background. About the same time or not much later inlaying of metal with precious stones like crystal and lapis lazuli, held in place by cells or cloisons, is first attested in the Aegean, and during the period after *c.* 1450 such inlays (using glass as well as stones) were very popular, especially for rings like illustration 207A. A development from this was cloisonné enamel, with coloured glass fused by heat into the cells, for which an Aegean origin has been suggested;[133] but it appears to be attested earlier in Egypt.[134] The sceptre from Kourion is an example of the technique, which was rarely used and soon forgotten, only to be rediscovered by Byzantine goldsmiths some two thousand years later. At the end of the fifteenth century a kind of champlevé enamel, with glass fused into hollows punched in a gold surface, also came into use in the Aegean, and this process may have been invented there.[135]

Two separate jewellers' working areas with stores of semi-precious stones and unfinished ornaments and beads have been identified at Thebes.[136] Glass also appears to have been made there. Finds from a similar working area at Mycenae among other objects include an unengraved seal.[137]

SEALS AND GEMS

Seals are more abundantly represented in the archaeological record of the Aegean Bronze Age than any other class of objects apart from pottery. Some five thousand prehistoric seals are known from the Aegean, many with two or more engraved faces. In addition there are about fifteen hundred devices from seals impressed in clay,[1] although few extant seals have been shown to be responsible for any of them. Most of the evidence comes from Crete, where seals appear to have been in continuous use from about the middle of the third millennium until the end of the Bronze Age. The number known, spread over this span of some one thousand five hundred years, averages four or five a year and is not impressively large, supporting the idea that many Aegean seals during the earlier part of the Bronze Age at least may have been made of perishable materials like wood (see below and pp. 214, 231-2).

In an age before the invention of locks, seals or engraved gems offered a way of identifying property and preventing access to it. A lump of clay over the lid of a jar, or covering the string which secured a box or door, could not be removed and replaced without detection if it was stamped with a seal, whose engraved device might add the deterrent of magic if the sealing was illicitly broken. Indeed seals were evidently a development from amulets and talismans: ornaments of materials thought to have magical and protective qualities, and carved in magical shapes or with magical designs.[2] Such charms, in the form of stone pendants, were already in use by the Halafian stage of Neolithic in northern Mesopotamia, and the earliest known seals are in effect pendants adapted for use as stamps. This adaptation had already taken place in Mesopotamia by an early phase of the Halaf period,[3] and even before that it seems elsewhere in the Near East.[4] Clay stamps occurred alongside stone pendants in the Neolithic settlement of Çatal Hüyük in Anatolia, and stamps of stone and clay like that of illustration 211A are found in the Neolithic of northern Greece, clay ones in that of the Balkans. Although these stamps appear to have been inspired by early seal usage further east,[5] there is no evidence that they were made as seals: they could have been employed for applying paint to the face and body, or for decorating cloth;[6] or they may have been just amulets. No stamps of this kind have yet been recovered from Neolithic contexts in Crete or the Cycladic islands, although there is always the chance that perishable wooden ones existed.[7]

The first evidence for seal usage in the Aegean dates from a mature phase of the Early Bronze Age: Early Minoan II in Crete, and the corresponding phases, Early Cycladic II and Early Helladic II, in the islands and on the mainland. These seals belonged to two different families: stamps and cylinders. Cylinder seals appear to have originated in southern Mesopotamia, where they are first attested during the Uruk period about the middle of the fourth millennium. The shape may be derived from an earlier use of sections of reed with designs engraved on their curving sides.[8] The fashion spread before long as far as Egypt, where cylinder seals were being made by the time of the First Dynasty *c.* 3000 or not much later.[9] However, while stamp seals are attested in Syria as early as Amuq Phase A in the sixth millennium, cylinders only appear there during Phase G, roughly parallel with the Egyptian First Dynasty and the Jemdet Nasr horizon which succeeds that of Uruk in Mesopotamia, although eventually they were to become the standard type in Syria as in Mesopotamia. But during Phase G both stamps and cylinders were in use, and it was probably during this period of 'incipient internationalism', as it has been called,[10] that the idea of seal usage spread from Syria to the Aegean.[11]

The standard Mesopotamian cylinder seal was reed-like, with a hole through the length. Some, however, were unperforated, and a variety of these had a loop handle at one end [211, C–E]. Most of the earliest Syrian cylinders were of this type with a loop handle, or had a U-shaped perforation at one end instead of a hole down the length, which was no doubt more difficult to make,[12] and cylinders of these Syrian types were eventually copied in the Aegean. While some Oriental cylinders of the standard type may have been imported to the Aegean during the third millennium,[13] cylinders of this type do not appear to have been manufactured there until later, and then only on a restricted scale.[14]

EARLY BRONZE AGE (c. 3000–2000 B.C.)

Crete

There is no evidence for the employment of seals in Crete before Early Minoan II, but by then they were being used and manufactured even in a small settlement like that at Fournou Korifi near Mirtos.[15] The majority of those from Fournou Korifi are long, somewhat conical stamps, of a kind which Evans tentatively assigned to Early Minoan I.[16] Most are engraved with combinations of crossing lines, an unenterprising system of design with a long history in Syria, and still found on seals there in Phase G, when cone-shaped ones, although not common, are also attested.[17] The settlement at Fournou Korifi was not a main centre, and more elaborate types of seals may have been in use elsewhere in Crete by this time.

The earliest Cretan seals were made of soft materials, like native serpentine and steatite, and imported ivory, or substitutes for it such as animal teeth, bone, and white stone. The ivory may have come from Syria, along with the original inspiration for seal usage. Resemblances between early Cretan seals and Egyptian stamp seals of the First Intermediary Period might reflect a common Syrian origin,[18] although Crete was probably in direct touch with Egypt long before this time. As in Egypt, wood may have been employed on quite an extensive scale for

the earliest Cretan seals. Another material occasionally used both now and later was clay, fired hard after it had been moulded and engraved. Soft materials like ivory allowed free scope for experiment.[19] Apart from cones [209A], geometrical shapes included pyramids, gables, knobs or hemispheres, rectangles, and cubes [209B]. One large ivory seal from an early communal tomb at Arkhanes near Knossos is in the form of three superimposed cubes, and has no less than fourteen engraved faces.[20] 'Signet rings' with circular or oval bezels may have developed from tubular beads with engraved facets. Disc-shaped bead seals have analogies in Syria in Phase G.[21]

Cylindrical seals are much in evidence. Some have looped handles,[22] a few, U-shaped string-holes in the top end, like early Syrian cylinders: but only the circular bottom is engraved with a device, and the curving sides are left plain – that is, the seals were not used for rolling impressions, and were in effect stamps. The majority had string-holes through the sides, like illustration 209C, leaving both ends free for engraved devices. Cretan cylinders were often made of ivory, and most, but by no means all, have been recovered from communal tombs of the Mesara region in the south.[23]

A shape that may have been adapted from the standard Oriental cylinder is the prism with equal-sided triangular section [209D].[24] The string-hole through the length is retained, but the curving sides are transformed into three flat engraved faces. Prism seals in this early period were almost invariably made of soft stone, and they were evidently most at home in northern and eastern Crete.[25] Their primitive appearance led Evans to assign the most crudely engraved to Early Minoan I, but they all seem to be later. Most of the seals from the workshop at Mallia dating from the beginning of the second millennium are prisms (see pp. 215–16, 232).

The largest and most elaborate of early Cretan seals were carved from ivory. Many have come from tombs in the Mesara, but a number have been found in northern Crete, especially at Arkhanes just south of Knossos. From Knossos itself there is a large ivory seal, in shape like a

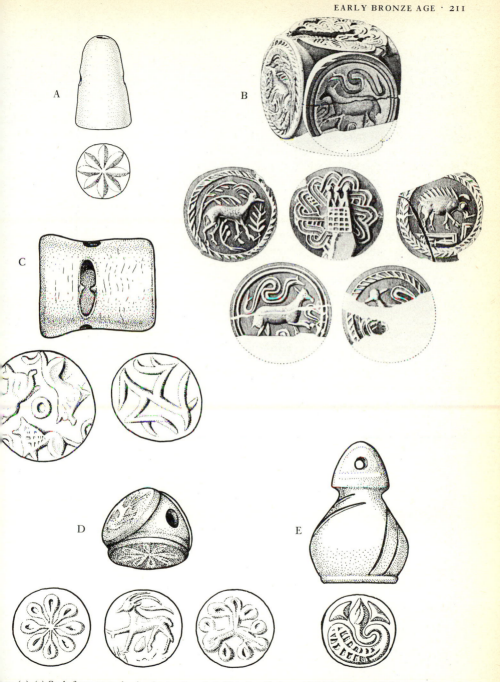

209. (A)–(E) Seals from an early circular tomb at Ayia Triadha. Early and Middle Minoan, before c. 1700. Ivory and steatite. Scale 3:2. *Herakleion Museum*

cylinder sliced in half, with an archer and his dog hunting a wild goat on the flat side, and what seems to be a courting scene on the curved one [210A].[26] This probably dates from the end of the period in Middle Minoan I c. 2000 or later. The Mesara seals display an extraordinary range in shape. Those from a tomb at Porti, which were comparatively few in proportion to the number of burials, included a cylinder, two more or less gable-shaped seals with flat circular engraved faces, a pair of ivory ring seals (ancestors of the 'signet rings' of later times), a small ivory seal in the form of a cockle shell, and another of soft white stone carved to represent an animal, surely a couchant lion rather than 'a small rodent squatting, probably a weasel', as suggested by the excavator.[27]

A number of early Cretan seals were made like this in the shape of animals or birds or their heads. One knob-shaped seal of ivory from the Trapeza burial cave in Lasithi is surmounted by a monkey [210C]:[28] even more elaborate are groups like the lion savaging a prostrate man

from Kalathiana[29] and the dove with a pair of young ones from Koumasa in the Mesara [210B].[30] Amulets in the shape of women in long robes,[31] or of human feet and the hoofs and paws of animals,[32] were sometimes engraved as seals.

The designs on early Cretan seals tend to consist of more or less elaborate patterns, sometimes symmetrical but often not. Lions, however, and other animals, and dangerous insects like scorpions and rogalidhas, the poisonous spiders native to Crete, are also represented, along with figures of men and women.

The Cyclades

A cylinder seal with a loop handle was recovered from what appears to have been a grave of a mature phase of the Early Bronze Age on Amorgos [211C].[33] Like the first Syrian cylinders, but unlike Cretan ones, this was engraved on the curving sides as well as on the bottom. Although the simple design of concentric circles has

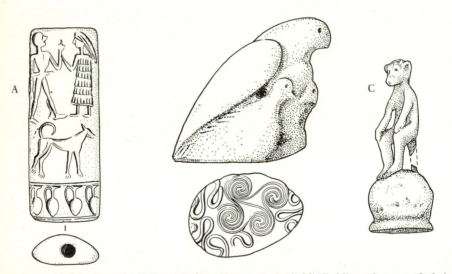

210. Ivory seals from Crete: (A) Half-cylinder from Knossos. Probably Middle Minoan I, c. 2000. Oxford, Ashmolean Museum (B) Seal in the shape of a dove with her young from Koumasa and (C) knob seal surmounted by a monkey from Trapeza, Lasithi. Early Minoan II–III, c. 2500 or later. Actual size. Herakleion Museum

Syrian analogies, the material, light grey-green calcite, appears to be local; but if the cylinder was locally made, it is curious that it should be almost unique in the Cyclades. Perhaps other Cycladic seals of this type were carved from perishable wood, like cylinders in contemporary Egypt, and many it seems in Syria and Palestine.[34]

Stamp seals may also have been in use in the islands, as they were in Crete and on the Greek mainland at this time. The evidence for them is tenuous, however, and none were recovered from Early or Middle Bronze Age levels at Phylakopi on Melos. Two seal stones are said to have been found on Melos with marble figurines, but one is a lentoid, and they both appear to be of much later date.[35] Circular stamps, however, were used by potters of the Syros culture (Early Cycladic II) to decorate certain types of vases, like the enigmatic 'frying-pans', with spirals and concentric circles [8].[36] Such stamps were presumably made of wood, and although they were not seals, the idea of them was no

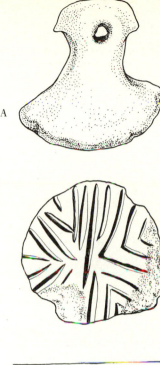

A

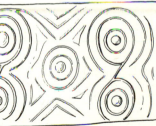

C

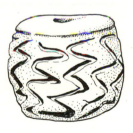

B

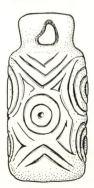

211. Stamps and cylinders from the mainland and the Cyclades: (A) Stamp from Sesklo, Thessaly. Neolithic. Clay (B) Cylinder from Dikili Tash, Macedonia. Late Neolithic. Clay (C) Cylinder seal from Amorgos. Early Cycladic, third millennium. Light grey-green calcite. Actual size

doubt inspired by seal usage. Wooden stamp seals may therefore have been current in the islands at the time; indeed actual seal impressions have been noted on clay vases of this period from the area. The circular impressions on a vase from the Kastri settlement at Chalandriani in Syros could have been made by an imported Egyptian seal rather than by the engraved end of a cylinder of local origin;[37] but a variety of seal impressions is reported on vases and hearth rims of the Early Cycladic II period at Ayia Irini on Kea.[38] Bone rings from contemporary tombs on Syros may have resembled early Cretan signets in shape, but their bezels were evidently not engraved.[39]

The Mainland

During the period when cylinder seals were first adopted in Syria some potters there took to using wooden cylinders or rollers to decorate clay vases. This fashion is attested in the Early Bronze Age in Cilicia, and by isolated examples from Samos and Troy. It also spread to the Greek mainland, where it flourished during the Early Helladic II period.[40] The potters' cylinders in use on the mainland had simple designs of zigzag lines or spirals. They were evidently of

212. Impression from Lerna made by a wooden cylinder. End of Early Helladic II, c. 2200. Clay. Scale 1:3

native manufacture, and one carved with two rows of spirals with a dog fitted into the space between them [212] was employed to decorate vases found at three different sites in the north-eastern Peloponnese: Lerna, Tiryns, and Zygouries.

No cylinders and not many stamp seals have been recovered from Early Helladic II contexts on the mainland. The stamp seals are like early Cretan ones and most of them could be imports from Crete.[41] But numbers of clay sealings have been found in fire-destroyed settlements on the eastern coast of the Peloponnese, notably at Lerna, where a couple of deposits are assigned to two successive destruction levels.[42] The Lerna sealings like illustration 215A were impressed by stamps. The designs, with their interlacing bands, round-bottomed jugs, lions, and spiders, do not closely resemble those of the wooden potters' cylinders current in the area, but are comparable to devices on some early Cretan seals – indeed some of the simpler ones are virtually identical;[43] for example the spiral net pattern on illustration 215A and that on an impression from the deposit at Phaistos [215B] which must be a couple of centuries or more later (see pp. 216–17).

The spiders which appear alongside dangerous creatures like scorpions and lions on early Cretan seals are no doubt the dreaded rogalidhas, still abundant in Crete, but not it seems attested on the mainland.[44] Spiders on some of the Lerna impressions are therefore particularly suggestive of Cretan inspiration. Nevertheless these seals may have been carved on the mainland, and if they were made of wood, as many Cretan seals of this early period appear to have been, it might explain why none with designs of this kind have yet been recovered there.

A number of seals have been found in Early Helladic III levels at Lerna.[45] Most of these are clay stamps of primitive appearance with simple devices. In contrast to the seals and seal impressions of Early Helladic II, they do not look Cretan, and their ancestry seems to lie in Anatolia, where similar stamps were in evidence from Neolithic times onwards. They may have been introduced by the Anatolian settlers who appear to have overrun southern Greece at the end of Early Helladic II. But a rough clay 'signet ring' is more likely to have been inspired by Cretan seals of this distinctive type.[46]

MIDDLE BRONZE AGE (*c.* 2000–1450 B.C.)

Crete

Hard stones like rock-crystal, amethyst, red and green jasper, cornelian, chalcedony, and agate, some of them already used for beads, now began to be exploited for seals,[47] and this was accompanied by the adoption of new techniques of engraving based upon the principle of the fast rotary drill. The use of the drill is clearly reflected in elements of design such as concentric circles, which first appear on seals in Egypt about the time of the Twelfth Dynasty from *c.* 2000 onwards. The employment of hard stones for the finer seals encouraged a trend towards the simplification of shapes, although ones in the shape of animals were still sometimes carved out of stones like amethyst [213F].[48]

The engraved faces of seals now tend to be made convex instead of flat, with the object no doubt of obtaining neater impressions. Thus the disc-shaped bead-seal with straight sides develops convex faces, and is eventually refined into the sharp-edged lentoid which becomes the standard type in the Late Bronze Age. The flat rectangular bead-seal similarly evolves in Middle Minoan III into the cushion-shaped 'flattened cylinder', with curving faces [213C and 222C], and ultimately with sharp edges like the circular lentoid. Both disc seals and flattened cylinders were often engraved on both sides.

Over a hundred engraved seals, whole or fragmentary, were recovered from a workshop area some two hundred metres west of the palace at Mallia.[49] The associated pottery suggests a date for these towards the end of Middle Minoan I *c.* 1900. The vast majority are prisms, mostly three-sided, but there are also cones, signets with stalks, and half-cylinders. Designs include abstract patterns, often with a twisted or whirling motion (torsion), and animals, birds, and fish, as well as spiders (presumably rogalidhas) and scorpions. There are boats, too, and human figures, including an archer, a potter with his vase, and a goddess with raised arms. Bone, evidently a substitute for ivory, lumps of rock-crystal, and softer stone were among the

213. Seals: (A) signet, (B) flattened cylinder, (C) prism with hieroglyphs, (D) façade design on disc, (E) lion-shaped, (F) scarab. Middle Minoan, *c.* 1800–1550. Cornelian, banded agate, rock-crystal, amethyst. Scale 3:2. *Oxford, Ashmolean Museum*

raw materials in stock. Bronze tools included little saws and drills, but obsidian was also used for working the seals it seems. The quality of the seals is very uneven, and appears to reflect the varying abilities of different craftsmen.

Several of the prisms from Mallia were engraved with signs of the so-called hieroglyphic script. Like the earlier prisms, hieroglyphic seals appear to be much at home in the northern and eastern parts of Crete. While most are three-sided like illustration 213C, some have four sides, and one with eight facets is virtually a cylinder.[50] Impressions made by early hieroglyphic seals have been found at Knossos in deposits assignable to the end of Middle Minoan I at the beginning of the second millennium.[51] Some of the later examples, dating from after c. 1700, are carved from hard stones and very finely engraved. One with a striking picture of a cat has reasonably been hailed as a royal seal [214].[52] While the three faces of the standard hieroglyphic seal offered a more ample field for inscriptions, other shapes, including signets and

214. Three-sided seal with signs of the hieroglyphic script and a cat. Bought in the Lasithi district, but evidently made at some major centre. Probably Middle Minoan IIB–IIIA, c. 1800–1600. Cornelian. L 0.018 m. *Oxford, Ashmolean Museum*

flattened cylinders, were also occasionally engraved with writing. The idea was perhaps derived from Egypt, where scarabs of the Middle Kingdom regularly sport inscriptions.[53] Egyptian scarabs of the Eleventh and Twelfth Dynasties certainly reached Crete and were sometimes reworked or imitated there [213F]; Oriental cylinder seals also continued to arrive, and a few Cretan beads of cylindrical shape carved with simple designs may have been meant for use as seals.[54] But neither the scarab nor the standard Oriental cylinder seems to have attracted the Cretans, although a few cylinder seals with string-holes through the length were made in fine imported stones like lapis lazuli and cornelian during Late Minoan I and II.

A new shape of stamp seal much in favour during Middle Minoan II was the signet on a stalk [213A]. The engraved face was sometimes rectangular, but normally circular, and convex. Some exceptionally elegant examples have faces of more complex design and elaborately carved stems. Most were made from soft stones like serpentine or steatite, although some were cut from hard stones, and a few of precious metals, gold and silver, have been recovered. The shape may represent a development from the conical and bottle-shaped seals of the earlier Bronze Age, like illustration 209, A and E, if it was not borrowed from Anatolia, with which Crete appears to have had close relations at the time. Impressions of seals of central Anatolian origin have been identified from the deposit at Phaistos.[55]

This deposit of clay sealings from the palace at Phaistos [215, B–D][56] seems to be assignable to the early part of Middle Minoan II c. 1800.[57] Nearly three hundred different devices are represented. Some appear to have been impressed by seals of hard materials, but most of those used may have been made of soft stones, as well as of ivory or wood. The impressions are mostly circular, but ovals, squares, rectangles, and other shapes occur. Over two-thirds of the devices are abstract patterns, which range from crossing lines like those on some Early Minoan seals, to elaborate spiraliform designs [215B]

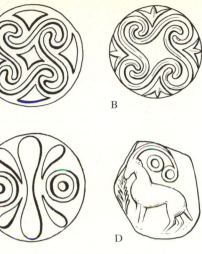

215. Seal impressions from the mainland and Crete: (A) From Lerna. End of Early Helladic II, *c.* 2100. *Argos Museum* (B)–(D) From the early palace at Phaistos. Probably Middle Minoan IB–IIA, *c.* 1900–1800. Scale 2:1. *Herakleion Museum*

and designs incorporating concentric circles made with the drill [215C]. A sophisticated class of design composed of crossing lines may be meant to represent the façade of a building or shrine; first attested in the Phaistos deposit, such façades often occur on the circular faces of disc-shaped seals [213D]. There are no impressions of northern prism seals at Phaistos, and only one type has a couple of signs of the hieroglyphic script, although hieroglyphic sealings are relatively common at Knossos about this time.

Animals, birds, and sea-creatures like octopuses abound, some of them rendered in a fine naturalistic style [215D]. Lions, goats [215D] and monkeys, even perhaps horses,[58] are represented, as well as imaginary griffins and sphinxes, Minoan genii (as they are called), and men and women. Once a man and woman appear to be holding hands, as on the large ivory half-cylinder from Knossos [210A] (see p. 212).[59]

A few seal impressions similar to those from Phaistos have been recovered from more or less contemporary deposits in the palace at Knossos.[60] Many of the Phaistos types also have analogues on seals from the communal tombs of the surrounding Mesara region, although here the use of the drill is hardly represented, suggesting in general an earlier date. It is true that a number of seals from the great tomb at Kamilari have drill-made designs resembling those on the Phaistos impressions,[61] but this was built after most of the others in the Mesara, and remained in use until the Late Bronze Age.

The sealings of the Hieroglyphic deposit from the palace at Knossos[62] [216, A and B] must date from a somewhat later period than those from Phaistos. They were found along with inscribed clay tablets in the fill below the stairway at the north end of the Long Corridor of the Magazines. Pottery evidence for the date of the deposit was lacking, but the archaic character of the inscriptions and the style of the impressions suggest the end of Middle Minoan II or the beginning of Middle Minoan III *c.* 1700–1600.[63]

One of the types, with a boy beneath a goat and spear [216A], has a background of crossing lines, an early feature that occurs on some of the Phaistos sealings. But the naturalism already

216. (A) and (B) Sealings from the Hieroglyphic deposit at Knossos. Probably *c.* 1700–1600. Clay. Actual size. *Herakleion Museum*

217. Seal impression with the head of a boy from the palace at Knossos. Middle Minoan IIb–IIIa, *c.* 1700–1600. Clay. *Herakleion Museum*

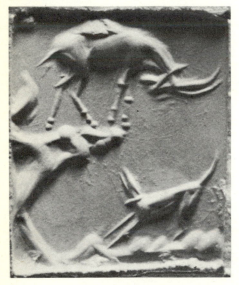

218. Impression from a small flattened cylinder seal, engraved with a wild goat and a collared hound, from Arkhanes. Probably Middle Minoan III, *c.* 1700–1550. Chalcedony. L 0.015 m. *Oxford, Ashmolean Museum*

apparent at Phaistos has been carried a stage further; indeed it looks as if some of the designs were chosen, not so much for their magical qualities, as for their beauty and power to delight. The subjects include animals like goats in rocky landscapes, and a remarkable marine scene with a fish and squid against a background of rockwork [216b]. Still more striking are three different heads [217], which might represent the features of a ruler of Knossos and members of his family rather than gods.[64]

The period from *c.* 1700 to *c.* 1450 saw the apogee of seal engraving as of the other arts in Crete. The finest products of Cretan seal engravers were unsurpassed anywhere else in the world at the time. Cretans had the advantage of being free of the limitations imposed by the cylinder shape of the Near East, and they were perhaps less constrained by tradition in their choice of subject and manner of presentation than their Oriental and Egyptian contemporaries. The tendency towards standardization in shapes, however, continued. Some stemmed signets were still being made, it seems, at the beginning of this period. The flattened cylinder also remained fashionable for a considerable time: its rectangular faces were ideal for pictures, and some of the finest examples of Cretan gem-engraving are found on seals of this shape assignable to Middle Minoan III (*c.* 1700–1550) [218, 231]. The flat-sided disc with convex faces evolved into, and was eventually replaced by, the thinner lentoid, or lens-shaped bead-seal, which could be worn conveniently on the wrist.[65] The amygdaloid, or almond-shaped seal, is first attested during this period. It seems to have evolved from the three-sided prism [213c], which also continued in use. Towards the end of the period a dumpy version of the prism is occasionally found, resembling the earlier illustration 209d in shape, but engraved only on two of the three faces.[66]

A type of seal which becomes increasingly prominent is the signet ring. The hoops of some of these are large enough to allow them to be worn on a finger, but often they are too small. At the beginning of the period the bezel was sometimes circular, but later it tended to be a

pronounced oval set with the long axis at right angles to the hoop [229]. A few signet rings were still made of stone or ivory, but the majority it seems were now of metal – bronze, gold with a core of some baser material, or solid gold – which allowed the engraving of fine detail in a way not possible on stone. Metal signets were therefore selected for representations of elaborate scenes of myth or cult. Some signets, all apparently assignable to the period after *c.* 1450, and mostly from the mainland, may have been plated with a combination of gold and contrasting silver, reminiscent of the shifts of colour in the background of wall-paintings (see p. 86).[67] Seals of other shapes were also sometimes made of precious metal (gold and silver), and occasionally of bronze.[68]

Seal-engraving, like other arts, was influenced by wall-paintings and painted reliefs, although their small size and shape made faithful reproduction of fresco scenes on seals difficult if not impossible. Some seals, however, and their impressions have a lower border of spirals or other designs reminiscent of the dadoes below many of the wall-paintings [219],[69] and it is even possible that some of the artists responsible for the

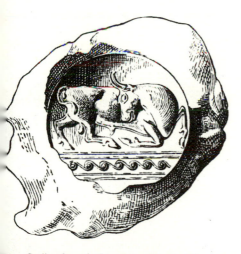

219. Sealing from the Isopata royal tomb at Knossos. Late Minoan II, *c.* 1400. Clay. Scale 2:1. *Herakleion Museum and Oxford, Ashmolean Museum*

paintings also engraved seals, on the analogy of Theodoros of Samos, engraver of gems, sculptor, and architect, in Archaic times.

The best seal engravers of this period are entirely free of any primitive *horror vacui*: their compositions reflect a sophisticated genius in the use of space, with the engraved scene often set unsymmetrically, balanced by emptiness. It is a far cry from the 'heraldic' scenes, and designs crammed to fill every part of the engraved face, characteristic of the later phases of the Bronze Age in the Aegean. Some of the most remarkable of the fine compositions assignable to the seventeenth and sixteenth centuries are found on gems of the rectangular flattened cylinder shape [218, 231][70] but striking ones also occur on amygdaloids and on the circular faces of discs and lentoids.

Materials used for seals apparently for the first time during the period after *c.* 1700 include meteorite; various imported stones like lapis lazuli from distant Afghanistan, lapis lacedaemonius or Spartan basalt from the Greek mainland, and haematite, a very hard black stone with a high metallic lustre; and the natural glass, obsidian.[71] Artificial glass was also being used to make seals in Crete before the end of Late Minoan I B *c.* 1450. The ends of the string-holes were sometimes capped with gold.

The pair of stone-lined cists known as the Temple Repositories in the palace at Knossos were apparently filled and abandoned at the end of Middle Minoan III *c.* 1550.[72] They contained the furniture of a shrine, including the series of exquisite faience plaques and statuettes (see p. 133). An important group of clay seal impressions was recovered from the eastern cist [220, A–D]. Scenes of bull-leaping and boxing [220B] on these, comparable with ones on the stone relief vase from Ayia Triadha,[73] may have been inspired by paintings or reliefs on the palace walls. There are also pictures of an armed woman, apparently a goddess, walking beside a lion, and a warrior, a king or god, attended by a lioness [220, C and D].[74] One remarkable group of impressions shows a man in a small boat under attack by some kind of sea-monster [220A].[75] Side by side with these scenes exe-

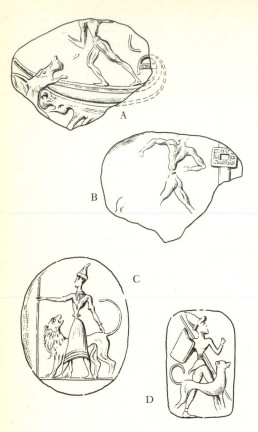

220. (A)-(D) Sealings from the Temple
Repositories at Knossos. Middle Minoan IIIB,
c. 1600. Clay. Scale 2:1. *Herakleion Museum.*

renders it difficult to secure a good impression,
which supports the idea that they were made as
charms or amulets in the first instance.[79] They
seem to be the successors of the earlier three-
sided prism seals like illustration 213C, which
may have fulfilled similar magical functions (see
p. 216) – a few are indeed prism-shaped with
devices engraved on one or more faces – but
they are for the most part of the amygdaloid
(almond) shape which evidently represents a
development from the prism.[80] The early prisms
were made of soft stones, but hard materials
were used for the talismanic gems, notably red
cornelian, less commonly green jasper. Con-
siderations apart from a regard for their attrac-
tive quality no doubt entered into the choice of
these stones. The criterion which above all dis-
tinguishes these gems, however, is the way in
which they were engraved: the designs were
executed in a brisk and time-saving technique,
with a wheel cutter for straight lines and a
tubular drill for circles and arcs; sometimes
indeed in so 'cursory and economical' a manner
that the designs are indecipherable. But the
work is usually neat and skilful, and the results
are often felicitous in a curiously abstract way.

Jugs with leafy sprays on talismanic gems
[221] indicate a concern with supplies of water.

cuted in a naturalistic style are some heraldic,
formally balanced, designs, and others of a
merely decorative character, including façades
of buildings [213D] of the type already in evi-
dence at Phaistos c. 1800 (see p. 217).[76] A couple
of the impressions were made by a seal engraved
with a 'talismanic' design.[77]

The so-called talismanic class of seals [221,
222, A and B][78] appears to have developed in
Middle Minoan III from c. 1700 onwards, and
may have had some special magical use. While
talismanic gems were occasionally employed for
sealing, the deep cutting on many of them

221. Impression from a talismanic gem,
engraved with a jug and leafy spray, from eastern
Crete. Middle Minoan III–Late Minoan IA,
c. 1700–1500. Cornelian. L 0.022 m.
Oxford, Ashmolean Museum

222. (A) and (B) Talismanic seals with a lion's mask and a rustic shrine (impression), (C) flattened cylinder from Palaikastro. *c.* 1700-1450. Black hematite, banded agate, steatite coated with gold leaf. Scale 4:3. *Oxford, Ashmolean Museum*

Lions' masks [222A] may be a charm for strength, flying birds for swiftness in the hunt or in war. Fish, octopuses, and cuttlefish, together with ships, suggest the interests of those who gained their living from the sea or voyages on it. Double axes may be symbols of divine guardianship, and pillared structures [222B] seem to represent rustic circular shrines for the existence of which in Crete there is some rather tenuous evidence.[81]

Large numbers of talismanic gems have been found in Crete, but relatively few in the Cyclades and on the Greek mainland. Their manu-

facture appears to have declined before *c.* 1450, when it may have ceased altogether. Their distribution suggests that they were most at home in the north, centre, and east of Crete, but there were impressions of several in the deposit of sealings buried *c.* 1450 at Ayia Triadha near Phaistos in the south.

A number of deposits of seal impressions have been recovered from the ruins of buildings destroyed at the time of the mainland conquest of Crete *c.* 1450. The two largest and most important were found in 1901 at Zakro [223, B-G],[82] and in the following year at Ayia Triadha near

223. (A) Design on a clay matrix from Knossos and (B)-(G) sealings from Zakro. Late Minoan I, before 1450. Scale *c.* 2:1. *Herakleion Museum*

224. (A)–(H) Sealings from Ayia Triadha. Late Minoan I, before *c.* 1450. Clay. Scale *c.* 2:1. *Herakleion Museun*

Phaistos [224, A–H].[83] A group from a basement on the southern edge of the palace at Knossos associated with the Palanquin fresco (see p. 58) appears to be assignable to this same horizon;[84] and another small but outstanding group came from a country house destroyed by fire *c.* 1450 at Sklavokampos in the foothills of Mount Ida west of Knossos.[85] The impressions were made by seals of various shapes, mostly it seems by lentoids, but also by amygdaloids and flattened cylinders, and by the oval bezels of metal signet

rings. At Ayia Triadha there are a few impressions of the long amygdaloids that appear to have come into use during this period, althoug they are more common after *c.* 1450. Impressions of hieroglyphic seals occur at Ayia Triadh: and Zakro, but it seems unlikely that seals wit hieroglyphic inscriptions were still being mad as late as this.

The representations are varied in characte A number show elaborate scenes of myth o ritual. What may be sanctuaries, akin to that o

the stone rhyton from Zakro (see p. 146), appear on two types from the deposit there associated with sacred figure-of-eight shields and once with a helmet [223B].[86] Another remarkable scene, with a female attendant making an offering to a seated goddess, is almost identical with a type well represented in the palace at Knossos by impressions, as well as by an actual clay replica (matrix) of the seal which was responsible for them [223A].[87]

Impressions from Ayia Triadha show a chariot [224G], and also women, apparently goddesses, rowing a bird-headed boat, or riding a dragon as on a fine seal of somewhat later date

225. Impression from a lentoid seal, engraved with a goddess riding on a dragon, from the area of the Tomb of Clytemnestra at Mycenae. Probably mainland work of Late Helladic II–IIIA, c. 1500–1300. Agate. D 0.027 m. *Athens, National Museum*

from the area of the Tomb of Clytemnestra at Mycenae [225].[88] Elaborate scenes of combat between warriors like illustration 224F, made by several different seals, are reminiscent of the battle of the Glen signet ring from Mycenae shaft grave IV [228A].[89] Bull-leaping is several times represented [224C], and at Ayia Triadha there are scenes with bulls caught in nets, as on one of the Vapheio cups [160], and on a fine gold almond-shaped seal from Routsi near Pylos on the mainland.[90] The bull sniffing a cow on the

other Vapheio cup [162] is paralleled by an impression from Zakro.[91]

Bulls and lions are the animals chiefly depicted, sometimes in combat with each other. From both Zakro and Ayia Triadha come types with altars or shrines flanked by lions [223C, 224B], reminiscent in a general way of the Mycenae Lion Gate [82].[92] A remarkable type occurring at Zakro, Ayia Triadha, and Knossos shows a pair of running lions with a palm tree in the background.[93] Other animals represented include wild goats and the occasional pig or wild boar. There are also imaginary sphinxes [223G] and griffins, and at Ayia Triadha butterflies and birds.

Many of the more elaborate scenes with their fine detail appear to have been impressed by the oval bezels of metal signets, but stone seals, mostly lentoids, were evidently responsible for the bulk of the types, and a number of them, notably at Ayia Triadha, were from talismanic gems. A special class of large circular impressions from Zakro shows monsters of one kind or another [223, D–F].[94] There are bulls with human arms, and a woman with a bull's head and wings. Other winged figures include 'Eagle Ladies' [223D] – women with the heads of eagles or hawks and sometimes with bird's tails – and men with goat's heads [223F] wearing tasselled 'shorts' like the men of the Mycenae lion hunt dagger [178] (pp. 179–81). One figure with a plumed helmet and bird's tail is holding her hands to her breasts. A pair of breasts has wings, and a helmet in place of a head [223E], and there is a lion-headed monster with the body of a bird and human arms. The quality of the seals responsible for these 'monster' impressions varied.[95] Some of the engraving was evidently very fine, with careful detail, but much of it was crude, degraded, simplified work. The seals appear to have been of local origin, and no doubt the designs had some magical import, rather than merely reflecting the aesthetic whims of their makers.[96]

A number of sealings which came from different sites destroyed c. 1450 appear to have been impressed by gems which were identical, or even in some cases by the same gem.[97] Most

instructive are the few impressions from the small country house at Sklavokampos with scenes of bull-leaping and chariotry connecting with ones like those of illustration 224, C and G, from Ayia Triadha and Zakro. The evidence suggests that the clay used was local, and that the impressions were made at Sklavokampos by gold signets of the finest quality, or by official clay replicas of them like the one of which the design is shown in illustration 223A actually found in a deposit of this period in the palace at Knossos (see p. 223). Indeed it has been suggested that the original gold signets may all have been the products of the workshop of a single Knossian master-craftsman. At all events these identical impressions afford a glimpse at the machinery of a complex bureaucratic system, and hint at the existence of some form of unified rule with Knossos as its centre.

The Cyclades

Seals are hardly attested in the islands during the earlier part of this period from c. 1700 onwards. Several have been found at Ayia Irini on Kea, but the settlement there appears to have received colonists from Crete in Middle Minoan III A: the seals might therefore be indistinguishable from Cretan ones even if they were locally made.[98] But the crudely engraved sphinx on a jasper lentoid from Thera, buried at the time of the eruption c. 1500, has the air of native work.[99] Even cruder and still more suggestive of a native style is the woman before a shrine on the circular bezel of an ivory signet ring from the settlement at Phylakopi on Melos.[100] This, the only seal recovered during the course of massive excavations on that extensive site, appears to have been lost at the time of some catastrophe – possibly more or less contemporary with the mainland conquest of Crete c. 1450 – which preceded the building of the small Mycenaean palace there. An isolated seal, however, alleged to come from one of the cemeteries at Phylakopi, seems to be Cretan of the talismanic class,[101] and a number of Bronze Age seals from graves of the Archaic period on Melos also look Cretan.[102]

The Mainland

Seals were virtually unknown on the mainland, it seems, during the two or three centuries between the end of the Early Helladic period c. 1900 and the time of the Mycenae shaft graves. Indeed only three seals are recorded from the graves of the earlier circle B,[103] and two of these are ordinary Cretan seals of the talismanic class, which had apparently been incorporated in necklaces worn by women.[104] Their presence in the richly endowed tombs of princely families at Mycenae illustrates in a vivid way the gulf that still existed between the civilized world of Crete and northern barbarism. The third seal, associated it seems with a man's burial, is a small, thick disc of amethyst with convex faces, one of which is engraved with a bearded male head [226].[105] This has been hailed as a portrait

226. Disc-shaped seal with the head of a bearded man from shaft grave circle B at Mycenae. Probably Cretan work of Middle Minoan IIIB–Late Minoan IA, c. 1600–1500. Amethyst. D less than 0.01 m. *Athens, National Museum*

of a Mycenaean prince, if not of the one whose face was covered by the electrum mask found in the same grave. But the gem is mean in size and the disc shape is common in Crete, while this is the only example of it found on the main

227. Bull's head and bearded man on a seal from Knossos. Late Minoan I, before *c.* 1450. Black steatite. Scale 2:1. *Herakleion Museum*

land to date. Moreover a comparable bearded man is represented on a seal of this shape from a more or less contemporary deposit at Knossos [227].[106] The Knossian seal has a device on each face, and is certainly Cretan work; other fine gems have been identified as probably engraved by the same skilled hand.[107]

Eight seals were recovered with the burials in circle A.[108] Three were of stone – two lentoids, and one of the amygdaloid (almond) shape with a couple of warriors in combat. The others, three flattened cylinders [228, B and C] and two magnificent signet rings [228A], were made of gold. The scenes of hunting and fighting with which most of these seals are engraved are in harmony with the presumed tastes of Mycenaean princes of the time. But similar portrayals were by no means foreign to Cretan seals of the period before the disasters of *c.* 1450, and one of the scenes of combat on impressions from Ayia Triadha [224F] is remarkably like that on the shaft grave signet of the Battle of the Glen [228A].[109] Moreover it is a curious fact that all these shaft grave seals were actually found with the burials of women: six were in the women's grave III, and the two signets, including illus-

B

A

C

D

228. (A)–(D) Impressions from gold flattened cylinders and signets from shaft grave circle A and its area at Mycenae. *c.* 1550–1400. Scale 3:2. *Athens, National Museum*

tration 228A, from the mixed grave IV had apparently been placed with the women there.[110] It therefore looks as if these gems with their manly scenes of combat and the chase were being worn by Mycenaean women as ornaments, not used by their menfolk as seals. There is indeed no evidence for seal usage at this time on the Greek mainland.

Were these fine gems engraved for seal usage in Crete? Or were they the creation of artists, whether Cretan or native, working on the mainland? The gems from circle A raise in an acute form the related problems of how to distinguish mainland from Cretan work, and the significance of any distinction that may exist. On the assumption that the rulers of Mycenae at this time had a different racial background and psychology from contemporary Cretans, efforts have been made to show that in their very structure the designs on these and other mainland seals differ radically from those on Cretan ones. In particular there has been an attempt to

demonstrate the structural differences between the design on the seal responsible for one of the scenes of combat on impressions from Ayia Triadha in Crete, and the Battle of the Glen on the Mycenae signet ring [224F, 228A].[111] But this is not wholly convincing, and the shaft grave seals, including the Battle of the Glen signet, are likely to have been the work of Cretan artists, if they were not made in Crete. Even in the following period many of the seals found on the mainland appear to be Cretan work, and numbers of them may be imports; but the sharp contrasts of style in the engraving on gems from the Vapheio tomb suggest that the manufacture of seals had begun in some parts of the Greek mainland by c. 1450.

An artist working in the region of Mycenae may have been responsible for the engraving of three gold signets assignable to the horizon immediately after the period of the shaft graves.[112] One of these, the Danicourt ring [229], has scenes of combat between men and lions, heral-

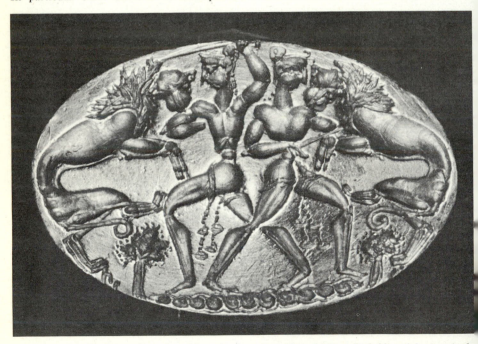

229. Bezel of the Danicourt signet ring with a pair of men in combat with lions. Probably mainland work of Late Helladic IIB, c. 1450. Gold. L 0.033 m. *Péronne Museum*

dically disposed in opposite pairs; and another found in the area of grave circle A shows a goddess sitting below a tree [228D]. The maker of these may have been a native of the mainland rather than a Cretan: the heavy style of the engraving, and the lack of feeling for composition, while not typical of Cretan signets, are reminiscent of the clumsy designs of some of the shaft grave gold – and of the ivory pyxis with griffins in relief from the Athenian agora [112] (see pp. 123–4).

The forty-three gems recovered from the Vapheio tholos tomb near Sparta represent the most important group of actual seals (as distinct from impressions of seals in clay) found in the Aegean area.[113] Among them are a couple of signet rings and some amygdaloids as well as long amygdaloids and barrel-shaped seals, but most are of the lentoid shape which became standard throughout the Aegean in the Late Bronze Age. The stones employed were almost all of fine quality, including lapis lazuli from Afghanistan, amethyst, jasper, onyx, and agate. One seal, however, was made of clay: nevertheless its string-holes were originally capped with gold like those of many of the other Vapheio gems.[114] The finely modelled picture of a dog scratching itself with its hind leg on this clay seal looks as if it must be Cretan work: seal impressions with comparable pictures of dogs have been recovered from Knossos and Ayia Triadha in Crete [224A].

Other subjects on gems from the Vapheio tomb include an elaborate scene of ritual or myth on a gold signet ring; gods and goddesses or their worshippers, some with attendant animals; and Minoan genii [230]. There are several hunting scenes with lions or wild boar as the quarry, and two pictures of horse-drawn chariots, otherwise curiously rare on seals found on the mainland.[115] Quite a few of the Vapheio seals are engraved with lions or bulls; and lions attack bulls, once against a background of palm trees. A goat, pairs of birds and dolphins, and dogs are among other animals represented. One lentoid has an elaborate version of a helmet mounted with boar's tusks, reminiscent of a sealing from Ayia Triadha in Crete.[116] An

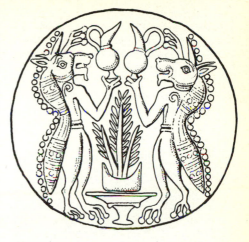

230. Impression from an agate lentoid from the tholos tomb at Vapheio. *c.* 1500–1450. D 0.020 m. *Athens, National Museum*

amygdaloid of the talismanic class is clearly from Crete, and about half the other seals appear to be imports assignable to Late Minoan I (*c.* 1550–1450):[117] the designs on some of them are very close to ones on impressions from Ayia Triadha and Zakro.[118] But others combine the use of fine stones with a crude style of engraving, and are reminiscent of seals of the following period as found in Crete as well as on the mainland: the oxen back to back on two of the Vapheio seals for instance closely resemble those on a gem from a Late Minoan II warrior grave at Knossos.[119] Possibly these and some of the other more crudely engraved gems are products of a mainland school whose traditions became established in Crete itself after the conquest *c.* 1450.

Most of the gems came from the solitary grave pit in the tomb, and were in two piles where the wrists of the prince buried there would have been, as if they were being worn as bracelets.[120] The earliest group of six gems from the tholos tomb at Routsi near Pylos in Messenia were similarly perhaps worn on the wrists of the person to whom they belonged:[121] they are of roughly the same period as the Vapheio gems, but other seals from the tomb appear to come from somewhat later contexts.[122]

The fact that gems were worn as bracelets does not necessarily mean that their owners regarded them as mere ornaments or charms, for seal usage seems to have become widely established on the Greek mainland by the end of the fifteenth century if not earlier, and impressions of seals have been recovered from later deposits in houses as well as palaces at some of the great

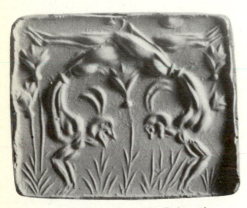

231. Impression from a flattened cylinder seal, engraved with a pair of acrobats among flowers, from the Knossos area. Probably Middle Minoan IIIB, c. 1600–1550. Chalcedony. L 0.021 m. *Oxford, Ashmolean Museum*

232. Impression from a lentoid seal, engraved with a pair of acrobats like the Cretan seal of illustration 231, from Mycenae. Late Helladic III, before c. 1200. Chalcedony. D 0.0135 m. *Athens, National Museum*

centres like Mycenae. Nevertheless the use of seals does not appear to have struck such deep roots there as it had in Crete.

LATER BRONZE AGE (c. 1450 B.C. ONWARDS)

At the time of the Vapheio tomb it was broadly speaking possible to classify the finer seals as being of Cretan, the more crudely engraved as of mainland manufacture. But this criterion no longer applies after the mainland conquest of Crete c. 1450: such differences as now exist are ones of emphasis rather than of basic style, and hardly seem to reflect profound divergences of national character, let alone an antithesis between Oriental and European, as has sometimes been claimed.

The Cretan sense of composition was never wholly absorbed on the mainland, where simple heraldic or antithetical arrangements always appear to have been more popular.[123] Even when a heraldic scene with Cretan antecedents is reproduced, significant differences may be noted: contrast the taut, interlocking composition and easy movement of the acrobats on illustration 231 impressed by a Cretan flattened cylinder, with the clumsy counterpart on the impression from a lentoid of later date found at Mycenae [232].

The subjects on mainland gems and their treatment are largely the same as on contemporary Cretan ones, but with some variations. Scenes of struggle of men against lions, for instance, are quite common on the mainland, but rare in Crete. A particular version of the bull-leaping scene, it has been suggested, may be a mainland invention.[124] A somewhat debased style of engraving, flat, with hard outlines, and crude by comparison with the Cretan naturalistic style, is already well represented among the Vapheio seals and may have evolved on the mainland, although its products are also found in Crete after c. 1450 [233]. The short, thick prism, engraved on two of its more or less circular faces, the third being left plain, although attested in Crete before 1450 (see p. 218) eventually seems more at home on the mainland.[125]

233. Impression from a lentoid seal, engraved with a pair of hunters carrying a stag, from Sellopoulo near Knossos. Late Minoan III, before *c.* 1200. *Herakleion Museum*

of the final destruction of the palace in the fourteenth century.[127] The devices represented are extremely varied. Heraldic scenes, where the design on one half of the seal is repeated on the other, appear to have been more prominent at this time than they were earlier in Crete, and this may reflect mainland taste. Designs of this class on the Knossos sealings show gods or god-

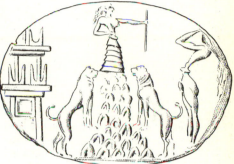

234. Sealing from the palace at Knossos. Late Minoan II, *c.* 1400. Clay. H 0.019 m. *Herakleion Museum*

Metal signet rings continued to be made and used on a large scale both on the mainland and in Crete. But the commonest type of seal was still the lentoid, which was often large and somewhat oval, like illustration 235B. Amygdaloid seals, usually with grooved backs, remained current, and long amygdaloid and barrel-shaped gems, already found in the Vapheio tomb, were much in evidence during the period immediately after *c.* 1450.

The materials favoured for gems of quality, apart from gold, were fine banded agate and cornelian, but small lentoids were made as before in cheap, easily worked serpentine or steatite. Exotic stones like haematite, lapis lacedaemonius (Sparta basalt), and lapis lazuli from Afghanistan were still used for seals,[126] which were also occasionally made of ivory, or amber from the Baltic, and not uncommonly from glass as already in Crete during the period before 1450. An earlier custom which remained very fashionable was that of capping the stringholes of the finer seal stones with gold.

Many seal impressions have been recovered from deposits at Knossos dating from the time

desses flanked by lions [234], and other comparable arrangements of animals. Some of the impressions, however, were evidently made by seals of earlier date which had been retained in use. Devices similar to those on sealings lost at the time of the final destruction of the palace there also occur on seals found in warrior graves of the late fifteenth century at Knossos, and on some from the important cemetery of the so-called Tombe dei Nobili at Kalyvia near Phaistos where the burials are assignable to the early fourteenth century, although some of the seals, notably two gold signets, their engraved faces worn by time and use, are clearly much older.[128]

Only one seal was recovered from the cemetery with comparable but somewhat earlier burials at Katsamba on the edge of the harbour town at Knossos [235A].[129] This shows a bull attacked by a lion, a motif already current in Crete before 1450, but more fashionable in the period immediately following the mainland conquest, when there appears to have been a

235. Impressions of seals from tombs at (A) Katsamba and (B) Ayios Ioannis near Knossos, drawn by Piet de Jong. Late Minoan II, *c.* 1400. Cornelian and banded agate. D 0.016 m. *Herakleion Museum*

taste for scenes of violent movement. Sometimes the composition of these scenes is extraordinarily apt, with a whirling motion, as on a large lentoid with the same theme as the Katsamba seal from a more or less contemporary warrior grave at Knossos [235B].[130] But the lentoid shape imposed its discipline. Efforts to squeeze animals into it led to curious although not altogether ineffective distortions, with jackknifed bodies and heads displaced in an impossible manner [236]. The engraver felt obliged

236. Contorted lion on an impression of a lentoid seal from Knossos. Late Minoan II, *c.* 1400. Rock-crystal. Scale 2 : 1. *Oxford, Ashmolean Museum*

to fill the circular field before him, and the art of leaving unsymmetrical blank spaces, as practised by the skilled gem-makers of earlier times in Crete [e.g. 218], has been largely forgotten.[131]

Technique is also apt to be sketchy now, even in the case of large gems of fine material. The bodies of animals are smooth-cut with hardly any anatomical markings or modelling. A tubular drill is used for the large staring eyes, the legs are rendered with two parallel lines and attached like sticks, the feet are added by drill holes.

Several fine gems of this period, the century or so after *c.* 1450, have been recovered from the mainland, notably from the unplundered tholos tomb at Dendra, where six were found in the gold octopus cup buried with the king (see p. 169).[132] These included a lentoid of dark agate engraved with a lion devouring a bull – a favourite scene also in Crete at the time, as seen in illustration 235, A and B. The Dendra gem, the largest that has yet come to light in the Aegean area, like other large lentoids of the period after 1450 is somewhat oval in shape.

Seal impressions from a number of deposits on the mainland assignable to the fourteenth and thirteenth centuries include an important group from the palace at Pylos destroyed by fire *c.* 1200;[133] some of the Pylos sealings were made by finely engraved gems, and a number of these recall impressions from destruction levels of the palace at Knossos in Crete a hundred years or more earlier. It is more likely that the gems which made these impressions were antiques, some of them perhaps Cretan,[134] than

that there was an archaistic revival of gem engraving in parts of the Aegean in the thirteenth century against the general background of decline there at the time;[135] for with these fine sealings at Pylos were others in a coarse and debased style [237] like that of seals found in tombs

237. Seal impression showing a woman, apparently a goddess, flanked by dolphins, from the palace at Pylos. Late Helladic IIIB, *c.* 1300–1200. Clay. L 0.022 m. *Athens, National Museum*

of the thirteenth century both in Crete and on the mainland. The woman between dolphins on illustration 237 may be a goddess. The crudity of the engraving has been unkindly emphasized by the fact that the upper part of her body was doubly impressed.

Many of the latest Bronze Age seals in the Aegean were made of soft materials, and the designs were sometimes engraved without the help of the drill. A number, mostly lentoids, show stiff, stick-like figures of men and animals [233]. The lentoid remained the standard shape into the thirteenth century, when it often had a high conical instead of a rounded back. but amygdaloids and flattened cylinders were still current on the mainland.

There is no evidence that gems continued to be used for sealing in any part of the Aegean after the destruction of the palaces on the mainland *c.* 1200. But older seals were still worn as ornaments, incorporated in strings of beads, and

a belief in their magical qualities may have persisted. In some parts of the Mycenaean world, notably in areas to which refugees had made their way after the disasters on the mainland *c.* 1200, the cutting of gems, if only for use as charms, might have persisted for a time.[136] A few seals have been found in tombs of that period on Kephallenia and Naxos,[137] and twelve were recovered from the extensive cemetery of the twelfth century at Perati on the eastern coast of Attica[138] – a small number in relation to the many hundreds of burials there. Moreover three were of foreign, Cypriote and Mitannian, origin, and most of the remaining nine, including two worn gold signet rings, were clearly of earlier (some of much earlier) date; indeed it seems most uncertain whether any of them were engraved during the time when the cemetery was in use.[139] The largest known Mycenaean gold signet ring similarly comes from a treasure buried at Tiryns during the period after 1200, but it was almost certainly made at the beginning of Late Helladic III *c.* 1400 if not earlier.[140]

Even if the art of cutting seals was still practised in some parts of Greece into the twelfth century, it seems unlikely on present evidence that a tradition of seal making survived in the Aegean area until the time of the revival of Bronze Age types and motifs with the Island Gems of the seventh and sixth centuries. But Bronze Age seals continued to have their uses: they have been found in tombs of the early part of the Iron Age, and they were occasionally placed as votives in later Greek sanctuaries. Under the name of galopetres (milk-stones) they were employed until quite recent times by Cretan women as charms to ensure a supply of milk after childbirth.[141]

MATERIALS AND TECHNIQUES

The earliest surviving Aegean seals are made of soft materials such as ivory, bone, shell, serpentine, and steatite, which were easily shaped and engraved with the kind of tools used for carving wood. Clay sealings from Early Helladic II levels at Lerna (see p. 214) appear to have been

impressed by wooden seals, and many Cretan seals may have been made of wood into the period of the early palaces if not later.

Unfinished stone seals of various periods have been found in Crete, and workshop areas with large numbers of them have been identified in the palace at Knossos,[142] and also at Mycenae on the mainland.[143] Seal-makers' tools were recovered from the workshop area dating from the earliest years of the second millennium at Mallia (see p. 215) together with actual seals, mostly of soft stone, but including some of rock-crystal – a hard material which, like amethyst, jasper, and obsidian, began to be used for seals in Crete around the beginning of the second millennium with the introduction of the drill to twirl an abrasive such as emery. Eventually even harder substances, like meteorite, haematite, and glass, came into sporadic use. Glass seals it seems were normally cast as beads and had the devices cut in them afterwards, although some of them may have been moulded with their devices.[144]

Seals were also made of metal, usually of gold, but also of silver and bronze, or of gold or silver plate over a core of some other material such as magnetite sand.[145] The devices on metal seals were normally, it seems, cast. Parts of a three-piece stone mould for casting a metal ring with its bezel have been recovered from Cyprus.[146] Another mould, from Eleusis, was engraved with a couple of oval bezels with devices on one side, and with a pair of circles for making rings on the other.[147] In this case the engraved faces of the bezels would have been cast separately and afterward soldered to the rings, but the devices appear to be cut in intaglio: that is to say, if the bezels were cast directly from these moulds they would be in relief. It is unlikely that lenses were used in engraving gems,[148] although their magnifying properties were known to Bronze Age Cretans, and crystal lenses have been recovered from tombs at Knossos.

Unlike modern gem engravers, the Bronze Age makers of seals evidently thought in terms of the picture on the seal and not of that on the impression. Thus the impressions, which reverse the pictures on the seals, show right hands as left, as in the case of worshippers, who by Aegean tradition invariably raise their right hands in adoration.[149]

The earliest Aegean seals were often bulky and may have been hung on strings round the neck. But the bead-seals of the later Bronze Age were normally worn on the wrist with the engraved face inwards.[150]

Most clay sealings have come from buildings destroyed by fire which has helped to harden and preserve them. But some have survived in other circumstances, notably the group of impressions stamped in clay to seal the blocked doorway of the Royal Tomb at Isopata near Knossos [219].[151]

CONCLUSION

The Aegean during the Neolithic was a part of the world of its time. Aegean Neolithic figurines of stone and clay belong to a family spread over a wide area stretching from the Near East through Anatolia into Europe. The Neolithic pottery of the Greek mainland at any rate reflects in a recognizable even if distant manner successive waves of fashion that had their origin in the Near East. Clay stamps with meander-like designs bear an obvious relationship to ones current from the earliest times in Anatolia.

The Early Bronze Age Koine in the Aegean

The third millennium B.C., covering roughly the period defined as the Early Bronze Age, saw the rise of a primitive but often refined and attractive art throughout the Aegean area. Its richest manifestations occurred in Crete, which was more fertile and almost certainly more prosperous and densely populated than the Cycladic islands or the mainland at the time. The early ascendancy of Crete is reflected in the number of Egyptian imports which found their way there. It is true that the inhabitants of the Cyclades alone of the Aegean peoples took to carving large figurines in stone (pp. 91–4), but this may simply reflect the lack of suitable wood for large images, together with the availability of attractive white marble and of the emery to work it.

While the peoples in each of the three main areas of the Aegean – Crete, the Cyclades, and the Greek mainland – had differing traditions, especially noticeable for instance in the style of their pottery and in their burial customs, they were at a similar stage of development, and there was much exchange of ideas and fashions between them. They adorned themselves with the same kind of jewellery, and probably with the same face paints; they used the same types of tools and weapons, and had similar kinds of seals. In a real sense the Aegean was a cultural *koine* at this time.

The Minoan Art of Crete

Before the end of the third millennium a high civilization with a comparatively sophisticated style of art and with knowledge of writing had begun to develop in Crete out of the Early Bronze Age *koine*. A notable characteristic of the civilized art of Crete was the capacity for 'Unity' decoration, in place of the simpler 'Tectonic' system typical of much primitive art:[1] that is to say, the surface to be decorated was considered as a field for the design as a whole, and not just as a surface to be covered with disconnected designs or repetitive systems of patterns. This Unity style of decoration is most clearly observed on pottery and to some extent on seals: fine examples are the Middle Minoan jar from Knossos [10] with an elaborate design in polychrome, and a Late Minoan IB Marine Style stirrup jar from Gournia [15A].

The essential quality of Cretan art, however, and the one which distinguishes it from the contemporary art of Egypt and Mesopotamia, is the power to suggest movement, and the feeling of life that springs from it. Even abstract designs, like that on the polychrome jar [10], vibrate with energy; still more do creatures like the octopus with its waving tentacles on the vase from Gournia [15A]. Animals and men in wall-paintings or in relief on vases of stone or metal, even in miniature on seals, are similarly alive with movement. Flowers writhe as if wind-blown in landscapes by Van Gogh, and the very rocks from which they grow seem restless as if dancing in perpetual earthquakes, in spite of their formal abstract character (see p. 56). This freedom of movement may reflect the tempera-

ment and outlook of a people living among mountains, more independent in their feelings, less circumscribed by governmental controls, than the peoples of the great river valleys of Egypt and Mesopotamia, or of the plains of Syria, from whom they learnt so much.

On a vase or in the small compass of a seal, especially one with a circular face, Minoan design often moves round a centre. This has been described as 'Torsion', or pivotal motion, and it can already be detected in the designs on pottery in some parts of the Aegean, although not in Crete, before the end of the Neolithic;[2] indeed it is traceable over a wide area of the Near East in early times. But torsional movement is very prominent in Aegean art from the beginning of the Bronze Age onwards, and a strongly developed feeling for it may have been one of the factors which stimulated the fashion for spirals and spiral-based designs that developed early in the Aegean Bronze Age before *c.* 2500, and continued until its close.

The Aegean peoples did not invent the spiral:[3] it occurs of course in nature, in some plants, and above all in shells, and has been fashionable as an element of design in various parts of the world from Palaeolithic times onwards. But few other peoples in history have made such intensive use of the motif as the Bronze Age inhabitants of the Aegean area. The fashion for decorating vases of clay and stone with spirals appears to have developed in the Cyclades in Early Cycladic II (the Syros phase of the Early Bronze Age), and afterwards spread to Crete, where they were first applied to stone vases like that of illustration 130, and eventually to clay ones. What triggered the fashion in the Aegean is obscure. Native genius, perhaps, inspired by the sight of shells?[4] Or the example of early Oriental jewellery with spiraliform designs in wire?[5] Alternatively the fashion may have spread from Anatolia or the Balkans, where spirals appeared on pottery and clay stamps long before they did in the Aegean, if radiocarbon dates are to be trusted. In that case the spirals on pottery of the latest Neolithic in Thessaly would represent a half-way house (see p. 30) – unless they were among fashions which

spread there from the Cyclades, assuming an overlap between the Cycladic Early Bronze Age and the end of Thessalian Neolithic.[6]

Whatever their origin, from their first appearance in the Cyclades spirals were not only linked together in lines (running spirals), but were combined to form net-patterns, where the movement of the design can be followed in all directions (unending *rapport*). Spiral nets continued to be fashionable during the flourishing part of the Bronze Age throughout the Aegean, appearing for instance on the Mycenae shaft grave stelai [78] (see p. 98), and on the Mallia leopard axe [170] (see p. 174), as well as on contemporary pottery from Crete. Spirals were also painted on walls; the running variety was particularly favoured for borders, while some Cretan ceilings appear to have been adorned with spiral nets [58A] (see p. 76). Their use in wall decoration may have been inspired by Syrian example, if the paintings in the palace at Mari are really earlier than anything comparable that existed in Crete (see pp. 236-7).

Cretan art was essentially primitive; in a sense it did not develop beyond an archaic stage,[7] and it never attained the naturalism and rounded perfection ultimately reached by the art of Classical Greece or the Renaissance. Possibly it would not have evolved much further even if its course had not been interrupted by the mainland conquest of *c.* 1450, and ultimately checked for good by the general dissolution which overwhelmed the whole Aegean world at the end of the Bronze Age some centuries later. While it would be rash to assume, as has sometimes been done in the past, that naturalism of the kind attained by the painters and sculptors of Classical Greece or the Renaissance was the ultimate in art, it can nevertheless reasonably be seen as a stage or goal towards which the arts of the civilized world of the Bronze Age in the Near East were consciously or unconsciously working, and towards which considerable progress was made, not only in the Aegean, but also in Egypt in the time of the Eighteenth Dynasty from *c.* 1550 onwards. Indeed some Egyptian artists of this period may have progressed further along the path of naturalism than the

artists of Crete in the heyday of Minoan art before c. 1450.

For in spite of its vivid, life-like character, animated as it is by the vigour of movement, Cretan art always remains highly formal, not to say stylized, and in some ways it is a good deal further from nature than that of contemporary Egypt. Contrast the conventions for rendering the human figure in Egypt and in Crete. In Crete all is exaggeration: the swelling breasts of the women as much as the wasp-like waists of the men, which are thin beyond the bounds of possibility, even allowing for the fact that thin waists were a physical characteristic of the people of Crete then as now. Similarly with the colours used to distinguish men from women: in Crete a violent contrast between dark brown and white; in contemporary Egypt, relatively subtle shades of light and dark. This impression of unnatural exaggeration might be modified if more of the relief frescoes and wooden statues had survived, but on the whole it is probably true to say that in depicting the human figure the Cretans never achieved the restrained naturalism of the best contemporary Egyptian art. The contrast is even clearer when it comes to representations of animals and birds, not to mention butterflies and plants.[8] In Egypt these are rendered with a much greater degree of truth to life – in that sense they are certainly more naturalistic; but Cretan animals and birds, stylized as they are and drawn with scant regard for accuracy, tend to look more alive, and therefore more real, than Egyptian ones.

This sense of life springs from the feeling for movement which, as has been said, is so characteristic of Cretan art. Animals for instance are regularly represented in an extended leap, or 'flying gallop' as it is usually called[9] – an obvious way of suggesting the rapid motion of four-legged creatures by no means peculiar to Crete; indeed it was employed by the artists of Late Palaeolithic times. But the convention was much used by Cretan artists, and is already attested in Crete in the time of the early palaces – it occurs for instance on seal impressions from the Middle Minoan deposit at Phaistos (see p. 217). Possibly therefore the idea of the flying gallop came to

Egypt from Crete. Like Cretan birds and animals, Cretan flowers, imbued as they are with movement, tend to look extraordinarily life-like, although they are often imaginary or conventionalized to a point where they defy identification with any particular species (see p. 56).

The flying gallop is only one aspect of the essentially primitive character of Cretan art. Another, also paralleled in the art of Palaeolithic and Mesolithic times, is the tendency to place figures of men and animals loose as it were against the background without relating them to any ground-line. This primitive feature is still found in some of the earliest surviving wall-paintings of the Near East: those of Neolithic Çatal Hüyük in Anatolia for instance, and the somewhat later ones of Teleilat Ghassul in Palestine. It is always possible that walls in Crete were being adorned with pictures from the beginning of the Bronze Age if not back in the Neolithic: if so, primitive conventions like this and the flying gallop might have descended without a break from Mesolithic tradition. An innate conservatism, a tendency to retain fashions and customs long after they had died out elsewhere in the civilized world of the Near East, is indeed the key to many aspects of the Minoan civilization of Crete.[10]

The cheerful way in which Cretan artists, and Mycenaean ones after them, dispensed with ground-lines, not invariably but when it suited their convenience, helped to give their compositions a flexibility denied to those of Egyptian contemporaries. This is most obvious when it comes to the rendering of landscapes in which Cretan artists excelled. An outstanding example of the best period is the newly discovered miniature frieze from the Akrotiri settlement on Thera, with its scenes on sea and land, which, although probably the work of a local Cycladic artist, are entirely in the Cretan manner (see pp. 63-5).

Landscape in Egypt was rendered as if in plan, with the figures of men and animals set in it in elevation. A similar rudimentary convention seems to underlie many Cretan landscapes;[11] their more lively appearance is due to the writhing movement of rocks and plants. The

rockwork, however, is in fact highly stylized: indeed it may have been inspired by the veined slabs of gypsum used to veneer the walls of palaces and houses (see p. 85). Similarly the rendering of water by means of an elaborate but uniform scale pattern, as on the Siege Rhyton [154], is as stylized and conventional as the chevrons used in Egypt; but, although if anything still further removed from nature, it gives a more watery impression. A curious convention of Cretan art was to hang the rockwork from the top of the scene as well as, or sometimes instead of, making it spring from the bottom, creating the effect of a cave with stalactites. This is in line with the Egyptian convention, whereby trees set round a pond may spring from it at right-angles, so as to appear upright at the top, but sideways or upside down elsewhere. When rockwork occurs in Cretan paintings and reliefs it normally does not occupy the whole of the background: spaces are left plain against which plants and flowers and figures of men and animals will show better. But in some relief work like the ivory pyxis from Katsamba [111] the whole of the background against which the scene is set consists of undulating rockwork (see pp. 121-2).

Human figures are rendered in a conventional manner, normally in profile; or with the head and legs in profile, but with the body facing the front. Frontal views of the head seem confined to small objects, such as jewellery [e.g. 193], seal-stones, and relief plaques. Eyes, however, are always shown as if seen from the front, even when the face is in profile. On some Cretan ivory statuettes and in the great plaster reliefs the modelling is exceedingly skilful and lifelike, but there is no attempt to copy nature with accuracy or to comprehend the underlying structure of bone and muscle.[12] The Cretan relief frescoes were really just an extension of wall-painting, and may have been inspired, not by the example of contemporary Egyptian stone reliefs, but by the desire to get some degree of contrast and shading into the paintings on the walls.[13] It may be no coincidence that the first rudimentary attempts at shading, on the figures of the Taureadors for instance [44], and on the

griffins of the Throne Room [50B], appear to date from the very time when the fashion for relief frescoes was on the wane (pp. 66, 77). In general Aegean paintings of the Bronze Age were entirely in one plane, the figures, human and animal, showing silhouette-like against a flat perspectiveless background. But this very lack of reality, along with the stylized, often imaginary character of the animals, birds, and plants, when combined with the vivid portrayal of movement and the life-like quality induced by it, helped to create that fairyland atmosphere which has often been noted in the best Minoan art.[14]

The debt of Crete to Egypt and the Near East was immense, and there is no doubt that Minoan art and Mycenaean after it were closer in spirit to the contemporary arts in those lands than to later Greek art. In that sense Minoan and Mycenaean art were essentially Oriental in a way that the art of Classical Greece was not. But it was never a case of slavish imitation of the kind which tended to prevail in Syria and Palestine, stifling the development of a vigorous independent artistic tradition. It is probably an exaggeration to say that the most flourishing periods of Minoan art coincided with those when the connections with Egyptian civilization were at their weakest,[15] but certainly the Cretans adapted rather than imitated.

Nor were the influences all one way. Indeed 'the compelling impression made by the volatile Minoan genius is evident throughout the eastern Mediterranean world'.[16] It would not be surprising if the splendours of Cretan wall-painting, known to us only from battered fragments, were imitated elsewhere in their time. Paintings of the eighteenth century from the great palace of Mari, and remains of seventeenth-century ones from Atchana in Syria, in spite of their early date (p. 48), have indeed been thought to reflect Cretan influence, although this is more credible in the latter case than in the former, since the rather earlier paintings from Mari are closer in style to Egyptian ones of Middle Kingdom date at Beni Hasan.[17] Spiral borders and painted imitations of veined slabs of stone at Mari are certainly reminiscent of Crete, but they may

indicate an Oriental source of inspiration for their Cretan equivalents, which on present evidence appear to be later.[18] Clay tablets found at Mari, however, show that Cretan imports were already valued there and elsewhere in the Near East.[19] If walls in Crete were being decorated with pictures and spiral designs during the period of the early palaces, as Evans supposed, the influence of Cretan painting could have been felt in Syria by the eighteenth century.[20]

The development of a fashion for spiraliform designs in Egypt has been thought to reflect Cretan influence, perhaps through the medium of imported woven fabrics. The fact that some of the earliest Egyptian spiral designs are on the ceilings of tombs, where the painted decoration may be derived from canopies or cloths hung from ceilings in houses, lends some support to this view. The very earliest such ceiling known is in the tomb of Hepzefa completed in the reign of Senusret I (1970–1936) at the beginning of the Twelfth Dynasty,[21] at about the time when spiral decoration is first attested on Egyptian scarabs.

Paintings of the fourteenth century at Amarna, notably those on floors, have been taken to reflect Aegean influence,[22] although in this case appearances may be deceptive, since the loosening of artistic conventions which culminated in the Amarna period under Amenhotep IV (1372–1354) is already apparent earlier in the Eighteenth Dynasty.[23] There were certainly contacts, however, and no doubt exchanges of ideas, between Egypt and the Aegean at the time,[24] and even if the paintings of Amarna are in a thoroughly Egyptian tradition, the impulse for pictured floors, hardly attested in Egypt before the reign of Amenhotep III (1408–1372), may have come from the Aegean.[25] In general, however, the signs of Egyptian influence on Aegean art are the more obvious, as might be expected in view of the large number of Egyptian objects found in Bronze Age contexts in the Aegean area, and especially in Crete. There is no evidence that any Egyptian artists or craftsmen worked in the Aegean, or that Aegean ones went to Egypt,[26] although it is known that artists did move from one country to another during this period of comparative internationalism at the end of the Bronze Age: thus a king of the Hittites, Hatusilis III, wrote to the Kassite king Kadashmanenlil asking him to send a Babylonian carver of reliefs to work for him as his father had done before him, and promising to return this sculptor as he had returned the first one.[27] The sphinxes which flank one of the city gates of the Hittite capital at Boğazköy are remarkably alive and refined in style in comparison with the other sculpture there, and their head-dresses with rosette-filled spirals have suggested possible Aegean influence.[28]

Some 'Old Syrian' cylinders, roughly parallel in date with Middle Minoan III and Late Minoan I, incorporate figures wearing what seems to be Cretan dress, together with scenes of bull-leaping and the flying gallop, while a number from later contexts in Cyprus are engraved with designs so Cretan in style as to indicate that they were the work of immigrant artists.[29] The story in the Ugaritic poems, where Kothar Wa-khasis, the god of handicrafts, has Kaphtor (Crete) as his throne, hints that Cretan artists may have worked in Syria,[30] as does an unfinished Cretan stone lamp from Atchana.[31] Moreover foreign craftsmen were often transplanted by conquerors,[32] and this may have led to intensification of Cretan influence on the Greek mainland after c. 1450, and again perhaps after the final destruction of the palace at Knossos a century or so later.

Other ways in which artistic ideas and fashions spread were by trade, and more especially by the exchange of costly gifts between rulers of states; this circulated small objects of vertu, such as ivory boxes, gold and silver plate, and stone vases, as well as weapons of parade.[33] A sumptuous Cretan weapon is listed among treasures at Mari back in the eighteenth century.[34] Designs with a background of niello on the dagger of Ahmose, founder of the Eighteenth Dynasty, although the work of an Egyptian craftsman, appear to have been inspired by Aegean inlaid daggers like those from the Mycenae shaft graves [177–9].[35] Other Egyptian objects of Eighteenth Dynasty date showing the influence of the Aegean include carved and

inlaid wooden boxes[36] – the round lid from Saq-qara [101], for instance, may have come from that area (see p. 115). Similarly a number of carved ivories of the fourteenth and thirteenth centuries from Syria and Cyprus were clearly influenced by Aegean ones, while some of those from the palace at Megiddo appear to have been imported from the Aegean, if they were not locally made by Aegean craftsmen (see p. 128).

It is often claimed that Minoan art excelled in small things,[37] and certainly Cretan seal-engraving at its best was of a remarkable quality and unique in the world at the time. It is not too much to say that 'the gem-cutters of the Ancient East and of later Greek art fell far short of the Minoan artist in his combination of technical mastery, wealth of imagination, inventive genius, skill in composition and feeling for miniature'.[38] The Minoan sense of composition may have been more successfully expressed on clay vases and gems than in the scenes on relief vases of stone and metal, and in the wall-paintings and plaster reliefs which inspired them. Painting, however, was probably in the eyes of contemporaries the art which counted for most, and attracted the best talents. The accident of climate has destroyed all except fragments of Cretan murals. Many paintings of the best period have indeed been wonderfully preserved in the Akrotiri settlement on Thera, but breathtaking as they are, they are not strictly Cretan, and might appear crude and provincial if placed beside the finest work of the time.

While something has survived of Cretan painting, nothing is left of sculpture, apart from a few small stone heads like illustration 75, and clay figures of comparatively modest size (pp. 103 ff.). There is a hint that large wooden statues existed, and the clay ones from Kea [89A, 90] may give some idea of what large Cretan wooden statues were like (see p. 106). The Kea statues appear to have been gaily painted, and so no doubt were wooden ones in Crete. If we could see a Cretan palace of c. 1500 with all its trappings it might give us a surprise if not a shock. What idea would we form of the extraordinarily rich and colourful art of the American North-west coast Indians if all traces of their wood-

work including their giant totem poles had vanished from us?

In the course of time Minoan, and after them Mycenaean artists, learnt many new techniques: how to carve stone vases and engrave gems with the help of drills and abrasives, and how to adorn jewellery with filigree and granulation, and eventually with enamel. They effected changes in the composition of wall-plaster, and adopted new kinds of paints. But much of their finest work resulted from skill and patience using comparatively simple methods. Thus the bronze statuettes of the best period before c. 1450 are extraordinarily vigorous and effective in spite of their rough finish which appears to reflect imperfect casting as a result of the poor alloy used in their composition (see p. 114). The truth is that while the struggle with technical problems may act as a spur to creation, the mastery of advanced techniques is by no means always a blessing. Indeed the potters of the Aegean area developed increasing skill in the use of the fast wheel and control of firing at the very time that their art, in terms of elegance of shape and vigour and inventiveness of decoration, was in manifest decline. Aegean armourers similarly continued to produce increasingly effective weapons until the end of the Bronze Age, but these were less agreeable in design and less nobly ornamented than weapons of the shaft grave period and its immediate aftermath.

Mycenaean Art

The Early Bronze Age civilization of the Greek mainland, with its elegant pottery and flourishing seal tradition, was brought to an abrupt end by invasion at the end of the third millennium, and the art which arose there in the ensuing comparatively primitive conditions was an amalgam, still largely reflecting the Early Bronze Age *koine*. Thus while many of its elements, notably spiral designs, can be matched in Crete, the best parallels are often to be found on objects assigned to the Cretan Early Bronze Age.

This art is best known from the Mycenae shaft graves which date from a time when Cretan influence – already long felt – was on the verge

of becoming dominant on the mainland. It is arguable whether Cretan plate had inspired the shapes of Middle Helladic metal-imitating pottery (see p. 40): but by the time of the shaft graves a good deal of the mainland pottery was certainly made in shapes, and decorated with designs, of Cretan derivation. While it is easy to distinguish a native from a Cretan tradition in the shaft graves, it may be difficult, if not impossible, on stylistic grounds alone to decide whether an object that is Cretan in style was made in Crete or on the mainland; and if made on the mainland, whether a Cretan or a native artist trained in the Cretan manner was responsible (see p. 23). An answer to the question is obviously of some historical interest, although not perhaps artistically significant. Some objects, such as a number of the seals from the Vapheio tomb, and the ivory box from the Athenian Agora [112], dating from the period immediately after the shaft graves, seem to reflect in a marked way the hand and outlook of a mainland craftsman, although the forms and the elements of the decoration are Cretan. But the conquest of Crete by people from the mainland c. 1450, and the centralization of rule under Mycenae which may have occurred after the final destruction of the palace at Knossos a century or so later, helped to promote a mixed civilization which was remarkably uniform throughout the Aegean. It was in some ways a reversion, but under different circumstances, to the *koine* which had existed in the Early Bronze Age.

There has been much earnest search in the past for differences of a basic kind between Mycenaean and Minoan art. The impetus for this has sprung from the widely held belief that the people of the mainland from c. 2000 onwards were Greeks, Greek in speech and ancestors of the non-Dorian Greeks of later times, while the people of Crete in the heyday of the Minoan civilization were not. This, it has been felt, should have given rise to radical dissimilarities, especially in the light of the profound and obvious differences between the art of Bronze Age Crete and that of later Greece. On this view there should be features common to later Greek

art and Mycenaean art, but lacking in Minoan art. At one extreme the quest has led to the suggestion that racial differences between the Bronze Age Cretans and the people of the Greek mainland were reflected in an entirely different way of seeing the things which they represented in their art. The Cretans on this theory were eidetics, that is to say, they had the primitive gift of projecting an image on to the blank surface which they were to decorate, and could then fill it in or draw round it; the people of the mainland, however, being Greeks, did not have this power.[39] This is an intriguing idea, but there does not seem to be any real evidence in support of it. Another theory would find difference of race expressed in basic divergences between the syntax or underlying structure of the composition of scenes on seals and signet rings of Cretan origin, and that on ones which, it is assumed, were made by mainland artists; even when the shapes of the seals, themes represented on them, and artistic conventions used, are all admittedly Minoan.[40] The way in which this ingenious theory has been applied, and the racial views combined with it, can be disputed, but it appears to have a certain basis of truth.

It does in fact look as if simple 'tectonic', heraldic, or formal systems of decoration were more at home on clay vases and seals made on the mainland, becoming increasingly predominant throughout the Aegean during the period of mainland ascendancy from c. 1450 onwards. But similar tendencies can be detected in the art of comparatively primitive societies in many parts of the world, and are not only visible in Cretan art from the earliest times, but continued alongside the more sophisticated 'Unity' decoration of the finest vases and seals throughout the heyday of the Minoan civilization in the sixteenth and fifteenth centuries. The differences between Minoan and Mycenaean art should not therefore be exaggerated. For example the Minoan sense of movement was reflected in Mycenaean art, and the old Aegean principle of torsion, of whirling movement, finds some of its clearest manifestations in the designs on the circular faces of gems engraved during the period of mainland ascendancy after c. 1450.

A recognition of the basic kinship of Minoan and Mycenaean art is in harmony with the view that the peoples of Crete and of the mainland during the Bronze Age were similar in their racial background and shared many traditions, like the Greeks and Macedonians of later times, or the Greeks and the Romans. Indeed it has often been suggested that the relationship was essentially similar to that between Greek and Roman, or even to that between Attic and Hellenistic art:[41] that is to say that the Minoan civilization of Crete was an original civilization in its own right, while the Mycenaean was essentially derivative, a reflected or moonlight civilization, as it has been called.[42] On this view it has been argued that not only the people of the mainland but also the Cretans themselves were Greeks, or were dominated by Greeks or by some other Indo-European-speaking people, from a comparatively early stage in their civilization. At the other extreme it can be held that all these peoples shared a similar non-Greek racial background and stock of traditions from the earliest times until the end of the Bronze Age, when the Greeks first broke into the Mycenaean world as its destroyers. The real cleavage is then between the art of the Aegean Bronze Age as a whole, and the Greek art which began with the birth of the Protogeometric style, reflecting the rise to dominance of the newly arrived Greek element.

The standard view today, however, sees the Mycenaeans as Greeks and the Aegean world as under Greek domination after the conquest of a non-Greek Crete by people from the mainland *c.* 1450. But this raises the problem of how a people later to display such genius, enterprise, and originality, could in the vigour of this youthful stage in their history submit to a slavish dependence not only on a non-Greek half-Oriental civilization such as the Minoan, but also on the civilizations of the Near East in general; for Oriental influences were probably stronger in the Aegean towards the end of the Late Bronze Age, the period of mainland domination, from *c.* 1400 onwards, than at any earlier time.[43] Certainly the art of the Mycenaean world was far closer to that of contemporary Egypt and the Near East than to that of later Greece.

On the assumption that the Mycenaeans were Greeks it has to be admitted that the native Greek genius was in some mysterious way stifled for a time by Oriental influences, and more particularly by the influence of that seductive fairy-world, the civilization of Minoan Crete; and that it was only rescued from this suffocating constraint with the collapse of the Mycenaean world and the harsh impetus of the entry of the semi-barbarous and as yet uncontaminated Dorian Greek tribes upon the scene in the centuries after *c.* 1200.[44]

End of the Bronze Age (from c. 1200 B.C. onwards)

In the thirteenth century the arts are in manifest decline throughout the Aegean: vase-decoration, seal-engraving, and wall-painting all betray the same symptoms of listless repetition and increasingly careless and incompetent workmanship. The reasons for this are as obscure as are those for the decline of the Greco-Roman world some fifteen hundred years later – indeed more so, in the absence of historical records which tell of apathy and discontent, corruption and economic collapse, against a background of mounting pressure from barbarians beyond the frontiers. The wilting of the arts was no doubt merely one aspect of a loss of vigour and direction in other fields of life, exposing the civilized Mycenaean world to successful onslaughts by barbarous peoples from outside it.

Whatever the immediate causes for the destruction of the palaces on the mainland, the Mycenaean world was in the event barbarized, and the arts of civilization, together with knowledge of writing, disappeared from the Aegean for centuries. At the same time the shock of these events was in a curious way stimulating. The art of making pottery on the fast wheel survived, and clay vases went on being decorated with lustrous paint in a version of the Mycenaean style. Moreover during the course of the twelfth century there is a marked revival in the quality of vase decoration, not only in areas

like the Peloponnese, where the Mycenaean centres had been destroyed, and where the revival could be attributed to the stimulus of a new intrusive element in the population, but also in regions to which Mycenaean refugees had escaped, such as the Cyclades (see p. 25). But this renascence was short-lived, and soon ran into the sand. The rise of the Protogeometric style from the ashes of Submycenaean about the middle of the eleventh century marks the beginning of the long development that eventually leads to the achievements of Archaic and Classical Greece.

Epilogue

The art of the Aegean Bronze Age belonged to the Oriental world of its time:[45] that is to say, it was far more Oriental in character than the art of later Greece was ever to be. Nevertheless something peculiarly European has been detected in the art of Minoan Crete, something which was inherited by the Mycenaean world, and which surfaced again in the awakening of Greek art in the Archaic period.[46]

How much the art of later Greece really owed to the Aegean Bronze Age is difficult to assess. Opinions range from 'the decayed nobleman's mite'[47] to the concept of the Archaic period as a Renaissance.[48] But if there was anything in the nature of a renaissance, it was one of the spirit, of talents and attitudes,[49] since there was no conscious attempt to imitate the artistic achievements of the Bronze Age, except to a limited extent in the field of gem-engraving, with the so-called Island Stones (see p. 231). In general the gulf between the art of the Aegean Bronze Age and that of later Greece is immense.

ABBREVIATIONS

A.A.	*Archäologischer Anzeiger*
A.A.A.	*Athens Annals of Archaeology*
A. Delt.	*Archaiologikon Deltion*
A.E.	*Archaiologiki Efimeris*
A.J.A.	*American Journal of Archaeology*
Annuario	*Annuario della Scuola Archeologica di Atene*
Arch. Reports	*Archaeological Reports for . . .*, published by the Council for the Society for the Promotion of Hellenic Studies and the Managing Committee of the British School at Athens
Ath. Mitt.	*Mitteilungen des deutschen archäologischen Instituts, Athenische Abteilung*
B.C.H.	*Bulletin de Correspondance Hellénique*
B.S.A.	*Annual of the British School at Athens*
Buchholz and Karageorghis	H.-G. Buchholz and V. Karageorghis, *Prehistoric Greece and Cyprus* (London, 1973)
C.I.M., I (1967)	*Atti e Memorie del Primo Congresso Internazionale di Micenologia* (Rome, 1967)
C.M.S.	*Corpus der minoischen und mykenischen Siegel*, ed. F. Matz and H. Biesantz (Berlin, 1964-)
Enc. dell'Arte	L. Banti, G. P. Caratelli, and D. Levi, 'Arte minoica e micenea', *Enciclopedia dell'Arte Antica, Classica e Orientale*, V, 42-102 (Rome, 1963)
Higgins, *Min. Myc. Art*	R. Higgins, *Minoan and Mycenaean Art* (London, 1967)
Hood, *The Minoans*	S. Hood, *The Minoans: Crete in the Bronze Age* (London, 1971)
J.d.I.	*Jahrbuch des deutschen archäologischen Instituts*
J.H.S.	*Journal of Hellenic Studies*
K. Ch.	*Kritika Chronika*
K.F.A.	A. J. Evans, *Knossos Fresco Atlas*, with Catalogue of Plates by M. Cameron and S. Hood (Farnborough, Gregg Press, 1967)
London Myc. Seminar	*Mycenaean Seminar of the University of London Institute of Classical Studies*
Marinatos and Hirmer	S. Marinatos and M. Hirmer, *Crete and Mycenae* (London, 1960)
Mochlos	R. B. Seager, *Explorations in the Island of Mochlos* (Boston and New York, 1912)
Mylonas, *Anc. Myc.*	G. E. Mylonas, *Ancient Mycenae, the Capital City of Agamemnon* (London, 1957)
Mylonas, *M.M.A.*	G. E. Mylonas, *Mycenae and the Mycenaean Age* (Princeton University Press, 1966)
P.A.E.	*Praktika tis en Athinais Archaiologikis Etaireias*
P.M.	A. J. Evans, *The Palace of Minos at Knossos*, 4 vols., with index vol. by J. and A. Evans (London 1921, 1928, 1930, 1935, 1936)
P. Nestor	*The Palace of Nestor at Pylos in Western Messenia:* vol. I, *The Buildings and Their Contents*, by C. W. Blegen and M. Rawson; vol. II, *The Frescoes*, by M. L. Lang; vol. III, *Acropolis and Lower Town*, by C. W. Blegen and others (Princeton University Press, 1966, 1969, 1973)
S.G.	G. Karo, *Die Schachtgräber von Mykenai* (Munich, 1930)
Smith, *Interconnections*	W. S. Smith, *Interconnections in the Ancient Near East* (New Haven, 1965)
Thera	S. Marinatos, *Excavations at Thera*, I-VI (seasons 1967-72) (Athens, 1968-73)
Tiryns, II	G. Rodenwaldt, *Tiryns*, II, *Die Fresken des Palastes* (Athens, 1912)
Vermeule, *G.B.A.*	E. Vermeule, *Greece in the Bronze Age* (Chicago, 1964)
V.T.M.	S. Xanthoudides, *The Vaulted Tombs of Mesara* (London, 1924)
Warren, *M.S.V.*	P. Warren, *Minoan Stone Vases* (Cambridge, 1969)
Zervos, *A. Cr.*	C. Zervos, *L'art de la Crète, néolithique et minoenne* (Paris, 1956)
Zervos, *Nais.*	C. Zervos, *Naissance de la civilisation en Grèce*, 2 vols. (Paris, 1962-3)

NOTES

Bold figures indicate page reference.

INTRODUCTION

18. 1. E. Drioton and J. Vandier, *L'Égypte*[4] (Paris, 1962), 627 ff.
2. E.g. by R. M. Dawkins, *B.S.A.*, XIX (1912–13), 1–2.
3. Cf. Higgins, *Min. Myc. Art*, 12.

CHAPTER 1

19. 1. K. W. Butzer, 'Physical Conditions in Eastern Europe, Western Asia and Egypt before the Period of Agricultural and Urban Settlement', *Cambridge Ancient History*[3], 1, part 1, 43, map 4.
20. 2. Rock-carvings in a cave at Asfendhou in western Crete have been claimed as Mesolithic, but appear to belong to a much later period (see p. 92).
3. J. D. Evans, *B.S.A.*, LIX (1964), 196.
4. D. R. Theochares, *I Avyi tis Thessalikis Proistorias* (Volos, 1967), 99 ff.
5. A. Perkins and S. S. Weinberg, 'Connections of the Greek Neolithic and the Near East', *A.J.A.*, LXII (1958), 225.
6. *Hesperia*, XL (1971), 391.
21. 7. K. Branigan, *The Tombs of Mesara* (London, 1970), with references.
8. C. Doumas, *The N.P. Goulandris Collection of Early Cycladic Art* (Athens, 1968), 14 f.
9. J. N. Coldstream and G. L. Huxley, *Kythera* (London, 1972), 275 f.
22. 10. E.-M. Bossert, 'Kastri auf Syros', *A. Delt.*, XXII, 1 (1967), 53–76.
11. J. W. Graham, 'The Relation of the Minoan Palaces to the Near Eastern Palaces of the Second Millennium', in E. L. Bennett, *Mycenaean Studies* (Madison, 1964), 195–215.
23. 12. But see the important article by G. E. Mylonas, 'Athens and Minoan Crete', in *Athenian Studies Presented to William Scott Ferguson* (*Harvard Studies in Class. Phil.*, Suppl. 1) (Cambridge, Mass., 1940), 11–36. This does not, however, take into account the relatively superficial character of much ancient conquest. The imposition of tribute would leave hardly a trace in the archaeological record, apart from cultural influence of the kind that is so clearly reflected on the Greek mainland from the direction of Crete in the shaft grave period and later, or destruction levels if the demand was resisted with ill success.
24. 13. S. Hood, 'Tholos Tombs of the Aegean', *Antiquity*, XXXIV (1960), 166–76.

25. 14. The surprisingly difficult problem of the date of the final destruction of the palace at Knossos is still under discussion. Evans himself changed his mind a good deal about this before eventually deciding in favour of a date *c.* 1400. The idea that the destruction was in fact considerably later was revived by C. W. Blegen in 1958 ('A Chronological Problem', in *Minoica* (Berlin, 1958), 61–6) and has been urged with much vigour by L. R. Palmer since 1960. Palmer at first suggested a date for the destruction as late as *c.* 1150. But opinion now seems to be crystallizing between a date early in L.M. IIIB, in the first half of the thirteenth century, as implied by J. Raison, *Les vases à inscriptions peintes de l'âge mycénien* (Rome, 1968), and one between 1400 and 1375, but nearer to 1375, as argued by M. Popham, who has ably published most of the relevant pottery from the palace area in *The Last Days of the Palace of Knossos* (*Studies in Mediterranean Archaeology*, V) (Lund, 1964), and *The Destruction of the Palace at Knossos* (*Studies in Mediterranean Archaeology*, XII) (Göteborg, 1970). There is still disagreement, however, as to what vases were actually in use at the time of the final destruction of the palace, and the dating of some of the relevant pottery is disputed.
15. R. Carpenter, *Discontinuity in Greek Civilisation* (Cambridge, 1966).
16. E.g. P. Åström, *C.I.M.*, 1 (1967), 56; W. A. McDonald, *ibid.*, 103 f.
17. Cf. F. Hampl, 'Die Chronologie der Einwanderung der griechischen Stämme und das Problem der Träger der mykenischen Kultur', *Museum Helveticum*, XVII (1960), 57–86; E. Grumach, *The Coming of the Greeks* (Manchester, 1969), reprinted from the *Bulletin of the John Rylands Library*, LI, no. 1 (1968) and no. 2 (1969).

CHAPTER 2

27. 1. Specialized potters' workshops appear to have existed by the Early Chalcolithic period in Anatolia (J. Mellaart, *Excavations at Hacilar* (Edinburgh, 1970), 30).
2. F. Matz, *Die Frühkretischen Siegel* (Berlin and Leipzig, 1928), 108 f.; *P.M.*, 1, 124, figure 93A. Mostly not well dated, and assigned to the E.M. period. But one from Mallia was engraved at the end of M.M. I or

early in M.M. II (*Comptes Rendus, Académie des Inscriptions et Belles-Lettres* (1957), 125). Cf. an impression from a deposit of approximately the same date at Phaistos (*C.M.S.*, 11, 5, no. 326). Compare E. A. Speiser, *Excavations at Tepe Gawra*, 1 (Philadelphia, 1935), plate clxiii, 91, from Stratum XII assignable to the early Uruk period when the use of the fast potter's wheel is first attested in Mesopotamia.

28. 3. *P.M.*, 11, 9; cf. G. A. S. Snijder, *Kretische Kunst* (Berlin, 1936), 15 f.

4. D. Levi, 'Le varietà della primitiva ceramica cretese', in *Studi Banti*, 223–39. Cf. *Arch. Reports for 1970–71*, 27, for Knossos.

5. The few sherds with dark-on-light decoration were thought to be imports of L.N. matt-painted ware from the Greek mainland (J. D. Evans and C. Renfrew, *Saliagos* (London, 1968), 42, 44 f., 82 f.).

30. 6. F. Schachermeyr, *Die ältesten Kulturen Griechenlands* (Stuttgart, 1955), 128.

7. A. Lane, *Greek Pottery*[3] (London, 1971), 3–7; R. Higgins, *Greek Terracottas* (London, 1967), 3 f.; *idem, Min. Myc. Art*, 23–5; S. Marinatos, 'New Advances in the Field of Ancient Pottery Technique', *A.A.A.*, v (1972), 293–7.

8. Schachermeyr, *op. cit.*, 126 ff.; H. Hauptmann and V. Milojčić, *Die Funde der frühen Dimini-zeit aus der Arapi-magula Thessalien* (Bonn, 1969), 37.

31. 9. C. Renfrew, *The Emergence of Civilisation, the Cyclades and the Aegean in the Third Millennium B.C.* (London, 1972), 77 ff.

10. *P.M.*, 1, 79 ff.

11. W. Schiering, *J.d.I.*, LXXV (1960), 17 ff. Cf. Higgins, *Min. Myc. Art*, 25.

32. 12. P. Warren, *Myrtos* (London, 1972), 207 f., plates 69–70. Cf. *V.T.M.*, 39, plate xix, nos. 4137, 4993, from Koumasa. Also *Ergon* (1969), 192 f., figure 235.

13. For 'frying pans' see G. Mylonas, *Aghios Kosmas* (Princeton University Press, 1959), 125 f.; C. Doumas, *The N.P. Goulandris Collection of Early Cycladic Art* (Athens, 1968), 18; Higgins, *Min. Myc. Art*, 54; Renfrew, *op. cit.*, 420 ff.

14. Cf. Higgins, *Min. Myc. Art*, 53.

33. 15. A. J. B. Wace and M. S. Thompson, *Prehistoric Thessaly* (Cambridge, 1912), 20, 180 ff.

16. J. L. Caskey, *Hesperia*, XXIX (1960), 126 ff.

17. S. S. Weinberg, *Antike Kunst*, XII (1969), 5 ff.

18. I owe this suggestion to Mr Leon Pomerance.

19. Renfrew, *op. cit.*, 357; E. Kunze, *Orchomenos*, III (Munich, 1934), 86 f., plate xxix, 3.

20. *A.E.* (1953–4), 71 f., figure 19.

21. S. Hood, 'An Early Helladic III Import at Knossos and Anatolian Connections', in *Mélanges offerts à André Varagnac* (Paris, 1971), 427–36.

22. Cf. *Enc. dell'Arte*, 21, for the idea that the polychrome style of vase decoration originated at Phaistos and spread later to Knossos.

34. 23. This use for the clay discs in question was first suggested, but afterwards rejected, by H. B. Hawes, *Gournia* (Philadelphia, 1908), 42, plate viii, nos. 32–3. See also I. Hazzidakis, *A.E.* (1912), 230 f., figure 39, citing Franchet; S. Xanthoudides, 'Some Minoan Potter's-Wheel Discs', *Essays in Aegean Archaeology presented to Sir Arthur Evans* (Oxford, 1927), 111–28. One from Mallia may be as early as M.M. I (*Études crétoises*, VII (1945), 61, no. 9328), but they are mostly from later contexts. Circular clay objects from the E.M. II settlement at Fournou Korifi have been claimed as turntables employed in making pottery before the advent of the fast wheel (Warren, *op. cit.*, 213 ff.).

24. W. Schiering, *J.d.I.*, LXXV (1960), 17 ff.; *P.M.*, 1, 87, 177 f., 413 f., and 11, 221, 435; Warren, *M.S.V.*, 172 f.

25. K. Müller, *J.d.I.*, XXX (1915), 265, considered that the gap between high art and vase-painting was never so narrow as during this period.

26. P. Pelagatti, 'Osservazioni sui ceramisti del I° Palazzo di Festos', *K.Ch.* (1961–2), 1, 99–111.

27. Marinatos and Hirmer, colour plate xi.

36. 28. *P.M.*, 1, 553.

29. *P.M.*, IV, 103, figure 69; *Annuario*, XXVII–XXVIII (1965–6), 335 ff., figure 30, plate i.

30. Marinatos and Hirmer, plate 74; Zervos, *A.Cr.*, plate 390. Cf. *Annuario*, XXVII–XXVIII (1965–6), 334, figure 29.

31. *P.M.*, 1, 603 ff.; J. Forsdyke, *Proceedings of the British Academy*, XV (1929), 53, 58 f.

32. W. Schiering, *J.d.I.*, LXXV (1960), 22, suggests that Tortoise Shell Ripple was copied from the veining of alabaster vases.

37. 33. Cf. *P.M.*, 1, 554, 609; 11, 468 ff.

34. Forsdyke, *op. cit.*, 49.

35. *Ibid.*, 69 ff., for a good account of the Marine Style.

38. 36. R. C. Bosanquet and R. M. Dawkins, *The Unpublished Objects from the Palaikastro Excavations 1902–1906* (London, 1923), plate xviii*b*; Marinatos and Hirmer, plate 82, right; R. B. Seager, *Pseira* (Philadelphia, 1910), 25 f., figure 8.

37. Forsdyke, *op. cit.*, 69.

40. 38. *Thera*, I–V, *passim*.

39. G. Mylonas, 'Vases with Bird Representations', *A.A.A.*, II (1969), 210–12; III (1970), 89–91.

40. J. L. Caskey, *Hesperia*, XXIX (1960), 298.

41. S. Hood, in *Mélanges offerts à André Varagnac* (Paris, 1971), 431.

42. A. Furumark, *The Mycenaean Pottery* (Stockholm, 1941), 14.

43. In the Aigina Museum. See G. Welter, *A.A.* (1937), 24.

41. 44. Schachermeyr, *op. cit.* (Note 6), 276. But contrast A. J. B. Wace, 'Middle and Late Helladic Pottery',

in *Epitimvion Christou Tsounta* (Athens, 1941), 345–50, who regards Ephyraean ware as reflecting the native Helladic sense for planned design and restraint.

45. M. R. Popham, *B.S.A.*, LXII (1967), 343 ff.; LXIV (1969), 299 ff.

42. 46. W. A. Heurtley, *B.S.A.*, XXV (1921–3), 146, had already hinted that the Palace Style of Crete might reflect mainland influence.

47. *P.M.*, IV, 305 ff.; Snijder, *op. cit.* (Note 3), 125 ff., plate 25.

48. A. W. Persson, *New Tombs at Dendra near Midea* (Lund, Leipzig, London, and Oxford, 1942), 135 ff., figure 117.

49. S. A. Immerwahr, 'The Use of Tin on Mycenaean Vases', *Hesperia*, XXXV (1966), 381–96; cf. M. Pantelidou, *A.A.A.*, IV (1971), 433–8. But note the reservations of S. Marinatos, *A.A.A.*, V (1972), 296.

50. Furumark, *op. cit.*, 504, discerns new influences from Crete on the pottery of the mainland at the beginning of Myc. IIIA.

51. E.g. C. W. Blegen, *Zygouries* (Cambridge, Mass., 1928), 143 ff., plates xvi–xviii.

43. 52. E. Gjerstad, *Opuscula Archaeologica*, III (1944), 107 ff.; Å. Åkerström, *Opuscula Atheniensia*, I (1953), 9 ff.; *C.I.M.*, I (1967), 48 ff.; H. W. Catling, *B.S.A.*, LVIII (1963), 94 ff., and LX (1965), 212 ff. But see F. H. Stubbings, *B.S.A.*, XLVI (1951), 176.

53. I. Tzedakis, 'Minoan Kitharodos', *A.A.A.*, III (1970), 111–12: assigned to early L.M. IIIB. Cf. *P. Nestor*, II, 79 f., 43 H 6.

54. Higgins, *Min. Myc. Art*, 116; V. Karageorghis, *A.J.A.*, LX (1956), 147 ff. The suggestion is a corollary of the view that the vases in question were made in Cyprus, where no Mycenaean wall-paintings are attested.

55. E.g. F. H. Stubbings, 'Some Mycenaean Artists', *B.S.A.*, XLVI (1951), 168–76; Åkerström, *op. cit.*, 9–28; S. I. Charitonides, *A.E.* (1953–4), II, 101–6; *idem*, *A. Delt.*, XVI (1960), 84–90; S. A. Immerwahr, 'The Protome Painter and Some Contemporaries', *A.J.A.*, LX (1956), 137–41; V. Karageorghis, 'Two Mycenaean Bull-Craters', *A.J.A.*, LX (1956), 143–9.

45. 56. Evans, *P.M.*, IV, 295 f., is eloquent and incisive about this, although his 'infusion of new and vigorous blood' may not be an explanation altogether congenial to modern taste. Cf. Vermeule, *G.B.A.*, 206 ff.

57. M. R. Popham and L. H. Sackett, *Excavations at Lefkandi, Euboea, 1964–66* (London, 1968), 18 f., figure 35.

58. B. Rutkowski, 'The Origin of the Minoan Coffin', *B.S.A.*, LXIII (1968), 219–27; *idem*, *Larnaksy egejskie* (Warsaw, 1966), with English summary 129 ff., reviewed by I. Pini, *Gnomon*, XLI (1969), 712–17; C. Mavriyannaki, *Recherches sur les larnakes minoennes de la Crète occidentale* (Rome, 1972).

46. 59. It is a coincidence that some later Greek wooden sarcophagi imitating houses or temples were similar in shape; cf. C. Watzinger, *Griechische Holzsarcophage* (Leipzig, 1905).

60. S. Alexiou, *A.E.* (1972), 86 ff., figure 1, plate 34.

61. I. Tzedakis, *A.A.A.*, IV (1971), 218.

62. E. Vermeule, *J.H.S.*, LXXXV (1965), 123–48; T. Spyropoulos, *A.A.A.*, III (1970), 184–97; *Ergon* (1969), 7 ff., figures 4–7; *ibid.* (1970), 19 ff., figures 17–19; *ibid.* (1971), 11 ff., figures 12–17. Cf. R. Lorandou-Papantoniou, *A.A.A.*, VI (1973), 169–76.

CHAPTER 3

47. 1. Cf. G. Rodenwaldt, *Der Fries des Megarons von Mykenai* (Halle, 1921), 7.

2. As suggested by Evans, *P.M.*, I, 366. But other interpretations of its use are possible.

3. Pottery: *P.M.*, I, 554, 603 ff., and II, 468 ff.; *Tiryns*, II, 220 f. Gems: *P.M.*, I, 675, 685 ff., and III, 186, 313, 116 f.; cf. IV, 615.

4. *P.M.*, II, 114. It is doubtful, however, whether the art of embroidery was practised by the Bronze Age Cretans. The elaborate designs on dress represented in the wall-paintings could have been woven (S. Marinatos, *Archaeologia Homerica*, I (Göttingen, 1967), A 16 and note 72; cf. A. J. B. Wace, 'Weaving or Embroidery?', *A.J.A.*, LII (1948), 51–5).

5. *P. Nestor*, II, 143.

6. E. H. Hall, *The Decorative Art of Crete in the Bronze Age* (Philadelphia, 1907), 41 f.; cf. F. Schachermeyr, *Die ältesten Kulturen Griechenlands* (Stuttgart, 1955), 225. But see Rodenwaldt, *Tiryns*, II, 221, for the view that there was a strong social differentiation between wall painters and vase decorators, 'die selbstverständlich niemals identisch gewesen sind'.

7. S. Alexiou, 'Ostrakon me Parastasin Anthropinis Morfis ek Knosou', in *Charistirion eis A. K. Orlandon*, II (Athens, 1966), 112–17. Alexiou dates it to L.M. II, and compares the face of the bull-leaping girl (*P.M.*, III, plate xxi opp. 216) (see pp. 60–1). Cf. the dancing lady (*P.M.*, III, 369 ff., colour plate xv), which may have been on the walls of the palace at the time of its final destruction. In later frescoes of women from the mainland, like *Tiryns*, II, plates viii, ix, the hair is more stylized.

8. Cf. Rodenwaldt, *Fries* (*op. cit.*), 20.

9. G. Gerola, *Elenco topografico delle chiese affrescate di Creta*, Greek ed. translated by K. E. Lassithiotakis (Herakleion, 1961), 18.

48. 10. For the earliest painted plaster in the Aegean see P. Warren, *Myrtos* (London, 1972), 305 ff.

11. Probably of the third millennium, but of the fourth or fifth according to calculations based upon radiocarbon dates (*Myrtos*, 311).

12. *P.M.*, I, 72.

13. Renfrew, *Emergence* (*op. cit.*, Chapter 2, Note 9), 436, reports red-painted plaster from Neolithic Phaistos, and K. Branigan, *The Foundations of Palatial Crete* (London, 1970), 41, notes house floors of red stucco assignable to E.M. I there. But these floors do not appear to be made of plaster (D. Levi, *Annuario*, XXXV–XXXVI (1958), 170, note 1), and the pottery from above them looks E.M. II in character.

14. D. Levi, *Bollettino d'Arte* (1955), 148, figure 6.

15. *Arch. Reports for 1964–65*, 29, figure 36; *B.C.H.*, LXXXIX (1965), 1000, figures 1–2.

16. Pernier, *Monumenti Antichi*, XII (1902), 20, 80 ff.; *P.M.*, I, 180, note 1.

17. *P.M.*, I, 251 f., figure 188*a,b.*

18. A decorative fragment, assigned by Evans to M.M. I or M.M. II (*P.M.*, I, 201, colour plate i*k*, opp. 231; II, 199, 200, figure 110A*k*; IV, 249, figure 187*k*; cf. Smith, *Interconnections*, 18), actually comes from the belt of a life-size male figure like those of the Procession fresco according to M. Cameron, *London Myc. Seminar* (3 June 1970), 362, note 1. Cf. H. Frankfort, *The Art and Architecture of the Ancient Orient (Pelican History of Art)*, 4th imp. (Harmondsworth, 1969), 131 f., figure 58, for a metal belt with spiral decoration of this kind.

19. L. Woolley, *Alalakh* (Oxford, 1955), 228 ff.

20. *Ibid.*, 231, plate xxxviiia.

21. A. B. Rowton, *Cambridge Ancient History*[3], I (Cambridge, 1970), 212–13.

22. The Atchana wall-paintings derive from Cretan models according to F. Matz, *Cambridge Ancient History*[3], II, ch. iv (*b*) Minoan Civilization (Cambridge, 1962), 33, and *Crete and Early Greece* (London, 1962), 113. Cf. Smith, *Interconnections*, 49.

23. *K.F.A.*, 27; *P.M.*, I, 265 f.

24. *P.M.*, I, 265, note 1.

25. *B.S.A.*, VI (1899–1900), 45. L. R. Palmer, *On the Knossos Tablets: The Find-Places of the Knossos Tablets* (Oxford, 1963), I, 210 ff., and *A New Guide to the Palace of Knossos* (London, 1969), 74 f., figure 12, claims that it was found above the latest of several floors in this area. But here and in some other parts of the palace the excavators appear to have gone through earth floors into earlier deposits from which the fragments of this fresco may have come.

26. J. D. S. Pendlebury, *The Archaeology of Crete* (London, 1939), 131; N. Platon, *K. Ch.* (1947), 505 f.; *ibid.* (1960), 504.

49. 27. As noted by Evans, *P.M.*, I, 265 f.

28. *Thera*, II, 53 f., figure 43.

29. *P.M.*, IV, 718 ff. Cf. M. Möbius, *J.d.I.*, XLVIII (1933), 9.

30. Evans came to favour a date in M.M. I, but he originally proposed M.M. IIB (*P.M.*, I, 265 f.; II, 728; III, 22; IV, 718; index, 52). He evidently thought

that frescoes survived in some parts of the palace when other parts were damaged or destroyed. The frescoes on the walls of the palace at any one time might therefore be of different ages. Moreover Evans seems to have assumed that frescoes from any given horizon of destruction were painted immediately after the one that preceded it in that area. Thus in assigning the Saffron Gatherer to M.M. IIB he may have been thinking of it as painted after a disaster towards the end of that period. This would approximate to the M.M. III dating proposed by G. A. S. Snijder, *Kretische Kunst* (Berlin, 1936), 28, and followed by Pendlebury and Platon (Note 26). Rodenwaldt, *Fries* (*op. cit.*, Note 1), 63, note 22, and M. Cameron (in conversation) have suggested still later dates.

50. 31. Cf. *P.M.*, II, 452. When a similar convention occurs in Egypt it is exceptional, but may not always reflect Cretan influence (Smith, *Interconnections*, 156 f., apropos of the tomb of Kenamun, as against Evans, *P.M.*, II, 448–50).

32. W. Schiering, *J.d.I.*, LXXV (1960), 26 ff., and *Antike Kunst*, VIII (1965), 10. Cf. J. Forsdyke, *Proceedings of the British Academy*, XV (1929), 57. Also M. H. Swindler, *Ancient Painting* (London, 1929), 90.

33. *P.M.*, I, 442–7, 527–8, figures 319, 321, 384–5, and II, 604, figure 377; *K.F.A.*, plates v. 1–2, vi. 12, vii. 1. Assigned by Evans to M.M. IIIB, but M. Cameron has suggested to me that they could be as late as L.M. II. Boxes in the Knossos Stratigraphical Museum with material allegedly from the lower cists in Magazine XIII contain debris of a stone vase maker's workshop and pottery of L.M. III date, but there is nothing about these in the original excavation report (see p. 149).

34. Best reproduced by Zervos, *A. Cr.*, colour plate v opp. 32.

51. 35. M. Cameron, *London Myc. Seminar* (3 June 1970), 363, has suggested that it might represent a rug or carpet made from leopard and possibly zebra hides.

52. 36. *P.M.*, II, 431–67; M. Cameron, *B.S.A.*, LXIII (1968), 1–31, with a full discussion and references to earlier publications.

37. M. Cameron, *B.S.A.*, LXIII (1968), 26.

38. L. Pernier and L. Banti, *Guida degli scavi italiani in Creta* (Rome, 1947), 31. Originally published in *Monumenti Antichi*, XIII (1903), 55–60, plates vii–x. See also *P.M.*, I, 538, figure 391. Smith, *Interconnections*, 77 ff., has suggested a restoration of the scene, but the description given in the text is based upon ideas which M. Cameron was generous enough to communicate to me.

39. Evans, *P.M.*, I, 538 f.; II, 447, 732 f.; index, 52, assigns the Ayia Triadha paintings to the later part of M.M. IIIB (after the earthquake at Knossos), and regards them as contemporary with those from the House of the Frescoes.

40. The figure interpreted by Evans, *P.M.*, I, 354, figure 201, as a roe is headless and appears to be a goat according to M. Cameron, *B.S.A.*, LXIII (1968), 29, no. 27. Cameron, *ibid.*, 25 f., has suggested that a picture incorporating goats and crocuses adorned a room adjacent to that with the monkeys and blue birds in the House of the Frescoes at Knossos.

53. 41. Compare H. T. Bossert, *The Art of Ancient Crete* (London, 1937), 133 plate 241, 135 plate 244, with *P.M.*, II, 479 figure 286, 455 figure 266c.

42. Bossert, *op. cit.*, 136 plate 245; cf. *B.S.A.*, LXIII (1968), plate 5.1,2.

43. Bossert, *op. cit.*, 134 plate 242.

44. *Excavations at Phylakopi in Melos, conducted by the British School at Athens* (London, 1904), 72 ff.; *P.M.*, I, 544-7, and III, 41 f., figure 26.

45. M. Cameron suggested to me that they were griffins.

46. *P.M.*, I, 547 ff., figure 399.

47. *Phylakopi* (*op. cit.*), 76 f.; *B.S.A.*, IV (1897-8), 16.

48. Evans, *P.M.*, I, 544 ff.; cf. Furumark, *Opuscula Archaeologica*, VI (1950), 192 ff.

49. I am much indebted to Professor Colin Renfrew for calling my attention to Mackenzie's notebooks, and for allowing me to refer to the results of the new excavations directed by him at Phylakopi on behalf of the British School at Athens.

54. 50. Cf. *Tiryns*, II, 195.

51. S. Marinatos and M. Hirmer, *Kreta, Thera und das mykenische Hellas* (Munich, 1973), 56 ff., plates 149-53, colour plates XXXIV, XXXVI-XXXIX. Also *Thera*, II, 53 f.; III, 41 ff., plates B, 59-62; IV, 45 ff., plates A-F, 112-26; V, 37 ff., plates C-K, 91-102; VI, 34 ff., colour plates 3-9; and *A.A.A.*, IV (1971), 407-12; VII (1974), 87-94. The paintings are displayed in the Thera exhibition of the National Museum in Athens.

52. Marinatos and Hirmer, *op. cit.* (Note 51), 54.

53. *Ibid.*, 56.

55. 54. *Ibid.*, 56 f., colour plates XXXVI-XXXVII; *Thera*, IV, 20 ff., 49 ff.

55. Compare *Thera*, IV, colour plate A with Bossert, *op. cit.* (Note 41), 135, plate 244.

56. *Clara Rhodos*, X (1941), 66 ff., plates VII, XI; Furumark, *op. cit.* (Note 48), 177. From Stratum I (L.M. IA) and Stratum IIB.

57. *P.M.*, I, 537, colour plate VI; *K.F.A.*, plate VIII, figure I.

58. *P.M.*, II, 455, figure 266c.

59. *P.M.*, I, 578, 604 f., figure 443, and index, 128; Marinatos and Hirmer, colour plate XXV.

60. Marinatos and Hirmer, colour plate XXII; *P.A.E* (1932), 76-94; *A.A.* (1933), 287-95.

61. Marinatos and Hirmer, *op. cit.* (Note 51), 57, plate 150; *Thera*, V, plates E, 94.

62. S. Marinatos, *Thera*, V, 43; *A.A.A.*, VII (1974), 88; cf. *P. Nestor*, II, 76, 33 H sw.

56. 63. Marinatos and Hirmer, *op. cit.* (Note 51), 57, colour plate XXXIV.

64. J. Hazzidakis, *Tylissos à l'époque minoenne* (Paris, 1921), 63; *P.M.*, III, 35; *A.A.* (1972), 186.

65. *P.M.*, II, 378 f., figure 211c.

66. M. Möbius, 'Pflanzenbilder der minoischen Kunst in botanischer Betrachtung', *J.d.I.*, XLVIII (1933), 1-39.

67. But five-petalled flowers are represented on the later frieze of women from Thebes on the Greek mainland (H. Reusch, *Die zeichnerische Rekonstruktion des Frauenfrieses im Böotische Theben* (Berlin, 1956), plate 2, fr. no. 10).

68. M. Cameron, *B.S.A.*, LXIII (1968), 3 f., 8. Contrast *P.M.*, II, 448, 454.

58. 69. *P.M.*, III, 37 ff., figures 20-2 and figure 27 (from a third figure?). But M. Cameron, *London Myc. Seminar* (3 June 1970), 361, argues that figure 20 is from the codpiece of a girl bull-leaper, while figure 21 may be from a man's kilt. Evans makes a comparison between these Knossian figures and those from Pseira, but assigns them all to M.M. IIIB.

70. *K.F.A.*, Cat. 42, no. 7, with references. But Evans, *P.M.*, III, 37, note 1, remarks that the deposit contained 'some L.M. III fresco patterns' and was 'superposed on wall-stumps of "Reoccupation" date'. M. Cameron, *London Myc. Seminar* (3 June 1970), 361, shows reason to believe that fragments of later frescoes, including part of 'La Parisienne', came from here.

71. *P.M.*, III, 37, figure 20. Cameron, *op. cit.*, 361, suggests that the fragment comes from the kilt of a female bull-leaper.

72. Cameron, *op. cit.*, 363.

73. *P.M.*, II, 679-82.

74. *P.M.*, I, 546-7, figures 397-8, and II, 333, 682, 730; *K.F.A.*, plate XIIb. Perhaps from a religious scene. Cf. C. Picard in *Epitimvion Christou Tsounta* (Athens, 1941), 447.

75. *P.M.*, I, 546-7; II, 682, 730; index, 52.

76. *P.M.*, 730 f.

77. *P.M.*, IV, 284 f.

78. *P.M.*, II, 108-16.

79. *P.M.*, II, 770-3, and IV, 398-401; *K.F.A.*, plate C, figures 1,3.

80. N. Platon, *K. Ch.* (1959), 332; M. Cameron, in *K.F.A.*, Cat. 19, plate C, figure 3.

60. 81. N. Platon, *K. Ch.* (1955), 565; S. Alexiou, *A.A.* (1964), 785-804; M. Cameron, *A.A.* (1967), 330-44.

82. M. Cameron, *A.A.* (1967), 341 ff.

83. Evans, *P.M.*, II, 768, 770, claims that the deposit 'could not be later than L.M.I'. Cf. S. Alexiou, *A.A.* (1965), 797 ff.; N. Platon, *K. Ch.* (1955), 565.

84. *P. Nestor*, II, 69, 18 H 43; 92, 57 H nws.

85. *P.M.*, III, 209-24. Rodenwaldt, *op. cit.* (Note 1),

19, suggested that some of the panels might have depicted boxing scenes, but there appears to be no evidence for this.

86. M. R. Popham, *The Destruction of the Palace at Knossos* (*Studies in Mediterranean Archaeology*, xii) (Göteborg, 1970), 40 f. But some of the fragments may have been incorporated in the late walls in the Court of the Stone Spout (J. Boardman, *On the Knossos Tablets: The Date of the Knossos Tablets* (Oxford, 1963), 51).

87. *P.M.*, iii, 216, colour plate xxi; *K.F.A.*, plate A, figure 2.

61. 88. As noted by D. L. Page in an unpublished lecture (*J.H.S.*, lxxxix (1969), 182).

89. *P.M.*, iii, 210; index, 53. Cf. *Tiryns*, ii, 198. But note the captions to *P.M.*, ii, supplementary plate xiii *d,e*: 'L.M. II'!

62. 90. Cf. M. Cameron, *Kadmos*, iv (1965), 14, note 22.

91. *P.M.*, index, 52, s.v. Frescoes: Miniature class. E. Sapouna-Sakellarakis, *Minoikon Zoma* (Athens, 1971), 157 ff., 163 figure 68 for butterflies.

92. *P.M.*, iii, 40, figure 25; *K.F.A.*, plates E, iv. H. Frankfort, *B.S.A.*, xxxvii (1936–7), 116, suggested that the textiles represented were imports rather than native Cretan work, but this seems unlikely, although sphinxes and griffins certainly reached Crete from the Orient.

93. M. Gill, 'The Minoan "Frame" on an Egyptian Relief', *Kadmos*, viii (1969), 85–102, esp. 88 f., figure 2.

94. *P.M.*, iii, 39, figure 23; *K.F.A.*, plate E, figures 3, e, f. They are in any case probably not wind instruments according to B. Aign, *Die Geschichte der Musikinstrumente des ägäischen Raumes bis um 700 vor Christus* (Frankfurt am Main, 1963), 51.

95. *P.M.*, ii, 603, figures 375–6, and iii, 59 f., figure 35; cf. *K.F.A.*, 31, plate iv, figure 15.

96. *P.M.*, iii, 42–80; *K.F.A.*, plates ii, iia, iv, figures 1–3. M. Cameron, in *Europa: Festschrift Ernst Grumach* (Berlin, 1967), 65 ff., for an addition to the Sacred Dance.

63. 97. *P.M.*, iii, 49 f.

98. Maria C. Shaw, 'The Miniature Frescoes of Tylissos Reconsidered', *A.A.* (1972), 171–88; Hazzidakis, *op. cit.* (Note 64), 62, plate viii; *P.M.*, iii, 35 f. figures 17–19, 88 figure 49. Apparently from House A, and perhaps from the walls of a banqueting chamber above Rooms 16 and 17. But remains of fine paintings of flowers comparable with those of the Ayia Triadha frescoes were found in House C (J. Hazzidakis, *Les villas minoennes de Tylissos* (*Études crétoises*, iii) (Paris, 1934), 37).

99. *P.A.E.* (1955), 314–18, figure 2. The associated clay vases, esp. *ibid.*, plate 120, seem consistent with a date for the destruction of the building *c.* 1450 rather than earlier.

100. *Hesperia*, xxxv (1966), 374, plate 90*a*; Maria C. Shaw, *A.A.* (1972), 186.

101. Most fully described and illustrated in *Thera*, vi, 23 f., 38 ff., colour plates 7–9. Cf. Marinatos and Hirmer, *op. cit.* (Note 51), 58–61, colour plates xl–xlii. Cf. *A.A.A.*, vi (1973), 289–92, colour plate A; *Thera*, v, 41, plate 97*b*; *Ergon* (1972), 105, figure 100; *A.A.A.*, vi (1973), 288–92, 494–7, vii (1974), 87–94; S. Marinatos, in *Archaeologia Homerica*, Bd i, Kap. G (Göttingen, 1974), 141–51, for the ships.

64. 102. Marinatos and Hirmer, *op. cit.* (Note 51), 62, colour plate xliv, below; *Thera*, v, 43 f., plates C, 102; vi, 27.

65. 103. *P.M.*, iii, 108 ff., colour plate xix, and iv, 930, figure 900*d*; Hood, *The Minoans*, plate 88; *B.S.A.*, vi (1899–1900), 41. *P.M.*, iii, 88, for a similar plaque with an architectural façade from the south-west angle of the palace.

104. For the register system of wall decoration in Egypt and its spread to the Aegean, see Smith, *Interconnections*, 73, 129 ff., 173; cf. *P.M.*, iv, 880 f. Reusch, *Frauenfries* (*op. cit.*, Note 67), 46, suggested that the idea of painting processional friezes originated on the mainland, but this view is rejected by M. Lang, *P. Nestor*, ii, 58.

105. Cf. Smith, *Interconnections*, 133.

106. *P.M.*, ii, 719–36.

66. 107. Evans assigned them to L.M. Ib (*P.M.*, index, 53), or to the redecoration after the earthquake towards the end of L.M. Ia (*P.M.*, ii, 682) which was completed in L.M. Ib (*P.M.*, iv, 878 ff.).

108. *P.M.*, ii, 735 f.

109. *P.M.*, ii, figure 450, no. 1. Cf. Reusch, *Frauenfries*, plates 4 no. 15, 5 nos. 16, 17.

110. *P.M.*, ii, 720.

111. *P.M.*, ii, 704–12, colour plate xii. Evans suggested that the yellow was meant for copper, which seems improbable in this context.

112. N. Platon, *Zakros* (New York, 1971), 87.

113. *P.M.*, iv, 905–15, 1012 f., colour plate xxxv*c*. M. Cameron, *London Myc. Seminar* (3 June 1970), 360 f., answers criticisms by Palmer, *New Guide* (*op. cit.*, Note 25), 66–8, 126, and C. Hopkins, *A.J.A.*, lxvii (1963), 416–19, but admits that the existing restoration is erroneous in detail.

114. The surviving palm tree is clearly visible in *P.M.*, iv, 915, figure 889. Cf. *ibid.*, 906, figure 881.

115. *P.M.*, iv, 912 f. But see M. Lang, *P. Nestor*, ii, 102.

116. *P. Nestor*, ii, 102, plates 12, 121, 16 H 43. Cf. *ibid.*, plates 48, 6 C nw; 52, 15 C ne; 56; 57; 102. Also *Tiryns*, ii, 19 f., no. 26 (bird).

117. *P.M.*, iii, 306. For a recent discussion of the problem see I. Kritseli-Providi, *A.A.A.*, vi (1973), 178 note 10, 181.

118. N. de G. Davies, *The Tomb of Ken-amun* (New York, 1930), i, plates xvi, xvii.

68. 119. *P.M.*, 11, 605, implies a date in L.M. II, but *P.M.*, IV, 364 f., 379–96, indicates the early part of L.M. IB. Cf. *P.M.*, index, 53 (L.M. IB); *K.F.A.*, plate v, figures 3–5 etc. New restoration by N. Platon, *K. Ch.* (1959), 319–45, corrected by M. Cameron, *K. Ch.* (1964), 38–53, cf. *Europa: Festschrift Ernst Grumach* (Berlin, 1967), 67 f., in the light of an addition to 'La Parisienne'.

120. Popham, *op. cit.* (Note 86), 50–3.

121. As first emphasized by M. B. Mackeprang, *A.J.A.*, XLII (1938), 546. Evans, *P.M.*, IV, 364 f., had already compared a silver goblet from the Isopata Royal Tomb and a bronze one from the Tomb of the Tripod Hearth at Knossos.

70. 122. Marinatos and Hirmer, colour plates XVII–XX. Originally published by R. Paribeni, *Monumenti Antichi*, XIX (1908), 5–86. Good description by M. Robertson, *Greek Painting* (Geneva, 1959), 28 ff. F. Matz, *Göttererscheinung und Kultbild im minoischen Kreta* (Wiesbaden, 1958), 398 ff., for the idea of a separation between a cult of the gods and a cult of the dead.

71. 123. Rodenwaldt, *Ath. Mitt.*, XXXVII (1912), 139, note 2. Cf. J. P. Nauert, *Antike Kunst*, VIII (1965), 92. Cf. *A.J.A.*, LXXVI (1972), 327, 437.

124. *Monumenti Antichi*, XIX (1908), 68, figures 21–3; L. Pernier and L. Banti, *Guida degli scavi italiani in Creta* (Rome, 1947), 12, figure 21; M. Borda, *Arte cretese-micenea nel museo Pigorini di Roma* (Rome, 1946), 75, plate LV.

125. For evidence of painted decoration in tombs in Crete, *P.M.*, IV, 975; on the mainland, Vermeule, *G.B.A.*, 299 f., 349, note 9. Also Mylonas, *Anc. Myc.*, 161; *A.A.A.*, IV (1971), 161–4; *Arch. Reports for 1970–71*, 14 f.; J. N. Coldstream and G. L. Huxley, *Kythera* (London, 1972), 223.

126. *P.M.*, 11, 755–7, colour plate XIII; IV, 886–7. Cf. one of the latest frescoes from Tiryns (*Tiryns*, 11, plate XI, 5) where a man also carries two spears on his shoulder.

127. Negroes appear on fragments of the earlier series of frescoes from Pylos (*P. Nestor*, 11, 61, 94).

128. J. W. Graham, *The Palaces of Crete* (Princeton, 1962), 208.

129. *Thera*, 11, 21, figure 11.

130. *P.M.*, 1, 355 ff., figures 255–6. N. Heaton, *Journal of the Royal Institute of British Architects*, XVIII (1911), 707, indicates that plaster floors with simple chequerwise designs in red and white or black and white were not unusual in the palace at Knossos.

131. *P.M.*, 1, 356, figure 255.

132. *P.M.*, 1, 542–6; III, 377–9. Evans compared the flying-fish fresco from Phylakopi and assigned it to M.M IIIB.

133. M. Guarducci, *Annuario*, 1–11 (1939–40), 232–4; L. Banti, *Annuario*, 111–IV (1941–3), 28–40, figure

18; M. P. Nilsson, *The Minoan-Mycenaean Religion*[2] (Lund, 1950), 96–8, figure 23.

134. This is clear from the detailed account by L. Banti; cf. Pernier and Banti, *op. cit.* (Note 124), 36. *Enc. dell'Arte*, 19, wrongly assigns it to L.M. III. Cf. S. Alexiou, *Minoan Civilization* (Herakleion, 1969), 63.

135. For the method of making the reliefs, *P.M.*, 1, 531; 11, 782.

136. Cf. K. Müller, *J.d.I.*, XXX (1915), 272.

137. R. W. Hutchinson, *Prehistoric Crete* (Harmondsworth, 1962), 181.

138. *P.M.*, III, 189; index, 146.

139. *P.M.*, index, 146.

72. 140. E.g. (1) area of the Spiral fresco above the Loom-weight Basement (see Note 153); (2) beneath the floor of the South Light-well of the Hall of the Double Axes; and (3) under the Service Stair south of the Hall of the Colonnades (*P.M.*, 1, 375, note 1).

141. *P.M.*, 11, 310.

142. *P.M.*, III, 166–77. *A. Delt.*, XVII, 2 (1961–2), 282, for the addition of a new fragment and consequent adjustment of the position of the horns.

143. *P.M.*, III, 171, 190 f.

73. 144. Palmer, *Knossos Tablets* (*op. cit.*, Note 25), plate XV. Contrast *P.M.*, III, 170 f., figure 114.

145. Palmer, *Knossos Tablets*, 119, 5 May 1900.

146. *P.M.*, III, 171.

147. *Ibid.*, 172 ff.

148. *Tiryns*, 11, 195; cf. *P.M.*, III, 168, note 1.

149. *P.M.*, 11, 332 f., figure 188, assigned to M.M. IIIA; IV, 538, figure 489; index, 146: M.M IIIB.

150. *P.M.*, IV, 538. S. Marinatos, *A.A.* (1928), 102 ff., interpreted it as a bull and connected the fragment with the bull reliefs of the North Entrance. M. Cameron has suggested to me that the 'mane' belongs to a bull, while the leg may be that of a griffin.

151. *P.M.*, III, 495–515; *B.S.A.*, VII (1900–1), 87–90.

152. *P.M.*, III, 495, and plan, figure 340; Palmer, *New Guide* (*op. cit.*, Note 25), 92, 97.

153. *P.M.*, 1, 375 f., figure 273; 11, 355; III, 189. *P.M.*, 1, 250, figures 187a, b, for plan and section. Description of the find circumstances in *B.S.A.*, VII (1900–1), 87–90.

74. 154. At first interpreted by Evans as a rhyton (*B.S.A.*, VII (1900–1), 88; cf. Palmer, *New Guide*, 92). K. Müller, *J.d.I.*, XXX (1915), 270, recognized it as a horn.

75. 155. Mentioned by M. Cameron, *London Myc. Seminar* (3 June 1970), 363.

156. *P.M.*, 1, 525 f., figure 383 (from a drawing); 11, 682, 817 f.; III, 50, 485 f.; IV, 285, 518; *K.F.A.*, plate B, figure 2 (apparently from a photograph).

157. *P.M.*, 11, 685, 774–90, colour plate XIV; *B.S.A.*, VII (1900–1), 14–16; *ibid.*, X (1903–4), 2.

76. 158. Palmer, *New Guide*, 111 f.
159. Cameron, *op. cit.* (Note 155), 362. N. Platon, K. *Ch.* (1959), 239, claims to have detected traces of rosy paint on the body.
160. *P.M.*, 11, 781.
161. *B.S.A.*, VII (1900-1), 15 f.
162. It is not by any means certain that all Aegean Bronze Age sphinxes were feminine according to A. Dessenne, *Le Sphinx* (Paris, 1957), 149, 153.
163. *S.G.*, 43, no. 1, 72, no. 230.
164. *A.E.* (1888), 156 f.; V. Stais, *Guide illustré du Musée National d'Athènes*, 11, *Collection mycénienne²* (Athens, 1915), 133, no. 2476; S. Alexiou, 'A Parallel to the Priest-King Relief from Knossos', *A.A.A.*, 11 (1969), 429-35, citing A. Dessenne, *R.E.G.*, LXXIII (1960), xxxiii.
165. Palmer, *New Guide*, 112, suggests that the crown belonged to a sphinx.
166. *P.M.*, 111, 30 f., colour plate xv.
167. *Journal of the Royal Institute of British Architects* (1902), 119, figure 42, plate i.
168. Palmer, *Knossos Tablets* (*op. cit.*), 119, 30 April 1900.

77. 169. *Ergon* (1964), 138, figure 164; *P.A.E.* (1964), 150, plate 147a; Platon, *op. cit.* (Note 112), 172 f.
170. Marinatos and Hirmer, plate 161.
171. *P.M.*, 111, 371-4, figure 247; IV, 874 f., figure 864; index, 147. Assigned by Evans to L.M. I A.
172. A. *Delt*, XXV (1970), Chronika 466; *Enc. dell'Arte*, 17; *Palaikastro* (*op. cit.*, Chapter 2, Note 36), 148, from E 18; H. B. Hawes, *Gournia* (Philadelphia, 1908), 35.
173. R. B. Seager, *Pseira* (Philadelphia, 1910), 11, 15 plate v; *P.M.*, 11, 731, 111, 28, 38, and index, 146; G. Rodenwaldt, 'Rekonstruktionen der Stuckreliefs aus Pseira', *A.A.* (1923/4), 268 ff.
174. Rodenwaldt, *op. cit.*, 275 f., figure 3.
175. C. W. Blegen, *Zygouries* (Cambridge, Mass., 1928), 37 f., plate iii.
176. For frescoes from outside the citadel walls at Mycenae, e.g. *B.S.A.*, XLVIII (1953), 12, 14 f.
177. E.g. Rodenwaldt, *op. cit.* (Note 1), 53; Snijder, *op. cit.* (Note 30), 127 f.
178. *B.S.A.*, XXV (1921-3), 155-9, plate xxvb, 1, 2.
179. The pottery from the deposit included a small sherd of 'stippled or thrush-egg pattern' which is unlikely to be before L.H. IIA according to A. Furumark, *The Mycenaean Pottery* (Stockholm, 1941), 421 ff., Motive 77.
180. W. Lamb, *B.S.A.*, XXIV (1919-21), 189 ff. Probably not from the palace as suggested by Evans, *P.M.*, 1, 444.
181. A. J. B. Wace, *Mycenae, an Archaeological History and Guide* (Princeton, 1949), 64 f.
182. *B.S.A.*, XXV (1921-3), 78-84. Nothing later than L.H. IIIA2 according to A. Furumark, *The*

Chronology of Mycenaean Pottery (Stockholm, 1941), 55.
183. H. Reusch, *A.A.* (1953), 29, thinks the Ramp House frescoes could be L.H. I-II. But they are assigned to the fourteenth century by Smith, *Interconnections*, 70, 87.
184. *B.S.A.*, XXIV (1919-21), plate viii. 8, 9; cf. *P.M.*, 1, figure 397.
185. *B.S.A.*, XXIV (1919-21), plate vii. 2; cf. *K.F.A.*, plate ii; *P.M.*, 111, colour plate xvi opp. 47.
186. *B.S.A.*, XXIV (1919-21), plate vii. 5; cf. *K.F.A.*, plate ix; *P.M.*, 111, figure 144.
187. *B.S.A.*, XXIV (1919-21), plate vii. 4.
188. A. J. B. Wace, in E. L. Bennett, *The Mycenae Tablets*, 11 (Philadelphia, 1958), 8 f.
189. E. French, 'Pottery from Late Helladic IIIB1 Destruction Contexts at Mycenae', *B.S.A.*, LXII (1967), 149-93.

78. 190. *P. Nestor*, 11, *passim*.
191. *Ibid.*, 77, 36 H 105.
192. H. Bulle, *Orchomenos*, 1 (Munich, 1907), 79 f., plate xxviii. 8.
193. Rodenwaldt, *Tiryns*, 11, 165; H. Schliemann, *Tiryns* (London, 1886), 303 ff., plate xiii.

79. 194. Reusch, *Frauenfries* (*op. cit.*, Note 67); *A.E.* (1909), 90-5, plates 1-3; Higgins, *Min. Myc. Art*, 102.
195. S. Marinatos, *Gnomon*, XXIX (1956), 534, 536; *P. Nestor*, 11, 57 f., notes 35, 37.
196. *A.E.* (1909), 88 f. The frescoes were apparently found above a burnt layer with many vases. Another thick burnt layer was identified at a higher level above them.
197. *P.A.E.* (1911), 143 ff. Cf. *P.A.E.* (1921), 33; *A.E.* (1930), 33; *Tiryns*, 11, 189.
198. *P.A.E.* (1927), 42 f.; *A.E.* (1930), 33.
199. Furumark, *op. cit.* (Note 182), 52, assigned the destruction to L.H. IIIA1 *c.* 1400, but only by excluding the very few fragments of fine decorated pottery which Keramopoullos had recovered. Dates suggested for these have ranged from L.H. IIIA2 (S. Hood, *Kadmos*, IV (1965), 43; R. Hope Simpson, *A Gazetteer and Atlas of Mycenaean Sites* (London, 1965), 121) to early in L.H. IIIB (A. Hunter, quoted by P. Ålin, *Das Ende der mykenischen Fundstätten* (*Studies in Mediterranean Archaeology*, 1) (Lund, 1962), 118, note 5), or about the middle of L.H. IIIB *c.* 1275-50 (J. Raison, *Revue de Philologie*, XLI (1967), 141, note 4; cf. *Les vases à inscriptions peintes de l'âge mycénien* (Rome, 1968)). The final destruction by fire revealed by the new excavations at Thebes and involving Linear B tablets is assigned to the end of L.H. IIIB by T. G. Spiropoulos, *A.A.A.*, III (1970), 322-7.
200. As Evans, *P.M.*, 11, 749, recognized. Reusch, *Frauenfries*, 45 f., regards it as contemporary if not somewhat earlier, but Lang, *P. Nestor*, 11, 58, and Marinatos, *Gnomon*, XXIX (1956), 536, implicitly agree with Evans.

201. Reusch, *Frauenfries*, plates 4 no. 15; 5 nos. 16, 17; 13 no. 36. Probably painted in the fourteenth century according to Smith, *Interconnections*, 87.

202. Reusch, *Frauenfries*, plates 6 no. 18; 10 no. 29; 11 no. 30.

203. *B.S.A.*, XXV (1921–3), 166 ff., plate xxviii*h*, *i*.

204. *Tiryns*, 11, 69 ff., plate x. 1, 2, 7.

205. Marinatos and Hirmer, colour plate xl, plate 226.

206. G. Mylonas, *P.A.E.* (1970), 123, plate 171; cf. *Ergon* (1970), 99 f., colour plate; *Istoria tou Ellinikou Ethnous*, 1 (Athens, 1970), 315.

207. *P. Nestor*, 11, 51, 83 ff., plate 33, 49a H nws.

80. 208. *P. Nestor*, 11, 51 ff.; *B.S.A.*, XXV (1921–3), 166, nos. 6–7; H. Reusch, 'Vorschlag zur Ordnung der Fragmente von Frauenfriesen aus Mykenai', *A.A.* (1953), 26–56; *Tiryns*, 11, 94, no. 112.

209. *P. Nestor*, 11, *passim*.

210. Rodenwaldt, *Fries* (*op. cit.*, Note 1), 17, suggested that the men of the Knossian Procession fresco were foreign or native tribute bearers.

211. *A.E.* (1896), 1 ff., plates 1, 2. 2. In the panel below is a line of warriors, and beneath them a row of deer. Rodenwaldt, *Tiryns*, 11, 187, thought that the painting was done by a vase painter, if not by the painter of the Warrior Vase itself.

212. *P. Nestor*, 11, 71, 22 H 64; cf. 25 H 64, 31 H nws. Cf. Rodenwaldt, *Fries*, 40.

213. E.g. Rodenwaldt, *Fries*, 52.

214. *P.M.*, 1, 301 ff.

215. E.g. *Palaikastro* (*op. cit.*, Chapter 2, Note 36), 136 f., figure 118; cf. *P.M.*, 1, 676, figure 496. Warren, *M.S.V.*, 85, P.473; cf. *P.M.*, 111, 100, 106, figure 59.

216. *K.F.A.*, plate iv, figures 1, 2; cf. *P.M.*, 111, 82 f., figure 45. Additions by M. Cameron, in *Europa: Festschrift Ernst Grumach* (Berlin, 1967), 67.

217. Rodenwaldt, *Fries*; W. Lamb, *B.S.A.*, XXV (1921–3), 249 ff. There is a good short description of the frieze by Vermeule, *G.B.A.*, 200 f. It is certainly L.H. III and perhaps L.H. IIIA in date, as Lamb, *B.S.A.*, XXV, 254 f., implies. Rodenwaldt's dating to the Shaft Grave period (L.H. I) is untenable.

81. 218. Rodenwaldt, *Fries*, 40, Beilage III. 11; *Ath. Mitt.*, XXXVI (1911), 237, plate xii. 2.

219. A classic example is the mistake in the layout of the floor of the megaron at Pylos (*P. Nestor*, 1, 83).

220. *Tiryns*, 11, 96 ff.

221. *Ibid.*, 111, no. 141.

222. *Ibid.*, 140 ff.

82. 223. W. Taylour, *Antiquity*, XLIII (1969), 96 f., figure 2, plate x*a*; and XLIV (1970), 276 f.; *Istoria tou Ellinikou Ethnous* (*op. cit.*), 316.

224. Compare *Istoria tou Ellinikou Ethnous*, plates on 315 and 317 with that on 316.

83. 225. *B.S.A.*, XXV (1921–3), 232 f., 238, 240. But see Wace, *op. cit.* (Note 181), 136.

226. Mycenae: *J.d.I.*, XXXIV (1919), 87 ff.; *B.S.A.*,

XXV (1921–3), 193 ff., 240 f. Tiryns: *Tiryns*, 11, 222 ff. Pylos: *P. Nestor*, 1, 68 ff., 74, 82 ff., 212, 214.

227. S. Marinatos, *A.A.A.*, 1 (1968), 11, 16, colour plate.

228. *P. Nestor*, 11, 190, cf. 203, 205, 209. Cf. Keramopoullos, *A.E.* (1909), 88 f.

229. *P.M.*, 11, 333, 680. J. W. Shaw, *Annuario*, XLIX (1971), 215, figure 243.

230. *Journal of the Royal Institute of British Architects* (1911), 698. For this and Minoan plaster in general see Shaw, *op. cit.*, 207 ff.

231. Warren, *Myrtos* (*op. cit.*, Note 10), 312–14.

232. E.g. T. Fyfe, 'The Painted Plaster Decoration at Knossos', *Journal of the Royal Institute of British Architects* (1902), 108; N. Heaton, *Journal of the Royal Society of Arts*, LIII (1910), 10 f., and *Tiryns*, 11, 216; Evans, *P.M.*, 1, 528 ff.

233. E.g. J. A. Schneider-Franken, *Ath. Mitt.*, XXXVIII (1913), 187 ff.; A. Eibner, *Entwicklung und Werkstoffe der Wandmalerei* (Munich, 1926), 59 ff.; cf. R. C. Bosanquet, in *Phylakopi* (*op. cit.*, Note 44), 79.

234. *P. Nestor*, 11, 10.

235. Cf. Schneider-Franken, *loc. cit.*

236. S. Marinatos, *A.A.A.*, V (1972), 297; Maria C. Shaw, *A.A.* (1972), 183.

237. Taut string was also employed for making straight guide-lines for paintings in Egypt (H. Frankfort, *The Mural Painting of El-Amarneh* (London, 1929), 18 f.).

84. 238. E.g. *P.M.*, 11, 681.

239. Ioanna Kritseli-Providi, *A.A.A.*, VI (1973), 179, 181; Rodenwaldt, *Fries* (*op. cit.*), 41.

240. *P. Nestor*, 11, 11, 153, 155.

241. *P.M.*, 1, 533.

242. *Tiryns*, 11, 209.

243. M. Cameron, *Kadmos*, VII (1968), 56–8; *B.S.A.*, LXIII (1968), 3.

244. *P. Nestor*, 11, 10 ff., 112; cf. *Tiryns*, 11, 165.

245. *Enc. dell' Arte*, 16; *P.A.E.* (1932), 87; cf. *A.A.* (1933), 293.

246. *P.M.*, 1, 72, 533 note 3; M. Cameron, in Warren, *Myrtos* (*op. cit.*), 307.

247. Cf. *P.M.*, 11, 680.

248. *P.M.*, 1, 533 f.; *P. Nestor*, 11, 229 f.

249. N. Heaton, *Journal of the Royal Society of Arts*, LIII (1910), 209 f.; cf. *P.M.*, 1, 534; *Archaeology*, IX (1956), 196.

250. *Tiryns*, 11, 215.

251. *P.M.*, 1, 534. Cf. *A.J.A.*, XLVII (1943), 473; A. Lucas, *Ancient Egyptian Materials and Industries*[4] (London, 1962), 340 ff.; E. R. Caley and J. F. C. Richards, *Theophrastus on Stones* (Columbus, Ohio, 1956), 183 ff.

252. Cf. Frankfort, *op. cit.* (Note 237), 24.

253. C. Renfrew, *A.J.A.*, LXXIII (1969), 23. Six of

the stone bowls and eleven of the bone paint tubes from the E.C. II cemetery of Chalandriani on Syros had remains of blue colour in them according to Tsountas, *A.E.* (1899), 100, 104.

254. *Archaeology*, IX (1956), 196. Cf. Caley and Richards, *loc. cit.*, for the use of powdered lapis lazuli as paint in later times. But see Lucas, *op. cit.*, 343.

255. *Tiryns*, II, 216; cf. Lucas, *op. cit.*, 344 f.; *P.M.*, IV, 933.

256. *P. Nestor*, II, 8 and note 7.

85. 257. *Tiryns*, II, 199.

258. *P.M.*, III, 361 ff. But see the reservations of W. Arndt, 'Bildliche Darstellungen von Schwämmen im kretisch-mykenischen Kulturbereich', *Sitzungs-berichte der Gesellschaft naturforschender Freunde* (26 October 1935), 182–92.

259. *P.M.*, II, 460; *B.S.A.*, LXIII (1968), 22.

260. E.g. *P.M.*, II, 354: Saffron Gatherer and Ladies in Blue; III, 44: Miniature Frescoes.

261. *P.M.*, II, 109 f., figure 49.

262. E.g. *P. Nestor*, II, 157 ff.

263. *P. Nestor*, II, 160.

264. *P.M.*, II, 447, plate x.

265. E.g. *P. Nestor*, II, plate 123, 26 H 64.

266. *Tiryns*, II, 219.

267. *P. Nestor*, II, 5 note 3, 89. Cf. Fyfe, *op. cit.* (Note 232), 112 f.

268. *Phylakopi* (*op. cit.*, Note 44), 71.

269. *Ergon* (1972), 105; *Thera*, VI, 35 f.

270. E.g. *P. Nestor*, II, 157.

271. E.g. *P. Nestor*, II, 164 ff.; *Thera*, VI, 22.

272. *P.M.*, II, 444, figure 260; *B.S.A.*, LXIII (1968), 14, no. 51.

273. *P.M.*, I, 355 f., figure 255 (M.M. III); index, 52 (M.M. IIIA). Cf. *P.M.*, II, 700 f., figure 439.

274. E.g. *Thera*, V, colour plates I, J.

86. 275. *Phylakopi* (*op. cit.*), 74, 77.

276. *P. Nestor*, II, 43.

277. *Tiryns*, II, 215, cf. 180.

278. *P. Nestor*, II, 21 ff. M. Lang notes that the wavy background divisions can hardly be derived from conventional landscape as Evans assumed.

.279. *Thera*, IV, colour plate E; V, colour plates G, H, J.

280. *P. Nestor*, II, 25, note 32.

281. Warren, *Myrtos* (*op. cit.*), 307.

282. N. Heaton, *Journal of the Royal Institute of British Architects* (1911), 704.

283. W. Lamb, *B.S.A.*, XXV (1921–3), 172.

284. *Ibid.*, 188 ff.

285. G. Rodenwaldt, *J.d.I.*, XXXIV (1919), 93 ff. But see W. Lamb, *B.S.A.*, XXV (1921–3), 192, note 1.

286. *B.S.A.*, XXV (1921–3), 240.

287. E.g. *P.A.E.* (1927), 42; *A.E.* (1930), 33. Cf. *P.M.*, II, 676; *Thera*, V, 45.

288. *P. Nestor*, II, 4. In the case of the monkey fresco from Akrotiri hunks of old fresco had been used

as backing (*Thera*, V, 37, plates 91–2).

87. 289. P. Faure, *B.C.H.*, XCIII (1969), 196–8.

290. *A.A.A.*, IV (1971), 161–4; cf. Buchholz and Karageorghis, 79, 81, no. 1058.

291. Vermeule, *G.B.A.*, 299 f., 349 note 9; Mylonas, *Anc. Myc.*, 161.

CHAPTER 4

89. 1. S. S. Weinberg, 'Neolithic Figurines and Aegean Interrelations', *A.J.A.*, LV (1951), 121–33.

2. P. J. Ucko, *Anthropomorphic Figurines* (Richmond, 1968).

3. Ucko, *op. cit.*, 258, no. 15.

4. *Hesperia*, XXV (1956), 175–7.

90. 5. E.g. P. Warren, *Myrtos* (London, 1972), 211 f., 219 f., figure 95, plates 71–3, for examples from a settlement.

6. K. Branigan, 'Cycladic Figurines and their Derivatives in Crete', *B.S.A.*, LXVI (1971), 57–78; LXVII (1972), 21–3, with additions; and *The Tombs of Mesara* (Letchworth, 1970), 74 ff. Also Zervos, *A. Cr.*, plates 92–3, 105, 188–91; *Ergon* (1972), 121 f., figure 117, from Arkhanes.

7. *V.T.M.*, 67, no. 171; Zervos, *A. Cr.*, plate 231.

8. *Ergon* (1967), 99, figure 105; *Arch. Reports for 1967–68*, 22, figure 36.

9. *B.S.A.*, XXXVI (1935–6), 121 f., plate 19; J. D. S. Pendlebury, *The Archaeology of Crete* (London, 1939), 90, plate xiii.

10. N. Platon, *K. Ch.* (1951), 96–160.

92. 11. C. G. Papoutsakis, *K. Ch.* (1972), 107–39; P. Faure, *Amaltheia* (1971), 277–83, and *B.C.H.*, XCV (1972), 406–13; A. A. Zois, *Epetiris Epistimonikon Erevnon* (1972), 456 f.; S. Hood, 'Primitive Rock Engravings from Crete', *The J. Paul Getty Museum Journal*, I (1975), 101–11.

12. F. N. Pryce, *Catalogue of Sculpture in the Department of Greek and Roman Antiquities of the British Museum*, I, part 1: *Prehellenic and Early Greek* (London, 1928), 3–5, is still an excellent introduction. Also F. Matz, *Crete and Early Greece* (London, 1962), 62 ff.; C. Renfrew, 'The Development and Chronology of the Early Cycladic Figurines', *A.J.A.*, LXXIII (1969), 1–32, with lists and references (criticisms of his typology by J. L. Caskey, *Hesperia*, XL (1971), 125 f.). The typology followed here is based upon that of P. G. Preziosi and S. S. Weinberg 'Evidence for Painted Details in Early Cycladic Sculpture', *Antike Kunst*, XIII (1970), 4–12, which takes that of Renfrew into account but is more streamlined. There is a good survey of figurines in C. Doumas, *The N. P. Goulandris Collection of Early Cycladic Art* (Athens, 1968). For the way figurines were made see S. Casson, *The Technique of Early Greek Sculpture* (Oxford, 1933), 15 ff.; Higgins, *Min. Myc. Art*, 58 ff.

13. *Hesperia*, XXXIII (1964), 316 ff., plate 46.

14. Renfrew, *Emergence* (*op. cit.*, Chapter 2, Note 9), 424. P. Demargne, *Aegean Art* (London, 1964), 43, assumes they are goddesses. For other interpretations see Doumas *op. cit.*, 88 ff.

15. J. Thimme, 'Die religiöse Bedeutung der Kykladenidole', *Antike Kunst*, VIII (1965), 79.

16. D. G. Hogarth, 'Aegean Sepulchral Figurines', in *Essays in Aegean Archaeology Presented to Sir Arthur Evans* (Oxford, 1927), 55–62.

17. C. Renfrew, *A.J.A.*, LXXIII (1969), 6 ff.

18. *Ibid.*, 27 ff.

19. P. G. Preziosi and S. S. Weinberg, *Antike Kunst*, XIII (1970), 7.

20. C. Renfrew, *A.J.A.*, LXXIII (1969), 8 f.; Stais, *op. cit.* (Chapter 3, Note 164), 211, no. 6140.

21. There were only four of the Folded-arm type from a total of 540 graves according to C. Renfrew, *A.J.A.*, LXXIII (1969), 12.

22. E.g. R. Higgins, *The Greek Bronze Age* (London, British Museum, 1970), 30, plate 16.

23. E.g. P. Wolters, *Ath. Mitt.*, XVI (1891), 46, from Amorgos (height 0.29 m.).

93. 24. For a selection of appreciations ranging from the ecstatic to wholesale condemnation see M.-L. and H. Erlenmeyer, 'Von der frühen Bildkunst der Kykladen', *Antike Kunst*, VIII (1965), 59 ff.

25. F. Zafiropoulos, *A.A.A.*, I (1968), 98 f., figures 2–4.

26. Marinatos and Hirmer, plate 11, top.

27. Doumas, *op. cit.* (Note 12), 82; Renfrew, *Emergence* (*op. cit.*), frontispiece in colour.

28. E.g. *B.C.H.*, XCVI (1972), 766, figures 415–16; Zervos, *A. Cr.*, plate 113.

29. B. Aign, *Die Geschichte der Musikinstrumente des ägäischen Raumes bis um 700 vor Christus* (Frankfurt am Main, 1963), 29–34. J. S. Bent, *J.H.S.*, IX (1888), 82, for a harp player from a cemetery on Cape Krio near Knidos.

30. J. S. Bent, *J.H.S.*, V (1884), 51; Pryce, *op. cit.* (Note 12), S, 13, A 34; F. Zafiropoulou, *A.A.A.*, I (1968), 98 f.

31. C. Renfrew, *A.J.A.*, LXXIII (1969), 23 f.

94. 32. Renfrew, *Emergence* (*op. cit.*), 410.

33. Vermeule, *G.B.A.*, 333, note 7.

34. Renfrew, *op. cit.* (Note 31), 21 ff.

35. C. Zervos, *L'Art des Cyclades, du début à la fin de l'âge du bronze* (Paris, 1957), plates 342–3; Buchholz and Karageorghis, 99, no. 1196.

36. E.g. the evidence from Kea, *Hesperia*, XL (1971), 113–26.

37. F. Zafiropoulos, 'A Prehistoric House Model from Melos', *A.A.A.*, II (1969), 406–8. Cf. S. Sinos, *Die vorklassischen Hausformen in der Ägäis* (Mainz, 1971), 34, figure 92, for the 'house'. But these model buildings placed in graves probably represented gran-aries, as noted by F. Oelmann, 'Das Kornspeichermodell von Melos', *Ath. Mitt.*, L (1925), 19–27.

38. *A.J.A.*, LXXIII (1969), 26.

39. *A. Delt.*, XVIII.2 (1963), 276–8; *ibid.*, XX.1 (1965), 41–64; Renfrew, *Emergence* (*op. cit.*), 178.

40. C. W. Blegen, *Zygouries* (Cambridge, Mass., 1928), 185 f., plate xxi.

41. H. Tzavella-Evjen, *A.A.A.*, V (1972), 467–9, with references to other E.H. figurines of animals.

95. 42. Warren, *M.S.V.*, 134 f.

43. The evidence for wooden statues is summarized by Evans, *P.M.*, IV, 612. A fragment of a clay mould from the First Palace at Phaistos suggests that the Cretans were already casting life-size statues by the *cire perdue* process before *c.* 1700 (C. Laviosa, 'Una Forma minoica per fusione a cera perduta', *Annuario*, XLV–XLVI (N.S. XXIX–XXX) (1967–8), 499–510.

44. *P.M.*, III, 522 ff., figures, 365–6. Doubted by G. Rodenwaldt, *Der Fries des Megarons von Mykenai* (Halle, 1921), 8, 63 note 18. Cf. G. A. S. Snijder, *Kretische Kunst* (Berlin, 1936), 90; *Enc. dell'Arte*, 23.

45. *P.M.*, III, 413 f., figure 276.

46. E.g. figures from the Taureador frescoes, *K.F.A.*, plate X.

47. From an earlier deposit in the Fetish Shrine. *B.S.A.*, XI (1904–5), 11 f.; A. Alexiou, *K. Ch.* (1972), 424.

48. K. Branigan, 'Four "Miniature Sickles" of Middle Minoan Crete', *K. Ch.* (1965), 179–82.

49. *Mochlos*, 55, VI.28.

50. *P.M.*, I, 344; V. Hehn, *Kulturpflanzen und Hausthiere* (Berlin, 1894), 276 ff.; Theophrastus, *Historia plantarum*, IV. i. 3; Pliny, *H.N.*, XVI, 141–2.

51. Frazer, *Pausanias*, IV, 246 (Pausanias, VIII. xvii. 2, cf. *ibid.*, VI. xviii. 7); Theophrastus, *Historia plantarum*, V. iii. 7 (cf. *ibid.*, V. iv. 2, where cypress is considered the most enduring of all woods).

96. 52. Cf. J. Forsdyke, *Proceedings of the British Academy*, XV (1929), 62; P. Demargne, *La Crète dédalique* (Paris, 1947), 104; R. V. Nicholls, in *Auckland Classical Essays presented to E. M. Blaiklock* (Auckland, 1970), 21 f.

53. R. W. Hutchinson, *Prehistoric Crete* (Harmondsworth, 1962), 166 ff., plate 14a. J. D. S. Pendlebury, *The Archaeology of Crete* (London, 1939), 121, regarded it as an import, and A. W. Lawrence, *B.S.A.*, XLVI (1951), 81, note 1, called it Sumerian of *c.* 2000 B.C.

54. *B.S.A.*, LIX (1964), 94, plate 12e.

55. *P.M.*, III, 518, figure 363; *B.S.A.*, VI (1899–1900), 31.

56. *P.M.*, II, 162 ff., 590 ff., 695 ff.; IV, 221 ff. Evans assigned them to M.M. III, but they appear to have been in position at the time of the final destruction of the palace, as emphasized by L. R. Palmer, *Mycenaeans and Minoans²* (London, 1965), 265.

57. *P.M.*, IV, 650 ff.

58. Forsdyke, *op. cit.* (Note 52), 69.

59. Hood, *The Minoans*, 128; Buchholz and Karageorghis, 49, no. 430; cf. H. Frost, in *Ugaritica*, VI (Paris, 1969), 235-45.

60. A. J. B. Wace, *A Cretan Statuette in the Fitzwilliam Museum* (Cambridge, 1927); condemned on technical grounds by Casson, *op. cit.* (Note 12), 5 ff.

61. *P.M.*, III, 426 f. Cf. *ibid.*, IV, 35 f., 193 ff., for other stone goddess figurines which are even more suspect.

62. Zervos, *A. Cr.*, plate 459.

63. *B.S.A.*, XXV (1921-3), 236 f. Cf. H. Schliemann, *Mycenae and Tiryns* (London, 1878), 96 ff., nos. 151-4, apparently from shaft grave circle A, if not from a shrine erected there (S. Marinatos, in *Geras Antoniou Keramopoullou* (Athens, 1953), 82 f.).

64. H. Schliemann, *Tiryns* (London, 1886), 284-92; K. Müller, *Tiryns*, III, *Die Architektur der Burg und des Palastes* (Augsburg, 1930), 139 ff., plate 41.

65. *A.E.* (1909), 102 f., figure 19.

66. Müller, *Tiryns*, III (*op. cit.*), 178.

97. 67. R. A. Higgins, *B.S.A.*, LXIII (1968), 331 f., figure 1, for the best restoration.

68. Marinatos and Hirmer, plate 161.

69. W. A. Heurtley, *B.S.A.*, XXV (1921-3), 126-46. Cf. Evans, *P.M.*, IV, 244 ff., and *The Shaft Graves and Bee-hive Tombs of Mycenae* (London, 1929), 50 ff.; *S.G.*, 29 ff. Vermeule, *G.B.A.*, 90 ff., for a lively appreciation.

70. G. E. Mylonas, *O Tafikos Kiklos B ton Mikinon* (Athens, 1973), 33 f., 50 f. (cf. *M.M.A.*, 107 f.); Marinatos, *op. cit.* (Note 63), 66 ff., and *A.A.A.*, I (1968), 175-7. Most of the graves of circle B appear to have been marked by piles of stones, not stelai.

71. J. L. Caskey, *Hesperia*, XXXV (1966), 375, plate 90*b*; Buchholz and Karageorghis, 94, no. 1169.

98. 72. *B.S.A.*, XLVII (1952), 256 ff. For early Aegean helmets in general see H. Hencken, *The Earliest European Helmets* (*Peabody Museum Bulletin* no. 28) (1971).

73. C. W. Blegan, *Hesperia*, Suppl. VIII (1949), 41 f., plate 7.6; Buchholz and Karageorghis, 94, no. 1168.

74. *P.M.*, II, 478 ff. Cf. *P.M.*, I, 700, figure 524 on a sealing from the Knossian Temple Repositories. Also S. Marinatos, *B.S.A.*, XLVI (1951), 106 f.

75. *B.S.A.*, XXV (1921-3), 126-46.

76. *Ibid.*, 143 and 144 note 1.

77. C. Schuchhardt, *Schliemann's Excavations* (London, 1891), 168 f., suggested that the plain stelai were for women. But there are more sculptured stelai than men buried in the graves, although no sculptured stelai were found over graves which only contained burials of women. See, however, Marinatos, *op. cit.* (Note 63), 77, and Mylonas, *M.M.A.*, 93, and *Kiklos B* (*op. cit.*), 50.

78. As argued with much force by A. D. Keramopoulos, *A.E.* (1918), 58 ff. Cf. Evans, *op. cit.* (Note 69), 57.

79. W. Reichel, *Die mykenischen Grabstelen* (Vienna, 1893), 31, suggested that stele I of circle A with its rougher surfaces might have been plastered and painted, the other stelai being merely painted. Possible traces of blue paint have been noted on a fragment of architectural relief from Mycenae (*B.S.A.*, XXV (1921-3), 236).

80. *A.E.* (1896), 1 ff., plates, 1, 2. 2. For other grave stelai at Mycenae and in Crete, see Tsountas and Manatt, *The Mycenaean Age* (London, 1903), 152 f., figure 53; Evans, *P.M.*, IV, 244 ff., and *Shaft Graves and Bee-hive Tombs*, 61 ff.

81. Casson, *Technique* (*op. cit.*, Note 12), 35.

82. *Ibid.*, 35.

99. 83. G. Mylonas, *A.J.A.*, LV (1951), 134-47, and *M.M.A.*, 94.

84. *S.G.*, 143, nos. 808-11. Cf. Marinatos and Hirmer, plates 198-9.

85. W. Reichel, *Die mykenischen Grabstelen* (Vienna, 1893), 30.

86. *P.M.*, IV, 247 ff. Note that the fragment of fresco *ibid.*, 249, figure 187*k*, actually comes from the belt of a life-size figure of L.M. I–II date according to M Cameron, *London Myc. Seminar* (3 June 1970), 362 note 1.

87. *P.M.*, IV, 256 ff., figures 191*a*,*b*.

88. *B.S.A.*, XXV (1921-3), 145; cf. *P.M.*, IV, 247 f. 253, 255.

89. *Enc. dell' Arte*, 37. Cf. Casson, *Technique* (*op. cit.* Note 12), 35.

100. 90. G. Mylonas, *A.J.A.*, LV (1951), 146 f.

91. For tamed lions accompanying some Egyptian pharaohs in war and the hunt, see A. Erman and H Ranke, *Aegypten*[2] (Tübingen, 1923), 275.

92. *P.M.*, IV, 252.

93. Zervos, *A. Cr.*, plate 528.

94. *B.S.A.*, XXV (1921-3), 145 f.

95. *P.M.*, III, 192 ff. The head was first recognize as that of a charging bull by F. Hauser, *J.d.I.*, I (1894), 54-6.

96. But A. J. B. Wace, *Mycenae, an Archaeologica History and Guide* (Princeton, 1949), 136, has sug gested the possibility of Kephallenia as a source.

97. The inner chamber according to A. J. B. Wace, i *Geras Antoniou Keramopoullou* (Athens, 1953), 314 Cf. Higgins, *Min. Myc. Art*, 93, and *B.S.A.*, LXII (1968), 331; Mylonas, *M.M.A.*, 189, note 6. But not the objections raised by Evans, *P.M.*, III, 193, note 3 when W. R. Lethaby originally proposed this in 1920

98. Cf. Smith, *Interconnections*, 56, for the removal c large Egyptian sculptures to Nineveh after th Assyrian conquest.

99. *P.M.*, III, 200 f., figure 138.

101. 100. P. Åström and B. Blomé, 'A Reconstructio

of the Lion Relief at Mycenae', *Opuscula Atheniensia*, V (1964), 159-91, with references.

101. Chrysoula Kardara, 'The Meaning of the Lion Gate Relief', *A.A.A.*, III (1970), 238-46.

102. E. Protonotariou-Deïlaki, 'Peri tis Pilis ton Mikinon', *A.E.* (1965), 7-25, makes an attractive restoration with a pair of griffins whose bronze wings spread over the face of the wall each side of the stone relief. Cf. Nojorkam, *C.I.M.*, I (1967), 232-4. Arguments against griffins are put forward by G. E. Mylonas, 'The Lion in Mycenaean Times', *A.A.A.*, III (1970), 421-5.

103. E.g. *C.M.S.*, I, nos. 98, 171 (griffins); 46, 144-5, 172 (lions); all from Mycenae.

104. Cf. F. Matz, *Crete and Early Greece* (London, 1962), 202.

105. As suggested by Åström and Blomé, *op. cit.*, 179.

106. Casson, *Technique* (*op. cit.*, Note 12), 34, 30 note 3. Cf. Nojorkam, *loc. cit.*

102. 107. Casson, *Technique*, 23 ff.

108. S. Adam, *The Technique of Greek Sculpture* (London, 1966), 78 f.

109. *A.E.* (1902), 1 ff., plates 1-2; *P.M.*, III, 518 ff.; cf. Rodenwaldt, *op. cit.* (Note 44), 52 and 63 note 18. Also *Tiryns*, II, 31 note 3, 238; Casson, *Technique*, 10; Mylonas, *M.M.A.*, 155; P. Nestor, II, 57; Marinatos and Hirmer, colour plates xli-xlii. A sandstone head from Corinth published as Mycenaean (*Corinth*, IX, 4 ff., no. 2) was shown to be Coptic by O. Broneer, *A.J.A.*, XL (1936), 204-9. Cf. Vermeule, *G.B.A.*, 285, note 5.

110. Higgins, *Min. Myc. Art*, 93 f.

111. A. J. B. Wace, *J.H.S.*, LIX (1939), 210, figure 1; Helen Wace, *Ivories from Mycenae No. i 1939: The Ivory Trio* (Athens, no date), figures 23-5.

112. H. Biesantz, *A.A.* (1959), 57-74; M. Andronikos, *A. Delt.*, XVII. I (1961-2), 170 f.; Buchholz and Karageorghis, 15.

113. *Ath. Mitt.*, LXXVIII (1963), 17 ff., figure 9, Beilage 6-7; V. R. d'A. Desborough, *The Last Mycenaeans and their Successors* (Oxford, 1964), 80, 84.

114. A. W. Persson, *The Royal Tombs at Dendra near Midea* (Lund, London, Oxford, Paris, and Leipzig, 1931), 100 ff., 117. Cf. J. Bouzek, *Památky archeologické*, LVII (1966), 269, for a stele from Illmitz in Austria assigned to Central European Bronze D.

103. 115. T. Passek and B. A. Latynine, 'Sur la question des "kamennye baby"', *Eurasia Septentrionalis Antiqua*, IV (1929), 290-311; G. Tontchèva, *Bulletin du musée national à Varna*, III (XVIII) (1967), 3-19. I am very grateful to Mr E. Ralston for discussing these figures with me and for helpful information about them.

104. 116. Zervos, *A. Cr.*, plate 254.

117. *Ibid.*, plate 253.

118. *K. Ch.* (1951), 124 ff.; R. W. Hutchinson, *Prehistoric Crete* (Harmondsworth, 1962), 219.

119. *B.S.A.*, XL (1939-40), 43, plate 20.2. But it had already been recognized as Bronze Age with suggested dates ranging from M.M. I to L.M. I (L. B. Holland, *A.J.A.*, XXXIII (1929), 189 figure 6; H. T. Bossert, *The Art of Ancient Crete* (London, 1937), 163, plate 286). N. Platon, *K. Ch.* (1951), 135, calls it the most beautiful of all Minoan clay heads.

120. *Mochlos*, 45, 49, figure 21; Bossert, *op. cit.*, plate 287b.

121. *A. Delt.*, XVII (1961-2), Chronika 287; *Arch. Reports for 1961-62*, 24.

105. 122. D. Levi, *Annuario*, XXXIX-XL (1961-2), 122 ff.; S. Alexiou, *Gnomon*, XLIII (1971), 279, assigns them to L.M. I.

123. *Palaikastro* (*op. cit.*, Chapter 2, Note 36), 88, figure 71; Zervos, *A. Cr.*, plate 794.

124. *P.M.*, IV, 24 ff., figure 13; Zervos, *A. Cr.*, plate 578.

125. A. Lebesis, *P.A.E.* (1970), 269 f., plate 380.

106. 126. *P.M.*, II, 753 f., figure 487.

127. *Ibid.*, 752, figure 486; Warren, *M.S.V.*, 85, p.474.

128. *Bollettino d'Arte*, III (1959), 247, figure 19.

129. *Ibid.*, 245, figure 16a.

130. R. A. Higgins, *Greek Terracottas* (London, 1967), 11; *Min. Myc. Art*, 124.

131. H. B. Hawes, *Gournia* (Philadelphia, 1908), 35; Zervos, *A. Cr.*, plates 516-17.

132. *B.S.A.*, IX (1902-3), 375 f., plate xii.34; N. Platon, *K. Ch.* (1951), 121 f., note 61. Cf. C. Laviosa, *Annuario*, XLI-XLII (1963-4), 24.

133. *A. Delt.*, XVII (1961-2), Chronika 287; cf. *K. Ch.* (1951), 111 f., from Maza.

134. *Hesperia*, XXXI (1962), 278-80; XXXIII (1964), 328-31; XXXV (1966), 369-71.

107. 135. J. L. Caskey, *Hesperia*, XXXIII (1964), 331, doubts if they could all have been cult images. But see M. P. Nilsson, *The Minoan-Mycenaean Religion*[2] (Lund, 1950), 309.

108. 136. H. Thiersch, in A. Furtwängler, *Aegina* (Munich, 1906), 370, 374. But to judge from the Mycenaean pottery found there the figurines are not all necessarily of L.H. IIIc date as implied by E. French, *B.S.A.*, LXVI (1971), 142.

137. The gable-lidded clay coffins of the Late Bronze Age in Crete appear to be less expensive versions of the wooden chests used for some of the richer burials (H. van Effenterre, *Nécropoles du Mirabello (Études crétoises*, VIII) (Paris, 1948), 9; cf. I. Hatzidakis, *A. Delt.*, IV (1918), 86 f.; S. Hood, *B.S.A.*, LI (1956), 86 f.).

138. Nicholls, in *Blaiklock Essays* (*op. cit.*, Note 52), 4 ff.

139. See especially S. Alexiou, *I minoiki thea meth'*

ipsomenon cheiron (Herakleion, 1958). Cf. Nicholls, *op. cit.*, 5.

140. Hawes, *op. cit.* (Note 131), 48.

141. D. Levi, *Bollettino d'Arte* (1959), 237 ff.; 'Immagini di culto minoiche', *La Parola del Passato*, LXVIII (1959), 377–91.

142. For the dispute about the date of those from Kannia see Nicholls, in *Blaiklock Essays*, 25, note 31, with references.

143. Y. Tzedakis, *B.S.A.*, LXII (1967), 203–5; cf. *B.S.A.*, LXI (1966), 172, no. 6. The curiously squat appearance of the figure may be due to the loss of the skirt cylinder (Nicholls, *op. cit.*, 25, note 32).

109. 144. C. Laviosa, *Annuario*, XLI–XLII (1963–4), 23, notes the resemblance between the heads of the Kannia statues and one from Kea. But this is denied by Y. Tzedakis, *B.S.A.*, LXII (1967), 205, note 20.

145. Buchholz and Karageorghis, 103, no. 1247.

146. K. Dimakopoulou, 'Mikinaïki Pilini Kefali', *A. Delt.*, XX.1 (1970), 174–83. It is suggested that the face may be that of a sphinx.

147. Nicholls, in *Blaiklock Essays* (*op. cit.*), 6 f.

148. W. Taylour, *Antiquity*, XLIII (1969), 91 ff., and XLIV (1970), 270 ff.; S. Marinatos, 'Demeter Erinys in Mycenae', *A.A.A.*, VI (1973), 189–92, argues that they are all female.

110. 149. O. Frödin and A. W. Persson, *Asine* (Stockholm, 1938), 307 f., figure 211. Well illustrated in J. Hawkes, *Dawn of the Gods* (London, 1968), 247.

150. C. Laviosa, 'Il Lord di Asine è una "Sfinge"?', *C.I.M.*, 1 (1967), 87–90.

151. Nicholls, in *Blaiklock Essays* (*op. cit.*), 6.

152. E.g. Crete: *B.S.A.*, XXVIII (1926–7), 254, 263, 290 f., from the Mavrospelio cemetery at Knossos. These appear to date from the very beginning of L.M. III, before the final destruction of the palace. Cf. C. Laviosa, *Annuario*, XLI–XLII (1963–4), 21. Mainland: *B.S.A.*, XVI (1909–10), 11, plate ii*k*, from the Menelaion at Sparta. For other wheel-made figurines from the mainland see R. A. Higgins, *Greek Terracottas* (London, 1967), 15 f.; Nicholls, *op. cit.*, 7.

153. E. French, *B.S.A.*, LXVI (1971), 148, notes an imported M.M. figurine from Ayios Stefanos in Laconia.

154. E.g. One from tholos 2 at Peristeria (*P.A.E.* (1962), 96, plate 97; *Ergon* (1962), 115 ff., figure 139). Some fragmentary statuettes of long-robed women (the largest, with raised arms and headless, 0.30 m. high) found by chance just north of Olympia look remarkably Cretan, although clearly of local manufacture, but their date and context are not yet established for certain (P. Themelis, *A.A.A.*, 11 (1969), 248–56).

155. Mycenaean clay figurines were first classified by Tsountas, *A.E.* (1888), 167 f.; later by A. Furumark, *The Chronology of Mycenaean Pottery* (Stockholm,

1941), 86 ff.; more elaborately now by E. French, 'The Development of Mycenaean Terracotta Figurines', *B.S.A.*, LXVI (1971), 101–87.

156. The Cretan origin of some types of Mycenaean figurine was recognized by C. W. Blegen, *Prosymna* (Cambridge, 1937), 360; cf. H. Thiersch, in A. Furtwängler, *Aegina* (Munich, 1906), 370; W. Taylour, *The Mycenaeans* (London, 1964), 70. See now C. Laviosa, *Annuario*, XLI–XLII (1963–4), 7–24, and 'Origini minoiche della plastica micenea', in *Pepragmena tou B Dhiethnous Kritologikou Sinedhriou*, 1 (Athens, 1968), 374–82.

157. Nicholls, in *Blaiklock Essays* (*op. cit.*), 3.

158. S. E. Iakovidis, 'A Mycenaean Mourning Custom', *A.J.A.*, LXX (1966), 43–50; *Ergon* (1960), 190, figures 216–17 (without a crown).

159. Blegen, *op. cit.*, 255 f.

111. 160. S. Hood, 'A Mycenaean Cavalryman', *B.S.A.*, XLVIII (1953), 84–93.

161. G. E. Mylonas, 'Seated and Multiple Mycenaean Figurines', in *The Aegean and the Near East, Studies presented to Hetty Goldman*, ed. S. S. Weinberg (New York, 1956), 110–21.

162. R. A. Higgins, *Greek Terracottas* (London, 1967), 14, figure 7; G. M. A. Richter, *The Furniture of the Greeks, Etruscans and Romans* (London, 1966), 9, figures 24–5; Buchholz and Karageorghis, 103, no. 1248.

163. *B.S.A.*, LXVI (1971), 173 f.; *Hesperia*, XXXI (1962), 273, plate 99 *f*.

164. D. Levi, 'La dea micenea a cavallo', in *Robinson Studies*, 1 (1951), 108–25; Higgins, *op. cit.*, 15.

165. Frances E. Jones, 'Three Mycenaean Figurines', in *Goldman Studies* (*op. cit.*), 122–5, plate xvi.5,6.

166. C. W. Blegen, 'A Mycenaean Breadmaker', *Annuario*, VIII–IX (1946–8), 13–16.

167. J. M. Cook, 'Pilino omoioma mikinaïkou foreiou', *K. Ch.* (1955), 152–4.

168. L. Banti, *Annuario*, III–V (1941–3), 52 ff.

169. *Ibid.*, 54 ff.; C. Laviosa, *C.I.M.*, 1 (1967), 87–90.

170. Higgins, *op. cit.* (Note 162), 16 f.; Nicholls, in *Blaiklock Essays* (*op. cit.*), 8 ff.

112. 171. *Monumenti Antichi*, XII (1902), 123 ff., figure 54; G. Maraghiannis, *Antiquités crétoises*, ll (Candia, 1912), plate xv; Zervos, *A. Cr.*, plates 795–6; Marinatos and Hirmer, plate 134.

172. But Nicholls, *loc. cit.*, argues for a mainland origin.

173. V. Karageorghis, 'Notes on some Centaurs from Crete', *K. Ch.* (1965), 50–4.

174. There are good accounts by W. Lamb, *Greek and Roman Bronzes* (London, 1929), 18 ff., and Higgins, *Min. Myc. Art*, 135 f. Additions to the lists of worshippers by H. Biesantz, *Kretisch-mykenische Siegelbilder* (Marburg, 1954), 169 f. Also J. Boardman *The Cretan Collection in Oxford* (Oxford, 1961), 6 ff.

I. K. Raubitschek, *C.I.M.*, I (1967), 241–3; K. Davaras, 'Trois Bronzes minoens de Skoteino', *B.C.H.*, XCIII (1969), 620–50.

175. As suggested by Lamb, *op. cit.*, 21.

176. Nicholls, in *Blaiklock Essays* (*op. cit.*), 18.

177. In Berlin, said to be from the Troad, but almost certainly from Crete. See *A.A.* (1889), 93, no. 7; Lamb, *op. cit.*, 26 f., no. 13. F. Matz, *Die Antike*, XI (1935), 187 ff., for an appreciation.

178. H. Thiersch, in A. Furtwängler, *Aegina* (Munich, 1906), 372; cf. Evans, *P.M.*, I, 507; Lamb, *op. cit.*, 26 f.

179. H. Prinz, *Ath. Mitt.*, XXXV (1910), 157, note 5; cf. Nilsson, *op. cit.* (Note 135), 312, note 18.

180. Boardman, *op. cit.* (Note 174), 8, 11, no. 22, is surely right in suggesting a Bronze Age date for it.

181. L. Banti, *Annuario*, III–IV (1941–3), 52 ff.; Zervos, *A. Cr.*, plates 472–7, assigned to L.M. I.

113. 182. Zervos, *A. Cr.*, plate 484. Herakleion Museum nos. 822–3.

183. Now in the British Museum. Higgins, *Min. Myc. Art*, 136, frontispiece; Lamb, *op. cit.* (Note 174), 27, no. 18, plate vi, before restoration. J. D. S. Pendlebury, *The Archaeology of Crete* (London, 1939), 217, heard that it had been found in one of the gorges leading down to Preveli south of Rethimno.

184. R. Higgins, *The Greek Bronze Age* (London, British Museum, 1970), 17.

114. 185. *Phylakopi* (*op. cit.*, Chapter 3, Note 44), 186 ff., plate xxxvii.

186. *Hesperia*, XXXI (1962), 280 f., plate 102c, from a L.H. IIIc context.

187. *A.E.* (1887), 170, plate 13, no. 25.

188. For the technique of manufacture see Lamb, *op. cit.*, 19 f.; Casson, *Technique* (*op. cit.*, Note 12), 13 f.; Higgins, *Min. Myc. Art*, 136.

189. Higgins, *op. cit.* (Note 184), 16 f.; cf. *Min. Myc. Art*, 136.

190. As suggested by Casson, *Technique*, 13.

191. *P.M.*, II, 540, figure 344; Zervos, *A. Cr.*, plate 769; S. Alexiou, *K. Ch.* (1958), 204 f.

192. Stais, *op. cit.* (Chapter 3, Note 164), 157 f., nos. 3301–2; Marinatos and Hirmer, plates 224–5; Tsountas and Manatt, *The Mycenaean Age* (London, 1903), 160, plate xvii; W. Taylour, *The Mycenaeans* (London, 1964), plate 53.

CHAPTER 5

115. I. B. Schweitzer, 'Hunde auf dem Dach', *Ath. Mitt.*, LV (1930), 107–18, plate xxix; *S.G.*, 144 f. no. 812, 245 f.; H. Schliemann, *Mycenae* (London, 1878), 332. Stais, *op. cit.* (Chapter 3, Note 164), 69 f., no. 812, states that the wood of the box is sycamore, which is a northern tree; unless the Egyptian sycamore fig is meant, as implied by A. W. Persson, *New Tombs at* *Dendra* (Lund, Leipzig, London, and Oxford, 1942), 181, and assumed by F. H. Stubbings, *Cambridge Ancient History*[3], II, part 1 (Cambridge, 1973), 633. For the sycamore fig see A. Lucas, *Ancient Egyptian Materials and Industries*[4] (London, 1962), 446 f.

2. *P.M.*, III, 513 f., figure 359; cf. *P.M.*, I, 512, figure 368. See also V. Karageorghis, 'Notes on Some Mycenaean Capitals from Cyprus', *A.A.A.*, IV (1971), 101–7.

3. As argued by Persson, *op. cit.*, 179–81. Karo, *S.G.*, 319, regards them as mainland work.

4. *A.A.* (1891), 41 f.; E. Naville, *Revue Archéologique*, XXXIII (1898), ii, 2 ff.; D. Fimmen, *Die kretisch-mykenische Kultur* (Leipzig and Berlin, 1921), 166 f., figure 164; A. W. Persson, *The Royal Tombs at Dendra* (Lund, London, Oxford, Paris, and Leipzig, 1931), 46 f., figure 27. H. J. Kantor, *The Aegean and the Orient in the Second Millennium B.C.* (Bloomington, Indiana, 1947), 97, and Fimmen argue for a date in the fourteenth century; F. Matz, *Die Frühkretische Siegel* (Berlin and Leipzig, 1928), 98 f., considered it Egyptian.

116. 5. R. D. Barnett, in C. Singer, E. J. Holmyard, and A. R. Hall, *A History of Technology*, I, *From Early Times to Fall of Ancient Empires* (Oxford, 1954), I, 670 f.

6. Evans, *P.M.*, II, 46; IV, 110, citing *P.M.*, I, 48, figure 13, no. 20.

7. *B.S.A.*, XXXVI (1935–6), 122, nos. 6–7.

8. C. Renfrew, *A.J.A.*, LXXIII (1969), 8.

9. *P.M.*, I, 170; IV, 93.

10. *P.M.*, II, 45 f., figure 21a,b; Hood, *The Minoans*, plate 66.

11. *Monumenti Antichi*, XII (1902), 129, plate viii.1; Zervos, *A. Cr.*, plate 518; Hood, *The Minoans*, plate 119. M. P. Nilsson, *The Minoan-Mycenaean Religion*[2] (Lund, 1950), 372 f., emphasized Babylonian influence and thought it might be an import.

12. *P.M.*, IV, 931 f.

13. *P.M.*, index, 196.

14. For Spondylus see N. J. Shackleton, in J. D. Evans and C. Renfrew, *Saliagos* (London, 1968), 127 f.

15. E.g. R. Tringham, *Hunters, Fishers and Farmers of Eastern Europe, 6000–3000 B.C.* (London, 1971), index, s.v. Spondylus.

117. 16. Renfrew, *op. cit.* (Chapter 2, Note 9), 446.

17. *Ath. Mitt.*, XXXIV (1909), 282 ff.

18. *P.M.*, I, 496.

19. *B.S.A.*, IX (1902–3), 280, 279 figure 1.

20. C. Aldred, 'Fine Wood-Work', in Singer, Holmyard, and Hall, *op. cit.*, 685.

21. The 'fragment of unworked ivory' illustrated by A. Mosso, *The Dawn of Mediterranean Civilization* (London, 1910), 70, figure 31a (cf. *P.M.*, II, 742), from a Neolithic level at Phaistos, looks as if it was really a piece of a large bone.

22. *V.T.M.*, 83, no. 821. *P.M.*, ii, 55, figure 26 for a better illustration and more cheerful, if less probable, interpretation of the scene.

23. *V.T.M.*, 30, no. 516; *P.M.*, i, 117, figure 86.

24. I. A. Sakellarakis, *C.I.M.*, i (1967), 246.

25. *B.S.A.*, xxxvi (1935-6), 100, no. 7; Zervos, *A.Cr.*, plate 208; P. Demargne, *Aegean Art* (London, 1964), figure 89.

26. *P.M.*, i, 119.

27. R. D. Barnett, *Palestine Exploration Quarterly* (1939), 5 f.

28. N. Platon, *Zakros* (New York, 1971), 245.

29. E.g. *V.T.M.*, 121 ff., from Platanos. I. A. Sakellarakis, *C.I.M.*, i (1967), 247; Zervos, *A. Cr.*, plates 188-91.

30. *Annuario*, xiv-xvi (1952-4), 408, 414, figure 36; Hood, *The Minoans*, 123, figure 100.

31. *V.T.M.*, 32, 123, from Koumasa and Platanos.

32. Sakellarakis, *loc. cit.*

33. *P.M.*, i, 387 f., 472 ff.

119. 34. *Études crétoises*, vii (1945), 57 f., plate lxvii.5.

35. *B.S.A.*, viii (1902), 70-4; *P.M.*, iii, 428-33; F. Matz, *Crete and Early Greece* (London, 1962), 127.

36. *Arch. Reports for 1957*, 21 f.; *1958*, 20; *1959-60*, 24; *1960-61*, 26 f.; *1961-62*, 27.

37. *Arch. Reports for 1961-62*, 27, figure 40.

120. 38. *Arch. Reports for 1957*, 22, plate 2*a*.

39. E.g. *P.M.*, iii, 444 f.; iv, 28 ff.

40. E.g. Nilsson, *The Minoan-Mycenean Religion²* (Lund, 1950), 313, note 20.

41. Published in detail by L. D. Caskey, 'A Chryselephantine Statuette of the Cretan Snake Goddess', *A.J.A.*, xix (1915), 237-49. Caskey noted many points in which the statuette differed from any other Bronze Age figures known at the time.

42. E.g. Evans, *P.M.*, iii, 438 ff.; Nilsson, *op. cit.*, 312; G. Karo, *Greifen am Thron* (Baden-Baden, 1959), 110 f.; Higgins, *Min. Myc. Art*, 34 f.

43. Zervos, *A. Cr.*, plate 521.

44. *Palaikastro* (*op. cit.*, Chapter 2, Note 36), 125, where 'Late Minoan II' is L.M. Ib; Zervos, *A. Cr.*, plates 523, 530.

45. *P.M.*, iii, 446; cf. K. Müller, *J.d.I.*, xxx (1915), 279; C. Laviosa, *Pepragmena tou B Dhiethnous Kritologikou Sinedhriou*, i (Athens, 1968), 379.

46. *Arch. Reports for 1960-61*, 27, figure 30; Hood, *The Minoans*, plate 84.

47. *P.M.*, iii, 415, figures 278-9; Zervos, *A. Cr.*, plate 525.

48. *B.S.A.*, xi (1904-5), 284 f., figure 14*a*; Zervos, *A. Cr.*, plate 528. For the bird cf. *Tiryns*, ii, 139, plate xvi.1; Rodenwaldt, *ibid.*, 139, note 3, considered it to be more like a heron.

121. 49. *P.M.*, ii, 388, figure 222.

50. M. R. Popham, *The Destruction of the Palace at* Knossos (*Studies in Mediterranean Archaeology*, xii) (Göteborg, 1970), 59; cf. *B.S.A.*, lxii (1967), 341, note 14.

51. Platon, *op. cit.* (Note 28), 131, 148.

52. S. Alexiou, *Isterominoikoi Tafoi Limenos Knosou* (*Katsamba*) (Athens, 1967), 55 f., 71 ff., plates 30-3.

53. Alexiou, *ibid.*, 71, assigns it to L.M. Ib at the latest. But I. A. Sakellarakis, *C.I.M.*, i (1967), 246, note 13, argues for a later date.

122. 54. O. Frödin and A. W. Persson, *Asine* (Stockholm, 1938), 256 f., figure 181.

55. G. Karo, *Ath. Mitt.*, xl (1915), 169; cf. *S.G.*, 69, under no. 210.

56. G. E. Mylonas, *O Tafikos Kiklos B ton Mikinon* (Athens, 1973), 22, 86, 89, 118 f., 140, 189, 207, 322, 349; *Anc. Myc.*, 137, 140-1, 143, 150-1, 156-7, 170.

57. *S.G.*, 141 f., no. 785; J. Schäfer, *Ath. Mitt.*, lxxiii (1958), 81 f., figure 5.

58. *S.G.*, 187, 84, no. 310. The clumsy gold covering appears to be a later addition.

123. 59. Higgins, *Min. Myc. Art*, 129.

60. T. L. Shear, *Hesperia*, ix (1940), 283 ff., figures 27-9; P. Demargne, *La Crète dédalique* (Paris, 1947), 53 f.; Buchholz and Karageorghis, 106 f., no. 1281.

124. 61. I. A. Sakellarakis, 'Elefantosta ek ton Arkhanon', *C.I.M.*, i (1967), 245-61.

62. Stais, *op. cit.* (Note 1), 167 f., nos. 1972, 1974; Buchholz and Karageorghis, 106, no. 1273. Probably parts of two lyres made for funerary use and not for playing according to B. Aign, *Die Geschichte der Musikinstrumente des ägäischen Raumes bis um 700 vor Christus* (Frankfurt am Main, 1963), 82 f.

63. *A.E.* (1888), 164, plate 8.5; Stais, *op. cit.*, 93, nos. 2472, 2578; H. T. Bossert, *The Art of Ancient Crete* (London, 1937), plate 82; *A.E.* (1957), Arch. Chron., 4 f.; *Ergon* (1963), 67 figure 68, 68 figure 82*b*; *A. Delt.*, xix.2 (1964), 131, plate 131*a*; *P.A.E.* (1965), 95, plate 102; C. W. Blegen, *Prosymna* (Cambridge, 1937), 461 ff., figures 729-31.

64. A. J. B. Wace, *J.H.S.*, lix (1939), 210, and *Mycenae* (Princeton, 1949), 83 f.; Helen Wace, *Ivories from Mycenae No. i 1939: The Ivory Trio* (Athens, no date); Marinatos and Hirmer, plates 218-19; Higgins, *Min. Myc. Art*, 130, figure 159; Vermeule, *G.B.A.*, 220, plate xxxviii; Buchholz and Karageorghis, 106, no. 1280.

126. 65. C. Picard, in *Epitimvion Christou Tsounta* (Athens, 1941), 446-51; Wace, *Mycenae* (*op. cit.*), 86. Doubts as to whether the ivory triad represents deities are expressed by Mylonas, *Anc. Myc.*, 62 f.; cf. Nilsson, *op. cit.* (Note 40), 314, note at bottom.

66. R. A. Higgins, *Catalogue of the Terracottas in the British Museum* (London, 1954), 87, no. 231, from Rhodes. Cf. *B.C.H.*, lxxxv (1961), 869, for figurines of this type from Olous in Crete.

67. W. Taylour, *Antiquity*, xliv (1970), 275, plate xli.

68. E.g. *Archaeologia*, LXXXII (1932), 212.

127. 69. *Hesperia*, IX (1940), 287, figure 31.

70. Marinatos and Hirmer, plate 223.

71. Described and illustrated by Stais, *op. cit.*, 133 f., no. 2916; Demargne, *op. cit.* (Note 60), 84, 152, 193 f., plate i; Mylonas, *M.M.A.*, 196, figure 143; Vermeule, *G.B.A.*, 219, plate xxxix *c*; Smith, *Interconnections*, 117 and note 91; Buchholz and Karageorghis, 106, no. 1272.

72. It has often been called a Syrian import (e.g. Demargne, *op. cit.*, 84; G. Karo, in Pauly-Wissowa-Kroll, *Realencyclopädie*, XI, s.v. Kreta col. 1787; E. Kunze, *Ath. Mitt.*, LX/LXI (1935-6), 226, note 1.

73. The remains of what might have been an ivory conical rhyton were recovered at Prosymna, but the ivory was plain and was combined with bronze (Blegen, *op. cit.* (Note 63), 461).

74. C. F. A. Schaeffer, *Syria*, XXXI (1954), 62 f., figure 9, assigned to the fourteenth century. Cf. *Ugaritica*, IV (Paris, 1962), 17.

75. I. A. Sakellarakis, 'Elefantinon Ploion ek Mikinon', *A.E.* (1971), 188-233.

76. A. J. Evans, *The Prehistoric Tombs of Knossos* (London, 1906), 44 f., figure 41, 14*w*; cf. Mylonas, *M.M.A.*, 196, plate 142.

77. Evans, *ibid.*, figure 40, 14*v*.

78. E.g. A. J. B. Wace, *B.S.A.*, XLIX (1954), 235 ff.

79. Quoted by H. J. Kantor, *Archaeology*, XIII (1960), 14.

80. M. Ventris and J. Chadwick, *Documents in Mycenaean Greek* (Cambridge, 1956), 332 f., 389 ff.; L. R. Palmer, *The Interpretation of Mycenaean Greek Texts* (Oxford, 1963), chapter xiii.

128. 81. I. A. Sakellarakis, *C.I.M.*, I (1967), 253 ff.; cf. *Archaeologia*, LXXXII (1932), 84, figure 30; Persson, *op. cit.* (Note 1), 47, plate ii.

82. *B.S.A.*, XLIX (1954), 235 f., plates 33*a*, 35*e*.

83. *B.C.H.*, LXXI-LXXII (1947-8), 174 ff., plate xxix; H. Gallet de Santerre, *Délos primitive et archaïque* (Paris, 1958), 129, plate xxv. 57; *Archaeology*, XIII (1960), 21, figure 10*b*.

84. E.g. Marinatos and Hirmer, plate 223, bottom right.

85. E.g. *ibid.*, plates 214-15.

86. *P. Nestor*, I, 155, plate 284.4.

87. Listed and illustrated by B. Wesenberg, *Kapitelle und Basen* (Düsseldorf, 1971).

88. Bossert, *op. cit.* (Note 63), 37, plate 53; Vermeule, *G.B.A.*, 220, plate xxxvii*a*; Buchholz and Karageorghis, 107, no. 1282.

89. *Arch. Reports for 1964-65*, 15, figure 18; *A. Delt.*, XX.2 (1965), 235, plate 280; S. Symeonoglou, *Kadmeia I: Mycenean Finds from Thebes* (Göteborg, 1973), 44 f., plates 63-8, 70-5.

90. G. Loud, *The Megiddo Ivories* (University of Chicago, Oriental Institute Publications, LII) (Chic-

ago, 1939), plate 9, nos. 32-3; Vermeule, *G.B.A.*, 221, plate xxxvii*d*.

91. H. J. Kantor, *Archaeology*, XIII (1960), 18 ff.

129. 92. *B.C.H.*, LXXI-LXXII (1947-8), 162 ff., plates xxvi-xxvii.

93. Persson, *op. cit.* (Note 4), 59.

94. *A.E.* (1888), 156 f.; Stais, *op. cit.* (Note 1), 133, no. 2476.

95. *A.E.* (1888), 162, plate 8.1. The background of the plaque has rotted away, so that the figure appears as if cut *au jour*. See Kantor, *op. cit.* (Note 91), 23, figure 23, below.

96. Stais, *op. cit.*, 96, no. 5897; Bossert, *op. cit.*, 36, plate 51; Marinatos and Hirmer, plate 217; Demargne, *op. cit.* (Note 25), plate 342; Kantor, *op. cit.*, 24, figure 23, above.

97. *B.C.H.*, LXXI-LXXII (1947-8), 156 ff., plate xxv; Higgins, *Min. Myc. Art*, 134, figure 164; Vermeule, *G.B.A.*, 221, plate xxxix*b*; Buchholz and Karageorghis, 107, no. 1289.

131. 98. Marinatos and Hirmer, plate 222, bottom; Smith, *Interconnections*, 77; Buchholz and Karageorghis, 106, no. 1278.

99. Listed by J. Schäfer, 'Elfenbeinspiegelgriffe des zweiten Jahrtausends', *Ath. Mitt.*, LXXIII (1958), 73-87.

100. I. A. Sakellarakis, *C.I.M.*, I (1967), 252, plates iii-iv.

101. Tsountas and Manatt, *The Mycenaean Age* (London, 1903), 187 f., figures 82-3; Marinatos and Hirmer, plates 220-1.

102. Persson, *op. cit.* (Note 4), 76 f., 96, figures 71-2, plate xxxiii.

103. C. F. A. Schaeffer, *Ugaritica*, I (Paris, 1939), 32 f., frontispiece; Kantor, *op. cit.*, 23, figure 24; Buchholz and Karageorghis, 107, no. 1290.

104. *P.A.E.* (1965), 93, plate 106; *Hesperia*, XXXV (1966), 425, plate 96*a*; Buchholz and Karageorghis, 44, 50, no. 509; *Antiquity*, XLIII (1969), 94. Cf. Symeonoglou, *op. cit.* (Note 89), 61, 91, note 384, for a possible workshop at Thebes.

105. B. Haussoullier, 'Catalogue descriptif des objets découverts à Spata', *B.C.H.*, II (1878), 204 ff.; Marinatos and Hirmer, plates 215-16.

106. R. D. Barnett, in Singer, Holmyard, and Hall, *op. cit.* (Note 5), 674 ff.

107. J. Hazzidakis, *Les villas minoennes de Tylissos* (*Études crétoises*, III) (Paris, 1934), 96, plate xxvii.

108. V. G. Childe, in Singer, Holmyard, and Hall, *op. cit.*, 192 f.; cf. *ibid.*, 518, 688.

132. 109. Cf. Barnett, *op. cit.* (Note 27), 7.

110. R. D. Barnett, in Singer, Holmyard, and Hall, *op. cit.*, 670 f.

111. Evans, *P.M.*, III, 431; A. J. B. Wace, *B.S.A.*, XLIX (1954), 242; I. A. Sakellarakis, *A.E.* (1971), 230;

cf. R. D. Barnett, in Singer, Holmyard, and Hall, *op. cit.*, 669 f., for Egyptian examples.

112. *Il.*, iv, 141 ff.

113. H. Reusch, *Die zeichnerische Rekonstruktion des Frauenfrieses im Böotischen Theben* (Berlin, 1956), plate 6, no. 18.

114. *P.M.*, I, 548 f.; *B.S.A.*, IX (1902–3), 61.

115. *Ath. Mitt.*, XXXIV (1909), 283 f.

116. Frödin and Persson, *op. cit.* (Note 54), 388; I. A. Sakellarakis, *A.E.* (1971), 223 f.

117. J. F. S. Stone and L. C. Thomas, 'The Use and Distribution of Faience in the Ancient East and Prehistoric Europe', *Proceedings of the Prehistoric Society*, XXII (1956), 37–84, especially 38 f.; V. G. Childe, *New Light on the Most Ancient East* (London, 1952), 63, 135, 209; J. V. Noble, 'The Technique of Egyptian Faience', *A.J.A.*, LXXIII (1969), 435–9; Lucas, *op. cit.* (Note 1), 156 ff.

118. *Mochlos*, 54 f., VI.22, 35; *P.M.*, I, 85, figure 53.

119. *V.T.M.*, 31, cf. *ibid.*, 48, 69, 124.

120. *B.S.A.*, IX (1902–3), 94 ff.; *P.M.*, I, 170.

121. *P.M.*, I, 252.

122. *B.S.A.*, VIII (1901–2), 14–22; *P.M.*, I, 301 ff.

123. *B.S.A.*, IX (1902–3), 31 ff.; *P.M.*, I, 451 f.

124. *B.S.A.*, IX (1902–3), 62 ff.; *P.M.*, I, 463 ff.

133. 125. *P.M.*, I, 500 ff.; Marinatos and Hirmer, plate 70 and colour plate xxiv. Cf. Nilsson, *op. cit.* (Note 40), 311 f., for the belief that they are goddesses. But this has been denied by F. Matz, 'Göttererscheinung und Kultbild im minoischen Kreta', *Mainz Akad. d. Wiss. u. d. Lit. Abhandl. d. Geistes u. Sozialwiss. Kl.* (1958), no. 7, 412, and *Crete and Early Greece* (London, 1962), 127, 152.

126. *P.M.*, I, 506, figure 364.

127. *P.M.*, I, 510 ff., figures 366–9; Marinatos and Hirmer, plate 71.

134. 128. *P.M.*, I, 499 f., figure 358; IV, 1013 f., figure 963.

129. *P.M.*, I, 521 f., figure 379.

130. *P.M.*, I, 480 ff., figure 344.

131. *P.M.*, I, 498 f., figures 356–7.

132. *B.S.A.*, VIII (1901–2), 69; *P.M.*, III, 434.

133. J. V. Noble, *A.J.A.*, LXXIII (1969), 437.

134. H. B. Hawes, *Gournia* (Philadelphia, 1908), 35.

135. Mylonas, *Kiklos B* (*op. cit.*, Note 56), 27, 341 plate 16; cf. *M.M.A.*, 101.

136. *S.G.*, 60 f. nos. 123–4, 63 no. 153, 64 f. no. 166.

137. *S.G.*, 68 nos. 201–3.

138. *S.G.*, 71 no. 223. Egyptian according to J. D. S. Pendlebury, *Aegyptiaca* (Cambridge, 1930), 55, no. 89.

135. 139. *S.G.*, 116 no. 566.

140. *S.G.*, 116 nos. 567, 573.

141. *S.G.*, 115 nos. 555–6, 568.

142. *A.E.* (1912), 223 f., figure 33; *P.M.*, I, 482, figure 345.

143. *S.G.*, 114 f. nos. 553–4, 557–64, 569–71.

144. *S.G.*, 146 no. 828. The neck (*ibid.*, no. 567) is from grave IV and does not belong here. For similar faience-mounted ostrich-egg rhytons from Akrotiri see *Thera*, V, 35, colour plate B.

145. *S.G.*, 155 no. 899.

146. Cf. G. Karo, *Ath. Mitt.*, XL (1915), 167; *S.G.*, 243.

147. *S.G.*, 64 no. 166a; cf. *Arch. Reports for 1970–71*, 31.

148. *S.G.*, 64 no. 166b; cf. H. Gallet de Santerre, 'Grand Rhyton de pierre trouvé à Mallia', *B.C.H.*, LXXIII (1949), 1–18.

149. E.g. *S.G.*, 54 no. 71, 58 under nos. 111 etc.; Mylonas, *Anc. Myc.*, 147, 158, and *M.M.A.*, 101, 104.

150. *S.G.*, 60 f., nos. 123–4.

151. It is certainly not Egyptian as suggested by J. D. S. Pendlebury, *Aegyptiaca* (Cambridge, 1930), 56, no. 90, and *Journal of Egyptian Archaeology*, XVI (1930), 86.

152. *Ath. Mitt.*, XXXIV (1909), 293.

153. Platon, *op. cit.* (Note 28), 149; Higgins, *Min. Myc. Art*, 129; Hood, *The Minoans*, plate 80.

154. *Arch. Reports for 1970–71*, 31.

136. 155. *P.M.*, II, 824 f., figure 540.

156. S. Alexiou, *Isterominoikoi Tafoi Limenos Knosou (Katsamba)* (Athens, 1967), 55, plate 36a.

157. *P.M.*, II, 702; *A.E.* (1888), 165, plate 8. 9; Persson, *op. cit.* (Note 1), 57 f.

158. Exhibited in Volos Museum.

159. A. J. B. Wace, *B.S.A.*, LI (1956), 109–12. But in E. L. Bennett, *The Mycenae Tablets*, II (Philadelphia, 1958), 6, Wace suggested that they were probably of Syrian fabric.

160. E.g. V. Karageorghis, *Mycenaean Art from Cyprus* (Nicosia, 1968), 43 f., plate xxxix; cf. *P.M.*, IV, 534 f.

161. *S.G.*, 54 no. 71, which are glass according to T. E. Haevernick, *Jahrbuch des Römisch-Germanischen Zentralmuseums Mainz*, VII (1960), 49.

162. G. Karo, *Ath. Mitt.*, XL (1915), 167; *S.G.*, 60 no. 209; T. E. Haevernick, 'Nuzi-Perlen', *Jahrbuch des Römisch-Germanischen Zentralmuseums Mainz* XII (1965), 35–40.

163. *Ath. Mitt.*, XXXIV (1909), 278, plate xii.5.

164. R. A. Higgins, *Greek and Roman Jewellery* (London, 1961), 13, 42 f., with references; E. Vermeule, *Kadmos*, V (1966), 144 ff.; *Arch. Reports for 1966–67*, 9, figure 13; H. Hughes-Brock, in J. N. Coldstream, *Knossos: the Sanctuary of Demeter* (London, 1973), 121.

165. D. Barag, in A. L. Oppenheim and others, *Glass and Glassmaking in Ancient Mesopotamia* (Corning N.Y., 1970), 133 ff.

166. D. B. Harden, *The Archaeological Journal* CXXV (1968), 48.

167. G. Weinberg, 'Two Glass Vessels in the Heraclion Museum', *K. Ch.* (1961–2), I, 226–9. For other views see P. Fossing, *Glass Vessels before Glass-Blowing* (Copenhagen, 1940), 27, and S. Marinatos, *A. Delt.*, XI (1927–8), 81 ff.

168. *Ath. Mitt.*, XXXIV (1909), 296 f., figure 13. A. Furumark, *The Chronology of Mycenaean Pottery* (Stockholm, 1941), 47, for the date of the pottery from the tomb. Fragments of other glass vessels assignable to the Bronze Age from the mainland and Crete noted by S. Marinatos, *A. Delt.*, XI (1927–8), 83. Mrs Hughes-Brock has kindly drawn my attention to a small three-handled glass jar of Mycenaean appearance from a tomb at Megalo Kastelli by Thebes (*A. Delt.*, XXII.2 (1967), 228, plate 160a).

169. Harden, *op. cit.*, 51.

170. Haevernick, *op. cit.* (Note 161), 45, plate 6.1.

171. S. E. Iakovides, *Perati*, II (Athens, 1970), 378 ff.

CHAPTER 6

137. 1. V. G. Childe, *New Light on the Most Ancient East* (London, 1952), 94.

2. P. Dikaios, *Khirokitia* (Oxford, 1953).

3. D. Theochares, *Ath. Mitt.*, LXXI (1956), 24 f., figures 45–6, plates 16–17.

4. D. Theochares, *Thessalika* (1962), 77 ff., esp. 80. Cf. C. Tsountas, *Ai Proistorikai Akropoleis Diminiou kai Sesklou* (Athens, 1908), 33.

5. G. E. Mylonas, *Excavations at Olynthus*, I, *The Neolithic Settlement* (Baltimore, 1929), 76, figure 81a.

6. Buchholz and Karageorghis, 91, no. 1131.

7. G. Mylonas, *Aghios Kosmas* (Princeton, 1959), 142.

8. E.g. O. Frödin and A. W. Persson, *Asine* (Stockholm, 1938), 243. Possibly *Hesperia*, XXV (1956), 164, figure 4, which may come from the House of Tiles at Lerna.

138. 9. J. D. Evans and C. Renfrew, *Saliagos* (London, 1968), 65, figure 22.

10. *Hesperia*, XXXI (1962), 265, plate 92d. *Arch. Reports for 1961–62*, 20, figure 25.

11. Tsountas, *A.E.* (1898), 185 f.

12. C. Renfrew and J. S. Peacey, *B.S.A.*, LXIII (1968), 45 ff.

13. *A.A.A.*, I (1968), 100, figures 5–6; C. Doumas, *The N. P. Goulandris Collection of Early Cycladic Art* (Athens, 1968), 171 ff.; cf. Renfrew, *Emergence* (*op. cit.*, Chapter 2, Note 9), plate 24.1.

14. Renfrew, *Emergence*, plate 1.1. Cf. Zervos, *A. Cr.*, plates 116, 187.

15. C. Zervos, *L'art des Cyclades, du début à la fin de l'âge de bronze* (Paris, 1957), 58, plate 13; *A. Delt.*, XVIII.1 (1961/2), 116, plate 48; cf. *ibid.*, XXV.2 (1970), 430, plate 373 for a clay example from Kato Koufonisi. For the Mesopotamian origin of the type see M. Mellink, 'A Four-spouted Krater from Karataş', *Anatolia*, XIII (1969), 69–76.

16. Amorgos: H. T. Bossert, *The Art of Ancient Crete* (London, 1937), plate 402. Syros: N. Aberg, *Bronzezeitliche und Früheisenzeitliche Chronologie*, IV (Stockholm, 1933), 83, figure 153. Naxos: Zervos, *op. cit.*, plate 30. Melos: *ibid.*, plates 28–9.

139. 17. First recognized as a granary by F. Oelmann, 'Das Kornspeichermodell von Melos', *Ath. Mitt.*, L (1925), 19–27.

18. E. M. Bossert, *J.d.I.*, LXXV (1960), 1–16.

19. *Ergon* (1972), 94, figure 88; cf. F. Matz, *Die Frühkretischen Siegel* (Berlin and Leipzig, 1928), plates 6.3, 11.8, 21. Warren, *M.S.V.*, 81, notes the possibility that the vases of this group were Cretan products. But F. Oelmann, *Ath. Mitt.*, L (1925), 19, states that the Melos granary model is made of Siphnian 'Topfstein'.

20. *Phylakopi* (*op. cit.*, Chapter 3, Note 44), 195.

21. *Ibid.*, 196 ff.

22. *Hesperia*, XXXI (1962), 272 f.

23. Warren, *K. Ch.* (1965), 7–43.

24. Warren, *M.S.V.*, 82.

25. J. Forsdyke, *Proceedings of the British Academy*, XV (1929), 50.

26. M. Money-Coutts, 'A Stone Bowl and Lid from Byblos', *Berytus*, III (1936), 129–36. But the vase does not appear to be of Aegean manufacture as there suggested (Warren, *M.S.V.*, 82, note 1).

140. 27. *P.M.*, II, 15 f., figure 6 (Warren, *M.S.V.*, 112, G.6; cf. *K. Ch.* (1965), 34), from the lower level of houses in the Central Court of the palace. The upper level of houses, of which only traces survived, may be assignable to E.M. I (Warren, *M.S.V.*, 109, note 1).

28. S. Alexiou, *Isterominoikoi Tafoi Limenos Knosou* (*Katsamba*) (Athens, 1967), 80.

29. Warren, *M.S.V.*, 106. But this is denied by J. Vercoutter, *L'Égypte et le monde égéen* (Cairo, 1956), 407 f., who argues that the first contacts between Crete and Egypt were c. 2200 B.C.

30. Warren, *M.S.V.*, 105.

31. P. Warren, *Myrtos* (London, 1972), 236 f.

32. *A.A.A.*, IV (1971), 395.

33. K. Branigan, *The Tombs of Mesara* (Letchworth, 1970), 77.

34. P. Warren, *Proceedings of the Prehistoric Society*, XXXIII (1967), 45 f. Evans, *P.M.*, II, 697, note 2, reports the existence of great stone pithoi of M.M. III date in the palace at Knossos.

35. Warren, *op. cit.* (Note 34), 44, Q.1; *S.G.*, 94 no. 389.

141. 36. N. Platon, *Zakros* (New York, 1971), *passim*. Cf. *Ergon* (1963), 168 ff., figures 180–3; *P.A.E.* (1963), 180 ff., plates 146–50 and others from other parts of the palace.

37. *P.M.*, II, 820 ff., figure 537.

38. Warren, *M.S.V.*, 84, for the date of the vases. But see *K. Ch.* (1963), 336–8. The stratigraphic posi-

tion of the deposit is not clear. Evans, however, noted that it was 'quite separate' from the deposit of Linear B tablets found next to it in burnt debris of the final destruction of the palace (L. R. Palmer, *On the Knossos Tablets*, I, *The Find-Places of the Knossos Tablets* (Oxford, 1963), 75).

39. P. Warren, *K. Ch.* (1963), 336-8; *M.S.V.*, 91, P.498.

40. L. Pernier, *Il Palazzo minoico di Festòs*, I (Rome, 1935), 235 f., figure 113; Zervos, *A. Cr.*, plate 381.

41. A stone rhyton with holes for inlays was recovered from a context of L.H. IIIB date at Mycenae (*B.S.A.*, LI (1956), 112, plate 22).

42. *P.M.*, I, 413 f., figure 297.

43. Warren, *M.S.V.*, 43; *P.M.*, I, 411, and IV, 229 for an architectural fragment with plaitwork decoration from the Tomb of Clytemnestra at Mycenae (*B.S.A.*, XXV (1921-3), 366 f.).

44. Warren, *M.S.V.*, 104.

45. R. Paribeni, *Monumenti Antichi*, XIV (1904), 749-53; *P.M.*, III, 420 ff.; Zervos, *A. Cr.*, plate 387. The comparable sphinx and attendant goddess published by Evans as from Tylissos may be modern forgeries.

46. R. Dussaud, *Iraq*, VI (1939), 63.

142. 47. *P.M.*, III, 424; cf. Warren, *M.S.V.*, 104. A. Dessenne, *Le Sphinx* (Paris, 1957), 134 f., 150, no. 300, was inclined to regard it as Hittite, but with every reserve. G. Karo, *Greifen am Thron* (Baden-Baden, 1959), 79, argued for a Cretan origin.

48. G. E. Mylonas, *O Tafikos Kiklos B ton Mikinon* (Athens, 1973), 203-5, 344 f. plates 183-5; *M.M.A.*, 103, plate 99; Marinatos and Hirmer, plate 212, below.

49. Cf. Platon, *Zakros* (*op. cit.*), 136; Higgins, *Min. Myc. Art*, 162; I. A. Sakellarakis, *A.E.* (1971), 218, 226 f.; Mylonas, *Kiklos B* (*op. cit.*), 205.

50. Zervos, *A. Cr.*, plate 385; *P.M.*, I, 221 ff.

51. Warren, *M.S.V.*, 91.

143. 52. *P.M.*, II, 527 ff. Warren, *M.S.V.*, 89, for others similar.

53. *P.A.E.* (1963), 185, plate 152a; Platon, *Zakros*, 160 ff. and frontispiece.

54. *P.M.*, II, 827 ff. Warren, *M.S.V.*, 90, for the stone.

55. Warren, *M.S.V.*, 25, P.143.

56. *Ergon* (1971), 222 f., figure 272; *B.C.H.*, XCVI (1972), 793, 797, figure 475. From a fill with pottery that was mostly M.M. IIIA.

57. *P.M.*, II, 227 figure 130, 502 figure 307; Warren, *M.S.V.*, 88; Zervos, *A. Cr.*, plate 515. It was assigned by Evans to M.M. IIIB.

58. Cf. *P.M.*, II, 502 ff.

59. L. Banti, in *Geras Antoniou Keramopoullou* (Athens, 1953), 123; Warren, *M.S.V.*, 174. But see K. Müller, *J.d.I.*, XXX (1915), 257 f.

145. 60. J. Forsdyke, *Journal of the Warburg and*

Courtauld Institutes, XV (1952), 13-19; Marinatos and Hirmer, plates 100-2; K. Müller, *J.d.I.*, XXX (1915), 244-7; Buchholz and Karageorghis, 94, no. 1166.

61. Marinatos and Hirmer, 147, interpret all the figures as children.

62. J. Forsdyke, *Journal of the Warburg and Courtauld Institutes*, XVII (1954), 1-9; Marinatos and Hirmer, plates 103-5; L. Savignoni, *Monumenti Antichi*, XIII (1903), 77-132; K. Müller, *J.d.I.*, XXX (1915), 251-7; Buchholz and Karageorghis, 94, no. 1165.

146. 63. Marinatos and Hirmer, plates 106-7; Zervos, *A. Cr.*, plates 544-7; K. Müller, *J.d.I.*, XXX (1915), 247-51.

64. *P.M.*, III, 65.

65. Platon, *Zakros* (*op. cit.*), 164-9; Warren, *M.S.V.*, 87.

147. 66. S. Alexiou, *K. Ch.* (1963), 339-51; *A.A.A.*, II (1969), 84-8.

67. See an interesting article on open-air pillars and trees as the means of epiphany of the lightning god by Chrysoula Kardara, *A.E.* (1966), 149-200.

68. Cf. F. Halbherr, *Monumenti Antichi*, XIII (1903), 17; K. Müller, *J.d.I.*, XXX (1915), 263 f.

69. *P.M.*, I, 676, figure 496; *Palaikastro* (*op. cit.*), Chapter 2, Note 36), 136 f., figure 118; Warren, *M.S.V.*, 86.

70. *P.M.*, III, 100, figure 59; Warren, *M.S.V.*, 85, P.473; Buchholz and Karageorghis, 93, no. 1164.

71. J. Sakellarakis, 'Fragment of a Relief Stone Vase from Tiryns', *A.A.A.*, VI (1973), 158-63; M. Mayer, *J.d.I.*, VII (1892), 80-1; A. Reichel, *Ath. Mitt.*, XXXIV (1909), 94, figure 13.

72. A. Sakellariou, 'Scène de bataille sur un vase mycénien en pierre?', *Revue Archéologique* (1971), 3-14.

73. Warren, *op. cit.* (Note 34), 37.

74. *P. Nestor*, I, 155, 159, 167, 215, 286, 301 ?, 316; Warren, *M.S.V.*, 277.

75. Warren, *M.S.V.*, 124 ff. and figures 2-4 for the distribution of deposits of these stones in Crete.

76. *Ibid.*, 135 f. The obsidian vase of which a scrap was found in a level of E.M. II date at Knossos appears to have been an import (*A.A.A.*, V (1972), 394, note 3).

77. *Ibid.*, 135 f.; C. Renfrew, *B.S.A.*, LX (1965), 240; *Proceedings of the Prehistoric Society*, XXXII (1966), 39, 66.

148. 78. *P.M.*, I, 170, figure 119b; cf. P. Warren, *B.S.A.*, LXII (1967), 200, note 35.

79. Warren, *M.S.V.*, 87; Platon, *Zakros* (*op. cit.*), 135 ff.

80. S. Marinatos, *A.E.* (1931), 158-60.

81. *S.G.*, 147, no. 829.

82. Warren, *M.S.V.*, 109, P.591 and 593; Platon, *Zakros*, 137 ff.

149. 83. Warren, *M.S.V.*, 132.

84. P. Warren, *B.S.A.*, LXII (1967), 195-201; M. R. Popham, *The Destruction of the Palace at Knossos* (*Studies in Mediterranean Archaeology*, XII) (Göteborg, 1970), 53.

85. Warren, *op. cit.* (Note 84), 201. Add C. W. Blegen, *Prosymna* (Cambridge, 1937), 459 f.; I. Sakellarakis, *A.E.* (1971), 192 f.

86. Warren, *op. cit.* (Note 84), 200 f.

150. 87. Warren, *M.S.V.*, 157-65.

88. A. Lucas, *Ancient Egyptian Materials and Industries*[4] (London, 1962), 424.

89. See S. Adam, *The Technique of Greek Sculpture* (London, 1966), 78 f., for methods of using abrasives.

90. L. Woolley, *Alalakh* (Oxford, 1955), 293 f. Level VII. For the date of the destruction see *Cambridge Ancient History*[3], I (Cambridge, 1970), 212 f.

91. Cf. S. Casson, *The Technique of Early Greek Sculpture* (Oxford, 1933), 37, 40, with special reference to AE 962 in AM, but this has a spout and handles (Warren, *M.S.V.*, 96).

92. Warren, *M.S.V.*, 161, 165.

93. P. Warren, *B.S.A.*, LXII (1967), 198 f.; *M.S.V.*, 158 f.; Casson, *op. cit.*, 215, note 1.

94. Warren, *M.S.V.*, 49-60.

151. 95. *P.M.*, I, 344 f., figure 249; Warren, *M.S.V.*, 57, HM 66.

96. Warren, *M.S.V.*, 163.

97. *P. Nestor*, I, 59, 64, 71, 105 ?, 224 ?, 242-3; Warren, *M.S.V.*, 276.

CHAPTER 7

153. 1. V. G. Childe, *New Light on the Most Ancient East* (London, 1952), 93.

2. Cf. *ibid.*, 129 f.; A. L. Perkins, *The Comparative Archaeology of Early Mesopotamia* (Chicago, 1948), 149 f.

3. Higgins, *Min. Myc. Art*, 62; C. Renfrew, *A.J.A.*, LXXI (1967), 18, no. 17; cf. H. Hauptmann and V. Milojčić, *Die Funde der frühen Dimini-zeit aus der Arapi-magula Thessalien* (Bonn, 1969), 37, Beilage 4, no. 23.

4. G. M. A. Richter, *Metropolitan Museum of Art: Handbook of the Greek Collection* (Harvard, 1953), 16, plate 11,i; D. E. Strong, *Greek and Roman Gold and Silver Plate* (London, 1966), 28 f., plate 1,b; C. Renfrew, *A.J.A.*, LXXI (1967), 7, plate 10e.

5. D. von Bothmer, *Ancient Art from New York Private Collections* (New York, 1961), 21, no. 96.

6. B. Segall, *Museum Benaki, Katalog der Goldschmiede-Arbeiten* (Athens, 1938), 11 ff., 211-12, plates 1-3, 67-8, 69; Strong, *op. cit.*, 28 f.

7. V. G. Childe, 'A Gold Vase of Early Helladic Type', *J.H.S.*, XLIV (1924), 163-5. Republished by S. S. Weinberg, 'A Gold Sauceboat in the Israel Museum', *Antike Kunst*, XII (1969), 3-8.

8. *P.M.*, II, 12.

9. *Mochlos*, 52, VI.8; Strong, *op. cit.*, 30; C. Davaras, 'Early Minoan Jewellery from Mochlos', *B.S.A.*, LXX (1975), 101-14.

154. 10. F. B. de la Roque, G. Contenau, and F. Chapouthier, *Le trésor de Tôd* (Cairo, 1953). Their place of origin is disputed. Anatolia: F. Schachermeyr, *Die ältesten Kulturen Griechenlands* (Stuttgart, 1955), 80, 82. Syria: A. Dessenne, *Le Sphinx* (Paris, 1957), 46, note 2, with references; W. Culican, *The First Merchant Venturers* (London, 1966), 30. Crete: H. J. Kantor, *The Aegean and the Orient in the Second Millennium B.C.* (Bloomington, Indiana, 1947), 19 f., and in R. W. Ehrich, *Chronologies in Old World Archaeology* (Chicago, 1965), 19 ff.; R. A. Higgins, *Greek and Roman Jewellery* (London, 1961), 62; R. W. Hutchinson, *Prehistoric Crete* (Harmondsworth, 1962), 105 (M.M. IA), *ibid.*, 196 f. (M.M. IIA); Hood, *The Minoans*, 41 (M.M. IB). F. Matz, *Cambridge Ancient History*[3], II, part 1 (Cambridge, 1973), 163, notes that the closest parallels are in the Ayia Fotini ware of the Phaistos area corresponding to M.M. IB/IIA at Knossos.

11. For lapis lazuli see G. Hermann and J. C. Payne, *Iraq*, XXX (1968), 21-61.

12. H. B. Hawes, *Gournia* (Philadelphia, 1908), 56, 60, plate C.1; *P.M.*, I, 191 f.

13. E.g. *B.S.A.*, XL (1939-40), plate 14m, from Palaikastro.

14. Strong, *op. cit.* (Note 4), 38, plate 2b; Richter, *op. cit.* (Note 4), 16, plate 11h.

15. A. Lucas, *Ancient Egyptian Materials and Industries*[4] (London, 1962), 247.

16. H. F. Mussche and others, *Thorikos*, III (1965 season) (Brussels, 1967), 22-4; date not entirely certain, but probably end of sixteenth century. Cf. *Arch. Reports* (1967-8), 6, referring to this. Evidence for the extraction of lead and perhaps silver from ore in the West House at Akrotiri: *Thera*, VI, 29 ff.

17. *Syria*, III (1922), 273 ff.; *P.M.*, II, 654 f.

18. *P.M.*, II, 824 ff.

155. 19. E.g. *P.M.*, I, 570, figure 415b.

20. R. A. Higgins, *B.S.A.*, LII (1957), 54, plate 14.

21. *P.M.*, II, 387, figure 221. For the date of the destruction see M. R. Popham, *The Destruction of the Palace at Knossos* (*Studies in Mediterranean Archaeology*, XII) (Göteborg, 1970), 59.

22. N. Platon, *Zakros* (New York, 1971), 87.

23. Kantor, *Aegean and Orient (op. cit.)*, 41 ff.; J. Vercoutter, *L'Égypte et le monde égéen préhellénique* (Cairo, 1956).

24. Strong, *op. cit.*, 17.

25. E.g. *Hesperia*, XXVI (1957), 154, plate 43b, from Lerna; G. Welter, *Aigina* (Berlin, 1938), 21, figure 24.

26. Strong, *op. cit.*, xxv-xxvi.

27. G. E. Mylonas, *O Tafikos Kiklos B ton Mikinon* (Athens, 1973), 74 f., 88, 119, 173, plates 58, 71, 101, 152. Cf. *Anc. Myc.*, 139, 150-2, 169.

157. 28. E.g. Marinatos and Hirmer, plates 190 top, 191 bottom, 193-4.

29. F. B. de la Roque, G. Contenau, and F. Chapouthier, *op. cit.* (Note 10), 24, plate XXXI.

30. *P.M.*, I, 245.

31. *S.G.*, 54, no. 73, 226 figure 95.

32. *S.G.*, nos. 220, 627-8, 912; Marinatos and Hirmer, plate 193 bottom.

33. *S.G.*, nos. 213, 480, 519.

34. *S.G.*, nos. 509, 871.

35. *S.G.*, 103, no. 440; Marinatos and Hirmer, plate 192 bottom.

36. Strong, *op. cit.*, 38; R. Hope Simpson, *B.S.A.*, LII (1957), 239 f.; Richter, *op. cit.* (Note 4), 16 plate 11h.

37. *S.G.*, 94, no. 390; Marinatos and Hirmer, plate 186.

38. A. A. Moss, 'Niello', *Studies in Conservation*, I (1952), 49-62; H. Maryon, *Metalwork and Enamelling*[5] (New York, 1971), 161 ff. See Higgins, *Min. Myc. Art*, 140, for an account of Mycenaean niello; Lucas, *op. cit.* (Note 15), 249 ff., for Egyptian use of niello.

158. 39. *Ergon* (1964), 90, figure 108, top; *B.C.H.*, LXXXIX (1965), 743, figure 19, top; cf. Marinatos and Hirmer, plate 170, top.

40. *P.M.*, IV, 1002, suppl. plate lxviia.

41. E.g. *P.M.*, III, 410 f., figure 273; cf. *A.J.A.*, IX (1905), 284, no. 23, 280, figure 1, centre right; Higgins, *op. cit.* (Note 10), 63.

42. *S.G.*, nos. 427, 520.

159. 43. *A.E.* (1957), Arch. Chron., 6 f., figure 3 (*S.G.*, no. 122 combined with no. 151b).

44. *S.G.*, 91, no. 351; Marinatos and Hirmer, plate 187.

45. *S.G.*, 125 f., no. 656; Marinatos and Hirmer, plate 192, top.

46. H. Schliemann, *Mycenae and Tiryns* (London, 1878), 235 ff., figure 346; *S.G.*, 100, no. 412; Marinatos and Hirmer, plate 188. It bears no relation to Nestor's cup as described by Homer (A. Furumark, *Eranos*, XLIV (1946), 41-53).

47. *P.M.*, IV, 390 ff.

48. *P. Nestor*, III, 93 f., figure 174.1; V. Karageorghis, *Kipriakai Spoudhai*, XXV (1961), 9.

49. *S.G.*, 118, no. 600.

50. S. Marinatos, 'Der "Nestorbecher" aus dem IV. Schachtgrab von Mykenae', in R. Lullies, *Neue Beiträge zur klassischen Altertumswissenschaft (Festschrift zum 60. Geburtstag von B. Schweitzer)* (Stuttgart, 1954), 11-18.

160. 51. Marinatos, *op. cit.*, 15 f., argues that they are copies of Egyptian Horus-falcons.

52. *S.G.*, nos. 72, 83-4, 391.

53. E.g. *S.G.*, 110, no. 511. Fragments of others were recovered.

54. *S.G.*, 148, no. 855; cf. *P.M.*, II, 645 ff.

55. Cf. M. Popham, *B.S.A.*, LXII (1967), 341, figure 2.4, plate 80a.

56. A. Sakellariou, *A.E.* (1957), Arch. Chron., 7 f.

57. A. Sakellariou, 'Un cratère d'argent avec scène de bataille provenant de la IVème Tombe de l'acropole de Mycènes', *Antike Kunst*, XVII (1974), 3-20; cf. *C.I.M.*, I (1967), 262-5. G. Karo, *Ath. Mitt.*, XL (1915), 215, thought it had three or more handles, and corresponded to a shape known in clay in Crete in L.M. times. See K. Müller, *J.d.I.*, XXX (1915), 317 ff., for another early appreciation.

58. E.g. *P.M.*, I, 707, figure 531a-c; *J.H.S.*, XXII (1902), 80, no. 34.

59. *P.M.*, I, 498, figure 356, centre. The handles of this faience vase from the Temple Repositories at Knossos are among the earliest dated representations of figure-of-eight shields in Crete. Earlier examples cited by Evans appear to be doubtful or from uncertain contexts. F. Matz, *Cambridge Ancient History*[3], II, part 1 (Cambridge 1973), 575, has suggested that the figure-of-eight shield was evolved in connection with the use of chariots as a means of transport to the place of combat. E. Vermeule, *The Art of the Shaft Graves of Mycenae* (Cincinnati, 1975), 30, note 46, implies a mainland origin for it.

60. F. Matz, *Crete and Early Greece* (London, 1962), 157.

61. Hood, *The Minoans*, 119 f.

62. *P.M.*, IV, 867 f., figures 854, 856.

63. *S.G.*, 106 ff. no. 481; Vermeule, *G.B.A.*, 362, for references. Discussed at length by J. T. Hooker, 'The Mycenae Siege Rhyton and the Question of Egyptian Influence', *A.J.A.*, LXXI (1967), 269-81; V. Stais, 'Das silberne Rhyton des vierten Grabes der Burg von Mykenai', *Ath. Mitt.*, XL (1915), 45-52, 112; S. Marinatos, *A. Delt.*, X (1926), 78-90, and *B.C.H.*, XCV (1971), 5-11; Evans, *P.M.*, III, 89 ff., with detailed drawings. For new drawings and a fresh reconstruction see Vermeule, *G.B.A.*, 100 ff., and Smith, *Interconnections*, 65 ff., figure 84. The fragment which W. Reichel, *Homerische Waffen* (Vienna, 1891), 13, figure 17c (cf. *P.M.*, IV, 820, figure 798), interpreted as a chariot is really part of the sea with a figure swimming in it (*P.M.*, III, 96, figure 54, left; Smith, *Interconnections*, 66, note 5; cf. Karo, *S.G.*, 108).

161. 64. A. Sakellariou, *Revue Archéologique* (1971), 12, note 2.

65. Cloaks according to Stais, *Ath. Mitt.*, XL (1915), 50, Rodenwaldt, *Tiryns*, II, 203 f., note 2, and Karo, *S.G.*, 107. But this seems unlikely, although the men have both hands free. Cf. H. L. Lorimer, *Homer and the Monuments* (London, 1950), 141.

163. 66. G. Rodenwaldt, *Der Fries des Megarons von Mykenai* (Halle, 1921), 51, and *Tiryns*, II, 203, note 2,

considers it the work of a Cretan artist celebrating an expedition of a ruler of Mycenae. Marinatos, *B.C.H.*, XCV (1971), 5–11, places the scene in the Balearic Islands!

67. The use of the sling is attested in the Cyclades during the Bronze Age (Renfrew, *Emergence* (*op. cit.*, Chapter 2, Note 9), 392; *A.E.* (1899), 120; *A. Delt.*, XIX.2 (1964), 412). H.-G. Buchholz, 'Die Schleuder als Waffe im ägäischen Kulturkreis', *Jahrbuch für Kleinasiatische Forschung*, II (1965), 133–59, discusses the sling in connection with the Siege Rhyton.

68. *P.M.*, I, 301 ff.; cf. Smith, *Interconnections*, 65 ff.

69. *S.G.*, 77 f., no. 273, 93, no. 384; *P.M.*, II, 530 ff.; G. Karo, 'Minoische Rhyta', *J.d.I.*, XXVI (1911), 249 ff.

70. *S.G.*, 94, no. 388; Schliemann, *op. cit.* (Note 46), 257; F. von Bissing, *A.A.* (1923/4), 106 f.; Marinatos and Hirmer, plate 177; cf. T. and N. Özgüç, *Ausgrabungen in Kültepe* (*T.T.K.*, V, Seri xii) (Ankara, 1953), 223 f., plates 38–9. Possibly made in the Cyclades according to Vermeule, *op. cit.* (Note 59), 15.

164. 71. *S.G.*, 37, 180 f., 320 ff., nos. 253–4, 259, 623–4; Marinatos and Hirmer, plates 162–6. G. Mylonas, *A.E.* (1969), 125–42, has argued that the 'mumny' burial with a beardless mask in shaft grave V was that of a woman; but Schliemann, *Mycenae* (London, 1878), 302 f., 304 f., seems to make it clear that swords were in fact associated with this.

72. Mylonas, *Kiklos B* (*op. cit.*, Note 27), 76, plate 60 (cf. *Anc. Myc.*, 138 f., 170 f., plate 50); Marinatos and Hirmer, plate 167.

73. *S.G.*, 121, no. 624, 328 ff.; cf. C. W. Blegen, 'Early Greek Portraits', *A.J.A.*, LXVI (1962), 245–7.

74. *S.G.*, 75, nos. 253–4.

75. *S.G.*, 122, nos. 625–6.

76. *S.G.*, 62, 181, no. 146.

77. *Ergon* (1965), 92, figures 110–12; *P.A.E.* (1965), 117, plates 135–9; J. Hawkes, *Dawn of the Gods* (London, 1968), plate 33.

166. 78. *A. Delt.*, XXI.2 (1966), 167, plate 168; *Ergon* (1965), 84 f., figure 103; *P.A.E.* (1965), 113 f., plate 128, bottom.

79. Tsountas, *A.E.* (1889), 136–72. The tomb itself was noted by Gropius in 1805 (E. Curtius, *Peloponnesos*, II (Gotha, 1852), 248). G. Perrot and C. Chipiez, *Art in Primitive Greece* (London, 1894), II, 228–39, have interesting observations derived from prolonged study of the cups. The description here is based upon Evans, *P.M.*, III, 177–85. Good illustrations in Marinatos and Hirmer, plates 178–85.

80. *P.M.*, III, 182.

167. 81. A. Riegl, *Jahreshefte des Österreichischen archäologischen Instituts*, IX (1906), 8; W. Schiering, *Antike Welt*, II (1970), part 4, 6.

82. Cf. Perrot and Chipiez, *op. cit.*, 238 f.; K. Müller, *J.d.I.*, XXX (1915), 325 ff.

83. Contrast the heads and feet of the bulls on Marinatos and Hirmer, plates 180 and 185.

84. Ellen N. Davis, 'The Vapheio Cups. One Minoan and one Mycenaean?', *The Art Bulletin* (1974), 472–87. K. Müller, *J.d.I.*, XXX (1915), 325, inferred that the cups came from a centre in the western part of Crete having a strong influence on the mainland. G. A. S. Snijder, *Kretische Kunst* (Berlin, 1936), 120, argued that they were both of mainland origin.

85. A. Furumark, *The Chronology of Mycenaean Pottery* (Stockholm, 1941), 49.

86. *A.E.* (1899), 146 f., plate 7.15.

87. *B.S.A.*, LI (1956), 87 ff., plate 13.

88. *S.G.*, nos. 213, 519.

89. *B.S.A.*, LI (1956), 73, no. 14.

90. I. A. Sakellarakis, *Archaeology*, XX (1967), 278, figure 8.

91. *P.M.*, IV, 388 ff., figures 323–5, colour plate xxxi; *K.F.A.*, plate vi, figures 1, 2; M. B. Mackeprang, *A.J.A.*, XLII (1938), 546.

92. A. J. Evans, *The Prehistoric Tombs of Knossos* (London, 1906), 155, no. 39.

93. For other examples besides those described here see Strong, *op. cit.* (Note 4), 46 ff.

94. H. Thomas, 'The Acropolis Treasure from Mycenae', *B.S.A.*, XXXIX (1938–9), 65 ff.; Marinatos and Hirmer, plate 189.

168. 95. Thomas, *op. cit.*, 77 ff.; cf. G. Karo, *J.d.I.*, XXVI (1911), 258; Marinatos and Hirmer, plate 199, top.

96. *P.A.E.* (1956), 195, plate 88*a*.

97. A. W. Persson, *New Tombs at Dendra* (Lund, Leipzig, London, and Oxford, 1942), 87 ff.

98. *Ibid.*, 89 f., no. 37, 137 ff.

99. *Ibid.*, 90 f., no. 39.

100. *Ibid.*, 74 f., no. 19.

169. 101. A. W. Persson, *The Royal Tombs at Dendra* (Lund, London, Oxford, Paris, and Leipzig, 1931), 66, figure 46; A. Furumark, *The Mycenaean Pottery* (Stockholm, 1941), 610, type 164: L.H. IIIA 1.

102. Persson, *op. cit.* (Note 101), 33 f., 50 ff.

103. *Ibid.*, 33, 52 ff.

104. *Ibid.*, 33, 52 ff.

105. *Ibid.*, 31 f., 42 ff.

106. Persson, *ibid.*, 45, regards it as Cretan work of *c.* 1500.

107. *Ibid.*, 38, 48 ff.

108. C. F. A. Schaeffer, *Enkomi-Alasia*, I (Paris, 1952), 379 ff.

109. Cf. Schaeffer, *op. cit.*, 381. Contrast C. Picard, 'De Midéa à Salamis de Chypre', in *Geras Antoniou Keramopoullou* (Athens, 1953), 1–16.

110. Higgins, *Min. Myc. Art*, 150.

170. 111. *A.E.* (1888), 159, plate vii.2; Marinatos and Hirmer, plate 196, top.

112. *P. Nestor*, I, 57 f.

266 · NOTES TO CHAPTERS 7 AND 8

113. *A.E.* (1957), Arch. Chron., 6 f., no. 2874.
114. *B.S.A.*, LI (1956), 121, plate 28.
115. *Ath. Mitt.*, LXXXII (1967), 52 f., plates 30-1; cf. Higgins, *Min. Myc. Art.*, 150.
116. *Ergon* (1960), 191, figure 218.
117. *Ergon* (1958), 168, figure 175.
118. *V.T.M.*, 87, plate xlv, no. 1491.
119. F. B. de la Roque, G. Contenau and F. Chapouthier, *op. cit.* (Note 10), plate xviii; cf. Hood, *The Minoans*, 40, figure 16, bottom right.
120. J. Hazzidakis, *Tylissos à l'époque minoenne* (Paris, 1921), 54 ff.; Zervos, *A. Cr.*, plate 595.
121. *P.M.*, II, 627 ff.
122. *P.M.*, II, 631 ff., figure 395.
171. 123. *P.M.*, II, 637 ff.
124. *A.J.A.*, XIII (1909), 287 f., figure 11.
125. *Mochlos*, 62, figure 31, XII f.
126. *S.G.*, 146, no. 827.
172. 127. *S.G.*, 65, no. 170, 156, plate clxiv.
128. E.g. *S.G.*, nos. 468, 472, 475.
129. Persson, *op. cit.* (Note 104), 75 ff., 91 ff.
130. Evans, *op. cit.* (Note 92), 36 ff.; cf. *ibid.*, 51 ff., no. 36, the Chieftain's Grave.
131. J. de Mot, *Revue Archéologique* (1904), II, 204; Vercoutter, *op. cit.* (Note 23), 354, plate lix.
132. S. E. Iakovides, *Perati*, II (Athens, 1970), 372, plate 50, M.6, plate 113, M.141.
133. G. H. McFadden, 'A Late Cypriote III Tomb from Kourion', *A.J.A.*, LVIII (1954), 131-42.
134. M. Markides, 'A Mycenaean Bronze in the Cyprus Museum', *B.S.A.*, XVIII (1911-12), 95-7; Evans, *P.M.*, II, 652-4; H. W. Catling, *Cypriot Bronzework in the Mycenaean World* (Oxford, 1964), 158 ff.; V. Karageorghis, *Mycenaean Art from Cyprus* (Nicosia, 1968), 29 f., plate xxiv.
135. H. Maryon, 'Metal Working in the Ancient World', *A.J.A.*, LIII (1949), 93-125; Strong, *op. cit.* (Note 4), 7 ff.
136. Strong, *op. cit.*, 8 f.; cf. A. Mutz, *Die Kunst des Metalldrehens bei den Römern* (Basel and Stuttgart, 1972).
137. E.g. *B.S.A.*, LI (1956), 87; cf. Persson, *op. cit.* (Note 101), 31, plate xi; Schaeffer, *op. cit.* (Note 108), suppl. pl. D opp. 382.
138. Strong, *op. cit.*, 42; cf. *ibid.*, 9, 25.
139. H. J. Plenderleith, in Schaeffer, *op. cit.*, 386 ff.
140. H. Maryon, *A.J.A.*, LIII (1949), 107 ff.; Maryon and Plenderleith, in C. Singer, E. J. Holmyard, and A. R. Hall, *op. cit.* (Chapter 5, Note 5), 649 ff.
141. *P.M.*, II, 637, 642. Cf. W. Lamb, *Greek and Roman Bronzes* (London, 1929), 12. But soldered, not welded (Singer, Holmyard, and Hall, *op. cit.*, 652).

CHAPTER 8

173. 1. *V.T.M.*, 47; *P.M.*, I, 100; K. Branigan, *Copper and Bronze Working in Early Bronze Age Crete* (*Studies in Mediterranean Archaeology*, XIX) (Lund, 1968), 63.
2. Branigan, *op. cit.*, 49; *V.T.M.*, 107.
3. J. A. Charles, 'The First Sheffield Plate', *Antiquity*, XLII (1968), 278-84. For the date see F. H. Stubbings, *ibid.*, 284-5. K. Branigan, *Antiquity*, XLIII (1969), 137-8, argues for an earlier date. But there is a blade with inlays from Prosymna of exactly this shape, and with similar large silver-capped rivets, assignable to L.H. II *c*. 1450 (C. W. Blegen, *Prosymna* (Cambridge, 1937), 330 f.; Marinatos and Hirmer, colour plate xxxviii, bottom).
4. E.g. *V.T.M.*, 20, plate xxiii, nos. 850-3; *Mochlos*, 77, XXI.8.
5. Branigan, *op. cit.*, 82, SS.I.1; Zervos, *A. Cr.*, plate 192, bottom left.
6. *Mochlos*, 37, 107, II.51; Branigan, *op. cit.*, 79, LD.Xa.7. But it came from a M.M. III level, and was classed by Seager as of that date.
7. *Mochlos*, 30, II.14.
8. Branigan, *op. cit.*, 64.
9. J. Charbonneaux, 'Trois armes d'apparat du palais de Mallia (Crète)', *Monuments Piot*, XXVIII (1925-6), 1-18.
174. 10. A. Lebesis, *P.A.E.* (1967), 208 f., plate 193a.
11. A. J. Evans, *The Tomb of the Double Axes* (London, 1914), 14 ff., figure 25, from tomb 3, assigned to L.M. IIIA1 by A. Furumark, *The Chronology of Mycenaean Pottery* (Stockholm, 1941), 104.
12. *P.M.*, I, 468 f., figure 336 (Knossos); *A.E.* (1912), 217, no. 6, figure 23 (Tylissos); *A.E.* (1939-41), 72, plate 3.3 (Sklavokampos); *Monumenti Antichi*, XIV (1904), 728, figure 26 (Ayia Triadha); *Palaikastro* (*op. cit.*, Chapter 2, Note 36), 134, plate XXX, B 4; N. Platon, *Zakros* (New York, 1971), 9.
13. F. Chapouthier, *Deux épées d'apparat découvertes en 1936 au palais de Mallia* (*Études crétoises*, V) (Paris, 1938).
14. N. Sandars, 'The First Aegean Swords and their Ancestry', *A.J.A.*, LXV (1961), 17-29.
15. W. Dörpfeld, *Alt-Ithaka* (Munich, 1927), 229, R. 7, Beilage 61a.3; 237, R. 17a, Beilage 61a.4, b.3.
175. 16. *Ibid.*, Beilage 63a.3, 4. Cf. Branigan, *op. cit.* (Note 1), 77, LD Type 5a; *V.T.M.*, 107, plate lv, no. 1886.
17. Dörpfeld, *op. cit.*, 229, Beilage 62.3. Called a 'Schwert', although it is only *c*. 0.45 m. long. Two other sword or dagger blades were found here.
18. *S.G.*, 200 ff.; Sandars, *loc. cit.*
19. Sandars, *op. cit.*, 25.
20. *Ibid.*, 22 f.; cf. K. Branigan, *B.S.A.*, LXIII (1968), 194.

21. E.g. *P.M.*, 11, 629, figure 392, no. 17, from a hoard assignable to L.M. I at latest. Cf. Sandars, *op. cit.*, 23. *Ergon* (1971), 231, figure 280 from Zakro. Branigan, *op. cit.* (Note 20), 192 ff., for others.

22. *S.G.*, 133 f., no. 727.

23. E.g. Mylonas, *M.M.A.*, 101, figure 95, from shaft grave circle B.

24. *S.G.*, 99, no. 402.

176. 25. *S.G.*, 101, no. 417, 136, no. 748.

26. *S.G.*, 99, no. 404; cf. *ibid.*, 104, no. 456.

27. W. Lamb, *Greek and Roman Bronzes* (London, 1929), 7.

28. E.g. *S.G.*, 98, no. 398, 136 f., no. 752.

29. Bronze: *S.G.*, nos. 417, 432. Silver: *S.G.*, no. 400. Cf. Mylonas, *Anc. Myc.*, 156.

30. Marinatos and Hirmer, plate 170, bottom; G. E. Mylonas, *O Tafikos Kiklos B ton Mikinon* (Athens, 1973), 85 f., figure 8, plates 67-8, *Anc. Myc.*, 140 f., figure 51, and *M.M.A.*, 101, figure 96.

31. *S.G.*, 204, 99 f., no. 407, 123, no. 634, 132 f., no. 723.

32. *S.G.*, 98, no. 398.

33. *S.G.*, 203, esp. nos. 408, 435 (type B swords). Cf. N. K. Sandars, *A.J.A.*, LXVII (1963), 120; *A.E.* (1897), 109, 122, plate vii.6 (Mycenae); *Ath. Mitt.*, XXXIV (1909), 298 f. (Kakovatos); A. W. Persson, *The Royal Tombs at Dendra* (Lund, London, Oxford, Paris, and Leipzig, 1931), 35 f., 62 f. Possibly also *A.E.* (1889), 146 (Vapheio), and *P.M.*, IV, 854 (Knossos). For a similar technique on dagger hafts of the Early Bronze Age in Brittany and southern England see S. Piggott, *Proceedings of the Prehistoric Society*, IV (1938), 62-4, 95.

34. E.g. *S.G.*, 114, no. 550a.

35. *S.G.*, 141 f., no. 778g.

36. *S.G.*, 83, no. 295b.

37. *S.G.*, 82, no. 295a, 204.

177. 38. *S.G.*, 194 ff.

39. *S.G.*, 82, no. 294.

178. 40. G. Dossin, *Syria*, XX (1939), 112.

41. *S.G.*, 101, no. 417.

42. *S.G.*, 135 f., no. 747. Length 0.43 m.

43. *S.G.*, 97, no. 396.

44. *S.G.*, 135, no. 746.

45. *S.G.*, 135, no. 744. For niello see pp. 157-8.

46. *S.G.*, 137, no. 764.

47. *S.G.*, nos. 395, 394, 765; Marinatos and Hirmer, colour plates xxxv-xxxvii.

179. 48. *S.G.*, 97, no. 395.

49. *S.G.*, 95 ff., no. 394.

181. 50. *S.G.*, 138 f., no. 765.

51. *Ergon* (1956), 93, figures 90-1.

52. *Ibid.*, 89, figure 88.

53. *P.M.*, III, 127 f.; S. Marinatos, 'The "Swimmers" Dagger from the Tholos Tomb at Vaphio',

in *Essays in Aegean Archaeology presented to Sir Arthur Evans* (Oxford, 1927), 63-71.

54. *P.M.*, III, 127, note 2. The flying fish were recovered from above the floor of the tomb, not from the pit containing the gold relief cups and most of the seals and other finds (*A.E.* (1889), 143).

55. Blegen, *op. cit.* (Note 3), 330 f.; Marinatos and Hirmer, colour plate xxxviii, bottom.

56. Higgins, *Min. Myc. Art*, 140 f.

57. J. J. A. Worsaae, *Des âges de pierre et de bronze* (Copenhagen, 1881), 234, colour plate i; G. Perrot and C. Chipiez, *Art in Primitive Greece* (London, 1894), 11, 450, figure 541; Tsountas and Manatt, *The Mycenaean Age* (London, 1903), 234 f., figure 118. The low midrib suggests a dagger rather than a sword blade.

58. *P.M.*, I, 719 f., figure 541; cf. Higgins, *Min. Myc. Art*, 43; K. Branigan, 'A Transitional Phase in Minoan Metallurgy', *B.S.A.*, LXIII (1968), 185-203, no. 22. Now in the Metropolitan Museum, New York.

183. 59. The Lasithi dagger is probably M.M. III according to R. W. Hutchinson, *Prehistoric Crete* (Harmondsworth, 1962), 249.

60. *Hesperia*, XXIV (1955), 32 ff.; XXV (1956), 155 ff.

61. N. Platon, *K. Ch.* (1949), 534-73.

62. Marinatos and Hirmer, plates 172-3.

185. 63. A. J. Evans, *The Prehistoric Tombs of Knossos* (London, 1906), 57 f., nos. 36h,i; Marinatos and Hirmer, plates 112-13.

64. *B.S.A.*, XLVII (1952), 265 ff., 11.3,4.

65. I. A. Sakellarakis, *Archaeology*, XX (1967), 278, figure 8; *Ergon* (1966), 141, figure 166; *Arch. Reports for 1966-67*, 20, figure 35.

66. Persson, *op. cit.* (Note 33), 34 ff., 60 ff.

67. *Ibid.*, 34 f., no. 10 (Persson's type A!).

68. *Ibid.*, 35 f., 62 f.

69. *Ars Antiqua Auktion*, III (1961), 30 f., no. 70; N. K. Sandars, *A.J.A.*, LXVII (1963), 145.

70. *A.E.* (1897), 106, plate 7.3,6.

71. *S.G.*, 205 f.; Mylonas, *Anc. Myc.*, 106, 150-1, 156 f., and *M.M.A.*, 102.

72. E.g., *S.G.*, 282 ff., nos. 403, 638, 690, 723-4. Cf. Mylonas, *Anc. Myc.*, 106, 150, 156 f., figure 79.

73. *P.M.*, IV, 931 ff., figures 903-4.

74. A. M. Snodgrass, *Arms and Armour of the Greeks* (London, 1967), 24 f.

75. Cf. H. L. Lorimer, *Homer and the Monuments* (London, 1950), 211 f.

76. V. R. d'A. Desborough, *The Last Mycenaeans and their Successors* (Oxford, 1964), 80, 84, plate 24a; N. M. Verdelis, *Ath. Mitt.*, LXXVIII (1963), 17 ff., figure 9, Beilage 6-7.

186. 77. Buchholz and Karageorghis, 58, no. 711; A. Snodgrass, *Early Greek Armour and Weapons* (Edinburgh, 1964), 86; E. Vermeule, *A.J.A.*, LXIV

(1960), 13 f., plate 5.35; N. Yialouris, *Ath. Mitt.*, LXXV (1960), 42 ff., Beilage 28. Contrast the decoration on the Early Geometric greaves from Athens (*Arch. Reports for 1967–68*, 4 f., figure 4; *A. Delt.*, XXI.2 (1966), 36, figures 1–2, plate 59).

CHAPTER 9

187. 1. Zervos, *Nais.*, I, 152, plates 66–7.
2. *B.S.A.*, LIX (1964), 237, figure 59, 1–4.
3. C. Tsountas, *Ai Proïstorikai Akropoleis Diminiou kai Sesklou* (Athens, 1908), 350 f., figure 291.
188. 4. *Mochlos*, 104–6 and *passim*.
5. R. A. Higgins, *Greek and Roman Jewellery* (London, 1961), 59 (hereafter referred to as Higgins, *Jewellery*); R. W. Hutchinson, *Prehistoric Crete* (Harmondsworth, 1962), 195.
189. 6. Higgins, *Jewellery*, 55 f.
7. *Mochlos*, 106, 32, 11. 30, 35, 36; cf. *ibid.*, 55, VI. 31.
8. *V.T.M.*, 111.
9. For one from the Ailias cemetery at Knossos see Hood, *The Minoans*, plate 67.
10. E.g. *S.G.*, 55, no. 78, plate xxii.
11. *Mochlos*, 26 f., 11. 4, 5.
12. C. Davaras, *B.S.A.*, LXX (1975), 103 f. figure 3, 108 ff., plate 18*a*.
13. *Arch. Reports for 1958*, 16, figure 24; *B.C.H.*, LXXXIII (1959), 744, figure 10; *V.T.M.*, 83, plate viii, no. 394; Higgins, *Jewellery*, 60 f.
14. *Mochlos*, 106.
15. *Ibid.*, 26 ff., 11. 4–6, 19.
16. The pins or poppies are made separately so that they can be removed.
17. H. Schliemann, *Ilios* (London, 1880), 454 ff., nos. 685–8.
18. A pair of tiny silver pendants might have come from earrings according to Seager, *Mochlos*, 54, VI.25*a*,*b*; cf. K. Branigan, *A.J.A.*, LXXII (1968), 220. But they resemble stone phallus pendants from the Cyclades in shape (Higgins, *Jewellery*, 58).
190. 19. *Mochlos*, 30 f., 11.18,68, XVI.13.
20. *V.T.M.*, IX, 67; K. Branigan, 'Silver and Lead in Prepalatial Crete', *A.J.A.*, LXII (1968), 219–29.
21. S. Marinatos, *P.A.E.* (1930), 98, figure 9; V. Milojčić, *Germania*, XXXI (1953), 8 f.
22. Zervos, *A. Cr.*, plate 203; cf. K. Branigan, *The Tombs of Mesara* (London, 1970), 68 ff.
23. *Mochlos*, 54, VI.23, 48, IV.7; Zervos, *A. Cr.*, plate 201, top left.
24. *Ergon* (1972), 120 f., figure 116.
25. O. Montelius, *La Grèce préclassique* (Stockholm, 1924), 23, figures 81, 87.
26. *A.E.* (1898), 165, plate 8.24–5; cf. *Mochlos*, 22, figure 6, 1.m; 72, XIX.14.
27. *A.E.* (1898), 160, 165, plate 8.16–17,23; cf.

Mochlos, 48, IV.7; Zervos, *A. Cr.*, plate 201, top left.
28. *A.E.* (1898), 165, plate 8.22; cf. Zervos, *A. Cr.*, plate 203.
29. Higgins, *Jewellery*, 52 f.
192. 30. National Museum in Athens, no. 5234. *A.E.* (1899), 123 f. plate 10.1; C. Zervos, *L'art des Cyclades, du début à la fin de l'âge du bronze* (Paris, 1957), 258. J. L. Caskey in *Marsyas: Essays in Memory of Karl Lehmann*, ed. Lucy F. Sandler (New York, 1964), 65, figure 5, for the complete restoration.
31. National Museum in Athens, no. 4729. *A.E.* (1898), 154, plate 8.1.
32. Cf. Chrysoula Kardara, *A.J.A.*, LXIV (1960), 344, plate 98.
33. National Museum in Athens, no. 4730. *A.E.* (1898), 154, plate 8.66; cf. *S.G.*, 75, no. 245.
34. C. W. Blegen, *Zygouries* (Cambridge, Mass., 1928), 180 f., 47, plate xx, no. 7; 51, 53, plate xx, no. 11.
35. Higgins, *Jewellery*, 51.
36. Blegen, *op. cit.*, plate xx.9; cf. Zervos, *op. cit.* (Note 30), plate 261.
37. Blegen, *op. cit.*, 181 f.
38. W. Dörpfeld, *Alt-Ithaka* (Munich, 1927), 235, R. 15*b*, Beilage 60. 3, 4, 7, 8.
39. *Ibid.*, 241, R. 24, Beilage 61 a. 5. Associated with weapons!
40. A. Greifenhagen, *Schmuckarbeiten in Edellmetall*, I (Berlin, 1970), 17, plates 1–2; Higgins, *Jewellery*, 50 ff.; Karo, *S.G.*, 188, 353; Buchholz and Karageorghis, 108.
41. E. R. Knauer, *Antike Welt*, III (1972), 2, suggests that the necklace may be an import from the Near East.
194. 42. Higgins, *Jewellery*, 59.
43. *V.T.M.*, 82 f., 110 f.
44. Higgins, *Jewellery*, 60, 18 ff., for the techniques involved. Cf. *Min. Myc. Art*, 46.
45. *V.T.M.*, 29; Higgins, *Min. Myc. Art*, 47, figure 43. Surely not a toad!
46. *V.T.M.*, 29, 82, 110; Higgins, *Min. Myc. Art*, 47, figures 43–4.
47. Cf. K. R. Maxwell-Hyslop, *Western Asiatic Jewellery* (London, 1971), 28, 114 ff., etc.
48. *P.M.*, I, 312, figure 231.
49. E.g. *B.S.A.*, LII (1957), 51 f., nos. 13–15; *P.A.E.* (1967), 205, plate 186.
50. J. N. Coldstream and J. L. Huxley, *Kythera* (London, 1972), 208, plate 59; *P.M.*, III, 411 f.; *B.S.A.*, VII (1900–1), 50; VIII (1901–2), 38 f., 84; M. Rosenberg, *Geschichte der Goldschmiedkunst auf technischer Grundlage: Granulation* (Frankfurt, 1918), 28 ff., figures 41–4, with good photos of the duck and lion.
51. *P.A.E.* (1967), 205, plate 186.
52. E.g. *P.M.*, II, 681 f., figure 431.

53. *Études crétoises*, VII (1945), 54, plate xxii, no. 561. A bronze pin of similar type from Palaikastro was surmounted by a dog (*Palaikastro* (*op. cit.*, Chapter 2, Note 36), 121, figure 101).

195. 54. *Études crétoises*, VII (1945), 54-6, plate lxvi, no. 559. More likely bees than hornets or wasps, as O. W. Richards, *Antiquity*, XLVIII (1974), 222, argues, in view of the similar way that Egyptians rendered bees (S. Hood, 'The Mallia Gold Pendant: Wasps or Bees?', in *Tribute to an Antiquary. Essays presented to Marc Fitch*, ed. F. Emmison and R. Stephens (London, 1976), 59-72).

55. R. A. Higgins, 'The Aegina Treasure Reconsidered', *B.S.A.*, LII (1957), 42-57.

197. 56. *Ibid.*, 50, no. 11. Cf. G. E. Mylonas, *O Tafikos Kiklos B ton Mikinon* (Athens, 1973), 201, 339, plate 181; *A.A.A.*, II (1969), 212, figure 3. This small but important point is ignored by those who insist on a later date for the whole of the Aigina Treasure (e.g. C. Hopkins, *A.J.A.*, LXVI (1962), 182-4; *Enc. dell'Arte*, 27; G. Becatti, *Oreficerie antiche* (Rome, 1955), 38 f.).

57. The loop for suspension suggests that this is a pendant, not the head of a pin like the rather comparable object from Mycenae shaft grave III (*S.G.*, 54 f., no. 75).

58. See M. A. V. Gill, 'The Minoan "Frame" on an Egyptian Relief', *Kadmos*, VIII (1969), 85-102, for a discussion of their nature.

59. *Thera*, V, 33.

60. *Thera*, IV, colour plates E, F; V, colour plates G, H, J, K.

61. *Thera*, V, colour plate E.

62. *Phylakopi* (*op. cit.*, Chapter 3, Note 44), 73 f., figure 61; cf. *Études crétoises*, I (1928), 59, figure 19.

63. Higgins, *Jewellery*, 54; Blegen, *op. cit.* (Note 34), 202, figure 189; *B.S.A.*, LXVII (1972), 217, illustrated in *Arch. Reports for 1963-64*, 9, figure 8, and *A. Delt.*, XIX.2 (1964), plate 148*a*.

64. G. Sotiriades, *A.E.* (1908), 96, 93, figure 16.

65. E.g. *B.S.A.*, XVI (1909-10), 74 f., figure 4.

66. *Hesperia*, XXVI (1957), 148, plate 42*b*.

67. T. L. Shear, *A.J.A.*, XXXIV (1930), 406-9; C. W. Blegen, *Corinth*, XIII (Princeton, 1964), 3 f., 8, figure 1, plate 4.

68. T. G. Spiropoulos, *A.A.A.*, V (1972), 16 ff., figure 4; *Arch. Reports for 1971-72*, 12, figure 22.

69. *S.G.*, 173 ff.; Mylonas, *Anc. Myc.*, 128 ff.

198. 70. *S.G.*, 49, no. 32; *Monumenti Antichi*, XIV (1905), 730, figure 30.

71. *S.G.*, nos. 61, 75, 263.

72. *B.S.A.*, LII (1957), 49.

73. Both types occur in Asshur grave 20 together with quadruple spiral beads like some from Mycenae shaft grave III (A. Haller, *Die Gräber und Grüfte von Assur* (Berlin, 1954), 10, plate 10*a*; Maxwell-Hyslop, *op. cit.* (Note 47), 70 f., figure 46).

74. M.-L. and H. Erlenmeyer, *Kadmos*, III (1964), 177-8, have ingeniously suggested that a flowered diadem and diadem rays from grave III are Kassite work accompanying a princess of that nation buried there. But the evidence which they cite does not seem very conclusive.

75. *P. Nestor*, III, 16, figure 108; 147, 166 f., figures 225.1, 230.15.

76. *Ergon* (1965), 92, figure 109; *P.A.E.* (1965), 117, plate 134.

77. Cf. Mylonas, *Anc. Myc.*, 170.

78. *S.G.*, 178, 73, nos. 236-9.

79. *P.M.*, II, 775 ff., figure 504*b*.

80. *S.G.*, 182 f.; Chrysoula Kardara, *A.J.A.*, LXIV (1964), 344, plate 98. The strengthening of the rays with wire has no meaning if they were to be employed to decorate a wooden sarcophagus of the Egyptian type as surmised by M. Meurer, 'Der Goldschmuck der mykenischen Schachtgräber', *J.d.I.*, XXVII (1912), 208-27.

199. 81. *P. Nestor*, III, 146 f., 156, figures 225.6, 227.8.

82. Mylonas, *Anc. Myc.*, 147, figure 63; *Kiklos B* (*op. cit.*, Note 56), 178 ff.

83. *S.G.*, 186 f. Mylonas, *Kiklos B*, 30, 189, 203, 234, 326 f.; *Anc. Myc.*, 144 f., figure 57: three crystal-headed pins from grave Omicron. Mylonas believes that they are dress pins. But see Hood, *B.S.A.*, LXIII (1968), 214.

84. S. Marinatos, *A.E.* (1937), 287; cf. Mylonas, *Anc. Myc.*, 145, plate 57*a*,*b*.

200. 85. *S.G.*, 58, no. 105.

86. Originally published by E. J. Forsdyke, *B.S.A.*, XXVIII (1926-7), 267, figure 38; S. Alexiou and W. C. Brice, 'A Silver Pin from Mavro Spelio with an Inscription in Linear A: Her. Mus. 540', *Kadmos*, XI (1972), 113-24. Cf. *ibid.*, XV (1976), 18-27, from Platanos.

87. *S.G.*, 54 f., no. 75. Enlarged colour picture in J. Hawkes, *Dawn of the Gods* (London, 1968), plate 44.

201. 88. *S.G.*, 186, 57, nos. 93-6.

89. *S.G.*, 173 ff.

90. *S.G.*, 162, no. 924.

91. *S.G.*, 75, nos. 246-7.

92. *S.G.*, 75, no. 245; cf. *A.E.* (1898), 154, plate 8.66. A small 'toggle-pin' with simple conical head was recovered from a tomb of L.H. I date near Pylos (*A. Delt.*, XXI.2 (1966), 166, plate 168). But after this period 'toggle-pins' do not seem to be attested in the Aegean area.

93. *S.G.*, 52, no. 61.

94. E.g. *B.S.A.*, LI (1956), 87 ff., plate 13; LXII (1967), 341, plate 80*a*.

95. Mylonas, *Kiklos B*, 200 f., plate 180*a*; *Anc. Myc.*, 145, figure 58; cf. Maxwell-Hyslop, *op. cit.* (Note 47), 28, plate 24*b*.

96. *S.G.*, 51 f., nos. 53-4.

97. J. Bouzek, *Památky archeologické*, LVII (1966), 254 f., 251 figure 8. Cf. M. Gimbutas, *Bronze Age Cultures in Central and Eastern Europe* (The Hague, 1965), 57, figure 21.

98. *S.G.*, 188, 52 f., nos. 56–9, 63–7, 133; Mylonas, *Kiklos B*, 199 f., plates 178–9.

99. Maxwell-Hyslop, *op. cit.*, 34 f.

100. *A.A.A.*, I (1968), 10, figures 14–15.

101. *P. Nestor*, III, 115, figure 190.10,12.

202. 102. *P.M.*, II, 705. For armlets in general, see *B.C.H.*, LXXI–LXXII (1947–8), 159 f.

103. *S.G.*, 179, 75, nos. 255–6.

104. *S.G.*, 76 f., no. 263.

105. Cf. Evans, *P.M.*, II, 705.

106. H. Frankfort, *The Art and Architecture of the Ancient Orient (Pelican History of Art)*, 4th imp. (Harmondsworth, 1969), 131 f., figure 58.

107. M. Cameron, *London Myc. Seminar* (3 June 1970), 362, note 1, in reference to *P.M.*, I, 201, colour plate i*k*, opp. 231.

108. *S.G.*, 212 f. Karo, *S.G.*, 175, thought that the Mycenaeans, unlike the Cretans, did not wear belts, and interpreted all these as shield or sword baldrics slung across one shoulder: but *S.G.*, nos. 260–1, might have been belts to judge from their length (just over a metre).

109. *B.S.A.*, XLVII (1952), 272, III.19, with references; *Ath. Mitt.*, LXXXII (1967), 59.

110. *P.M.*, II, 726.

111. *S.G.*, 188 ff.; Mylonas, *Kiklos B*, 342 f.; *Anc. Myc.*, 143, 145, 155, 158, from graves Gamma, Omicron, Xi, Mu, and Upsilon, mostly at any rate with the burials of women.

112. *S.G.*, 110, no. 513.

113. *S.G.*, 189, 137, nos. 757–9.

203. 114. For lunulae see now Joan J. Taylor, *Proceedings of the Prehistoric Society*, XXXVI (1970), 38–81.

115. *S.G.*, 188, 52, nos. 56–9.

116. *S.G.*, 189, 50, nos. 38–40, 52.

117. *S.G.*, 188, 59, no. 112.

118. *Ath. Mitt.*, XXXIV (1909), 271, 294, 301, plates xii.8, xiii.27, xiv.1; *A.E.* (1897), 124–7.

119. Mylonas, *Anc. Myc.*, 150, from grave Nu.

120. *S.G.*, 190, Group (b). In view of their flimsy character Karo thought they were only for funerary use.

204. 121. *Ergon* (1965), 92, figures 113–16; *P.A.E.* (1965), 118 f., plates 140–1; cf. *Ergon* (1962), 116, figure 140; *ibid.* (1964), 89, figure 109, from tholos 2; Marinatos and Hirmer, plate 203, from Kakovatos.

122. *S.G.*, plates xxviii–xxix; Marinatos and Hirmer, plate 202.

205. 123. Higgins, *Jewellery*, 68 ff.; *idem, Min. Myc. Art*, 172 ff.

124. *Comptes Rendus, Académie des Inscriptions et Belles-Lettres* (1909), 384 f., figure 2.

125. E.g. A. J. Evans, *The Prehistoric Tombs of Knossos* (London, 1906), 53 ff., figures 53, 60: 36*k*.

126. Higgins, *Jewellery*, 72 f. One from Vathipetro is almost certainly older than *c.* 1450 (S. Marinatos, *P.A.E.* (1952), 605 f.).

206. 127. *P. Nestor*, I, 75, plate 273.20.

128. Higgins, *Jewellery*, 83.

129. L. B. Holland, *A.J.A.*, XXXIII (1929), 173 ff.; cf. Persson, *op. cit.* (Chapter 8, Note 33), 64 f.; Wace, *B.S.A.*, XXV (1921–3), 397–402; Higgins, *Jewellery*, 77.

130. N. Yalouris, *C.I.M.*, I (1967), 179 ff., plate iii.7; Buchholz and Karageorghis, 111, no. 1346.

131. G. H. McFadden, *A.J.A.*, LVIII (1954), 141, no. 38; Vermeule, *G.B.A.*, 225 ff.; V. Karageorghis, *Kipriakai Spoudhai* (1961), 16, plate 8*a*.

207. 132. S. Hood, *B.S.A.*, LXIII (1968), 214–18.

133. Higgins, *Jewellery*, 25 f.; *idem, Min. Myc. Art*, 180.

134. Dr Reynold Higgins has kindly drawn my attention to C. H. V. Sutherland, *Gold* (London, 1959), 38, describing a pectoral of Amenemhet I (1991–1962).

135. K. R. Maxwell-Hyslop, *Iraq*, XXII (1960), 111; Higgins, *Jewellery*, 23 ff.; *idem, Min. Myc. Art*, 172 f.

136. For one, see *P.A.E.* (1928), 47 ff.; *A.E.* (1930), 35 ff.; for the other, S. Symeonoglou, *Kadmeia I: Mycenaean Finds from Thebes* (Göteborg, 1973), 63 ff.

137. *A.E.* (1897), 121, note 1.

CHAPTER 10

209. 1. J. Boardman, *Greek Gems and Finger Rings* (London, 1970), 16 (hereafter referred to as Boardman, *Gems*); V. E. G. Kenna, *A.A.* (1964), 913.

2. V. E. G. Kenna, *Cretan Seals* (Oxford, 1960), 1 f. (hereafter referred to as Kenna, *C.S.*).

3. A. J. Tobler, *Excavations at Tepe Gawra*, II (Philadelphia, 1950), 177.

4. E. Porada, in R. W. Ehrich, *Chronologies in Old World Archaeology* (Chicago, 1965), 140.

5. Unless the Neolithic of Çatal Hüyük proves to belong to an earlier horizon than the Halafian.

6. J. Mellaart, *Çatal Hüyük* (London, 1967), 220.

7. For wooden seals in the Aegean see Boardman, *Gems*, 26, 378 f.

8. E.g. H. R. Hall, *The Ancient History of the Near East*[11] (London, 1950), 89. But see W. H. Ward, *The Seal Cylinders of Western Asia* (Washington, 1910), 3 ff.; H. Frankfort, *Cylinder Seals* (London, 1939), 3.

9. Frankfort, *op. cit.*, 293.

10. R. J. and L. S. Braidwood, *Excavations in the Plain of Antioch*, I (Chicago, 1960), 517.

11. Cf. L. Woolley, *Liverpool Annals of Art and Archaeology*, IX (1922), 49.

210. 12. Braidwood, *op. cit.*, 331 ff., figure 254. The type with a U-shaped perforation was comparatively short-lived and may have been a Syrian invention (*ibid.*, 488, note 15).

13. V. E. G. Kenna, *A.J.A.*, LXXII (1968), 322-4.

14. Perforated clay cylinders with simple incised designs have been recovered from Troy and from Late Neolithic contexts in Macedonia and Albania. These are unlikely to have been used as seals, even if they were copied from Oriental cylinders, which in the case of the Balkan examples is difficult to reconcile with the suggested radiocarbon dates. See S. Hood, 'An Early Oriental Cylinder Seal Impression from Romania?', *World Archaeology*, V (1973), 187-97.

15. P. Warren, 'The Primary Dating Evidence for Early Minoan Seals', *Kadmos*, IX (1970), 29-37.

16. *P.M.*, I, 68.

17. Braidwood, *op. cit.*, 329 ff., figure 253.

18. H. Frankfort, 'Egypt and Syria in the First Intermediate Period', *Journal of Egyptian Archaeology*, XII (1926), 80-99, for the Syrian inspiration of Egyptian stamp seals, and *ibid.*, 90, for a cylinder of Syrian type with loop handle allied to them.

19. F. Matz, *Die Frühkretischen Siegel* (Berlin and Leipzig, 1928), 5 ff.; Boardman, *Gems*, 387 f.

20. J. A. Sakellarakis, *Archaeology*, XX (1967), 276, figure 6; *C.M.S.*, II, 1, no. 391.

21. Braidwood, *op. cit.*, 331, figure 253.6. But this is unperforated.

22. E.g. *C.M.S.*, II, 1, nos. 22-4, 46-7, 50, 89, 157, 174, 181, 210, 445.

23. N. Platon, in *Festschrift für Friedrich Matz*, ed. G. M. A. Hanfmann (Mainz, 1962), 14-18, has explained holes in the engraved faces of a number of early Cretan seals, some of them with fillings on which the design is continued, as due to the fact that part of the seal was made detachable. Most of the holes in question are on the engraved ends of seals of cylindrical shape which are reported to be of ivory. But if sections of bone were used instead of ivory, the central hollow would need filling, as seen in the case of a bone cylinder from Lebena (*C.M.S.*, II, 1, no. 210).

24. Cf. Matz, *op. cit.* (Note 19), 101. F. Chapouthier, 'De l'origine du prisme triangulaire dans la glyptique minoenne', *B.S.A.*, XLVI (1951), 42-4, argues that the prism developed from the gable shape, which is also found in Crete, as well as in Anatolia, and in Syria in Phases F and G (Braidwood, *op. cit.*, 253, figure 191). But gable seals are normally flatter and they are engraved on the wide lower face alone.

25. A. Xenaki-Sakellariou, 'Sur le cachet prismatique minoen', in *Minoica, Festschrift Johannes Sundwall*, ed. E. Grumach (Berlin, 1958), 451-60.

212. 26. M. A. V. Gill, 'On the Authenticity of a Middle Minoan Half-Cylinder', *Kadmos*, VI (1967), 114-18.

27. *V.T.M.*, 68, plate viii.

28. *B.S.A.*, XXXVI (1935-6), 97; Zervos, *A. Cr.*, plate 208; *C.M.S.*, II, 1, no. 435.

29. *C.M.S.*, II, 1, 149, no. 130; *V.T.M.*, 83, no. 821; *P.M.*, II, 55, figure 26; Zervos, *A. Cr.*, plate 206, right.

30. *C.M.S.*, II, 1, 153, no. 133; *P.M.*, I, 117, figure 86; *V.T.M.*, 30, no. 516.

31. E.g. *V.T.M.*, 25, no. 525; *Études crétoises*, X (1958), 1, no. 1.

32. I. Pini, 'Weitere Bemerkungen zu dem minoischen Fussamuletten', *Studi micenei*, XV (1972), 179-87.

33. B. Buchanan, *Catalogue of Ancient Near Eastern Seals in the Ashmolean Museum*, I, *Cylinder Seals* (Oxford, 1966), 127, 135, no. 741. No. 742 of the same material and type may also be Cycladic. There is a clay seal of this type from Troy (H. Schliemann, *Ilios* (London, 1880), 415, no. 499; H. Schmidt, *Schliemann's Sammlung Trojanischer Altertümer* (Berlin, 1902), 303, no. 8866). But ones of ivory from Poliochni V (Yellow) corresponding to Troy II or somewhat later (L. B. Brea, *Proceedings of the Prehistoric Society*, XXI (1955), 153, plate xvii; *Bollettino d'Arte*, III-IV (1957), 193, 206, figures 1, 25), and from Troy VI (C. W. Blegen, *Troy*, III (Princeton, 1953), 29, 298, plates 296, 304: 35-478), appear to be imports from further east.

213. 34. *World Archaeology*, V (1973), 195.

35. A. J. B. Wace and J. S. Thompson, *Prehistoric Thessaly* (Cambridge, 1912), 165, figure 112b,c. But seals including one of lead are reported from early tombs on Naxos (*Ergon* (1970), 142 f., figure 157).

36. Eva-Maria Bossert, 'Die Gestempelten Verzierungen auf Frühbronzezeitlichen Gefässen der Ägäis', *J.d.I.*, LXXV (1960), 1-16.

214. 37. *Ibid.*, 14 f., figures 11-12; *A.E.* (1899), 122, plate 9.15.

38. *Hesperia*, XXXVIII (1969), 519; XLI (1972), 366.

39. *A.E.* (1899), 114, plate 10.8.

40. Martha Heath Wiencke, 'Banded Pithoi of Lerna III', *Hesperia*, XXXIX (1970), 94-110.

41. E.g. O. Frödin and A. W. Persson, *Asine* (Stockholm, 1938), 234 ff.; C. W. Blegen, *Zygouries* (Cambridge, Mass., 1928), 189 f.; G. Mylonas, *Aghios Kosmas* (Princeton, 1959), 29 f., 157 ff.; *Hesperia*, XXXVI (1967), 26, 41, plate 11d, from Corinth. Boardman, *Gems*, 387, for others.

42. Martha Heath (Wiencke), 'Early Helladic Clay Sealings from the House of the Tiles at Lerna', *Hesperia*, XXVII (1958), 81-121; *eadem*, 'Further Seals and Sealings from Lerna', *Hesperia*, XXXVIII (1969), 500-21; F. Matz, *Crete and Early Greece* (London, 1962), 67 ff., 154 f.

43. Compare from the earliest group of Lerna sealings, *Hesperia*, XXXVIII (1969), 506 f., s. 73, 77, 74, with *Annuario*, XIII–XIV (1933), 212, figure 112a, no. 253; 210, figure 105, no. 244; and *V.T.M.*, 114, plate xiii, no. 1029. Cf. A. Sakellariou, *K. Ch.* (1961–2), 1, 79–87.

44. The site of the palace at Knossos, where the soil is left undisturbed, acts as a kind of nature preserve for these burrowing creatures. I saw many rogalidhas there during the course of soundings in the summer of 1973.

45. *Hesperia*, XXXVIII (1969), 509 ff. The clay seals assigned to M.H. levels at Asea (E. J. Holmberg, *The Swedish Excavations at Asea in Arcadia* (Lund, 1944), 117, figure 12) may also belong to this earlier period.

46. *Ibid.*, 509 ff., no. 198.

215. 47. Obsidian and hard stones including lapis lazuli were being used for seals long before this in the Near East (e.g. Tobler, *op. cit.* (Note 3), 176).

48. *P.M.*, IV, 486, figures 415–16; *C.M.S.*, VII, 71, no. 39, allegedly found at Mycenae.

49. A. Dessenne, *B.C.H.*, LXXXI (1957), 693–5; *Comptes Rendus, Académie des Inscriptions et Belles-Lettres* (1957), 123–7.

216. 50. Kenna, *C.S.*, 111, no. 165; E. Grumach, 'Das Achtseitige Siegel des Ashmolean Museums 1938. 1166', *Kadmos*, 11 (1963), 84–97.

51. E.g. *P.M.*, 1, 165 ff., figure 119d. From the Vat Room deposit, part of which seems assignable to M.M. IB.

52. Kenna, *C.S.*, 113, no. 174; *P.M.*, 1, 277 f., figure 207a.

53. V. E. G. Kenna, *A.A.* (1964), 928.

54. Kenna, *C.S.*, 37; *Annuario*, XXXIX–XL (1961–2), 96, figures 124, 133 N.7.

55. V. E. G. Kenna, in *Arch. Reports for 1962–63*, 30, apropos of *Annuario*, XXXV–XXXVI (1957–8), 117 f., Tipo 234. The design as it appears in *C.M.S.*, 11, 5, no. 282, is somewhat different, however, and J. H. Betts, *B.S.A.*, LXII (1967), 39, doubts if the impression was made by an Anatolian seal. But *Annuario*, XXXV–XXXVI (1957–8), 95, Tipo 152, also has many parallels in Kara Hüyük in central Anatolia (e.g. S. Alp, *Zylinder- und Stempelsiegel aus Kara-höyük bei Konya* (Ankara, 1968), 224 ff., nos. 225–37), and closely resembles a seal impression from Troy II (C. W. Blegen, *Troy*, 1 (Princeton, 1950), 256, figure 408).

56. D. Levi, 'L'archivio di Cretule a Festòs', *Annuario*, XXXV–XXXVI (1957–8), 7–192; I. Pini, *C.M.S.*, 11, 5.

57. For a discussion of the date see I. Pini, *C.M.S.*, 11, 5, ix ff.

217. 58. *Annuario*, XXXV–XXXVI (1957–8), 113 f., Tipo 226.

59. *Ibid.*, 128 ff., Tipo 253.

60. E.g. *B.S.A.*, IX (1902–3), 20, figure 9; cf. *Annuario*, XXXV–XXXVI (1957–8), 111, Tipo 218.

61. *Annuario*, XXXIX–XL (1961–2), 95 ff.

62. *B.S.A.*, VIII (1899–1900), 25, 59 ff.; A. J. Evans, *Scripta Minoa*, I (Oxford, 1909), 20 ff.; *P.M.*, 1, 271 ff.; F. Matz, *Cambridge Ancient History*[3], 11, part 1 (Cambridge, 1973), 157 f.

63. Evans himself wavered between a date early in M.M. III or late in M.M. II (*P.M.*, 1, 272, note 2). J. J. Reich, *A.J.A.*, LXXIV (1970), 406–8, makes a strong case for M.M. IIIA.

218. 64. *A.A.* (1964), 930, for a third head.

65. Lentoids appear to be attested at Knossos before the end of M.M. II (*B.S.A.*, XXXVIII (1926–7), 280, XVII P. 11–13).

66. E.g. one with gold-capped string-hole from a tomb at Poros near Herakleion (*Ergon* (1967), 124, figure 125; *P.A.E.* (1967), 207, plate 188).

219. 67. Boardman, *Gems*, 56.

68. V. E. G. Kenna, 'Design for a Water Garden', in *Drerup Festschrift, Marburger Winckelmann-Programm 1968* (Marburg, 1969), 1–4, has suggested that two bronze seals were in effect beads with inlays of gold and silver.

69. *P.M.*, 1, 669 ff., esp. 694 f.; Kenna, *C.S.*, 51 f.; A. Sakellariou, *Mykenaiki Sfragidoglifia* (Athens, 1966), 79 f.

70. E.g. *P.M.*, III, 186, figure 129.

71. For obsidian see H. M. C. Hughes and P. Warren, 'Two Sealstones from Mochlos', *K. Ch.* (1963), 352–5.

72. M. A. V. Gill, *B.S.A.*, LX (1965), 69–71, with full references; *B.S.A.*, IX (1902–3), 53 ff.; *P.M.*, 1, 494 ff., with illustrations on 505, 515, 565, 686, 689, 694 ff., 696–700.

73. *P.M.*, 1, 694, figure 514, 689, figure 509.

74. *P.M.*, 1, 505, figure 363a,b. An impression of the goddess with a lion made by the same gem is alleged to have been found at Zakro (*B.S.A.*, XVII (1910–11), 265, figure 2; M. A. V. Gill, *B.S.A.*, LX (1965), 69). But J. H. Betts, *Kadmos*, VI (1967), 19, thinks that the sealing in question may be one from the Knossian Temple Repositories which later became confused with Zakro material.

75. Gill, *op. cit.*, 71, L49; *P.M.*, 1, 698, figure 520, and IV, 952, figure 921.

220. 76. *P.M.*, 1, 565, figure 411a,b.

77. J. H. Betts, 'Trees in the Wind on Cretan Sealings', *A.J.A.*, LXXII (1968), 149 f.; cf. Gill, *op. cit.*, 70, L15 and L22.

78. *P.M.*, 1, 672–4, and IV, 446–50; V. E. G. Kenna, *The Cretan Talismanic Stone in the Late Minoan Age* (*Studies in Mediterranean Archaeology*, XXIV) (Lund, 1969); Boardman, *Gems*, 42 ff.; J. H. Betts, 'Ships on Minoan Seals', *Colston Papers*, XXIII (London, 1971), 325–38.

79. V. E. G. Kenna, *A.A.* (1964), 932.

80. A. Xenaki-Sakellariou, in *Minoica* (*op. cit.*, Note 25), 457.

221. 81. Hood, *The Minoans*, 33. For a review of all the evidence and a degree of scepticism see C. Mavriyannaki, 'Modellini fittili di costruzioni circolari dalla Creta minoica', *Studi micenei*, XV (1972), 161–70.

82. D. G. Hogarth, 'The Zakro Sealings', *J.H.S.*, XXII (1902), 76–93; *idem*, 'Note on Two Zakro Sealings', *B.S.A.*, XVII (1910–11), 264–5; D. Levi, 'Le Cretule di Zakro', *Annuario*, VIII–IX (1929), 157–201.

222. 83. D. Levi, 'Le Cretule di Haghia Triada', *Annuario*, VIII–IX (1929), 71–156.

84. Gill, *op. cit.*, 74–6. For the date see *P.M.*, II, 762 ff., and IV, 593 f.; V. E. G. Kenna, *Kadmos*, IV (1965), 74–7; J. H. Betts, *Kadmos*, VI (1967), 28.

85. S. Marinatos, *A.E.* (1939–41) (published 1948), 69–96, esp. 87–93.

223. 86. *J.H.S.*, XXII (1902), 88, nos. 130–1.

87. *Ibid.*, 77, no. 3; *P.M.*, II, 767 f., figure 498, and IV, 395, figure 331. The clay matrix is here drawn from an impression in reverse.

88. *C.M.S.*, I, no. 167. Possibly from the Tomb of Clytemnestra.

89. *J.H.S.*, XXII (1902), 78, nos. 12–14; *Annuario*, VIII–IX (1929), 122 f., nos. 112–15; cf. *C.M.S.*, I, no. 16.

90. *C.M.S.*, I, no. 274.

91. *J.H.S.*, XXII (1902), 86, no. 99.

92. *J.H.S.*, XXII (1902), 88, no. 128; *Annuario*, VIII–IX (1929), 99, no. 49.

93. *J.H.S.*, XXII (1902), 86, no. 105; *Annuario*, VIII–IX (1929), 145, no. 146; *Kadmos*, VI (1967), 18 f.

94. *J.H.S.*, XXII (1902), 78 ff.

95. The variation in quality, stressed by Hogarth, is against the idea that they were all the work of one artist, as suggested by Boardman, *Gems*, 42.

96. As argued by Hogarth, *J.H.S.*, XXII (1902), 91, and by many others since his time.

97. J. H. Betts, 'New Light on Minoan Bureaucracy', *Kadmos*, VI (1967), 15–40.

224. 98. *Hesperia*, XL (1971), 373, from tomb 31 early in the period of M.M. III imports. Another gem was found in a deposit with pottery assignable to L.H. IIIB (*Hesperia*, XXXI (1962), 280, plate 101*f.*).

99. *Thera*, V, 36, plate 85.

100. *Phylakopi* (*op. cit.*, Chapter 3, Note 44), 21, 193, 266 f., figure 162; *C.M.S.*, I, no. 410.

101. J. Boardman, *Island Gems* (London, 1963), 97, no. 6; F. Dümmler, *Ath. Mitt.*, XI (1886), 170; Buchholz and Karageorghis, 116, no. 1405.

102. Boardman, *op. cit.* (Note 101), 96 ff.; A. Zazoff, *A.A.* (1965), 6 ff.; *Antike Gemmen in Deutschen Sammlungen*, III (Wiesbaden, 1970), 187 ff.

103. *C.M.S.*, I, nos. 5–7. A fourth seal (no. 8) was recovered from the atypical and evidently later built tomb Rho.

104. Mylonas, *Anc. Myc.*, 145, 155, figures 58, 80.

105. *Ibid.*, 139, figure 49; Boardman, *Gems*, plate 44; Buchholz and Karageorghis, 116, no. 1399; H. Biesantz, 'Die minoischen Bildnisgemmen', *Marburger Winckelmann-Programm* (1958), 9–25. Sakellariou, *op. cit.* (Note 69), 24 ff., 129, considers that it was engraved by a Cretan artist for a Mycenaean ruler.

225. 106. *P.M.*, IV, 217 f.; Buchholz and Karageorghis, 116, no. 1398. A lentoid with a bearded head from Anopolis south of Herakleion is published by S. Marinatos, 'Minoische Porträts', *Max Wegner Festschrift* (Münster, 1962), 9–12. Beards may have been a sign of rank. The admiral of the fleet in the miniature fresco from the West House at Akrotiri appears to have a beard (*Thera*, VI, 54).

107. V. E. G. Kenna, 'Some Eminent Cretan Gemengravers', *Matz Festschrift* (*op. cit.*, Note 23), 4–13.

108. *C.M.S.*, I, nos. 9–16.

109. *Annuario*, VIII–IX (1929), 122 f., no. 113. There are fragments of sealings with a comparable scene of combat from Knossos (M. A. V. Gill, *B.S.A.*, LX (1965), 87; J. H. Betts, *Kadmos*, VI (1967), 19).

226. 110. *S.G.*, 180.

111. H. Biesantz, *Kretisch-mykenische Siegelbilder* (Marburg, 1954); cf. A. Sakellariou, *Die mykenische Siegelglyptik* (*Studies in Mediterranean Archaeology*, IX) (Lund, 1964). Boardman, *Gems*, 58, also argues for the existence of mainland studios by the time of the shaft graves of circle A.

112. J. Boardman, 'The Danicourt Ring', *Revue Archéologique* (1970), 1, 3–8.

227. 113. *C.M.S.*, I, nos. 219–61; Kenna, *C.S.*, 54, 80–2. J. G. Younger, 'The Vapheio Gems: A Reconsideration of the Find-Spots', *A.J.A.*, LXXVII (1973), 338–40, for the identification of which seals were found in the grave pit and elsewhere in the tomb. The use of the tomb is dated by pottery to L.H. IIA, which should overlap with L.M. IB in Crete.

114. *C.M.S.*, I, no. 256. For its Cretan workmanship see Sakellariou, *op. cit.* (Note 69), 52.

115. Sakellariou, *op. cit.*, 11 f., 42 f., 128.

116. *Annuario*, VIII–IX (1929), 87, no. 6.

117. Kenna, *C.S.*, 52 ff.; *Kadmos*, III (1964), 35.

118. Kenna, *C.S.*, 52 f.; Hogarth, *J.H.S.*, XXII (1902), 89 f.

119. *C.M.S.*, I, nos. 240–1; cf. *B.S.A.*, XLVII (1952), 273, III.21.

120. J. G. Younger, *A.J.A.*, LXXVII (1973), 338 ff.

121. *C.M.S.*, I, nos. 269–74.

122. *Ibid.*, nos. 275–86.

228. 123. Sakellariou, *op. cit.*, 75 f., 92 ff., 134 f.

124. *Ibid.*, 58 f., 60 ff., 131 f.

125. J. H. Betts, *J.H.S.*, XC (1970), 258.

229. 126. Lapis lazuli was already in use for Cretan seals before 1450. But the manufacture of seals from lapis lacedaemonius is not certainly attested until L.M. II according to Boardman, *Gems*, 47.

127. Full references in M. A. V. Gill, 'The Knossos Sealings: Provenance and Identification', *B.S.A.*, LX (1965), 58–98. Additions by J. H. Betts, *B.S.A.*, LXII (1967), 27–45.

128. V. E. G. Kenna, 'The Seals of Kalyvia Messara', *K. Ch.* (1963), 327–38. But the seals are unlikely to be plunder from the final destruction of the palace at Knossos, since the burials for the most part at any rate appear to be earlier.

129. S. Alexiou, *Isterominoikoi Tafoi Limenos Knosou (Katsamba)* (Athens, 1967), 47, figure 34.

230. 130. *B.S.A.*, LI (1956), 93 f., figure 5, no. 4.

131. Cf. *P.M.*, IV, 587 f.

132. Persson, *op. cit.* (Chapter 8, Note 33), 32, 57, 124 f.

133. *C.M.S.*, I, nos. 302–82.

134. J. Betts, *London Myc. Seminar* (1 November 1967), 342. Boardman, *Gems*, 397, reckons that nearly one quarter of the impressions from Pylos listed in *C.M.S.*, I, were made by L.H. IIIA gems and signet rings. Cf. J. L. Benson, 'Aegean and Near Eastern Seal Impressions from Cyprus', in *Goldman Studies* (*op. cit.*, Chapter 4, Note 161), 59–77, for the use of earlier cylinder seals at Bamboula (Kourion) in the fourteenth and thirteenth centuries. But in this case the seals were being used to decorate pottery.

231. 135. As suggested by Sakellariou, *op. cit.* (Note 69), 117 f., 136.

136. *Ibid.*, 6, note 5, 108 f.

137. *A.E.* (1933), 90, figure 39.

138. S. E. Iakovides, *Perati*, II (Athens, 1970), 322 ff., 457 f.; *C.M.S.*, I, nos. 390–6.

139. See the analysis of eight of these by V. E. G. Kenna, 'Seals and Sealstones from the Tombs at Perati', *Charistirion eis A. K. Orlandon*, II (Athens, 1966), 320–6.

140. *C.M.S.*, I, no. 179; Sakellariou, *op. cit.*, 23.

141. Boardman, *Gems*, 19; A. J. Evans, *Scripta Minoa*, I (Oxford, 1909), 10.

232. 142. *P.M.*, IV, 594 f.; Kenna, *C.S.*, 76 f.; L. R. Palmer and J. Boardman, *On the Knossos Tablets* (Oxford, 1963), 11, 12 ff., plate viib.

143. *A.E.* (1897), 121, note 1. Cf. A. Furtwängler, *Die Antiken Gemmen* (Leipzig and Berlin, 1900), III, 29.

144. Kenna, *C.S.*, 77; *P.M.*, II, 238, figure 134; G. M. A. Richter, *Metropolitan Museum of Art : Handbook of the Greek Collection* (Harvard, 1953), 17, plate 8i.

145. Cf. A. J. B. Wace, *Archaeologia*, LXXXII (1932), 27. Karo, *S.G.*, 49, no. 33, 74, no. 241, suggested lead in the case of those from the Mycenae shaft graves, but this seems improbable.

146. F. H. Marshall, *Catalogue of the Jewellery, Greek, Etruscan and Roman, in the British Museum* (London, 1911), 40, figure 7, no. 609.

147. G. E. Mylonas, *P.A.E.* (1953), 80, figures 5–7. Well illustrated by Buchholz and Karageorghis, 49, no. 459.

148. Boardman, *Gems*, 382.

149. Tsountas, *Revue Archéologique* (1900), II, 13; A. Furtwängler, *Die Antiken Gemmen* (Leipzig and Berlin, 1900), III, 31; Biesantz, *op. cit.* (Note 111).

150. V. E. G. Kenna, *J.H.S.*, LXXXI (1961), 103, note 37; Boardman, *Gems*, 62 f., 398.

151. A. J. Evans, *The Prehistoric Tombs of Knossos* (London, 1906), 154 f., figure 138; *P.M.*, IV, 562 f., figure 530.

CHAPTER 11

233. 1. A. Furumark, *The Mycenaean Pottery* (Stockholm, 1941), 112 ff.

234. 2. F. Matz, *Die Frühkretischen Siegel* (Berlin and Leipzig, 1928). Elaborated and modified in his *Torsion: eine formendkundliche Untersuchung zur ägäischen Vorgeschichte* (Mainz, 1951). For a sympathetic outline of Matz's theories in English see H. Groenewegen-Frankfort, *Arrest and Movement* (London, 1951), 191 ff. Also R. W. Hutchinson, *Prehistoric Crete* (Harmondsworth, 1962), 126 ff.

3. G. Kaschnitz-Weinberg, 'Zur Herkunft der Spirale in der Ägäis', *Prähistorische Zeitschrift*, XXXIV/V (1949/50), I, 193–215; V. Milojčić, 'Zur Frage der Herkunft des Mäanders und der Spirale bei der Bandkeramik Mitteleuropas', *Jahrbuch des Römisch-Germanischen Zentralmuseums Mainz*, XI (1964), 57–74; F. Matz, 'Zur Frühgeschichte der Spirale', *Mélanges Mansel* (Ankara, 1974), 171–83.

4. Cf. *P.M.*, IV, 110.

5. F. Matz, *Crete and Early Greece* (London, 1962), 49; S. Alexiou, *Minoan Civilization* (Herakleion, 1969), 19.

6. S. S. Weinberg, *Cambridge Ancient History*[3], I, part 1, 604 f.

7. Rodenwaldt, *Tiryns*, II, 195.

235. 8. For the contrast between Cretan and Egyptian butterflies see Evans, *P.M.*, II, 787; plants, D. G. Hogarth, *J.H.S.*, XXII (1902), 336 f.; animals, Hutchinson, *op. cit.*, 131 f.

9. S. Reinach, 'La représentation du galop dans l'art ancien et moderne', *Revue Archéologique* (1900), I, 216–51 (reprinted as a book with additions, Paris, 1925); Evans, *P.M.*, I, 713 ff.; H. J. Kantor, *The Aegean and the Orient in the Second Millennium B.C.* (Bloomington, Indiana, 1947), 106 f. and *passim*; Vermeule, *G.B.A.*, 93 f.; F. Schachermeyr, *Ägäis und Orient* (Vienna, 1967), 44 f.

10. Cf. Hood, *The Minoans*, 31.

11. Cf. O. Walter, 'Studie über ein Blumenmotiv als Beitrag zur Frage der kretisch-mykenischen Perspektive', *Jahreshefte des Österreichischen archäologischen Instituts*, XXXVIII (1950), 17-41.
236. 12. E.g. G. A. S. Snijder, *Kretische Kunst* (Berlin, 1936), 3 f., and despite Sir William Richmond in *P.M.*, II, 783; III, 506 f.

13. K. Müller, *J.d.I.*, XXX (1915), 265; Snijder, *op. cit.*, 42.

14. Cf. V. Müller, 'Die kretische Raumdarstellung', *J.d.I.*, XL (1925), 85-120.

15. Evans, *P.M.*, II, 361 f.

16. Smith, *Interconnections*, 46.

17. A. Parrot, *Mari*, II, *Le Palais: Peintures murales* (Paris, 1958), 109, considers the paintings of Alalakh VII at Atchana as being partly inspired by those of Crete, as well as by those of Mari, which themselves have little in common with Cretan ones.

237. 18. Cf. W. Culican, *The First Merchant Venturers* (London, 1966), 30.

19. G. Dossin, *Syria*, XX (1939), 111 f.

20. Cf. Matz, *op. cit.* (Note 5), 113.

21. Maria C. Shaw, 'Ceiling Patterns from the Tomb of Hepzefa', *A.J.A.*, LXXIV (1970), 25-30; W. S. Smith, *Art and Architecture of Ancient Egypt* (Harmondsworth, 1965), 116 f.

22. H. Frankfort, *The Mural Painting of El-Amarneh* (London, 1929). Cf. Evans, *P.M.*, III, 168, and IV, 748; Smith, *Interconnections*, 154 f.; P. Demargne, *Aegean Art* (London, 1964), 264.

23. M. Wegner, *Mitt. des deutschen Instituts für ägyptische Altertumskunde in Kairo*, IV (1933), 157 f.; cf. G. A. S. Snijder, *A.A.* (1934), 318.

24. See the sensible remarks by J. Vercoutter, *Essai sur les relations entre Égyptiens et Préhellènes* (Paris, 1954), 155 f.

25. F. W. von Bissing, *Der Fussboden aus dem Palaste Königs Amenophis IV. zu el Hawata* (Munich, 1941), 33 ff.

26. H. B. Hawes, in *Gournia* (Philadelphia, 1908), 6, note 92, suggested that the dispersion of Cretan artists after the downfall of Knossos might have been responsible for signs of Aegean influence on the art of Amarna.

27. Smith, *Interconnections*, 31; *The Assyrian Dictionary*, IV, 350, under ēṣiru.

28. F. Matz, 'Zu den Sphingen vom Yerkapu in Bogazköy', *Marburger Winckelmann-Programm* (1957), 1-6; cf. *idem, op. cit.* (Note 5), 222.

29. J. Boardman, *Greek Gems and Finger Rings* (London, 1970), 64 f.

30. Smith, *Interconnections*, 46, 91; H. L. Ginsberg, in J. B. Pritchard, *Ancient Near Eastern Texts*[2] (Princeton, 1955), 138.

31. L. Woolley, *Alalakh* (Oxford, 1955), 191, 294 f. But Warren, *M.S.V.*, 55 f., 133 f., suggests that the stone is native to Crete.

32. Smith, *Interconnections*, 55 f.

33. *Ibid.*, 32. Cf. H. Seyrig, 'Note sur le trésor de Tôd', *Syria*, XXXI (1954), 218-24, on the way in which valuable objects travel long distances from the places where they were made.

34. *Syria*, XX (1939), 111 f.

35. Kantor, *op. cit.* (Note 9), 63 ff.; Smith, *op. cit.* (Note 21), 126, and *Interconnections*, 29, 77, 155, 157, figure 37; *P.M.*, I, 714 f.

238. 36. E. Naville, 'Une boite de style mycénien trouvée en Égypte', *Revue Archéologique*, XXXIII (1898), II, 1-11; Schachermeyr, *op. cit.* (Note 9), 52 ff., figures 172-9; Kantor, *op. cit.*, 84.

37. E.g. M. P. Nilsson, *Homer and Mycenae* (London, 1933), 81 f., opposed by Evans, *P.M.*, IV, 613.

38. F. Matz, *Cambridge Ancient History*[3], II, part 1, 570.

239. 39. Snijder, *op. cit.* (Note 12), and *A.A.* (1934), 315-38. Cf. Hutchinson, *op. cit.* (Note 2), 129 ff., for a sympathetic and understanding exposition of his views.

40. H. Biesantz, *Kretisch-mykenische Siegelbilder* (Marburg, 1954).

240. 41. P. Demargne, *La Crète dédalique* (Paris, 1947), 53, compares the relationship between the Mycenaean *koine* and Cretan civilization with that between Hellenistic and Attic.

42. Cf. F. Schachermeyr, *Die ältesten Kulturen Griechenlands* (Stuttgart, 1955), 268 ff.

43. Cf. A. Dessenne, *Le Sphinx* (Paris, 1957), 188.

44. Cf. A. J. B. Wace, 'Middle and Late Helladic Pottery', in *Epitimvion Christou Tsounta* (Athens, 1941), 345-50.

241. 45. Smith, *Interconnections*, 178 f., 185; Demargne, *op. cit.* (Note 41).

46. Schachermeyr, *op. cit.*, 214 ff., has a sober discussion of this. Snijder, *op. cit.* (Note 12), 16 ff., for references to earlier literature.

47. J. D. Beazley and B. Ashmole, *Greek Sculpture and Painting* (Cambridge, 1966), 5.

48. E.g. E. J. Forsdyke, *Proceedings of the British Academy*, XV (1929), 71 f.; Demargne, *op. cit.* (Note 41), and *idem, op. cit.* (Note 22), 271.

49. Cf. Higgins, *Min. Myc. Art*, 190.

BIBLIOGRAPHY

I. BACKGROUND

A. ENVIRONMENT

BUTZER, K. W. 'Physical Conditions in Eastern Europe, Western Asia and Egypt before the Period of Agricultural and Urban Settlement', *Cambridge Ancient History*, 3rd ed., I, part I, chapter 11. Cambridge, 1970.

B. NEOLITHIC

WEINBERG, S. S. 'The Stone Age in the Aegean', *Cambridge Ancient History*, 3rd ed., I, part I, chapter x, with bibliography pp. 664–72. Cambridge, 1970.

C. GENERAL

Archaeologia Homerica, in separate fascicles by different authors, in publication at Göttingen, 1967 onwards.

CASKEY, J. L. 'Greece, Crete, and the Aegean Islands in the Early Bronze Age', *Cambridge Ancient History*,

3rd ed., I, part 2, chapter XXVI(*a*), with bibliography pp. 982–8. Cambridge, 1971.

CASKEY, J. L. 'Greece and the Aegean Islands in the Middle Bronze Age', *Cambridge Ancient History*, 3rd ed., II, part I, chapter IV(*a*), with bibliography pp. 732–8. Cambridge, 1973.

HAWKES, J. *Dawn of the Gods*. London, 1968.
Some very fine pictures.

HIGGINS, R. *The Greek Bronze Age*. London, British Museum, 1970.

HOOD, S. *The Home of the Heroes. The Aegean before the Greeks*. London, 1967.

Istoria tou Ellinikou Ethnous, vol. A. Athens, 1970. Now available in English as *History of the Hellenic World : Prehistory and Protohistory* (ed. G. Phylactopoulos, translation directed by P. Sherrard). Athens, 1974.
In modern Greek by various authors. Very fine illustrations, all in colour.

LORIMER, H. L. *Homer and the Monuments*. London, 1950.

LUCAS, A. *Ancient Egyptian Materials and Industries*. 4th ed., revised and enlarged by J. R. Harris. London, 1962.

D. CRETE

1. General

ALEXIOU, S. *Minoan Civilization*. Herakleion, 1969.

ALEXIOU, S., PLATON, N., and GUANELLA, H. *Ancient Crete*. London, 1968.

BRANIGAN, K. *The Foundations of Palatial Crete*. London, 1969.
Covers the earlier part of the Bronze Age.

BRANIGAN, K. *The Tombs of Mesara*. Letchworth, 1970.
For early circular tombs in Crete.

EVANS, A. *The Palace of Minos at Knossos*, I–IV and index. London, 1921–36, reprinted 1964.

GRAHAM, J. W. *The Palaces of Crete*. Princeton, 1962.
For architecture.

HOOD, S. *The Minoans. Crete in the Bronze Age*. London, 1971.
A short introduction.

HUTCHINSON, R. W. *Prehistoric Crete*. Harmondsworth, 1962.
An excellent comprehensive survey.

KARO, G. *Greifen am Thron. Erinnerungen am Knossos*. Baden-Baden, 1959.
With an eye-witness account of early work at Knossos.

MATZ, F. 'The Maturity of Minoan Civilization' and 'The Zenith of Minoan Civilization', *Cambridge Ancient History*, 3rd ed., II, part I, chapters IV(*b*) and XII, with bibliographies pp. 738–40, 799–801. Cambridge, 1973.

PENDLEBURY, J. D. S. *The Archaeology of Crete*. London, 1939, reprinted, New York, 1963.
Still useful.

PERNIER, L., and BANTI, L. *Guida degli scavi italiani in Creta*. Rome, 1947.

SCHACHERMEYR, F. *Die minoische Kultur des alten Kreta*. Stuttgart, 1964.
Exhaustive and very well documented.

SHAW, J. W. *Minoan Architecture: Materials and Techniques*. Rome, 1973.

2. Sites

Gournia

HAWES, H. B. *Gournia, Vasiliki, and other Prehistoric Sites on the Isthmus of Hierapetra*. Philadelphia, 1908.

Knossos

EVANS, A. *The Palace of Minos at Knossos, passim*.

EVANS, A. *The Prehistoric Tombs of Knossos*. From *Archaeologia*, LIX. London, 1906.

EVANS, A. *The Tomb of the Double Axes and Associated Group*. From *Archaeologia*, LXV. London, 1914.

Reports in *B.S.A.* for excavations and studies since the Second World War.

Mallia

Études crétoises, I, Paris, 1928, and later volumes of the series, together with reports and studies in *B.C.H.*

Mirtos

WARREN, P. *Myrtos. An Early Bronze Age Settlement in Crete*. Oxford, 1972.

Mochlos

SEAGER, R. B. *Explorations in the Island of Mochlos*. Boston and New York, 1912.
For the cemeteries.

SEAGER, R. B. *A.J.A.*, XIII (1909), 273–303.
For the town.

Palaikastro (in chronological order)

BOSANQUET, R. C., and DAWKINS, R. M. *The Unpublished Objects from the Palaikastro Excavations 1902–1906* (British School at Athens Supplementary Paper no. 1). London, 1923.
With references to excavation reports in *B.S.A.*, VIII–XII. *B.S.A.*, XL (1939–40), 38–50, for other unpublished finds.

SACKETT, L. H., and POPHAM, M. *B.S.A.*, LX (1965), 248–315; LXV (1970), 203–42, for new excavations in 1962–3.

Phaistos

PERNIER, L. *Il palazzo minoico di Festòs*, I, Gli strati piu antichi e il Primo Palazzo. Rome, 1935.

PERNIER, L., and BANTI, L. *Il palazzo minoico di Festòs*, II, Il Secondo Palazzo. Rome, 1951.

LEVI, D. *The Recent Excavations at Phaistos* (Studies in Mediterranean Archaeology, XI), Lund, 1964, and reports in *Annuario* or *Bollettino d' Arte*, 1950–62.

Pseira

SEAGER, R. B. *Excavations on the Island of Pseira* (University of Pennsylvania Museum Anthropological Publications, III, no. 1). Philadelphia, 1910.

Sklavokampos

MARINATOS, S. *A.E.* (1939–41), 69–96.

Tylissos

HAZZIDAKIS, J. *A.E.* (1912), 197–233.
HAZZIDAKIS, J. *Tylissos à l'époque minoenne*. Paris, 1921.
HAZZIDAKIS, J. *Les villas minoennes de Tylissos* (Études crétoises, III). Paris, 1934.

Zakro

HOGARTH, D. G. *B.S.A.*, VII (1900–1), 121–49.
PLATON, N. *Zakros: The discovery of a lost palace of ancient Crete*. New York, 1971.

3. Final Destruction of the Palace at Knossos

HOOD, S. *The Minoans*, 149 f. and bibliography p. 166. Add:
PALMER, L. R. 'Mycenaean Inscribed Vases', *Kadmos*, X (1971), 70–86; XI (1972), 27–46; XII (1973), 60–75.
POPHAM, M. R. *The Destruction of the Palace at Knossos* (Studies in Mediterranean Archaeology, XII). Göteborg, 1970.
RAISON, J. *Les vases à inscriptions peintes de l'âge mycénien et leur contexte archéologique*. Rome, 1968.
Has important bearings on the problem.

E. THE CYCLADES

1. General

RENFREW, C. *The Emergence of Civilisation. The Cyclades and the Aegean in the Third Millennium B.C.* London, 1972.
With extensive bibliography.

2. Sites

Akrotiri (on Thera)

MARINATOS, S. *Excavations at Thera*, I–VI. Athens, 1968–72.
Annual reports, richly illustrated, of work in the Akrotiri settlement from 1967 onwards.

Ayia Irini and Kefala (on Kea)

CASKEY, J. L. 'Keos Excavations: Preliminary Reports', *Hesperia*, XXXI (1962), 263–83; XXXIII (1964), 314–45; XXXV (1966), 363–76; XL (1971), 359–96; XLI (1972), 357–401.

Chalandriani (on Syros) (in chronological order)

TSOUNTAS, C. *A.E.* (1899), 73–134.
BOSSERT, E.-M. FISCHER. 'Kastri auf Syros', *A. Delt.*, XXII. 1 (1967), 53–76.

Phylakopi (on Melos)

Excavations at Phylakopi in Melos, conducted by the British School at Athens (The Society for the Promotion of Hellenic Studies Supplementary Paper no. 4). London, 1904.
Still basic.

Saliagos (between Paros and Antiparos)

EVANS, J. D., and RENFREW, C. *Excavations at Saliagos near Antiparos*. London, 1968.

F. THE MAINLAND

1. General

MYLONAS, G. E. *Mycenae and the Mycenaean Age*. Princeton, 1966.
SIMPSON, R. HOPE. *A Gazetteer and Atlas of Mycenaean Sites*. London, 1965.
STAÏS, V. *Guide illustré du Musée National d'Athènes*, II, *Collection mycénienne*. 2nd ed. Athens, 1915.
TAYLOUR, LORD W. *The Mycenaeans*. London, 1964.
TSOUNTAS, C., and MANATT, J. I. *The Mycenaean Age: A Study of the Monuments and Culture of pre-Homeric Greece*. London, 1903.
VERMEULE, E. *Greece in the Bronze Age*. Chicago, 1964.
The best study, with very full bibliographies.

2. Sites

Asine

FRÖDIN, O., and PERSSON, A. W. *Asine, Results of the Swedish Excavations 1922–1930*. Stockholm, 1938.

Ayios Kosmas

MYLONAS, G. *Aghios Kosmas, an Early Bronze Age Settlement and Cemetery in Attica*. Princeton University Press, 1959.

Dendra

PERSSON, A. W. *The Royal Tombs at Dendra near Midea*. Lund, London, Oxford University Press, Paris, Leipzig, 1931.

PERSSON, A. W. *New Tombs at Dendra near Midea.* Lund, Leipzig, London, Oxford University Press, 1942.

Dhimini and Sesklo

TSOUNTAS, C. *Ai Proïstorikai Akropoleis Diminiou kai Sesklou.* Athens, 1908.

Eutresis

GOLDMAN, H. *Excavations at Eutresis in Boeotia.* Cambridge, Mass., Harvard University Press, 1931.

Korakou

BLEGEN, C. W. *Korakou, a Prehistoric Settlement near Corinth.* Boston and New York, 1921.

Mycenae

KARO, G. *Die Schachtgräber von Mykenai.* Munich, 1930.

MYLONAS, G. E. *Ancient Mycenae, the Capital City of Agamemnon.* London, 1957.

MYLONAS, G. E. *O Tafikos Kiklos B ton Mikinon.* Athens, 1973.

WACE, A. J. B. *Mycenae, an Archaeological History and Guide.* Princeton University Press, 1949.

Orchomenos

BULLE, H. *Orchomenos,* I, *Die älteren Ansiedlungsschichten.* Munich, 1907.

KUNZE, E. *Orchomenos,* II, *Die neolithische Keramik*; III, *Die Keramik der frühen Bronzezeit.* Munich, 1931, 1934.

Perati

IAKOVIDIS, E. *Perati.* 2 vols. Athens, 1970.

Pylos

The Palace of Nestor at Pylos in Western Messenia. Vol. I, *The Buildings and Their Contents,* by C. W. Blegen and M. Rawson. Vol. II, *The Frescoes,* by M. L. Lang. Vol. III, *Acropolis and Lower Town,* by C. W. Blegen and others. Princeton University Press, 1966, 1969, 1973.

Tiryns

Tiryns, I–VII (1912–74).

Zygouries

BLEGEN, C. W. *Zygouries, a Prehistoric Settlement in the Valley of Cleonae.* Cambridge, Mass., Harvard University Press, 1928.

G. END OF THE BRONZE AGE IN THE AEGEAN

ÅLIN, P. *Das Ende der mykenischen Fundstätten auf dem griechischen Festland* (Studies in Mediterranean Archaeology, I). Lund, 1962.

CARPENTER, R. *Discontinuity in Greek Civilization.* Cambridge, 1966.

DESBOROUGH, V. R. D'A. *The Last Mycenaeans and their Successors.* Oxford, 1964.

DESBOROUGH, V. R. D'A. *The Greek Dark Ages.* London, 1972.

SNODGRASS, A. M. *The Dark Age of Greece.* Edinburgh, 1971.

II. ART

A. GENERAL

ADAM, S. *The Technique of Greek Sculpture.* London, 1966.

BANTI, L. 'Il sentimento della natura nell'arte minoica e micenea', in *Geras A. Keramopoullou,* 119–27. Athens, 1953.

BANTI, L., CARATELLI, G. P., and LEVI, D. 'Arte minoica e micenea', in *Enciclopedia dell'arte antica, classica e orientale,* V, 42–102. Rome, 1963.

BOARDMAN, J. *Pre-Classical: From Crete to Archaic Greece.* Harmondsworth, 1967.

BORDA, M. *Arte cretese-micenea nel museo Pigorini di Roma.* Rome, 1946.

BOSSERT, H. T. *The Art of Ancient Crete from the Earliest Times to the Iron Age.* London, 1937.
A corpus of pictures which is still useful.

BUCHHOLZ, H.-G., and KARAGEORGHIS, V. *Prehistoric Greece and Cyprus.* London, 1973.
An up-to-date and comprehensive corpus of pictures with very full references.

CASSON, S. *The Technique of Early Greek Sculpture.* Oxford, 1933.

CHARBONNEAUX, J. *L'art égéen.* Paris, 1929.

DEMARGNE, P. *La Crète dédalique.* Paris, 1947.
Important for the end of the Bronze Age, and for the relationship of Minoan art to Mycenaean, and of both to later Greek art.

DEMARGNE, P. *Aegean Art, the Origins of Greek Art.* London, 1964.
Very well illustrated.

DOUMAS, C. *The N. P. Goulandris Collection of Early Cycladic Art.* Athens, 1968.

EVANS, A. J. *The Palace of Minos at Knossos,* 4 vols., passim.

FORSDYKE, E. J. 'Minoan Art', *Proceedings of the British Academy,* XV (1929), 45–72.
An outstandingly good short survey.

GOMBRICH, E. H. *Art and Illusion.* 4th ed. London, 1972.

GROENEWEGEN-FRANKFORT, H. A. *Arrest and Movement*. London, 1951.
Acute and eloquent about Minoan and Mycenaean art, and the contrast between them and the arts of contemporary Egypt and Mesopotamia.

GROENEWEGEN-FRANKFORT, H. A., and ASHMOLE, B. *Art of the Ancient World*, chapter 3. New York, 1972.

HALL, E. H. *The Decorative Art of Crete in the Bronze Age*. Philadelphia, 1907.

HIGGINS, R. *Minoan and Mycenaean Art*. London, 1967.
An excellent introduction. Especially good on jewellery.

KAISER, B. *Untersuchungen zum minoischen Relief*. Bonn, 1976.
This important study appeared too late to be considered.

KARDARA, C. P. 'The Roots of Hellenic Art History', *A.A.A.*, IV (1971), 444–57.

KARO, G. 'Kreta und die Anfänge hellenischer Kunst', *A.A.* (1922), 135–8.

LAVIOSA, C. 'Una Forma minoica per fusione a cera perduta', *Annuario*, XLV–XLVI (N.S. XXIX–XXX) (1967–8), 499–510.

LEVI, D. 'Continuità della tradizione micena nell'arte greca arcaica', *C.I.M.*, I (1967), 185–212.

MARINATOS, S., and HIRMER, M. *Crete and Mycenae*. London, 1960.
Very good pictures of most of the important monuments.

MARINATOS, S., and HIRMER, M. *Kreta, Thera und das mykenische Hellas*. Munich, 1973.
New German edition of the above expanded to include the discoveries from Akrotiri on Thera.

MATZ, F. *Die frühkretischen Siegel*. Berlin and Leipzig, 1928.
Aesthetic theories, developed and modified in the following work.

MATZ, F. *Torsion: eine formendkundliche Untersuchung zür ägäischen Vorgeschichte*. Mainz, 1951.

MATZ, F. 'Die kretisch-mykenische Kunst', *Die Antike*, XI (1935), 170–210.

MATZ, F. *Crete and Early Greece*. London, 1962.
Sound, and important for German aesthetic theories, with good colour illustrations.

MÜLLER, K. 'Frühmykenische Reliefs aus Kreta und vom griechischen Festland', *J.d.I.*, XXX (1915), 242–336.
Still valuable.

MÜLLER, V. 'Kretisch-mykenische Studien I. Die kretische Raumdarstellung', *J.d.I.*, XL (1925), 85–120.

PERROT, G., and CHIPIEZ, C. *History of Art in Primitive Greece. Mycenian Art*. 2 vols. London, 1894.

REINACH, S. 'La représentation du galop dans l'art ancien et moderne', *Revue archéologique* (1900), I, 216–51. Reprinted as a book with additions, Paris, 1925.

SCHACHERMEYR, F. 'Die Szenenkomposition der minoischen Bildkunst', *K.Ch.* (1961–2), I, 177–85.

SNIJDER, G. A. S. *Kretische Kunst, Versuch einer Deutung*. Berlin, 1936.
Still valuable, with very full references to the older literature for Mycenaean as well as Minoan art.

VERMEULE, E. T. *The Art of the Shaft Graves of Mycenae* (Lectures in Memory of Louise Taft Semple). Cincinnati, 1975.
An important study published too late to be considered in detail.

WALTER, O. 'Studie über ein Blumenmotiv als Beitrag zur Frage der kretisch-mykenischen Perspektive', *Jahreshefte des Österreichischen archäologischen Instituts*, XXXVIII (1950), 17–41.

WASER, O. 'Das Formprinzip der kretisch-mykenischen Kunst', *A.A.* (1925), 253–62.

ZERVOS, C. *L'art de la Crète néolithique et minoenne*. Paris, 1956.
Corpus of large pictures.

ZERVOS, C. *L'art des Cyclades du début à la fin de l'âge du bronze, 2500–1100 avant notre ère*. Paris, 1957.

ZERVOS, C. *Naissance de la civilisation en Grèce*. 2 vols. Paris, 1962–3.

B. SPECIAL ASPECTS

1. Relations between the Aegean and the Near East

KANTOR, H. J. *The Aegean and the Orient in the Second Millennium B.C.* (The Archaeological Institute of America Monograph no. 1). Bloomington, Indiana, 1947.

MATZ, F. 'Zu den Sphingen vom Yerkapu in Bogazköy', *Marburger Winckelmann-Programm* (1957), 1–6.

SCHACHERMEYR, F. *Ägäis und Orient. Die überseeischen Kulturbeziehungen von Kreta und Mykenai mit Ägypten, der Levante und Kleinasien unter besonderer Berücksichtigung des 2. Jahrtausends v. Chr.* Vienna, 1967.

SHAW, M. C. 'Ceiling Patterns from the Tomb of Hepzefa', *A.J.A.*, LXXIV (1970), 25–30.

SMITH, W. S. *Interconnections in the Ancient Near East. A Study of the Relationships between the Arts of Egypt, the Aegean, and Western Asia*. New Haven and London, 1965.
Very important and suggestive.

VERCOUTTER, J. *Essai sur les relations entre Égyptiens et Préhellènes*. Paris, 1954.

VERCOUTTER, J. *L'Égypte et le monde égéen préhellénique*. Cairo, 1956.

2. Monsters

Dragons (in chronological order)

LEVI, D. 'The Dragon of Babylon in Crete?', *A.J.A.*, XLIX (1945), 270–80.

GILL, M. A. V. 'The Minoan Dragon', *London Institute of Classical Studies Bulletin*, X (1963), 1–12.

Genii

GILL, M. A. V. 'The Minoan Genius', *Ath. Mitt.*, LXXIX (1964), 1–21.

GILL, M. A. V. 'Apropos the Minoan "Genius"', *A.J.A.*, LXXIV (1970), 404–6.

Griffins (in chronological order)

FRANKFORT, H. 'Notes on the Cretan Griffin', *B.S.A.*, XXXVII (1936–7), 106–22.

DESSENNE, A. 'Le Griffon créto-mycénien: inventaire et remarques', *B.C.H.*, LXXXI (1957), 203–15.

LEVI, D. *Annuario*, XIX–XX (1957–8), 122 f. Tipo 243–5.

Sphinxes

DESSENNE, A. *Le Sphinx*. Paris, 1957.

3. Spirals

KASCHNITZ-WEINBERG, G. 'Zur Herkunft der Spirale in der Ägäis', *Prähistorische Zeitschrift*, XXXIV/XXV (1949/50), I, 193–215.

MILOJČIĆ, V. 'Zur Frage der Herkunft des Mäanders und der Spirale bei der Bandkeramik Mitteleuropas', *Jahrbuch des Römisch-Germanischen Zentralmuseums Mainz*, XI (1964), 57–74.

III. BIBLIOGRAPHY BY CHAPTERS

CHAPTER 2: POTTERY

1. General

FORSDYKE, E. J. *Catalogue of the Greek and Etruscan Vases in the British Museum*, I, part 1, *Prehistoric Aegean Pottery*. London, 1925.
 Still valuable.

HIGGINS, R. *Minoan and Mycenaean Art*. London, 1967.
 Good summaries by periods.

LACY, A. D. *Greek Pottery in the Bronze Age*. London, 1967.
 The only comprehensive account. Useful, although amateurish and discursive.

MARINATOS, S. 'New Advances in the Field of Ancient Pottery Technique', *A.A.A.*, V (1972), 293–7.

SCOTT, L. 'Pottery', in C. Singer, *A History of Technology*, corrected ed., I, 376–412. Oxford, 1965.
 Excellent for the background.

2. Neolithic

WEINBERG, S. S. 'The Stone Age in the Aegean', in *Cambridge Ancient History*, 3rd ed., I, part 1, chapter X, 557–618, with bibliography 664–72. Cambridge, 1970. Add to this:

LEVI, D. 'Le varietà della primitiva ceramica cretese', in *Studi in onore di Luisa Banti*, 223–39. Rome, 1965.

EVANS, J. D., and RENFREW, C. *Excavations at Saliagos near Antiparos*. London, 1968.

HAUPTMANN, H., and MILOJČIĆ, V. *Frühe Dimini-Zeit aus der Arapi-magula*. Bonn, 1969.

MILOJCIC VON ZUMBUSCH, J., and MILOJCIC, V. *Otzaki-Magula*, I. Bonn, 1971.

3. Crete

EVANS, J., and EVANS, SIR A. *Index to the Palace of Minos*, 118 ff., s.v. Pottery. London, 1936.

BRANIGAN, K. *The Tombs of Mesara*, 56 ff. London, 1970.

GROENEWEGEN-FRANKFORT, H. *Arrest and Movement*, 193 ff. London, 1951.
 A fine analysis of Middle and Late Minoan vase decoration.

POPHAM, M. R. 'Some Late Minoan III Pottery from Crete', *B.S.A.*, LX (1965), 316–42.

POPHAM, M. R. 'Late Minoan Pottery, A Summary', *B.S.A.*, LXII (1967), 337–51.

POPHAM, M. R. 'The Late Minoan Goblet and Kylix', *B.S.A.*, LXIV (1969), 299–304.

POPHAM, M. R. 'Late Minoan IIIB Pottery from Knossos', *B.S.A.*, LXV (1970), 195–202.

ZOIS, A. 'Faistiaka', *A.E.* (1965), 27–109.

ZOIS, A. 'Erevna peri tis minoikis kerameikis', *Epetiris epistimonikon erevnon tou Panepistimiou Athinon* (1967), 703–32.

ZOIS, A. 'Iparkhei P. M. III epokhi?', in *Acts of the Second Cretological Congress*, I, 141–56. Athens, 1968.

ZOIS, A. *Der Kamares-Stil, Werden und Wesen*. Tübingen, 1968.

ZOIS, A. 'Erevnai peri tis minoikis kerameikis', *A.A.A.*, I (1968), 172–4.

ZOIS, A. *Provlimata khronologias tis minoikis kerameikis: Gournes, Tylissos, Malia*. Athens, 1969.

4. The Cyclades

Excavations at Phylakopi in Melos (The Society for the Promotion of Hellenic Studies Supplementary Paper no. 4), 80 ff. London, 1904.

CASKEY, J. L. 'Investigations in Keos Part ii: A Conspectus of the Pottery', *Hesperia*, XLI (1972), 357–401.

5. The Mainland

BUCK, R. J. 'Middle Helladic Mattpainted Pottery', *Hesperia*, XXXIII (1964), 231–313.

FRENCH, E. Articles on Mycenaean Pottery from Mycenae, in *B.S.A.*, LVIII (1963), 44 ff.; LIX (1964), 241 ff.; LX (1965), 159 ff.; LXI (1966), 216 ff.; LXII (1967), 149 ff.; LXIV (1969), 71 ff.

FURUMARK, A. *The Mycenaean Pottery, Analysis and Classification.* Stockholm, 1941.

FURUMARK, A. *The Chronology of Mycenaean Pottery.* Stockholm, 1941.

FURUMARK, A. 'The Mycenaean IIIc Pottery and its Relation to Cypriote Fabrics', *Opuscula Archaeologica*, III (1944), 194–265.

SLENCZKA, E. *Tiryns*, VII, *Figürlich bemalte mykenische Keramik aus Tiryns.* Mainz, 1974.

WACE, A. J. B., and BLEGEN, C. W. 'The Pre-Mycenaean Pottery of the Mainland', *B.S.A.*, XXII (1916–18), 175–89.

CHAPTER 3: PAINTING

1. General

EVANS, A. *The Palace of Minos at Knossos, passim.*

FRANKFORT, H. *The Mural Painting of El-Amarneh.* London, 1929.

ROBERTSON, M. *Greek Painting*, 19–33. Geneva, 1959.

SWINDLER, M. H. *Ancient Painting*, chapter IV. London, 1929.

2. Crete

ALEXIOU, S. 'Neue Wagendarstellungen aus Kreta', *A.A.* (1964), 785–804.

ALEXIOU, S. 'Ostrakon me parastasin anthropinis morfis ek Knossou', in *Charistirion eis A. K. Orlandon*, II, 112–17. Athens, 1966.

CAMERON, M. A. S. 'An Addition to "La Parisienne"', *K. Ch.* (1964), 38–53.

CAMERON, M. A. S. 'Four Fragments of Wall Paintings with Linear A Inscriptions', *Kadmos*, IV (1965), 7–15.

CAMERON, M. A. S. 'Unpublished Fresco Fragments of a Chariot Composition from Knossos', *A.A.* (1967), 330–44.

CAMERON, M. A. S. 'Notes on some new Joins and Additions to well known Frescoes', in *Europa: Festschrift Ernst Grumach*, 45–74. Berlin, 1967.

CAMERON, M. A. S. 'Unpublished Paintings from the "House of the Frescoes" at Knossos', *B.S.A.*, LXIII (1968), 1–31.

CAMERON, M. A. S. 'New Restorations of Minoan Frescoes from Knossos', *London Myc. Seminar*, 3 June 1970, 360–4; *Institute of Classical Studies*

Bulletin, XVII (1970), 163–6.

CAMERON, M. A. S. 'The Lady in Red: a Complementary Figure to the Ladies in Blue', *Archaeology*, XXIV (1971), 35–43.

CAMERON, M. A. S. 'The Plasters', in P. Warren, *Myrtos*, 305–14. London, 1972.

EVANS, A. J. *Knossos Fresco Atlas*, with Catalogue of Plates by M. Cameron and S. Hood. Farnborough, Gregg Press, 1967.

FYFE, T. 'Painted Plaster Decoration at Knossos', *Journal of the Royal Institute of British Architects* (1902), 107–31.

GRAHAM, J. W. *The Palaces of Crete*, 199 ff. Princeton, 1962.

LEVI, D. 'The Sarcophagus of Hagia Triada Restored', *Archaeology*, IX (1956), 192–9.

MÖBIUS, M. 'Pflanzenbilder der minoischen Kunst in botanischer Betrachtung', *J.d.I.*, XLVIII (1933), 1–39.

PLATON, N. 'O Krokosillektis Pithikos', *K.Ch.* (1947), 505–24.

PLATON, N. 'Simvoli eis tin Spoudhin tis minoikis toichografias', *K.Ch.* (1959), 319–45.

RODENWALDT, G. 'Rekonstruktionen der Stuckreliefs aus Pseira', *A.A.* (1923/4), 267–76.

SCHIERING, W. 'Steine und Malerei in der minoische Kunst', *J.d.I.*, LXXV (1960), 17–36.

SCHIERING, W. 'Die Naturanschauung in der altkretischen Kunst', *Antike Kunst*, VIII (1965), 3–12.

SHAW, M. C. 'The Miniature Frescoes of Tylissos Reconsidered', *A.A.* (1972), 171–88.

3. The Cyclades

BOSANQUET, R. C. 'The Wall-Paintings', in *Excavations at Phylakopi in Melos*, 70–9. London, 1904.

MARINATOS, S. *Thera*, I–VI. Athens, 1968–74.

MARINATOS, S. 'Andron iroon theios stolos', *A.A.A.*, VI (1973), 289–92.

4. The Mainland

KRITSELI-PROVIDI, I. 'A Shield Fresco from Mycenae', *A.A.A.*, VI (1973), 176–81.

LAMB, W. 'Excavations at Mycenae. Frescoes from the Ramp House', *B.S.A.*, XXIV (1919–21), 189–99.

LAMB, W. 'Excavations at Mycenae. Palace Frescoes', *B.S.A.*, XXV (1921–3), 249–55.

LANG, M. L. *The Palace of Nestor*, II, *The Frescoes*. Princeton, 1969.

REUSCH, H. 'Ein Schildfresko aus Theben', *A.A.* (1953), 16–25.

REUSCH, H. 'Vorschlag zur Ordnung der Fragmente von Frauenfriesen aus Mykenai', *A.A.* (1953), 26–56.

REUSCH, H. *Die zeichnerische Rekonstruktion des Frauenfrieses im böotischen Theben.* Berlin, 1956.

RODENWALDT, G. *Tiryns*, II, *Die Fresken des Palastes*. Athens, 1912.

RODENWALDT, G. 'Mykenische Studien, I, Die Fussböden des Megarons von Mykenai', *J.d.I.*, XXXIV (1919), 87-106.

RODENWALDT, G. *Der Fries des Megarons von Mykenai*. Halle, 1921.

5. Technique (in chronological order)

HEATON, N. 'The Mural Paintings of Knossos: an Investigation into the Method of their Production', *Journal of the Royal Society of Arts*, LIII (1910), 206-13.

HEATON, N. 'Minoan Lime-Plaster and Fresco Painting', *Journal of the Royal Institute of British Architects*, XVIII (1911), 697-710.

HEATON, N., in *Tiryns*, II, 211-21.

SCHNEIDER-FRANKEN, J. A. 'Die Technik der Wandgemälde von Tiryns', *Ath. Mitt.*, XXXVIII (1913), 187-90.

Criticism of Heaton's view that the paintings were all true frescoes, with suggestive observations.

EVANS, A., in *P.M.*, I, 528 ff.

Repeats Heaton's view.

EIBNER, A. *Entwicklung und Werkstoffe der Wandmalerei*, 59 ff. Munich, 1926.

DUELL, P., and GETTENS, R. J. 'A Review of the Problem of Aegean Wall Painting', *Technical Studies in the Field of the Fine Arts*, X (1942), 178-223, an important paper, summarized in *A.J.A.*, XLVII (1943), 472-3.

LEVI, D. *Archaeology*, IX (1956), 196.

CAMERON, M. *Kadmos*, VII (1968), 56-8.

LANG, M., in *P. Nestor*, II, 10 ff.

MARINATOS, S. *A.A.A.*, V (1972), 297.

Brief but important observations based upon the frescoes from Thera.

SHAW, M. C. *A.A.* (1972), 182-3.

PROFI, S., WEIER, L., and FILIPPAKIS, S. E. 'X-Ray Analysis of Greek Bronze Age Pigments from Mycenae', *Studies in Conservation*, XIX (1974), 105-12.

CHAPTER 4: SCULPTURE

1. Neolithic Figurines

CASKEY, J. L., and ELIOT, M. 'A Neolithic Figurine from Lerna', *Hesperia*, XXV (1956), 175-7.

MILOJCIC VON ZUMBUSCH, J., and MILOJCIC, V. *Otzaki-magula*, I, part 1, 83 ff. Bonn, 1971.

UCKO, P. J. *Anthropomorphic Figurines*. Richmond, 1968.

WACE, A. J. B. 'Prehistoric Stone Figurines from the Mainland', *Hesperia Suppl.*, VIII (1949), 423-6.

WEINBERG, S. S. 'Neolithic Figurines and Aegean Interrelations', *A.J.A.*, LV (1951), 121-33.

2. Early Cycladic Figurines

BRANIGAN, K. 'Cycladic Figurines and their Derivatives in Crete', *B.S.A.*, LXVI (1971), 57-78.

CASKEY, J. L. 'Marble Figurines from Ayia Irini in Keos', *Hesperia*, XL (1971), 113-26.

DOUMAS, C. *The N. P. Goulandris Collection of Early Cycladic Art*. Athens, 1968.

ERLENMEYER, M.-L. and H. 'Von der frühen Bildkunst der Kykladen', *Antike Kunst*, VIII (1965), 59-71.

HÖCKMANN, O. 'Zu Formenschatz und Ursprung der schematischen Kykladenidole', *Berliner Jahrbuch für Vor- und Frühgeschichte*, VIII (1968), 45-75.

HOGARTH, D. G. 'Aegean Sepulchral Figurines', in *Essays in Aegean Archaeology Presented to Sir Arthur Evans*, 55-62. Oxford, 1927.

PREZIOSI, P. G., and WEINBERG, S. S. 'Evidence for Painted Details in Early Cycladic Sculpture', *Antike Kunst*, XIII (1970), 4-12.

PRYCE, F. N. *Catalogue of Sculpture in the Department of Greek and Roman Antiquities of the British Museum*, I, part 1, *Prehellenic and Early Greek*. London, 1928.

RENFREW, C. 'The Development and Chronology of the Early Cycladic Figurines', *A.J.A.*, LXXIII (1969), 1-32.

THIMME, J. 'Die religiöse Bedeutung der Kykladenidole', *Antike Kunst*, VIII (1969), 72-86.

TOULOUPA, E. *A.A.A.*, I (1968), 267-9.

ZAFIROPOULOU, F. 'Early Cycladic Finds from Ano Koufonisi', *A.A.A.*, III (1970), 48-51.

3. The Mycenae Shaft Grave Stelai

HEURTLEY, W. A. 'The Grave Stelai', *B.S.A.*, XXV (1921-3), 126-46.

MARINATOS, S. 'Peri tous neous vasilikous tafous ton Mikinon', in *Geras A. Keramopoullou*, 54-88. Athens, 1953.

MARINATOS, S. 'The Stelai of Circle B at Mycenae', *A.A.A.*, I (1968), 175-7.

MYLONAS, G. E. 'The Figured Mycenaean Stelai', *A.J.A.*, LV (1951), 134-47.

REICHEL, W. *Die mykenischen Grabstelen*. Vienna, 1893.

4. The Mycenae Lion Gate

ÅSTRÖM, P., and BLOMÉ, B. 'A Reconstruction of the Lion Relief at Mycenae', *Opuscula Atheniensia*, V (1964), 159-91.

With full references.

KARDARA, C. 'The Meaning of the Lion Gate Relief', *A.A.A.*, III (1970), 238-46.

MYLONAS, G. E. 'The Lion in Mycenaean Times', *A.A.A.*, III (1970), 421-5.

NOJORKAM. 'Le bas-relief de la Porte des Lionnes n'est pas mycénien', in *C.I.M.*, I (1967), 232-40.

PROTONOTARIOU-DEÏLAKI, E. 'Peri tis Pilis ton Mikinon', *A.E.* (1965), 7-25.

5. Clay Statues and Figurines

ALEXIOU, S. *I minoiki thea meth' ipsomenon cheiron*. Herakleion, 1958.
 In modern Greek.

BLEGEN, C. W. 'A Mycenaean Breadmaker', *Annuario*, VIII-IX (1946-8), 13-16.

CASKEY, J. L. *Hesperia*, XXXI (1962), 278-80; XXXIII (1964), 328-31; XXXV (1966), 369-71.
 For the Kea statues.

COOK, J. M. 'Pilino omoioma mikinaïkou foreiou', *K.Ch.* (1955), 152-4.

DIMAKOPOULOU, K. 'Mikinaïki Pilini Kefali', *A. Delt.*, XXV. I (1970), 174-83.

FRENCH, E. 'The Development of Mycenaean Terracotta Figurines', *B.S.A.*, LXVI (1971), 101-87.
 Classifies and lists the small figurines of the mainland with references.

HIGGINS, R. A. *Greek Terracottas*. London, 1967.
 A good introduction.

HOOD, S. 'A Mycenaean Cavalryman', *B.S.A.*, XLVIII (1953), 84-93.

IAKOVIDIS, S. E. 'A Mycenaean Mourning Custom', *A.J.A.*, LXX (1966), 43-50.

JONES, F. F. 'Three Mycenaean Figurines', in S. S. Weinberg (ed.), *The Aegean and the Near East, Studies Presented to Hetty Goldman*, 122-5. New York, 1956.

KARAGEORGHIS, V. 'Notes on some Centaurs from Crete', *K.Ch.* (1965), 50-4.

LAVIOSA, C. 'Sull'origine degli idoletti fittili micenei', *Annuario*, XLI-XLII (1963-4), 7-24.

LAVIOSA, C. 'Origini minoiche della plastica micenea', in *Acts of the Second Cretological Congress*, I, 374-82. Athens, 1968.

LAVIOSA, C. 'Il Lord di Asine è una "Sfinge"?', *C.I.M.*, I (1967), 87-90.

LEVI, D. 'Immagini di culto minoiche', *La Parola del Passato*, LXVIII (1959), 377-91.

MARINATOS, S. 'Demeter Erinys in Mycenae', *A.A.A.*, VI (1973), 189-92.
 Argues that statues from the shrine at Mycenae (see under TAYLOUR below) are all female.

MYLONAS, G. E. 'Seated and Multiple Figurines in the National Museum of Athens, Greece', in S. S. Weinberg (ed.), *The Aegean and Near East, Studies Presented to Hetty Goldman*, 110-21. New York, 1956.

NICHOLLS, R. V. 'Greek Votive Statuettes and Religious Continuity, c. 1200-700 B.C.', in *Auckland Classical Essays Presented to E. M. Blaiklock*, 1-37.
 Auckland, New Zealand, 1970.
 An important article dealing with wheel-made figures.

TAYLOUR, LORD W. *Antiquity*, XLIII (1969), 91 ff.; XLIV (1970), 270 ff.
 Cf. the following.

TAYLOUR, LORD W. *A.A.A.*, III (1970), 72-80.
 Late Bronze Age wheel-made statues from a shrine at Mycenae.

TŽEDAKIS, Y. 'A Minoan "Goddess" Idol from Sakhtouria', *B.S.A.*, LXII (1967), 203-5.

6. Bronze Figurines

BOARDMAN, J. *The Cretan Collection in Oxford*, 6 ff. Oxford, 1961.

DAVARAS, K. 'Trois bronzes minoens de Skoteino', *B.C.H.*, XCIII (1969), 620-50.

EVANS, A. 'On a Minoan Bronze Group of a Galloping Bull and Acrobatic Figure from Crete', *J.H.S.*, XLI (1921), 247-59.

HOORN, G. VAN. 'Eine minoische Bronze in Leiden', *J.d.I.*, XXX (1915), 65-73.

LAMB, W. *Greek and Roman Bronzes*, 18 ff. London, 1928.

RAUBITSCHEK, I. K. 'The Stanford Adorant', *C.I.M.*, I (1967), 241-3.

CHAPTER 5: WOOD, SHELL, BONE, AND IVORY; FAIENCE AND GLASS

1. Wood

ALDRED, C. 'Fine Wood-Work', in C. Singer, *A History of Technology*, corrected ed., I, 684-703. Oxford, 1965.

NAVILLE, E. 'Une boîte de style mycénien trouvée en Égypte', *Revue archéologique*, XXXIII (1898), II, 1-11.

SCHWEITZER, B. 'Hunde auf dem Dach', *Ath. Mitt.*, LV (1930), 107-18.

2. Ivory

General

BARNETT, R. D. 'Phoenician and Syrian Ivory Carving', *Palestine Excavation Quarterly* (1939), 4-19.

BARNETT, R. D. 'Early Greek and Oriental Ivories', *J.H.S.*, LXVIII (1948), 1-25.

BARNETT, R. D. 'Fine Ivory-Work', in C. Singer, *A History of Technology*, corrected ed., I, 663-83. Oxford, 1965.

BUCHHOLZ, H.-G., and KARAGEORGHIS, V. *Prehistoric Greece and Cyprus*, 105 ff. London, 1973.
 With references.

DEMARGNE, P. *La Crète dédalique*, 188 ff. Paris, 1947.

LOUD, G. *The Megiddo Ivories*. Chicago, 1939.

SCHÄFER, J. 'Elfenbeinspiegelgriffe des zweiten Jahrtausends', *Ath. Mitt.*, LXXIII (1958), 73-87.

Crete

ALEXIOU, S. *Isterominoikoi Tafoi Limenos Knosou (Katsamba)*, 55 ff., 71 ff. Athens, 1967.
Ivory pyxis from Katsamba.

CASKEY, L. D. 'A Chryselephantine Statuette of the Cretan Snake Goddess', *A.J.A.*, XIX (1915), 237-49.

EVANS, A. *P.M.*, index s.v. Ivory, and *P.M.*, III, 415 ff., 428 ff.
For the Ivory Deposit below the latest floors of the Residential Quarter at Knossos.

SAKELLARAKIS, I. A. 'Elefantosta ek ton Arkhanon', *C.I.M.*, I (1967), 245-61.
For later ivories in Crete.

The Cyclades

GALLET DE SANTERRE, H., and TRÉHEUX, J. 'Dépôt égéen et géométrique de l'Artémision à Délos', *B.C.H.*, LXXI-LXXII (1947-8), 148-206.

The Mainland

HAUSSOULLIER, B. 'Catalogue descriptif des objets découverts à Spata', *B.C.H.*, II (1878), 204-18.

KANTOR, H. J. 'Syro-Palestinian Ivories', *Journal of Near Eastern Studies*, XV (1956), 153-74.

KANTOR, H. J. 'Ivory Carving in the Mycenaean Period', *Archaeology*, XIII (1960), 14-25.

SAKELLARAKIS, I. A. 'Elefantinon Ploion ek Mikinon', *A.E.* (1971), 188-233.

SPYROPOULOS, T. 'An Ivory Handle from Thebes', *A.A.A.*, III (1970), 268-73.

SYMEONOGLOU, S. *Kadmeia, I: Mycenaean Finds from Thebes, Greece, Excavations at 14 Oedipus St.* (Studies in Mediterranean Archaeology, XXXV). Göteborg, 1973.

VERMEULE, E. *Greece in the Bronze Age*, 218-21, 375. Chicago, 1964.
With references.

WACE, H. *Ivories from Mycenae No. i, 1939. The Ivory Trio.* Athens, n.d.

3. Faience

NOBLE, J. V. 'The Technique of Egyptian Faïence', *A.J.A.*, LXXIII (1969), 435-9.

STONE, J. F. S., and THOMAS, L. G. 'The Use and Distribution of Faience in the Ancient East and Prehistoric Europe', *Proceedings of the Prehistoric Society*, XXII (1956), 37-84.

4. Glass

FOSSING, P. *Glass Vessels before Glass-Blowing.* Copenhagen, 1940.

HAEVERNICK, T. E. 'Mycenaean Glass', *Archaeology*, XVI (1963), 190-3.

HAEVERNICK, T. E. 'Mykenisches Glas', *Jahrbuch des Römisch-Germanischen Zentralmuseums Mainz*, VII (1960), 36-53.

HAEVERNICK, T. E. 'Nuzi-Perlen', *Jahrbuch des Römisch-Germanischen Zentralmuseums Mainz*, XII (1965), 35-40.

HARDEN, D. B. *The Archaeological Journal*, CXXV (1968), 46-53.

HIGGINS, R. A. *Greek and Roman Jewellery.* London, 1961.

MARINATOS, S. *A. Delt.*, XI (1927-8), 81-7.

OPPENHEIM, A. L., BRILL, R. H., BARAG, D., and SALDERN, A. VON. *Glass and Glassmaking in Ancient Mesopotamia.* Corning, New York, 1970.

WEINBERG, G. 'Two Glass Vessels in the Heraclion Museum', *K.Ch.* (1961-2), I, 226-9.

CHAPTER 6: STONE VASES

1. General

MONEY-COUTTS, M. 'A Stone Bowl and Lid from Byblos', *Berytus*, III (1936), 129-36.

OELMANN, F. 'Das Kornspeichermodell von Melos', *Ath. Mitt.*, L (1925), 19-27.

WARREN, P. 'The First Minoan Stone Vases and Early Minoan Chronology', *K.Ch.* (1965), 7-43.

WARREN, P. 'Minoan Stone Vases as Evidence for Minoan Foreign Connexions in the Aegean Late Bronze Age', *Proceedings of the Prehistoric Society*, XXXIII (1967), 37-56.

WARREN, P. 'A Stone Vase-Maker's Workshop in the Palace at Knossos', *B.S.A.*, LXII (1967), 195-201.

WARREN, P. *Minoan Stone Vases.* Cambridge, 1969.
With full references.

2. Relief Vases

FORSDYKE, J. 'Minos of Crete', *Journal of the Warburg and Courtauld Institutes*, XV (1952), 13-19.

FORSDYKE, J. 'The "Harvester" Vase of Hagia Triada', *Journal of the Warburg and Courtauld Institutes*, XVII (1954), 1-9.

SAKELLARAKIS, J. 'Fragments of a Relief Stone Vase from Tiryns', *A.A.A.*, VI (1973), 158-63.

SAKELLARIOU, A. 'Scène de bataille sur un vase mycénien en pierre?', *Revue archéologique* (1971), 3-14.

CHAPTER 7: METAL VASES

1. General

CATLING, H. W. *Cypriot Bronzework in the Mycenaean World.* Oxford, 1964.

CHILDE, V. G. 'A Gold Vase of Early Helladic Type', *J.H.S.*, XLIV (1924), 163-5.

KARO, G. 'Minoische Rhyta', *J.d.I.*, XXVI (1911), 249-70.

KARO, G. *Die Schachtgräber von Mykenai.* Munich, 1930.

MARINATOS, S. 'Der "Nestorbecher" aus dem IV. Schachtgrab von Mykenae', in R. Lullies, *Neue Beiträge zur klassischen Altertumswissenschaft (Festschrift zum 60. Geburtstag von B. Schweitzer)*, 11–18. Stuttgart, 1954.

MARKIDES, M. 'A Mycenaean Bronze in the Cyprus Museum', *B.S.A.*, XVIII (1911–12), 95–7.

MARYON, H. 'Metal Working in the Ancient World', *A.J.A.*, LIII (1949), 93–125.

MARYON, H. *Metalwork and Enamelling.* 5th ed. New York, 1971.

MARYON, H., and PLENDERLEITH, H. J. 'Fine Metal-work', in C. Singer, *A History of Technology*, corrected ed., I, 623–62. Oxford, 1965.

PERSSON, A. W. *The Royal Tombs at Dendra near Midea.* Lund, 1931.

PERSSON, A. W. *New Tombs at Dendra near Midea.* Lund, 1942.

PICARD, C. 'De Midéa à Salamis de Chypre', in *Geras A. Keramopoullou*, 1–16. Athens, 1953.

PLENDERLEITH, H. J., in C. F. A. Schaeffer, *Enkomi-Alasia*, 381–9. Paris, 1952.

ROQUE, F. -B. DE LA, CONTENAU, G., and CHAPOUTHIER, F. *Le trésor de Tôd.* Cairo, 1953.

SAKELLARIOU, A. 'Un cratère d'argent avec scène de bataille provenant de la IVème tombe de Mycènes', *C.I.M.*, I (1967), 262–5.

SAKELLARIOU, A. 'Un cratère d'argent avec scène de bataille provenant de la IVe tombe de l'acropole de Mycènes', *Antike Kunst*, XVII (1974), 3–20.

STRONG, D. E. *Greek and Roman Gold and Silver Plate.* London, 1966.
An excellent introduction.

THOMAS, H. 'The Acropolis Treasure from Mycenae', *B.S.A.*, XXXIX (1938–9), 65–87.

WEINBERG, S. S. 'A Gold Sauceboat in the Israel Museum', *Antike Kunst*, XII (1969), 3–8.

2. The Mycenae Siege Rhyton (in chronological order)

STAIS, V. 'Das silberne Rhyton des vierten Grabes der Burg von Mykenai', *Ath. Mitt.*, XL (1915), 45–52, 112.

MARINATOS, S. 'Nea ermineia tou aryirou rhitou ton Mikinon', *A. Delt.*, X (1926), 78–90.

HOOKER, J. T. 'The Mycenae Siege Rhyton and the Question of Egyptian Influence', *A.J.A.*, LXXI (1967), 269–81.

MARINATOS, S. 'Les égéens et les îles gymnésiennes', *B.C.H.*, XCV (1971), 5–11.
Places the scene on the rhyton in the Balearic Islands.

3. The Vapheio Cups (in chronological order)

RIEGL, A. 'Zur kunsthistorischen Stellung der Becher von Vafio', *Jahreshefte des österreichischen archäologischen Instituts*, IX (1906), 1–19.

MÜLLER, K. *J.d.I.*, XXX (1915), 325–31.

SCHIERING, W. 'Die Goldbecher von Vaphio', *Antike Welt*, II (1970), part 4, 3–10.

DAVIS, E. N. 'The Vapheio Cups: One Minoan and One Mycenaean?', *The Art Bulletin* (1974), 472–87.

CHAPTER 8: ARMS

BRANIGAN, K. *Copper and Bronze Working in Early Bronze Age Crete* (Studies in Mediterranean Archaeology, XIX). Lund, 1968.

BRANIGAN, K. 'A Transitional Phase in Minoan Metallurgy', *B.S.A.*, LXIII (1968), 185–203.

BRANIGAN, K. *Aegean Metalwork of the Early and Middle Bronze Age.* Oxford, 1974.

CHAPOUTHIER, F. *Deux épées d'apparat découvertes en 1936 au palais de Mallia* (Études crétoises, V). Paris, 1938.

CHARBONNEAUX, J. 'Trois armes d'apparat du palais de Mallia (Crète)', *Monuments Piot*, XXVIII (1925–6), 1–18.

CHARLES, J. A. 'The First Sheffield Plate', *Antiquity*, XLII (1968), 278–85.

KARO, G. *Die Schachtgräber von Mykenai.* Munich, 1930.

MARINATOS, S. 'The "Swimmers" Dagger from the Tholos Tomb at Vaphio', in *Essays in Aegean Archaeology presented to Sir Arthur Evans*, 63–71. Oxford, 1927.

SANDARS, N. K. 'The First Aegean Swords and their Ancestry', *A.J.A.*, LXV (1961), 17–29.

SANDARS, N. K. 'Later Aegean Bronze Swords', *A.J.A.*, LXVII (1963), 117–53.

SNODGRASS, A. *Early Greek Armour and Weapons.* Edinburgh, 1964.

SNODGRASS, A. *Arms and Armour of the Greeks.* London, 1967.

CHAPTER 9: JEWELLERY

BECATTI, G. *Oreficerie antiche dalle minoiche alle barbariche.* Rome, 1955.

BRANIGAN, K. 'Silver and Lead in Prepalatial Crete', *A.J.A.*, LXXII (1968), 219–29.

DAVARAS, C. 'Early Minoan Jewellery from Mochlos', *B.S.A.*, LXX (1975), 101–14.

DEMARGNE, P. 'Bijoux minoens de Mallia', *B.C.H.*, LIV (1930), 404–21.

ERLENMEYER, M.-L. and H. 'Kassitische Goldarbeiten aus dem Schachtgrab III in Mykene', *Kadmos*, III (1964), 177–8.

HIGGINS, R. A. 'The Aegina Treasure Reconsidered', *B.S.A.*, LII (1957), 42–57.

HIGGINS, R. A. *Greek and Roman Jewellery*. London, 1961.
A comprehensive summary with bibliography and references.

HOLLAND, L. B. 'Mycenaean Plumes', *A.J.A.*, XXXIII (1929), 173–205.

HOPKINS, C. 'The Aegina Treasure', *A.J.A.*, LXVI (1962), 182–4.

KARO, G. *Die Schachtgräber von Mykenai*. Munich, 1930.

MARSHALL, F. H. *Catalogue of the Jewellery, Greek, Etruscan and Roman, in the Department of Antiquities, British Museum*. London, 1911.

MAXWELL-HYSLOP, K. R. *Western Asiatic Jewellery c. 3000–612 B.C.* London, 1971.

MEURER, M. 'Der Goldschmuck der mykenischen Schachtgräber', *J.d.I.*, XXVII (1912), 208–27.

ROSENBERG, M. *Geschichte der Goldschmiedekunst auf technischer Grundlage: Granulation*. Frankfurt, 1918.

ROSENBERG, M. *Niello*, I, *Bis zum Jahre 1000 nach Chr.* Frankfurt, 1924.

CHAPTER 10: SEALS AND GEMS

1. General

BENSON, J. L. 'Aegean and Near Eastern Seal Impressions from Cyprus', in S. S. Weinberg (ed.), *The Aegean and Near East, Studies Presented to Hetty Goldman*, 59–77. New York, 1956.

BETTS, J. H. 'Dating Sealstones in LM/LH', *London Myc. Seminar*, 1 November 1967, 341–2; *London Institute of Classical Studies Bulletin*, XV (1968), 142.

BIESANTZ, H. *Kretisch-mykenische Siegelbilder*. Marburg, 1954.
Some suggestive ideas.

BOARDMAN, J. *Greek Gems and Finger Rings*. London, 1970.
An excellent and well documented survey.

Corpus der Minoischen und Mykenischen Siegel, I–, edited by F. Matz and H. Biesantz. Berlin, 1964–.

EVANS, A. J. *P.M.*, *passim* and index, 164–94.
Still basic.

FRANKFORT, H. *Cylinder Seals*. London, 1939.

FURTWÄNGLER, A. *Die Antiken Gemmen*. Leipzig and Berlin, 1900.

KARO, G. 'Mykenische Gemmen und Ringe', *Ath. Mitt.*, XXXV (1910), 178–82.
First attempt at a chronological survey of Minoan and Mycenaean seals.

KENNA, V. E. G. *Cretan Seals, with a Catalogue of the Minoan Gems in the Ashmolean Museum*. Oxford, 1960.

2. Crete

ALP, S. *Zylinder- und Stempsiegel aus Karahöyük bei Konya*. Ankara, 1968.

BETTS, J. H. 'Some Unpublished Knossos Sealings and Sealstones', *B.S.A.*, LXII (1967), 27–45.

BETTS, J. H. 'New Light on Minoan Bureaucracy: A Re-examination of Some Cretan Sealings', *Kadmos*, VI (1967), 15–40.

BETTS, J. H. 'Trees in the Wind on Cretan Sealings', *A.J.A.*, LXXII (1968), 149–50.

BETTS, J. H. 'Ships on Minoan Seals', *Colston Papers*, XXIII, 325–38. London, 1971.

BIESANTZ, H. 'Die minoischen Bildnisgemmen', *Marburger Winckelmann-Programm* (1958), 9–25.

BRANIGAN, K. 'Minoan Foot Amulets and their Near Eastern Counterparts', *Studi Micenei*, XI (1970), 7–23.

CHAPOUTHIER, F. 'La glyptique crétoise et la continuité de la civilisation minoenne', *B.C.H.*, LXX (1946), 78–90.

CHAPOUTHIER, F. 'De l'origine du prisme triangulaire dans la glyptique minoenne', *B.S.A.*, XLVI (1951), 42–4.

ERLENMEYER, H., and ZAI-BÖRLIN, H. 'Von minoischen Siegeln', *Antike Kunst*, IV (1961), 9–20.

GILL, M. A. V. 'The Knossos Sealings: Provenance and Identification', *B.S.A.*, LX (1965), 58–98.

GILL, M. A. V. 'On the Authenticity of the M.M. Half-Cylinder, Oxford 1938.790', *Kadmos*, VI (1967), 114–18.

GILL, M. A. V. 'The Minoan "Frame" on an Egyptian Relief', *Kadmos*, VIII (1969), 85–102.

GRUMACH, E. 'Das Achtseitige Siegel des Ashmolean Museums 1938.1166', *Kadmos*, II (1963), 84–97.

HOGARTH, D. G. 'The Zakro Sealings', *J.H.S.*, XXII (1902), 76–93.

HOGARTH, D. G. 'Note on Two Zakro Sealings, *B.S.A.*, XVII (1910–11), 264–5.

HUGHES, H. M. C., and WARREN, P. 'Two Sealstones from Mochlos', *K.Ch.* (1963), 352–5.

KENNA, V. E. G. 'Some Eminent Cretan Gem-Engravers', in G. M. A. Hanfmann (ed.), *Festschrift für Friedrich Matz*, 4–13. Mainz, 1962.

KENNA, V. E. G. 'Seals and Script', *Kadmos*, I (1962), 1–15; II (1963), 1–6; III (1964), 29–57.

KENNA, V. E. G. 'The Seals of Kalyvia Messara', *K.Ch.* (1963), 327–38.

KENNA, V. E. G. 'The Historical Implications of Cretan Seals', *A.A.* (1964), 911–54.

KENNA, V. E. G. 'Ancient Crete and the Use of the Cylinder Seal', *A.J.A.*, LXXII (1968), 321–36.

KENNA, V. E. G. *The Cretan Talismanic Stone in the Late Minoan Age* (Studies in Mediterranean Archaeology, XXIV). Lund, 1969.

KENNA, V. E. G. 'Economy in the Middle Minoan Age', *A.A.A.*, V (1972), 255-8.

LEVI, D. 'Le cretule di Haghia Triada' and 'Le cretule di Zakro', *Annuario*, VIII-IX (1929), 71-201.

LEVI, D. 'L'archivio di cretule a Festòs', *Annuario*, XXXV-XXXVI (1957-8), 7-192.

MARINATOS, S. 'Minoische Porträts', in *Max Wegner Festschrift*, 9-12. Münster, 1962.

MATZ, F. *Die frühkretischen Siegel*. Berlin and Leipzig, 1928.
 Still basic for the earlier Cretan seals.

PINI, I. 'Weitere Bemerkungen zu den minoischen Fussamuletten', *Studi Micenei*, XV (1972), 179-87.

PLATON, N. 'Mia sfragistiki idiorrithmia tis proanaktorikis minoikis periodhou', in G. M. A. Hanfmann (ed.), *Festschrift für Friedrich Matz*, 14-18. Mainz, 1962.

WARREN, P. 'The Primary Dating Evidence for Early Minoan Seals', *Kadmos*, IX (1970), 29-37.

XENAKI-SAKELLARIOU, A. *Les cachets minoens de la Collection Giamalakis* (Études crétoises, X). Paris, 1958.

XENAKI-SAKELLARIOU, A. 'Sur le cachet prismatique minoen', in *Minoica. Festschrift zum 80. Geburtstag von J. Sundwall*, 451-60. Berlin, 1958.

3. The Cyclades

BUCHANAN, B. *Catalogue of Ancient Near Eastern Seals in the Ashmolean Museum*, I, *Cylinder Seals*. Oxford, 1966.

ZAZOFF, P. 'Gemmen in Kassel', *A.A.* (1965), 6 ff.

ZAZOFF, P. *Antike Gemmen in Deutschen Sammlungen*, III, 187-90. Wiesbaden, 1970.

4. The Mainland

BOARDMAN, J. 'The Danicourt Ring', *Revue Archéologique* (1970), I, 3-8.

KENNA, V. E. G. 'Seals and Sealstones from the Tombs of Perati', in *Charistirion eis A. K. Orlandon*, II, 320-6. Athens, 1966.

SAKELLARIOU, A. *Mikinaiki Sfragidhoglifia*. Athens, 1966.
 An important study of Mycenaean seals. In modern Greek.

WIENCKE, M. HEATH. 'Early Helladic Clay Sealings from the House of the Tiles at Lerna', *Hesperia*, XXVII (1958), 81-121.

WIENCKE, M. HEATH. 'Further Seals and Sealings from Lerna', *Hesperia*, XXXVIII (1969), 500-21.

WIENCKE, M. HEATH. 'Banded Pithoi of Lerna III', *Hesperia*, XXXIX (1970), 94-110.

YOUNGER, J. G. 'The Vapheio Gems: a Reconsideration of the Find-Spots', *A.J.A.*, LXXVII (1973), 338-40.

LIST OF ILLUSTRATIONS

All dates are B.C. The location of a work is given in italic, the sources of drawings and photographers' names in parentheses. Where no photographer's name is quoted, the location is also the source of the photograph.

the Cyclades, but found in Attica. Late Helladic III C, c. 1150. Clay. H 0.243 m. *Copenhagen, National Museum* (Department of Near Eastern and Classical Antiquities)

23. Jar with pair of griffins and their nest from Lefkandi. Late Helladic III C, c. 1150. Clay. H 0.183 m. *Khalkis Museum* (British School at Athens, courtesy Mervyn Popham)

24. Rectangular coffin with gabled lid, decorated with papyrus plants, water birds, and fish, from Vasiliki Anoyia in the Mesara. Late Minoan III A, c. 1350. Clay. *Herakleion Museum* (Hirmer Fotoarchiv, Munich)

25. Bathtub used as coffin from a tomb at Pakhiammos near Gournia. Late Minoan III A, c. 1350. Clay, H 0.48 m. *Herakleion Museum* (Courtesy Peter Clayton)

26. Side of a rectangular coffin from Tanagra. Late Helladic III C, c. 1150. L 0.69 m. H 0.43 m. *Private Swiss Collection* (Courtesy Mrs E. Vermeule, Boston, Mass.)

27. Saffron Gatherer fresco from the palace at Knossos. Shown as restored by Evans, but the boy is in fact a monkey [cf. 28]. Probably Middle Minoan III A, c. 1700–1600. c. 0.46×0.25 m. *Herakleion Museum* (*P.M.*, I, plate iv)

28. Saffron Gatherer fresco from the palace at Knossos [cf. 27] restored with a monkey (after Hood, *The Minoans*, figure 39)

29. Head of a charging bull on fragment of a wall-painting from the palace at Knossos. Probably Middle Minoan III B, c. 1600. 0.157×0.099 m. *Herakleion Museum* (Courtesy Professor M. A. S. Cameron)

30. Group of spectators on fragment of a wall-painting from the same area as illustration 29. Probably Middle Minoan III B, c. 1600. 0.016×0.011 m. *Herakleion Museum* (Courtesy Professor M. A. S. Cameron)

31. Wall-paintings in the House of the Frescoes at Knossos as restored by M. Cameron (*B.S.A.*, LXIII (1968), 26, figure 13)

32. Blue bird fresco (restored) from the House of the Frescoes at Knossos. Late Minoan I A, c. 1550. H 0.60 m. *Herakleion Museum* (Leonard von Matt, Buochs)

33. Crocuses on fragments of wall-painting from the House of the Frescoes at Knossos. Late Minoan I A, c. 1550. 0.13×0.073 m., 0.12×0.117 m. *Herakleion Museum* (Courtesy Professor M. A. S. Cameron)

34. Cat stalking a pheasant-like bird on a wall-painting from Ayia Triadha. Late Minoan I A, c. 1550. H 0.395 m. *Herakleion Museum* (Photo Hassia, Paris)

35. Richly dressed women, apparently goddesses, seated on rocks in (A) a wall-painting from Phylakopi and (B) a relief fresco from Pseira. c. 1500. *Athens,*

National Museum, and Herakleion Museum (*P.M.*, III, 43, figure 26; 28, figure 15A)

36. Spring fresco, with swallows and red lilies, from Akrotiri on Thera. Late Minoan I A, c. 1550. *Athens, National Museum* (TAP Service, Athens, courtesy the late Professor S. Marinatos)

37. White lilies on a fragmentary wall-painting from Amnisos. Probably Late Minoan I B, c. 1500. H c. 1.80 m. *Herakleion Museum* (Leonard von Matt, Buochs)

38. Priestess on a wall-painting from Akrotiri on Thera. Late Minoan I A, c. 1550. *Athens, National Museum* (TAP Service, Athens, courtesy the late Professor S. Marinatos)

39. Blue monkey on a wall-painting from Akrotiri on Thera. Late Minoan I A, c. 1550. *Athens, National Museum* (TAP Service, Athens, courtesy the late Professor S. Marinatos)

40. Partridge fresco in the Caravanserai at Knossos, as restored by Evans (*P.M.*, II, 117, figure 55)

41. Partridge frieze from the Caravanserai at Knossos. Section as restored showing partridges and a hoopoe. Possibly Late Minoan I B, c. 1500. H 0.28 m. *Herakleion Museum* (*P.M.*, II, part I, frontispiece)

42. (A) and (B) Heads of men in the Palanquin fresco from the palace at Knossos. c. 1500. *Herakleion Museum* (M. Cameron, *A.A.* (1967), 337, figure 6, A, E)

43. Chariot scene associated with the Palanquin fresco as restored by M. Cameron (*A.A.* (1967), 340, figure 12)

44. Taureador fresco from the palace at Knossos. Restored panel, one of a series, with bull-leaping scenes. Probably Late Minoan II, c. 1450. H with borders c. 0.70 m. *Herakleion Museum* (Leonard von Matt, Buochs)

45. Fragments of wall-paintings from Knossos showing woven designs on dresses: (A) bull's head, (B) sphinx, (C) griffin, and (D) possible quivers. Late Minoan I, c. 1550–1450. *Herakleion Museum* (*P.M.*, III, 41, figure 25, a, d, e; 39, figure 23)

46. Spectators by a shrine, restored miniature fresco from the palace at Knossos. Probably Late Minoan II, c. 1450. H without border c. 0.26 m. *Herakleion Museum* (Courtesy Professor M. A. S. Cameron)

47. Miniature fresco with ships from the West House at Akrotiri on Thera. Late Minoan I A, c. 1550. H c. 0.40 m. *Athens, National Museum* (TAP Service, Athens)

48. Charging bull painted on the back of a crystal plaque from the palace at Knossos. Probably Late Minoan I, before c. 1450. H 0.055 m. *Herakleion Museum* (George Xylouris, Herakleion)

49. Cup-bearer fresco from the palace at Knossos. Probably Late Minoan II, c. 1450. H 1.194 m. *Herakleion Museum* (Courtesy Professor M. A. S. Cameron)

50. Frescoes from Knossos: (A) 'sacral ivy' from the

71. Figurines of the earlier Bronze Age, (A)–(H) from the Cyclades, Early Cycladic, before *c.* 2000, marble, (I) from Crete, probably Middle Minoan I, *c.* 2000, clay: (A) Schematic, probably female, from Antiparos (B) Male of the Plastiras type from Antiparos (C) Male of the Plastiras type (D) Male related to the Folded-arm type (like G and H) from Syros (E) and (F) Females of the Folded-arm type from Amorgos and Syros (G) and (H) Male pipes player and apparently male harp player from Keros (I) Female in long robe from Chamaezi ((A)–(H) after C. Zervos, *L'art des Cyclades* . . ., plates 58, 105, 43, 253, 107, 254, 302, 333; (I) after Zervos, *A. Cr.*, plate 224)

72. Female figurine of the Folded-arm type from Amorgos. Early Cycladic II, *c.* 2400. White marble. H 0.257 m. *Athens, National Museum* (TAP Service, Athens)

73. Head of a statuette from Amorgos. Probably Middle Cycladic, *c.* 2000–1500. White marble. H 0.095 m. *Oxford, Ashmolean Museum*

74. Plaques with figures of men, (A) in a boat, (B) hunting deer, (C) fighting or dancing, from Korfi t'Aroniou, Naxos. Apparently Early Cycladic, before *c.* 2000. Marble. *Naxos Museum* (after C. Doumas, *A. Delt.*, xx (1965), 53, figures 7, 6, 11)

75. Male head from Monastiriako Kefali, Knossos. Probably Middle Minoan II–III, *c.* 1800–1550. White limestone. *Herakleion Museum* (after R. W. Hutchinson, *Prehistoric Crete*, plate 14, *a*)

76. Anchor with octopuses in relief from the palace at Knossos. Probably Late Minoan I, *c.* 1550–1450. Purple gypsum. H 0.41 m. *Herakleion Museum* (after *P.M.*, IV, figure 635)

77. Shaft grave circle A at Mycenae (*B.S.A.*, xxv (1921–3), plate xviii)

78. Stele V from shaft grave V at Mycenae with relief of chariot. Late Helladic I, *c.* 1550. H 1.34 m. *Athens, National Museum* (Josephine Powell, Rome)

79. Hexagonal box from shaft grave V at Mycenae. Probably Late Helladic I, *c.* 1550. Wood, mounted with gold plaques decorated in repoussé. H *c.* 0.085 m. *Athens, National Museum* (TAP Service, Athens)

80. Spiral design on a stele from shaft grave circle A at Mycenae (H. J. Kantor, *op. cit.*, plate IV, G)

81. Latest of the carved stelai from shaft grave circle A at Mycenae. *c.* 1500. H 1.12 m. *Athens, National Museum* (A. Evans, *The Shaft Graves and Bee-hive Tombs of Mycenae*, 55, figure 42)

82. The Lion Gate at Mycenae. Late Helladic III, before *c.* 1200. Limestone (Hirmer Fotoarchiv, Munich)

83. Head of goddess or sphinx from Mycenae. Probably Late Helladic III B, *c.* 1250. Plaster with painted decoration. H 0.168 m. *Athens, National Museum* (Hirmer Fotoarchiv, Munich)

84. Slab carved in the shape of a warrior or armed goddess from Soufli Magula, Thessaly. Possibly very late Bronze Age, *c.* 1200 or later. Stone. H *c.* 2.00 m. *Larissa Museum* (Courtesy C. J. Gallis)

85. Figurine of a man in a loincloth with a dagger from a sanctuary on Petsofa. Middle Minoan I–II, *c.* 2000 or somewhat later. Clay. H 0.175 m. *Herakleion Museum* (Leonard von Matt, Buochs)

86. Heads of female figurines from Piskokefalo. Probably Middle Minoan III, *c.* 1700 or later. Clay. H 0.08, 0.075 m. *Herakleion Museum* (George Xylouris, Herakleion)

87. Head, apparently of a woman, from Mochlos. Middle Minoan III, *c.* 1600. Clay. *Herakleion Museum* (*Mochlos*, 49, figure 21)

88. Model of a shrine with offerings being presented to divine couples from Kamilari. Probably Middle Minoan III, *c.* 1700 or later. Clay. *Herakleion Museum* (D. A. Harissiadis, Athens)

89. Clay goddesses of the Late Bronze Age, (A) a statue, (B)–(D) figurines with bodies made on the fast wheel: (A) From Ayia Irini on Kea. Late Cycladic I, *c.* 1550–1450 (after *Hesperia*, XXXIII (1964), plate 61) (B) From Kannia (Mitropolis) in the Mesara. Probably Late Minoan IB, *c.* 1500–1450 (after *Bollettino d'Arte*, III (1959), 261, figure 34) (C) From the palace at Knossos. Probably Late Minoan IIIA, *c.* 1375 or later (after *P.M.*, II, 340, figure 193) (D) From the citadel at Mycenae, with attendant snake. Late Helladic IIIB, *c.* 1250 (after Lord William Taylour, in *Antiquity*, XLIII (1969), plates xii, *b* and ix, *b*)

90. Upper part of a statue of a goddess from Ayia Irini on Kea. Probably Late Cycladic I, *c.* 1500. Clay. H preserved 0.535 m. *Kea Museum* (Courtesy Professor J. L. Caskey)

91. Top of a goddess from Kannia (Mitropolis) in the Mesara. Probably Late Minoan I, *c.* 1500. Clay. *Herakleion Museum* (Leonard von Matt, Buochs)

92. Goddess with poppy-headed pins in her diadem from Gazi. Probably Late Minoan IIIA, *c.* 1350. Clay. H 0.79 m. *Herakleion Museum* (Leonard von Matt, Buochs)

93. Goddess from the refuge settlement on Karfi. Subminoan, after *c.* 1050. Clay. H 0.86 m. *Herakleion Museum* (Leonard von Matt, Buochs)

94. Figurines: (A) Phi type, (B) Tau type, and (C) Psi type. Late Helladic III, after *c.* 1400. Clay (after Higgins, *Min. Myc. Art*, figures 149–51)

95. Bull from Phaistos. Late Minoan IIIC, after 1200. Clay, both horns and three legs restored. H without horns *c.* 0.35 m. *Herakleion Museum* (George Xylouris, Herakleion)

96. Figurine of a woman standing in worship, allegedly from the Troad, but of Cretan origin. Late Minoan I, before *c.* 1450. Bronze. H 0.184 m. *(West) Berlin, Staatliche Museen der Stiftung Preussischer Kulturbesitz (Antikenabteilung)* (Staatsbibliothek, Berlin)

leion Museum, Paris, Louvre, and Athens, National Museum (P.M., 11, 778, figure 506; H. J. Kantor, *op. cit.,* plates XXII, J, F; XXIV, I)

123. Statuette, apparently of a goddess, from the palace at Knossos. Middle Minoan IIIB, *c.* 1600. Faience. H 0.295 m. *Herakleion Museum* (Josephine Powell, Rome)

124. Plaque with a goat suckling her young from the palace at Knossos. Middle Minoan IIIB, *c.* 1600. Faience. L 0.195 m. *Herakleion Museum* (Leonard von Matt, Buochs)

125. Vases from the Temple Repositories at Knossos. Middle Minoan IIIB, *c.* 1600. Faience. *Herakleion Museum (P.M.,* I, 499, figure 357)

126. Vase in the shape of an argonaut shell from the palace at Zakro. Late Minoan I, before *c.* 1450. Faience. *Herakleion Museum* (Courtesy Professor N. Platon)

127. Spouted jar from the Central Treasury at Knossos. Probably Late Minoan I, before *c.* 1450. Faience. *Herakleion Museum (P.M.,* 11, 825, figure 541, *b*)

128. (A) Jar from Paros. Probably Early Cycladic I, *c.* 2500 or earlier. White marble. *Athens, National Museum* (after C. Zervos, *L'art des Cyclades . . .,* plate 6) (B) Cup from Mycenae shaft grave IV. Probably Cretan work of Middle Minoan III–Late Minoan I, *c.* 1600-1500. White marble-like stone. *Athens, National Museum* (after Marinatos and Hirmer, plate 213)

129. Cosmetic jar in the shape of a granary complex, apparently from Phylakopi. Early Cycladic I–II, *c.* 2500. Serpentine. H 0.10 m. *Munich, Museum of Antiquities* (Studio Koppermann, Gauting)

130. Cosmetic jar with lid from Maroneia. Early Minoan II, *c.* 2500. Chlorite. *Herakleion Museum* (H. J. Kantor, *op. cit.,* plate 11, F)

131. Lid with dog handle from Mochlos. Early Minoan II, *c.* 2500. Chlorite. *Herakleion Museum (Mochlos,* 21, figure 5)

132. (A) 'Bird's Nest' and (B) 'Blossom' bowls from Crete. Stone (after Hood, *The Minoans,* figure 79)

133. (A) Vase with a pair of incised doves and holes for inlays from the earlier palace at Phaistos. Probably Middle Minoan II, *c.* 1800. Black serpentine. *Herakleion Museum* (B) Jar from the palace at Knossos. Middle Minoan IIIA, *c.* 1700-1600. Brown limestone with white inlays. *Herakleion Museum* (after Zervos, *A. Cr.,* plates 381, 418)

134. Bowl with open spout and handle in the form of a duck's head from shaft grave circle B at Mycenae. Probably Middle Minoan III, after *c.* 1700. Rock-crystal. L 0.132 m. *Athens, National Museum* (D. A. Harissiadis, Athens)

135. (A) and (B) Libation vessels shaped like the heads of a bull and a lioness and (C) triton shell vase from Knossos. Late Minoan I, before *c.* 1450. Serpentine,

limestone, and Egyptian alabaster. *Herakleion Museum (Archaeologia,* LXV (1914), 83, figure 90, and 85, figure 91; *P.M.,* IV, 823, figure 539)

136. Octopus on a vase fragment from the Throne Room at Knossos. Late Minoan I, before *c.* 1450. Chlorite. *Herakleion Museum (P.M.,* 11, 503, figure 307)

137. The Chieftain Cup from the palace at Ayia Triadha. Middle Minoan III–Late Minoan I, *c.* 1650-1500. Serpentine. H 0.115 m. *Herakleion Museum* (Photo Hassia, Paris)

138. The Harvester Vase, upper part of a libation vessel in the shape of an ostrich egg, from the palace at Ayia Triadha. Middle Minoan III–Late Minoan I, *c.* 1650-1500. Serpentine. H preserved 0.096 m. *Herakleion Museum* (Leonard von Matt, Buochs)

139. The Boxer Rhyton, fragmentary conical libation vase from the palace at Ayia Triadha. Middle Minoan III–Late Minoan I, *c.* 1650-1500. Serpentine. H without handle 0.465 m. *Herakleion Museum* (Hirmer Fotoarchiv, Munich)

140. Pear-shaped libation vase from the palace at Zakro, with reliefs of a peak sanctuary. Middle Minoan III–Late Minoan I, *c.* 1650-1500. Chlorite. H without neck 0.311 m. *Herakleion Museum* (Courtesy Professor N. Platon)

141. Pear-shaped libation vase from the palace at Zakro. Late Minoan I, before *c.* 1450. Rock-crystal. *Herakleion Museum* (Leonard von Matt, Buochs)

142. Egyptian stone bowl of the Protodynastic period (early third millennium) transformed into a spouted jar of Cretan type in Middle Minoan III–Late Minoan I, *c.* 1650-1500. From the palace at Zakro. Porphyritic rock with white crystals. H 0.173 m. *Herakleion Museum* (George Xylouris, Herakleion)

143. 'Sacral ivy' on a pedestal lamp from Knossos. Late Minoan I, before *c.* 1450. Antico rosso. *Herakleion Museum (P.M.,* I, 345, figure 249)

144. Early Aegean plate: (A) Bowl from Amorgos. Early Cycladic I–II, *c.* 2500. Silver. *Oxford, Ashmolean Museum* (after C. Renfrew and J. A. Charles, *A.J.A.,* LXXI (1967), plate 10, no. 17) (B) and (C) Bowls allegedly from Euboea. Probably Early Bronze Age, *c.* 2500. Silver and gold. *Athens, Benaki Museum* (after P. Demargne, *Aegean Art,* plates 31, 32) (D) 'Sauceboat' drinking cup allegedly from Heraia, Arcadia. Early Helladic II, *c.* 2500-2100. Gold. *Paris, Louvre* (after S. Weinberg, *Antike Kunst,* XII (1969), 8, plate i(1)) (E) Two-handled cup with scalloped rim from Gournia. Middle Minoan IB–IIA, *c.* 2000-1800. Silver. *Herakleion Museum* (after H. B. Hawes, *Gournia,* plate C.1)

145. (A) and (B) Two-handled cup and bowl from Tôd, Upper Egypt. Probably Middle Minoan IB, *c.* 2000-1900. Silver. *Paris, Louvre* (after Hood, *The Minoans,* figure 16)

grave circle B at Mycenae. Possibly Cretan work of Middle Minoan IIIB, c. 1600-1550. Gold. Greatest W 0.079 m. *Athens, National Museum* (Hirmer Fotoarchiv, Munich)

174. Lion chasing a panther on a pommel from shaft grave IV at Mycenae. c. 1550-1500. Gold. *Athens, National Museum* (*S.G.*, plate lxxviii, no. 295)

175. Dagger hilts: (A) From Mochlos. Probably Middle Minoan III, after c. 1700. Bronze. *Herakleion Museum* (after *Mochlos*, 62, figure 31) (B) From the shaft graves at Mycenae. Middle Minoan IIIB-Late Minoan IA, c. 1600-1500. Bronze, with gold plated hilt inlaid with lapis lazuli and rock crystal. *Athens, National Museum* (after *S.G.*, plate lxxxvii left) (C) From the shaft graves at Mycenae. Late Helladic I, c. 1550-1500. Ivory with gold pins. *Athens, National Museum* (after *S.G.*, plate lxxxvii right)

176. (A) Horses on a sword and (B) griffin on a dagger from shaft graves IV and V at Mycenae. c. 1550-1500. Bronze. *Athens, National Museum* (G. Perrot and C. Chipiez, *Art in Primitive Greece*, 11, 224, figures 360-1)

177. Dagger blade with lions in relief from Mycenae shaft grave IV. Possibly mainland work of Late Helladic I, c. 1500. Bronze, inlaid with gold and silver against a background of niello; the lions plated with gold. W 0.045 m. *Athens, National Museum* (Hirmer Fotoarchiv, Munich)

178. The Lion Hunt dagger blade from Mycenae shaft grave IV. Perhaps Cretan work of Late Minoan IA, c. 1550-1500. Bronze, inlaid with gold and silver against a background of niello. W 0.063 m. *Athens, National Museum* (Hirmer Fotoarchiv, Munich)

179. Dagger blade inlaid with Nilotic scene from Mycenae shaft grave V. Probably Cretan work of Late Minoan IA, c. 1550-1500. Bronze inlaid with gold and silver against a background of niello. W 0.047 m. *Athens, National Museum* (Hirmer Fotoarchiv, Munich)

180. Dagger with gold-plated hilt, and scenes of large cats hunting on the blade, from a tholos tomb at Routsi in Messenia. Possibly made on the mainland in Late Helladic II-IIIA, c. 1450-1350. Bronze inlaid with gold and silver. L 0.32 m. *Athens, National Museum* (Hirmer Fotoarchiv, Munich)

181 and 182. Plating of sword hilt and pommel from a grave on Skopelos. Late Helladic I-II, c. 1550-1450. Gold. L 0.24 m., D of pommel 0.14 m. *Athens, National Museum* (Hirmer Fotoarchiv, Munich)

183. Sword hilt from Knossos. Late Minoan II, c. 1400. Gold-plated. *Herakleion Museum* (A. J. Evans, *Archaeologia*, LIX (1905), 447, figure 59)

184. Early Aegean jewellery: (A) Plugs for ear or nose from Soufli Magula, Thessaly. Prepottery Neolithic. Polished stone. *Volos Museum* (after Zervos, *Nais.*,

plate 67) (B)-(F) Ring pendants: (B) From Sesklo, Thessaly. Late Neolithic. Gold. *Athens, National Museum* (after C. Tsountas, *Ai Proistorikai Akropoleis Diminiou kai Sesklou*, 250, figure 291) (C) From Dhimini, Thessaly. Late Neolithic. Stone. *Athens, National Museum* (after Zervos, *Nais.*, plate 444) (D) From Amnisos. Assigned to Early Minoan III, c. 2200. Silver. *Herakleion Museum* (after S. Marinatos, *P.A.E.* (1930), 97, figure 9) (E) From Ayios Onoufrios near Phaistos. Probably Middle Minoan, c. 2000 or later. Bronze plated with gold. *Herakleion Museum* (after O. Montelius, *La Grèce préclassique*, 23, figure 87)

185. (A)-(C) Jewellery from Mochlos. Early Minoan II, c. 2500. Gold. *Herakleion Museum* (*Mochlos*, 28, figure 9, 11.3-5; 33, figure 11, 11.24c, 29a, 35, 36; 72, figure 42, XIX.11)

186. Pendants and beads from early Cretan tombs: (A) Bird from Mochlos, crystal, (B) lion from Koumasa, gold with granulation, (C) cylindrical bead from Kalathiana, gold with filigree, (D) animal, probably a seated monkey, from Platanos, ivory, (E) fish from Koumasa, ivory. Early Minoan II-Middle Minoan I, c. 2500-2000 or later. *Herakleion Museum* (after Zervos, *A. Cr.*, plates 201, 203)

187. Early Aegean dress pins: (A) and (B) With spirals and a jug as heads from the Cyclades. Early Cycladic, third millennium. Bronze and silver. *Athens, National Museum* (C) Toggle-pin surmounted by a bird from Lerna. Middle Helladic, early second millennium. Bronze. *Argos Museum* (D) Toggle-pin with flower head from Chrysolakkos, Mallia. Probably Middle Minoan I-II, c. 2000 or later. Gold. *Herakleion Museum* (E) Toggle-pin in the shape of a length of stag's horn and (F) pin surmounted by an ibex with an enlargement of the head from Mycenae shaft grave IV. Probably Late Helladic I, c. 1550-1500. Gold. *Athens, National Museum* (G) Pin with ram's head from the Cyclades. Early Cycladic, third millennium. Silver. *Athens, National Museum* (after *A.E.* (1899), plate 10 (15, 10); J. L. Caskey, *Hesperia*, XXVI (1957), plate 42, *b*; *P.M.*, IV, 75, figure 47; *S.G.*, plate xviii, nos. 246, 245; *A.E.* (1898), plate 8(66))

188. Diadem from Chalandriani on Syros. Possibly c. 2000 or later. Silver. *Athens, National Museum* (C. Zervos, *L'art des Cyclades*, 258)

189. Jewellery from graves at Zygouries (A)-(B) and on Levkas (C)-(F): (A) Gold ring-pendant, (B) silver earring with gold pendant, (C) triple gold rings, probably an earring, (D) gold earring, (E)-(F) silver bracelets. Early Helladic II, c. 2500-2200. *Corinth and Levkas Museums* (after C. W. Blegen, *Zygouries*, plate XX (1, 7); W. Dörpfeld, *Alt-Ithaka*, Beilage 61, 5, Beilage 60, 4, 5, 7, 8)

190. Head-shaped bead in the Jewel fresco from Knossos, now destroyed (*P.M.*, I, 312, figure 231)

191. Bee pendant from the Chrysolakkos funerary complex at Mallia. Probably Middle Minoan IIB–IIIA, *c.* 1800–1600. Gold, with filigree and granulation. W 0.046 m. *Herakleion Museum* (C. M. Dixon, London)

192. Earring from the Aigina Treasure, possibly from the Chrysolakkos funerary complex like illustration 191, and almost certainly Cretan work of Middle Minoan III, *c.* 1700–1550. Gold, with cornelian beads. W 0.065 m. *London, British Museum*

193. Pendant from the Aigina Treasure, possibly from the Chrysolakkos funerary complex like illustration 191, and almost certainly Cretan work of Middle Minoan III, *c.* 1700–1550. Gold. H 0.06 m. *London, British Museum*

194. Ornament in the shape of a crouching lion from Mycenae shaft grave III for contrast with illustration 195. Late Helladic I, *c.* 1550–1500. Gold. L 0.036 m. *Athens, National Museum* (TAP Service, Athens)

195. Ornament in the shape of a crouching lion from a tomb at Ayia Triadha, for comparison with illustration 194. Probably Late Minoan I, *c.* 1550–1450. Gold. L 0.027 m. *Herakleion Museum* (Hirmer Fotoarchiv, Munich)

196. Diadem with attached flowers from Mycenae shaft grave III. Late Helladic I, *c.* 1550–1500. Gold. H *c.* 0.27 m., L 0.625 m. *Athens, National Museum* (TAP Service, Athens)

197. Flower head of a pin from Mycenae shaft grave III. Late Helladic I, *c.* 1550–1500. Gold. W 0.185 m. *Athens, National Museum* (TAP Service, Athens)

198. Hairpins: (A) With crocuses in relief and an inscription down the length from the Mavrospelio cemetery at Knossos. Probably Late Minoan I, before *c.* 1450. Silver. *Herakleion Museum* (after S. Alexiou and W. C. Brice, *Kadmos*, XI (1972), plate ii) (B) and (C) From shaft grave III at Mycenae with burials of women. Late Minoan I or Late Helladic I, *c.* 1550–1500. Bronze with crystal heads. *Athens, National Museum* (after *S.G.*, plate xxxi, nos. 102–3)

199. Head of a silver pin from Mycenae shaft grave III. Possibly Cretan work of Late Minoan IA, *c.* 1550–1500. Gold. H 0.067 m. *Athens, National Museum* (German Archaeological Institute, Athens)

200. Earring from Mycenae shaft grave III. Probably Cretan work of Late Minoan IA, *c.* 1550–1500. Gold. W 0.075 m. *Athens, National Museum* (German Archaeological Institute, Athens)

201. (A) Earring and (B) spiral bead of native types from shaft grave III at Mycenae. Late Helladic I, *c.* 1550. Gold. *Athens, National Museum* (G. Perrot and C. Chipiez, *Art in Primitive Greece*, II, 447, figure 533; 459, tailpiece)

202. Armlet from shaft grave IV at Mycenae. Cretan work of Late Minoan IA, *c.* 1550–1500. Gold and silver. *Athens, National Museum* (after *S.G.*, plate xlii, no. 263)

203. (A)–(I) Cut-outs from the shaft graves at Mycenae. Late Minoan I or Late Helladic I, *c.* 1550–1500. Gold worked in relief, except (I) which is incised. *Athens, National Museum* (after *S.G.*, plates xxvi, nos. 45, 50; lxv, no. 689; xxiv, no. 51; xliv, no. 386; xxvii, nos. 29, 27, 26)

204. (A)–(C) Roundels with incised designs from shaft grave III at Mycenae. Probably Late Helladic I, *c.* 1550–1500. Gold. *Athens, National Museum* (after *S.G.*, plates xxviii, nos. 18, 2; xxix, no. 16)

205. System of making designs with a compass on shaft grave gold ornaments (*S.G.*, 270, figure 106)

206. Earring with granulated pendant from the Mavrospelio cemetery at Knossos. Probably Late Minoan IB–IIIA, *c.* 1500–1300. Gold. L *c.* 0.035 m. *Herakleion Museum* (Hirmer Fotoarchiv, Munich)

207. (A) Gold ring from Phaistos and (B) fish bead from the palace at Knossos with (C) later beads of gold and lapis lazuli from tombs at Knossos. *c.* 1500–1400. *Herakleion Museum* (*Monumenti Antichi*, XIV (1904), 592, figure 53; *P.M.*, III, 411, figure 274; A. J. Evans, *Archaeologia*, LIX (1905), 448, figure 60, 461, figure 80, 466, figure 85, 542, figure 130)

208. Sceptre from a royal tomb of *c.* 1100 at Kourion in Cyprus. Probably made in the Aegean in Late Minoan/Late Helladic III, before *c.* 1200. Gold with enamel. H 0.165 m. *Nicosia, National Museum of Cyprus* (Courtesy the Director of Antiquities and the Cyprus Museum, Nicosia)

209. (A)–(E) Seals from an early circular tomb at Ayia Triadha. Early and Middle Minoan, before *c.* 1700. Ivory and steatite. *Herakleion Museum* (*Annuario*, XIII–XIV (1930–1), 207, figure 95; 213, figure 115; 201, figure 72; 212, figure 112; 210, figure 104)

210. Ivory seals from Crete: (A) Half-cylinder from Knossos. Probably Middle Minoan I, *c.* 2000. *Oxford, Ashmolean Museum* (after M. A. V. Gill, *Kadmos*, VI (1967), 118) (B) Seal in the shape of a dove with her young from Koumasa and (C) knob seal surmounted by a monkey from Trapeza, Lasithi. Early Minoan II–III, *c.* 2500 or later. *Herakleion Museum* (after *P.M.*, I, figure 86, *a*, *b*; Zervos, *A. Cr.*, plate 208)

211. Stamps and cylinders from the mainland and the Cyclades: (A) Stamp from Sesklo, Thessaly. Neolithic. Clay (after Zervos, *Nais.*, figures 296, *a* and 297, *a*) (B) Cylinder from Dikili Tash, Macedonia. Late Neolithic. Clay (after *ibid.*, figure 582) (C) Cylinder seal from Amorgos. Early Cycladic, third millennium. Light grey-green calcite (after B. Buchanan, *Catalogue of Ancient Near Eastern Seals in the Ashmolean Museum*, I, no. 741)

212. Impression from Lerna made by a wooden cylinder. End of Early Helladic II, *c.* 2200. Clay (after

Hesperia, XXXIX (1970), plate 27, S 87)

213. Seals: (A) signet, (B) flattened cylinder, (C) prism with hieroglyphs, (D) façade design on disc, (E) lion-shaped, (F) scarab. Middle Minoan, *c.* 1800–1550. Cornelian, banded agate, rock-crystal, amethyst. *Oxford, Ashmolean Museum* (*P.M.*, I, 275, figure 204, *l*, *m*, *s*; 565, figure 411, *c*; A. J. Evans, *Scripta Minoa*, I, 139, figure 80; *P.M.*, I, 199, figure 147)

214. Three-sided seal with signs of the hieroglyphic script and a cat. Bought in the Lasithi district, but evidently made at some major centre. Probably Middle Minoan IIB–IIIA, *c.* 1800–1600. Cornelian. L. 0.018 m. *Oxford, Ashmolean Museum* (R. A. Wilkins, Oxford)

215. Seal impressions from the mainland and Crete: (A) From Lerna. End of Early Helladic II, *c.* 2100. *Argos Museum* (after *Hesperia*, XXVII (1958), plate 22, S 47) (B)–(D) From the early palace at Phaistos. Probably Middle Minoan IB–IIA, *c.* 1900–1800. *Herakleion Museum* (after *Annuario*, XIX–XX (1957–8), figures 216 T.151, 256 T.191, 283 T.218)

216. (A) and (B) Sealings from the Hieroglyphic deposit at Knossos. Probably *c.* 1700–1600. Clay. *Herakleion Museum* (*P.M.*, I, 273, figure 202, *b*, *e*)

217. Seal impression with the head of a boy from the palace at Knossos. Middle Minoan IIB–IIIA, *c.* 1700–1600. Clay. *Herakleion Museum* (George Xylouris, Herakleion)

218. Impression from a small flattened cylinder seal, engraved with a wild goat and a collared hound, from Arkhanes. Probably Middle Minoan III, *c.* 1700–1550. Chalcedony. L. 0.015 m. *Oxford, Ashmolean Museum* (R. A. Wilkins, Oxford)

219. Sealing from the Isopata royal tomb at Knossos. Late Minoan II, *c.* 1400. Clay. *Herakleion Museum and Oxford, Ashmolean Museum* (*P.M.*, IV, 562, figure 530)

220. (A)–(D) Sealings from the Temple Repositories at Knossos. Middle Minoan IIIB, *c.* 1600. Clay. *Herakleion Museum* (*P.M.*, I, 698, figure 520; *B.S.A.*, IX (1902–3), 56, figure 35, and 59, figures 36, 38)

221. Impression from a talismanic gem, engraved with a jug and leafy spray, from eastern Crete. Middle Minoan III–Late Minoan IA, *c.* 1700–1500. Cornelian. L 0.022 m. *Oxford, Ashmolean Museum* (R. A. Wilkins, Oxford)

222. (A) and (B) Talismanic seals with a lion's mask and a rustic shrine (impression), (C) flattened cylinder from Palaikastro. *c.* 1700–1450. Black hematite, banded agate, steatite coated with gold leaf. *Oxford, Ashmolean Museum* (*P.M.*, I, 673, figure 492, *e*; 674, figure 493, *b*; 675, figure 495, *a*, *b*)

223. (A) Design on a clay matrix from Knossos and (B)–(G) sealings from Zakro. Late Minoan I, before *c.* 1450. *Herakleion Museum* (*P.M.*, IV, 395, figure

331; *J.H.S.*, XXII (1902), 88, figure 29, no. 130; 87, figure 28, no. 112; 79, figure 8, no. 20; 79, figure 10, no. 25; 80, figure 12, no. 34; 83, figure 19, no. 74)

224. (A)–(H) Sealings from Ayia Triadha. Late Minoan I, before *c.* 1450. Clay. *Herakleion Museum* (*Annuario*, VIII–IX (1929), 98, figure 68; 99, figure 70; 101, figure 75; 110, figure 100; 117, figure 117; 123, figure 130; 125, figure 133a; 135, figure 145)

225. Impression from a lentoid seal, engraved with a goddess riding on a dragon, from the area of the Tomb of Clytemnestra at Mycenae. Probably mainland work of Late Helladic II–IIIA, *c.* 1500–1300. Agate. D 0.027 m. *Athens, National Museum* (TAP Service, Athens)

226. Disc-shaped seal with the head of a bearded man from shaft grave circle B at Mycenae. Probably Cretan work of Middle Minoan IIIB–Late Minoan IA, *c.* 1600–1500. Amethyst. D less than 0.01 m. *Athens, National Museum* (Hirmer Fotoarchiv, Munich)

227. Bull's head and bearded man on a seal from Knossos. Late Minoan I, before *c.* 1450. Black steatite. *Herakleion Museum* (*P.M.*, IV, 218, figure 167)

228. (A)–(D) Impressions from gold flattened cylinders and signets from shaft grave circle A and its area at Mycenae. *c.* 1550–1400. *Athens, National Museum* (*P.M.*, I, 691, figure 513; IV, 463, figure 388; 546, figure 507; A. J. Evans, *Mycenaean Tree and Pillar Cult*, 10, figure 4)

229. Bezel of the Danicourt signet ring with a pair of men in combat with lions. Probably mainland work of Late Helladic IIB, *c.* 1450. Gold. L 0.033 m. *Péronne Museum* (R. L. Wilkins, Oxford)

230. Impression from an agate lentoid from the tholos tomb at Vapheio. *c.* 1500–1450. D 0.020 m. *Athens, National Museum* (*P.M.*, IV, 453, figure 378)

231. Impression from a flattened cylinder seal, engraved with a pair of acrobats among flowers, from the Knossos area. Probably Middle Minoan IIIB, *c.* 1600–1550. Chalcedony. L 0.021 m. *Oxford, Ashmolean Museum* (R. A. Wilkins, Oxford)

232. Impression from a lentoid seal, engraved with a pair of acrobats like the Cretan seal of illustration 231, from Mycenae. Late Helladic III, before *c.* 1200. Chalcedony. D 0.0135 m. *Athens, National Museum* (TAP Service, Athens)

233. Impression from a lentoid seal, engraved with a pair of hunters carrying a stag, from Sellopoulo near Knossos. Late Minoan III, before *c.* 1200. *Herakleion Museum* (British School of Archaeology at Athens)

234. Sealing from the palace at Knossos. Late Minoan II, *c.* 1400. Clay. H 0.019 m. *Herakleion Museum* (*P.M.*, IV, 608, figure 597A, *e*)

235. Impressions of seals from tombs at (A) Katsamba

All the drawings (apart from those reproduced direct from other publications) were executed by Patricia Clarke, with the following exceptions: maps and plans of Pylos and Knossos by Donald Bell-Scott; chronological table by Arthur Shelley; illustrations 40 and 78 by Sheila Gibson. Author and publisher are greatly indebted to these artists for their skill and unstinting cooperation, and are also specially grateful to the Trustees of the Estate of the late Sir Arthur Evans for permission to reproduce material from *The Palace of Minos at Knossos* and to the American School of Classical Studies at Athens for allowing the use of material from R. B. Seager, *Explorations on the Island of Mochlos.*

INDEX

For further references to objects in museums,
see under the object's provenance.